In the Beauty of Holiness

IN THE BEAUTY OF HOLINESS

Art and the Bible in Western Culture

David Lyle Jeffrey

WILLIAM B. EERDMANS PUBLISHING COMPANY

GRAND RAPIDS, MICHIGAN

Wm. B. Eerdmans Publishing Co.
4035 Park East Court SE, Grand Rapids, MI 49546
www.eerdmans.com

Hardcover edition 2017
Paperback edition 2022

ISBN 978-0-8028-8320-9

Library of Congress Cataloging-in-Publication Data

Names: Jeffrey, David Lyle, 1941– author.
Title: In the beauty of holiness : art and the Bible in western culture / David Lyle Jeffrey.
Description: Grand Rapids : Eerdmans Publishing Co., 2017. |
 Includes bibliographical references and index.
Identifiers: LCCN 2017027355 | ISBN 9780802883209 (pbk. : alk. paper)
Subjects: LCSH: Christianity and art.
Classification: LCC BR115.A8 J44 2017 | DDC 246—dc23
 LC record available at https://lccn.loc.gov/2017027355

This book is gratefully dedicated to my Baylor

Honors College students and Crane Scholars,

whose lively questions, *fides quarens intellectum*,

have inspired every chapter.

Contents

List of Images ix

Acknowledgments xxi

Introduction 1

PART 1
Art and Worship to 1500

1. Beauty and Holiness as Terms of Art 11

2. The Paradoxical Beauty of the Cross 37

3. Beauty and Proportion in the Sanctuary 59

4. The Beauty of Light 83

5. The Beauty of Holiness Alfresco 104

6. Beauty on the Altar 125

PART 2
Art and the Bible after 1500

7. Beauty, Power, and Doctrine 159

8. Beauty and the Eye of the Beholder 193

9. Romantic Religion and the Sublime 219

10. Art after Belief 253

11. Art against Belief 288

12. Return of the Transcendentals 316

Epilogue 364

APPENDIX A: *Ecclesial Architecture in the Protestant Tradition* 368

APPENDIX B: *Sources for Iconography* 376

APPENDIX C: *Medieval Manuscript Illumination* 379

Bibliography 383

Index 410

List of Images

CHAPTER 1

FIG. 1 Sarcophagus of the Shepherds, Catacomb of Praetextatus, late fourth century CE. Museo Pio Cristiano, Vatican Museums. Photo Credit: Scala / Art Resource, NY.

FIG. 2 *Donna Velata*, Catacomb of Priscilla, Rome, fourth century.

FIG. 3 Jonah Sarcophagus (Jonah and the Whale, resurrection of Lazarus, and other scenes). Early Christian sarcophagus, St. John Lateran, third century. Museo Lateranense, Vatican Museums. Photo Credit: Alinari / Art Resource, NY.

FIG. 4 The Fiery Furnace, Catacomb of Priscilla, Rome, third century.

FIG. 5 Catacomb of Marcellinus and Peter, Rome, third century.

FIG. 6 Wall painting from Dura Europos synagogue, ca. 235 CE. National Museum, Damascus. Photo Credit: www.BibleLandPictures.com / Alamy Stock Photo.

FIG. 7 Illustration of Genesis 3 from *Speculum humanae salvationis*, early fourteenth century. Used by permission of the Museum of the Bible, Washington, DC.

CHAPTER 2

FIG. 8 Sarcophagus with Chi Rho (monogram of Christ) and various scenes from the life of Christ. Early Christian, fourth century CE. Museo Pio Cristiano, Vatican Museums. Photo Credit: Scala / Art Resource, NY.

FIG. 9 Maskell Ivories, ca. 425, Rome. British Museum. © The Trustees of the British Museum. Photo Credit: British Museum Images.

FIG. 10 Mosaic of Jesus the Teacher, Apse of Santa Pudenziana, ca. 400. Rome. Photo Credit: Jozef Sedmak / Alamy Stock Photo.

FIG. 11 Apse Mosaic, Sant' Apollinare in Classe, ca. 549. Ravenna.

FIG. 12 Vatican Cross (*Crux Vaticana*). Reliquary Cross of Justin II (r. 565–578). Byzantine (Constantinople), sixth century CE, with later additions. Museum of the Treasury, St. Peter's Basilica, Vatican. Photo Credit: Scala / Art Resource, NY.

CHAPTER 3

FIG. 13 Roman and Christian basilicas compared.

FIG. 14 Reliquary, Limoges, ca. 1200–1230. British Museum. © The Trustees of the British Museum. Photo Credit: British Museum Images.

FIG. 15 Chalice of Abbot Suger of Saint-Denis, twelfth century. National Gallery, Washington, DC. Courtesy National Gallery of Art, Washington.

FIG. 16 Page from Codex Amiatinus, English, seventh century, Florence, The Biblioteca Medicea Laurenziana, ms. Amiatino 1, f. IIv–IIIr. Reproduced with permission of MiBACT. Further reproduction by any means is prohibited.

FIG. 17 Duke of Sussex Hebrew Bible, MS Parma 2810, fol. 8, Spain, early fourteenth century. © The British Library Board, Add. 15250 ff3v-4.

FIG. 18 Richard of St. Victor, *Commentary on Ezekiel*. © The British Library Board, Harley MS 461.

FIG. 19 Nicholas Lyra, *Postilla super totam Bibliam*, volume 1. Nuremberg edition of 1488. Courtesy Green Collection.

FIG. 20 Ground and elevation plan of Hagia Sophia. Photo Credit: Wikimedia Commons.

FIG. 21 Floor plan of Salisbury Cathedral.

CHAPTER 4

FIG. 22 S. Maria Maggiore, Rome, portal mosaic, added thirteenth century. Photo Credit: Wikimedia Commons, Creative Commons license. Photographer: Matthias Kabel.

FIG. 23 *Bible moralisée*, God as Architect of the Universe, Codex Vindobonensis 2554, fol. 1v, ca. 1220. Austrian National Library, Vienna. © ONB Vienna.

FIG. 24 Saint-Denis Cathedral, nave. Photo Credit: Wikimedia Commons, Creative Commons license. Photographer: Gilles Messian.

FIG. 25 Saint-Denis Cathedral, apse and altar. Photo Credit: Wikimedia Commons, Creative Commons license. Photographer: Bordeled.

FIG. 26 The glass of Sainte Chapelle de Paris. Photo Credit: Wikimedia Commons, Creative Commons license. Photographer: Ed Ogle.

FIG. 27 Rose window of the Upper Chapel of Sainte Chapelle de Paris. Photo Credit: Wikimedia Commons, Creative Commons license. Photographer: Mark Mitchell.

FIG. 28 *Bible moralisée*, MS Codex 1179, fol. 83v, ca. 1220, Austrian National Library, Vienna. © ONB Vienna.

FIG. 29 Sainte Chapelle window series.

CHAPTER 5

FIG. 30 Duccio, *Calling of the Apostles Peter and Andrew*, tempera on panel, ca. 1310. National Gallery, Washington, DC. Courtesy National Gallery of Art, Washington. Photo Credit: Wikimedia Commons.

FIG. 31 Cimabue, *Madonna of the Holy Trinity*, painted around 1260 for the Church of the Trinity (S. Trinita) in Florence. Wood, 385 × 223 cm. Inv. 8343. Uffizi, Florence, ca. 1290–1300. Photo Credit: Scala / Ministero per i Beni e le Attività culturali / Art Resource, NY.

FIG. 32 Giotto, *Dream of Innocent III* fresco, 270 cm × 230 cm, San Francesco, Assisi, ca. 1298. Photo Credit: Wikimedia Commons.

FIG. 33 Giotto, *Stigmata* fresco, upper basilica, San Francesco, Assisi, ca. 1299. Photo Credit: Wikimedia Commons.

FIG. 34 Giotto, *Annunciation* fresco, Arena (Scrovegni) Chapel, Padua, ca. 1308.

FIG. 35 Giotto, *Annunciation* fresco, Arena Chapel, Padua, ca. 1308.

FIG. 36 Giotto, *Baptism of Christ* fresco, Arena Chapel, Padua, ca. 1305.

FIG. 37 Giotto, *Marriage at Cana* fresco, Arena Chapel, Padua, ca. 1305. Photo Credit: Scala / Art Resource, NY.

FIG. 38 Giotto, *The Lamentation of Christ* fresco, Arena Chapel, Padua, ca. 1305. Photo Credit: Scala / Art Resource, NY.

FIG. 39 Giotto, *Pentecost: Descent of the Holy Spirit* fresco, Arena Chapel, Padua, ca. 1305. Photo Credit: Scala / Art Resource, NY.

FIG. 40 Donatello, *Mary Magdalene*, wooden sculpture, originally painted, 1453–1455. Museo dell' Opera del Duomo, Florence. Photo Credit: Wikimedia Commons, Creative Commons license. Photographer: Marie-Lan Nguyen.

FIG. 41 Fra Angelico, *Annunciation* fresco, 230 cm × 321 cm (90.5″ × 132″), ca. 1440–1445. Museo di S. Marco, Florence, Italy. Photo Credit: Scala / Art Resource, NY.

CHAPTER 6

FIG. 42 Altar in the crypt of Notre Dame de la Couture, Le Mans, France, sixth century. Photo Credit: Wikimedia Commons, Creative Commons license. Photographer: Benchaum.

FIG. 43 Rood screen in Sheepstor parish church on Dartmoor, England. Photo Credit: Wikimedia Commons, Creative Commons license. Photographer: Nilfanion.

FIG. 44 Matthias Grünewald, *The Isenheim Altarpiece*, closed, ca. 1515. Crucifixion, saints and entombment (in the predella). Limewood, 269 × 650 cm. Musee d'Unterlinden, Colmar, France. Photo Credit: Erich Lessing / Art Resource, NY.

FIG. 45 *Isenheim Altarpiece*, wings open. Photo Credit: Scala / Art Resource, NY.

FIG. 46 Jan van Eyck, *The Ghent Altarpiece*, closed state: Annunciation, Prophets Zachariah and Micah, Eritrean and Cumean Sibyls, Donors, Saints John the Baptist and John the Evangelist. Saint Bavo Cathedral, Ghent, Belgium, 1432. Photo Credit: Scala / Art Resource, NY.

FIG. 47 *Ghent Altarpiece*, open view: Polyptych with the Adoration of the Mystical Lamb. 1432. Top center: God the Father with John the Baptist and the Virgin. Lower half, center: the adoration of the mystic lamb by angels and by saintly personages from the Old and New Testaments. Side panels: Adam and Eve; pilgrims, hermits. Oil and tempera on wood panels, 11′ 3″ × 14′ 5″. Photo Credit: Erich Lessing / Art Resource, NY.

FIG. 48 *Ghent Altarpiece*, closed state, left panel: the Angel of the Annunciation, from the center of the workday panels. Oakwood, 164.8 × 71.7 cm. Photo Credit: Erich Lessing / Art Resource, NY.

FIG. 49 *Ghent Altarpiece*, closed state, right panel: the Virgin Mary of the Annunciation, from the center of the workday panels. Oakwood, 164.8 × 71.7 cm. Photo Credit: Erich Lessing / Art Resource, NY.

FIG. 50 Rogier van der Weyden, *Annunciation*, ca. 1455, left panel of a triptych, the *Three Kings Altarpiece* (Columba altarpiece), oil on oak, 139.4 × 72.9 cm. Inv. WAF 1190. Alte Pinakothek, Bayerische Staatsgemaeldesammlungen, Munich, Germany. Photo Credit: BPK, Berlin / Alte Pinakothek, Bayerische Staatsgemaeldesammlungen, Munich / Art Resource, NY.

FIG. 51 *Merode Altarpiece*, from the workshop of Robert Campin (Netherland-

ish, ca. 1375–1444 Tournai), oil on wood, overall dimensions (open): 25 3/8″ × 46 3/8″ (64.5 cm × 117.8 cm), center panel 25 1/4″ × 24 7/8″ (64.1 cm × 63.2 cm); side panels 25 3/8″ × 10 3/4″ (64.5 cm × 27.3 cm), ca. 1428. Metropolitan Museum, New York, The Cloisters Collection, 1956. Photo Credit: www.metmuseum.org.

FIG. 52 Botticelli, *Madonna of the Magnificat (Coronation of the Madonna and Child, with Five Angels)*. Tondo, tempera on wood, diameter 118 cm, ca. 1483. Uffizi, Florence, Italy. Photo Credit: Erich Lessing / Art Resource, NY.

FIG. 53 Petrus Christus, *The Virgin of the Dry Tree*, ca. 1465. Oil on panel, 14.7 × 12.4 cm. Inv. N.: 1965.10. Museo Thyssen-Bornemisza, Madrid, Spain. Photo Credit: Museo Thyssen-Bornemisza / Scala / Art Resource, NY.

CHAPTER 7

FIG. 54 Floor plans of St. Peter's Basilica: Old Saint Peter's, Bramante's plan, Michelangelo's plan, and Maderno's plan.

FIG. 55 Michelangelo, *Pietà*, marble, Saint Peter's Basilica, Vatican, 1498–1499. Photo Credit: Wikimedia Commons, Creative Commons license. Photographer: Stanislav Traykov, Niabot (cut out).

FIG. 56 Raphael, *Disputa del Sacramento*, *secco* mural, Stanza della Segnatura, Vatican, ca. 1512. Photo Credit: Wikimedia Commons.

FIG. 57 Michelangelo, *Last Judgment* fresco, Sistine Chapel, Vatican, finished 1541. Photo Credit: Wikimedia Commons.

FIG. 58 Titian, *Saint Mary Magdalene*, oil on panel, 33″ × 27″, Palazzo Pitti, Florence, 1533. Photo Credit: Alfredo Dagli Orti / The Art Archive at Art Resource, NY.

FIG. 59 Lucas Cranach the Elder, *Venus*, mixed media on beechwood panel, ca. 1532. Städelsches Kunstinstitut und Gallerie, Frankfurt am Main.

FIG. 60 Titian, *Sacred and Profane Love (Amor Sacro and Amor Profano)*, oil on canvas, 9′ 2″ × 3′ 10″, ca. 1514. Galleria Borghese, Rome. Photo Credit: Alinari / Art Resource, NY.

FIG. 61 Masaccio, *Expulsion from Eden* fresco, 7′ × 2′ 11″, Brancacci Chapel, S. Maria del Carmine, Florence, ca. 1424–1427. Photo Credit: Wikimedia Commons.

FIG. 62 Giovanni Lanfranco, *Assumption of the Magdalene*, oil on canvas, Capodimonte Museum, Naples, 1605.

FIG. 63 Albrecht Dürer, *Virgin and Child on a Crescent with a Crown of Stars and*

a Scepter, copper plate engraving, 118 mm × 74 mm, ca. 1516. Photograph © 2016, Museum of Fine Arts, Boston.

FIG. 64 Francisco Pacheco, *Immaculate Conception*, 1621. Palazzo Arzobispal, Seville, Spain. Photo Credit: Scala / Art Resource, NY.

FIG. 65 Esteban Murillo, *Walpole Immaculate Conception*, oil on canvas, 67.7″ × 112.2″, 1678. The State Hermitage Museum, St. Petersburg. Photograph © The State Hermitage Museum / photo by Vladimir Terebenin.

FIG. 66 Girolamo da Treviso, *Protestant Allegory*, grisaille with gold highlighting on panel, 26 3/4″ × 33 1/4″, 1543, Royal Collection, London. Royal Collection Trust / © Her Majesty Queen Elizabeth II 2016.

FIG. 67 Lucas Cranach the Younger, *The Crucifixion with the Allegory of Salvation* (central panel). Epitaph-altarpiece of Johann Friedrich the Magnanimous, 1555, painting. Photo Credit: BPK, Berlin / Sts. Peter and Paul, Weimar, Germany / Roland Dreßler / Art Resource, NY.

FIG. 68 Leonardo da Vinci, *Saint John the Baptist*, 1513–1515. Oil on wood, 69 × 57 cm. Louvre (Museum), Paris, France. Photo Credit: Erich Lessing / Art Resource, NY.

CHAPTER 8

FIG. 69 Peter Comestor, biblical paraphrase of 2 Samuel 11, thirteenth-century French translation. Museum Meermano MMW 10B 23, fol. 145r. Museum Meermanno Westreenianum, Den Haag.

FIG. 70 MS Den Haag MMW 10 F 33, penitential psalms, 1524. Museum Meermanno Westreenianum, Den Haag.

FIG. 71 Hans Memling, *Bathsheba Bathing*, mixed media on oak, 1485. Photo Credit: BPK, Berlin / Staatsgalerie, Stuttgart, Germany / Art Resource, NY.

FIG. 72 Luther, *Seven Penitential Psalms*, 1525.

FIG. 73 German Catechism, 1531.

FIG. 74 Lucas Cranach the Elder, *David and Bathsheba*, 1526. Oil on red beech wood, 38.8 × 25.7 cm. Inv. 567 B. Gemäldegalerie, Staatliche Museen, Berlin, Germany. Photo Credit: BPK, Berlin / Jörg P. Anders / Art Resource, NY.

FIG. 75 Zurich Bible, 1536.

FIG. 76 Michael Helding, *Brevis institutio ad Christianum pietatem*, 1548.

FIG. 77 Philipp Melanchthon and Johannes Coglerus, *Imagines elegantissimae*, 1558.

FIG. 78 Jan David, *Christeliicken Waersegger*, 1603. Photo Credit: Open Library.

FIG. 79 Jan Massys, *David and Bathsheba*, oil on wood panel, 63.8″ × 77.6″, 1562. Musée du Louvre, Paris, France. Photo Credit: Alfredo Dagli Orti / The Art Archive at Art Resource, NY.

FIG. 80 Peter Paul Rubens, *Bathsheba at the Fountain*, oil on oakwood, 175 × 126 cm, 1635. Staatliche Kunstsammlungen, Dresden. Photo Credit: Erich Lessing / Art Resource, NY.

FIG. 81 Rembrandt, *Bathsheba at Her Bath*, 1654. Oil on canvas, 142 × 142 cm. MI957. Musée du Louvre, Paris, France. Photo Credit: © Musée du Louvre, Dist. RMN-Grand Palais / Angèle Dequier / Art Resource, NY.

FIG. 82 Rembrandt, *David and Uriah (Haman Recognizes His Fate)*, oil on canvas, 46″ × 50″, 1665. The Hermitage, St. Petersburg, Russia. Photo Credit: Scala / Art Resource, NY.

FIG. 83 Willem Drost, *Bathsheba Receiving David's Letter*, oil on canvas, 40.6″ × 34.3″, 1654. Musée du Louvre, Paris, France. Photo Credit: Gianni Dagli Orti / The Art Archive at Art Resource, NY.

CHAPTER 9

FIG. 84 Caravaggio, *The Incredulity of St. Thomas*, oil on canvas, 42″ × 57″, Sanssouci, Potsdam, 1601–1602. Photo Credit: Wikimedia Commons.

FIG. 85 Nicolas Poussin, *The Baptism of Christ*, 1641–1642, overall: 95.5 × 121 cm (37 5/8 × 47 5/8 in.); framed: 123.8 × 149.9 × 14 cm (48 3/4 × 59 × 5 1/2 in.). Samuel H. Kress Collection. National Gallery of Art, Washington, DC. Courtesy National Gallery of Art, Washington. Photo Credit: National Gallery of Art Images.

FIG. 86 Caspar David Friedrich, *Cross in the Mountains* (the *Tetschener Altar*), 1808. Oil on canvas. Inv. Gal. Nr. 2197 D. Galerie Neue Meister, Staatliche Kunstsammlungen, Dresden, Germany. Photo Credit: BPK, Berlin / Elke Estel / Hans-Peter Klut / Art Resource, NY.

FIG. 87 Caspar David Friedrich, *Monk by the Sea*, 1808–1810. Post 2015 restoration. Oil on canvas, 110 × 171.5 cm. Inv.: NG 9/85. Nationalgalerie, Staatliche Museen, Berlin, Germany. Photo Credit: BPK, Berlin / Andres Kilger / Art Resource, NY.

FIG. 88 Caspar David Friedrich, *Abbey in an Oak Forest*, 1809–1810. Post 2015 restoration. Oil on canvas, 110.4 × 171 cm. Inv.: NG 8/85. Nationalgalerie, Staatliche Museen, Berlin, Germany. Photo Credit: BPK, Berlin / Andres Kilger / Art Resource, NY.

FIG. 89 Caspar David Friedrich, *Morning in the Riesengebirge*, 1810–1811. Oil on canvas, 108 × 170 cm. GK I 6911. Neuer (Schinkel) Pavillon, Charlotten-

burg Castle, Stiftung Preussische Schlösser & Gärten Berlin-Branden-burg, Berlin, Germany. Photo Credit: BPK, Berlin / Neuer (Schinkel) Pa-villon, Charlottenburg Castle, Stiftung Preussische Schlösser & Gärten Berlin-Brandenburg / Jörg P. Anders / Art Resource, NY.

FIG. 90 Caspar David Friedrich, *Wanderer above a Sea of Fog*, ca. 1817. Oil on canvas, 94.8 × 74.8 cm. Inv.: 5161. Hamburger Kunsthalle, Hamburg, Germany. On permanent loan from the Foundation for the Promotion of the Hamburg Art Collections. Photo Credit: BPK, Berlin / Hamburger Kunsthalle, Hamburg / Elke Walford / Art Resource, NY.

CHAPTER 10

FIG. 91 Johann Overbeck, *Jesus Raising the Daughter of Jairus*, ink, watercolor, 1815. Staatliche Museen, Berlin. Photo Credit: BPK, Berlin / Jörg P. An-ders / Kupferstichkabinett, Staatliche Museen, Berlin / Art Resource, NY.

FIG. 92 Johann Overbeck, *The Triumph of Religion in the Arts*, oil, 143.5″ × 143.5″, 1840. Städelsches Kunstinstitut, Frankfurt am Main.

FIG. 93 Peter von Cornelius, *Last Judgment*, oil on plaster, 62″ × 38″, 1836–1840. St. Ludwig's Church, Munich, Germany. Photo Credit: Erich Lessing / Art Resource, NY.

FIG. 94 Dante Gabriel Rossetti, *The Girlhood of Mary Virgin*, 1848–1849, oil on canvas, 83.2 × 65.4 cm. Tate Gallery, London. Photo Credit: © Tate, Lon-don / Art Resource, NY.

FIG. 95 Dante Gabriel Rossetti, *Ecce Ancilla Domini! (The Annunciation)*, 1849–1850. Oil on canvas, 72.4 × 41.9 cm. Purchased 1886. Tate Gallery, Lon-don. Photo Credit: Tate, London / Art Resource, NY.

FIG. 96 William Holman Hunt, *The Finding of the Saviour in the Temple*, oil on canvas, 55 1/2″ × 33 3/4″, 1854–1860. Birmingham Museum and Gallery. Photo © Birmingham Museums Trust.

FIG. 97 Vincent van Gogh, *Still Life with Bible*, oil on canvas, 26″ × 30 1/2″. 1885. By permission of the Van Gogh Museum, Amsterdam (Vincent van Gogh Foundation).

FIG. 98 Vincent van Gogh, *The Sower*, oil on burlap, 29″ × 37″, 1888. E. G. Bührle Collection. © Foundation E. G. Bührle Collection, Zurich.

FIG. 99 Vincent van Gogh, *The Starry Night*, Saint Rémy, June 1889. Oil on can-vas, 29 × 36 1/4″ (73.7 × 92.1 cm). Acquired through the Lillie P. Bliss Bequest. Museum of Modern Art, New York City, NY. Digital image © The Museum of Modern Art / Licensed by Scala / Art Resource, NY.

FIG. 100 Paul Gauguin, *Self-Portrait*, 1889. Oil on canvas, 79.2 × 51.3 cm (31 3/16 × 20 3/16″). Chester Dale Collection, National Gallery of Art, Washington, DC. Courtesy National Gallery of Art, Washington.

FIG. 101 Paul Gauguin, *Vision of the Sermon (Jacob Wrestling with the Angel)*, oil on canvas, 28.4″ × 35.8″, 1888. National Galleries of Scotland, Edinburgh. © Scottish National Gallery.

FIG. 102 Paul Gauguin, *D'où venons-nous? Que sommes-nous? Où allons-nous?*, oil on canvas, 1894. Musée Maurice Denis–Le Prieuré, Saint-Germain-en-Laye, France. Photo Credit: Erich Lessing / Art Resource, NY.

FIG. 103 Maurice Denis, *Mystère Catholique (Catholic Mystery)*, oil on canvas, 28″ × 46″, 1890. Musée Maurice Denis, Paris. © Artists Rights Society (ARS), New York.

FIG. 104 Maurice Denis, *The Women Find Jesus' Tomb Empty (Luke 20:11–18)*, oil on canvas, 29 1/2″ × 39 1/3″, 1894. Musée Maurice Denis–Le Prieuré, Saint-Germain-en-Laye, France. © Artists Rights Society (ARS), New York. Photo Credit: Erich Lessing / Art Resource, NY.

CHAPTER 11

FIG. 105 Grünewald, *Isenheim Altarpiece*, wings closed, central panel. Photo Credit: Erich Lessing / Art Resource, NY.

FIG. 106 Edvard Munch, *Madonna*, 1894–1895. Oil on canvas, 90.5 × 70.5 cm. National Gallery, Oslo, Norway. © 2017 Artists Rights Society (ARS), New York. Photo Credit: Scala / Art Resource, NY.

FIG. 107 Edvard Munch, *Golgotha*, oil, 80 cm × 120 cm, 1900. Munch Museum, Oslo. © 2017 Artists Rights Society (ARS), New York. Photo Credit: Erich Lessing / Art Resource, NY.

FIG. 108 Pablo Picasso, *The Crucifixion*, 1930, oil on plywood, 51.5 × 66.5 cm. MP 122. Photo: René-Gabriel Ojéda. Musée Picasso, Paris. © 2017 Estate of Pablo Picasso / Artists Rights Society (ARS), New York. Photo Credit: © RMN Grand-Palais / Art Resource, NY.

FIG. 109 Pablo Picasso, *Guernica*, 1937, oil, 137.4″ × 305.5″. Museo Nacional Centro de Arte Reina Sofia, Madrid, Spain. © 2017 Estate of Pablo Picasso / Artists Rights Society (ARS), New York. Photo Credit: Art Resource, NY.

FIG. 110 Max Ernst, *Triumph of Surrealism (L'ange du foyer)*, 1937, oil, 114 cm × 146 cm. Private collection. © 2017 Artists Rights Society (ARS), New York / ADAGP, Paris. Photo Credit: Art Resource, NY.

FIG. 111 Max Ernst, *Virgin Mary Spanking the Infant Jesus before Three Witnesses, André Breton, Paul Éluard, and the Artist*, oil, 196 cm × 130 cm, 1926. Mu-

seum Ludwig, Cologne. © 2017 Artists Rights Society (ARS), New York / ADAGP, Paris. Photo Credit: Museum Ludwig, Cologne.

FIG. 112 Jean-François Millet, *The Angelus*, oil on canvas, 55.5 × 66 cm, 1857. Musée d'Orsay, Paris. Photo Credit: Erich Lessing / Art Resource, NY.

FIG. 113 Salvador Dali, *Atavism at Twilight*, oil, 1934. Kunstmuseum, Bern. © Salvador Dalí, Fundació Gala–Salvador Dalí, Artists Rights Society (ARS), New York 2017.

FIG. 114 Salvador Dali, *The Madonna of Port Lligat*, oil on canvas, 59.9, 19.3″ × 14.8″, 1949. Gift of Mr. and Mrs. Ira Haupt. Collection of the Haggerty Museum of Art, Marquette University. © Salvador Dalí, Fundació Gala–Salvador Dalí, Artists Rights Society (ARS), New York 2017.

FIG. 115 Salvador Dali, *Crucifixion–Corpus Hypercubus*, oil on canvas, 76.5″ × 48.7″ (194.3 × 123.8 cm), 1954. Metropolitan Museum, New York. Gift of The Chester Dale Collection, 1955. © Salvador Dalí, Fundació Gala–Salvador Dalí, Artists Rights Society (ARS), New York 2017. Photo Credit: funny.pictures.picphotos.net.

CHAPTER 12

FIG. 116 Georges Rouault, *Girl with Mirror*, 1906, oil on canvas. Musée National d'Art Moderne, Centre Georges Pompidou, Paris. © 2017 Artists Rights Society (ARS), New York / ADAGP, Paris. Photo Credit: Erich Lessing / Art Resource, NY.

FIG. 117 Georges Rouault, *The Clown*, 1907, oil, ink, and watercolor on cut-and-pasted paper on board, 16 × 12 3/4″ (40.6 × 32.4 cm). The William S. Paley Collection. © 2017 Artists Rights Society (ARS), New York / ADAGP, Paris. Photo Credit: Digital Image © The Museum of Modern Art / Licensed by SCALA / Art Resource, NY.

FIG. 118 Georges Rouault, *Head of Christ*, oil on paper, pasted on canvas, 41 3/4″ × 29 1/2″, ca. 1937. Cleveland Museum of Art. Oil on canvas; framed: 128.91 × 99.06 × 8.89 cm (50 3/4 × 39 × 3 1/2 inches); unframed: 104.80 × 75.00 cm (41 1/4 × 29 1/2 inches). The Cleveland Museum of Art, Gift of the Hanna Fund 1950.399. © 2017 Artists Rights Society (ARS), New York / ADAGP, Paris.

FIG. 119 Marc Chagall, *Solitude*, oil on canvas, 1933. Museum of Art, Tel Aviv, Israel. © 2017 Artists Rights Society (ARS), New York / ADAGP, Paris. Photo Credit: Scala / Art Resource, NY.

FIG. 120 Marc Chagall, *The Calling of Ezekiel*, 1952–1956, on vellum paper (imita-

tion), 44.4 × 33.2 cm. AM83-522-3(29). Musee National d'Art Moderne, Centre Georges Pompidou, Paris. Photo: Philippe Migeat. © 2017 Artists Rights Society (ARS), New York / ADAGP, Paris. Photo Credit: © CNAC/MNAM/Dist. RMN–Grand Palais / Art Resource, NY.

FIGS. 121 AND 122 *Chrystus frasiblowiy* wayside sculptures.

FIG. 123 Marc Chagall, *The Yellow Crucifixion*, 1942. Oil on canvas, 140 × 101 cm. AM1988-74. Musee National d'Art Moderne, Centre Georges Pompidou, Paris. Photo: Philippe Migeat. © 2017 Artists Rights Society (ARS), New York / ADAGP, Paris. Photo Credit: © CNAC/MNAM/Dist. RMN–Grand Palais / Art Resource, NY.

FIG. 124 Marc Chagall, *Exodus*, oil on canvas, 50″ × 61″, 1952–1966. Private collection. © 2017 Artists Rights Society (ARS), New York / ADAGP, Paris. Photo Credit: Scala / Art Resource, NY.

FIG. 125 Marc Chagall, *The Sacrifice of Isaac*, 1960–1965. Oil on canvas, 230 × 235 cm. MBMC7. © 2017 Artists Rights Society (ARS), New York / ADAGP, Paris. Photo: Gérard Blot. Musée National Marc Chagall, Nice, France. Photo Credit: © RMN–Grand Palais / Art Resource, NY.

FIG. 126 Marc Chagall, *La branche (The Branch)*, 1950, oil on canvas, 150.1 × 120 cm. © 2017 Artists Rights Society (ARS), New York / ADAGP, Paris. Photo Credit: Banque d'Images, ADAGP / Art Resource, NY.

FIG. 127 Arcabas, *La Nativité*, oil on jute, Polyptych of the Infancy of Christ, 2002, Archepiscopal palace, Malines, Brussels. © 2017 Artists Rights Society (ARS), New York / ADAGP, Paris. Photograph courtesy of the artist.

FIG. 128 Arcabas, *La Nativité*, detail.

FIG. 129 Arcabas, *Visitation*, oil on jute, Polyptych of the Infancy of Christ, 2002, Archepiscopal palace, Malines, Brussels. © 2017 Artists Rights Society (ARS), New York / ADAGP, Paris.

FIG. 130 Arcabas, *Madonna with the Messiah* (L'enfance series), oil on jute, 2002, Archepiscopal Palace, Malines, Brussels. © 2017 Artists Rights Society (ARS), New York / ADAGP, Paris.

FIG. 131 Arcabas, *The Samaritan Woman*, oil on jute, 2002. © 2017 Artists Rights Society (ARS), New York / ADAGP, Paris. Photograph courtesy of the artist.

FIG. 132 Arcabas, Emmaus polyptych, 1993, Chapel of the Piturello di Torre à Rivere, Bergamo. © 2017 Artists Rights Society (ARS), New York / ADAGP, Paris. Photograph courtesy of the artist.

FIG. 133 Arcabas, *The Breaking of the Bread*, Emmaus polyptych, 1993, Chapel of the Piturello di Torre à Rivere, Bergamo. © 2017 Artists Rights Society (ARS), New York / ADAGP, Paris.

FIG. 134 Arcabas, *Disappearance*, Emmaus polyptych, 1993, Chapel of the Pi-

turello di Torre à Rivere, Bergamo. © 2017 Artists Rights Society (ARS), New York / ADAGP, Paris.

APPENDIX A

FIG. 135 Pieter Saenredam, Interior of the Buurkerk, Utrecht. 1645. Oil on panel. 22-7/8 × 20 in. (58.1 × 50.8 cm). AP 1986.09. Kimbell Art Museum, Fort Worth, Texas. Photo Credit: Wikimedia Commons. Source: Google Art Project.

FIG. 136 Jean Perrisin, *Le Temple de Paradis* (Lyon), late sixteenth century. Bibliothèque Publique et Universitaire, Geneva. Courtesy Bibliothèque de Genève.

FIG. 137 Old Baptist Chapel, Tewkesbury, England, seventeenth century.

FIG. 138 Moody Memorial Church, Chicago, interior, early twentieth century.

FIG. 139 First Baptist Church, Amarillo, Texas, narthex, 1929. Used by permission of the Rev. Howard Batson and the Board of FBC Amarillo.

FIG. 140 First Baptist Church, Amarillo, Texas, interior. Used by permission of the Rev. Howard Batson and the Board of FBC Amarillo.

FIG. 141 First Baptist Church, Amarillo, Texas, column detail. Used by permission of the Rev. Howard Batson and the Board of FBC Amarillo.

FIG. 142 First Baptist Church, Amarillo, Texas, courtyard and fountain. Used by permission of the Rev. Howard Batson and the Board of FBC Amarillo.

FIG. 143 Warrior Run Presbyterian Church, Northumberland County, Pennsylvania, interior.

APPENDIX C

FIG. 144 Matthew page, Lindisfarne Gospels, ca. 725, British Museum, London. © The British Library Board, Cotton Nero D IV f25v.

FIG. 145 Elizabeth de Bohun Book of Hours and Psalter, GC MS 000761, ca. 1340, Green Collection. Used by permission of the Museum of the Bible, Washington, DC.

FIG. 146 Rothschild Miscellany, Psalms, ca. 1460–1480, by special courtesy of the Israel Museum, Jerusalem.

Acknowledgments

The project reflected in this book began more than forty-five years ago. During that time I have been preoccupied with literary aspects of biblical tradition, then with its spiritual history in meditative religious reflection and biblical commentary. My interest in the biblical sources of Christian art has been focused intermittently on articles and chapters in collections, beginning with a lecture at the Free University in Amsterdam on an altarpiece by Hieronymus Bosch, his *Hooiwagen* triptych, which was later published in *Viator* in 1971. This essay was subsequently revised and reprinted in my book *Houses of the Interpreter* (Baylor University Press, 2003). But the slow, deliberate preparation of the present book has been more largely shaped by the research I have done directly in connection with a course on art and theology in the Christian West that I have taught over the last twenty years, beginning at Augustine College in Ottawa and then since 2006 here at Baylor University. This course has been concerned with the long experiment in western European Christendom to dedicate beauty to worship, and art to the development as well as communication of doctrine, and this book is a reflection of those interests. Only three chapters borrow and rework material that has appeared previously in articles. I am most indebted in that regard to *Nova et Vetera* (2014) in chapter 2, additionally to the University of Edinburgh Press for permission to reprint a portion of a chapter of the volume edited by Stephen Prickett, *The Edinburgh Companion to the Bible and the Arts* (2014; reproduced with permission of Edinburgh University Press via PLSclear). The germination of chapter 8 began with a short essay for *Seen* (2000) and a longer essay for the University of Toronto Press volume *Sacred and Profane: Essays in Chaucer and Late Medieval Literature* (2010), edited by

Robert Epstein and William Robins. And in chapter 12 my discussion of Marc Chagall draws on my essay published by *Religion and the Arts* (2012). For these borrowings from my own earlier work I wish to acknowledge the graciousness of those publishers. I also wish to thank the Green Collection and Museum of the Bible for their permission to include three images from their collection by courtesy, and one image by courtesy of the Israel Museum.

I have been richly blessed by the friendship and collegial criticism of many scholars in whose shade I gratefully stand. Among those who have provided me with both critique and encouragement over the years, some have passed on to a higher view, including Hans Rookmaaker, E. H. Gombrich, Lynn White Jr., D. W. Robertson Jr., Rosalie B. Green, and Alan Gowans. But my indebtedness to still-living colleagues and mentors is to a larger company: perforce I must be brief. In addition to Bruce Cole, former director of the National Endowment of the Humanities with whom I team-taught a course at the University of Rochester in 1972, and Anthony F. Janson, whose historical scholarship has long been an inspiration, and who graciously acknowledged my modest return on his massive investment in the sixth and seventh editions of his *History of Art*, others whose wisdom is invisibly subsumed here include my former mentor at Princeton, John V. Fleming; former fellow undergraduate student William A. Dyrness; and current colleagues Alexander Pruss, Jeff Fish, Daniel H. Williams, Michelle P. Brown, Mikeal Parsons, Heidi Hornik, Jeff Levin, Tom Hibbs, Elizabeth Corey, Phillip Donnelly, Rod Stark, Byron Johnson, Philip Jenkins, Darin Davis, and Gregory Jones. Colleagues now farther afield who in various ways and to varying degrees have encouraged me thoughtfully over the years include Graeme Hunter, Dominic Manganiello, Michael D. O'Brien, Robert C. Roberts, Eleonore Stump, Jeremy Begbie, Makoto Fujimura, Cameron Anderson, Stephen Westerholm, Stephen Chapman, Reinhardt Hütter, Holly N. Flora, Amy Neff, and John Wilson, the editor of *Books and Culture*. To these I must add the practical help of four of my graduate assistants in philosophy, Karl Aho, Mengyao Yan, Ryan West, and Caroline Paddock; of my daughter Kirstin Jeffrey Johnson, who introduced me to the work of Arcabas in France; and of my honors thesis student Kirsten Appleyard El-Koura, now a curator at the National Gallery of Canada, from whose excellent thesis on Arcabas I have continued to profit. I have been blessed with an attentive and learned editor, James Ernest, and his patient and resourceful associate editor, Jenny Hoffman. Greater than all these thanks, nonetheless, are due to my beloved wife and most persistent intellectual friend, Katherine Bentley

Jeffrey, who reads everything I write perceptively and correctively as an act of charity to all my other readers; without her my congenitally Celtic weave of words and thought could easily obscure what most I would clarify, as both kith and kin can well attest.

* * *

I wish to dedicate this book to my students over the years in the Honors College at Baylor University, a finer lot of lively and engaging minds than I could have wished for or hoped to deserve, and among them especially the Crane Scholars.

DLJ

Introduction

HOW to keep—is there ány any, is there none such, nowhere
 known some, bow or brooch or braid or brace, láce,
 latch or catch or key to kéep
Back beauty, keep it, beauty, beauty, beauty . . . from vanishing
 away?

GERARD MANLEY HOPKINS

For as long as we have evidence, generations of poets and other artists have noted this paradoxical character of beauty, that while mortal beauty arouses in us an infinite longing, we are painfully aware that the sources of such beauty are themselves most finite. The sense of beauty's transience is therefore a recurrent theme in the art that honors it, the work of art itself often an attempt to hold on to beauty, or as the poet puts it, to "keep it . . . from vanishing away." The epigraphic opening of the poem cited above is thus an epitome, its question timeless. In "The Leaden Echo and the Golden Echo" (1882), Gerard Manley Hopkins poses it in the form of a maiden's lament, sung by her as she first perceives herself to be showing the faintest signs of aging. In Hopkins's epigraph her lament is set at St. Winifred's Well in Wales, a healing spring visited by Christian pilgrims since the seventh century. There, the legend has it, a beautiful girl was mortally wounded as she sought to escape the predatory assault of a man whose advances she had rejected. The backstory captures an ageless theme, namely, that the human desire to seize and possess mortal beauty is often deeply disordered and consequently can become ugly, destructive of the beauty to which it was attracted; we may

recognize in this Celtic story an affinity with Ovid's Latin tale of Daphne's flight from the lustful ardor of Apollo, an image made memorable by Bernini's extraordinary sculpture. Hopkins's poem superimposes upon this theme its equally perennial counterpart, a lament over the inevitable decay of all mortal beauty, come what may and despite all that human art may do, and therefore the futility of any imagination that we can suspend time or somehow stave off decay. All flesh is grass, as the prophet says, and wisdom accepts that reality. Calypso's proposition of immortality to Odysseus in Homer's great epic is seen by him at last as chimerical. On this point, too, the poets of biblical and classical tradition agree: all such wishes are both illusory and self-defeating.

There is, however, a perspective on mortal beauty, on the persistence of our desire for it, and for a discovery of what our desire itself may signify, on which artists in the biblical tradition have something else to say. As I shall endeavor to show in this book, artists both Jewish and Christian, though fully aware of the evanescence of beauty in the world, characteristically point us toward possibilities and meanings that substantially extend the horizon and heighten our appreciation of mortal beauty while we have it.

What I intend in this book is an exploration of some of the ways in which a biblical imagination is tutored to receive all beauty as a gift, a gift with a Giver, and thus to refer it, in forms of gratitude that are themselves beautiful, back to the source. This "giving back," as we shall see, has created some of the most beautiful art in Western culture.

Hopkins's image for the first and universal recognition, that beauty is impermanent, is an echo from the well of our common human self-reflection: he calls it a "leaden" echo. This echo is perennial, repeated over and over in song and story, because we are beings who love life and long to keep it, yet are sometimes filled with nostalgia and even remorse because we know full well that such keeping is impossible.

Happily, says the poet, there is another echo. It, too, is repeated distinctively in the painting, poetry, sculpture, and art of biblical tradition. Hopkins calls this echo "golden" because it is luminous and inspiring, transmuting our wistfulness and regret into joy and hope:

Give beauty back, beauty, beauty, beauty, back to God, beauty's self and beauty's giver.

We should acknowledge that the impulse to give beauty back to God may also be universal, though clearly it can take quite different forms. In this Welsh tale the beautiful maiden was not turned into a tree; rather,

her deadly wound was miraculously healed by the monk Saint Bueno, to whose chapel she was fleeing as her would-be lover struck her with his sword. Bearing a large scar on her neck for the rest of her life, she nevertheless lived to enter a convent, there to devote her beauty to holiness in a life of prayer. Hopkins, as a student and teacher of classical literature, was keenly aware of both the parallels and the divergences in classical, Celtic, and Christian tales of metamorphoses such as this one.

If we pursue this line of reflection a little further, we may observe that in the ritual of many religions in past centuries the dedication of virgins to the god or goddess has been a developed form of communal piety, although a closer examination of some ancient practices—in fertility religions especially—will reveal actual rites that seem to turn the ostensible dedication inside out. The offering of infants and young virgins to the gods in sacrifice, so deeply disturbing to a biblical perspective, is likewise found in many places, and not always with the sense of horror that attends the Greek story of Agamemnon's sacrifice of his beautiful daughter Iphigenia in a supposed exchange for favorable winds to sail into battle. Still more horrible was the ancient Canaanite practice of "passing children through the fire" to Moloch; yet this too is recognizably a deviant way of offering beauty—in this case the beauty of innocence—back to the gods.

If we wish to locate biblical sources for a transmutation of sacrifice to the deity, then long before the formal worship of tabernacle and temple we find a hint of it already in the early story of Abraham and Isaac, and an almost-sacrifice of a horrible, Moloch-like nature. How can Abraham offer on the altar, as God has asked, the very apple of his eye, the promised son of his old age on whose life the entirety of God's promise depends? The Akedah ("binding" of Isaac for sacrifice) narrative is charged with tension at least as acute as that in the Iphigenia story, although the tension is released with a last-second substitution, the lamb provided by God. Divine intervention becomes an exemplar, and substitution in many species becomes thereafter normative in biblical tradition.

In biblical tradition, when beauty is given to God it undergoes a metamorphosis, but it is quite different from the metamorphoses we associate with tales of Ovid such as the myth of Daphne and Apollo. Rather than fear and frustrated desire, followed by a dramatic decay of the original beauty as it is absorbed into the vegetable world, in New Testament stories the transformation, at first blush invisible, does not annihilate the original beauty in any way. Strikingly, the love of God for mortal beauty is consummated; in the story of the annunciation, God enters with consent, and as a result of the divine "marriage" human beauty takes on a far greater

radiance than it could otherwise have known. In his poem "The Garden," Andrew Marvel seems to juxtapose the Ovidian and Christian story, deepening the irony: "The gods that mortal beauty chase / Still in a tree did end their race." Here the love is more than *erōs*, the identification so complete that the god will die that mortal souls may live. In the passion, even the ugliness of sin and death is transformed into the beauty of holiness and a promise of new life. A form is transformed, re-formed, in such a way that beauty is not lost but magnified, or to use the biblical term, "glorified." Eventually the whole creation is to share in this metamorphosis: "Behold," the Master Artist says, "I make all things new" (Rev. 21:5).

In Christian tradition, gratitude for the new metamorphosis produces a new art and a new worship, characterized by what I am calling here the beauty of holiness.[1] From the beauty of the *qodesh ha qodeshim* in the tabernacle and later the splendors of Solomon's Temple, it is echoed again in the high vaulted arches, altars, and stained glass windows of the magnificent cathedrals of the Middle Ages, and beyond that in a multitude of expressions: manuscript illumination, painting, the art of the jeweler as well as the architect, and the collaborative arts of poets and musicians. This is the first story I wish to tell, at least in précis: the story of the flourishing of the arts of the holy in Western Christian biblical tradition, and the evolution of ideas and representation of holy beauty over time.

We begin with definitions of the biblical terms for beauty and holiness in chapter 1, in the context of the earliest extant Christian art; the biblical language for beauty, especially in its relation to holiness, will give us indispensable conceptual understanding of the Jewish foundations of Christian aesthetic theology. In chapter 2 we consider the way in which Hellenistic ideas about the place and meaning of beauty are transformed by Augustine of Hippo through his comparative reading of the Jewish and Christian Scriptures into an aesthetic focused not merely on the beauty of objects but, more fundamentally, on beauty as self-giving action. In chapter 3 we come to one of the central ideas in this book, namely, that the marriage of beauty and holiness in late medieval art and aesthetics produces a deeply satisfying sense of the harmonious coinherence of mortal and eternal beauty in the actions and sacred settings of Christian worship. Through medieval commentaries on the tabernacle and temple,

1. Two valuable earlier studies, though differently focused in important ways, are John Saward, *The Beauty of Holiness and the Holiness of Beauty: Art, Sanctity, and the Truth of Catholicism* (San Francisco: Ignatius, 1996), and James Alfred Martin Jr., *Beauty and Holiness: The Dialogue between Aesthetics and Religion* (Princeton: Princeton University Press, 1990).

and a biblical aesthetic infused with an appreciation for mathematical symbolism, we can gain a much better sense of the radical dedication of medieval architects and theologians to identify medieval sanctuaries with the new Jerusalem; it turns out that the structure of complex poems such as Dante's *Commedia* and the Middle English *Pearl* can compose in the imagination an analogous temple. Chapter 4 turns our eyes upward to the stained glass windows of medieval churches and chapels, and to the light metaphysics and theological symbolism of light developed in the thirteenth century, much of which is both anticipated and echoed in early hymns of the church. Chapter 5 explores the impact of the revolution in affective spirituality associated with Saint Francis, the *Meditations on the Life of Christ*, and the great style change of the thirteenth century, a spiritual revolution in art reflected especially well in some splendid alfresco wall paintings by Giotto by which medieval worshipers came to know the contours and major episodes in the biblical narrative as intimate participatory drama. Chapter 6 takes us, so to speak, to the altar itself, to the medieval place of thanksgiving for the coming of immortal beauty into the corporeal world; we shall consider altarpiece paintings by van der Weyden and the van Eyck brothers as celebrations of the archetype of celestial and holy marriage, and the great *Isenheim Altarpiece* of Matthias Grünewald as a summation of the biblical narrative of salvation.

The second story I wish to tell is of the gradual dislocation of the artistic idealism reviewed in the first half of this book. Here we consider with considerable empathy the uncertainties of post-Reformation artists. What happens to the artist when, little by little, whether for sacred or secular venues, there is a visible divorce of beauty from transcendence, from its hitherto secure home in relation to the true, the good, and holy Being? While holiness, like beauty, is what Rudolf Otto calls "a category of interpretation," it is distinctively pertinent to religious understanding of a kind now distant from us. Until the Renaissance beauty and holiness were intimately conjoined in art for worship, evoking the presence of the holy for believers, offering an encounter with the *mysterium tremendum*. Through representations of the Divine in majesty, literally *sacer/hagios/qodesh*, art could signal the presence of the Wholly Other, prompting largely uncritical contemplation and worship. After the rise of realism, the cult of virtuosity, and competitive patronage, this conjunction became increasingly strained. Chapter 7 takes us to a point of critical tension, even fracturing of the older vision, driven in large part by the temptation to acquisitiveness, to hankering after beauty for the sake of carnal gratification and political power, especially in Rome. The spectacular achieve-

ments of artists such as Michelangelo, Raphael, Leonardo, and Titian are discussed in the context of the burgeoning criticism of Reformation and Counter-Reformation voices alike, the latter as seen especially in the Council of Trent and in subsequent episcopal treatises on the place of art. This chapter concludes with the artistic responses to Luther's teaching made visible in the painting of Lucas Cranach and his son, as well as some reflection on the role of Albrecht Dürer in forging a more realist northern style. Chapter 8 considers some signal works of art from the late medieval to the early modern period in which biblical subjects and narratives, especially stories with erotic potential such as the narrative of David and Bathsheba, become occasions for an indulgence in beauty "for beauty's sake," often an explicit encouragement to the commodification of sexual beauty and voyeurism. Special attention is given here to Massys, Rubens, and Rembrandt. Then in chapter 9 we consider the related efforts of the German painter Caspar David Friedrich and the English poet William Wordsworth to relocate holy beauty in nature. Romantic artists in search of the "sublime," in their indebtedness both to pietism and to the critical thought of such figures as Schleiermacher, Herder, Hamann, and Kant, lay the foundation for a post-Christian aesthetic. Chapter 10 explores select works of the postimpressionists Paul Gauguin and Vincent van Gogh, for whom beauty becomes the end of art, a substitute for traditional religious experience, Catholic and Reformed respectively. Others in this vein include Dante Gabriel Rossetti and the other Pre-Raphaelites, with their "Art-Catholicism," the Nazarenes, and the Nabis, who in various ways share with the postimpressionists their desire to make art itself the place of the holy. Chapter 11 turns to artists in the early twentieth century, who take increasingly scornful views of religion or transcendence of any kind, questioning even the validity of beauty in art in a postreligious age. Here our representative artists are Edvard Munch, Max Ernst, Salvador Dali, and Pablo Picasso; their antipathy is reflected in published manifestos of surrealists, and in support for other modernist art movements. Finally, in chapter 12 we come to three modern artists, one Jewish, two Christian (Chagall, Rouault, and Arcabas), all three of whom worked in acute consciousness of the terrible nihilism of the First and Second World Wars, yet whose work attempts to recover beauty in both an aesthetic and a religious sense, restoring its potential for ultimate meaning by effectively giving it back to God. In these three artists this recovery of beauty implies an encounter with holiness that transcends art even as it returns art to the service of meditation and worship. This late encounter proves to be fundamentally transformative, re-presenting a challenge raised by many

of the masterworks we study; an epilogue to this book will reflect on that challenge. Is holiness itself, as the work of Rudolf Otto and others suggests, perhaps the most truly beautiful thing of all?

A general disclaimer is in order: because the focus of this book is particularly on art in which the relationship of beauty to holiness is at issue, it has been necessary to bracket off not only much of the overtly secular art since the French Revolution and the Enlightenment, but also most landscape painting, whether from the Low Countries or America, for even when wrought in a spirit of gratitude for creation, the relation in its biblical sense is at best tacit. Similarly, didactic art, whether as represented by painters such as Jan van Steen and Franz Hals in Holland or the engravings of Hogarth in England, lies outside the scope of this study.

Regarding translations, all translations from nonbiblical texts in German, French, Italian, and Middle English are by me unless otherwise noted, that is, through a citation in the footnotes to someone else. For translations from the Bible, the reader will notice more complexity. Given the content, in chapter 1 I use either the KJV or my own translation from the Hebrew or Greek. In chapter 2 I am translating from the Latin text used by Augustine, often in his case the Vetus Latina rather than the Vulgate, although in most instances these will be closely related. In chapters 3–7, where largely the Vulgate Latin is normative, we also have situations (Bede and Bonaventure are examples) where the English that appears may be from a published translation of their work as cited—or my own translation of their Latin original where not. That is because medieval writers worked from memory rather than a Bible manuscript, and often what they represent as a quotation is in fact a paraphrase. In chapter 4, where John's Gospel is the primary text, I have regularized the varia by making use of the ESV on occasion. The KJV reappears in chapters 8–10 and 12, either where actually used by an artist originally (e.g., Van Gogh) or where French artists have cited the Segond or Chouraqui French translations and I represent them in English.

Finally, this book is not a history of art, even of Christian art in the European tradition, because so much other work, even such as would fit well into the framework of my inquiry, has had to be left aside in the interests of economy. My hope is that the special focus of this volume will nevertheless help to illuminate a fundamental cultural, theological, and spiritual trajectory for Christian art in the West, and perhaps go some way toward explaining to students as well as general readers the "why" rather than merely the "what" and "how" questions of the great legacy that both religious and secular lovers of art still share.

Art and Worship to 1500

1 BEAUTY AND HOLINESS AS TERMS OF ART

Worship the LORD in the beauty of holiness.

PSALM 29:2

In this book we shall be thinking together about the meaning for Christian art in Western culture of two qualities: beauty and holiness. We shall also be considering what happens when beauty and holiness are brought together successfully in a work of art. The words "beauty" and "holiness" are themselves normative and simple English terms for concepts or qualities that are evidently complex, rich, and mysterious—hence harder than we might think to define as precisely as we wish. For example, one of the classic definitions for beauty is that given by the medieval philosopher Thomas Aquinas: "that which is pleasing to the eye." The value of the almost childlike simplicity of this famous definition is limited; one can also imagine wishing to account for that which seems beautiful to the ear (music)[1] or to the mind when it becomes cognizant of an elegant relation of numbers (mathematics).[2] There is more to beauty than meets

1. A vast literature exists, but for an introduction see Jeremy Begbie, ed., *Beholding the Glory: Incarnation through the Arts* (Grand Rapids: Baker, 2000); for the specific point here, Philip V. Bohlman, "Ontologies of Music," in *Rethinking Music*, ed. Nicholas Cook and Mark Everist (Oxford: Oxford University Press, 2001), and Eduard Hanslick, *On the Musically Beautiful*, trans. Geoffrey Pryzant (Indianapolis: Hackett, 1986).

2. K. Devlin, "Beauty from Chaos," in *Mathematics: The New Golden Age* (New York: Columbia University Press, 1999), chap. 4; M. Emmer, ed., *The Visual Mind: Art and Mathematics* (Cambridge, MA: MIT Press, 1993); H. E. Huntley, *The Divine Proportion: A Study in Mathematical Beauty* (New York: Dover, 1970); David Oliver, *The Shaggy*

the eye. Indeed, beauty often provokes wonder about unseen realities; as a recent writer on the subject puts it, "something beautiful fills the mind yet invites the search for something beyond itself, something larger."[3] This sense that an experience of beauty invites us to something beyond itself suggests an inherently metaphysical or religious dimension that lies behind the surface of beauty, and to which beauty, for one who has the golden key, may somehow become a portal.

There seem to be few cultures in which the beauty of art is not associated in its beginnings with noumenal or religious awareness. The oldest epics are about creation and the gods; the earliest known dramatic art in all cultures typically represents the mysteries of transgression and atonement; the earliest extant songs in a wide range of cultures are hymns. So too with the visual arts: the mysteries of transcendence seem to seek symbol, and an intriguing variety of means to capture beauty. Individual works of art often become tokens of desire, even signs of human longing for the eternal and ineffable. Historically, art attracts a culture of consecration not normally accorded to the more narrowly functional things humans make, even in ostensibly "secular" contexts.[4] It is for this reason, we may conjecture, that art often adorns, even authenticates, what is taken to be a place of the "holy."

Later on, in what we call "developed" societies, this awareness may be dimmed by various types of compartmentalization, and may be lost altogether when religious consciousness becomes marginal to daily life. Even people who are more or less familiar with the Bible, but exclusively in contemporary translation, may not think of the canonical Scriptures as having a great deal to say about the subject of beauty. Perhaps especially for those who are in some measure heirs of Reformation theology and spirituality, sensory beauty may seem at best marginal to a properly religious orientation to the world and at worst prone to idolatrous rather than worshipful contemplation. There are usually good historical reasons for such reticence, and those whose disposition is sincerely ascetic rather than aesthetic deserve respect.

Yet beauty just happens to be a highly significant subject in the most foundational religious text for Western art, the Bible, and it is religiously

Steed of Physics: Mathematical Beauty in the Physical World (New York: Springer-Verlag, 1994).

3. Elaine Scarry, *On Beauty and Being Just* (Princeton: Princeton University Press, 1999), 19.

4. For more on this point, see Richard Harries, *Art and the Beauty of God: A Christian Understanding* (London: Mowbray, 2000).

significant in that context not least because the uses of beauty raise questions about how true worship and false worship are to be distinguished. The historic foundation for a biblical reflection on beauty as we find it in Torah explains why this should be so: from the beginning, beauty in the Bible is connected to *holiness*, principally to that holiness that is God's alone. Secondarily, and derivatively, holiness refers to attitudes that God's faithful people are in the Bible urged to adopt in their worship, whether formally in liturgy or even informally in a spontaneous act of praise or thanksgiving. We may best understand the spirit and the workmanship of the Psalms, for example, as poetic works of exquisite artistic beauty offered up to the "beauty of the LORD" (Ps. 27:4), and Christian as well as Jewish art reflect this understanding in many ways—musically (one thinks of the magnificent settings for the Psalms such as those by Tomás Luis de Victoria, Giovanni Gabrieli, or Heinrich Schütz)[5] and also in imitative poetry such as we find wonderfully crafted in the work of John Donne, George Herbert, and Gerard Manley Hopkins. But the impulse to worship also with *visual* beauty has its roots deep down in both Testaments as well, as even a brief consideration of the earliest Christian art will demonstrate.

PROLEGOMENA FROM THE UNDERGROUND

The earliest surviving examples of Western Christian art are found in *coemetaria*, a Latin word derived from the Greek word for "dormitory," a place where people sleep. In Rome, beginning about 200 CE when Christians were still being actively persecuted, Christians began to adorn the grave sites of their deceased loved ones with two types of art. For those wealthy enough to afford it, the carved stone sarcophagus in the general Roman style was an option, but with distinctively Christian imagery. For those of more modest means, wall paintings in the Roman style began to appear in the catacombs with similarly recognizable Christian subjects. This practice continued until the late fourth century, and in the scores of reasonably intact examples that remain we can study the foundations of artistic culture in the Christian West.[6]

The proximity of traditional Roman sarcophagi and wall paintings

5. See Eleonore Stump, "Beauty as a Road to God," *Sacred Music* 134, no. 4 (Winter 2007): 11–24.

6. Jas Elsner, *Imperial Rome and Christian Triumph: The Art of the Roman Empire, AD 100–450* (Oxford and New York: Oxford University Press, 1998), 145–65.

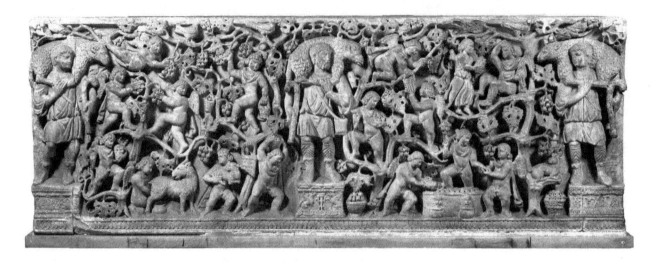

Figure 1. Sarcophagus of the Shepherds, Catacomb of Praetextatus, Rome, late fourth century CE

permits consideration of both the continuity of Christian funerary art with the pagan mainstream culture and its divergence from that culture. While pagan art in both genres strives to associate the deceased with classical myths and mortal fame, the Christian equivalents feature biblical narrative and an emphasis on resurrection and eternal life. What they share in common besides style and technique is a conviction that art is appropriate to honoring the dead; what distinguishes them is that the traditional appropriation of beauty to honor the deceased in the eyes of men is in Christian art replaced by a celebration of honor in the eyes of God. If the first sort of art honors *pietas* toward the Romanum, the second reflects a sense of "citizenship not of this world" (see Phil. 3:20) but in the kingdom of heaven—an allegiance that led to more than a few martyrdoms, on the grounds that Christians were "unpatriotic," worshiping a forbidden deity rather than the gods and emperors of Rome.

It is clear from the considerable evidence of these grave sites that not only prominent martyrs but also ordinary Christians were honored by their families and community with funerary art. These images do not feature an individual life in its particulars, and there are scarcely any attempts at a physical likeness; the attempt is rather to remember their spiritual life "in Christ." In a striking sarcophagus of the fourth century, Christ is figured in biblical metaphors both as the Good Shepherd and as the vine (John 15:1–5) that sustains the branches, Christians, whose faithful life yields a vintage that now the angels harvest (fig. 1).

The Good Shepherd, "who gives his life for the sheep" (John 10:11; cf. Ps. 23), is one of the most recurrent images in the catacombs; though

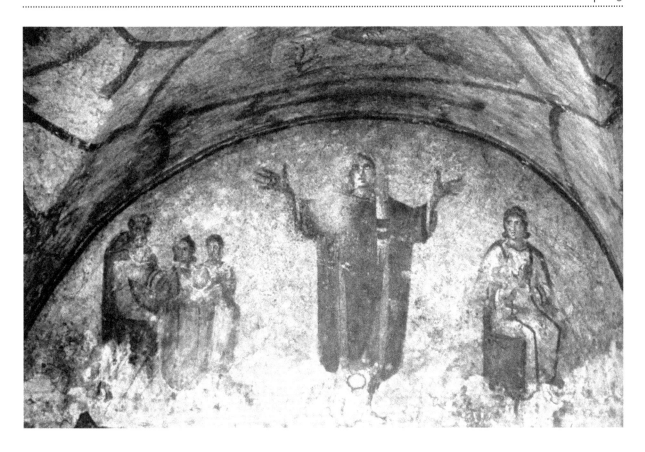

now faded by time, most were beautifully executed in color (fig. 2). The *orans* figure in the Catacomb of Priscilla praying in the Jewish manner, arms raised, has a head covering resembling also a Jewish prayer shawl or *tallit*, but many other features point to a Christian context, including the Good Shepherd image on the ceiling above. The birds flanking the scene are doves, indicating the presence of the Holy Spirit, but also assurance of peace for the redeemed, since the dove that returned to Noah with an olive branch in its beak (Gen. 8:11) and the dove that descended on Jesus at his baptism (Matt. 3:16; Mark 1:10; Luke 3:22; John 1:32) were closely associated in Christian iconography of the time as signs of God's redeeming purpose for the world.

Jonah provides another popular motif, his three days in the belly of the fish (here in fig. 3 represented as Leviathan) before being deposited on the shore of Nineveh typologically presaging the resurrection of Jesus after three days (cf. Matt. 12:40). Jonah's descent and return served as a sign of the general resurrection, when all the faithful, having been "buried with Christ in the waters of baptism" and having lived a holy life,

Figure 2. *Donna Velata,* Catacomb of Priscilla, Rome, fourth century

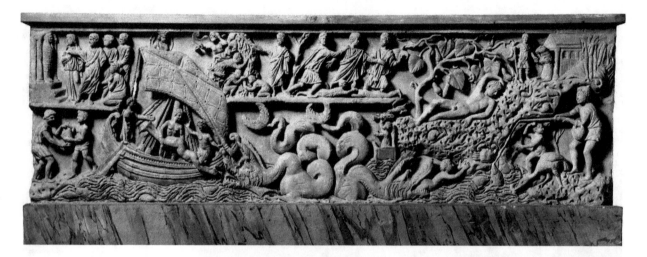

Figure 3. Jonah Sarcophagus, St. John Lateran, Rome, third century

Figure 4. The Fiery Furnace, Catacomb of Priscilla, Rome, third century

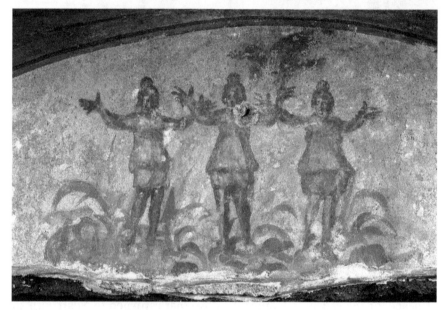

could look forward to completing their journey with Christ in heaven (fig. 3).

Other Old Testament miracles, such as the survival of Daniel in the lions' den (Dan. 6), would have evoked contemporary associations, as perhaps would the story of his three friends (Dan. 3) who, for their refusal to worship the emperor (Nebuchadnezzar), were cast into the fiery furnace (fig. 4). In this example we see the three youths, Shadrach, Meshach, and Abednego, in the familiar posture of prayer, but the fourth figure of the biblical account, so astonishing to Nebuchadnezzar (Dan. 3:25) and

thought by him like "the Son of God," is represented by a dove, figuring the Holy Spirit. This is not a literal illustration of the biblical narrative so much as a spiritual interpretation of it, connecting the biblical miracle to the presence of the Comforter (cf. John 14:26) when prayers of the faithful are offered *in extremis*.

Allusions to New Testament miracles also abound, such as the turning of water into wine at Cana, a symbol for the wine of the Eucharist (as well as of the sacramental character of Christian marriage), or the feeding of the five thousand with five loaves and two fish, another eucharistic symbol (John 6:1–14), especially in the context of Jesus's subsequent description of himself as the "bread of life" (John 6:22–51). A number of these images were executed in colors that have survived well enough to give us a sense of their original beauty; one of the most vivid depicts Christ healing the woman who suffered from a chronic issue of blood (Luke 8:43–48), although one could imagine it to depict the encounter between Mary Magdalene and the resurrected Christ in the garden (John 20:11–17)—the *noli me tangere* (do not touch me) motif so frequently found in painting centuries later (fig. 5).

In the catacombs we have already many of the themes and a body of iconography that will carry forward in the era in which Christians were to enjoy freedom of worship and artistic expression in more public places. We have also a visual record of Christians' sense of continuity with the Jewish Scriptures and forms of worship with which they were for some time associated in the Roman mind. While before the mid-fourth century this art was largely inaccessible to the eyes of all but those willing to descend, torch in hand, into the dark underground passageways of the catacombs, it would be clear to any Roman who did so that considerable effort was made to adorn with beauty the burial sites of deceased Christians, but in such a way as to make of that art a kind of exposition of the Christian message. This underground art, moreover, bore witness to quite another story. For Christians the *historia humanae salvationis* had already superseded the myths of Virgil and Statius as the story they would live by and suffer for if necessary, and in any case, into which they would die in the hope of the resurrection. It would be clear also to any such visitor that worship and prayer were major themes in this art, that its celebration of holy living and holy dying placed *beauty* above all at the service of honoring *holiness*. It is to the meaning of these key terms in their biblical context that we must turn to obtain a deeper understanding of the development of Christian ideas about art and worship.

Figure 5. Catacomb of
Marcellinus and Peter,
Rome, third century

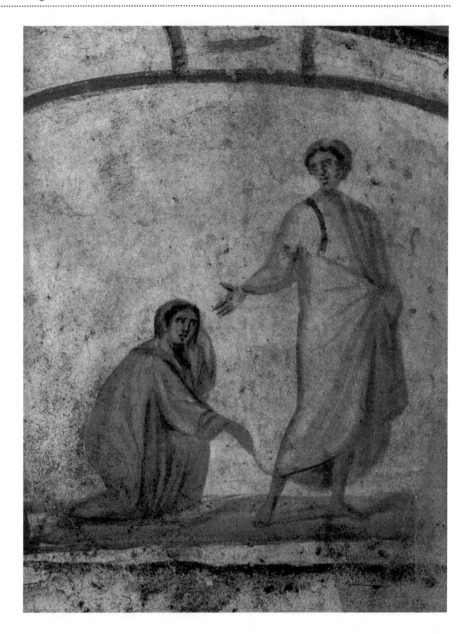

Holiness in the Bible

Just as we typically regard poetry as set apart from everyday discourse, something special, reserved for a higher purpose because it is more beautiful than a merely functional or conversational idiom, so also the concept of holiness or the sacred entails the idea of something deliberately

set apart from ordinary use (the precise literal meaning of the Hebrew word *qodesh*, "holy," is "set apart"). With respect to *holiness* in the Bible, perhaps because it likewise gets less attention in Western cultures than once it did, most readers do not perceive the subject as so inherently challenging as in fact it really is. Torah commandments such as "Be holy: for I the LORD your God am holy" (Lev. 19:2; 11:44–45; etc.; quoted in 1 Pet. 1:15–16) spring readily to mind. What does this mean? Essentially, it seems to entail something like a commandment to imitate God. At this thought the sober mind boggles. The paradigm example given in the New Testament is of course Jesus himself, yet while his disciples readily admire his life and teaching, they are slow to grasp the full implications of his sacred identity, even when demons recognize Jesus as "the Holy One of God" (Luke 4:34). Later, the promise of Jesus to send the Holy Spirit, his abiding presence with those faithful to him, becomes central to his final commission of the apostles and transformative for the earliest worship of the church (e.g., John 14:16; Acts 2:4; 19:1–7; etc.). Precisely what this idea of the holy might mean for the way believers are to use language, hear the Scriptures, or comport themselves in worship is not always clear to contemporary adherents of Christian religious tradition either, let alone to secular observers or others who do not share their faith. Nonetheless, the terms "holy" and "holiness" have not in the past been taken lightly by either Jews or Christians, nor have they been restricted to specific matters of religious rite and ritual. In the Bible the terms "holy" and "holiness" are used with scrupulous precision to refer to God, to the tabernacle and temple, to Jesus, to the presence of the Holy Spirit among the faithful, and even to "every word of God," hence to the Scriptures, and reciprocally, to a certain quality of life in general, the character of thought, word, and deed befitting those who seek to "become holy" in response to the biblical call in either Testament.

The basic Hebrew term employed all over the Old Testament is *qodesh/qadosh* or a variant. While quite literally it means "set apart," it applies to unblemished character as well as physical wholeness and purity. It may, for example, refer to the very best of the best, reserved for an acceptable sacrifice to the Lord, in both senses (Lev. 6:16–27; 7:6; 24:9; cf. Exod. 12:5; Lev. 1:3–10, etc.; Num. 6:14, etc., especially chaps. 28–29; Ezek. 43:22–23; 45:18–23; 46:4–13). Knowledge of this principle provides context for a retrospective reading of the Cain and Abel story in Genesis (Gen. 4:1–7), and it gives rise to innumerable representations in both Jewish and Christian art of the inherited diminishment of beauty and holiness alike that extends down through the centuries

among Cain's descendants.[7] Consistent with the Old Testament context, especially with regard to worship in the sanctuary (e.g., Lev. 20:7, 26; 23:9–12; 27:9ff.), the faithful believer in the New Testament is instructed to present himself or herself before the Lord as "holy and without blemish" (Eph. 5:27). Likewise, in a context deliberately reflective of Old Testament conceptions of holiness, the writer to the Hebrews urges his readers to "Pursue peace with all men, and holiness [*hagiasmos*], without which no man shall see the Lord" (12:14). This is the sense also of Paul (Rom. 6:19, 22; 1 Thess. 4:7; 1 Tim. 2:15; Rom. 12:1; etc.). In fact, holiness is of the essence of faithful life for Paul, both in the church and in the family; holiness is what should make Christian marriage a thing of beauty, reflecting in the home the sanctification of the whole church by Christ's sacrifice (Eph. 5:24–27).

BEAUTY IN THE OLD TESTAMENT

In the Bible, beauty and holiness are inseparably linked from the beginning. In fact, there seems to be no fully accurate access to what the Scriptures mean by beauty except through appreciation of the holy. This is made apparent in the book of Exodus, where the strict and detailed instructions given to Moses concerning the building and furnishing of the tabernacle feature beauty in the work of the artistic craftsmen as essential to creating a holy space, namely, a sanctuary (*miqdash*) for the divine presence (*shekinah kabod*—"presence of the Glory"), a "tent of meeting" for God and his worshiping people. Special "set apart" terms are employed to signify the gift of artistic creativity bestowed upon Bezalel, son of Uri (a sculptor whose name means "shadow of God"), on his assistant Oholiab, and on the artistic women whose workmanship produced the tabernacle's fine textiles. Each is identified for Moses by the Lord as possessing

7. In Talmudic commentary, the reason given for God's displeasure with the sacrifice of Cain is typically that Cain offered it in haughty selfishness and lack of real reverence for God (Zohar Hadash 24a on Gen. 4:2; cf. Bereshit Rabbah 22, 5–6, in which the smoke of his failed sacrifice blows back in his face, darkening his countenance, diminishing its original radiance, and anticipating his permanent disfigurement, the "mark of Cain"). This becomes a motif in later Christian literature, which shows awareness of the Jewish exegesis: see Ruth Mellinkoff, *The Mark of Cain: An Art Quantum* (Berkeley: University of California Press, 1981); also David Lyle Jeffrey, "Medieval Monsters: Skôgsra, eoten, feond, þyrs," in *Manlike Monsters*, ed. Marjorie Halpin and Michael M. Ames (Vancouver: University of British Columbia Press, 1980), 47–64.

chokma-lev, "wise-heartedness" (Exod. 35:21–35; especially 36:1–2, 8), the Hebrew term used to identify artistic creativity.[8]

It is clear that the sanctuary in both tabernacle and temple is to be resplendent with fine artwork: these are by no means merely "functional" buildings. Even the vestments of Aaron and the priests are to be holy (*qadosh*), and the sign of their holy purpose is that they are to be made "for glory and for beauty" (*kabod v' tipharet*, Exod. 28:2, 40); thus they are an adornment functioning as a signifier of the holy, much as would be the ark and the mantle around a Torah scroll today (fig. 6). The Hebrew word here for "glory," *kabod*, a word otherwise used widely in the Old Testament for the radiance of the Lord himself, suggests that the glory of these garments, made distinctive in their beauty, is to be under-

Figure 6. Wall painting from Dura Europos synagogue, ca. 235 CE

8. This term occurs in only one other place in Scripture, in 1 Kings 3:12, where it is God's gift to Solomon, surpassing the king's request for wisdom, *chokma*: "Lo," says the Lord, "I have given you *chokma-lev*, a wise and understanding heart." Solomon too, we should remember, has been chosen to build a sanctuary for the Lord. Cf. Peter J. Leithart, "Making and Mis-making: Poiesis in Exodus 25–40," *International Journal of Systematic Theology* 2, no. 3 (November 2000): 307–18.

stood as reflective, derivative of the divine radiance. The Hebrew word for beauty in the same phrase, *tipharah*, signifies stunning natural beauty, such as that spoken of in 2 Chronicles where we are told that Solomon adorned the walls of the temple "with precious stones for beauty" (3:6). After Solomon's Temple had been destroyed, the later prophecies in Isaiah mention the aching nostalgia felt by the Jewish exiles for "the house of our holiness and our beauty" (*qodeshenu v' tipharethenu*); holiness and beauty remain inseparably linked (Isa. 64:11). This term for the beauty of the sanctuary recurs elsewhere, for example, in Psalm 96:6, "strength and beauty (*topharot*) are in his sanctuary," a passage that enjoins praise of the Lord for his glory and contains the memorable lines, "O worship the Lord in the beauty of holiness" (v. 9, *behaderot qodesh*; cf. Pss. 29:2; 96:9; 2 Chron. 20:21). Additional references (e.g., Isa. 13:19; 28:1; Lam. 2:1) suggest that this term for beauty has about it the aura of royal splendor, allowing it to be used in Hebrew parallelism almost as a synonym for *kabod* (Isa. 28:5); yet it clearly refers elsewhere to human beauty as well (Isa. 44:13). Since this is the beauty a sculptor tries to capture—a beauty that, as a faithful Jew would immediately realize, may all too easily be perverted to idolatrous purposes, even when used as a way of expressing grief and enduring affection for a deceased loved one, as in the golden ephod commemorating Gideon (Judg. 8:22–27), or in undue veneration for a political leader (cf. Wisd. of Sol. 13–14)—it may be dangerous. Here, then, is a source of tension, namely, the proximity of sacred beauty to beauty that has become in some way profane. On the one hand, beauty is explicitly connected with the holiness of the sanctuary and the glory of the Lord who is holy; Scriptures from Torah, the Psalms, the Historical Books, and the prophet Isaiah all call for beauty to be directed to praise of God. On the other hand, the ancient book of Judges and the Wisdom of Solomon, a deuterocanonical text of the late second century BCE, remind us forcibly of the peril when beauty becomes an end in itself, permitted thus to become a conduit to idolatry.

Tipharah, the word for beauty first used in connection with holiness in Exodus 28, is but one of fourteen Hebrew words for beauty found in the Old Testament.[9] The Hebrew vocabulary for beauty, contrary to popular impressions since Matthew Arnold's *Culture and Anarchy*,[10] had

9. Cf. Luke Ferreter, "The Power and the Glory: The Aesthetics of the Hebrew Bible," *Literature and Theology* 18, no. 2 (2004): 123–38, notes fewer terms but comes to similar conclusions about the often neglected importance of beauty as a biblical concept in the Old Testament.

10. In the fourth chapter of his enormously influential book (1869), Arnold contrasts

a range greater and more precise than anything in Greek or Latin, let alone in our contemporary Western languages. One of the reasons we don't think of beauty in the Bible as much as we should, perhaps, may be simply that contemporary English is by comparison poor in "beauty" words. Hence, translators of the Bible are forced to translate with the one word, "beauty," or at best varying with two adjectives of affect ("lovely," "comely"), a far more nuanced and supple range of terms in the Hebrew of the Old Testament.

But what about those other Hebrew words? Do they all attach themselves to holiness in the specific way suggested by the Exodus story of the making of the tabernacle? In a word, no. Here we may see an advantage of the richer, more associative Hebrew lexicon: some of the words translated in English Bibles as "beauty" apply to female (and occasionally masculine) physical beauty, some apply to holy beauty only, and some retain the flexibility to be used poetically in such a fashion as to suggest both, enabling a reflexive recognition that the beauty of the divine artist, the Creator, is reflected in his creation, his art, not excluding the beauty of a beautifully proportioned human body.

One locus for that particular manifestation of divine art is clearly in the form most to be associated with the phrase from Genesis "in his own image" (Gen. 1:26–27), including suggestively the visible form shaped at the apex of creation, sculpted from the clay and infused with the Creator's own breath of life (*neshemat cha'im*, Gen. 2:7). In Christian tradition especially, the image of God is construed as being borne not by Adam alone, but by Adam and Eve in a complementary unity, which is why we find so many images in the medieval period especially depicting God in the Garden of Eden before the Fall joining Adam and Eve in the original marriage (fig. 7).[11] While ancient and early Christian commentators alike note that the image of God in man ought to be primarily understood in terms of the reasoning and imaginative faculties (including our tendency to be inspired by beauty), they see in the beauty of human form an analogous expression or reflection of the beauty of God.

When Old Testament writers describe human beauty in physical

"Hebraism and Hellenism," associating the former with the stern asceticism of those who, like the Puritans as he imagines them, focus on moral order to the exclusion of aesthetic appreciation.

11. *Speculum humanae salvationis*, here from a Netherlandish block-book with movable type. In many of the 350 surviving manuscripts the caption is *copulatio ade et eve*, relating the episode in Gen. 2:22–25 to the sacrament of marriage; in the illustration, on the right side, Satan in the guise of a serpent tempts Eve to spiritual adultery.

Figure 7. Illustration of Genesis 3 from *Speculum humanae salvationis*, early fourteenth century

terms, or aesthetically, the dominant word they use for beauty is *yapheh* or one of its derivatives. Early Christian commentators, writing in Latin, tended to use a variety of proximate terms: *pulcher* and occasionally *decor*. *Yapheh* is thus, as we would say today, a "loaded" term, grounded in earthy meaning. We see it employed in much the same way we would see its equivalent in English; for example, the meaning of *yapheh* is plainly associated with female sexual attractiveness in Proverbs, "Lust not after her beauty in thy heart" (Prov. 6:25; cf. 31:30), and it is clearly her sexual beauty that the drunken King Ahasuerus has in mind when he orders his eunuchs to fetch Queen Vashti and parade her before his guests (Esther 1:11); using the same phrase, the narrator in Esther later remarks of her, "the maid was fair and beautiful" (2:7).[12] When the psalmist in his love song for a royal marriage writes, "So the king will greatly desire your beauty" (Ps. 45:11), he uses *yophi*, which is a form of this same word, while

12. Cf. Alexander Pruss, "The Unwritten Esther," *Judaic Seminar* 1, vol. 8, http://www .shamash.org/tanach/tanach/commentary/j-seminar/volume1/v1n8.

the nominative form *yapheh* appears recurrently to describe the beauty of the beloved in the love song ascribed to Solomon (e.g., Song of Sol. 6:4; 7:1). But *yapheh* is notably also used of the king of whom the psalmist says, "you are the most beautiful of the sons of mankind" (Ps. 45:2), and, in the messianic or christological reading of this psalm from earliest times, the radiant beauty of the Lord is applied to Jesus, so becoming the subject of familiar hymns such as "Fairest Lord Jesus."[13] *Yapheh* can appear as a term for masculine sexual appeal in a somewhat negative context, as in the case of Absalom (2 Sam. 14:25), or positively in reference to the beauty of something in creation, like the majestic tree of Ezekiel's vision (Ezek. 31:8), or a beautiful natural setting ("beautiful for situation, the joy of the whole earth, is mount Zion" in Ps. 48:2). It may thus be applied to the Holy City, "Jerusalem . . . the perfection of beauty" (Lam. 2:15; cf. Ezek. 27:3, 4, 11), and interestingly, even to the beauty of a gentile civilization (Ezek. 28:12, 17; 31:8). What may surprise us, perhaps, is that *yapheh* also appears in reference to the beauty of the Lord himself, just at that moment when he rises up to return in judgment to his people, as in Isaiah's promise "Your eyes will see the King in his beauty" (Isa. 33:17; Ezek. 28:12, 17; 31:8; Zech. 9:17), in this context clearly a terrible beauty such as Michelangelo was possibly thinking about when he painted Christ's return in judgment in the Sistine Chapel. Here again, *yapheh*, a term for aesthetic beauty, can be used poetically to create a word picture for the invisible God being made visible.

With other Hebrew words for beauty also, the polarity can reverse in such a way that a divine attribute can be used evocatively as a metaphor for beauty in the world. In Isaiah 40, in one of the most beautiful poetic passages in the Bible, we read, "All flesh is grass, and all its beauty is like the flower of the field" (Isa. 40:6 RSV and ESV). The Hebrew word here translated "beauty" is entirely counterintuitive in this context, namely, *chesed*, the word typically used to characterize nothing less than God's

13. This Jesuit hymn, written as "Schönster Herr Jesu," was published in the Münster Gesangbuch in 1677, and translated into English by Joseph Seiss in 1873. In the language of historic Christian prayer, the "glory" of the Lord has often been described as his "beauty." During the American Civil War, William Reed Huntingdon composed this prayer: "O God, who on the mount didst reveal to chosen witnesses thine only-begotten Son wonderfully transfigured, in raiment white and glistening: Mercifully grant that we being delivered from the disquietude of this world, may be permitted to behold the King in his *beauty*, who with thee, O Father, and thee, O Holy Ghost, liveth and reigneth, one God, world without end. Amen." This language appears likewise in the famous "Battle Hymn of the Republic," written in 1861 by Julia Ward Howe, especially in the last stanza.

tender and enduring covenant love for his people. It is clear that in this passage the translators have understood the poet to be making, by radically asymmetrical analogy, an indirect and contrapuntal statement about what is not at all evanescent but everlasting, and far more beautiful than frail flesh or flowers of the field, namely, "the word of our God . . . which stands forever" (Isa. 40:8).

Other beauty words in Hebrew would seem to be more narrowly aesthetic: *tovath mareh* seems to have an exclusive reference to ideal physical form: in the story about David's adultery with Bathsheba, the narrator observes, "the woman was very beautiful to look upon" (2 Sam. 11:2). In a similar vein, but here with more emphasis on sexual fruitfulness, one finds *yephath to'ar*, "Rachel was beautiful and well favoured" (Gen. 29:17; cf. Deut. 21:11). *Tsir* seems to mean something like "bloom" or "glowing complexion," as in "their beauty shall consume in the grave" (Ps. 49:14), whereas *hadar*, as in "the beauty of old men is the grey head" (Prov. 20:29) or "array thyself with glory and beauty," part of the Lord's taunt to Job on his dung heap (Job 40:10), seems to be associated with grooming and adornment, reflected in Jerome's Latin as *decor/decorum*. Other adornment or grooming words for beauty include *pe'er*, as in "I will give them beauty for ashes" (Isa. 61:3), and *tsebo/tsevi*, "attractiveness," as in jewelry, "as for the beauty of his ornament" (Ezek. 7:20), while the verb *pa'ar*, "to make beautiful," as in the direction to "beautify the house of the Lord" (Ezra 7:27; Isa. 60:13), is applied elsewhere in a spiritual sense, "he will beautify the meek with salvation" (Ps. 149:4), which I suppose we might think of as a kind of ultimate "makeover."

A few more examples and we may begin to draw some initial conclusions. The word *chamad*, as in "Thou makest his beauty to consume away" (Ps. 39:11), seems analogous to *tsir*, but is rooted in a semantic range that foregrounds sexual desire and appeal. *Hod*, as in "his beauty shall be as the olive tree," may refer to the natural beauty of fruitfulness in creation (Hosea 14:6). "Pleasing to the eye," the definition Thomas Aquinas gives for beauty in regard to its reception (*pulchra sunt quae visa placent*),[14] is in Hebrew *no'am*; yet this same word is used by David to refer to nothing less than the divine presence in the temple (Ps. 27:4):

One thing have I desired of the Lord.
That will I seek:
That I may dwell in the house of the Lord

14. Thomas Aquinas, *Summa theologiae* I, q. 5, a. 4, ad 1.

All the days of my life,
To behold the beauty of the LORD (*no'am yhwh*)
And to inquire in his temple.

In this ardently worshipful poem of the psalmist we have come full circle, back to the sanctuary, the place of the holy.

There is much more to beauty in the Old Testament, of course. Many books have been devoted, for example, just to the high art of biblical poetry, its beauty of lyrical style and structure.[15] But regarding basic philological evidence, the lexical resources for an acute appreciation for beauty in many contexts, I think that enough has been adduced here already to correct a fairly widespread misprision. Any notion that the ancient Jews were blind to beauty is clearly without warrant, as deficient as is the prejudice among aestheticians that "Sacred Scripture does not reflect . . . theologically on the nature of beauty" or that "this [reflection on beauty] would have been foreign to the Semitic mind."[16] No better, as we shall see, is an assertion of the aesthetician James Kirwan that "the identification of God with beauty is . . . fundamentally a Hellenistic concept rather than a biblical one." Kirwan further argues that the cross-cultural "identification of beauty with God . . . is a consequence of the nature of beauty."[17] Given the rich and nuanced language for beauty in the Hebrew Scriptures, what I would suggest with regard to the Bible and biblical tradition is just the opposite; namely, that a just study of beauty and the beautiful in Scripture and biblical tradition reveals their profoundly Semitic character, nowhere more obviously than in the abundant textual evidence that while beauty is most certainly identified with God, beauty in the world is seen by theologians and artists alike as derivative, a consequence or effect of the nature of God. To restate this: on the biblical view, God is not simply a projection from the ephemeral nature of beauty. Beauty, and the desire it awakens in us for a wholeness we do not possess, offers nonetheless a primal intuition of the existence of a transcendent Source of all that is beautiful: "He hath made everything beautiful (*yapheh*) in his time; also, he has set eternity (*'olam*) in their hearts, so that no one can find out the work that God makes from the beginning to end" (Eccles. 3:11).

15. Notable here are Robert Alter, *The Art of Biblical Poetry*, 2nd ed. (New York: Basic Books, 2011), and Adele Berlin, *The Dynamics of Biblical Parallelism* (Bloomington: Indiana University Press, 1985).

16. Thomas Dubay, *The Evidential Power of Beauty: Science and Theology Meet* (San Francisco: Ignatius, 1999), 41.

17. James Kirwan, *Beauty* (Manchester: Manchester University Press, 1999), 32, 35.

THE FADING OF BEAUTY IN THE NEW TESTAMENT

What then of the place of beauty in the Christian New Testament? Here we are in for a surprise. In few matters is the language of the New Testament more evidently different from that of the Old, and probably not simply because the New Testament has come down to us in Greek rather than Hebrew. A concordance search of Greek words that unambiguously require translation as "beauty" or "beautiful" in the English New Testament discovers only four instances of a single term. The word is *hōraios*, a term that in classical Greek denotes ripeness or fittingness. Two of these occur in Acts (3:2, 10), in which Peter and John perform a healing miracle on the man lame from birth who begged at the gate of the temple "called Beautiful" (*legomenēn Hōraian*). (Perhaps this is the "eastern gate" mentioned by Josephus as having been wonderfully crafted in ornate Corinthian bronze;[18] there is in fact no antecedent Hebrew name recorded for this gate.) A third instance is Paul's quotation in Romans 10:15 of the liturgical phrase "how beautiful are the feet of them that bring good news" in which *hōraios* translates *na'ah* from Isaiah 52:7, a distinctly minor Hebrew word for "beautiful." One New Testament citation remains: in Matthew 23:27, in which Jesus utters the terrible rebuke: "Woe to you, scribes and Pharisees, hypocrites! For you are like whitewashed tombs which indeed appear beautiful on the outside, but inside are full of dead men's bones." The tenor of the Greek word for beauty here (still *hōraios*) suggests the beauty of mere appearances, of a misleading superficiality. However disappointing, that's pretty much it for "beauty" in the New Testament, at least in most English translations.

What, we may ask, has happened to the rich Hebrew language for beauty? Has it been suppressed as extrinsic to the primary purposes of the gospel, or as in some way alien to Jewish conceptions reconstrued in the light of Christ? To put it in another way, is it possible that the moral asceticism of Matthew Arnold's "Hebraism" finds its source not in the Old Testament, but in the New?

BEAUTY IN HELLENISTIC THOUGHT AND THE GREEK OLD TESTAMENT

To answer this question we need first to accept that the New Testament was circulated in Hellenistic Greek, and therefore is limited by the work-

18. Josephus, *Bellum Judaicum* 5.5.3.

ing lexicon of that language at the time when the texts of the New Testament were written down. As it happens, even classical Greek had many fewer terms for beauty than did Hebrew (however counterintuitive for Arnoldians), only between four and six, depending on context. Of these, the one that had clear dominance in Greek literary culture was *kalos*. In ancient Greek texts it carries the sense of whole, healthy, fit, or beautiful in shape (e.g., Homer, *Odyssey* 17.307). For Plato it means anything that awakens desire. The theologian Walter Grundmann argues that when applied to human character, *kalos* took on also the sense of "morally fit," the virtue equivalent of visible nature that evidenced design (*taxis*) and symmetry in proportions thus blended with terms for "the good."[19] The phrase *kalos kai agathos*, "beautiful and good," and its derivative noun *kalokagathia* appear frequently in Greek philosophy, notably in the conversation of Socrates as Plato depicts him. At one level, Socrates famously argued that visible beauty was not the distinguishing feature of *kalos kagathos*, that it pertained rather to intellectual virtue, indeed, that *dikaiosynē*, "righteousness," should be regarded as the essence of the beautiful good (*Symposium* 3.4). More recently, Elaine Scarry has suggested that for Plato in the *Phaedrus* and elsewhere, beauty, by heightening our awareness, makes us in some sense more morally attuned; in the presence of all that is "fair" in the aesthetic sense, she argues, we are more inclined to seek that which is "fair" in the moral sense.[20] Scarry's thesis is essentially a reiteration of Plato against an astringent contemporary philistinism, a concern for social justice that finds beauty an unwelcome distraction. Both this complaint and her rejoinder are a reiteration of an old Athenian debate. Yet indisputably the profound influence of Plato's teaching on subsequent Greek thought entailed making the semantic value of *kalos* a register of meaning as much or more for ethics as aesthetics. As Werner Jaeger put it long ago, in Plato's schema, "Beauty and good are only two closely allied aspects of one and the same reality—two aspects which were fused into one by general Greek idiom, since the highest Greek *aretē* was called 'beauty and goodness.'"[21] In Plato's *Timaeus*, that which is *kalon* reveals itself as the form of the good in the world that has come into being (*Timaeus* 29a, 30b).[22] This is the cosmological dimension, but we would

19. In Gerhard Kittel, ed., *Theological Dictionary of the New Testament*, trans. Geoffrey W. Bromiley, 10 vols. (Grand Rapids: Eerdmans, 1965), 3:536–43.

20. Scarry, *On Beauty*, 73–93.

21. Werner Jaeger, *Paideia: The Ideals of Greek Culture*, 3 vols. (Oxford: Basil Blackwell, 1944), 2:194.

22. The *Timaeus* was the only work of Plato known to the Middle Ages in its full text;

sell Plato short if we failed to acknowledge his religious tone. Remarkably, at the end of the *Phaedrus* Plato has Socrates pray for "inward beauty," the only prayer in Plato's works. Jaeger calls this, somewhat wistfully, a "pattern and example of the philosopher's prayer."[23]

We draw closer to grasping the way in which Plato influenced subsequent hellenized thinkers toward a spiritualization of the idea of beauty when we read Philo of Alexandria (a Jewish near contemporary of Saint Paul), for whom beauty has religious significance in the Hebrew Scriptures in a way closely comparable to Plato's "beautiful good."[24] Plotinus, Philo's follower, develops the idea that beauty is an intelligible good in the *peri tou kalou* section of his *Enneads* (1.6), where he says that the beauty of things in this world thus reveals the "glory, power, and goodness of the spiritual world" (1.6.2; 4.8.6, 8). True beauty is on this account a transcendental, belonging to the "world above," real beauty (in the Platonic sense) being beauty of the soul (1.6.9). From the perspective of the Hebrew Bible, however, this sort of language gets things only half right. Justice, or doing the moral good, seems to lie in the direction of the Hebrew linking of beauty with holiness, but, as we shall see, holiness on the biblical view is a more comprehensive and demanding concept than justice, even though it entails it.

The translators of the Greek Septuagint seem very much to have been influenced by Platonic emphases in their use of a narrower Hellenic vocabulary for beauty. Tellingly, there is *no* occurrence of *kalos* in the aesthetic sense in the canonical books of the LXX at all, unless we count its appearance to translate *tov* in Genesis 1:31, "and God saw that it was good." It appears in many places, however, to translate a range of terms meaning "good" in the moral sense and synonymously with *agathos* (Mal. 2:17; Num. 24:1; Deut. 6:18; 2 Chron. 14:2; Mic. 6:8; Isa. 1:17, where *kalon* translates Hebrew *mishpat*, "justice"). Briefly, the wide and supple range of Hebrew terms signifying beauty has been reduced in the Greek of later Hellenism to its main term, *kalos*, which then gradually dissolves, becoming almost a synonym for "good" in its moral register.

Kalos in its sense of "beautiful" has not entirely disappeared in the LXX, however, and it or one of its derivatives occurs there sometimes in the place of Hebrew *yapheh*, and occasionally in Hellenistic apocry-

translated with a commentary by Chalcidius, it had a formative influence on medieval Christian cosmogony as well as, indirectly, aesthetics.

23. Jaeger, *Paideia*, 2:196.

24. Philo, *De specialibus legibus* 1.318.

phal (or deuterocanonical) texts. Notable among such works is the pseud-epigraphic Wisdom of Solomon (composed in Greek probably about 100 BCE), in which the author argues that the pursuit of justice (the good) is the proper form of embodied wisdom. Various impediments to justice, accordingly, are presented as examples of folly. A primary example of mis-direction is the way love of beauty in art and nature can lead to idolatry, in effect a kind of deification of mortal beauty, just the kind of predication of God upon beauty in the world thought by Kirwan to be universal and here countered by the ancient Jewish author: "If it was through delight in the beauty (*kalon*) of these things that men supposed them gods, they ought to have understood how much better is the Lord and Master of it all; for it was by the prime author of all beauty (*kalos*) that they were cre-ated" (Wisd. of Sol. 13:3). Our Second Temple writer goes on to explain, more accommodatingly than would likely have been the case at an earlier period, that perhaps such people "are not greatly to be blamed" (13:6), because they may have been led astray in a sincere attempt to find God. "Passing their lives among his works and making a close study of them, they are persuaded by appearances because what they see is so beautiful" (*kala*, 13:7).

I have quoted this passage from the Wisdom of Solomon at length because it expresses both a Jewish taboo and a Hellenistic norm, namely, that while beauty in art and nature is on the biblical view in-tended to lead us to acknowledge its source, the divine artist, it doesn't always work out that way. When loved too much for themselves, things of beauty can become a substitute for God, or, in Plato's sense, they can cause a neglect of *aretē*, the Homeric ideal of the completeness of a worthy life. Such idolatry, the author goes on to say, is more than a problem of arrested spiritual development; it leads directly to a whole range of moral evils:

> And those whom men could not honor in presence, because they dwelt far off, they brought their resemblance from afar, and made an express image of the king whom they had a mind to honor: that by this their diligence, they might honor as present, him that was absent.
>
> And to worshipping of these, the singular diligence also of the ar-tificer helped to set forward the ignorant.
>
> For he being willing to please him that employed him, labored with all his art to make the resemblance in the best manner.
>
> And the multitude of men, carried away by the beauty of the work, took him now for a god that a little before was but honored as a man.

And this was the occasion of deceiving human life: for men serving either their affection, or their kings, gave the incommunicable name to stones and wood. (Wisd. of Sol. 14:17–21)

It will be evident that apprehension about perverting beauty away from its creational purpose, or bending it toward worship of anything other than God, reflects a specifically Jewish aversion to a common form of idolatry as we find it condemned from the second commandment in Exodus forward. One may not sculpt a graven image to represent divine Being without making a god in one's own image and imagination; for the Hebrew Bible, the divine artist remains fundamentally incomparable to anything in a human perceptual field (Isa. 40:25; 46:5; 55:8–9).

To hypothesize: the tendency in Platonic thought somewhat to diminish individual instances of tangible beauty in an affirmation of the transcendent Beautiful, coupled with a continuing Jewish anxiety about idolatry, would seem to have cautioned the LXX translators away from the rich vocabulary for beauty found in the Hebrew Bible; *kalos* appears in the LXX far less frequently than Hebrew *yapheh* would seem to have required, and for some instances of *yapheh* we typically find *doxa*, the Greek word for "glory," also used to translate Hebrew *kabod*. This severely reduces the full range of meaning in the Hebrew Scriptures where beauty is concerned, even in its relation to the holy. Perhaps in part because *kalon* does not in the canonical books of the LXX occur in its aesthetic sense, in most cases where it does appear it has become synonymous, as I have noted, with *agathos*, "morally good," often used otherwise simply as a translation for Hebrew *tov*, "good" of any kind. A corollary seems to be that *doxa* has subsumed *kalos*.

The Place of Beauty (*Kalos*) in the New Testament

What then of the Greek of the New Testament? We have already seen that there are only four occurrences of a single Greek word for beauty, *hōraios*, each of which is in the English New Testament typically translated as "beauty" or "beautiful." By comparison, in classical Greek texts, terms such as *eidalimos*, "very beautiful" (Homer, *Odyssey* 24.279), and *eueidēs*, "shapely" (Xenophon, *Memorabilia* 3.11.4), like *eumorphos* (Herodotus 1.196), *euprosōpos* (Herodotus 7.168), and *euprepēs*, all refer to a beautiful face or appearance and in fact occur very rarely in later Greek literature; of these, only the last three occur in the LXX, while only *eu-*

prepeia and the verb form of *euprosōpos* occur, and but once each, in the New Testament.[25]

By contrast, the primary classical Greek word for beauty, *kalos*, is to be found everywhere in the Greek of the New Testament, but almost exclusively to signify "good" in its ethical register rather than "beautiful," and it is translated as such in almost all English versions. Thus, when Jesus refers to himself as the good shepherd who lays down his life for the sheep, the phrase is *ho poimēn ho kalos* (John 10:11, 14) in a context in which Jesus, whether speaking in Hebrew or Aramaic, was likely saying *tov*. In 1 Timothy, when Paul is instructing Timothy not to press gentile converts into strict observance of Jewish *kashrut* food laws, he says: *pan ktisma Theou kalon*, "every creature of God is good" (1 Tim. 4:4), adding "and nothing [is] to be put away, but received with thanksgiving for through God's word and prayerful intercession it is made holy" (vv. 4–5). There are many other such cases of *kalos/kalon* in the sense of "good," but the context of worship or holy presence attends upon these examples. One of the most frequent of these usages is in the phrase *kala erga*—"good works" or, as we might in some contexts translate it, "works of love." These too may take the form of a gesture of worship, as when the woman in Matthew's Gospel pours a small bottle of expensive perfume on the head of the Lord. Not all present approve her worship as a "good work," and so Jesus is prompted to defend the woman against the accusation of Judas that her perfume should have been sold and the money given to the poor (Matt. 26:10). In fact, this is a test case for the equivocal sense of *kalos*, for the question of what counts as a "good work" is evidently in debate. Judas asserts a preference for the sorts of practical good works that are obligatory and normative in a faithful Jewish life (*mitzvot*), and with precisely the same reasoning that contemporary opponents of beauty sometimes employ—it is a distraction from social justice.[26] Such good works are of course commanded in many places in the New Testament as well, for example, in the letters of Paul, who urges Timothy to encourage young Christians to "do good and to grow rich in noble deeds [*ergois kalois*]" (1 Tim. 6:18; cf. 5:10, 25; cf. Titus 2:7, 14; etc.). Jesus, on the other hand, here describes the extravagant action of the woman anointing him as *kala erga*, saying, "she has wrought a good work on me," regarding her

25. In James 1:11 *euprepeia* keeps the unusual sense of *hesed* in a direct quotation of Isa. 40:6, while *euprosōpēsai* is used pejoratively in Gal. 6:12 to mean "keeping up appearances in a hypocritical way."

26. These contemporaries are challenged by Elaine Scarry in *On Beauty and Being Just*, cited above.

action, effectively, as one of spontaneous worship of the person she takes to be *Christos*, the Anointed One; here the aesthetic sense of *kala erga* has been restored. While the King James Version has translated this phrase in Matthew's Gospel as "a good thing," and the New English Bible as "a fine thing," the Revised Standard Version and English Standard Version have done better, rendering the Greek as "for she has done a *beautiful thing* to me." Here a contemporary idiom succeeds where the more strictly literal rendition falls short, spiritually. In the original text, it seems clear enough that Jesus was redirecting Judas's insistent prioritizing of social justice, the ethical register of *kalos*, toward another order of the good, namely, a gracious and loving act of worship that, in the context of much of the usage of the Hebrew Scriptures as well, may be described rightly in our contemporary vernacular as "a beautiful thing." We may reasonably suspect *yapheh* or *tipharah* here (or their Aramaic equivalents) as what Jesus said in Hebrew, so that the point of this passage is a rehabilitation (in a startling context) of the *mitzvah* as a work of love, both work and worship (in Hebrew one word, *'avodah*, can signify both "work" and "worship"; cf. Greek *leitourgia* and English "service"). In philological terms, the ethical register of *kalos* has been reunited with its aesthetic significance as the "beauty of holiness."

Kalos appears once more in an aesthetic context in the New Testament. In the temple, as Jesus and the disciples are visiting it for a last time before his passion, some were marveling at the beauty of the temple, including the fact that it was decorated with "beautiful stones (*lithois kalois*) and gifts" (Luke 21:5), much as had been Solomon's Temple originally. Jesus foretells the imminent demise of this beauty, which had also become for some perhaps an end in itself: "as to these things you see, the days are coming in which not one stone (*lithos*) will be left upon another" (v. 6).

In the Hebrew Bible, the beauty made by men, no less than the beauty in creation, is transitory; like the beauty of the flowers of the field, it will pass away. That doesn't mean it isn't real beauty, but rather we are reminded that there is a higher Beauty to which it should be referred, as in right worship it is referred to a beauty that does not pass away. Nor should we think, therefore, despite the limitations of late Hellenistic Greek vocabulary, that the Hebrew idea of beauty disappears in the New Testament. Paul, for example, in Philippians (4:8), may well have the beautiful in mind when he urges his audience to meditate on "whatsoever things are lovely" (though his word here, *prosphilē*, is more homely, it conveys "beauty" as well). But in the perspective afforded by Jesus's prophecy that the temple would be destroyed (Matt. 24:1–2), and his reference to his own body as

the temple (John 2:19–21), as in Paul's declaration that the community of believers "are the temple of God" in which the Holy Spirit, like the *she-kinah kabod*, dwells (1 Cor. 3:16–17; 2 Cor. 6:16), and in his teaching that the individual believer should accordingly be chastened by the realization that through the indwelling of Christ his or her body "is the temple of the Holy Spirit" (1 Cor. 6:19), there are deeper resonances of the long association in Hebrew of beauty with holiness, the deeds of a consecrated life, where any action may become worship. Socrates's prayer at the end of the *Phaedrus* is not so far off. Notably, in a world in which the temple is about to be destroyed, the locus of holy beauty is internalized. Such passages call to mind a phrase of the psalmist in his marriage song, especially considered in its messianic register: "the king's daughter is all glorious within" (Ps. 45:13), a context in which, as so often is the case, beauty and glory are characteristics of the bride, her faithful reflection of the beauty and glory of the Lord to whom she is betrothed.

Conclusion

We may sense that in the topic of beauty we have entered an ambivalent yet indispensable sphere of meaning, even in the Bible. First, beauty is both glorious and dangerous in the Old Testament: glorious because it is a reflection of the glory of the Lord; dangerous because if beauty is not referred to the divine artist, it ceases to be a sign and can become simply an object of idolatry. Nevertheless, rightly referred, artistic beauty flourishes in the service of holiness, and that context informs much of the aesthetic as well as religious language in the Hebrew Scriptures. Thus, though New Testament Greek usage appears to be chastened by late Hellenistic apprehensions about the risk in visible beauty, beauty is reflected in other Greek words used to translate the Hebrew and Aramaic of Jesus and the apostles—transitive verbs implying action. The Old Testament sense of a "set apart–ness" of beauty for holiness comes through by association in some of the parables (e.g., the man without a wedding garment) as well as in accounts of the worshipful love for the Lord of those who come to him. Jesus himself receives with special affection the transformation of erotic beauty in Matthew 26 (the repentant courtesan in Luke 7 is another example); both are acts of repentant worship in which beauty is embodied as an action. The connection of beauty and desire, so evident in the Hebrew Scriptures, thus persists in the New Testament, focusing, as Psalm 45 anticipates, on the Messiah as Bridegroom for the faithful daughter

of Zion, in New Testament terms the bride of Christ, his church, who is herself to be perfected in beauty, "without spot or wrinkle" (Eph. 5:26–27). As the art of the catacombs illustrates, beauty in the service of holiness is honorable when it celebrates the desire of believers to imitate, as did the saints of old, the One who alone is wholly holy.

The Old Testament sage Qoheleth thus turns out to have captured something that makes beauty profoundly a topic for philosophical and theological reflection, and at the same time a harbinger of eschatological hope: "He hath made every thing beautiful in his time; also he hath set eternity in their heart, so that no man can find out the work that God maketh from the beginning to the end" (Eccles. 3:11). These words go deeply indeed into the matter of our study. Beauty provokes in most of us a stirring of inchoate desire, a mixture of infinite longing and sometimes regret. To encounter mortal beauty in its fragile radiance is sometimes akin to being granted a momentary glimpse into the meaning of the cosmos, an awakening to an untraveled eternity (*'olam*) in the heart that pulls us on toward the unfathomable mysteries of the beauty of God. We yearn. We long for immortal beauty. Yet no one can discover, says our biblical poet, the nature of God's artistry, his work of love, from beginning to end.[27] On the biblical view, in mortal beauty, if we have but eyes to see just that much, we are set on a path toward beauty's source, the glory of the Lord. For Plato, beauty awakens in us a desire for truth and justice. These prove to be nearly commensurable views. Acknowledgment of the desire for holiness is, however, qualitatively an extra dimension in Western thinking about art informed by both foundations. The place of the holy has been for more than three millennia of artists an *ohel mo'ed*, a meeting place where mortal beauty and the beauty of God may commune.

27. It may be that this passage directly informs the words ascribed to Christ by Saint John the Divine, "I am the Alpha and Omega, the beginning and the end" (Rev. 1:8, 11).

2 THE PARADOXICAL BEAUTY OF THE CROSS

His deformity was our beauty.

AUGUSTINE, *SERMON 27*

While Augustine has been generally regarded as, more than any other, the foundational figure for hermeneutics and biblical exegesis in the West, his name is not so often associated with aesthetics or theories of beauty. This is perhaps understandable, given his famous self-deprecatory remark in his *Confessions* that while he had once written a book entitled *De pulchro et apto* (Of beauty and proportion)—"in two or three volumes, I think," he says rather laconically—it was somehow lost. There is not the slightest hint of regret in this remark, and given that it forms part of Augustine's acknowledgment of his preconversion preoccupation with inferior subjects out of dubious motives,[1] the lost work on aesthetics can seem to be something that in his own mind he lumped together with the adolescent pranks and other misdirected pursuits of his old life.

But nothing could be further from the truth. The questions he had attempted to pursue in the lost books, first among them the nature of the beautiful and its compelling "allure," as he calls it, are, following his conversion, reframed in a larger intellectual context; far from being dis-

1. Augustine, *Confessions* 4, especially 4.13.20 through 16.31. I have used here the translation of J. G. Pilkington, corrected on occasion by the translation of F. J. Sheed, recently reedited by Michael P. Foley, *Augustine's Confessions* (Indianapolis and Cambridge: Hackett, 2006).

missed as spiritually or philosophically unworthy, they are revalorized and made central to the meaning of his new life. In brief, the basic questions of the lost *De pulchro et apto* remain at the center of Augustine's work as a Christian theologian and philosopher. Any reflection on his aesthetics must accordingly take into account the theological matrix in which his aesthetic ideas, as we have them, are formulated.

Two extrinsic contexts, one ancient, the other modern, have obscured our appreciation of the ongoing pertinence for Augustine of his early questions about the nature of corporeal beauty and its seductive allure. The oldest of these draws heavily upon the language of Neoplatonism, to which Augustine was certainly indebted, but by which he has been sometimes characterized too narrowly as a metaphysical realist or even a dualist.[2] More recently, the paradigmatic post-Kantian disposition in aesthetics, namely, to reject metaphysics altogether, has found much of Augustine's biblical and theological language, as well as his argument, to be mere piety, a kind of mysticism. Both of these approaches miss the mark. As we shall see, Augustine is not such a strict Neoplatonist as some believe, and his metaphysical teleology is certainly not abstracted from physical reality and bodily experience. Considered canonically, Augustine's aesthetic ideas reveal themselves to be fundamentally more Hebraic than Hellenic—which is to say, they are much more biblical, historically grounded, and tangibly mediated than some of his apparently Neoplatonic language might on the surface seem to indicate. Thus, while metaphysical realities are obviously crucial to Augustine's overall theory of beauty, his mature ideas about the beautiful, and indeed about the nature of its allure (he often uses the sensual word *allicit*, from *allicere*, "to entice"), depend absolutely upon sensible appreciation and corporeal experience. In this context, his novel ideas about the beauty of the cross form the crux of his general theological aesthetics.

The Beautiful as an Object of Love

To return to the *Confessions* (ca. 397–401), as Augustine reflects further on the questions that prompted his lost work, we immediately encounter

2. Augustine's fellow North African Albert Camus wrote a master's thesis with this emphasis (University of Algiers, 1939); the major study by K. Svoboda, *L'esthétique de Saint Augustin et ses sources* (Brno, 1933), known to Camus, is the most important study taking this view.

a word that might seem indecorous in a Neoplatonic context and a type of category mistake in a post-Kantian aesthetic. That word is "love" (*amor*):

> I loved these lower beauties . . . and I said to my friends, "Do we love anything but the beautiful? What, then, is the beautiful? And what is beauty? What is it then that allures and unites us to the things we love, for unless there were a grace and a beauty in them, they could by no means attract us to themselves." And I marked and perceived that in bodies themselves there was a beauty, from their forming a kind of whole, and another from mutual fittingness, one part of the body with its whole, or a shoe with a foot, and so on. (*Confessions* 4.13.20, trans. Pilkington)

Augustine's strong early connection of both beauty and proportion with desire in his lost book is not at all lost in his subsequent Christian reflections on beauty.

A Neoplatonic rhetorical ambience in his subsequent discussions of beauty is nonetheless apparent. As Carol Harrison has observed in her landmark study, Augustine's familiarity with Plotinus in particular provided him with both a useful paradigm and a vocabulary.[3] Yet Plotinus's *Peri tou kalou* (*Ennead* 1.6) is as important as a foil to Augustine's own thinking as it is as a prompt to it.[4] For Plotinus, Supreme Beauty is part of the transcendent order to which all earthly beauty is at best a pale simulacrum; he claims that only the soul can come to know it, and then only by rising above sense-bound experience. Harrison speculates that after the hard and dualistic materialism of the Manicheans had lost its appeal for Augustine, the transcendental idealism of Plotinus must have seemed a refreshing antidote, and she thinks that preference for the soul in his soul-body dialectic in the early Christian works is clearly indebted to Plotinus.[5]

3. Carol Harrison, *Beauty and Revelation in the Thought of Saint Augustine* (Oxford: Clarendon, 1992), exhibits admirable balance, and is still the best general study. See also her "An Essay in Saint Augustine's Aesthetics," *Federación Agustiniana Española, Estudio Agustiniano* (1990): 205–15.

4. Plotinus, *The Enneads*, ed. Stephen Mackenna, 5 vols. (London: Medici Society, 1917–1930; reprint, New York: Pantheon, 1965). For Plotinus, the One (or Good) is beyond Being; for Augustine, "God"—another name for Being—is highest.

5. Harrison, *Beauty and Revelation*, 4–6, 12–15; she notes that Augustine's interest in created beauty becomes much more pronounced in the course of his theological writings. I wish to correct that contextually warranted view by showing how much it already figures in his early writings.

Any such indebtedness, however, involves a less mystical notion of soul progress in Augustine than one finds in Plotinus. This is evident as early as *De ordine* (ca. 386), a work of Augustine's Cassiciacum period, in which he stresses that the soul is ordered toward its higher potential through a rigorous intellectual training in the disciplines of the liberal arts. Reason is developed through experience, in which governance by number is seen to provide the order, harmony, and form we observe and confirm in the created world (1.8.24).[6] One of Augustine's most favored biblical texts supporting the thesis of *De ordine* is Wisdom 11:20, "Thou hast ordered all things in measure, weight, and number."[7] This recurrent text, referring as it does for Augustine to the physical creation, offers an important clue to his emphatic parallel, emphasized so strongly in *De ordine*, of divine authority with reason (2.9.26–27; cf. 2.4.12–2.5.14). In *De ordine* Plotinus is never mentioned, nor is Plato. Aristotle is cited, however, and lineaments of Aristotle's thought are visible at a number of points (e.g., 2.11.31; cf. 2.5.16). There is an aspect, then, of Augustine's use of the notion of ascent in learning that sees "corporeal things as definite steps" en route to an apprehension of incorporeal or intelligible realities; in reading Augustine one should not pass too swiftly over these "steps."[8] As he puts it in *De musica* (ca. 397), the things of mortal beauty are beautiful in their own kind and order, and by an overarching order they are joined together in a harmonious unity that he describes as a "poem of the universe" (6.10.28).[9] It is possible for Augustine to find beauty even in a cockfight; in its own way, he insists, it too is an evidence of the pervasiveness of order (cf. *apto* in the title *De pulchro et apto*): "We could see their intent heads stretched forward, hackles raised, mighty thrusts of beak

6. Augustine, *On Order (De ordine)*, trans. Silvano Borruso (South Bend, IN: St. Augustine's Press, 2007), 31. For a discussion of Augustine's classification of the arts, which differs slightly from later orderings of the *trivium* and *quadrivium*, see Danuta R. Shanzer, "Augustine's Disciplines: *Silent diutius Musae Varronis?*" in *Augustine and the Disciplines: From Cassiciacum to Confessions*, ed. Karla Pollmann and Mark Vessey (New York: Oxford University Press, 2005), 69–75.

7. Wisd. of Sol. 11:20–21 is one of Augustine's most frequently cited biblical texts in this connection, though the aura of Pythagoreanism contextualizes it. Cf. the discussion by Henri-Irénée Marrou in *Saint Augustin et la fin de la culture antique*, 3rd ed. (Paris: Brossard, 1958), 262–75, and the ripostes to I. Hadot, *Arts libéraux et philosophie dans la pensée antique* (Paris, 1984), by Danuta Shanzer, as well as the articles by William Klingshirn and Philip Burton, all in Pollmann and Vessey, *Augustine and the Disciplines*, 69–164.

8. Cf. his *Retractions* 1.6; Harrison, *Beauty and Revelation*, 25.

9. Augustine, *De musica*, trans. Robert C. Taliaferro, Fathers of the Church, vol. 4 (New York: Cima, 1947).

and spur, uncanny dodgings. There was nothing amiss in every motion of those irrational beasts. There was clearly another Reason controlling everything from on high, down to the universal law of victor and vanquished. The first crowed in triumph and puffed its feathers in a clear sign of superiority. The other had ended up with a featherless neck, voiceless, and crippled. I don't know how, but everything was a hymn to the beauty and harmony of nature" (*De ordine* 1.8.25). What to some tastes might be a more fitting example of ugliness and disorder, Augustine here describes as a "hymn to the harmony and beauty of nature," apparently in all seriousness. Later, in *De libero arbitrio* (ca. 395), he will return to this point in a more formal, theological way, praising the divine wisdom that "speaks to us in the beauty of every created thing" (2.16).[10] His characteristically frank appreciation for physical beauty in a wide range of objects and phenomena portends later reflections on the way in which, for him, the beauty and harmony of mortal life necessarily entail a frisson of opposition and contraries.

It is clear thus that contemplation of beauty in the natural order is, like Augustine's view of the exercise of reason by training in the liberal arts, certainly an *anagogicus*; it offers an upward-leading way or ascent of the soul toward a fuller vision of intelligible beauty.[11] He has a variety of ways of troping out this notion of ascent, but as in this passage, the motif of an educational journey predominates among them: "For those, therefore, who are ascending upwards the first action may be called, for the sake of instruction, quickening; the second, sensation; the third, art; the fourth, virtue; the fifth, tranquility; the sixth, entry; the seventh, contemplation. They may also be thus named: of the body, through the body, about the body, the soul towards itself, the soul in itself, towards God, with God. And again thus: beauty from another thing, beauty through another thing, beauty about another thing, beauty towards the beautiful, beauty in the beautiful, beauty towards Beauty, beauty in Beauty."[12] That mortal beauty is a means to transcendent Beauty makes his point; beauty of the soul does not cancel out beauty in the body, but necessarily begins in and

10. *Saint Augustine: On Free Choice of the Will*, trans. Anna S. Benjamin and L. H. Hackstaff (Indianapolis and New York: Bobbs-Merrill, 1964).

11. Cf. Saint Bonaventure's *De reductione artium ad theologiam* (Retracing the arts to theology), ed. and trans. Sister Emma Thérèse Healy, in *Works of Saint Bonaventure*, ed. Philotheus Boehner et al. (Saint Bonaventure, NY: Franciscan Institute Publications, 1955); this was written nine centuries later; see chap. 3 following here.

12. Augustine, *De animae quantitate* 70–76; cf. 35.79; cf. Svoboda, *L'esthétique de Saint Augustin et ses sources*, 60–61.

depends upon it. This is a point he makes firmly against Mani and the Manicheans (ca. 390s).[13] The soul is "a great force of a non-bodily nature," but its works we nevertheless see as they are embodied, and by them, as with the works of the creator God, we are frequently "amazed": "Look round at the order imposed on things, at the beauty of cultivated fields, of thickets uprooted, of fruit trees planted and grafted, all the things we see and love in the countryside; look at the very order of the state, at the noble piles of buildings, at the variety of arts and crafts, at the number of languages, at the depths of memory, at the ripeness of eloquence. All these things are works of the soul. How many and how great are the works of the soul, all of which you can see, and you can't see the soul itself!"[14] It becomes apparent to Augustine that a keener awareness of the work of the artist, including most notably the divine artist, makes us want to know the artist. This is to him only natural:

> Should one look at the works and not look for the craftsman? You look at the earth bearing fruit, you look at the sea full of its animals, you look at the air full of flying creatures, you look at the sky bright with stars; you recognize the changes of the seasons, you consider the four parts of the year, how the leaves fall from the trees and come back again, how their seeds are given their numbers, and each thing has its measurements, its weights, how all things are being administered in their own ranks and order, the sky up above with total peace, the earth down below having its own proper beauty, the beauty *sui generis* of things giving way to and succeeding each other. Gazing on all these things you behold

13. Sermon "On God's Providence" (Dolbeau, 29), 4, in *The Works of Saint Augustine*, ed. John E. Rotelle, OSA, trans. Edmund Hill, OP, ser. 3, vol. 11 (New York: New City Press, 1997), 57. In *Sermon* 243.8, Augustine exclaims, "If such a great corporeal beauty (*tanta corporis pulchritudine*) is manifest in our flesh even now, how much greater will it be there." In such remarks we hear echoes of Saint Paul in 1 Cor. 2:9, "Eye hath not seen or ear heard, nor hath it entered into the heart of man, the things which God has prepared for those who love him" (quoting, in turn, Isa. 64:4; 65:17). To Mani he says, "let us praise God because he has given such a great good even to this beauty, though it is the least. Yet let us not cling to it as lovers of it, but let us pass beyond it as lovers of God, in order that, situated above it, we may judge concerning it and may not be entangled in it and judged with it. And let us hasten to the good that is not spread out in space, and does not pass in time, and from which all natures in places and times receive beauty and form. In order to see that good, let us cleanse our heart by faith in the Lord Jesus Christ, who said, *Blessed are the clean of heart because they shall see God* (Matt. 5:8)." *Answer to the Letter of Mani Known as The Foundation (Contra epistulam Manichaei quam vocant fundamenti)* 42.48.

14. Augustine, *Sermon* 360B.9, in *Works of Saint Augustine*, 371.

them now all given life by created spirit, and you don't go looking for the craftsman of such a great work?[15]

This passage comes from a sermon whose purpose was explicitly Christian apologetics, and the language here is naturally far more indebted to biblical passages than it is to Plotinus. But this is typical, and not only in his sermons. Seminal biblical texts in his lifelong address to the beauty of creation include Wisdom of Solomon 11:20–21, alluded to here, and Psalm 19, a poem that provides much of the framework for Augustine's method and is likewise quoted everywhere in his writings. This biblical grounding is the element most often overlooked, I think, when Augustine's "Neoplatonism" is emphasized too strongly, as it certainly is in Karol Svoboda's *L'esthétique de Saint Augustin et ses sources*,[16] a work that has had a significant influence in characterizing Augustine's aesthetics in Western scholarship generally. James O'Donnell has more recently examined the role of Neoplatonism in Augustine's writings and concluded more accurately, "It is not that he discovered that the Plotinian method did not work; he discovered that it did work, and that it was not enough."[17]

CREATED BEAUTY

The distinction between *use* of something and *enjoyment* of something for its own sake is basic to the argument of Augustine in *On Christian Doctrine*,[18] his book on hermeneutics and what we should now categorize as a species of "literary theory."[19] Here Augustine is elaborating a method for reading the text of Scripture in such a way that readers will not be distracted by preoccupation with matters of style and language (however important these are) from a deeper intellectual purpose in reading, namely,

15. Augustine, *Sermon* 198.31, in *Works of Saint Augustine*, 202.

16. See note 2 above.

17. James J. O'Donnell, *Augustine: Confessions; Commentary in Three Volumes* (Indianapolis and New York: Bobbs-Merrill, 1958). David Bentley Hart reflects Augustine when he says that "the idea of the beautiful—which somehow requires the sensual to fulfill its 'ideal' nature—can never really be separated from the beauty that lies near at hand." *The Beauty of the Infinite: The Aesthetics of Christian Truth* (Grand Rapids: Eerdmans, 2003), 20.

18. Augustine, *On Christian Doctrine* 1.3–5, trans. D. W. Robertson Jr. (Indianapolis and New York: Bobbs-Merrill, 1958), translation of *De doctrina Christiana*.

19. See David Lyle Jeffrey, *People of the Book: Christian Identity and Literary Culture* (Grand Rapids: Eerdmans, 1996), chaps. 1 and 3 for an extended discussion.

to come to an understanding of the divine authorial intention. That is to say, meaning resides not in the sign, but in the person who signifies; we are asked to refer the beauty of the art object back to the intellectual being who created it. For Augustine, attention must be devoted to matters of composition as a means we use en route to our enjoyment of a primary encounter with meaning in the text. He allows that some elements we may both "enjoy *and* use" (1.3), but his concern is that the goal of our intellectual journey not be frustrated or detained through arrested development, such as too narrow a preoccupation with style or method, or indeed any other species of idolatry of the sign. He does not deny to literary language its beauty; indeed, he will go on to say that its various beauties are indispensable, the means of drawing us on in our quest for meaning, and hence to be considered most carefully. His point is cautionary, simply that we should guard lest "the beauty of the country through which we pass, and the very pleasure of the motion, charm our hearts, and turning these things which we ought to use into objects of enjoyment, we become unwilling to hasten to the end of our journey; and becoming engrossed in a factitious delight, our thoughts are diverted from that home whose delights would make us truly happy" (1.4).[20]

The rind or outer husk of an edible fruit is what attracts us to it, and therefore is a critical element of our knowledge. Yet it is not the ultimate good we seek; that is the kernel or meat within (3.7.11; cf. 3.5.9).[21] Analogously, when we are said to "enjoy" the company of a noble intellect or virtuous person, says Augustine, we should not "stop short upon the road, and place our hope of happiness in man or angel" (1.33.36), but rather recognize that "when [we] have joy of a man in God, it is God rather than man that [we] enjoy" (1.33.37, trans. Shaw). For Augustine, so far from denigrating the person in question, this recognition gives to that person the full measure of his value as a creature made in the image of God. In all these examples, the issue is right reference, and Augustine's classic defense of Greek and Roman pagan poetry in the education of Christians depends upon it. But here too we see that the paradigm he draws upon is biblical, even as he is acknowledging the value of Neoplatonism:

20. *St. Augustine's City of God and Christian Doctrine*, trans. J. F. Shaw, in *Nicene and Post-Nicene Fathers*, ser. 1, vol. 2 (1887; Peabody, MA: Hendrickson, 2004). For an account of the almost thirty-year hiatus in his writing of this book, see David Lyle Jeffrey, "Self-Examination and the Examination of Texts: Augustine's *Confessions* and *On Christian Doctrine*," in *Houses of the Interpreter: Reading Scripture, Reading Culture* (Waco: Baylor University Press, 2003), 39–53.

21. See the discussion by H. I. Marrou in *S. Augustin et la fin de la culture antique*, 413.

Moreover, if those who are called philosophers, and especially the Platonists, have said aught that is true and in harmony with our faith, we are not only not to shrink from it, but to claim it for our own use from those who have unlawful possession of it. For the Egyptians had not only the idols and heavy burdens which the people of Israel hated and fled from, but also vessels and ornaments of gold and silver, and garments, which the same people when going out of Egypt appropriated to themselves, designing them for a better use, not doing this on their own authority, but by the command of God. (2.40.60, trans. Shaw)

Right reference for meaning is in this context essentially a matter of discerning between rightly ordered affection and idolatry of the mere sign, in which, for Augustine as for most readers of the Bible in his day, we are instructed by the Scriptures narratively. For example, it may occur to the reader of Exodus that the gold with which Aaron fashioned the golden calf idol may well have had the same source as that which was later, more properly, appropriated by the artists Bezalel, Oholiab, and the "wise-hearted women" to adorn the tabernacle for God's presence in the sanctuary.[22] This passage is but one of many biblical archetypes on which Augustine drew for his distinction between use and enjoyment. To distinguish is not to denigrate; Augustine shows that what is frequently at issue in such narratives is an argument for the reader's acquisition of rightly ordered love; such love, he will say repeatedly, does not disparage the body or any beautiful thing in the world, since they are expressions of a universal language of love emanating from the "Maker of all things, visible and invisible" (Nicene Creed). In this context his pervasive praise for the beauties of nature (creation) is poetic, and itself beautiful. It may be too much to say, as does Hans Urs von Balthasar, that such praise of nature constitutes effectively a contradiction of all Platonism, but it certainly qualifies it.[23]

Creation itself, rightly viewed, is for Augustine the beauty that awakens us to Beauty. Reciprocally, Beauty lets us in turn appreciate mortal beauty in a fuller way. His rhetoric seldom soars as high as when he turns his prose to this subject:

22. See David Lyle Jeffrey, "Translation and Transcendence: The Fragile Future of Spiritual Interpretation," *Modern Theology* 28, no. 4 (2012): 692; see also, Jeffrey, *People of the Book*, 52–59.

23. Hans Urs von Balthasar, *The Glory of the Lord: A Theological Aesthetics*, ed. Joseph Fessio, SJ, and John Riches, trans. Andrew Louth, Francis McDonagh, Brian McNeil, et al., 7 vols. (San Francisco: Ignatius, 1982), 2:123. Cf. Harrison, *Beauty and Revelation*, 130–31.

Ask the loveliness of the earth, ask the loveliness of the sea, ask the loveliness of the wide airy spaces, ask the loveliness of the sky, ask the order of the stars, ask the sun making the day light with its beams, ask the moon tempering the darkness of the night that follows, ask the living things which move in the waters, which tarry on the land, which fly in the air; ask the souls that are hidden, the bodies that are perceptive; the visible things which must be governed, the invisible things which govern—ask all these things, and they will all answer thee, Lo, see we are lovely. Their loveliness is their confession. And these lovely but mutable things, who has made them, save Beauty immutable?[24]

Finally, in the incarnation Christ made manifest God's own immutable Beauty in visible form; thus for Augustine the incarnate God is "beautiful in heaven; beautiful on earth; beautiful in the womb; beautiful in his parents' hands," and even "beautiful on the Cross" (*Enarrationes in Psalmos* 44.3; cf. 45.7).[25] Here, immutable Beauty itself has come to have a corporeal form that draws us to the beauty of creation's meaning; this is a principle that was to be realized abundantly in the plastic and graphic arts over the next millennium and beyond, especially in regard to the restoration of creation (or re-creation) effected in the atonement. Thus, for Augustine and the artists who follow in this train, it is entirely fitting to speak of the cross, of the crucifixion, as beautiful: "'He had no form or comeliness that we should look at Him.' The deformity of Christ forms you. For if He had not wished to be deformed you would not have received back the form that you lost. Therefore, He hung deformed upon the cross, but His deformity was our beauty."[26]

24. Augustine, *Sermon* 241.2.2, trans. Erich Przywara, *An Augustinian Synthesis* (London: Sheed and Ward, 1939), 116. Cf. Wisd. of Sol. 13.

25. Augustine, *Enarrationes in Psalmos*, trans. A. Cleveland Cox, in *Nicene and Post-Nicene Fathers*, ser. 1, vol. 8 (1888; Peabody, MA: Hendrickson, 1994), 146, 148. See here Richard Viladesau, *The Beauty of the Cross: The Passion of Christ in Theology and the Arts from the Catacombs to the Eve of the Renaissance* (New York: Oxford University Press, 2006), 9–12, 31–33; also Francesca Aran Murphy, *Christ the Form of Beauty: A Study in Theology and Literature* (Edinburgh: T. & T. Clark, 1995).

26. Augustine, *Sermon* 27.6, cited in Harrison, *Beauty and Revelation*, 234.

TRANSCENDENT BEAUTY

By Plato and, to a lesser degree, by Aristotle, the transcendentals—the True, the Good, the Beautiful—were considered to be properties of Being. Aquinas came to settle for a different schema: the One, the True, and the Good. The Beautiful came again to be normatively recognized as a transcendental in the writing of Bonaventure.[27] But that is to speak about aesthetic history formally; the Beautiful is a transcendental everywhere in Augustine, and it is clear that Bonaventure straightforwardly follows him in this respect, as in so many others.

When we read his sermons and biblical tractates, we see that for Augustine the content of each of the transcendentals is, consistently, more defined by biblical than by pagan sources; this is to say, the articulation may owe something to Platonism but the governing philosophy is biblical. When, for example, Augustine discusses Plato's *Timaeus* at some length in *The City of God*, he finds a host of similarities or parallels between the Athenian and the Hebrew Scriptures especially, and nowhere more so than the burning bush incident, in which the invisible God answers Moses's request for his name by saying, "I am who I am" (Exod. 3:14; *De civitate Dei* 8.11). This suggests to Augustine a definition for Being precedent to that of Plato but compatible with it; he even speculates in this passage that Plato may have been influenced somehow by the books of Moses.

Yet neither Augustine nor anyone else could have been expected to associate a death by crucifixion with transcendent Beauty. Indeed, to a degree that can be obscure to our contemporaries, to refer to the cross as beautiful in the fourth century was to put considerable strain on the aesthetic idea of proportion or "fittingness." While Christians were from the outset identified as *crucis religiosi* (devotees of the cross), it was not a compliment; their association of salvation with the most ignoble of executions was still, as Paul put it, "a stumbling block to the Jews, and foolishness to the Gentiles" (1 Cor. 1:23).[28] To sign oneself on the forehead with the cross seems to have become customary in the second century, at least according to Tertullian. It seems likely that there was an implied biblical warrant, with repeated self-crossing an indication of penitence and grief for the consequences of sin (perhaps recollecting the tau on the foreheads of "those who sigh" in Ezekiel 9:4–6) and a declaration of a willingness to

27. Umberto Eco, *The Aesthetics of Thomas Aquinas*, trans. Hugh Bredin (Cambridge, MA: Harvard University Press, 1998), 45.

28. Tertullian, *Apologeticus adversus gentes pro Christianis*, Patrologia Latina 1:365–66.

take up one's cross (Luke 9:23), if necessary unto martyrdom.[29] Alex Stock has argued that Paul's reference to the cross as "stigma" and "stigmata" (Gal. 6:17) is analogous to the branding of slaves, and yet also parallel to the commandment in Deuteronomy 11:18 to bind Torah "as a sign on your hand and frontlets between your eyes" (cf. Deut. 6:8).[30] But visual appearances of the cross in Christian art come later, and appear slowly, even secretly.[31] We do not find the cross in fresco art of the catacombs, for example; where we might expect it we find other symbols such as an anchor, a lamb, a shepherd, even the cryptogram *ichthys*. Indirect references to Christ's death such as the staurogram, a compression of the tau and rho (*T* and *R*) in the Greek word *stauros* (cross), may have appeared as a proto-ligature, as a species of *nomen sacrum* (*nomina sacra* are abbreviations used for "holy names" in early Christian manuscripts) in Papyri Bodmer P45, P66, and P75. As Larry Hurtado has noted, the two-letter unigraph, to those prepared to look for it, might suggest the figure of a man on a cross.[32] Since these manuscripts considerably predate Constantine's famous *labarum*, his cross-in-the-sky vision on the Milvian bridge, and its triumphalist motto, *in hoc signo vinces* (in 312), the use of the staurogram suggests for Hurtado a proleptic use of an image that will appear in more typical contexts only much later, in the mid to late fourth century. Given the dating, the question naturally arises: Was it Constantine who made the sign of the cross publicly acceptable?

In the first part of his reign, Constantine continued to crucify convicted slaves. Eusebius tells us that he later gave the practice up, in honor of the passion.[33] It is sometimes noted that a medallion with the bust of Constantine, wearing a helmet with a tiny, nearly invisible Christogram, was minted around 315, but this is not really a representation of the cross.[34] About thirty-five years later a Roman sarcophagus was carved

29. Viladesau, *Beauty of the Cross*, 42–43.

30. Alex Stock, *Poetische Dogmatik: Christologie; Figuren* (Paderborn: Ferdinand Schöningh, 2001), 318–19.

31. Bruce Longenecker, *The Cross before Constantine: The Early Life of a Christian Symbol* (Minneapolis: Fortress, 2015).

32. Larry Hurtado, "The Staurogram in Early Christian Manuscripts: The Earliest Visual Reference to the Crucified Jesus?" in *New Testament Manuscripts*, ed. Thomas Kraus (Leiden: Brill, 2006), 207–26.

33. Eusebius, *Historia ecclesiae* 1.8.

34. Johannes G. Deckers, "Constantine the Great and Early Christian Art," in *Picturing the Bible: The Earliest Christian Art*, ed. Jeffrey Spier (New Haven: Yale University Press, 2007), 89; cf. Josef Engemann, *Deutung und Bedeutung frühchristlicher Bildwerke* (Darmstadt, 1997).

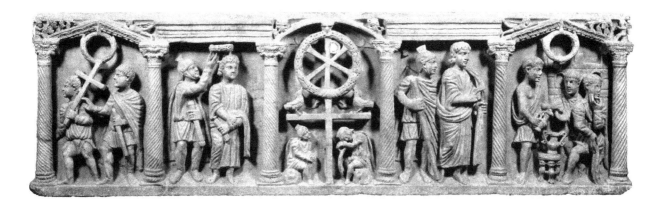

with a cross, in relief, on which the Christogram is superposed through the imposition of a laurel wreath; with the head of Sol on the right and Luna on the left, we have a clear imitation of earlier depictions of the emperors here attached to the "triumphant cross" (fig. 8).[35]

Figure 8. Sarcophagus with Chi Rho, ca. 350

This example is unique, but clearly Constantinian. Elsewhere, however, the use of the cross continues to be minimalist, even when a subject might seem to warrant its more purposeful use. In the Mausoleum of Santa Costanza in Rome, a church built by Constantine as a mausoleum for his daughter in 354, there is an apse mosaic of the *traditio legis* (handing down of the law) in which the representation of Christ, who is passing on the Law to Peter (*Dominus legem dat*—"the Lord gives the Law"), is identified in part by a tiny unadorned *x* floating above his head, asymmetrically.[36]

35. Deckers, "Constantine the Great," 105–6.

36. Deckers, "Constantine the Great," 95; Fabrizio Bisconti, "Variazioni sul tema della traditio legis: Vecchie e nuove acquisitioni," *Vetera christianorum* 40 (2003): 251–70. It is a curiosity worthy of further reflection that Augustine's vocabulary for divine beauty, while drawn from his exegesis, is synthetic, more theological than philologically or semantically driven. He does not know Hebrew, yet seems to have sensed, despite the filter of the LXX, what the *Vetus Latina* could not alone give him. The Hebrew Scriptures use terms for beauty, as we have seen, more or less equally to refer to feminine beauty, artistic beauty, and divine beauty. A rare Hebrew term for beauty, *mareh*, occurs in Isa. 53:2, a passage crucial to Augustine in our context. The Septuagint translates *yapheh* with *doxa* in passages in which the term may signify "glory" or "radiance" as well as beauty (e.g., Pss. 29:2; 96:6–8), but *kalos, kalon* in places where aesthetic or feminine beauty would seem to be signified (e.g., Ezek. 27:3, 4, 11), as well as for "splendor" or "magnificence" (e.g., Ezek. 28:12, 17; 31:8). In Isa. 44, which refers to the realistic beauty of comeliness in a statue, Hebrew *tip'ara* is rendered with *kalē*, and so also is *mareh* (Isa. 53:2 with *kalos*). When we come to the *Vetus Latina* renderings, where there were several versions possibly available, we can be less than certain, but if the Vulgate can be assumed to replicate the norms of usage for these terms, in those

All these signs remain cryptographic; none gives us the crucifixion of Jesus with verisimilitude.

There are small but important exceptions. Somewhere around the beginning of the third century, perhaps in Syria, someone carved an amulet out of jasper, probably for a pagan magician, which depicts Jesus hanging naked on the cross, surrounded by magical names.[37] It is not inconceivable that such a magical amulet, however discouraged by the bishops, may have given rise to a more orthodox gemstone carving of Jesus crucified with all twelve disciples gathered around the cross. In this latter miniature, also likely Syrian and of the mid-fourth century, above Jesus's head appears the acrostic *ichthys* (Greek for "fish," and an anagram for "Jesus Christ, God's Son, Savior").[38] Like other medallions of the sort, it was probably used as a signet ring. But full scenes of the passion, such as the four carved ivory reliefs known as the Maskell ivories, do not appear until after the first quarter of the fifth century (fig. 9). These, like the gemstone signets, are all personal objects; so too would have been the plain iron cross worn by Saint Macrina (d. 379), discovered by her brother Saint Gregory of Nyssa at her death.[39] None may be associated with public worship. Processional crosses begin to appear in the fifth to sixth centuries, but then as staurograms, not crucifixes.[40]

What Augustine calls the "beautiful cross," the adorned, exalted cross such as we find in the mosaic apses of prominent churches in Rome, appears first around 400. A splendid example is the figure of Christ enthroned, surrounded by the apostles in the heavenly city, in the apse of Santa Pudenziana (ca. 400) (fig. 10).[41] Here a beautiful jeweled cross hovers

passages of Scripture that are crucial to Augustine's view of the beauty of the cross the Latin texts themselves do not provide his vocabulary. Whereas in the Vulgate for Isa. 53:2 we have *neque decor*, for the doubled *yapheh* and of Ps. 45:2 (Greek: *hōraios kallei*) we have *speciosus forma*. Augustine will occasionally use the latter phrase, but in discussing the Ps. 45 and Isa. 53 texts he prefers above all *pulcher, pulchritudo*, terms that in the Vulgate are most frequently found in the Song of Songs, referring to the beauty of the bride and bridegroom. Yet this is the term preferred where Augustine is building up from those counterpoised passages his cruciform aesthetics. *Pulcher*, however, comports better with the dominant Hebrew terms—a result, perhaps, of Augustine's often uncanny contextual discernment.

37. Spier, *Picturing the Bible*, 228.

38. Spier, *Picturing the Bible*, 229; cf. the helpful notes by Felicity Harley.

39. *Catholic Encyclopedia*, ed. Charles G. Hebermann et al., 15 vols. (New York: Encyclopedia Press, 1908), 4:524b.

40. Spier, *Picturing the Bible*, 233–36, provides examples in iron from the fifth and early sixth centuries.

41. Anne-Orange Poilpré, *Maiestas Domini: Une image de l'Eglise en occident Ve–IXe*

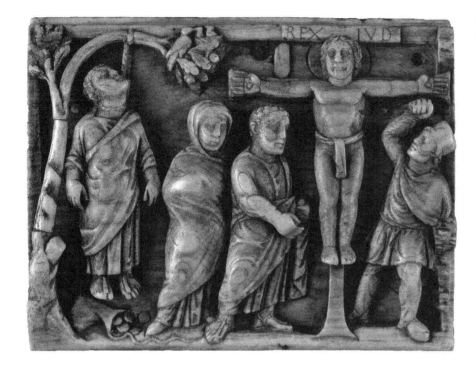

Figure 9. Maskell Ivories, Rome, ca. 425

over the head of Christ on his throne. It is striking, and not duplicated until the resplendent "beautiful crosses" of churches in Ravenna more than a century later, such as in the apse of Sant' Apollinare in Classe (fig. 11) (about 549); in Santa Pudenziana, the cross is already meant to be both beautiful and a focus of worship.[42] In Santa Pudenziana the images of the four evangelical beasts suggest both the divine presence in Ezekiel's vision and the sign in the sky of the returning Christ from Revelation. In Sant' Apollinare in Classe, the gem-studded golden cross has a head of Christ where the beams cross, and the scene is of the transfiguration, with the cross representing the transfigured Lord. In nearby San Vitale, angels hover over the Abraham Akedah mosaic with a beautiful medallion cross, and in Sant' Apollinare Nuovo the cross nimbus behind the enthroned Christ repeats the *pantocrator* mosaics of the Byzantine Hagia Sophia and of Santa Maria Maggiore in Rome; all are mid-fifth century or later, and the matchless Vatican Cross, a reliquary cross of Justin II, is sixth century (fig. 12). In the richly illustrated Rabbula Gospels (586), the crucifixion of

siècle (Paris, 2005); Fabrizio Bisconti, ed., *Termi di iconografia paleochristiana* (Rome: Vatican City, 2000); cf. Spier, *Picturing the Bible*, 113.

 42. Herbert L. Kessler, "Bright Gardens of Paradise," in Spier, *Picturing the Bible*, 129.

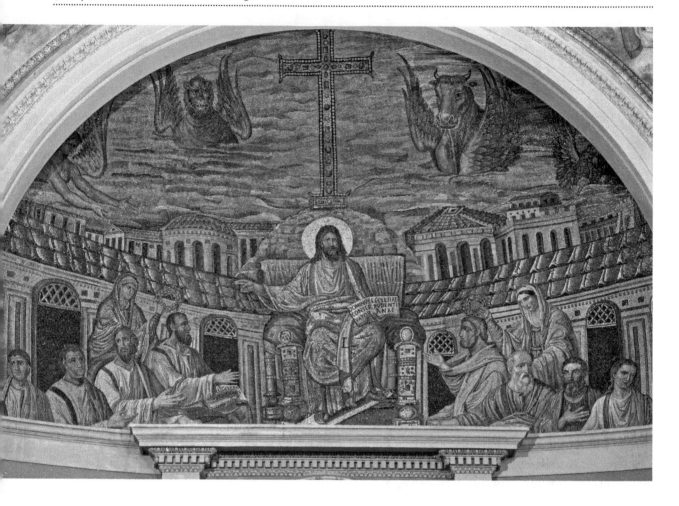

Figure 10. Mosaic of Jesus
the Teacher, Apse of Santa
Pudenziana, Rome, ca. 400

Jesus is depicted with verisimilitude—the earliest known such depiction
in painting.[43]

Thus, sometime between about 350 and 425, the depiction of the cross
went from being a code, a staurogram, a secret sign for believers, to being
a subject fit for the finest focal artwork of great sanctuaries. What were
the reasons for this remarkable change? One may simply be the public
image of Christianity after the triumph of Constantine. Augustine seems
indirectly to acknowledge this when he says of Christ in *Sermon* 87: "You
see, he has come forth from hidden obscurity to being a celebrity. Christ
is known now, Christ is preached everywhere. . . . He was once someone

43. Written in Syriac translation (the Peshitta); the crucifixion, resurrection, and as-
cension illuminations may have been lifted from a Greek Gospel (Spier, *Picturing the Bible*,
276, following Massimo Bernabò et al.).

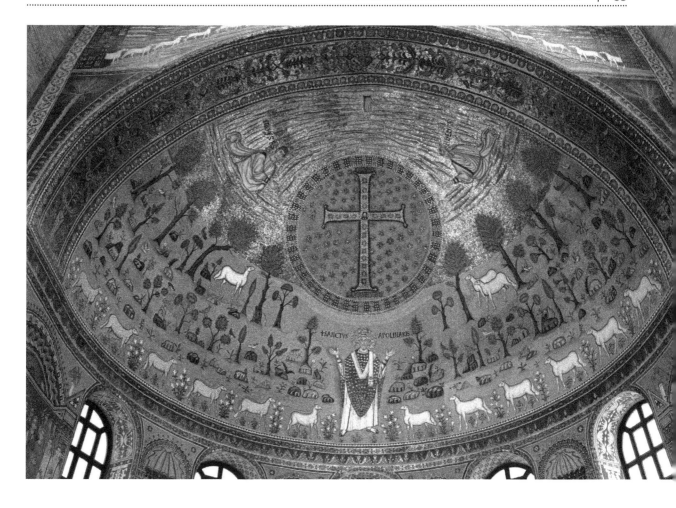

laughable" (87.9).[44] Our bishop elsewhere seems to take a more nuanced view of the public reason given for Constantine's ban on crucifixion: "Then, there was nothing more unbearable in the flesh; now, there is nothing more glorious on the forehead. What did he who gave such honor to his punishment save for his faithful? Indeed, now among the punishments of the convicted it is no longer in use by the Romans; for where the cross of the Lord has been honored, it has been thought that a guilty man would also be honored if he were crucified" (*Tractatus in Ioannem* 36.5; ca. 409). On Augustine's view, the cross had already gained more honorable than dishonorable associations in the public square. What once was nec-

Figure 11. Apse Mosaic, Sant' Apollinare in Classe, Ravenna, ca. 549

44. In *Sermons on the New Testament*, in *The Works of Saint Augustine*, ed. John E. Rotelle, OSA, trans. Edmund Hill, OP (Brooklyn: New City Press, 1991), 3:412. All sermon quotations are from this translation, unless otherwise noted.

Figure 12. Vatican Cross,
ca. 570

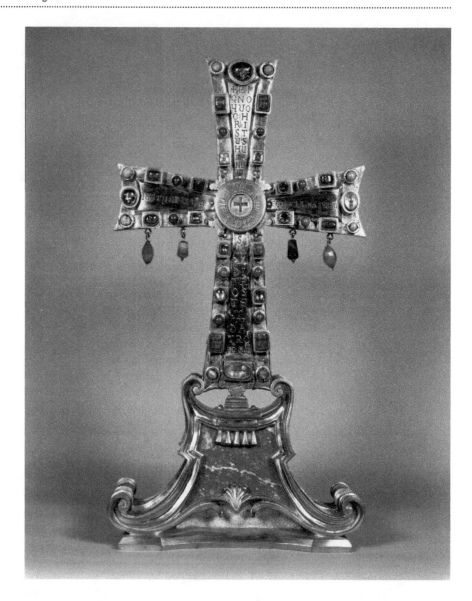

essarily to be hidden had now, in a variety of ways, entered mainstream culture; it could not be hidden anymore.

Yet there are deeper reasons—theological and aesthetic—why Augustine clearly wanted to revise residually negative social views of the cross. For Christians, he argued, it is no longer a symbol of shameful death, nor even just a permissible sign of the *religiosi crucis*; it is the very signature of divine beauty. He asks his fellow Christians to see the cross not just through the eyes of faith, but especially through the eyes of love—the eyes of the church as bride of Christ. What this perspective creates initially is

irony and paradox where the crucifixion is concerned, but such paradox as is interpretable by love, beginning with the love of the bride. Thus, though the beauty of the bride has been degraded by sin, "it is made beautiful (*pulchra*) by him" (*Sermon* 138.6); she then develops correspondingly a powerful spiritual love for the Bridegroom. In the thrall of this love she loves Christ "crowned with thorns, ugly and without dignity" (Isa. 53:2). "What is it that she loves?" Augustine asks; "is it a fine figure of a man above the sons of men?" The reference here to Psalm 45 juxtaposes the two biblical texts in such a way as to create contradiction for the unbeliever yet a beautiful paradox or mystery for the bride. "That bridegroom," he says, "became ugly for the sake of his ugly bride, in order to make her beautiful" (*pulchram*) (*Sermon* 95.4). Speaking elsewhere of these two texts (Isa. 53 and Ps. 45), Augustine calls them "two flutes, playing, as it were, differing tunes, but one Spirit blows into both . . . [so] they are not discordant" (*In epistolam Joannis* 9.2; ca. 429). The unbeliever hears only cacophony. Now we see where Augustine is going with his biblical trope. Just as there can be no meaningful concept of truth without the possibility of falsification, that is, of giving the lie to a claim, so too there can be no concept of the Beautiful without a contrary, the Ugly. On the cross, two poles, as John Donne would later say, "meet" in a startling frisson.[45] So Augustine: "For the sake of your faith Christ became deformed, yet Christ remains fair—fair in form above the sons of men." How so? Or, as Augustine says in a similar passage (*Sermon* 44.2), "Where does all this beauty come from?" His answer: "Christ's deformity is what gives form (*forma, formosa*) to you. If He had been unwilling to be deformed, you would never have gotten back the form you lost. So He hung on the cross, deformed; but His deformity was our beauty (*sed deformitas illius pulchritrudo nostra erat*)" (*Sermon* 27.6; cf. 44.4). In this way, "a foul sight, the sight of a man crucified . . . produced beauty. What beauty? that of the Resurrection" (*Sermons on the Liturgical Seasons*, 346).[46] Hence, for the bride, who longs to see the Bridegroom's face, "Woe to that love of thine, if thou canst conceive anything more beautiful than Him, from whom is all Beauty" (comment on Ps. 44:16). Transcendent Beauty is the source and grounding of that beauty seen in her crucified beloved by the bride. "He loved us first who

45. John Donne, "Upon the Annunciation and Passion, falling upon one day, 1608 [March 25]," in *Selections from Divine Poems, Sermons, Devotions, and Prayers*, ed. John Booty (New York: Paulist, 1990), 98–99.

46. The question is well put by Viladesau, *Beauty of the Cross*, 9. Text trans. Sr. Mary Sarah Muldowney, RSM, *Fathers of the Church*, vol. 38 (Washington, DC: Catholic University of America Press, 1959; repr. 1984; 2008).

is always beautiful," Augustine says elsewhere, and "by loving [him] we in turn are made beautiful" (*In epistolam Joannis* 9.9).[47]

There is thus another paradox in Augustine's idea of beauty in the cross, namely, that transcendent Beauty reveals itself only to those who have "eyes to see" in the sense that the prophets mean it. In this much, for Augustine, we might almost say that "beauty is in the eyes of the beholder." Speaking of those who crucified Christ, he notes that "they had not eyes whereby Christ could seem beautiful. To what sort of eyes did Christ seem beautiful? To such as Christ himself sought" (comment on Ps. 128:8). To see his beauty, he adds, our "eyes must be cleansed." Beauty in the cross is possible to believers because "he healed our eyes" (*Tractatus in Ioannem* 2.16.2). What counts as beautiful is not a matter of random subjectivity, therefore, but is, in the manner the prophets understood, determined by a precondition of the heart.

As Hans Urs von Balthasar comments, it is in this "converted" sense that Augustine can speak of the beauty of the cross. Balthasar argues accordingly that Christ crucified "is the basis and standard of everything that is beautiful and all ideas of the beautiful. . . . We have to learn from [him] what beauty is."[48] When Augustine reads Psalm 45, "out of Zion is the semblance of his beauty," he sees transcendent Beauty informing terrestrial beauty, yet for him, of course, this transcendent Beauty actually inhabited the world, not as the beauty of an object, but in the beauty of a work of love (comment on Ps. 45:4). Christ never abandoned, even in his disfigurement on the cross, "that beauty which is in the form of God" (comment on Ps. 104:5); transcendent Beauty shines through the "form of one who hung upon the cross," he says, and it transfigures that form with glory. Since "God is always beautiful, never deformed, never changeable" (*In epistolam Joannis* 9.9), our beauty, and our perception of beauty, will be clarified to the degree that our love recognizes his beauty.

This is the sense of "aesthetic" in Augustine that leads Michael Hanby to his conclusion, following Balthasar, that for Augustine "salvation is aesthetic. It consists in the restoration of beauty from the beautiful itself, and

47. *St. Augustine: Tractates on the Gospel of John*, trans. John W. W. Rettig (Washington, DC: Catholic University of America Press, 1988), 257.

48. Quoted in Viladesau, *Beauty of the Cross*, 10 (but the reference is inaccurate). A somewhat more intricate argument for the transcendent or absolute beauty of the cross, offered as a modification of Balthasar by way of Thomas Aquinas and Basil the Great, is suggested by Stephen Fields, "The Beauty of the Ugly: Balthasar, the Crucifixion, Analogy and God," *International Journal of Systematic Theology* 9, no. 2 (2007): 172–83.

it takes the form of the love of the beautiful—because the beautiful *is* love, and because apart from participation in this love there is finally nothing."[49]

In tractate 118 of his work on the Gospel of John, Augustine comments on the Gospel accounts of the crucifixion of the Lord in such a way as to show it to be the paradigmatic *kairos*, time and eternity conjoined. He applies to it the prayer of Paul in Ephesians "that Christ may dwell in your hearts through faith; that you, being rooted and grounded in love, may be able to comprehend with all the saints what is the width and length and depth and height—to know the love of Christ which passes knowledge; that you may be filled with all the fullness of God" (Eph. 3:17–19). He then interprets this beautiful apostolic prayer in a cruciform way, saying of the cross:

> Its breadth lies in the transverse beam, on which the hands of the Crucified are extended; and signifies good works in all the breadth of love. Its length extends from the transverse beam to the ground, and is that whereto the back and feet are affixed, and signifies perseverance through the whole length of time to the end. Its height is in the summit, which rises upwards above the transverse beam; and signifies the supernal goal, to which all works have reference, since all things that are done well and perseveringly, in respect of their breadth and length, are to be done also with due regard to the exalted character of the divine rewards. Its depth is found in the part that is fixed into the earth, for there it is both concealed and invisible, and yet from thence spring up all those parts that are outstanding and evident to the senses; just as all that is good in us proceeds from the depths of the grace of God, which is beyond the reach of human comprehension and judgment. (*Tractatus in Ioannem* 118.5)[50]

The cross of Christ is thus the sign of his glory, but it has been rooted and grounded in the mortal dirt of our reality, indeed, in the reality of our deformity. This transcending gift of identification, above all, says Augustine, makes the cross beautiful in our eyes.

It is of pertinence to Augustine's view of the transcendentals that he connected Exodus 3:14 and the divine name to the acquisition of "Egyptian

49. Michael Hanby, *Augustine and Modernity* (London and New York: Routledge, 2003), 55.

50. Trans. John Gibb and James Innes, in *Nicene and Post-Nicene Fathers* (Peabody, MA: Hendrickson, 2004), 7:432.

gold" during his own search for Truth, here applying the biblical trope to "the Athenians," to whom Paul observed, "In Thee we live and move and have our being"—an understanding of the revelation of Being to being that Paul claimed to have found in the Athenians' own poets (Acts 17:28; *Confessions* 7.9.15). By a similar series of more obvious connections, the Good is a property of Being on the biblical model also (*De Trinitate* 8.2.3; 8.3.4–5, commenting on Acts 17:28).[51] Hovering in the text of all these passages in Augustine, more often than not explicitly, is another of his own favorite paradigm passages, Romans 1:18–25, which is as much as to say that for him idolatry is simply a refusal to refer created and mutable goods to the uncreated Being in whom their archetypes are found. But this is not to be more Platonist than Saint Paul himself in the Romans passage.

Conclusion

For Augustine God is that Being who can be known through his art: "God the Good and the Beautiful, in whom and by whom and through whom those things are good and beautiful which anywhere are good and beautiful" (*Soliloquies* 1.1.3). *Kalos* as beauty and *kalos* as the moral good enacted, the beauty of creation and the beauty of a work of love, have in Augustine's understanding been reunited. For the flourishing of the arts in the Christian West, this was a development of enormous fruitfulness. His revolutionary characterization of the cross as the supreme expression of divine beauty made visible was transformative for Christian art and worship space for more than a millennium.

51. It seems to me that Hanby has it right when he says that "beauty and its convertibility with goodness and truth [is] integral" to the procession of the Son and the Spirit from the Father in Augustine's discussion of the nature of the Trinity (Hanby, *Augustine and Modernity*, 47, 48–51).

3 BEAUTY AND PROPORTION IN THE SANCTUARY

Thou hast ordered all things in measure, number, and weight.

<div align="right">WISDOM OF SOLOMON 11:20</div>

There is an important sense in which all worship space in Christian tradition is eschatological; it both reflects and anticipates a consummation of worship in the eternal presence of God. The earthly sanctuary, as the writer to the Hebrews put it, is like the Law itself, a "shadow of heavenly things" (Heb. 10:1; cf. 8:2–5); its furnishings and its artifice of space were considered by Jewish tradition since Moses a "copy" of the eternal exemplar "in the heavens" (9:23–24). A sanctuary is thus *sanctus*, "holy," both by consecrated imitation and by participated anticipation. In the midst of tempest and tumult of war, in consciousness of the destruction of the temple in 70 CE and loss of the earthly Jerusalem, late medieval Christians almost as much as orthodox Jews yearned for the "Jerusalem which is to come" (12:22). "Jerusalem," according to Augustine, signifies a higher reality, a "vision of peace," something now glimpsed only "far off" (11:13), but in a sacramental sense also present in the Eucharist in such a way as to supercharge every experience of worship with timeless meaning. Each consecrated altar, often referred to as the Jerusalem Stone, came to be regarded as a symbol of the celestial as well as the historical Jerusalem; the tabernacle that was then and is now inhabited by the divine presence in the consecrated Host anticipates that Host more fully present in the heavens, the locus of perpetual intercession made by the "great high priest" (10:21). The holiness of any person, place, or action engaged in authentic Christian life and worship is on this view effected by *participa-*

tion—partaking of the immutably holy. For the medieval Christian, there could be nothing in experience quite so beautiful as being in the presence of the Lord; as Catherine of Siena put it, "there is a heaven all the way to heaven; for He said, 'I am the Way.'"[1] In this chapter we shall consider some aesthetic ramifications of this idea of metaphysical participation as it finds expression in the thought and work of late medieval philosophers, theologians, and, most especially, architects and artists, whose task it was to make the place of the holy a place of proportionate beauty.

In the millennium that followed Augustine, spanning to the high Middle Ages and the verge of the Reformation, enormous changes took place in European culture. Among the most momentous of these changes for art was the continuing demise of the western Roman empire and the rise of contesting sociolinguistic groups with distinct tribal cultures that presaged the nation-state. But through all the external turmoil there was a steady trajectory in religious and artistic expression in which much of the thinking of Augustine about the relationship of beauty and holiness persisted, so that a time traveler from the fourteenth century might find it hard to believe that so many centuries of political change had wrought so little effect upon basic Christian ideas about beauty and worship. Part of this continuity owed to the abiding authority of Augustine himself; in the writings of such formative figures as Bede, Anselm, Hugh of St. Victor, Bonaventure, and Aquinas, for example, he is quoted more often than any other authority except the Bible. But even more significant for art than continuity in biblical theology was consistency in the forms of Christian worship. Though there had been modifications, of course, in the liturgy (and some minor regional variations), a fifth-century Christian accustomed to attending Mass according to the Roman rite in Santa Maria Maggiore in Rome or Sant'Apollinare in Ravenna, if suddenly transported to Chartres or Salisbury a millennium later, would readily be able to follow the liturgy of the Rouen or Old Sarum rites (themselves closely similar) and also to refer the new magnificence of the art of chancel and altar to their eternal archetypes without stumbling or doubting for an instant where, in a spiritual sense, he or she "was."

This is not to say that the architectural differences between the penumbral Roman basilica and the light-filled Gothic cathedral would not have seemed astonishing to a fifth-century worshiper. For one thing, the Roman basilica was, in effect, a transformed law court (fig. 13). At the time,

1. Regis Martin, *The Last Things: Death, Judgment, Hell, Heaven* (San Francisco: Ignatius, 1998), 39.

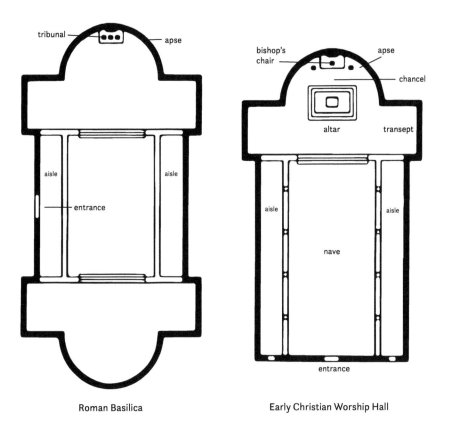

Figure 13. Roman and
Christian basilicas compared

Roman Basilica Early Christian Worship Hall

this must have seemed completely natural. As we saw in the apse mosaic in Santa Costanza in the previous chapter, the idea of the *traditio legis*, the handing on of the law from the Roman imperium to the kingdom of Christ, made perfect cultural and hence visual sense after Constantine. In Rome in the fourth century, one inevitably thought of the new order in juxtaposition with the old order in many ways. By contrast, later European Romanesque and Gothic cathedrals and churches were designed to serve the purpose of Christian worship alone, and their predecessor was biblical and Jewish more than Roman. Yet in no other period of Western cultural history has art *within* and *for* the sanctuary been so consistently formed—over several centuries and across numerous cultures—in a collectively self-conscious and traditional way, so that what appears to be new in the high Middle Ages is typically also a "handing down," an enrichment or adornment rather than a divergence from earlier core language of the art dedicated to worship space. While "enrichment" and "adornment," down to the finest details of design and ornament, grew to be a passionate preoccupation in late medieval Christian art, a first love for aesthetic

Figure 14. Reliquary,
Limoges, ca. 1200–1230

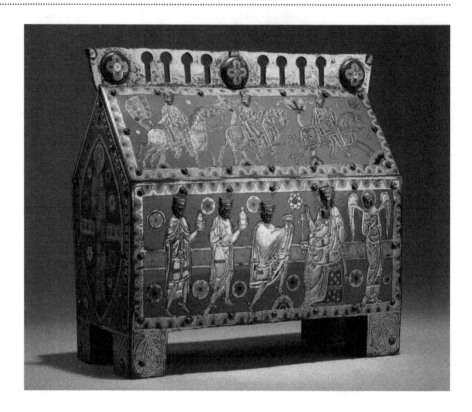

proportion, order, and ratio, whether in the design of a grand cathedral or in the crafting of a miniature reliquary casket, still reveals itself in a desire for *aptus*, a "fittingness" harmonious with *pulcher*, "beauty" (fig. 14). Notably, the design of a reliquary will often echo the design of a cathedral; since those who have died in the faith remain part of the church, the memorial reliquary makes a visual connection. Graveyards surrounding places of worship, or tombs within them, were other ways of making the same point.

Aesthetic correspondence in this period is a consequence of perceived universal design, visible not only in the texts of the Book of God's Word but also, as Bonaventure would later say, in the Book of God's Works.[2] In an ordered universe, one could expect reiterations of the divine cosmic pattern everywhere and trace it experimentally, confident in the ultimate correspondence of Light and light, Creator and creation, the grand music of the spheres and familiar ratios of the octave delicately plucked out on

2. See the discussion and citation in the following chapter. The metaphors have their roots in the Bible, especially in the Prophets (e.g., Isa. 34:4) and in the Revelation of John (Rev. 5:1; 10:8–11; etc.).

the strings of a harp, all of them together expressing a harmony of cosmos and canticle. This correspondence is premised metaphysically in such a way as to make terms like "participation" and "coinherence" perhaps more apt with regard to the medieval understanding of sacred art than the Thomistic idea of "analogical predication." Kantian aesthetic categories, as will become evident later, have far less purchase on medieval ideas about the nature and meaning of beauty and holy consecration.

SERMONS IN STONES

A modern time traveler, working backward from the twenty-first century to the fourteenth century (even if a practicing Roman Catholic), would experience a much greater sense of dislocation in the form of worship than was felt by our earlier time traveler, moving forward from the fourth century to the fourteenth. Not only has the liturgy more dramatically changed—and since the Reformation, fragmented—but additional barriers of diverging (and secularizing) local and national tastes in ecclesial art and architecture have grown up since the Enlightenment. One of the most basic lessons of cultural history is that taste is acculturated, and over time and distance taste varies to reflect cultural change in many dimensions. Thus, while sometimes we like to quote the Aristotelian adage *de gustibus non est disputandum* (there is no disputing taste), by which we advert to the variability in individual preferences, taste was in the past regarded in a much less individualistic way.

A notion of common or communal taste prevailed in European cultures well into the eighteenth century, in which era there began to be plenty of public dispute about such matters, much of it directed negatively at the art and expression of the medieval period especially. Sometimes it is helpful for perspective on cultural history to look at the aesthetic of one period in a culture through the lenses of another era. An indicative example is to be found in Lord Kames's discussion in his *Sketches of the History of Man* of what he regards as "the Progress of Taste" (1778). He quotes from a letter of Pope Innocent III (dated 1207), written by the pontiff to accompany a gift of jewels to King John of England, which Kames takes to be a particularly disgusting example of bad taste. As it happens, the text that offended Lord Kames's neoclassical standards affords us excellent insight into what thirteenth-century people of high culture, by contrast, thought about beauty, proportion, and their purpose:

Consider this present with respect to form, number, matter, and color. The circular figure of the ring denotes eternity, which has neither beginning nor end. And by that figure your mind will be elevated from things terrestrial to things celestial. The number of four, making a square, denotes the firmness of a heart, proof against both adversity and prosperity, especially when supported by the four cardinal virtues, justice, strength, prudence, and temperance. By the gold, which is the metal of the ring, is denoted wisdom, which excels among the gifts of Heaven, as gold does among metals. Thus it is said of the Messiah, that the spirit of wisdom shall rest upon him: nor is there anything more necessary to a king, which made Solomon request it from God preferably to all other goods. As to the color of the stones, the green of the emerald denotes faith; the [azure] purity of the sapphire, hope; the red of the garnet, charity; the clearness of the topaz, good works. You have therefore in the emerald what will increase your faith; in the sapphire, what will encourage you to hope; in the garnet, what will prompt you to love; in the topaz, what will excite you to act; till, having mounted by degrees to the perfection of all the virtues, you come at last to see the God of gods in the celestial Sion.[3]

It will be apparent that the aesthetic "taste" that Kames believed himself to have identified is inadequately described by that word; he has, in effect, made a category mistake—an instructive one. What he has revealed to us is his general rejection of a worldview that for two millennia consistently viewed all forms of materiality, natural and man-made, as part of a semiotic system—a metalanguage. Innocent III's letter presumes an inherent spiritual legibility in the world, even in gemstones, and is conventional in seeing material reality as a body of signs referring to spiritual reality.[4] As with Augustine, whose aesthetics had not been divorced from metaphysics, material beauty in Innocent's letter is ordered to transcendent Beauty.[5] Accordingly, he draws on both classical (Neoplatonic) and biblical

3. Lord Kames [Henry Home], *Sketches of the History of Man*, 3 vols. (London, 1778), 1:203–5.

4. Numerous books on gemstones and their spiritual value have survived from the late Middle Ages, not only in Latin but also in the vernacular. See, e.g., Joan Evans and Mary Serjeantson, eds., *English Medieval Lapidaries*, Early English Text Society, o.s., 190 (London: Oxford University Press, 1933).

5. Augustine, *On Christian Doctrine*, trans. D. W. Robertson Jr. (Indianapolis and New York: Bobbs-Merrill, 1958), 1.

categories of reference for understanding the language of the universe.[6] We are not in this letter of the thirteenth century so very far removed from the glorious mosaic apse crosses of Ravenna and the resplendent sixth-century Vatican Cross (fig. 12), though the vocabulary for describing and understanding beauty, both verbal and visual, had by then considerably expanded.

Classical and biblical thought and vocabularies continue to be mutually reinforcing in medieval thinking about beauty, in much the same way we find anticipated in Augustine. Neoplatonic terms, Aristotelian analytics, and the study of biblical virtues and spiritual gifts are by this point so thoroughly blended that medieval writers perceive in beautiful objects an *anagogicus mos*, an upward-leading way from temporal and physical things to eternal spiritual realities, yet they are scarcely ever conscious of the classical element in their language of description as a discrete component. By the thirteenth century, to write like this about the relationship of beauty and meaning was simply to express a normative Christian cultural view. Beauty was a language bespeaking the harmony of all things *sub specie aeternitatis*, with its origin in what Dorothy Sayers has called "the mind of the Maker."[7] After all, the principle of reference from physical objects to spiritual meaning had already been articulated in the writings of Saint Paul—for example, in his letter to the Romans, where he refers to the creation as a universal language in which "the invisible things of him [God] from the creation of the world are clearly seen, being understood by the things that are made, even his eternal power and Godhead" (Rom. 1:20; cf. Ps. 19:1–4). On this point, Augustine was sufficiently impressed with the harmony of Platonic and Hebrew understandings of ultimate reality to conclude that Plato was in some sense indebted to Moses. To construe the cosmos in this universally intelligible way is to see everything in it as an articulate expression of ultimate, transcendent Truth, a language of God waiting to be learned. Given his Enlightenment empiricism, Lord Kames's sense of "good taste" was understandably offended by the overt allegory; like most of his contemporaries, he preferred his stones to remain silent.

Perhaps the most famous ecclesiastical architect in the medieval period, Abbot Suger of Saint-Denis (1081–1151), on the principle that stones did speak, gave as much attention to the bejeweling of altars, liturgical

6. Though it is not central to my thesis here, it is evident that medieval people loved art that puzzled, requiring solution, the achievement of which was playful as well as instructive. For this aspect, see Mary Carruthers, *The Experience of Beauty in the Middle Ages* (Oxford: Oxford-Warburg Studies, 2013).

7. Dorothy Sayers, *The Mind of the Maker* (San Francisco: Harper and Row, 1987).

utensils, and the large (21′ high) cross he placed in the middle of his Gothic sanctuary at Saint-Denis as he did to the structural features of his great cathedral. His rationale for both is the enhancement of worship by beauty in the place of the holy: "[W]hen my whole soul is steeped in the enchantment of the beauty of the house of God, when the charm of many colored gems leads me to reflect, transmuting things that are material into the immaterial, on the diversity of the holy virtues, I have a feeling that I am really dwelling in some strange region of the universe which neither exists entirely in the slime of the earth, nor entirely in the purity of heaven; and that by God's grace I can be transported from this inferior to that high world in an anagogical manner (*anagogicus mos*)."[8] Suger assembled an astonishing quantity of gemstones, mostly through donations, as he dutifully records, and he placed his massive bejeweled cross near the altar frontal, itself a Carolingian work. That there might be a seamless artistic harmony between the ninth-century altar and the new cross, he brought in workmen from a province in which the old Carolingian style of work was still being done.[9] It will be apparent that the desire for continuity in such a gesture expresses a commitment to something more valuable than novelty. Sadly, although Suger's chalice survives (fig. 15),[10] the great cross of Saint-Denis is now no more, its jewels long since put to other uses. Yet Suger's description of it, and the descriptions of others, enables us to see that the "beautiful cross" of Augustine had become at Saint-Denis an object of sacred art par excellence. If we feel that what was expressed by Suger's great cross may perhaps have been less akin to Augustine's appreciation of the atoning death of Christ as a "beautiful deed" than a more immanent focus on the beauty and splendor of the holy site in which daily Mass is commemorated, the cruciform juxtaposition of beauty and holiness is nevertheless persistent.

8. Quoted from Erwin Panofsky, *Meaning in the Visual Arts* (1955; Middlesex: Peregrine, 1970), 162. Panofsky edited and translated the full *De administratione* and *Scriptum consecrationis* (Princeton: Princeton University Press, 1946). This text is also available online. See also, Conrad Rudolph, *Artistic Change at St. Denis: Abbot Suger's Program and the Early Twelfth-Century Controversy over Art* (Princeton: Princeton University Press, 1990).

9. Georges Duby, *The Europe of the Cathedrals, 1140–1280*, trans. Stuart Gilbert (Geneva: Editions d'Art Albert Skira, 1966), 16–17.

10. This extraordinary chalice incorporates a second- or first-century carved sardonyx cup, possibly from Alexandria. Suger's goldsmiths mounted it and adorned it with gemstones.

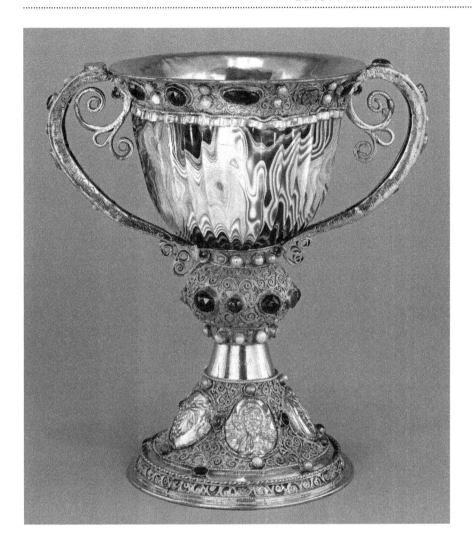

Figure 15. Chalice of Abbot Suger of Saint-Denis, twelfth century

THE TEMPLE AS HOLY PATTERN

The medieval cathedral is certainly a very far cry from the very earliest places of Christian worship. In the first century the followers of the Way were beleaguered and for the most part poor, marginalized both by the synagogue out of which most had come and by gentiles everywhere. They typically worshiped in ordinary houses, and sometimes in the arcosolium of a catacomb, where the sarcophagus of a martyr might serve as an altar. When Constantine granted Christians freedom to worship openly, they began to use a variety of larger public spaces, and soon, as in Santa Maria Maggiore in Rome, adapted the Roman basilica or law court to

their purposes, happy to reconsecrate sites of the "old law" of the Roman imperium to the "new law" in Christ. Among the legacies of the adoption of Roman legal architecture, the semicircular apse behind the altar and the placement of the altar itself, immediately front and center of the apse, were to have an influence persisting through and beyond the late Gothic period. As the prestige of Rome and its imperial culture waned, however, the classic basilica was less and less the exclusive model for the cathedral or grand church. Another, quite different form was to emerge from the Jewish past and commend itself as a design more fitting, because it had been since Moses and Solomon dedicated to worship exclusively by the authority of divine revelation.

Even for early medieval Christians in Europe, holy sites were *consecrated* in the biblical sense, truly "set apart," distinctive, carefully constructed by harmonious artistic expression in worship space and worship symbols to a degree that we now find difficult, perhaps, to appreciate. In particular, behind the Romanesque or Gothic facade of a medieval cathedral, spiritually speaking, was a growing consciousness of continuity and analogy with the tabernacle in the wilderness and especially with the Temple of Solomon.[11] We can see this idea already articulated in the first commentaries on these biblical "places of the holy" by the Venerable Bede, who was, like Suger, a Benedictine monk, though in a much less affluent time and place. Writing about 725, Bede nevertheless shows himself in his *De tabernaculo* and *De templo*[12] to be much closer in his aesthetic to Archbishop Suger in the middle years of the twelfth century than either of them are to the views of Lord Kames, though Kames was certainly no stranger to beautiful churches and cathedrals. Moreover, as already suggested, we can see in Bede's works something far deeper than taste at work, namely, a deep conviction that from Moses onward the biblical sanctuaries of the Jews were made beautiful precisely for the sake of

11. A good general study is by Helen Rosenau, *Vision of the Temple: The Image of the Temple of Jerusalem in Judaism and Christianity* (London: Oresko, 1979); see also, T. C. Bannister, "The Constantinian Basilica of St. Peter at Rome," *Journal of the Society of Architectural Historians* 27 (1968): 3–21; Rudolf Hausherr, "Templum Salomonis und Ecclesia Christi: Zu einem Bildvergleich des *Bible moralisée*," *Zeitschrift für Kunstgeschichte* 31 (1968): 101–21; cf. Otto von Simson, *The Gothic Cathedral: Origins of Gothic Architecture and the Medieval Concept of Order* (Princeton: Princeton University Press, 1964), 8–12, 37–40, 95–99.

12. Bede's original title for the first of these works bespeaks the characteristic harmony: *De tabernaculo et vasis eius ac vestibus sacerdotum, libros III* (On the tabernacle and its vessels and the priestly vestments, in three books); the translation cited here is by Arthur G. Holder, *Bede: On the Tabernacle* (Liverpool: Liverpool University Press, 1994).

spiritual meaning, a meaning encoded in both tabernacle and temple in loving detail. A passage from the second of Bede's texts, *De templo*, commenting on the workmanship ordered by Solomon in 2 Chronicles 2 and 3, nicely introduces the theological aesthetic that will reappear in Suger's allegorical dedication of his lapidary cross. Here is Bede, commenting on the biblical account (in bold face) of Solomon's Temple line by line:

And all was lined with boards of cedar, and no stone at all could be seen in the wall. Together the stones of the wall [and] the floor and the [overlaid visible] boards and the gold denote the life of the saints in the Church, but with this distinction, of course, that when they are compared, the living stones are the saints joined to each other by their faith in one and the same rule (of faith); the planks of cedar and fir are the saints joined to each other in one and the same faith by reason of the compass of their various virtues according to the gifts of the Holy Spirit; the sheets of gold leaf are the saints who have a love that surpasses knowledge and rejoice together in its most delightful splendor. These three things the Apostle comprised in one sentence, saying, "For in Christ Jesus neither circumcision nor the lack of it is of any use but the faith which works through love" (Gal. 5:6). For the stone was a figure of unconquered faith, the cedar a figure of fragrant action, the gold a figure of all-transcending love, and the stone wall is covered with it lest without works it be judged useless or dead. But because the law was written in stone whereas the teaching of the gospel was confirmed by the wood of Christ's passion, so too the people were circumcised by a flintstone in the foreskin whereas we are consecrated by a sign of the Cross on the forehead. The stone walls of the Temple or the floor paved with the most precious marble can quite appropriately be taken as a type of those who lived faithfully and perfectly in the law, whereas the planks of cedar or fir can signify the righteous of the New Testament who in their desire to go after the Lord deny themselves and take up their cross daily and follow him. And since the common glory of a heavenly reward awaits the righteous of both eras, a third kind of material, that of gold leaf, is added to the stones and precious wood. (*De templo* 1.11.2)[13]

Bede was obviously aware of those passages in the New Testament in which Christians are reminded that Christ himself, resurrected, becomes

13. *Bede: On the Temple*, trans. Seán Connolly, introduction by Jennifer O'Reilly, Translated Texts for Historians 21 (Liverpool: Liverpool University Press, 1995), 41.

Figure 16. Page from Codex Amiatinus, Florence, seventh century

the new temple (Matt. 26:61; 27:40), and that his body in the world, those who are united to him in his death and resurrection by baptism, obedience, and eucharistic worship, forms in their universal communion a temple of both Jews and gentiles. This is obviously, for both the apostles and someone like Bede, a spiritual or metaphorical building "built upon the foundation of the apostles and prophets, Christ himself being the chief cornerstone, in whom all the building is framed together . . . into a holy temple to the Lord . . . in whom you also are built together into an habitation of God in the Spirit" (Eph. 2:20–22; cf. 1 Pet. 2:4–8).

Yet it is in fact this very apostolic allegory, itself presaged in Exodus (19:6), which prompted medieval interest in the referential possibilities for places of Christian worship inherent in the description both of Solomon's Temple and of Ezekiel's temple vision (Ezek. 40–44). This included close reflection on the temple fittings, the instruments of altar, ark, and



sacrifice given in the Hebrew texts. In the Codex Grandior, a manuscript Bible produced a century before Bede at the monastery of Cassiodorus in Vivarium, there were already drawings of these implements; similar drawings were repeated in the great pandect Bible, the Amiatinus Codex, produced in Bede's time under Ceolfrith at Wearmouth-Jarrow (fig. 16).[14] Such illustration, preceded in Jewish contexts at Dura Europos and even earlier,[15] was to reemerge in illustrated Hebrew manuscript Bibles of the Middle Ages, artwork created under the influence of, if not actually produced in, the workshops of Christian artists (fig. 17).[16]

Though Bede's commentary on these matters is more extensive than anything before it in Christian exegesis, he had been preceded in connecting the temple imagery of the Old Testament to Christian worship by Ambrose, Augustine, Gregory, and Eusebius, among others, simply because the connections were already so firmly drawn in the New Testament.[17] The same scriptural sources led to a distinction between the tabernacle, figurative for the church in the wilderness of time and the world, and the temple, figurative for the future church, even the worship of the new Jerusalem (Bede, *De templo* 1.1.2). Though in the next few centuries there would be great attention to the literal description of the tabernacle and temple, much of this was speculative and ill-informed, shaped less by the biblical text than by travelers' reports that confused the Al-Aqsa mosque and Dome of the Rock with the temples of Solomon, Zerubbabel, and Herod.[18] As we shall see, some degree of imitation of the

14. Biblioteca Medicea Laurenziana, MS Amiatino 1; see Michelle P. Brown, *The Book and the Transformation of Britain, 550–1050* (London: British Library, 2011), 6–7, 17–19, 45–52.

15. The discovery of the Magdala Stone, a low stone table carved with images of temple instruments, in the ruin of a first-century synagogue in Galilee, shows that such artistic allusions to the temple began even before its destruction in 70 CE; see Isabel Kershner, "A Carved Stone Block Upends Assumptions about Ancient Judaism," *New York Times*, December 8, 2015, http://www.nytimes.com/2015/12/09/world/middleeast/magdala-stone-israel-judaism.html?_r=0.

16. Joseph Gutmann, *Hebrew Manuscript Painting* (New York: George Braziller, 1978); see also, K. Kogman-Appel, *Jewish Book Art between Islam and Christianity: The Decoration of Hebrew Bibles in Medieval Spain*, Medieval and Early Modern Iberian World 19 (Leiden and Boston: Brill, 2004); David Lyle Jeffrey, "Medieval Hebrew Bibles: Art and Illumination," in *The Book of Books: Biblical Canon, Dissemination, and Its People*, ed. J. Pattengale, L. M. Schiffman, and F. Vukosavovic (Jerusalem: Bible Lands Museum, 2013), 66–72, 69.

17. Holder gives a useful account of these in "The Mosaic Tabernacle in Early Christian Exegesis," *Studia Patristica* 25 (1993): 101–6.

18. See Carol Herselle Krinsky, "Representations of the Temple of Jerusalem before 1500," *Journal of the Warburg and Courtauld Institutes* 13 (1970): 1–19. Reflection on the text

Figure 17. Duke of Sussex
Hebrew Bible, Spain, early
fourteenth century

original temple, owing more to the design and arithmetical proportions
given in the Bible (1 Kings 6:5–9, 25; 2 Chron. 3:1–7, 11), was to feature in
Christian cathedral architecture, but it is ultimately to the "building of
God, eternal in the heavens" (2 Cor. 5:1; cf. Heb. 8:2; 9:11, 23–24) that the
anagogicus mos of the medieval house of worship aspires, and to which it
self-consciously refers as its final cause. For the Venerable Bede, "Anagogy
is the [spiritual] sense leading upward whoever desires to see that beauty

more directly improved over the next three centuries, but did not entirely correct the late
medieval tradition of misrepresentation in drawing and painting.

of the house of the heavenly fatherland, not of course made by hands, but eternal in heaven."[19]

Interest in the physical character of the biblical temple was a matter of seeing in each element a God-ordained sign, something set down for the understanding, not a matter of happenstance. For example, Suger's contemporary Richard of St. Victor wrote a commentary of great interest on Ezekiel's vision of the eschatological temple to come (Ezek. 40–44), mathematically and geometrically described, which in some manuscripts is accompanied by illustrations closely based on the dimensions and de-scriptions in Ezekiel's text.[20] As Carol Krinsky has noted, "a widely used

Figure 18. Richard of St. Victor, *Commentary on Ezekiel*

19. Bede, *In Hexameron* 1.4; cf. Henri de Lubac, *Exégèse médiéval* (Paris: Aubier, 1969), 2:623.

20. Richard of St. Victor, *In visionem Ezekielis.* See Walter Cahn, "Architecture and Exegesis: Richard of St. Victor's Ezekiel Commentary and Its Illustrations," *Art Bulletin* 76, no. 1 (1994): 53–68.

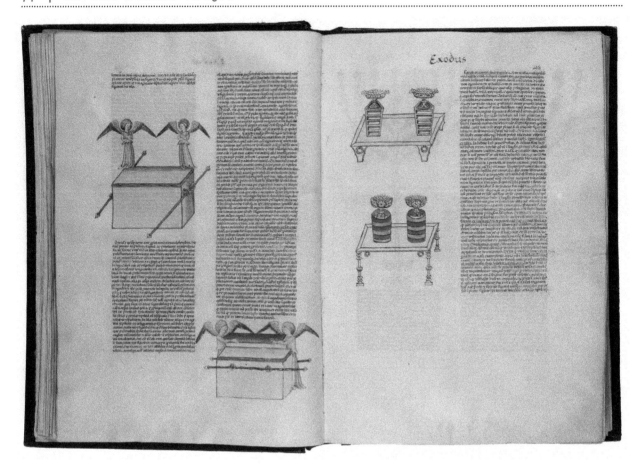

Figure 19. Nicholas Lyra, *Postilla super totam Bibliam,* volume 1, Nuremberg edition of 1488

method of suggesting that a building was Jewish was that of depicting it in the Romanesque style" (fig. 18).[21]

Nicholas Lyra, the fourteenth-century commentator so influential for Wycliffe and Luther, drew heavily on Bede, Richard, and Jewish sources—principally Rashi and Maimonides—for his *Postilla* (especially on Exodus, 1 Kings, 2 Chronicles, and Ezekiel); his ground plan for Solomon's Temple is in fact nearly identical to that found in Rashi and Maimonides. Lyra further illustrated his discussion of the altar, ark of the covenant, and other ritual fittings for the holy of holies in such a way as to distinguish vi-

21. Krinsky, "Representations of the Temple," 13. In time, consciously or unconsciously, though Protestant church architecture would typically eschew Gothic grandeur, for grand churches sometimes an imitation of Romanesque motifs will appear on facades—possibly a historical echo (see appendix A)—even as the interiors of many Protestant churches, lacking altars and emphasizing the expounded Word, more resemble synagogue design.

sually the minute differences that a close reading of 2 Chronicles 2–4 and 1 Kings 6–8 will reveal when those texts are compared with the account in Exodus (fig. 19).[22] Lyra here instances a characteristic commitment to getting an accurate picture of the literal descriptions in the biblical texts, since for him the spiritual meaning must always be anchored in the historical or literal sense of the text. Yet here, just as in Bede's commentary and the commentaries of earlier exegetes, Lyra assumes that the physical numbers and ratios of the biblical accounts were matters of specific divine revelation, bearing the weight of eternal truths, the "pattern in the heavens" referred to by Saint Paul and the writer of Hebrews; his interest in these discrepancies is not to discredit the text but rather to probe more deeply the meaning of the differences.

In her book *The Vision of the Temple*, Helen Rosenau begins by reminding her readers that "the word *templum* in its original Latin meaning defines a measured sacred space either on earth or in heaven."[23] Her concern is primarily with the detailed measurements prescribed for Solomon's Temple as well as the visionary temple of Ezekiel, both of which, like the tabernacle design so intricately laid out in Exodus 25–31, were a foundational influence on medieval conceptions of appropriately proportioned sacred space. Furnished already with Pythagorean and Neoplatonic notions of sacred number, Augustine found it natural to trace these ratios in the Bible as well, and to conclude that "the divine wisdom is reflected in numbers impressed on all things," and that beauty itself is a kind of cadence, a harmonious number.[24] How appropriate that such harmonies and proportions be reflected in the divine directions for the tabernacle and the once and future temple! Peter Abelard, following this expectation, saw in the biblical dimensions of both tabernacle and temple signs of a Platonic harmony, the dimensions of the temple given in 1 Kings 6 forming a perfect consonance: length 60 cubits, width 20 cubits, and height 30 cubits; the cella (inner chamber) 20 × 20 × 20; the aula (outer court) 40 × 20 × 30; the porch 20 × 10.[25] In the account of the first temple given in

22. Sarah Bromberg, in her dissertation, "The Context and Reception History of the Illuminations in Nicholas of Lyra's *Postilla super totam Bibliam*: Fifteenth-Century Case Studies" (University of Pittsburgh, 2013), has shown nevertheless that some early printed versions, such as that by Kolberger, subtly and variously alter the illustrations found in Lyra's manuscript so as to obscure some specifically Jewish elements.

23. Rosenau, *Vision of the Temple*, 13.

24. *Saint Augustine: On Free Choice of the Will*, trans. Anna S. Benjamin and L. H. Hackstaff (Indianapolis and New York: Bobbs-Merrill, 1964), 2.16.

25. Simson, *The Gothic Cathedral*, 37–38, in the 1988 expanded edition.

2 Chronicles 2, the dimensions of the main space are 40 × 20 cubits, or 66 × 33 meters, the ratio of 2:1 in these measurements being that of the octave; just such details attracted exegetes like Lyra. On these readings there is a musical or symphonic character to the divine geometry, uniting ultimately the music of the spheres and the beauteous harmonies of heaven with the earthly sanctuary as its signature and premier place of audition. As arcane as it may seem to us today, building carefully according to such ratios and *numbers* was seen as a high form of reverence for the divine wisdom expressed in the cosmos, really in itself a form of worship.[26] The beauty of proportion expressed spiritual truth.

The West was not singular in its attraction to these convictions. The same Platonic and Neoplatonic as well as biblical origins are visible in Byzantine environments as early as the sixth century. In building his magnificent sanctuary, the Hagia Sophia, as Ruth Dwyer has shown, the emperor Theodoric scrupulously adhered to the precepts of the quadrivium, working to realize them architecturally even as Boethius translated for him their classical sources, incorporating in the design of that great sanctuary intricate architectural renderings of mathematical ratios and geometrical harmonies (fig. 20). The principal architects (called then simply *michanikoi*) were two Greeks, a mathematician and a geometer, Isidore of Miletus and Anthemius of Tralles. Theodoric's choice of marble and the refraction of light achieved by the celestory in the huge dome (180′ from crown to the floor) led the writer Procopius, an early visitor, to describe the finished basilica as a "spectacle of marvelous beauty."[27] In this case the number that integrates the whole is 6, the number of the soul, with its integers of $1 + 2 + 3 = 6$ and $1 \times 2 \times 3 = 6$.[28] Holy Wisdom is divine, an uncreated wisdom; the tangibility of the incarnation gives us Wisdom of God (the Logos), second person of the Trinity, to whom the great sanctuary was dedicated. These sixth-century ideas and architectural achievements in places of the holy, much as is the case for the liturgy employed in them on through to the Reformation, were formative and reiterating.[29]

26. It has become a subject of enormous interest to contemporary architectural historians. See, e.g., Marie-Caroline Rondeau, "Laser Light on Gothic Architecture," *Reporter: The Global Magazine of Leica Geosystems* 68 (2013): 1–6.

27. Procopius, quoted in John Baggley, *Doors of Perception: Icons and Their Spiritual Significance* (London and Oxford: Mowbray, 1987), 16.

28. Ruth Dwyer, "Boethius, the Quadrivium and the *Hagia Sophia*," YouTube, June 17, 2013, https://www.youtube.com/watch?v=q3rOdkfQgAc.

29. In her *The Origins of Architecture: An English Sixteenth to Eighteenth Century Perspective* (Champaign, IL: Common Ground Publishing, 2013), Tessa Morrison argues that

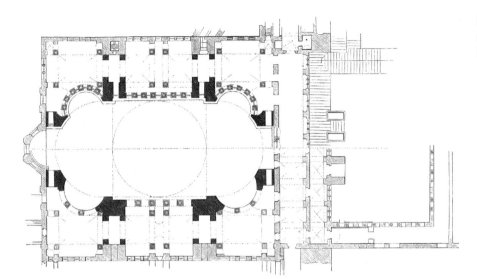

Figure 20. Ground
and elevation plan of
Hagia Sophia

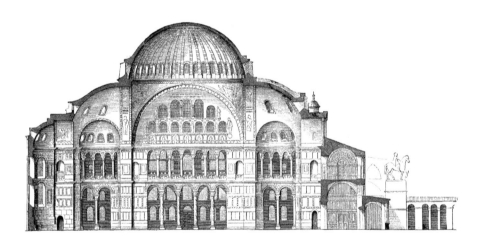

When we go as far away in time and geography as Salisbury Cathedral in the early thirteenth century, we should not be surprised that despite its very different external appearance, it still contains such ratios; the facade is 33 × 33 meters, while the height of the steeple is 123 meters. Other ca-

the biblically based tradition regarding the temple continued to be important not only for ecclesiastical architecture but also for architecture generally. The eschatological dimension she finds particularly developed in Spanish Jesuit Juan Bautista Vilalpando's *In Ezechielem explanationes et apparatus Urbis ac Templi Hierosylomitani* of 1604, but she notes that in England the tendency even in the eighteenth century, exemplified in Isaac Newton's *Temple of Solomon and His Reconstruction of Sacred Architecture* (London, 1728), was to privilege particular mathematical ratios in a fashion that lent themselves to architectural application.

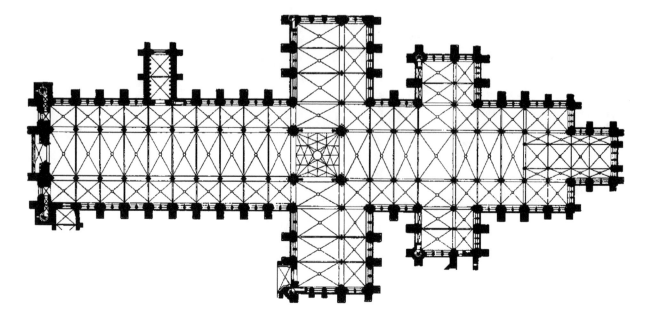

Figure 21. Floor plan of Salisbury Cathedral

thedrals, such as Amiens, incorporated the number 144 from the book of Revelation. The ground plan of cathedral churches by this time is however almost universally cruciform. In Salisbury Cathedral, the cruciform shape is that of the Greek cross (fig. 21).

The Sanctuary in Sacred Poetry

As the seventeenth-century pastor and poet George Herbert would one day make explicit, a poem or book of poems might also be created as a spiritual means of reflecting the beauty of the temple.[30] Perhaps the most perfect English poem of the Middle Ages, *The Pearl*, was consciously composed with an eye on the beauty of holiness as reflected ultimately in the new Jerusalem. Written by the anonymous author of *Sir Gawain and the Green Knight* and at least two other poetic works, theological meditations on the virtues of purity and patience,[31] this poem is presented as the report of a

30. The standard edition of Herbert's works is *The Works of George Herbert*, ed. F. E. Hutchinson (Oxford: Clarendon, 1941), with many subsequent reprints.

31. This author is sometimes credited also with *St. Erkenwald*, a beautiful poem about the baptism after death of a noble pagan; all four of the works certainly attributed to him are found in MS Cotton Nero A.x, Art. 3 of the British Library. For convenience, the edition used here is *The Complete Works of the Pearl Poet*, ed. Malcolm Andrew, Ronald Waldron,

dream vision in which the persona, a jeweler by trade, is wracked with grief after the death of his young daughter and falls into a depressive sleep in a garden at the site of her grave. He compares her to a peerless pearl "oute of orient" (l. 3) fit to please a prince, but now lost to him. In his dream he is transported to a beauteous landscape of which the rock outcroppings are beryl, and amidst the fruiting trees he sees that ordinary pebbles are actually emeralds, sapphires, and pearls (ll. 109–130). He comes to the crystal river and, sensing that Paradise itself is just beyond, he longs to ford the stream but cannot. Suddenly he sees a noble maiden on the far shore, and as he gazes into her face he gradually recognizes her as his lost child, but now somehow older, dressed in white, adorned with pearls, and crowned with a pearl tiara as a royal bride. He has found her, but she is not the same; she has been mysteriously transformed. Now in Paradise, she is able to communicate with him, but remains separated by the clear, flowing stream.

The poem is structured as a debate between the often obtuse and materially minded jeweler and his daughter, now mysteriously a young woman as mature in wisdom and theological probity as Dante's Beatrice in his *Paradiso*. The education of the dreamer thence becomes an education for the reader, specifically on the nature of grace, the reward of the blessed, and the eschatological telos of Christian life and worship—all presented by the maiden as qualitative gifts of God rather than quantitatively measured achievements of human merit. The dreamer has difficulty in accepting the equal reward of the laborers in the vineyard parable in Matthew 20:1–16, since it seems to him not to reward the laborers on their merits. The maiden argues at length that while good works are appropriate to the life of grateful faith, salvation is not merely a matter of counting up good works, but in every case is dependent on the gift of God, which alone makes for a qualitative transformation: "for the grace of God is gret enogh" (ll. 612, 624, 635, 648, 660). Innocence, she argues, has grace through baptism, because willed sin has not tarnished it. Yet crucially, for anyone willing,

> Grace innough the man may have
> That synnez thenne new, ʒif him repente. . . . (ll. 669–70)

All this can seem like just garden-variety Augustinian theology, to which the poem is a kind of artful catechesis. There is a further register,

and Clifford Peterson (Berkeley and Los Angeles: University of California Press, 1993), because the nonspecialist reader will thereby have access to the translation of Casey Finch, which is readable if occasionally rather loose.

however, just as in Dante's *Divine Comedy*, between number or quantity as symbol and the qualitatively transformative treasury of grace that cannot be fathomed so easily but can only be suggested. Dante's *Commedia* (his "invisible cathedral," as Émile Mâle famously called it)[32] has 100 terza rima stanzas (ratio of 2:1, symbolizing the octave of cosmic harmony), indicating perhaps that what is equivocal in our understanding in the language through which our thought moves may, in another dimension— God's—be univocal. This is a point that *The Divine Comedy* reiterates in a variety of ways at the structural and thematic level. The Middle English *Pearl* has 101 stanzas of twelve lines each, arranged in twenty fits, or groups, of five stanzas, each with keyword-interlocked final and first lines, creating verbally an *entrelacement* pattern that, with the addition of a sixth stanza to fit 15 to achieve a total of 101, suggests not completion, as with Dante's 100 cantos, but a cycle or circularity.[33] *Pearl* ends with the dreamer waking up and bearing witness that he has now learned the qualitative character of God's grace, and the importance of contrition to pleasing God. No more intent on amassing wealth or human merit (ll. 1195–1200), but rather on living in gratitude for grace received and for participation in eucharistic worship, the dreaming jeweler suggests that in being a faithful servant (*hyne*) to the Lord we may all, by grace, *become* precious pearls, pleasing to him. The last line of the poem thus echoes but transposes the first line from a literal and material connotation of earthly possession to a spiritual and eternal understanding in which the person who receives saving grace belongs to the Lord:

Perle plesaunte, to princes paye (l. 1)

Ande precious perlez unto His pay. Amen. Amen. (l. 1212)

Pearl is in structural respects another "measured space," pointing to the new Jerusalem it seeks to conjure in Gothic architectural fashion for the reader's imagination.[34] Drawing its content in this respect from the Apocalypse of Saint John the Divine, the poet makes of his vision a

32. Émile Mâle, *The Gothic Image: Religious Art in France of the Thirteenth Century*, trans. Dora Nussy (New York: Harper, 1958), 13.

33. Maren-Sofie Røstvig, "Numerical Composition in *Pearl*: A Theory," *English Studies* 48 (1967): 326–32.

34. The best treatment of the *Pearl* in its medieval aesthetic context is still Barbara Nolan's *The Gothic Visionary Perspective* (Princeton: Princeton University Press, 1977), 156–204.

foretaste of eternal beatitude. The biblical sources, not only chapters 21 and 22 of Revelation but also the symmetries of twelve tribes of Israel, twelve major and minor canonical prophets, and twelve disciples from the Gospels, had long established twelve as a symbol for divine revelation itself. The number of the innocents, 144,000, derives from Revelation 14:1–5 (cf. Rev. 7:4–9), and is introduced in fit 15 by our poet, not to signify a definitive literal quantity but, as in the Bible itself, to suggest that the mystical number of the redeemed reflects an eschatological completion of the divine symmetry projected to infinity: $12 \times 12 \times 1{,}000$ (ll. 854–888). Yet, as in Revelation, all these "innocents" are present in the new Jerusalem because of the "one death" of the Lamb in which, by participation, all the blessed have eternal life:

> Of on deth ful oure hope is drest,
> The Lamb us gladez, oure care is kest;
> He myrthez us alle at uch a mes.

> (On one death all our hope depends,
> The Lamb makes us merry, our cares are cast off;
> He makes us mirthful at every Mass.)
>
> (ll. 859–861, my translation)[35]

The new Jerusalem is thus sharply to be distinguished from the old Jerusalem, the historical city in which the Lamb was slain (fit 16, ll. 913–1072). The maiden leads the dreamer in fit 17 to see a city "brighter than the sun," descending to him as in Saint John's vision, shining with gems and gleaming glass (ll. 987–1020; Rev. 21:11),[36] twelve-tiered, with streets of gold and jasper walls, measured by the apostle John as $12 \times 12 \times 12$ furlongs, height, width, and depth. In this city, fittingly, there are three gates on each of the four walls, one gate each for each of Israel's sons (ll. 1032–1040), yet neither "chapel ne temple that ever was set" (l. 1062; Rev. 21:22), since the earthly temples, patterned after the eternal temple, are now melted away,

35. For a detailed exploration of this theme, see Kevin Marti, *Body, Heart, and Text in the Pearl Poet* (Queenston, ON: Mellen Press, 1991). Marti reads the entire poem as a replay of the eucharistic liturgy, with spatial relations in the poem figured as both human body and Gothic cathedral.

36. See Heather Phillips, "Medieval Glass-Making Techniques and the Imagery of Glass in *Pearl*," *Florilegium* 6 (1984): 195–215, for interesting connections between the techniques employed in stained glass and the imagery of light used by theologians as well as in the poem.

dematerialized, redundant in light of the original. There is no night in the celestial Jerusalem, for the Lamb himself is the light (l. 1047). The original garden is there more than restored, with twelve trees of life with their matchless fruit blooming twelve times a year (ll. 1078–1079; Rev. 22:1–2). The company of the blessed are all decked out with precious pearls, as is the Lamb, and all attend Mass (the marriage supper of the Lamb) with "gret delyt" (ll. 1112–1116). When the poem shortly thereafter ends with a reference to the eucharistic bread and wine on the altar on earth to which the dreamer, spiritually illumined, now returns, we can hardly be surprised. In each eucharistic act of worship in a holy sanctuary the ultimate worship with the saints and all angels has all along been prefigured. To "worship the LORD in the beauty of holiness" (Ps. 29:2; 96:9) is not to relinquish aspiration to the temple "eternal in the heavens" but to anticipate it by a holy participation. To this end, for a medieval Christian, a poem like *Pearl* serves the same purpose as the beauty of the cathedral: it is an invitation to encounter the Holy.

CONCLUSION

From the sixth to the twelfth century, aesthetics was in many ways a branch of metaphysics, making beauty, in effect, if not an attribute of holiness, then its acolyte. Architecture in the high Middle Ages draws heavily on both biblical and classical sources, which use measurement and ratios of number to express cosmic and spiritual truth for its creation of a beauty proportionate to holy worship. Whether in the construction of Theodoric and Boethius, the exegesis of Bede, or the architectural adornment of Suger, the aspirations to a relation of beauty and holiness may be seen to have imitated models "eternal in the heavens." These ideas in principle were to have ramifications in the literary as well as plastic arts, but the intricacy of number and ratio, along with their symbolic referents, would remain a kind of secret science, understood by theologians, architects, and poets, though largely invisible to ordinary worshipers and readers.

4 THE BEAUTY OF LIGHT

Every good and perfect gift comes down from the Father of Lights.

JAMES 1:17

e have seen how the influence of the Jerusalem temple upon the architecture and decor of Christian churches reached its apogee in Gothic cathedral design and interior adornment, particularly in the pursuit of symbolic number (proportion) and the allegory of beautiful gems and wrought gold and silver. But to stop there would be to leave out what to many is the most spectacular achievement of the medieval artists and architects as they pursued their desire to reflect the heavenly Jerusalem in their creation of worship space—the play of light. This innovation has its beginnings in the twelfth century, when the heavy, thick walls and necessarily dark nave of Romanesque architecture began to be challenged by the Gothic developments of pointed arches, vaulted ceilings, and flying buttresses, all of which made it possible to admit far more light into the sanctuary than would have been possible in either Jewish or pagan temples or, for that matter, in Roman basilicas. As often happens in cultural history, these developments in engineering coincided with new understandings in the natural sciences and in philosophy; in this case, the Gothic revolution in architecture was followed closely by breakthrough developments in physics, in particular, in optics, and, in philosophy, extended reflection on the metaphysical implications of light. The confluence of concept and engineering was to produce beauty in the sanctuary such as had never before been imagined. The warrant for these innovations in the building of spectacular

new sanctuaries was nonetheless to be given in familiar biblical and theological language.

LOGOS AND LIGHT

In the arch above the portal of Santa Maria Maggiore, the great Roman basilica church, there must have been artwork or a symbolic representation of some sort shortly after it was built, early in the fifth century. We cannot be certain now what it was, but had the structure previously been used as a Roman court (it so closely resembles one that it has sometimes been thought to be a converted imperial edifice),[1] the symbol in that location would likely have been the *sol invictus*, the unconquered sun, an emblem of the Roman emperors with deep roots in pagan religion.

Santa Maria Maggiore, however, was built *as* a church and begun within a year of the proclamation by the Council of Ephesus (431) that Mary was to be revered under the title "Mother of God." Finished eight years later, it includes remarkable biblical nave mosaics that were created at that time.[2] In the last decade of the thirteenth century, it was redecorated with arch mosaics in a similar style, now featuring more prominently Marian themes. In the inner portal arch, where in Roman antiquity there would have been the *sol invictus*, a mosaic with contrasting Christological features was then added (fig. 22). The image echoes an earlier interior mosaic in the cella representing Christ as a young emperor surrounded by four angel attendants, but here in the new arch mosaic he announces with his open Gospel text a biblical theme of great importance to thirteenth-century theology and aesthetics, directing the viewer to a central divine claim that directly challenged the Roman imperium even when first uttered: "I am the light of the world."

Looking up, we see Christ enthroned in place of the emperor, surrounded by angels most probably representing the "four daughters of God," Justice and Truth with their drawn swords, and above them Grace and Peace (cf. Ps. 84:10; Vulgate 84:11).[3] The text of Scripture Christ holds

1. Miri Rubin, *Mother of God: A History of the Virgin Mary* (New Haven: Yale University Press, 2009), 95.

2. Margaret Miles, "Santa Maria Maggiore's Fifth-Century Mosaics: Triumphal Christianity and the Jews," *Harvard Theological Review* 86, no. 2 (1993): 155–72, 158.

3. *Le Castel d' Amour*, an allegory in French written by Robert Grosseteste, father of the English Franciscans, in 1230, introduces this theme in reference to salvation history, representing the court of heaven as though it were a medieval court in which there is a

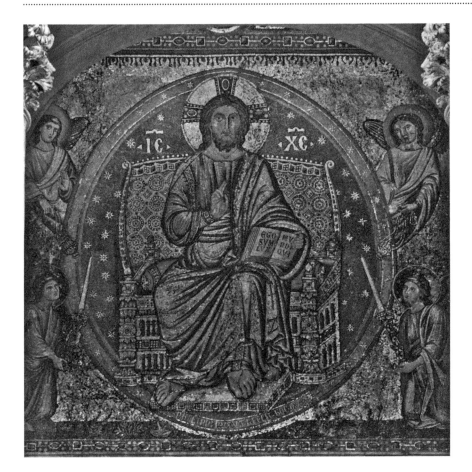

Figure 22. S. Maria Maggiore, Rome, portal mosaic, added thirteenth century

open is from John 8:12, which in Latin reads "Ego sum lux mundi, qui. . . ." The reader has to supply the rest from memory; space in a mosaic is limited. In such a situation as this, of course, recollection causes more than the text itself to be remembered: "qui sequitur me, non ambulat in tenebris, sed habebit lumen vitae"—"I am the light of the world. Whoever follows me will not walk in darkness, but will have the light of life" (ESV). For Roman Christians even at many centuries' remove, the darkness was fresh enough in memory, and its contrast with the light of Christ still sharp and well defined. Light for a Christian culture came to have significance richer and more complex than it had for its predecessors just

gracious and witty *débat* concerning what God should do about the fall of man and human lack of fealty. It was translated into Middle English and obtained a wide circulation; see R. F. Weymouth, ed., *The Castel off Love*, Early English Text Society (Oxford: Oxford University Press, 1864).

because of the extensive biblical association of light with God himself, beginning from the divine performative word in the creation story, *fiat lux* (Gen. 1:3), on through to the writings then associated with Saint John the Divine (the Gospel of John, his letters, and his Revelation, more frequently then called the Apocalypse of Saint John the Divine, or simply Apocalypse).

Given that the Bible had become such an important source for Christian ideas about beauty in the aesthetic as well as moral sense, it is understandable that the biblical doctrine of creation, with its presentation of God as the deliberate architect of a finite universe, should have persisted in a thoroughly Christian culture well after the discovery of Aristotle's cosmogony, in which the universe is assumed always to have been in existence. For medieval Christians in particular, the idea that the created order we inhabit is an artifice, artwork, begun by divine fiat and to be concluded by it (2 Peter 3), means that *in principio* ("in the beginning"; Gen. 1:1) and *consummatum est* ("it is finished"; Rev. 21:6), the structural beginning and end points of salvation history, are architectonic, echoed in everything made by human as well as divine creativity, even in the span of life itself. God who is Light ineffable was also the one who made "light visible," separating day from night (Gen. 1:14–19), and the diurnal cycle continues, with the ordered lights of the cosmos serving as signs "for seasons and for years" as well. Medieval Christians studied the cosmos for ultimate meaning, and, as we saw in the last chapter, noted that the noble pagans, especially the Greeks, had done so as well. They were especially interested in the Greek cosmogony in Plato's *Timaeus*, which until the Renaissance was the only work of Plato known to Europeans, having been made available to them in a translation with the commentary by Chalcidius, a fourth-century philosopher who was possibly himself a Christian.[4]

Briefly, the cosmogony outlined in the *Timaeus* offers a digest of the Platonic realism known to the Hellenic Jewish as well as early Christian world. The tangible features of the physical world are seen as predicated on their invisible but intelligible forms; for Plato the invisible forms are reality, and the things we see are indifferent copies, only shadowy manifestations of their pure source. Thus, what we think of as true, good, or beautiful are only imperfect instances, particulars rather than the universal, pale simulacra of the higher reality. The lives we see are likewise instances of "becoming," having behind them a form of Being that is universal. We cannot, unaided, see the higher reality because we are like

4. Johann Wrobel, ed., *Platonis Timaeus: Interprete Chalcidio cum euisdem commentario ad fidem librorum manu scriptorum* (reprint, Charleston, SC: Nabu Press, 2012).

people who live in a deep cave, far beneath the light of the sun. When the firelight makes shadows on the wall of our cave, we take that dim light for reality, knowing nothing else. For Plato, as in Socrates's myth of the cave in the *Republic*, the proper goal of philosophical learning is to find a way of progressing upward out of the cave of our occlusion, from darkness into the clear light of truth. For Plato this progress is made possible by dialectical inquiry, sharpening our sense of reality as we move from belief and opinion toward the clearer forms of intelligible truth, namely, *dianoia* and *gnōsis*.

It is not difficult to see how such a paradigm would interest medieval Christians as a species of partial but indicative truth, "Egyptian gold," as Augustine would have it, ready to be employed to aid in understanding. But all such pagan truths were mediated in the light of sacred Scripture. In pre-Renaissance Christian thought the Platonic paradigm was kept, but its meaning was transformed by an overlapping biblical account of ultimate reality expressed succinctly in the prologue of the Gospel of John. There we read: "In the beginning was the Word (*logos*), and the Word was with God, and the Word was God. He was in the beginning with God. All things were made through him, and without him was not any thing made that was made. In him was life, and the life was the light of men. The light shines in the darkness, and the darkness has not overcome it" (John 1:1–5 ESV). Echoes of Genesis 1 and Proverbs 8, in which the uncreated Wisdom that created the world is personified as feminine, locate this passage in John squarely within Jewish biblical tradition. But John's readers knew the Greek paradigm too, and because of it, John's words about the Logos coming into the world as a light that the darkness could not overcome could not help but be striking. Suddenly, for true knowledge one did not have to struggle dialectically to rise up out of the darkness of the cave, but rather, the Light had come down into the cave, dispelling the darkness. To be enlightened by this Light was thus an experience qualitatively different than that imagined by Socrates. The idea of the incarnation of the Logos as the Light of the World became more important to Christian theological aesthetics even than the doctrine of creation. John in his Gospel makes it clear that neither he himself nor John the Baptist is the light—they are just messengers (John 1:6–9). "The true light, which gives light to everyone, was coming into the world" (v. 9). For John this means that the divine light and glory was taking on the form of flesh and blood, an unprecedented actualization in the world of becoming, hence also of change and decay.

LIGHT AND LIGHTS

As we have already seen, from the overall architecture of the place of worship down to its most minute items of decoration, medieval churchmen, their builders and their craftsmen, shared a deep sense of obligation to what were thought to be divine patterns, a conviction that the physicality and adornments of sacred space ought to be themselves a kind of refraction of the light (*lumen*) that illumines the worshiper, yet registered spiritually, pointing beyond to the source of all light (*lux*). Of course, this *lux* was the "Light inaccessible, hid from our eyes," as the old Christian hymn has it, identifiable exclusively with "God only wise."[5] But medieval thinking about the relationship of visible to invisible light produced arresting philosophical reflection in the area of "light metaphysics," notably in treatises by Adam of Exeter and especially Robert Grosseteste, bishop of Lincoln, first chancellor of Oxford University, and spiritual father to the English Franciscans.[6] In Grosseteste's texts, the line between physics and metaphysics, philosophy and theology, is nearly imperceptible; as Simon Oliver puts it, "for Grosseteste . . . to study light was to study God, and all things in relation to God."[7] In works such as his commentary on the *Celestial Hierarchies* of Pseudo-Dionysius, in his *De luce* and *De lineis, angulis et figuris*, Grosseteste develops a theory that all bodily forms in the universe are extensions in three dimensions of light emanating from an original and singular point, then refracting so as to form tangible objects according to geometrical rules.[8] The least of these "extensions" still partic-

5. Hymn by Walter Chalmers Smith; see Erik Routley, *A Panorama of Christian Hymnody* (Collegeville, MN: Liturgical Press, 1979), 132. When first published in *Hymns of Christ and the Christian Life* (1867), the hymn had six verses.

6. For an overview, see Celia Panti, "Robert Grosseteste and Adam of Exeter's Physics of Light," in *Robert Grosseteste and His Intellectual Milieu: New Editions and Studies*, ed. John Flood, James R. Gunther, and Joseph W. Goering, Papers in Medieval Studies 24 (Toronto: Pontifical Institute of Medieval Studies, 2013), 165–75. Panti's translation of *De luce* occurs in this volume, as does a serviceable translation by Neil Lewis, pp. 239–47. To my knowledge, the still-unpublished dissertation of Mary Wilson, "Gothic Cathedral as Theology and Literature" (University of South Florida, 2009), is one of the most thorough and useful explorations of the themes of light metaphysics and symbolic number since the book by Otto von Simson.

7. Simon Oliver, "Robert Grosseteste on Light, Truth and 'Experimentum,'" *Vivarium* 42, no. 2 (2004): 151–80, 154.

8. This insight is anticipated better in Greek than in Latin; in Greek things are *phainomena*, derived from the verb *phainesthai*, which carries within it the root *phaos*, "light." Things are known by means of light.

ipates in the originary Light; hence, for Grosseteste, something of the divine wisdom is to be discovered in "the smallest fleck of dust, whirling in a sunbeam."[9] Grosseteste's theory of the refraction of light into color is far from fanciful; in fact, he is sufficiently anticipatory of modern quantum optics that he was proposed, along with a team of contemporary researchers from Durham University, as a corecipient of a 2014 research award![10] For nonscientists, perhaps the essential point to grasp is that on Bishop Grosseteste's hypothesis light operates in a profoundly mathematical way. In the redaction of Bruce Eastwood, "since mundane light is a reflection of metaphysical light, and since both act in accord with geometry, knowledge of optics is essentially knowledge of geometry."[11] This conception of the mathematical structure of reality, an application of the seminal text in Wisdom of Solomon 11:20, "Thou hast ordered all things in measure, number and weight" (Vulgate: "Omnia in mensura, et numero, et pondere disposuisti"), leads not only to a figural view of God in creation as a cosmic geometer, as in the famous representation in the *Bible moralisée* (fig. 23), but also to a view of the cosmos in which the mathematics of the One and the Many denominates a harmonious mutual participation in which there is no dualistic opposition of *lux* and *lumen*, but all that is to be seen is *lumen* and participates in the originary Light (*lux/fiat lux*).[12]

As in the earlier thinking about measured space, so here too all elements together, seen and unseen, measure, structure, and adornment, become effectually christological, because all that is *lumen* points to the incarnate Logos. John's Gospel calls the Logos the "light which comes into the world," "a light to lighten the darkness," which "the darkness has not overcome" (John 1:5). The value for the medieval worshiper, as Abbot Suger of Saint-Denis had already indicated, is that the beauty of gold, enamel, and gemstones is appreciated as a reflection of the divine Light, the original art of the Creator who said "*fiat lux*" and who became Light

9. Grosseteste, *In Hexaemeron* 7.4.5.

10. Michael Brooks, "The Medieval Bishop Who Helped to Unweave the Rainbow," *Guardian*, November 27, 2014, http://www.theguardian.com/science/blog/2014/nov/27/bishop-unweaved-rainbow-times-higher-education-award. The article nominating him, "All the Colours of the Rainbow," by Hannah E. Smithson, Giles E. M. Gasper, and Tom C. B. McLeish, appeared in *Nature Physics* 10 (2014): 540–42.

11. Bruce Eastwood, "The Case of Grosseteste's Optics," *Speculum* 43, no. 2 (1968): 306–21, 320. That *numerus* meant "rhythm" as well as "number" helps to account for the prominence of "harmony" and "proportion" as features of medieval discussions of the beauty of creation.

12. Oliver, "Robert Grosseteste on Light," 157.

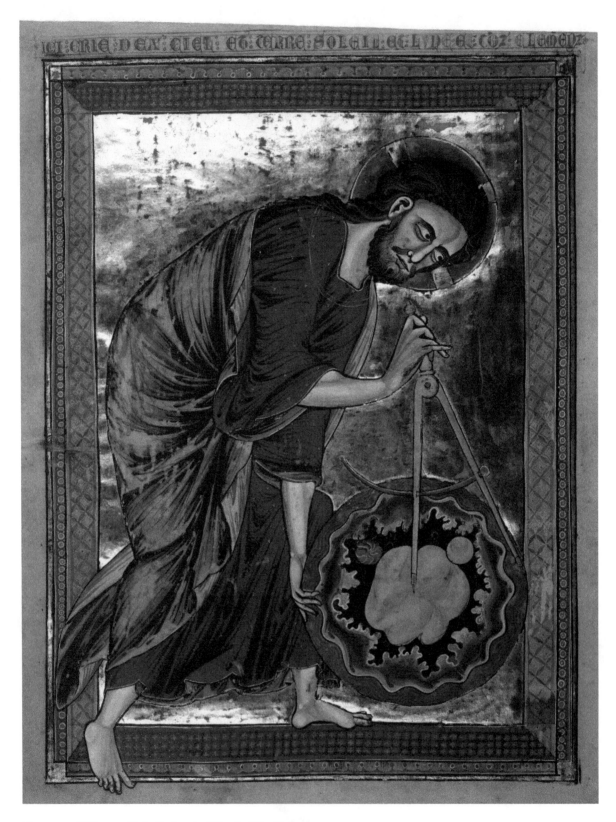

Figure 23. *Bible moralisée*, God as Architect of the Universe, ca. 1220

incarnate in Christ. Accordingly, one of Suger's inscriptions reads: "Whoever you may be, if you seek to do honor to these doors, praise not the gold or the cost of them, but the work and the art. Surely the noble work shines, but that which shines is its nobility; it enlightens men's minds and by these lights guides them to the true light whereunto Christ is the true door." When Suger tore down the rood screen dividing the altar from the nave in Saint-Denis, he said that it was to permit more light (fig. 24).[13] He meant this to be understood in the spiritual as well as physical sense. When he rebuilt the apse and transept with buttresses so as to permit vast expanses of stained glass in which the walls themselves seemed to melt away, it was to bathe the altar in the splendor of light, so that the supernal Light might shine within, creating a kind of mystical sense of the divine presence (fig. 25). When he had finished his work, anyone who entered by the beautiful doors of the western portal and walked down the long, dark Romanesque nave would be moving through shadows, illumined regularly by shafts of light, signs pointing forward toward maximal interior brightness at the altar, there to anticipate entering at last into the realm of perfect Light.[14]

THE LIGHT OF THE ARTS AS KNOWLEDGE OF THE HOLY

The most important theoretical work on the relationship of the arts to theology, and of the metaphysics of light as key to that relationship, was written by Saint Bonaventure at almost exactly the midpoint of the thirteenth century.[15] In Bonaventure's thinking, notably in his *Hexaemeron*, or "six days of creation," the ontological and mathematical connotations

13. Georges Duby, *The Europe of the Cathedrals, 1140–1280*, trans. Stuart Gilbert (Geneva: Editions d'Art Albert Skira, 1966), 15.

14. Andreas Speer has argued that Erwin Panofsky (in his *Abbot Suger on the Abbey Church of St. Denis and Its Art Treasures*, 2nd ed. [Princeton: Princeton University Press, 1979]) exaggerated Suger's indebtedness to Pseudo-Dionysius, making the case that he could easily have derived his theology of light from other traditional sources. See his "Is There a Theology of the Gothic Cathedral?" in *The Mind's Eye: Art and Theological Argument in the Middle Ages*, ed. Jeffrey F. Hamburger and Anne-Marie Bouché (Princeton: Princeton University Press, 2006), 65–83. Speer's argument does not alter the terms of our consideration here.

15. The date usually given is 1269, but the composition may have begun earlier. The edition used here, with Latin text and English translation, is *Saint Bonaventure's De reductione artium ad theologiam*, ed. and trans. Emma Thérèse Healy, in *Works of Saint Bonaventure*, ed. Philotheus Boehner et al. (Saint Bonaventure, NY: Franciscan Institute, 1955).

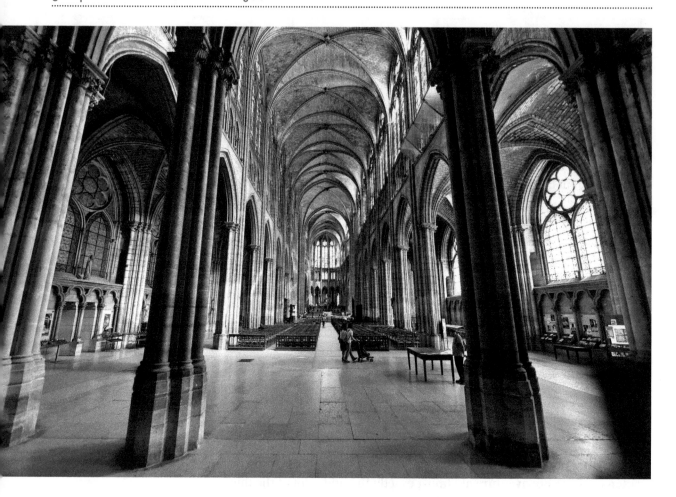

Figure 24. Saint-Denis Cathedral, nave

of light theory take a distinctly aesthetic turn, yet one still metaphysically grounded.[16] Beauty, including the *lumen* refracted in the arts, becomes more prominent as a subject, and beauty itself is treated as a transcendental. We should note here that the wider concern of Bonaventure's *De reductione artium ad theologiam*, typically translated as "the retracing of the arts to theology," can be somewhat obscured by the literal translation of its title into English. Responding to a tendency already appearing in the university to divide thinking about the various disciplines and practices of art from theological thought strictly so considered, Bonaventure intended in this brief text a taxonomy of "secular" knowledge (what we usually think of as the "disciplines") ordered clearly toward the knowledge

16. Lucia Miccoli, "Two Thirteenth-Century Theories of Light: Robert Grosseteste and St. Bonaventure," *Semiotica* 136, no. 1/4 (2001): 69–84; 77.

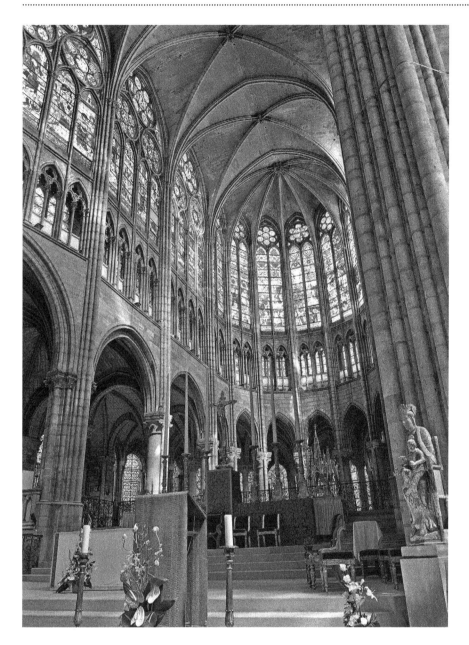

Figure 25. Saint-Denis
Cathedral, apse and altar

of God, and this design invites initially an epistemological reading of his
text; it comprises, in fact, a succinct theory of the relationship of external
perception to internalized personal knowledge. At the theological level,
however, the metaphysical/aesthetic presupposition was characteristi-
cally Franciscan in its theological and spiritual reach, for in the Fran-
ciscan mind everything in the visible universe was (as Hopkins, echoing

the Franciscan philosopher Duns Scotus, would say) charged with the "grandeur of God." There can be no absolute division between faith and reason or science and theology on such a view. Another way to put this scholastic conviction is found in the introduction to *Reductione artium* by Sister Emma Thérèse Healy, who observes of Bonaventure, "For him no sort of philosophy had a legitimate standing in the curriculum of studies if it discarded revelation."[17] Diligent study of the cosmos is indispensable in the search for truth, because in the divine artist's handiwork we may obtain real and even indispensable knowledge of his nature. Bonaventure himself said in his *Hexaemeron* that Christians are learners who read from two books simultaneously, the Book of God's Works and the Book of God's Word, and they come to see that the first is not fully intelligible without the second:

> Indeed, in every creature there is a refulgence of the divine exemplar, but mixed with darkness: hence it resembles some kind of opacity combined with light. Also, it is a way leading to the exemplar. As you notice that a ray of light coming in through the window is colored according to the shades of the different panes, so the divine ray shines differently in each creature and in the various properties. Again, it is a trace of God's wisdom. Wherefore the creature exists only as a kind of imitation of God's wisdom, as a certain plastic representation of it. And for all of these reasons it is a kind of book *written without*. When therefore the soul sees these things, it seems to it that it should go through them from the shadow to the light, from the way to the end, from the trace to the truth, from the book to veritable knowledge [which is in God].[18]

This kind of thinking can seem overwrought if we are not used to medieval philosophical discourse, yet the basic idea is simple, though certainly far-reaching. Each detail in the creational order refracts the *lumen veritatis* (light of truth), "which enlightens everyone that comes into the world" (John 1:9). Light and Truth are here two gifts from the same divine source. Bonaventure begins his brief, rich argument for the integration of theology and all learning (also his "aesthetics") with a quotation from the Epistle of James (1:17), a biblical point of departure he borrowed from Hugh of St. Victor's strategy in the latter's *Exposition on the Celestial Hi-*

17. Healy, introduction to *Saint Bonaventure's De reductione artium ad theologiam*, 17.
18. Bonaventure, *In Hexaemeron* 12.14–15, in *Opera S. Bonaventurae* (Florence: Quaracchi ed., *Doctoris Seraphici S. Bonaventurae . . . Opera Omnia* [1902], 5.386b).

erarchies of St. Dionysius the Areopagite.[19] Yet the more general claim at the beginning of John's Gospel that the Light of eternal Being entered into time (rather than being something we can attain to only in eternity) is very much at the heart of Bonaventure's schema as well.

It is worth recalling the role of John's prologue (1:1–14) in medieval liturgies. In the Old Roman rite, as well as the Sarum rite, this text was recited at the conclusion of every Mass, making this "Word from the beginning" the *last* word in every celebration of the medieval Eucharist before the congregation left the sanctuary. The theme of the incarnation as the Light that comes into our darkness is thus made to be a recurrent liturgical motif. The incarnation of the Logos as Jesus the Christ, not as the disembodied logos of the Neoplatonists, is the most foundational supposition of Bonaventure's text, yet he adverts here also to the passage in James so as to reinforce and locate the divine Light as originating with God the Father, from whom it proceeds as gift, and to whom it returns in the dynamism of the celestial hierarchy. The text from James allows him to underscore the axis between creation and the meaning of the creation revealed in Christ, and so to regard everything in the realm of human artistic creativity as likewise a gift received, a gift that refracts the gracious supernal light of the Giver: "These words of Sacred Scripture not only include the source of all illumination, but they likewise point out the generous flow of the manifold rays which issue from that fount of light" (*De reductione artium* 1.1). Bonaventure then divides the world of the knowable into four types of light: "what we may call the *external* light, or the light of mechanical art; the *lower* light, or the light of sense perception; the *inner* light, or the light of philosophical knowledge; and the *higher* light, or the light of grace and of Sacred Scripture. The first light illumines in regard to structure of *artifacts*; the second, in regard to *natural forms*; the third, in regard to *intellectual truth*; the fourth and last, in regard to *saving truth*."[20] It is clear that by "artifacts" Bonaventure means more than "art objects," though these are included. He also means things that we would now designate as "craft" and "manufacture"; the latter word meant then simply "made by hand," and it is evident that the production of all such things is for mundane creature comfort. Yet the citation he employs to signal the nature of "mechanical" art is from Horace, the Roman poet and author of the *Ars poetica*, a classical work of aesthetics from which this quotation is taken: "Either to serve or to please

19. In Migne, *Patrologia Latina* 175:923–1154.
20. Healy, introduction to *Saint Bonaventure's De reductione artium ad theologiam*, 21.

is the wish of poets."[21] Poetry, dramatic art, song, music, pantomime—all these for Bonaventure are intended "for the comfort or betterment of the exterior man," as needful for human flourishing as the provision of food, the medical arts, or the work of carpenter and stone mason.

The "lower light" is provided by the five senses, our physical means of engaging tangible realities by which we appropriate in use and enjoyment the products of the mechanical arts as well as the properties of nature. The third light is the light of philosophical knowledge, which aids us in understanding "intelligible truths," truths of reason such as we pursue in moral philosophy, natural philosophy, and the principles of interpretation. Here are the arts of the trivium (grammar, rhetoric, logic) and a triad of physics, mathematics, and metaphysics (1.4).

The fourth light, "the light of Sacred Scripture," Bonaventure calls "*higher* because it leads to things above by the manifestation of truths which are beyond reason and also because it is not acquired by human research but comes down by inspiration from the *Father of Lights*" (1.5). Bonaventure claims that Holy Writ is the *anagogicus mos* (upward-leading way) par excellence; in its polysemeity of literal, moral, allegorical, and anagogical (heavenly) meanings we are taught the relationship of creation to incarnation and at the same time the meaning and purpose of human life; in Bonaventure's words, "the eternal generation and Incarnation of Christ, the pattern of human life, and the union of the soul with God" (1.5). The light that comes down from above is thus refracted through all creation and allures in such a way as to draw us potentially upward to beatific vision of the Source of Light itself.

What all this means for art, our author goes on to explain, is that something of the divine wisdom itself is already given to us when we begin to examine the mechanical arts, the "external light," under the aegis of the higher light of "grace and Sacred Scripture" (1.11). We delight in our sense experience of these material things rightly when "our spiritual senses . . . seek with longing, find with joy, and time and again experience the beautiful, the harmonious, the fragrant, the sweet, or the delightful to the touch" (1.10), for the divine wisdom "lies hidden in sense perception," so as to lead us by this lower light to the higher light. As we obtain a fuller understanding, "the pattern of human life" becomes more visible in both the production and the appreciation of the arts. Eventually we become able to conceive of the good life itself as a work of art in which "every act

21. "Aut prodesse volunt, aut delectare poetae." Healy, introduction to *Saint Bonaventure's De reductione artium ad theologiam*, 21.

of ours should be characterized by *measure, beauty* and *order*" (1.17)—the very qualities associated with the temple by Bede and the cathedral by Suger—for we too are to be a "temple of the Holy Spirit."

We should remember perhaps that "measure," "beauty," and "order" are normative terms applied in the art theory of the ancients, reflected, as we saw, in Augustine's reminiscence on his lost volumes, *De pulchra et apto* (Of beauty and proportion). The juxtaposition of such aesthetic terms with language about worship and salvation, sanctuary and sanctification, is not happenstance in Bonaventure any more than it is in Augustine or any other medieval philosopher, but is rather a deliberate conjunction pointing to deeply integrated convictions about the nature of reality. Rightly referred, beauty is soteriological. The idea here is that by learning through imitation of Christ to make of each action of our lives "a beautiful thing"—*Lebensnachfolge*, as the German Franciscans were to call it—our brokenness may be healed and our new life become art, in turn a light for others. In living thus "beautifully" we realize in ourselves a greater fullness of the image of God by the imitation of Christ; as Bonaventure says elsewhere,[22] this is as much as to say that in following Christ closely we are re-formed through an admiration of the Son who himself is "the art of the Father" (*De reductione artium* 1.20). We shall return to these ideas in the next chapter as we consider the recrudescence of alfresco wall painting in Italy under the influence of Franciscan spirituality. Suffice it for now to say that Bonaventure's little book, perhaps the most perfect précis of medieval Christian theology that has come down to us, helps us see the way in which the light metaphysics of the high Middle Ages is profoundly integrative of all the "arts" under the aegis of theology, gathering up the beauty of art into the beauty of worship, a beauty supremely presented (or re-presented) sacramentally in the sacrifice of the altar.

Earthly Sanctuary and Celestial Jerusalem

The creation of holy space—a space set apart from worldly concerns and commerce in which one might enter the many-splendored light of prayer and holy presence—was an objective medieval architects and artists achieved distinctively. We may experience the ethereal otherworldliness they intended still, but only by visiting one of the more beautiful sanctuaries in person. To step away from the noise and bustle of the

22. Bonaventure, *Hexaemeron* 18.9.

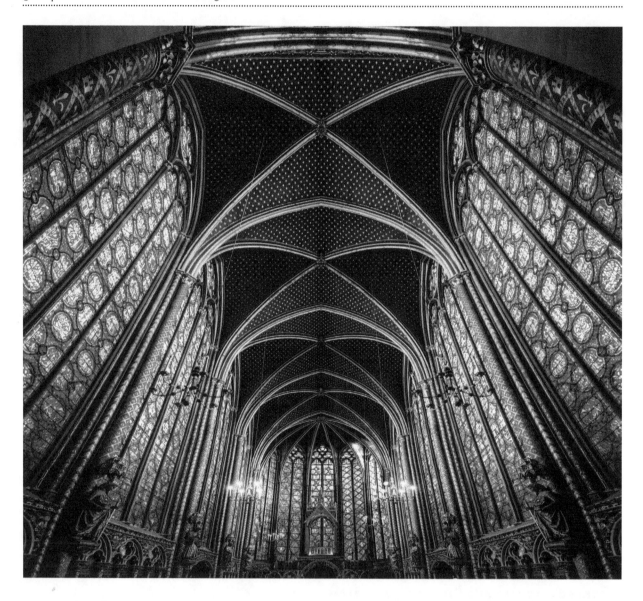

Figure 26. The glass of Sainte Chapelle de Paris

city streets into the quiet magnificence of Sainte Chapelle in Paris, for example, makes the theology of light an experience transcending the theoretical elegance of Grosseteste's theories and Bonaventure's theology. This chapel was built as part of the palace complex of King Louis IX the Pious (later canonized as Saint Louis). Louis saw himself and the French monarchy as descended spiritually from the kings of Israel in the golden age, especially Solomon. Finished in 1248 at a cost of 40,000 livres, his Sainte Chapelle was built as a great reliquary as well as an oratory, for it housed the putative Crown of Thorns, purchased by Louis from Venetian

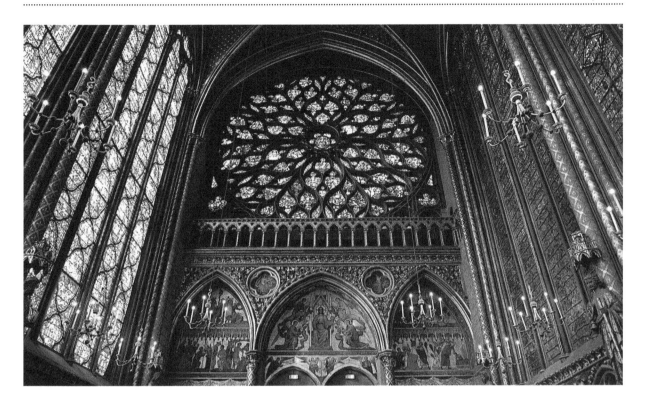

merchants (to redeem a loan made by them to the king of Constantinople, for the astonishing sum of 150,000 livres, nearly four times the cost of the extravagant chapel itself). Here, in this second-generation Gothic oratory, one not only sees the dramatic refraction of light into its seven prismatic colors, but one also *feels* it falling across one's body as one moves through the space. When one looks up to the windows themselves, so vast an expanse of glass in relation to the surrounding stone tracery and buttresses, tinted with blue, red, and gold, the effect is mesmerizing (figs. 26 and 27).

Bonaventure began teaching in Paris in 1248, the year Sainte Chapelle was completed; he almost certainly wrote his *De reductione artium ad theologiam* sometime between that date and 1257—that is, *after* he had seen Sainte Chapelle.[23] He surely would have marveled, as did almost everyone, at the internal splendor of the finished oratory. It may well be that this is one of those instances in which a great artistic and technical

Figure 27. Rose window of the Upper Chapel of Sainte Chapelle de Paris

23. P. Bonaventura Trimolé, "Deutung und Bedeutung der Schrift der hl. Bonaventura, 'De reductione artium ad theologiam,'" *Fünfte Lektorenconferenz der deutschen Franziskaner* (Werl: Franziskus-Druckerel, 1930), 114.

achievement was inspirational for theological and philosophical insight. Neither words nor photographs can capture the effect of this master-piece of the Rayonnant style of stained glass artistry, but Duby describes it as well as any when he writes: "The upper part of Sainte Chapelle in Paris is a vast net spread out to trap light in its meshes, and the walls vanish into thin air, so that the whole interior is flooded with a radiance more evenly distributed than ever before—which certainly would have delighted Suger." Speaking of the spread of the growing desire for this type of stained glass expanse elsewhere in France especially, he adds: "Everywhere rose windows blossomed forth, sometimes expanding so as to touch the masonry of the buttresses. Forming perfect circles, symbols of the rotation of the cosmos, they also signified the cyclic flux and reflux of light inaugurated by the Creator on the first day."[24]

For all the brilliance in architectural engineering and stained glass artistry that made for these stunning visual effects, we must not imagine that the intent was limited to a demonstration of technical mastery of the relevant branches of physics or the fabrication of a mere trompe l'oeil. The subject matter of the individual panes of glass was narratively ordered and crafted to portray to the dedicated observer the stories and the theological truths of the Bible. This was an apt visual demonstration of Bonaventure's contention that the "higher" light of sacred Scripture was from beginning to end the gift of God's revelation, the pedagogical means by which we can arise through the lower lights of the mechanical arts, sense perception, and philosophical knowledge to the supreme light available to man short of Paradise itself, namely, "the light of grace and sacred Scripture." At Sainte Chapelle, as elsewhere, depictions of narratives from the Bible trace out the *historia humanae salvationis*, stories reiterated in the liturgical readings of the Bible through the Christian year.[25] In Sainte Chapelle uniquely, the artistic design for representing these narratives seems to have drawn from the *Bible moralisée*; the medallion format of that beautiful book was copied quite faithfully in the glass (fig. 28).[26] Each of the four copies of the *Bible moralisée* has about thirteen thousand of these rounded images, providing stained

24. Duby, *Europe of the Cathedrals*, 105.

25. Saint Louis, as king of France, privileged also narratives having to do with kingship in this program. See Alyce A. Jordan, *Visualizing Kingship in the Windows of the Sainte-Chapelle* (Turnhout: Brepols, 2002).

26. Christine Hediger, ed., *La Sainte-Chapelle de Paris: Royaume de France ou Jérusalem céleste?* Actes du Colloque, Paris, Collège de France, 2001 (Turnhout: Brepols, 2007), especially the essays by Hediger (315–44) and John Lowden (435–63).

Figure 28. *Bible moralisée,* ca. 1220

glass artisans with an almost inexhaustible supply of biblical narrative illustration.

In this series of images on one page from the *Bible moralisée,* the story of Ruth the Moabitess and Boaz, the "kinsman-redeemer," is related typologically to the redemption of Israel and the gentiles by Jesus through his sacramental blood, picking up the powerful biblical theme in both Testaments of spiritual marriage between the Lord and his people.

Yet stories of adultery in the Old Testament (here the story of David and Bathsheba and the murder of Uriah) could likewise be read typologically into the New Testament and moralized, as in this example from the Sainte Chapelle windows, echoing the typological method and design of

Figure 29. Sainte Chapelle window series

the *Bible moralisée* (fig. 29). Altogether, 1,130 figures from the Bible are represented in these windows, in narratives from Genesis to Revelation. Thus, the *Lux* coming into the world, not just as *lumen* but as *logos*, informs, adorns, and enriches our understanding of the divine purpose in salvation history. By means of the mechanical arts, sense perception, and philosophical knowledge, we are turned toward intelligible beauty by the highest light, "the light of grace and sacred Scripture."

To what extent the astonishing beauty of Gothic interiors aided medieval worshipers in perceiving that the space into which they had come was truly set apart, a holy place, we can only imagine. For one Anglican priest and poet of the seventeenth century, George Herbert, there was in the beauty and narrative of the stained glass something that repeatedly overawed him, moving him to seek a like transparency and color in his life as well as verbal proclamation of the gospel. He captures some of this in his poem "The Windows":

Lord, how can man preach thy eternal word?
 He is a brittle, crazy glass;
Yet in thy temple thou dost him afford
 This glorious and transcendent place,
 To be a window, through thy grace.

But when thou dost anneal in glass thy story,
 Making thy life to shine within
Thy holy preachers, then the light and glory
 More reverend grows, and more doth win;
 Which else shows waterish, bleak, and thin.

Doctrine and life, colours and light, in one
 When they combine and mingle, bring
A strong regard and awe; but speech alone
 Doth vanish like a flaring thing,
 And in the ear, not conscience, ring.[27]

What we know is that the effect of such environments on visitors today who have no religious conviction at all, or at least none they wish to acknowledge, is often one of utter awe and a reduction to silence. More than a few such visitors have a moment of such emotional transport as to bring a tear, unbidden, to the eye. What the medieval architects and artisans seem to have known about more than many if not most of their successors is the universal human longing for beauty, for an inner sanctum for the soul, for a refuge from the world, a holy, inviolate space.

CONCLUSION

The Christian baptism of Platonic cosmogony with biblical tropes for creation and for the meaning of the incarnation makes the idea of the light coming *into* the world one with profound epistemological as well as theological implications. Bonaventure's *De reductione artium ad theologiam* (Retracing the arts to theology) builds on the prominence of the prologue to John's Gospel in medieval theology and liturgy to offer an integrative schema for understanding the role of theology in relation to the arts, one leading to an identification of the Light from the beginning (*Lux*) with the symbolic value of light streaming through the stained glass of the sanctuary and thence to the "light of grace and sacred Scripture" there pictured, returning the imagination of the worshiper in thanksgiving to the "Father of Lights."

27. *The Works of George Herbert*, ed. F. E. Hutchinson (Oxford: Clarendon, 1941), 67–68.

5 THE BEAUTY OF HOLINESS ALFRESCO

"New wine must be put into new bottles."

MARK 2:22

Wall paintings, especially interior murals, have a long history, dating back beyond the pyramid tombs in Egypt to the cave paintings at Lascaux in France; some are more than twenty thousand years old. In the imperial Roman era skilled artists composed paintings for domestic decor and executed them in still-wet plaster (alfresco). Some vivid examples have survived, preserved by the eruption of Mount Vesuvius at Pompeii and Herculaneum.[1] Jewish and Christian artists both borrowed similar Roman alfresco techniques to capture religious narrative and symbol on the walls of some of the catacombs,[2] and as we have seen, both Christian and Jewish sanctuaries at Dura Europos show that the medium was employed in the distant provinces as well as closer to the capital. In fourth-century Spain, the poet theologian Prudentius composed forty-nine quatrains to be painted beneath biblical murals for a church there, beginning with Adam and Eve and concluding with the scene in the fourth chapter of Revelation, with the twenty-four elders praising the Lamb that was slain.[3] Most of the surviving Christian

1. Shelley Hales and Joanna Paul, eds., *Pompeii in the Public Imagination from Its Rediscovery to Today* (Oxford: Oxford University Press, 2011).

2. See Jas Elsner, *Imperial Rome and Christian Triumph: The Art of the Roman Empire, AD 100–450* (Oxford: Oxford University Press, 1998); Jeffrey Spier, ed., *Picturing the Bible: The Earliest Christian Art* (London and New Haven: Yale University Press, 2007).

3. Prudentius 2.846–71. Latin text in *Prudentius*, ed. H. J. Thomson, 2 vols., Loeb Clas-

wall paintings from this period reflect the continuing dominant influence of the Jewish Scriptures, with signal moments in the biblical narrative clearly having symbolic or at least metonymic reference to major Christian as well as Jewish themes. The alfresco medium embeds vivid colors in the plaster itself, yet over time it proves fragile, extremely susceptible to damage from moisture and direct light. It is unsurprising that almost nothing remains from the early period other than what was buried by ash or rubble or, as in the catacombs, kept away from light at a more or less constant temperature and humidity for centuries. We do not now have much above-ground alfresco painting at all from earlier than the twelfth century.

But in the thirteenth century, especially in Rome and Tuscany, medieval wall painting came of age and suddenly began to rival the hitherto prestige medium of the mosaic image so clearly associated with the Byzantine iconic style. As evidenced in the examples from Rome and Ravenna mentioned in chapter 2, mosaics were a superior medium for durability, but had a limited range of colors and were best suited to two-dimensional depiction. By the thirteenth century, a major style change was commencing in which painters were seeking a more flexible and naturalistic form of representation, one that would allow them to experiment with projecting the three-dimensionality of living bodies even on a flat surface. At one level we may regard this as merely technical experimentation, but at a much deeper level it was being prompted by a desire to render the biblical stories in a more realistic way, so that in addition to their value as theological symbols, they might have an immediacy compelling to untutored eyes. It is this rationale more than anything else that drove the stylistic revolution of the thirteenth century.

TRANSITIONS

Two painters whose extant works show them to be right at the hinge of this revolution in style are Cenni de Pepi (ca. 1240–1302), known today by his nickname, Cimabue ("bull-headed"), and a contemporary, the Sienese painter Duccio di Buoninsegna (d. 1319). Both were somewhat flamboyant and even cantankerous characters, yet you would not know that from their work. Duccio's holy figures are serene and majestic, beautifully illus-

sical Library (Cambridge, MA: Harvard University Press, 1949); cf. Paulinus of Nola, Carmen 27, ll. 511ff., describing another such church.

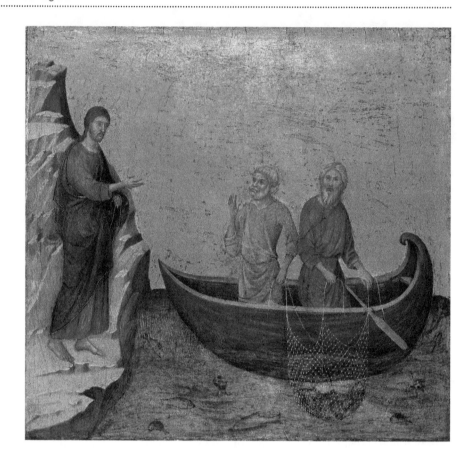

trated in his *Rucellai Madonna* (1285) for Santa Maria Novella in Florence, commissioned by the Campagnia dei Laudesi, a confraternity of singers devoted to praise of the Virgin Mary.[4] By comparison with Cimabue, Duccio's work is less emotionally wide-ranging. Otherwise, the parallels are considerable: both began their careers producing iconic altarpiece paintings in the flat two-dimensional "Greek style" and ended with much more naturalistic narrative paintings; each lived and worked in a city in which there was a buzz of spiritual renewal and encouragement of art associated with the Franciscans, and each admired that charismatic order and was inspired by its spirituality. Duccio's *Madonna of the Franciscans* (ca. 1300) has Mary adored by three Franciscans in supplication, and Cimabue's *Madonna Enthroned with St. Francis* (1295) suggests an equally close relationship with the order as well as patronage. These two artists would almost certainly have had a personal interest in the revival

4. Now in the Uffizi.

of lay piety and devotion that characterized their respective cities by the late third quarter of the century.

In *Calling of the Apostles Peter and Andrew*, a panel from Duccio's now-disassembled Siena Maestà Altarpiece (1304–1311),[5] we see the unmistakable moment of Jesus's first call to the disciples, the astonishing "follow me and I will make you fishers of men" (Matt. 4:19; Mark 1:17), yet without much hint of the astonishment. The scene is serene, and even the net filled with fish (alluding perhaps to the later, more elaborate story in Luke 5) is as still and calm as the glassy sea (fig. 30). Some details are given a high degree of verisimilitude, but the flat gold background we associate with Byzantine icon painting and the awkward suspension of two-dimensional objects in a kind of collage characterize Duccio's attempt at a more natural narrative presentation even as they show his sense of obligation to the Byzantine iconic style.

Cimabue's best-preserved work is also in the Byzantine style, an altarpiece of the Madonna enthroned in majesty, painted for Santa Trinita in Florence (ca. 1285), just before Duccio painted *Rucellai Madonna*, and like it, now in the Uffizi. It is in the classic *Hodegetria* manner ("she who shows the way"), with the Virgin pointing to a rather natural-looking child Jesus, his hand in the Trinitarian configuration or gesture, surrounded by angels. Yet the throne on which she sits has been painted in a new attempt at foreshortening, to suggest the illusion of depth. The Virgin's face, moreover, engages the viewer in a natural way, and the faces of the angels and Christ child express a warmth and human character rarely implied in a traditional icon of the Byzantine style (fig. 31).

Here were holy faces that looked approachable and inviting. Already this step, even if still obliged to the general iconic style then required for altarpieces, was a remarkable foray into new territory. To go more decisively in that direction, however, the artists would need to move beyond altarpieces, bound as they were at that time by fixed Byzantine rules and models, and try their hand at spaces less constrained for representing holy subjects. These spaces were the walls of chapels and churches themselves, large expanses in which to experiment that were situated such that the laity more than the clergy would be their audience. Different techniques would be required—not tempera on wood panels and carved gilt frames but something that could work on the plaster walls themselves. The venerable techniques of alfresco painting, applying the colors directly

5. This altarpiece was dismantled, with this panel now in the Samuel H. Kress Collection, the National Gallery, Washington, DC.

Figure 31. Cimabue,
Madonna of the Holy Trinity,
ca. 1290–1300

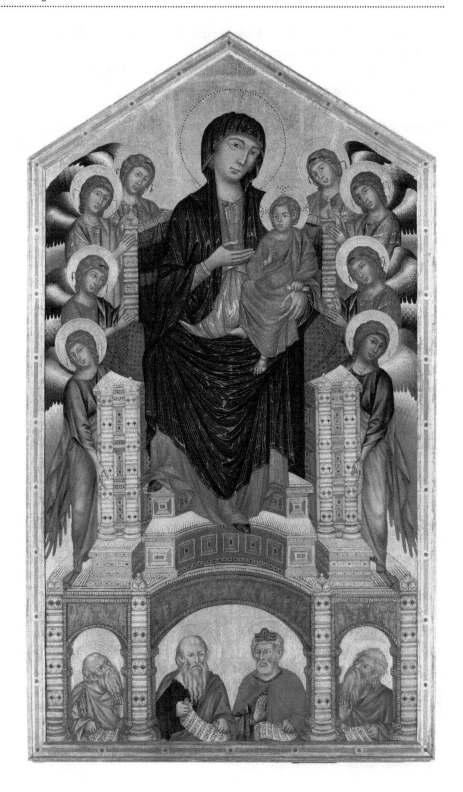

to wet plaster, came to many artistic minds at once. The challenge would be to find ways to give the works so painted a greater durability. Bit by bit the challenge was taken up, and the first real master of the form was a student of Cimabue, Giotto di Bondone (1266–1337), the great genius of Quattrocento Italian painting. Giotto's breakthrough was not simply a matter of technical mastery of a difficult medium and large space; it involved a more dynamic view of representing human forms and faces altogether. We can better understand his innovative work if we know more of the revolution in Christian spirituality that was stirring during his early years as Cimabue's apprentice and that so clearly affected him personally.

SPIRITUALITY AND THE STYLE CHANGE

Émile Mâle, the great French art historian of the last century, put it with admirable succinctness: "In the twelfth century, the Gospels appear above all as an idea; in the thirteenth, the Franciscans reimbue them with life."[6] Like both Duccio and Cimabue, Giotto was strongly influenced by the "little brothers" of Saint Francis throughout his career. If Cimabue's New Testament frescoes for the upper church of San Francesco in Assisi suggest a greater intimacy with the community itself than may have been the experience for Duccio, still more so was this the case for Giotto.[7] Historians of religion and culture generally agree that one cannot well understand Italian painting of this period except by reference to the enormous cultural impact of the Franciscans upon the devotional life and spirituality of lay Christians in the thirteenth century especially.[8] Because their ideas about what counts as holy and what counts as beauty took such a firm hold upon the popular imagination, it is helpful to get at least a general sense of their teaching, preaching, and approach to the arts.

6. Émile Mâle, *Religious Art from the Twelfth to the Eighteenth Century* (New York: Noonday Press, 1949, 1963), 122.

7. It is a notable expression of communal effort at San Francesco that art historians have had difficulty attributing these frescoes. An illuminating study of the unidentified artist called the Isaac Master provides a detailed examination of early Franciscan iconography: see Amy Neff, "Lesser Brothers: Franciscan Mission and Identity at Assisi," *Art Bulletin* 88, no. 4 (2007): 676–706.

8. Ernst Benz, *Ecclesia Spiritualis: Kirchenidee und Geschichtstheologie der Franziskanischen Reformation* (Stuttgart: W. Kohlhammer, 1934); also Millard Meis, *Giotto and Assisi* (New York: Norton, 1960), who shows the indebtedness of the Assisi frescoes to Pompeian and other early Roman work.

This is not, of course, the first time we have encountered Franciscans. In chapter 4 we were introduced to the Oxford scientist Robert Grosseteste and the Paris philosopher Bonaventure. They well represent the intellectual life spurred on by the Franciscan Order in its early years. But with regard to the arts of painting, poetry, and drama especially, we must look beyond the walls of the university to the streets, *borgos*, piazzas, and market fairs, there to discover the friars' dramatic style of teaching and preaching, whether within or without episcopal jurisdiction.

In their early days, Francis and his followers had begun as marginal, suspected of being yet another unruly and charismatic heretical movement among the many that rose up all over southern Europe in response to clerical abuses and disorder. Pope Innocent III was inclined to view the followers of Francis as just one more such heterodox group when, in the spring of 1210, he was approached by Francis and a ragtag band requesting papal permission to live in poverty, striving for a literal imitation of Christ and the disciples as their rule of life.[9] The biographers report that the Curia put up a stiff resistance, fearing always in such liminal movements a loss of central Roman control. But Francis had, in strict obedience to the Holy See, already put himself and his brothers under Roman jurisdiction by a freely willed choice. Innocent deferred his decision. That night the pope is reported to have had a dream in which the Lateran church was beginning to crumble and fall down until a tiny ragged man he understood to be Francis came, and by supernatural strength held it up. It would be difficult to instance a more prophetic or more insightful dream. The church at large in Europe was indeed tottering, but in a spiritual sense, beset not only by schism but also by widespread corruption. Innocent's dream, so decisive in his approving the order, was captured memorably by Giotto in his cycle for the life of Saint Francis in the upper basilica of San Francesco in Assisi, where he was painting from about 1291 to 1292 (fig. 32).[10]

All they wanted, Francis said, was to live in evangelical poverty, by a simple Rule "written with a few words, and making use above all of the texts of the Gospel." What Francis actually meant by this was a form of literal imitation more radical than the Curia imagined. Francis and his band of "little brothers" were nevertheless approved.

9. A translation of the Rule of Saint Francis in both the version of 1221 and that of 1223 is in *St. Francis of Assisi: Writing and Early Biographies*, ed. Marion A. Habig (Chicago: Franciscan Herald Press, 1975), 27–64.

10. Bonaventure's *Legenda maior* (1263), in which this story is most fully recorded, is translated in Habig, *St. Francis of Assisi*, 627–788.

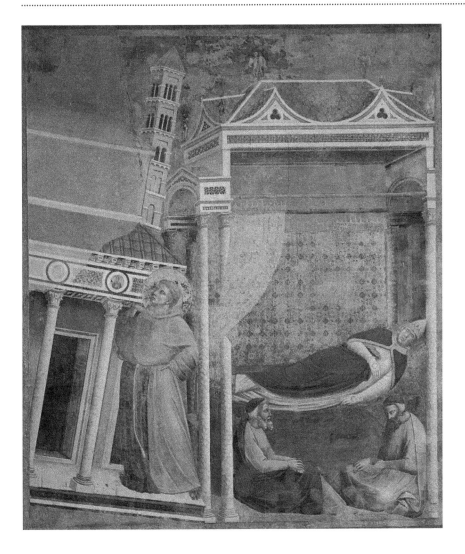

Figure 32. Giotto, *Dream of Innocent III* fresco, San Francesco, Assisi, ca. 1298

Within thirty years they had spread over much of Europe, everywhere evangelizing, preaching wherever a crowd might be gathered, teaching in the local dialect, composing and performing accessible vernacular hymns, songs, and plays. Though their ministry was originally itinerant, by mid-century they had a vigorous presence in specific parish churches in major urban centers such as Siena and Florence, where they were often far more popular than the regular clergy. The dedication of the Franciscans to living in poverty, supported only by what people would give them, was part of their initial appeal. They espoused a life of poverty, they said, just because Christ and his disciples had lived in itinerant poverty. More appealing still was their emphasis on the "life of the gospel" as one of joy

and liberty, unconstrained by the obligations of property and possessions. The contrast with some of the more affluent clergy was welcome. Joyous exuberance characterized their distinctive worship, which overflowed from the Mass into private devotion and public, charismatic praise in a language everyone understood.[11] Their emotional engagement with the sources of faith proved infectious, even when it progressed to a desire to "imitate" Christ not only in purity of life but also in identification with his suffering. Succinctly, for the first Franciscans, holiness was "life in Christ," all or nothing. Their forms of meditation featured prominently a contemplation of the passion and equally prominently an emotional engagement with the entirety of the Gospel narrative. For artists, this was to prove inspirational.

Meditations on the Life of Christ

Somewhere in Tuscany in the early second half of the thirteenth century, an anonymous Franciscan (his name is given in one manuscript as Joannes a Caulibus, "John of the Cabbages"—probably a pseudonym) wrote a very free Gospel paraphrase entitled *Meditations on the Life of Christ* in the vernacular Italian of his region. It didn't stay there. Hundreds of manuscripts of this text were produced (nearly 250 have survived), mostly in Italian or French vernacular, but some in Latin, even a few in English. More than twenty have episodic pen drawings of the Gospel narrative to accompany the text.[12] When we look at the style and manner of this book, we can immediately see why the Franciscan style was so attractive to artistic temperaments as well as the general laity. The text begins by identifying its audience: "The heart of one who wishes to follow and win Him [Jesus] must take fire and become animated by frequent contemplation: illumined by divine virtue, it is clothed by [human] virtue and is able to distinguish false things from true. Thus it is more the illiterate and simple

11. The *laude* (songs of praise) were produced not only by well-known poets such as Guittone d'Arezzo and the Franciscan Jacopone da Todi, but also by anonymous poets associated with confraternities of layfolk and the Third Order of Saint Francis. An edition of some of the best is by Giorgio Varanini, *Laude dugentesche*, Vulgares Eloquentes 8 (Padua: Antenore, 1972).

12. *Meditations on the Life of Christ: An Illustrated Manuscript of the Fourteenth Century*, trans. Isa Ragusa, ed. Isa Ragusa and Rosalie B. Green (Princeton: Princeton University Press, 1961). Hereafter, page references from this work will be given in parentheses in the text.

people who have recognized in this way the greatness and intensity of divine things" (3). The immediate exemplar in the path to union of the soul with God is none other than the *poverello* of Assisi, Saint Francis: "Do you believe that the Blessed Francis would have attained such abundance of virtue and such illuminated knowledge of the Scriptures and such subtle experience of the deception of the enemy and vices if not by familiar conversation [and] contemplation of his Lord Jesus? With such ardor did he change himself that he had become almost one with Him . . . and when he was finally complete and perfect in Jesus, by the impression of the sacred stigmata he was transformed into Him" (3). On this model, one does not read the Gospels for information about the teaching and miracles of Jesus merely, but imaginatively meditates on the stories ("contemplates") for the sake of a profound identification and spiritual transformation—literally an *imitatio Christi* (cf. 317).

The text of the *Meditations* begins with the story of the incarnation, namely, with the annunciation to Mary, which is, after the passion, the most important Franciscan feast (March 25) and subject in their art.[13] We learn that the Virgin herself was "best informed in the laws of God" and "best read in the verses of David," a projection based on the life of the Virgin found in the second-century apocryphal Protevangelium of James rather than in the canonical book of Luke.[14] However, the language of the *Meditations* came to influence Marian iconography in this period even more than that early legendary life.

Meditation "on the life of Christ" is the proper subject of this remarkable book, and it is with Christ that the book is most concerned. How should one meditate on Christ? With the assistance of Bernard of Clairvaux, his most consistently quoted medieval author, the author says that everything pertaining to Christ in the Gospels and elsewhere in Scripture can be divided into *three spheres* for contemplation: "of the humanity of Christ, of the celestial court, and of the divine majesty" (262). The student of medieval Christian art might usefully envision here the spheres of wall painting, altarpiece painting, and the relief sculpture found on facades and over the doors of cathedrals as well as in apse mosaics. But subtending this first distinction is another concerning the *two types* of contemplation, also borrowed from Saint Bernard, who with his fellow

13. The Franciscans made the Feast of the Annunciation a primary feast of the order at its "general chapter" meeting in Padua in 1263.

14. Protoevangelium of James, trans. Alexander Walker, in *Ante-Nicene Fathers*, vol. 8; see also, Frank Crane, *The Lost Books of the Bible* (New York: Alpha House, 1926), 16–24.

Cistercians is the link between Benedictine spirituality (e.g., Bede and Suger) and the spirituality of the Franciscan Order. Here precisely, in Bernard's words quoted by the *Meditations*, is the charismatic heart of what we now refer to as "Franciscan spirituality": "On this Bernard says in the 49th [sermon on the Song of Songs], 'There are two heights of blessed contemplation: the one in intellect and the other in affection; the one in light and the other in fervor; the one in action, the other in devotion. The chief is surely affection, and a breast warm with love and the infusion of holy devotion and the great spirit filled with zeal, or great fervor, are reputed, not perfectly, however, to be from the wine cellars'" (262–63). The necessary commencement for his reader, says our friar, indispensable to the rest, is to go to the wine cellar first—that is, to "first meditate on the humanity of Christ."

What traditional altarpiece painting in the Byzantine manner had before now most stressed is intellectual contemplation of divine glory in eternal splendor. Meditations focused on "the celestial court," as in the Maiestà altarpieces of Duccio and Cimabue or the portal mosaic of Santa Maria Maggiore, or in the contemplation of the majesty of God in *pantocrator* mosaics of Hagia Sophia and Ravenna, had been the dominant subjects of iconic representation. Not any longer. The insistence on the humanity of Christ as primary and antecedent focus introduces us to a new dimension in medieval religious art, a *cosa nova* in conception, not merely in style.

A New Dimension

Neither the Franciscans nor the artists inspired by them rejected the traditional emphasis in preaching and ecclesiastical painting of the Christ as the "King of kings and Lord of lords" (Rev. 19:16; 17:14). They simply saw another element of salvation history as more immediately compelling, namely, that the king of the universe had come to his world in an astonishingly humble way, content to be born to a poor peasant family, to be nurtured in plain village life and manual labor, to seek no worldly palace or kingdom but rather to make friends and disciples of simple fishermen, greasy tax collectors, and women of indifferent reputation. This basic fact—so obvious in the Gospels themselves—burst upon their imagination like a supernova. Suddenly the biblical stories, filled with the very human motives, attributes, and aspirations of flawed men and women such as themselves, were revealed as the actual locus of the good

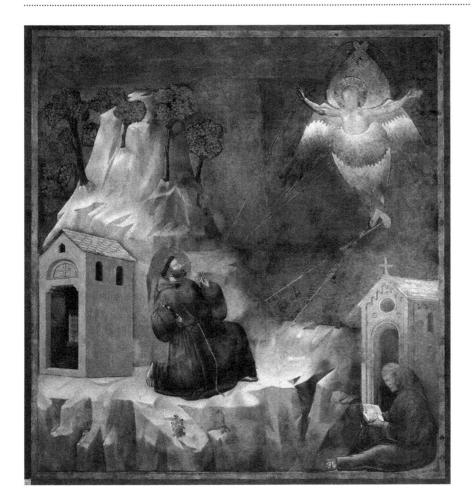

Figure 33. Giotto, *Stigmata* fresco, upper basilica, San Francesco, Assisi, ca. 1299

news. God was made man! The actuality of it had been almost eclipsed by eschatological anticipation of the reign of Christ in heaven. The Gospels were about this life too. The implications for Christian identity were enormous: the Gospel story became for whole communities "our story" in a wave of happy recognition. This happiness flowed over into song, poetry, and dance, as artists in various genres applied themselves to the Gospel stories with fresh enthusiasm. The new understanding of Christian life implied fresh conceptions of the holy, and indeed, of beauty.

Giotto was drawn directly into the Franciscan spiritual revolution right at its hub, namely, the church dedicated to Saint Francis in Assisi. In the upper basilica of this church are twenty-eight scenes from the life of the saint, drawn from the official biography of the order, by Bonaventure himself, in his *Legenda maior* (ca. 1263), and commissioned, it has been thought, by Fra Giovanni di Muro della Marea, general minister of

Figure 34. Giotto,
Annunciation fresco, Arena
Chapel, Padua, ca. 1308

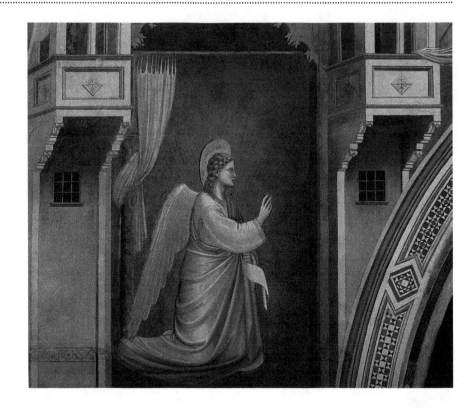

the Franciscan Order from 1296 to 1305.[15] The sparseness of records notwithstanding, most of the cycle is attributable to Giotto, though he had help from apprentice painters in various places, as in the final panel in the life-of-Francis sequence, which shows Francis receiving the *stigmata*, a miraculous outward sign of the inner reality of his life of *imitatio Christi* (fig. 33).

The two best cycles of Giotto's wall painting, though also in sadly worn and weary condition, are in the Bardi Chapel in Florence and the Scrovegni Chapel in Padua. In Padua, Enrico degli Scrovegni bought a property near the ruins of a crumbling Roman amphitheater (hence these frescoes are sometimes said to be from the "Arena Chapel"), next to which site a chapel was built, finished in 1305. Giotto, who may have been in Padua at the behest of the Franciscans, was asked to paint a "life of the Virgin"

15. According to Vasari in his *Lives of the Artists*, but supported also by Andrew Martindale, *The Complete Paintings of Giotto* (New York: Harry N. Abrams, 1966), 90. The influence of Bonaventure's text extended well beyond this period into the fifteenth century; see John V. Fleming, *From Bonaventure to Bellini: An Essay in Franciscan Exegesis* (Princeton: Princeton University Press, 1982).

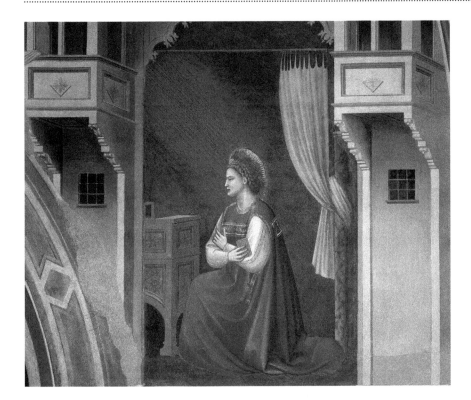

Figure 35. Giotto, *Annunciation* fresco, Arena Chapel, Padua, ca. 1308

(based largely on the apocryphal Protevangelium of James),[16] which, at the twenty-second scene, the Annunciation, introduces the life of Christ (figs. 34 and 35). Notable in this scene is how closely it reflects the descriptive language of the *Meditations on the Life of Christ.* Gabriel kneels in homage to Mary: "See . . . how the angel wisely and assiduously introduces and chooses his words, kneeling reverently before the Lady with pleasing and joyful countenance and fulfilling his embassy faithfully" (*Meditations,* 18–19). And then, right at the beginning of a very homely and peasant-like meditation on the life of Jesus and his disciples, there is a touch of the familiar regal and courtly manner (as we shall see, it will return). However, once we come to Giotto's *Baptism of Christ,* first of a series of fifteen in which Jesus is the central figure, we see in candid depiction only very ordinary people witnessing this event in the company of angels (fig. 36). Especially notable is Giotto's attention to the emotion registered in all the faces. In his *Marriage of Cana* one can almost read the thoughts of the

16. Despite the firm rejection of this life as noncanonical—for example, by the Gelasian Decretal (early sixth century)—it continued to attract attention and was distributed in manuscripts quite widely after the twelfth century.

Figure 36. Giotto, *Baptism of Christ* fresco, Arena Chapel, Padua, ca. 1305

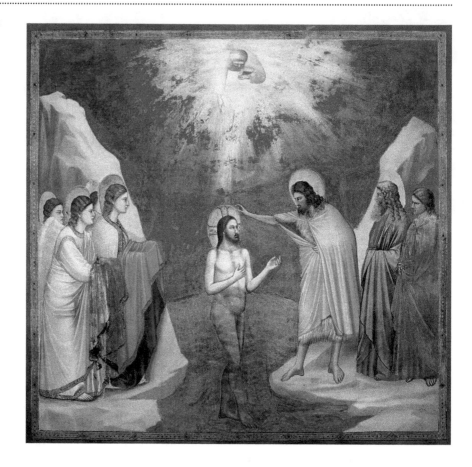

participants around the table; Jesus is attentive to the question of a serving girl, while the master of ceremonies (who clearly enjoys his job) is about to taste a wine the likes of which he has not dreamt (fig. 37).

Pent-up emotion explodes in the scene just below it on the wall, however, in which the disciples and Mary are stricken with a grief shared also by the angels swooping above them, dynamically "spun out" across the heavens (fig. 38). This is masterful work by comparison with anything in its time, and it compels the viewer's attention, even identification, at the affectual level.

Giotto's frescoes in the Peruzzi and Bardi chapels in Santa Croce, Florence, also commissioned by the Franciscans, include, respectively, remarkable depictions of Saint John the Evangelist having his vision on Patmos and of Saint Francis renouncing his possessions. These rival but do not surpass his work for the Scrovegni (Arena) Chapel. Taken together, Giotto's Arena Chapel series suggests that holy beauty is a gift of the Holy Spirit; in his *Pentecost: Descent of the Holy Spirit*, this is shown not in tongues of fire but

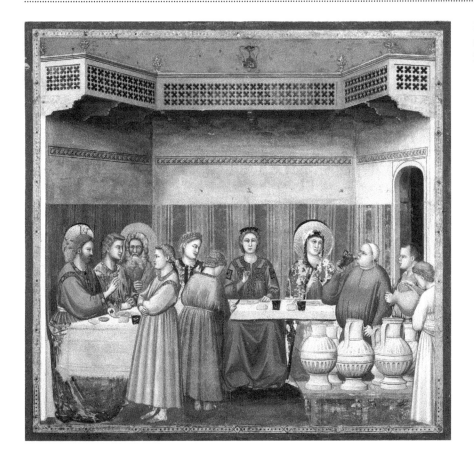

Figure 37. Giotto, *Marriage at Cana* fresco, Arena Chapel, Padua, ca. 1305

as a radiant effulgence of the divine light (fig. 39) producing in each holy life, in one way or another, an imitation of the beauty of Christ.

That this idea of imitation would lead, in these legendary lives of the Virgin, of Francis, and of other saints, to the introduction of nonbiblical or apocryphal parallels to events in the biblical life of Christ may strike us now as somewhat strained or artificial; the *Fioretti* has Francis being born in a stable and laid in a manger, having twelve disciples, and healing a leper. Mary's own "immaculate conception" and "assumption" into heaven, increasingly popular although at this point not yet official Catholic doctrine,[17] are likewise depicted in one way or another in this period,

17. These and other parallels are presented as facts in the *Fioretti*; the translation by Raphael Brown is in Habig, *St. Francis of Assisi*, 1269–1515. The immaculate conception of Mary and the assumption were hotly contested even at the Council of Trent, with neither becoming official teaching until 1854 (*Ineffabilis Deus*) and 1950 (*Munificentissimus Deus*), respectively.

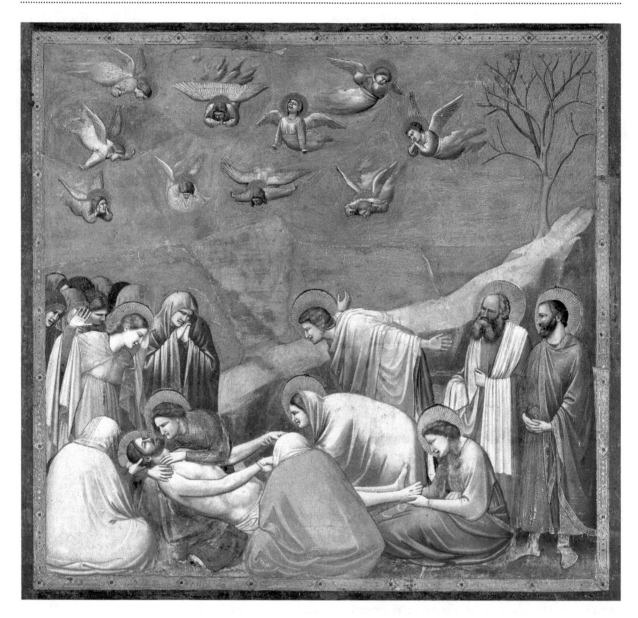

Figure 38. Giotto, *The Lamentation of Christ* fresco, Arena Chapel, Padua, ca. 1305

though not by Giotto.[18] In the broad arc of his extant work we can affirm the view of Georg W. F. Hegel in 1829, that the content of Giotto's painting indicates "the depicting of real people and the portrayal of actual personages, actions, passions, situations, attitudes, and gestures." We might

18. Giotto may have had a hand in the *Coronation of the Virgin* in the Baronelli Chapel in Santa Croce, Florence, and his workshop may be responsible for two versions of the *Deposition of the Virgin*, one in Ognizanti in Florence, also a Franciscan church (a panel now in the Berlin Staatliche Museum).

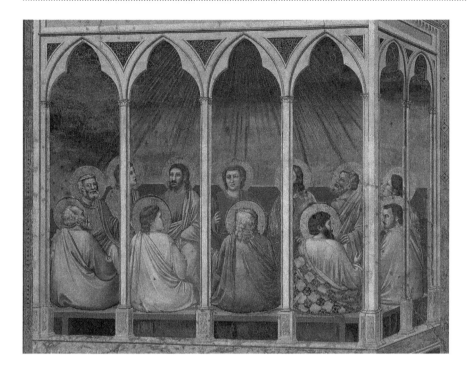

Figure 39. Giotto, *Pentecost: Descent of the Holy Spirit* fresco, Arena Chapel, Padua, ca. 1305

wish to modify Hegel's next sentence, but not by much: "This emphasis ... tended to obscure the element of grandiose and sacred austerity which had constituted the essence of all the best examples of art up to his own day."[19] What the alfresco painting of Giotto did accomplish above all is to make the events of the Gospel and the lives of holy saints both credible and beautiful to ordinary eyes, and not simply beautiful as art objects.

METAPHORS AND METONYMNS OF THE NEW LIFE

Giotto and Cimabue are linked by Dante in canto 2 of his *Purgatorio* in a disquisition by Odiersi de Gubbio on the ephemerality of artistic fame:

> Oh vana Gloria de l'humane posse!
> .
> Credette Cimabue ne la pittura
> tener lo campo, e ora ha Giotto il grido,
> se che la fama di colui e scura.

19. Hegel, *Vorlesung über die Aesthetik* (1828), quoted in Martindale, *Complete Paintings of Giotto*, 11.

(Oh empty glorying in human power!

. .

In painting it was Cimabue's belief
 he held the field; now Giotto's got the cry
 and Cimabue's fame is dim.) (*Purgatorio* 2.91–96)[20]

Cimabue (1250–1302) and Giotto (1267–1337) were Florentine contemporaries of Dante (1265–1321). All three were deeply affected by the Franciscan spiritual movement, and though Dante wrote no poem comparable to the painters' lives of Saint Francis, the praise of Francis put in the mouth of none other than Thomas Aquinas in *Paradiso*, canto 11, reveals Dante's reverence for Francis as an exemplar of Christian holiness (ll. 52–117). Thomas cites his being a lover faithful to his Lady Poverty, and calls attention to the very events in the saint's life depicted by Cimabue at Assisi and Giotto at Padua and in the Bardi chapel of Santa Croce in Florence. Dante would have known the frescoes in Santa Croce well, not least because of his own early attraction to Franciscan spirituality. There is good reason to think he was likely a Franciscan tertiary, and that when he was buried at Ravenna it may well have been in the tertiary's habit and cord.[21]

It was Dante, however, who gave to the burgeoning trecento revolution in style a name that applies as well to Giotto as to several of the finer vernacular poets and himself: *dolce stil nuovo*, the sweet new style (*Purgatorio* 24.49–63). In Dante's *Vita Nuova* (1295), a work in poetry and prose, writing of his beloved Beatrice ("she who blesses") becomes an occasion for describing in detail how poetry orders itself to Love, and how love, which is initially self-directed, comes, as it matures, eventually to love in a self-transcending way. Beatrice will reappear in Dante's *Paradiso*, as Love transcends poetry (i.e., Virgil) eternally, making possible a beatific vision of the source of all blessing. This, the greatest of all medieval Christian poems, beautifully exemplifies the new style. Vernacular and psychologically realistic, Dante's characters are from everyday life as well as from the storied past, and all are engaged in conversation, speaking naturally as they might in the world—whether among the redeemed or the damned.

Readers of the *Purgatorio* will know how important to Dante is the

20. Dante Alighieri, *Purgatorio*, trans. Anthony Esolen (New York: Modern Library, 2004), 121.

21. See Nick Havely, *Dante and the Franciscans: Poverty and the Papacy in the "Commedia,"* Cambridge Studies in Medieval Literature (Cambridge: Cambridge University Press, 2009); see also, Santa Casciani, ed., *Dante and the Franciscans* (Leiden: Brill, 2006), especially the essay by Giuseppe Mazzotta, "Dante's Franciscanism."

possibility of repentance, that he sees beauty in the process of recompense and remembered forgiveness, ascending through the beatitudes as far as the Earthly Paradise, "the divine forest rich and evergreen / whose branches cooled the brilliance of the dawn" (*Purgatorio* 28.2–3), leading thence to his reunion with Beatrice in canto 30. More accurately perhaps, this is to see repentance as restorative of a beauty that cannot be lost to the ravages of time. Donato di Niccoló di Betti Bardi, known as Donatello (1386–1466), who worked for the Franciscans in Santa Croce, made one of the most brilliant representations of this idea in his sculpture in wood of Mary Magdalene (fig. 40), for the Baptistry of the Duomo in Florence.

Donatello shows the Magdalene at the end of her (legendary) life, her body ravaged by time and perhaps also by disease consequent upon her supposed earlier life as a prostitute or courtesan. The body itself is brilliantly executed in all ugliness, yet as she touches her fingers together in a prayer of gratitude for her forgiveness, it is as though a great arc of transcendent holiness moves up through her decaying body and makes of her prayer the locus of a beauty far surpassing what she once possessed in her wanton youth. Here, too, is a metonym for the new life.

Fra Angelico (1382–1455), the Dominican friar whose majestic alfresco wall paintings adorned the cells of his Dominican convent at San Marco in Florence, is in many ways the premier inheritor of the "new style" in fifteenth-century Italy. His *Annunciation* (1450), found in the upper corridor at San Marco, captures in its visual simplicity, elegant structure, delicate color, and *sacra conversatione*, poised so precisely as Gabriel addresses the Virgin, the very essence of the *stil nuova* (fig. 41). "Here," as Dante might have said it, "begins the New Life."[22] Fra Angelico's alfresco depiction of the annunciation of the new life comes very close to being a visual metonym—even an epitome—of the beauty of holiness.

CONCLUSION

The profusion of wall paintings in Italian churches at the end of the thirteenth century marks a revolutionary moment in the history of ecclesiastical art. The energy and affection for the arts of the Franciscan movement provided a patronage for gifted painters such as Cimabue and Giotto, en-

22. *Incipit vita nova* are the words with which Dante begins his *Vita Nuova*, a reasonably good translation of which is by Barbara Reynolds, *Dante: La Vita Nuova* (Harmondsworth, UK: Penguin, 1969).

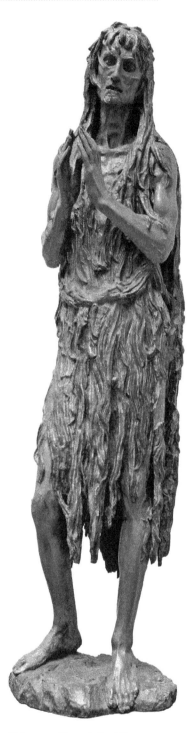

Figure 40. Donatello, *Mary Magdalene*, ca. 1455

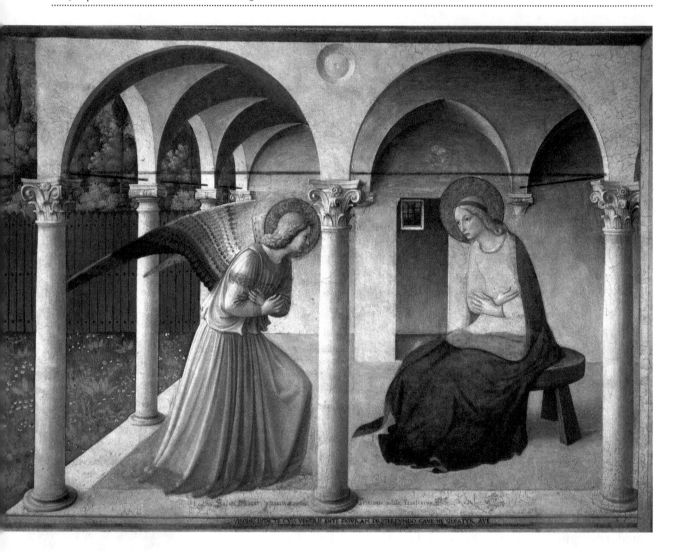

Figure 41. Fra Angelico, *Annunciation* fresco, San Marco, Florence, ca. 1440

couraging them to depict the events of the life of Christ and his disciples in the Gospels, as well as the lives of the Virgin Mary and Saint Francis, and to do it in such a way as to express the poverty and ordinariness of their lives with emotionally accessible realism. The face of the holy came to look much more like the face of a good neighbor, and beauty to find its home in exemplary deeds of self-transcending love. The legacy of these artists' work, like that of their compatriot Dante, was to be vital for developments in both poetry and painting in the Renaissance and early modernity.

6 BEAUTY ON THE ALTAR

. . . that the manner of our restoration might correspond to the manner of the fall.

BONAVENTURE

In the midst of tracking important ideas and their material expressions historically, it is sometimes helpful to step back and take a long view. If we could go back to the first three centuries of the church, we would see a rather unimpressive array of worship environments, including versions of sanctuary and altar almost as far removed from the splendid Gothic art and architecture of the late Middle Ages as from the Jerusalem temple that had been destroyed in 70 CE. They might not strike us as either beautiful or, in any obvious sense, holy. Worship in this era was forced back on its spiritual resources almost exclusively; vulnerable communities of believers were often necessarily peripatetic, and celebration of the Eucharist of necessity a movable feast. In retrospect, as historians have often felt obliged to note, this situation and its many adversities did not hinder but may in fact have helped in the growth and spread of Christianity.

Religiously, the loss of the temple and the sack of Jerusalem represented the greatest single rupture in Jewish worship tradition. Jews were scattered, and Christians, whose communities were born not in the temple but often in the synagogues, were soon scattered still farther. In their humble and often persecuted beginnings, Christian communities were poor, and because of their great emphasis on helping the poor with such resources as they could muster (2 Cor. 8:1–15), they had no imagination of their places of meeting as in any sense successors to the temple. Rather,

as the apostle Paul had written to the Corinthians, in place of the literal Jerusalem and the lost temple, Christians were encouraged to construe their own bodies as a "tent" or tabernacle and their communities as a people of God in transit (2 Cor. 6). The writer of the Epistle to the Hebrews makes it clear that the tabernacle, not the temple, was for the apostolic age the most relevant figure for comparison with their pilgrimage. Even so, explicit references to the tabernacle in the early apostolic writings are otherwise few, and the liturgical implements of the tabernacle, even the ark of the covenant as described in Exodus, are not much either allegorized or imitated by Christians before the third century. By this time, as we saw in Dura Europos (fig. 6 above), an aching communal memory of the lost altars and holy implements of temple sacrifice had apparently become a prompt to iconic representation among Jews of the Diaspora. The desire to "represent" in this sense is a desire for the presence of the holy, and for the awe that compels worship. As we shall see in this chapter, the search for a similar experience of the presence of the Holy, associated directly with the eucharistic celebration, adorned in a worshipful beauty of holiness, is what makes altarpiece painting such a focus in late medieval art.

Altars

As one might expect, the earliest Christian altars were by contrast with both their Jewish antecedents and Christian successors very simple. Remembering the ordinary table at which Jesus celebrated his last Passover with the disciples, believers used either wooden tables or portable box-like structures resembling them, since most often Christian eucharistic worship was conducted in private homes and the venue could be different from Sunday to Sunday, especially when there was still a danger of hostile interruption. In the outside world, however, elaborate marble altars and temples to pagan deities were everywhere to be seen, and were prominent in cities from Asia Minor to Greece and Rome. In the earliest New Testament reference to the Christian altar, Paul acknowledges the inevitability of invidious cultural comparison. He contrasts the "table of the Lord" (*trapēza kyriou*; *mensa domini* in Latin) with pagan altars such as his gentile converts had known well, calling them in distinctly unflattering terms "a table of devils" (1 Cor. 10:21). The early patristic writers in Latin began to use the generic term *altare*, from which we get our English word, to distinguish the *mensa domini* from *ara*, the term associated by them with pagan altars like those in the Roman temples of Venus and Mars, or

Figure 42. Altar in the crypt of Notre Dame de la Couture, Le Mans, France, sixth century

the magnificent marble *Ara Pacis* of Caesar Augustus. Among Christians, simple wooden altars continued in use well into the Middle Ages, and exclusively so until the sixth century, when gradually stone altars began to replace them in most of Europe. The model for these stone altars was most frequently the sarcophagi or tombs of the martyrs on which, in time of need, the Eucharist had been offered in the Roman catacombs during the first centuries, typically in the arcosolium, the open space adjacent to the smaller tombs and ledges called *cubiculi*.[1] The idea of offering the Eucharist on the tomb of a martyr was strongly symbolic, leading eventually to a decree that this practice should become universal in the establishment of new churches, each of which was to contain the tomb or at least a relic of a martyr.[2] Here too eschatological associations shaped the choice; Saint John in his vision had seen "under the altar the souls of them that were slain for the word of God" (Rev. 6:9). Celebrating the feast

1. A good account is available in Jeffrey Spier, ed., *Picturing the Bible: The Earliest Christian Art* (New Haven and London: Yale University Press, 2007), especially the essay by Robin Jensen, "Early Christian Images and Exegesis," 65–85; see also, Paul Corby Finney, *The Invisible God: The Earliest Christians on Art* (Oxford: Oxford University Press, 1994), 42–43, for a succinct statement of his general thesis, namely, that early Christians were not aniconic; and Hans Belting, *Likeness and Presence: A History of the Image before the Era of Art*, trans. Edmund Jephcott (Chicago: University of Chicago Press, 1994), which remains the best treatment of the Christian icon in antiquity.

2. The *Liber Pontificalis* attributes to Pope Felix I (269–274) a decree to the effect that Mass should be celebrated on the tombs of the martyrs (*constituit supra memorias martyrum missas celebrare* [*Le Liber Pontificalis*, ed. L. Duchesne (1886), 1:158]).

days of saints and martyrs had begun very early, and with it the naming of saints whose relics were under new altars as patrons of the local churches; this practice was already becoming normal by the fourth century. Still, before the sixth century, while reflecting this tradition, stone altars were not yet highly elaborate; one could still visually discern in them "the table of the Lord."

ROOD SCREENS

As we saw in chapter 2, by the fifth century altars of Christian churches or the apse wall above them began to have crosses, echoing a growing conviction that worship should, literally as well as figuratively, be under the sign of the cross. These apses were still open to the entire interior space, as in the basilica. By the later Middle Ages, when the eucharistic celebrant invariably faced the altar, itself at the eastern end of the sanctuary, he was in every overt visual as well as verbal sense thus made mindful of Calvary as the historical locus of the atonement. By the eleventh century, however, congregations were likely to have their mindfulness of the altar increasingly mediated through a more literal evocation of Christ's suffering and death, often through a lifelike crucifix surmounting the rood screen that separated lay worshipers in the nave from the altar. This move to a greater realism concerning the crucifixion of Jesus superseded the more symbolic "beautiful cross" of Augustine's era. While that innovation had been wonderfully helpful in bringing together the meaning of *kalos* as the moral good and *kalos* as beauty, it had become conventional, and to provide for an empathetic response to the "beautiful deed" of God in Christ at Calvary, greater realism was felt to be required, even though it must have seemed to many at first a difficult scene to ponder. The rood screen itself was an elaborate tracery of wood (less frequently stone or ironwork) that came to separate also the chancel and the choir, but it was employed especially to veil the mysteries of the altar sacrifice from the laity. Rood screens became common even in smaller churches. Parishioners stood in the nave during the Canon of the Mass, listening while the clergy performed the eucharistic sacrifice, perhaps peering through the tracery to catch a glimpse of the altar or an altarpiece painting (fig. 43).

A brief Middle English poem from a thirteenth-century manuscript entitled *Speculum ecclesiae* (A mirror [or glass] for the church) seems to capture imaginatively the meditative reflections of one such worshiper, perhaps as he might have experienced them at vespers (late afternoon prayer):

Figure 43. Rood screen in Sheepstor parish church on Dartmoor, England

Nou goth sonne under wode;
Me reweth, Marie, thi faire rode.
Nou goth sonne under tre;
Me reweth, Marie, thi sone and the.[3]

Four lines here nicely capture a great medieval theological paradox, namely, that the joy of human redemption was mixed with deep sorrow, especially for Mary herself.[4] Juxtaposing an element of natural beauty—the sun setting slowly behind a "wood" or forest—with the poet's imagination of the beauty of Mary's countenance ("rode" in Middle English can also mean "face"), his poem prompts a sudden flood of sorrow or pity (*reweth/rewen*, from Old English *hreowen*) rather than just awe and rejoicing in the forgiveness made possible through the cross. The second two

3. Anne Savage and Nicholas Watson, *Anchoritic Spirituality* (New York: Paulist, 1991), 155. The text is from Carleton Brown, ed., *English Lyrics of the XIII Century* (Oxford: Clarendon, 1932), 165–66.

4. The Five Joys of the Virgin Mary, later Seven Joys, were a later medieval devotional aid, with the Five Joys appearing in the Pearl poet's *Sir Gawain and the Green Knight* in the fourteenth century, and the "seven" format in prayers more commonly in the fifteenth century. See G. Schiller, *Iconography of Christian Art*, vol. 1 (London: Lund Humphries, 1971), 52. The feast of Our Lady of Sorrows was originated by a provincial synod of Cologne in 1423 as a response to the Hussite reformers, adding the parallel motif of Seven Sorrows; but this was not common outside of northern Europe before the sixteenth century, and is distinct from the Five Sorrowful Mysteries of the Rosary.

lines of the quatrain tell us why the speaker himself experiences both joy and sorrow simultaneously. At the literal level, a superficial reader might take the third line for a repetition of the first, replacing the forest (plural) with a singular metonymic tree. But that singularity is of course the point of the poem; it is the cross on Calvary that our anonymous poet means to be his deeper subject, but he makes that indirect, concluding in his final line: "I pity, Mary, your son and you." Rood screens notwithstanding, the cross had not disappeared from the actions of the altar; it and the sacrifice were merely filtered, at least in part to set apart the altar space as the "holiest of all." The English homonym by which the "sun" setting through and beyond the woods and the "Son" who dies on the tree gathers resonances, of course, from many sources. These associations are fused in the church's liturgical memory of the three hours on Good Friday when the sky grew so dark it was almost as though the world stopped turning. Recollection of that darkness calls up a spiritual reality Christians of many places and periods have often found deeply conflicting: the most sublime moment of salvation history occurs at just that moment when the self-offering of divine glory is almost eclipsed, as it were, by the ugliness of human cruelty.

It may be that the "rood screen" suggested in this poem, likely a tracery of wood reminiscent of the autumnal branches of the wood through which the red sun sets in the west, was evoked in its role of veiling a worshiper's eyes from the terrible beauty of the sacrifice in which all humanity is implicated.[5]

ALTARPIECE PAINTINGS

Altarpiece paintings, that is to say, that medieval species of reredos that functioned as the backdrop for the altar and its vessels, came later than rood screens for the most part. Through the fourteenth century, when the influence of the Franciscan *Meditations on the Life of Christ* was peaking, the invitation to contemplation of the cross as if one was present at the event itself came to be regarded as an ideal spiritual preparation for the

5. It has been conjectured that such rood screens, more popular in England than anywhere else in western Europe, may owe their development to the iconostasis in the Eastern churches, which functions in a similar (though not identical) way; iconostasis and rood screen alike recall the veil in the tabernacle and temple separating the holy of holies and its momentous sacrifice on the Day of Atonement from the inner court of the people and the liturgies of daily Jewish worship.

Mass. Accordingly, the artisans who created rood screens and altarpieces still often made the suffering of Christ on the cross the center of visual focus, especially in larger multipaneled altarpieces. If we begin in this chapter with an apogee of this development, it may help us get a more immediate sense of the power of such painting for spaces of public worship.

Probably the most brilliant extant achievement in this northern style of altarpiece painting, the magnificent *Isenheim Altarpiece* of Matthias Grünewald,[6] actually came at the very end of the medieval period; it was painted between 1512 and 1516 for the Antonine Order hospital chapel in Isenheim, Germany. Making a striking use of chiaroscuro technique, using oil as well as tempera on exceptionally large wood panels, the painter has composed his complex altarpiece in such a way as to connect the sacrament of baptism, the messianic prophecies that come to their culmination in John the Baptist, and the sacrifice of the altar (fig. 44). John the Baptist is connected in iconography to the lamb because of his early identification of Jesus as "the Lamb of God who takes away the sin of the world" (John 1:29). The lamb at his feet in this depiction bleeds into the chalice of the altar reserved for sacramental wine, a symbol for the identity of Christ's body and blood with the elements of the Eucharist. But John the Baptist's role as forerunner of the Messiah is likewise figured here, not just in his rough camel-hair garment but also in painted Latin letters from the same text, "*Illum oportet* . . . It is fitting that he must increase and I must decrease" (John 3:30 Vulgate).

The left wing depicts Saint Anthony, the patron of the order and hospital for which the work was done; the right panel depicts Saint Sebastian, a patron for those who suffer slow death. We see that the center panel is the familiar scene at Calvary, but in its graphic realism it is executed in such a way as to maximize an emotional response. Nothing is screened or softened; this is very much in the tradition of Franciscan-inspired invitations to contemplate the sufferings of Christ in a more immediate way. This is not the beautiful cross inspired by Augustine in the late fourth century, but a far more graphic depiction of the reality.[7] It is a beautiful rendering of what to other than eyes of faith could only seem ugly. As we

6. His actual name was Matthais Gotthart; the name by which his work continues to be known was ascribed in error by an early modern art historian.

7. An account, with pertinent medieval sources, may be had in David Lyle Jeffrey, *The Early English Lyric and Franciscan Spirituality* (Lincoln: University of Nebraska Press, 1975), 54–64. By 1670, an order of the Holy Office (September 11) forbade such graphic images of the crucifixion, and it seems the fame of the Isenheim altar was a specific prompt to the decree.

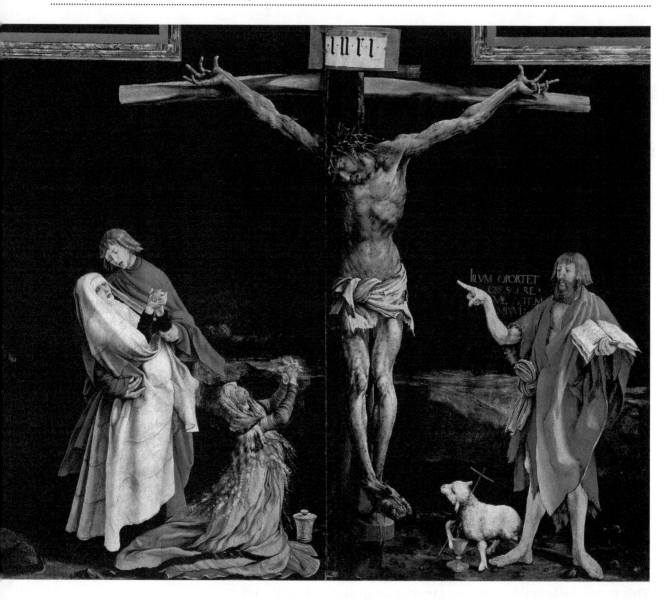

Figure 44. Matthias Grünewald, *Isenheim Altarpiece*, wings closed, central panel, ca. 1515

shall see in later chapters, the incongruity by which the ugliest of deaths becomes charged with transcendent Beauty in Grünewald's crucifixion panel would haunt artists in the modern period who thought they had left Christian faith behind.

Likewise, we are overtly reminded of the sorrows of Mary, dressed here like a nun or nursing sister in white habit, being comforted by the disciple John. At the foot of the cross, kneeling, is the forgiven Mary Magdalene. Her alabaster jar of ointment (bearing the date 1515) is placed by the cross as a "sweet savor," reminiscent of the narrative in Matthew's

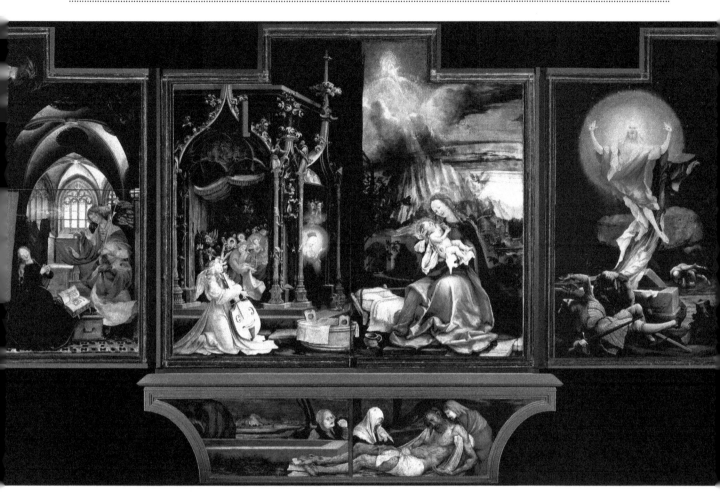

Gospel where a woman (almost universally then associated with Mary Magdalene) pours out a very expensive quantity of perfume on Jesus's head, provoking the disciples to complain about wasting resources that might have gone to assist the poor. Jesus's reply in that text associates her action of sacrificial love with the beauty of a holy sacrifice, especially his own: "Why do you trouble the woman? For she has done a beautiful thing to me. For you always have the poor with you, but you will not always have me. In pouring this ointment on my body, she has done it to prepare me for burial. Truly, I say to you, wherever this gospel is proclaimed in the whole world, what she has done will also be told in memory of her" (Matt. 26:10–13 ESV). The scene of Christ's burial at the foot of the composition ensures the viewer's explicit connection of the beauty of her sacrifice with the terrible but holy beauty of Christ's death on the cross and, indeed, the preparation of his body to be laid in the tomb (cf. Matt. 26:12).

Figure 45. *Isenheim Altarpiece*, wings open

In multipaneled altarpieces the crucifixion scene might, as in this case, be surrounded by depictions of other elements of the salvation narrative, to which the scene at Calvary is nonetheless the "centerpiece." In Grünewald's masterpiece, there is a second level (and a third), visible only when the first-view panels are folded out of the way. In this second view (fig. 45), beginning on the left with the annunciation, are subsequent events of a contrasting character, joy after sorrow; the rejoicing of the heavenly court and the glory of the resurrection of Christ are included. The faces of Gabriel and Mary in the annunciation panel are beautiful, as are the faces of Mary and her child, face-to-face, deeply gazing, in the center panel. Though brilliantly executed, these conceptions are otherwise mostly traditional; Grünewald's resurrection panel, however, is stunningly original. Much like the anonymous Middle English poet mentioned earlier, playing on the pun in German (as in English), though to quite different effect, he shows us the glory of the risen Savior juxtaposed with the *rising* of the sun, echoing the words of the prophet: "To you who fear my name the Sun of Righteousness shall arise, with healing in his wings" (Mal. 4:2). The face of the rising Christ is beautifully painted, radiant with holy joy, to which the sun itself has become the expected nimbus; the usual dark hair and olive skin of the crucified Lord are transfigured in his resurrection glory, shining like the sun. It may be that the emphasis given to the resurrection in this altarpiece owes in part to the painter's known interest in Luther's writings,[8] but whatever his inspiration, the effect of his juxtaposition is revolutionary in its capture of the gospel as "good news." Grünewald's second set of panels thus balances the dolorous centrality of Christ's sacrifice with the promise of a new day dawning as a result of it.

By the fifteenth century, the centering of the cross in an altarpiece was not any longer the universal pattern. In this respect alone the *Isenheim Altarpiece* is by its time something of an exception to late medieval fashion. Sometimes the cross, though still the most powerful and pervasive symbol for Christianity, and prominent when surmounting the rood screen, had come to be represented more tacitly in altar paintings, or, though literally absent, made present by other elements of the story of human salvation. In the large *Ghent Altarpiece* of the van Eyck brothers Jan and Hubert, painted for Saint Bavo in Ghent about 1432 (fig. 46), the

8. Reiner Marquardt, *Mathias Grünewald und die Reformation* (Berlin: Frank & Timme, 2009). Given the date, it seems to me more likely that the theme of the glorious resurrection draws on sources such as the Brethren of the Common Life and Devotio Moderna.

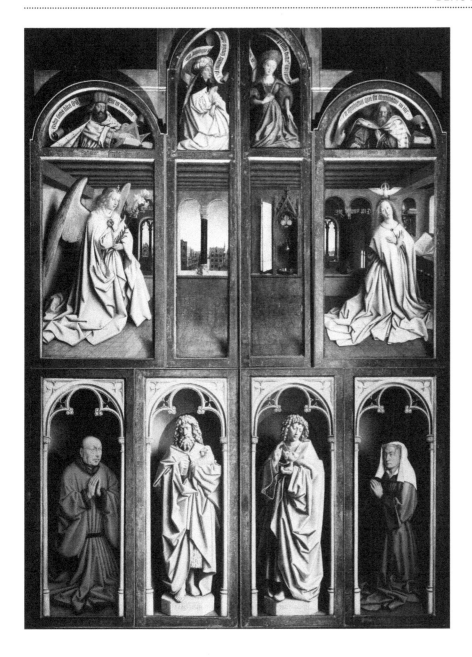

Figure 46. Jan van Eyck, *The Ghent Altarpiece*, closed state, Saint Bavo Cathedral, Ghent, Belgium, 1432

cosmic love expressed historically by the cross is evoked more gently in the closed panels.

When the panels are opened, we see an eschatological future vista (fig. 47). In all such biblical-narrative-based altarpieces,[9] it is God's love

9. Altarpieces by the late fifteenth century were being painted also by and for members

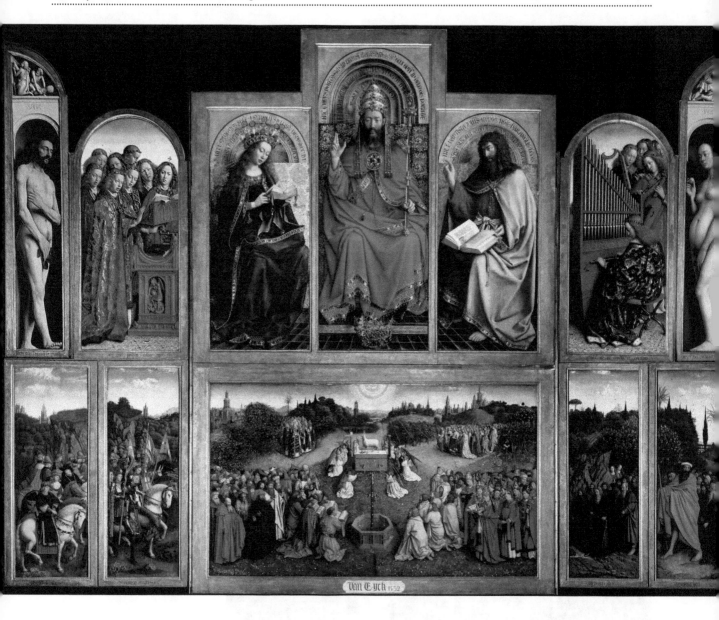

Figure 47. *Ghent Altarpiece,* open view

that centers the meaning of past but also future history; the sacrifice of the altar, the images say, in effect, is perpetual and eternal. Thus, in the ancient hymn of Prudentius, one sings "of the Father's Love begotten, / ere the worlds began to be" (cf. John 3:16) but with a specific reminder that

of new devotional lay movements, and they often took on a different aspect than most of those designed for churches. One of the painters whose altarpieces featured quite esoteric and nonbiblical scenes was Hieronymus Bosch.

the love focused in the cross is neither the beginning nor the end of the story, in that Christ "is Alpha and Omega / He the source, the ending he."[10]

> Corde natus ex parentis, ante mundi exordium
> Alpha et O cognominatus, ipse fons et clausula
> Omnium quae sunt, fuerunt, quaeque post futura sunt.

> (Born of the Father's love before the world's beginning,
> Alpha and Omega named, he is both the source and the end
> Of all things that are, were, or yet shall be.)

By the same token, in the *Ghent Altarpiece* the glory of God is depicted as "the glory of the only begotten Son of the Father, full of grace and truth" (John 1:14), now seated forever in eternal majesty, surrounded by worshiping angelic choristers and musicians, who sing "evermore and evermore" his praises. The outermost top frame shows us ourselves reflected "in Adam," under a faux relief carving of the sacrifice of Abel. That is, we are asked to see the story of human redemption in the context of our desperate need for it: Adam and Eve are ourselves, naked, ashamed, and sorrowful.

The late medieval altarpiece is typically, in one way or another, textually mediated: here the inscriptions surrounding the supreme figure of the Deity are both biblical and doctrinal: "*Rex regum, Dominus dominantium*" (King of kings and Lord of lords) is an anthem of the heavenly host as well as of the redeemed souls (1 Tim. 6:15; Rev. 17:14). John the Baptist holds a Bible open to Isaiah 40: "Comfort ye my people," since that chapter (e.g., vv. 6, 31) was taken by medieval exegetes to anticipate John's role in announcing the Messiah. The writing over Mary was altered more than a century after it was first painted, to refer to her immaculate purity (rather than, as originally, from Isaiah 7:14, to her virginal conception of Jesus). But in the lower panels the text is straightforwardly biblical: the adoration of the Lamb (Rev. 5) is the central composition of this polyptych

10. Aurelius Clemens Prudentius (348–413), cited also in the previous chapter (n. 3), was a Roman Christian poet, author of many magnificent hymns, some of which are still sung. "Corde natus ex parentis" is an extract from one of these. Cf. Prudentius, "Of the Father's Love Begotten," in *An Annotated Anthology of Hymns*, ed. J. R. Watson (Oxford: Oxford University Press, 2002), 18. Latin text in *Prudentius*, ed. H. J. Thomson, 2 vols., Loeb Classical Library (Cambridge, MA: Harvard University Press, 1949), 1:77–85. For a recording, see "Of the Father's Love Begotten," Concordia Theological Seminary Fort Wayne Kantorei, 1998, https://www.youtube.com/watch?v=7mkUAk94ThI.

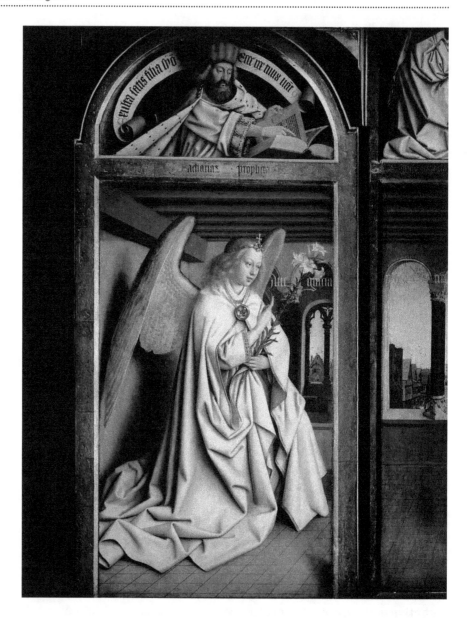

thematically. On the altar is written John 1:29: "Behold the Lamb of God,
which takes away the sin of the world." Above this to the left is "*Ihesus
via,*" to the right "*vita, V[er]ita[s]*" (John 14:6). The foreground fountain
quotes from Revelation 22:1, "a pure river of water of life, clear as crystal,
proceeding from the throne of God and of the Lamb," the same source
and crystal river as we encounter in the poem *Pearl.* The buildings are
meant, as the palm tree indicates, to suggest the heavenly Jerusalem. The
groups of personages that surround the altar, adoring the Lamb, include

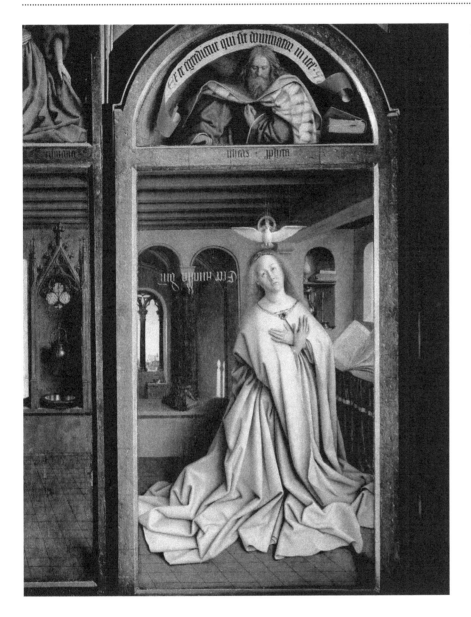

Figure 49. *Ghent Altarpiece,* closed state, right panel

the just judges, the holy warriors (martyrs), the holy recluses and holy pilgrims—metonymically, those who have given their life for Christ. In this sense the fourfold gathering is an eschatological *speculum ecclesiae,* a mirror of the faithful church of all the ages.

The scene was evidently intended by the artists to be one of compelling beauty, for, as an altarpiece, it would frame the daily presentation of that greatest and most holy beauty for which the Eucharist itself is the *symbolum.* Thus, at the precise center of this visual program, to remind

us of that which makes a living church possible, we see once again an arresting image of the Lamb with its lifeblood flowing into the eucharistic chalice: "Behold, the Lamb of God who takes away the sin of the world. Come, taste and see that the Lord is good," are the familiar words of the liturgical invitation to the faithful drawn from John's Gospel (1:29). Here, in stark verisimilitude, is the great sacrifice represented spiritually and liturgically, acknowledging human salvation's steep price, the immeasurable suffering of the blameless and holy Son of God.

But this is not, of course, in every season the view that meets the eye. With the altarpiece wings closed, as would be the case through Lent and Passiontide, one would see rather the artists' depiction of the annunciation, Gabriel appearing to Mary, within a multipanel frame in which they are surrounded by messianic prophets both classical and biblical (figs. 48 and 49).

This "outer" subject is, in fact, the most common of late medieval altarpiece subjects, conjoining the proclamation of the good news of the incarnation with the preaching of the gospel, and the van Eyck brothers' treatment here is in many ways typical. Beneath the prophet Zechariah, who cries out, "Rejoice greatly, O daughter of Zion; shout, O daughter of Jerusalem: behold, thy King cometh unto thee" (Zech. 9:9), the angel Gabriel seems to go down on one knee. This courtly gesture appears first in the Franciscan *Meditations on the Life of Christ*,[11] but visually it was copied almost immediately by Giotto in his *Annunciation* for the Arena Chapel. Here in the van Eyck work, Gabriel bears a lily (symbolic of the Virgin's purity), but holds it out to her in such a way as to evoke the idea of a romantic gift and courtly beseeching; in effect, he is making a kind of marriage proposal.[12] Gabriel's greeting, "Ave gratia plena, D[omi]nus tecum," from Luke's Gospel (1:28), is only the first part of his high compliment, "Hail, highly favored one" (Greek *kaire kecharitomenē*). Notably, this term, both in Greek and in its Latin equivalent (*plena gratia*), is also such an expression as might be used in a courtly address by a suitor to a lady who is the object of his or his master's desire. It suggests that Mary is being sought as a bride, and that she is all the more attractive to her suitor because, as the text of Psalm 45 (read as a messianic portent) says, she is "all glorious within" (v. 13). Interestingly, in the commentary of Saint Bonaventure on the annunciation narrative in Luke, Mary

11. *Meditations on the Life of Christ: An Illustrated Manuscript of the Fourteenth Century*, trans. Isa Ragusa, ed. Isa Ragusa and Rosalie B. Green (Princeton: Princeton University Press, 1961), figs. 12, 13.

12. The term employed by the *Meditations* to describe Gabriel is *paranymphus*, a Latin word meaning something like "best man" in English or *garçon d'honneur* in French.

is represented as externally beautiful as well, "exceedingly comely with an incredible beauty . . . in the eyes of all, gracious and loveable."[13] This characterization of the Virgin as a beautiful queen or princess seems to have begun in earnest with Saint Bernard in his allegories of the Song of Songs, notwithstanding his reputation for being an opponent of art in the sanctuary.[14] Allegorical readings of the Song of Songs applied such verses as "*Tu es pulchra, amica mea, et sine macula*" ("You are beautiful, my love, and there is no spot in you," Song of Sol. 4:7) to the Virgin Mary, with Christ or God the Father as the speaker. The Franciscans picked up the theme energetically in poetry and in painting, and made it into a topos in late medieval art.[15]

When we consider the visual and verbal framing of the Ghent *Annunciation*, we see that over the large, discreet, empty space between Gabriel and the Virgin, probably also copied from Giotto's representation, are two sibyls from classical mythology: on the left the Erythrean Sibyl paraphrases Virgil's *Aeneid* to suggest that Gabriel's words are not merely such as medieval people could associate with a noble courtship, but indicate that the angel makes a divine proposal. "Not offering human words, you are inspired by a divinity on high" (cf. *Aeneid* 6.50). The Cumaean Sibyl, for her part, quotes Augustine's *City of God* (18.23) to say "Your king of future centuries is coming in the flesh." Both of these phrases that "seers in old time, chanted . . . with one accord," as the hymn of Prudentius has it,[16] serve to heighten our awareness that Gabriel himself is a suitor on behalf of someone far greater, a celestial king, and thus they provide extra resonance to the courteous manner of the angelic proposal. (Such intermediation by an emissary or courtier was a well-understood practice in noble courtship.) But that the proposal is clearly of "marriage" is reinforced by the artists' quotation of the messianic prophecy of Micah concerning the faithful daughter of Zion, "Out of thee shall come forth that one who is to rule Israel" (5:2).

13. Bonaventure, *Commentary on the Gospel of Luke*, ed. and trans. Robert J. Karris, OFM, 3 vols. (Saint Bonaventure, NY: Franciscan Institute Publications, 2001–2003), 1.1.47.

14. Bernard accepted the need of images to instruct the illiterate, but felt they were an improper distraction in places of monastic worship: "We who have forsaken all precious and beautiful things for Christ's sake . . . whose devotion do we intend to excite by such means?" From a letter to William of St. Thierry in 1124; translation from G. H. Cook, *English Monasteries in the Middle Ages* (London: Phoenix, 1961), 145.

15. See, e.g., Alexander of Hales, *Glossa in Quator Libros Sententiarum Petri Lombardi*, P. P. Collegi S. Bonaventurae, Bibliotheca francescana scholastica medi aevi, vols. 12–15 (Florence: Quaracchi, 1951–1957).

16. Cf. n. 10 above.

Mary has been found by the angel, as almost always she is in northern annunciations of this period, kneeling before a copy of the Scriptures (sometimes it is a book of hours); she is intentionally presented as a student of the Word of God.[17] Her hands crossed over her breast indicate iconographically her assent to the sacred proposal. But here too are painted the words the gesture signifies: *"ecce ancilla domini"* ("Behold, the handmaiden of the Lord"). As the Spirit—iconographically, the dove—then "overshadows" her, we note further that curiously the words of her response are painted upside down and written from right to left. These words are evidently intended neither for us nor even for the angel who has come "courting." They are positioned to show that her assent to the sacred proposal is directed upward to her Lord most Holy, the coming King. If we are literally to read and pronounce these words—as, according to Bonaventure and other medieval theologians, to participate with the bride in her joy we must—then our reading must be with the aid of a mirror. This feature too has a richly spiritual significance, for figuratively the mirror (Latin *speculum*) invoked is conceptually also the *speculum ecclesiae*, or the *speculum historiae salvationis*, each a verbal mirror or glass in which the church may read itself in the redemptive design of God. Only in this full reciprocal context, the polyptych suggests, can the meaning of the gospel be fully understood, and only by willed participation in the Virgin's prior assent can the viewer become authentically part of the great story.

There is much more to this altarpiece than meets the eye. Medieval biblical commentary on the narrative provides further insights critical to understanding this theme in sacred art. One is well represented by Saint Bonaventure's commentary on Luke: "Now this fruitfulness took place through *God's action*, the *angel's annunciation*, and the *virgin's consent*, so that the manner of our restoration might correspond to the manner of the fall."[18] Bonaventure quotes Saint Bernard, who had said: "It pleased God to reconcile humanity to himself in the same way and order in which he knew it had fallen." The point of both biblical commentators is clear: the sacred proposal to Mary is a deliberate counterpoint to the unholy proposal of the serpent to Eve; Mary's holy assent to the divine proposal is a counterpoint to Eve's unholy seduction by an infernal proposition.

Both early modern and modern painters have on occasion subverted this connection—as, for example, in the *Annunciation* by Lorenzo Lotto,

17. David Lyle Jeffrey, *People of the Book: Christian Identity and Literary Culture* (Grand Rapids: Eerdmans, 1996), 215–30.

18. Bonaventure, *Commentary on the Gospel of Luke*, 1.1.40.

with its overt and seamy analogy to one of the rapes of Jupiter.[19] An insinuated coupling of implied sexual violence with the holy scene is evident also in Dante Gabriel Rossetti's version of the *Ecce Ancilla Domini* theme (see fig. 95 below). Such subversion, intentional or otherwise, degrades the sacred proposal intended by Bonaventure and the van Eyck brothers by denying Mary's agency, her freely willed and gracious obedience, which the biblical writer and subsequent commentators scrupulously present in chaste, nonsexual terms.

In quite a different fashion than Lotto's or Rossetti's depictions imagine, the viewer who comes at Lent and Easter to view the inner panel of the *Ghent Altarpiece* knows that there will of course be dire as well as glorious consequences to Mary's assent in the unfolding story. The angel's beckoning hand points not to himself but to the cross, under which sign he serves. In the liturgy of the medieval church and in its iconography, the sacred proposal here exemplified is an invitation not only to participate in the most sublime of human joys, but also to identify intimately with the way of the cross. There are not only the joys of the Virgin to think of here, but also her sorrows. This is what consent means for the church, the bride of Christ, of whom Mary in these scenes is the preeminent exemplar. The point of the juxtaposition of outer and inner panels in the *Ghent Altarpiece*—the distinction between the view from outside, so to speak, and the view from within the church's story—is now clear. This is beautiful art about beautiful deeds; its purpose is to invite participation in those deeds. Then, though in this life still awaiting the final consummation and full revelation of God's purposes, by the mediation of both word and image the attentive viewer may know that "the Lamb slain before the foundation of the world" (Rev. 13:8; cf. Heb. 9:26) once came into human space by a beautiful consent, and, more ominously, that one day as the King eternal he is coming again on terms none may refuse. Regarding this final consummation of the full *mysterium magnum*, the artists would surely acknowledge with the apostle that we know now only in part, and not the whole, yet in the overall narrative of their *Ghent Altarpiece* they point unmistakably to the coming parousia, John's vision in Revelation, as an assurance that the grand design is already in substance knowable for those who have (spiritually speaking) eyes to see. In the theology illumined by this painting, the van Eyck brothers' contemporaries are beckoned by the angel's annunciation—his holy proposal—to assent to the way of the

19. Massimo Firpo, "Storia religioso e storia dell'arte: I casi di Iacopo Pantormo e Lorenzo Lotto," *Belfagor: Rassegna di Varia Umanità* 59 (2004): 571–90.

cross, a way presented as indispensable for one whose desire is for the beatific vision and ultimate union of the soul with God.

CHIVALRIC STYLE AND COURTLY DECORUM

If the high medieval altar, carved, articulated, and graced with artwork, seems a long way removed from the simple "table of the Lord" (*mensa domini*) of the early Christian house churches, the depiction of the Virgin Mary as the noble lady of a manor, possessed of her own Bible or book of hours, not as the simple and almost certainly illiterate peasant girl she was, is at least as distant from historical representation. Cultural accommodation to the dominant literary fashion of the time, the chivalric romance popularized in vernacular poems of the twelfth through fourteenth centuries,[20] invited other associations. The Franciscans were particularly engaged by the possibilities. Early on they began to refer to themselves as "knights of Christ"[21] and to include extended conceits based on this motif in their sermons. There is at least one reference in an English manuscript to a "*sermone de rotunda tabula*" (sermon of the round table), and the *miles Christi* (soldier of Christ) theme is invoked in numerous Franciscan poems in which the poets present themselves as "Christ's own knight," or employ imagery in which Christ on the cross is a "champion knight" jousting against Satan on behalf of mankind.[22] The *miles Christi* theme can press the analogy of the individual friar as knight, with Christ as the Supreme Knight, in ways that highlight the Franciscans' conception of their religious vocation as "conformity to the Suffered-Christ."[23]

> . . . swete ihesu, I am thy knight
> Against him [the devil] I take the fight,
> stifly him to oppose.

20. A. C. Gibbs, ed., *Middle English Romances* (Evanston, IL: Northwestern University Press, 1966), 6–14, offers a useful, succinct account of the characteristic features.

21. See, for accessible examples, Carleton Brown, ed., *Religious Lyrics of the XIV Century* (Oxford: Oxford University Press, 1970), nos. 66, 125; also Brown, *English Lyrics of the XIII Century*, no. 43. Cf. Jeffrey, *The Early English Lyric*, 199. See also, R. L. Greene, ed., *The Early English Carol* (Oxford: Clarendon, 1975), nos. 237, 238B, 239.

22. A. G. Little, ed., *Franciscan History and Legend in English Medieval Art*, British Society of Franciscan Studies, no. 19 (Manchester: Manchester University Press, 1937).

23. Bonifatius Strack, "Das Leiden Christi im Denken des hl. Bonaventura," *Franziskanische Studien* 41 (1959): 129–62.

From thee I must borrow my arms:
My shield shall be the sword of sorrow,
 Marie, that stung you in heart.

The holy cross my banner borne,
my helmet the garland of sharp thorn,
 My sword the scourges smart.

My armor plates shall the nails be,
my lance the spear shaft,
 that pierced your sweet side.

Now I am armed so well,
Never will I flinch or flee,
 Come what may![24]

Notably, the poet's armor here is not drawn from the conventional Pauline passage in Ephesians (6:11–18), but is an invention based upon the instruments of the passion and the sorrows of the Virgin Mary combined. In an Anglo-Norman (French) Franciscan lyric, Mary is the lady who arms her knight, Christ, in her chamber before he engages his adversary on the cross.[25] Mary turns out to be, in fact, a parallel focus for chivalric imagery in Franciscan art and exegesis, at least as characteristically Franciscan as sermons on the royalty of Christ (as Jean LeClercq has demonstrated) are by contrast predominantly Dominican.[26] With Mary, analogously, there can be an implied extension or suggested personal conformity for a female religious, encouraging her choice for vocation. The Franciscan Thomas of Hales, at the request, we are told, of such a young woman, composed his well-known "Love Ron."[27] The pose in this somewhat playful poem (ca. 1270) is that the "maid of Christ" in question has asked for a love rhyme that will teach her how to win a true lover (*soth lefmon*); our friar's response is to show the superiority of Christ to Paris, Aeneas, Tristram, and even King Henry, and of Mary to Helen, Dido, and Yseult. Where, he asks, can the young woman find such a *knyghte* (l. 144)?

24. Brown, *Religious Lyrics of the XIV Century*, no. 125.
25. David Lyle Jeffrey and Brian J. Levy, eds., *The Anglo-Norman Lyric: An Anthology* (Toronto: Pontifical Institute of Medieval Studies, 1990), 186–91.
26. Jean LeClercq, "Le Sermon sur la Royauté du Christ du moyen age," *Archives d'histoire doctrinale et littéraire du moyen age* 18 (1943–1945): 143–80.
27. Brown, *English Lyrics of the XIII Century*, no. 43.

None of these courtly tropes are more charged, however, than the chivalric language and iconography that flower in connection with the annunciation during the fifteenth century. There the imagery associated with Mary in Franciscan treatment of the incarnation is a consequence of specific Franciscan biblical exegesis and, in turn, liturgical celebration.[28] This joint foundation, as we shall see, is transmitted in Franciscan-inspired poetry and painting in which *haute courtoisie* establishes the tone and theological register. It connects also with the surge of private devotion to the Virgin after the twelfth century in which she becomes for the medieval Christian of any social class "Our Lady."

When Rogier van der Weyden painted the annunciation (fig. 50) for what is now known as the *Saint Columba Altarpiece*, or *Three Kings Altarpiece* (ca. 1420), he made the idea of a sacred proposal of marriage still more explicit—there is, in this church-like setting, a marriage bed, red for royalty and charity, with its gathered bed curtain a womb symbol, and a descending dove. But the words of his greeting, *Ave Maria, gratia plena*, transverse the angel's scepter, fusing thus the joyous proclamation with the further announcement that the cross lies ahead. When Mary extends her hand over the open page, an iconographic gesture signifying her response in Luke's Gospel, "Be it unto me according to thy word" (Luke 1:38), the viewer understands hers to be a consent with long-term consequences.[29]

FAMILY ALTARS

The existence of household altars and household images of deities is attested from ancient times; an example from the biblical narrative itself is found in Rachel's theft of household gods from her father Laban (Gen. 31:34–35). Christians in the early centuries knew of such customs among their own neighbors, and seem to have copied them, even to the extent

28. Bonaventure offers a good example of the exegesis, and under his direction the Feast of the Annunciation (March 25) was made a primary feast of the Franciscan Order in 1263, with liturgies attending.

29. An analogy with those consequences takes the form of frame for human consent to a covenant of marriage in the more famous van Eyck work *Arnolfi Marriage*, in which we see in the convex mirror the painter and another person bearing witness to the marriage vows; the mirror's frame is itself a series of scenes from the passion of Christ, almost as if in commentary on Paul's analogy between Christian marriage and the spiritual marriage of Christ and the church as his bride (Eph. 5:24–33; Rev. 21:9–27).

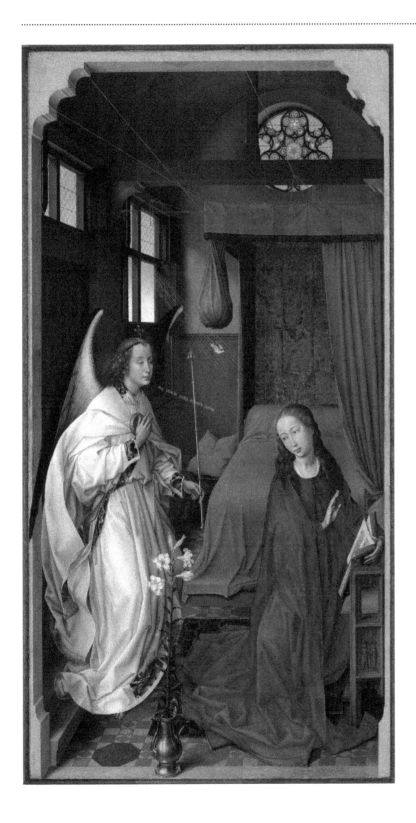

Figure 50. Rogier van der Weyden, *Annunciation* panel from the *Three Kings Altarpiece*, ca. 1455

of providing domestic altar paintings of a respected saint or bishop.[30] While there is less evidence of such practices among ordinary folk after the Constantinian freedoms made public assembly in a formal church both possible and desirable, there is increasing evidence from the age of Charlemagne forward (ninth century) that wealthier noble families would incorporate a chapel, even if a very small one, into their castles and grand homes. By the fourteenth and fifteenth centuries especially, this became a distinguishing mark of the pious well-to-do families of Europe, and also a practice of trade guilds and religious confraternities, who likewise often incorporated chapels and commissioned altarpieces for guildhalls and central meeting places.[31] Since the growing popularity of family altars coincided with the flowering of special devotion to the Virgin Mary tracing to Bernard and the Franciscans, it resulted in the production of some exceptionally high-quality smaller family altar paintings featuring Mary.

One of the best of these is a small work, generally but not certainly attributed to Robert Campin, or "the Master of Flemaille," painted for a private family about 1428, called the *Merode Altarpiece* (fig. 51). It is a small triptych, and visitors at the Metropolitan Museum of New York, where it now is, are often astonished to find it so much smaller than they expected. This owes, simply, to its being designed for a private family altar rather than for a church; the patrons are kneeling on the left looking at the scene of the annunciation, much as they would in their household chapel, while Saint Joseph, in his carpenter shop on the right, is seen fashioning a mousetrap.

Here we recognize several items of conventional iconography, as well

30. Saint Augustine, in his *De moribus ecclesiae cattolicae*, is troubled that many Christians reverence portraits of deceased family members and Christian leaders; Saint John Chrysostom expressed concern that the revered bishop Saint Meletus was featured frequently in religious portraiture that people seemed to treat as if it had spiritual powers; the apocryphal Acts of John the Evangelist explains how portraits of the apostle were made by his followers and displayed between candles on tables adorned with flowers. Eusebius, in his *Historia ecclesiastica*, claims that portraits of Christ and the apostles were made in their lifetime according to the manner for Roman emperors and likewise venerated; he likewise disapproves of the practice.

31. Confraternities, whether Third Order Franciscans, Dominican-sponsored Confraternities of the Rosary, or such groups as the Devotio Moderna and Brethren of the Common Life, were made up mostly of laypeople. These voluntary associations, as John W. O'Malley has observed, "provided many, perhaps most Catholics with their true spiritual homes, and were more important in their lives than the Parish church" (*Trent: What Happened at the Council* [Cambridge, MA: Belknap Press of Harvard University Press, 2013], 21; cf. 46–48).

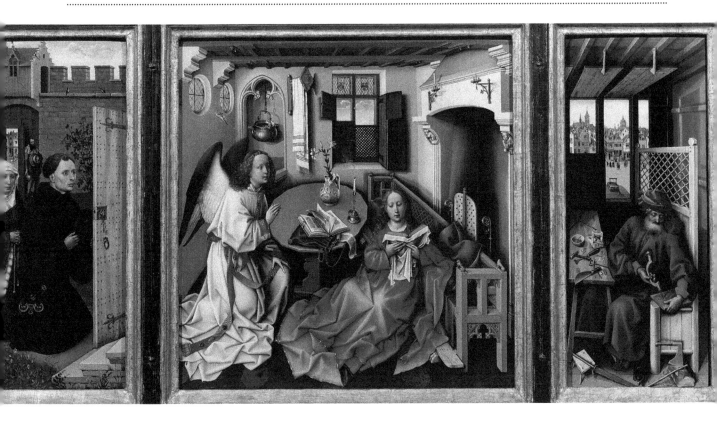

as several departures from convention. The room depicted, first of all, resembles more a common room in a university or an affluent home than a bedroom or church. The Virgin is a youthful but clearly scholarly reader; there are two large folio volumes, probably intended to represent the Law and the Prophets, and emerging from her book bag, perhaps here also a womb symbol like the brass kettle behind her, is her scrip of scholar's notes. A sign of her familial piety may be the white and blue cloth on its rack behind her, which is also strangely evocative of a *tallit*, a Jewish prayer shawl, and if we look closely at the vase on the table in which the virginal lilies are placed, we see what appear to be attempted Hebrew letters. Gabriel has yet to be noticed by the Virgin, though he has begun to kneel, and because the candle of the Old Law (Ps. 119:105) has just been extinguished by the angel's beating wings, she has begun to turn her eyes from the page she has been reading to the presence of the angel, a courtly page. The artist captures brilliantly that pivotal moment for salvation history as a split second in which, intent upon the Law, Mary is about to be surprised by grace. To one who has been found "full of grace," there now comes a unique confirmation of it, namely, the sacred proposal. Her love

Figure 51. *Merode Altarpiece,* ca. 1428

for the Word of God, figuratively the codex in her arms protected by a swaddling cloth (Latin *incunabula*), is an apt harbinger of her reverence and love for the Word now to be made flesh in the infant Jesus. This is not a fearful Mary, but one who, in the biblical sense of utter reverence, "fears the Lord." Long before this scene she has become *ancilla domini*, the handmaiden of the Lord.

For all the general orthodoxy of this family altarpiece, a theological novelty is occasioned by the miniature, cross-bearing *homunculus*, or fetus, coming in through the window, a fully formed though miniature presence of the second person of the Trinity. This oddity (more conventional would be the descending dove) is in the manner of some thirteenth-century Franciscan theological innovations that attempt to explain the nature of the incarnation and hypostatic union of divinity and humanity in Jesus. In the *Meditations on the Life of Christ* we read: "At that very point the soul was created and placed into the sanctified womb as a human being complete in all parts of His body, though very small and childlike. He was then to grow naturally in the womb like other children, but the infusion of the soul and the separation of the limbs were not delayed as in others. Thus he was a perfect God as well as a perfect man and as wise and powerful then as now."[32] This notion may owe to Bonaventure's idea in his *Breviloquium* that the "divine nature cannot exist in *suppositum* except in its own hypostasis," a consequence of his elaborate Trinitarian Christology, by which "this union cannot exist in the hypostasis of a human person, but rather that only of God."[33] Desirable as it may have seemed to convey such a view, imaging the teaching was to become problematic with respect to traditional theological understanding. In this altarpiece the conceit is invoked visually in such a way that the incarnation is reconstituted as a kind of transplantation or implantation. Mary becomes almost a surrogate mother. Later, with the Franciscan development of the doctrine of the immaculate conception by Bonaventure, Duns Scotus, and others, a new iconography would be required.[34]

The exaltation of Mary in the religious art of this period, as well as in the theology, took several different forms.[35] Attribution to her girlhood

32. *Meditations on the Life of Christ*, 19–20.

33. Bonaventure, *Breviloquium*, trans. Erwin Esser Nemmers (Saint Louis: Herder, 1946), 113; cf. 113–19.

34. See chap. 7 for the role of art in advancing the doctrine of the immaculate conception of Mary.

35. The Virgin's glory, according to the Franciscan master at Paris, Alexander of Hales, is proportional to the degree of her grace (*gratia plena*), and this grace is evidently greater

of a scholarly knowledge of Holy Scripture, especially the Law and the Prophets, is but one of the turns it took, though an important one. It begins early, when Saint Ambrose in the fourth century says that Mary's humility and receptivity to the Word "commends the Mother of the Lord to those who read the Scriptures and, as a credible witness, declares her worthy to be chosen to such an office."[36] On this basis Thomas Aquinas later declares her to be the patron saint of all those whose calling is to read and interpret the Scriptures in the church,[37] and from there she readily becomes the patron of Catholic higher education in general, as the name of many a university and college bears witness. The widely distributed topos in modern secular painting of a woman reading a book is almost certainly a secularization of late medieval annunciations depicting Mary as a model reader.

Another painter of family altars, later in the century and for a still more affluent clientele, was Sandro Botticelli. His *Madonna of the Book* (ca. 1483), housed in the Museo Poldi Pezzoli in Milan, is well known through reproductions, but is even smaller (58 cm × 34.5 cm) than the center panel of the *Merode Altarpiece*.[38] Botticelli likewise features in this small but beautiful work the Virgin Mary reading the Bible with an attentive infant Jesus on her lap.

Another Botticelli altar painting for a private family, the *Madonna with Five Angels*, or *Madonna of the Magnificat* (fig. 52), shows Mary not only as a reader, but also as a writer of poetry, penning her Magnificat (Luke 1:46–55). Botticelli's models were exquisitely beautiful by any standard, regal in a way not anticipated by Cimabue or Giotto, whose virgins have more the aspect of a wise woman of strong character, perhaps reflective of the early Roman Venus Genetrix. This elegance becomes the convention for other painters, such as Fra Lippo Lippi, Piero della Francesca, Raphael, and Leonardo, and this is certainly the kind of beauty we find exemplified in Michelangelo's *Pietà*. We do not know anything about the family for whom Botticelli's tondo (round painting) was done, but the work has features that suggest they wanted to celebrate the Virgin as a patron of

than that of the angels, even a "choir of angels" who might do her homage. Alexander concludes that grace was given to Mary according to her inherent regal status, "quod gratia erat data ei ad mensuram" (*Sententiae* 1.44.1.2).

36. Ambrose, *De officiis* 1.18.68–69.

37. Saint Thomas said that on account of the Virgin Mary being one who "pondered the Word of God in her heart," it was "fitting that she should be the mother of the Word made flesh" (*Summa contra Gentiles* 4.34).

38. Jeffrey, *People of the Book*, 221.

Figure 52. Botticelli,
Madonna of the Magnificat,
ca. 1485

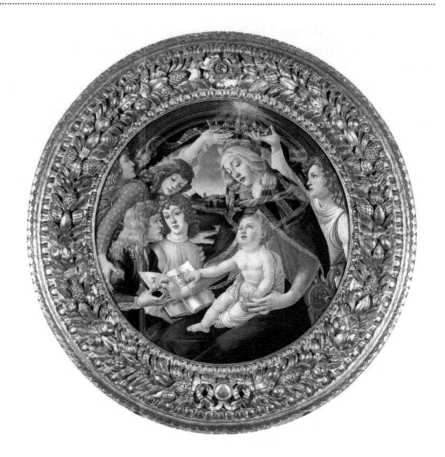

the arts. The angels surrounding Mary look like contemporary Florentine courtiers; we can infer their status largely from the two who have raised a crown above her head, indicating that she will become the "Queen of Heaven." One wonders, however, if the courtier holding the inkwell into which she dips her pen isn't intended to recall Saint Luke himself.

A still more extraordinary private devotional painting featuring Mary was executed by Petrus Christus, a painter from Bruges, in 1465, for a member of the Confraternity of Our Lady of the Dry Tree, a lay religious group in Bruges about which little is known other than its Marian devotion, but of which the painter and his wife were also members. (It may have been a Dominican-sponsored confraternity of the rosary.) By far the smallest of the family devotional paintings we have examined, it pictures the Virgin and Christ child suspended in a mandorla of dry and thorny branches, evoking a typological reading of Ezekiel 17:24 as referring to Mary: "I, the LORD, have brought down the high tree and exalted the low tree, dried up the green tree and made the dry tree flourish." The branches

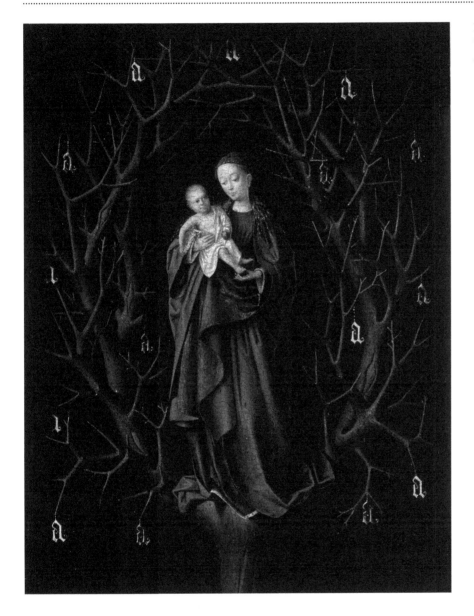

Figure 53. Petrus Christus, *The Virgin of the Dry Tree*, ca. 1465

of the tree bear fifteen *A* letters hanging as ornaments, each signifying an "Ave Maria," hence collectively signifying the mysteries of the rosary (fig. 53).

While the angel Gabriel's salutation in most altarpieces seems intended to reiterate the passage in Luke from which it is taken, it is probable that many medieval Christians would have mentally transferred the words to the "Ave Maria" (Hail Mary) prayer, since by the fifteenth century it was the prayer most frequently recited by medieval Christians, both lay

and clerical. Like the devotion to Mary itself, it sprang up in the twelfth century and in a Cistercian context, but reached full flower in the fifteenth century.[39] By the middle of the thirteenth century, the "Ave" was beginning to be used almost as frequently as the Lord's Prayer and the creed; by the fifteenth century it was far more common, repeated as often as 150 times in succession in praying the rosary; the New Advent Catholic Encyclopedia suggests that the repetition is perhaps an evocation of the endless angelic acclamation in heaven, "Holy, Holy, Holy" (Rev. 4:8), there addressed to the One seated on the throne himself.[40] Whatever analogies may present themselves (and there were many such analogies between Mary and her Son in the legendary lives of Mary), one thing is clear: by the closing years of the fifteenth century, devotion to the Virgin was very prominent, with the Virgin Mary herself considered by many to be the confluence of beauty and holiness most accessible to the imagination of western European Christians. Depictions of her as the quintessence of holy beauty acquired increasingly a cosmic aura, whether as the uncreated Wisdom of God (Prov. 8), the woman clothed with the sun in John's apocalyptic vision (Rev. 12:1), or the spotless bride of Christ in the new Jerusalem (Rev. 21:1–4, 9–14). These figural developments, though not at this point formally endorsed by the Roman magisterium, were to have further effect on the development of doctrine.

39. The entry in the New Advent Catholic Encyclopedia, after noting that the prayer is not to be found earlier than the last quarter of the twelfth century, observes as follows: "The great collections of Mary-legends which began to be formed in the early years of the twelfth century (see Mussafia, 'Marien-legenden') show us that this salutation of Our Lady was fast becoming widely prevalent as a form of private devotion, though it is not quite certain how far it was customary to include the clause 'and blessed is the fruit of thy womb.' But Abbot Baldwin, a Cistercian who was made Archbishop of Canterbury in 1184, wrote before this date a sort of paraphrase of the 'Ave Maria.'" "Hail Mary," in New Advent Catholic Encyclopedia, 2012, http://www.newadvent.org/cathen/07110b.htm.

40. The New Advent Catholic Encyclopedia article notes: "The idea is akin to that of the 'Holy, Holy, Holy,' which we are taught to think goes up continually before the throne of the Most High." In the time of King Louis the Pious it ended with the words of Elizabeth, "Blessed is the fruit of thy womb," but did not yet have the addition of the name of Jesus and following petitions. It took its present form, not from the Council of Trent, as is sometimes supposed, but from the Roman Breviary of 1568.

CONCLUSION

The evolution of altars and altar precincts in European churches rep-
resents in some ways a theological as well as a spiritual evolution. From
simple wooden tables to stone altars required by decree to house the relic
of a saint, from being open and immediate to the congregation to being
enclosed with a rood screen and subsequently surmounted with mas-
sive poly-paneled altarpieces depicting the history of human salvation
in précis, the altar grew to be the artistic center and visual high point of
many medieval churches and cathedrals. Wall painting receded into the
background by comparison, and with it the focus on the earthly ministry
of Christ and the apostles visually receded also. The most magnificent of
medieval altar paintings turn the Christian story once again to eschatol-
ogy and visions of the life to come, contemplations of the divine majesty
at the end of time, as in the *Ghent Altarpiece*, while in private altars for
family devotion the Virgin Mary becomes increasingly the artists' primary
subject, her royal face the epitome of holy beauty.

Art and the Bible after 1500

7 BEAUTY, POWER, AND DOCTRINE

What beauty is I know not, though it adheres to many things.

ALBRECHT DÜRER

In the last decade of the fifteenth century, a time when religious devotion was probably at a peak in Europe,[1] in Rome itself it was not the dominant preoccupation. Disquieting though it may be to pious reflection, many princes of the Holy Church in that period were focused primarily on sex, wealth, and the getting of power. Such appetites are not likely to conduce to holiness of life, no matter how many churches are in the neighborhood. But if holiness was neglected, beauty was pursued with passion; there have been few if any periods in Western history to match Rome in the first half of the sixteenth century in brilliance of artistic achievement.

By this time the Vatican church itself, having stood for more than a millennium, was in poor repair. Structural weaknesses in the walls of

1. Brad Gregory emphasizes the tension created by the high idealism of third-order lay Christians and the piety of the Devotio Moderna meeting with a dogged resistance to reform in Rome itself, because it "would have meant stripping themselves of pride and pretense, nakedly facing themselves and the call to conversion, as did those men and women who, depending on circumstances, deliberately declined professional religious life *in order* to pursue holiness, as did the Brothers and Sisters of the Common Life in the late fourteenth and fifteenth centuries." *The Unintended Reformation: How a Religious Revolution Secularized Society* (Cambridge, MA: Belknap Press of Harvard University Press, 2012), 141. These spiritual societies declined in the sixteenth century, because of both neglect by Rome and assimilation by the Reformers. See John W. O'Malley, *Trent: What Happened at the Council* (Cambridge, MA: Belknap Press of Harvard University Press, 2013), 21.

Constantine's basilica were becoming apparent—a metaphor perhaps. The first pope to consider repair and remodeling was Nicholas V (1447–1455), but he died without managing more than to demolish part of the Colosseum and remove 2,500 cartloads of stone to the basilica site.[2] His immediate successors were distracted by other preoccupations. Sixtus IV (1471–1484), formerly minister general of the Franciscan Order, made six of his nephews cardinals and altogether appointed two dozen more, many of whom were morally unfit for the job, and additionally enriched himself and his relatives by selling other offices and privileges, but he neglected the repair fund. His successor, Innocent VIII (1484–1492), continued obtaining revenue in this unseemly fashion, while spending extravagantly on personal pursuits; famously, "the great social event of his pontificate was the elaborate celebration in the Vatican of his son Franceschetto's marriage to the daughter of Lorenzo de Medici, the Magnificent, ruler of Florence."[3] Alexander VI (1492–1503) blazed a still more nefarious trail to the papacy; he fathered at least nine children, seven while Cardinal Borgia and two more after his election as pope. When Alexander died, Giuliano, nephew of Sixtus IV, was elected and took the name Julius II (1503–1513). Julius seems to have left his own paramours behind on his election as pontiff, dedicating himself instead to being a warrior pope and, for our purposes most importantly, to being one of history's greatest patrons of the arts.[4] It hadn't been a good half century for holiness, but Julius thought he could envision a way to make beauty serve his ambitions for papal power.

SAINT PETER'S BASILICA

The plans Julius II developed for Saint Peter's were accordingly much grander than those envisioned by Nicholas V. Concerned with his personal

2. It is one of the many ironies of Roman history that the stone for the Colosseum had originally been paid for by treasure looted at the siege of Jerusalem by Titus, and now the stone would go into Saint Peter's. See Amanda Claridge, *Rome: An Oxford Annotated Archaeological Guide* (Oxford: Oxford University Press, 1998), 276–82.

3. O'Malley, *Trent*, 32–33.

4. H. Burn-Murdoch, *The Development of the Papacy* (New York: Praeger, 1955), 322. The indispensable standard history is Ludwig Pastor, *The History of the Popes (1305–1732)*, trans. F. I. Antrobus and others, 40 vols., available online. Vols. 5–8 are the most pertinent here. A briefer but reliable summary is provided by Barbara W. Tuchman, *The March of Folly* (New York: Random House, 1984), 55–135.

legacy, Julius had already begun planning with Michelangelo for his own huge tomb, designed to be placed in the rebuilt and enlarged Saint Peter's (Michelangelo's *Moses* and *Dying Slave* were to be part of the facade that, had it been completed, would surely and intentionally have rivaled the *Ara Pacis* of Caesar Augustus).[5] Julius realized that such a grandiose tomb would require a bolder conception for Saint Peter's, so in 1505 he decided to demolish the old basilica altogether and start from scratch. Donato Bramante won the competition for design, and the work was begun the following year. To finance such a massive monument, unprecedented amounts of money would be needed. Albrecht, archbishop of Mainz and Magdeburg, was a leader among those who proposed that the moneys be raised by the selling of indulgences in German-speaking territories, and he put Johann Tetzel, the Dominican preacher, in charge. A general uproar of the populace ensued; as has often been noted, this was one of the principal factors leading to Martin Luther's Ninety-Five Theses and eventually the Reformation. Given all that followed, even those who now most love the art and architecture commissioned by Julius II for Saint Peter's are obliged to consider that the cost proved to be far greater than anyone then estimated, and that in more than one coinage.

Bramante's design was for a huge domed structure in the fashion of the Roman Parthenon, but having the form of a square Jerusalem cross inside, with four huge pillars supporting the dome (fig. 54). When Julius died in 1513, his successor, Leo X, appointed Giuliani da Sangallo, Fra Giocondo, and Raphael Sanzio (1483–1520) to take over the work. The first two died within two years, leaving Raphael alone to continue. Raphael modified Bramante's plan, imagining a more traditional nave, but when he himself died in 1520, the work was far from complete. Tumult, including a sack of Rome by unruly German and Spanish troops of Charles V (the Holy Roman emperor) in 1527 and innumerable other political as well as financial difficulties, occasioned a string of frustrated successors to the role of architect in chief. Finally in 1546, Pope Paul III, convening pope of the Council of Trent, appointed the aging Michelangelo Buonarroti (1475–1564), or rather commanded him, much against his will, to take charge. There had been some evolution in the design since Michelangelo had first become familiar with it; then it was to be the venue for the tomb of Julius II, but not much progress in the actual construction of the basilica itself had occurred. Considerable reworking as well as continued

5. The tomb was left at his death incomplete, then downsized dramatically and moved to the Basilica of San Pietro in Vincola.

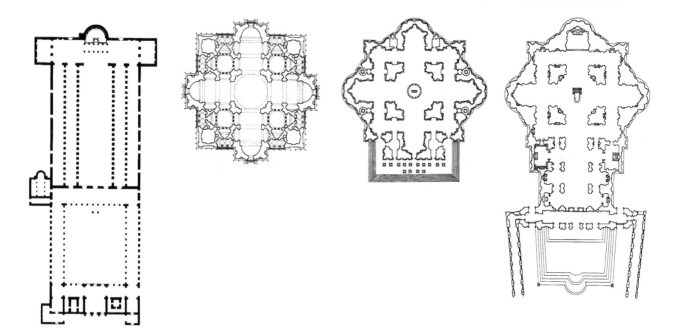

Figure 54. Floor plans of Saint Peter's Basilica: Old Saint Peter's, Bramante's plan, Michelangelo's plan, and Maderno's plan

fabrication was now required. The present structure reflects Michelangelo's work extensively, yet preserves much of Bramante's original design.

It took another century for the enormous edifice to be completed, but the result is generally taken to be the most impressive architectural monument of western Christendom. It is debatable, however, whether it is western Christendom's most spiritually impressive sanctuary. The hybrid form, with a nave elongated by Carlo Maderno, and the facade, with its oversized inscription honoring Pope Paul V Borghese (1605–1621), were finished in 1615. According to one prominent art historian, these concluding papal gestures definitively compromised Saint Peter's as a sanctuary in the normal sense, since celebrating Paul V "rather than the church itself or the apostle Peter, goes against all prescriptions of humility and overcomes allegiance to the Counter-Reformation, giving way to a new glorification of the patron, the head of Roman Catholicism."[6] Actually, it might be more accurate to describe Saint Peter's as a papal monument. Though it did not originally have a crypt, after Gregory XIII (1572–1585) the space under the floor and above the Constantinian basilica floor was used to house tombs of popes both ancient and more modern who had been initially buried in the old basilica. It would not have pleased Julius II,

6. Daniella Gallavotti Cavallero, in *The Lion Companion to Christian Art*, ed. Michelle P. Brown (Oxford: Lion Hudson, 2008), 271.

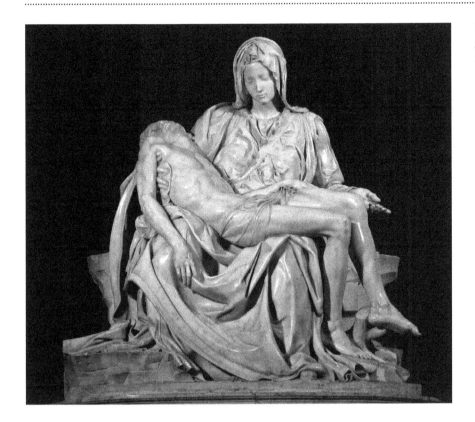

Figure 55. Michelangelo, *Pietà*, marble, Saint Peter's Basilica, Vatican, 1498–1499

who had wanted the new Saint Peter's to feature his own tomb uniquely, that his was not in the end even among them, the fragments of his unfinished tomb having to settle for a much less prestigious venue.[7]

When a visitor approaches Saint Peter's, its sheer size is overwhelming. In fact, with its massive concave arms of columns built by Bernini reaching out to bracket the square, each surmounted by serried ranks of exterior monumental sculptures, the usual initial impression is not that one is looking at a place of worship. One has to enter and slowly take in the interior sculpture to find ready referents for holy beauty, while the massive "place of the holy," lacking the intimacy of a smaller sanctuary, more than anything else projects strength and power. This, of course, is precisely what Julius II had in mind.

It is an almost universal consensus that Michelangelo's *Pietà*, finished when he was only twenty-two years of age, is the most beautiful of all the sculptures in Saint Peter's (fig. 55). The *Pietà* is incontestably a work of extraordinary genius. Not even the Greeks had shown more mastery in the

7. See note 5.

verisimilitude of flowing garments, and neither they nor the Romans had created a face of such beauty and tenderness as the visage of this Mary. The topos, one of the "Sorrows of the Virgin," is not attempting to depict a biblical scene, but rather a touchstone in Marian devotion. The dead body of her Son is cradled in Mary's lap in such a way as to bring about a juxtaposition in the viewer's imagination with images of Mary cradling the infant Jesus at the beginning of his life. The conjunction prompts unavoidably a second, unusually extended contemplation of the ageless face of the Virgin and her stunning youthful beauty overall. The perpetual virginity and sinlessness of Mary are here expressed by a face and body probably more alluring than that imagined by Bonaventure; in Michelangelo's sculpture she is ideal Beauty incarnate. Many contemporary visitors to Saint Peter's have no visual memory so abiding as that occasioned by this one work of art. The tombs of many popes, the *baldacchino*[8] by Bernini, and the side chapels, however impressive, seem by comparison what in fact they are, monuments, virtuoso artistic achievements declaring the power of the papacy.

Painting in the Vatican

The alfresco painting of Raphael and Michelangelo is typically more favored by lovers of art than is the architecture in which each maestro had a hand. After his friend Bramante had introduced him to Pope Julius II, Raphael was commissioned to paint the walls of all three rooms of the Stanza della Segnatura. Beginning sometime in the autumn of 1508, he worked on these wall paintings until 1513. The principal room was designed to provide an integrative account of theology, philosophy, law, and the "sister arts" sponsored by the nine muses. It is sometimes imagined on this account that the main *stanza* was originally intended as a papal library. In fact, it became rather a ceremonial room in which bulls and encyclicals were signed by the pope—hence its name. Raphael's workmanship, though damaged by time and the ravages of the sacking of Rome in 1527 (some lower panels still bear traces of the Lutheran graffiti scratched on them by German troops),[9] remains impressive for its color and intriguing detail as well as for its comprehensive humanist program.[10]

8. A *baldacchino*, sometimes called a ciborium, is a large canopy over an altar, here in bronze supported by marble pillars, finished by Gian Lorenzo Bernini in 1634.

9. John Pope-Hennessy, *Raphael: The Wrightsman Lectures* (London: Phaidon, 1970), 22.

10. Pope-Hennessy, *Raphael*, 58–71; cf. Sandro Magister, "The 'Extra' Synod Father: Raphael," *Chiesa*, October 17, 2005, http://chiesa.espresso.repubblica.it/articolo/40581?eng=y;

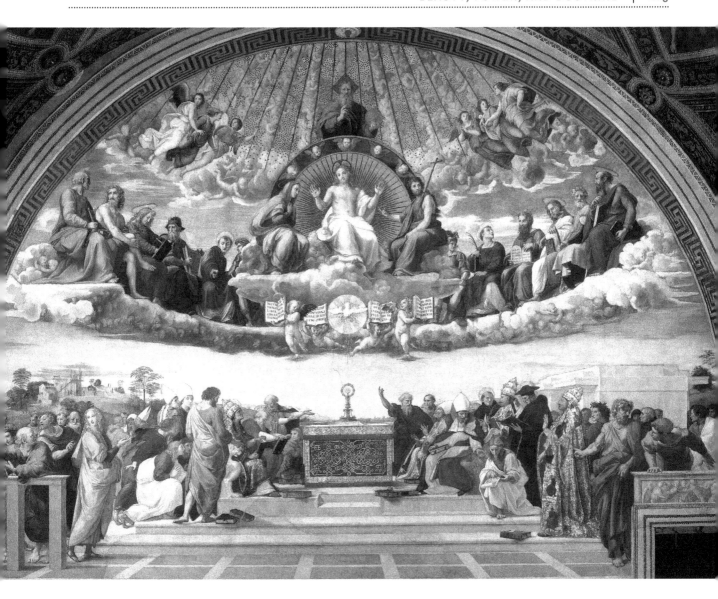

An examination of the entire room, mostly classical Renaissance in subject matter, is beyond the scope of this study, but Raphael's depiction of theology in the large *Disputa del Sacramento* provides about as good an image of the role it played in the Renaissance world of ideas as there is (fig. 56). The *Disputa* is an intellectual synthesis reflecting the weight of Catholic tradition on an issue central to Christian identity, the Holy

Figure 56. Raphael, *Disputa del Sacramento, secco* mural, Stanza della Segnatura, Vatican, ca. 1512

see, on the same web page, Timothy Verdon, "The 'Disputation on the Sacrament': A Manifesto in Which the Church Tells Its Own Story."

Sacrament. The painting is known to have been executed *secco* (on dry plaster), unlike most of Raphael's other works in the Stanza. The scene is artificial, of course, but not an allegory; rather, it is intended to represent the doctrine of transubstantiation in the context of ongoing theological debate concerning how best to understand the precise meaning of the eucharistic mystery.

Raphael's composition gives a traditional answer. Central is the Trinity, with God the Father in heaven, his eternal glory signified by radiant beams of pure gold. Below him is the risen Christ, seated in majesty on a golden throne; Mary adores him on one side while John the Baptist, looking out toward the figures both in heaven and on earth, points to the "lamb of God who takes away the sin of the world." The figures surrounding Christ's throne are suspended on a semicircular cloud now somewhat reminiscent of the *braccia*, the colonnaded semicircular arms extending on either side of Saint Peter's square (though they were not yet built at the time of the Stanza's decoration). On the left are Saint Peter with his key, Adam, John the Evangelist writing (presumably his apocalyptic revelation), King David with his harp, Saint Lawrence, and a prophet looking backward, his future vision now redundant. On the right, starting again from the front, are Saint Paul with his sword, Abraham holding his sacrificial knife, Saint James holding his book and perhaps silently praying, Moses with the tables of the Law, Saint Stephen with his martyr's palm, looking into the heavens, and a soldier, possibly either Judas Maccabeus or Longinus. All of this is traditional iconography.

The painting's geometry provides a striking horizontal axis to complement the vertical axis between God the Father, Christ, the dove of the Holy Spirit, and the altar. The line of clouds just above the altar separates time from eternity. On that line, but penetrating in a nimbus of gold to the world of time, headed toward the monstrance with its eucharistic wafer on the altar, is the dove of the Holy Spirit, who proceeds from the Father and the Son. The dove is surrounded by four "cherubs," each of whom carries an open book displaying the first words of each of the four Gospels, Matthew, Mark, Luke, and John. For the humanist adviser to Raphael, as indeed to the sixteenth-century viewers of the finished work, the horizontal axis must have resembled the invisible line of Plato's cosmogony in the *Timaeus*, the very book Plato carries, title plainly visible, in the painting on the wall directly opposite, the well-known *School of Athens*. Above the line of clouds is the unchanging world of perfect Light, Being, and Idea; beneath is the changing world of refracted light, becoming, and articulation.

Books are everywhere in the *Disputa*—on the floor near the altar, in the hands of figures who are human authors and readers. But the Sacrament of the Altar is what centers the discourse on earth and connects the world of imperfect understanding most directly to heaven. Whereas in the *School of Athens* the visual division is more tacit, with Plato and Aristotle gesturing toward their respective domains of metaphysical truth as they walk out from the half-finished arches and piers of Bramante's Saint Peter's, here it is explicit, but with one clear means of transit between temporal and eternal reality for the gathered church of all ages. The implication is that whatever understanding of the Sacrament of the Altar may be at a given place and time, authentic participation in the Eucharist constitutes believers as "one body in Christ" (Rom. 12:5).[11] On the left, closest to the altar, sits Saint Jerome, gazing intently at a book (next to the altar in front of him are his Vulgate Bible and *Letters*). Saint Gregory the Great gazes upward, reflecting also on the text of Scripture, seeking spiritual understanding; his *Moralia* on Job is at his feet. The priest behind Jerome points to the monstrance, while other figures in the tradition, authors and readers, contemplate the Blessed Sacrament. Nearest the viewer, curiously, is a figure said to be Bramante, trying to get three of the crowd to look at a book he holds in his hand, while he is himself turned entirely away from the altar. On the other side, Saint Ambrose is right next to the altar, his hand raised to heaven mirroring the gesture of Plato across the room—transcendent Truth is above all earthly reckoning. Saint Augustine dictates his own thoughts to a kneeling scribe, with some of his own books, including the *City of God*, on the floor before him. Other figures in the right-hand group include Thomas Aquinas, Bonaventure, Popes Innocent III and Sixtus IV, as well as Dante. The painting is large, over twenty-three feet wide, and it packs in a wealth of theological reflection. Though it may have the greatest claim of any of Raphael's work in the Stanza to being a work of holy beauty,[12] this is not because it induces a spirit of worship—it is too diagrammatic and intellectual a composition for that—but because it makes a formidable statement about the perennial dialogue between faith and reason.

11. The Council of Florence in 1439, in reconciliation with the Arminian church, affirmed seven sacraments and the doctrine of the "real presence" of Christ in the Eucharist. See O'Malley, *Trent*, 119.

12. Perhaps his most beautiful painting of all is his *Transfiguration*, now in the Pinacotecca Vaticana; but after some concluding touches by his artisan Giulio Romano, it was installed after Raphael's death (in 1520) over the high altar in San Pietro, Montono. See Pope-Hennessy, *Raphael*, 70–75.

Figure 57. Michelangelo, *Last Judgment* fresco, Sistine Chapel, Vatican, finished 1541

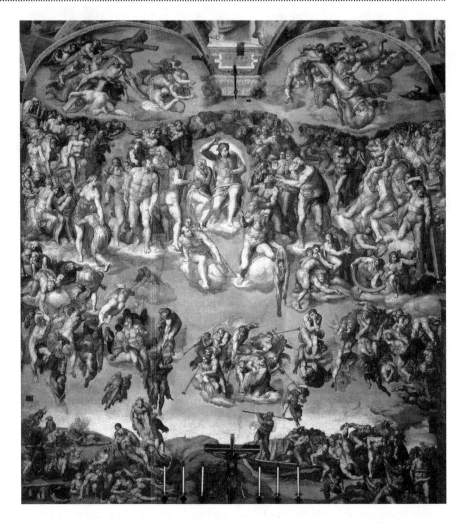

For much of the time Raphael was working on the Stanza, his rival Michelangelo was working in the very next room, on his Sistine Chapel ceiling (1508–1512) frescoes. Their work had much thematically in common, and it would have been natural to compare notes, but the two great artists were not on friendly terms; Michelangelo gave instructions that Raphael should be barred from viewing any of his work in progress.[13] The Sistine Chapel ceiling frescoes, a program of mixed classical and biblical subjects, is widely known and just as widely praised, but in light of the theme of this book our attention must go rather to Michelangelo's final Sistine work, the end wall *Last Judgment* (1536–1541), commissioned not by Julius II but by Pope Paul III much later, long after Raphael was dead (fig. 57).

13. Pope-Hennessy, *Raphael*, 29–32.

Michelangelo's depiction of the resurrected bodies of saints and others who are redeemed is dynamically centered by the returning Christ, nearly nude, with his mother beside him. This very animated scene surmounts a chaos of rejected and writhing sinners, with Dante's Charon ferrying the dead across the river Styx, beating away the damned with his oar. Almost all the figures, saved or damned, are depicted nude. This was somewhat daring even for Rome, and, as we shall see, it occasioned partial censorship within a very few years, following the decrees of the Council of Trent.

Raphael's frescoes for the Stanza della Segnatura (he did all three rooms) and Michelangelo's for the Sistine Chapel are among the most ambitious and accomplished of all ecclesial wall paintings in European Christian tradition. Art historians discussing them rarely employ the words "beauty" or "beautiful," however, to describe their excellence. One wonders, despite their Vatican location, how many viewers, ordinary or learned, think of them as holy, as images inviting a worshipful response. Each room inspires awe, certainly, but rarely affectual contemplation or even spiritual stocktaking; indeed, their purpose is quite different.

LOSING THE BEAUTY OF HOLINESS

We tend to think of the time of the Reformation, whether from a Catholic or a Protestant perspective, in terms of paradigmatic doctrinal oppositions. Unfortunately, nothing in the realms of politics, theology, spirituality, let alone art in that period, really maps on to any such paradigm conveniently. For example, Rome was by this point at last indisputably the singular Holy See, the center of religious authority,[14] but, as we have in measure seen, it was still racked with ecclesiastical corruption and a visible absence of personal holiness among senior churchmen. The raw facts of this state of things were not fully apparent except to those who had occasion to know or visit Rome. When Martin Luther came to Rome in 1510, he was still a very loyal and idealistic Catholic, hoping to advocate for reform within his own Augustinian Order;[15] he celebrated Mass daily while there, and had not yet begun to think of rebellion. Nonetheless, he

14. From 1309 to 1378 there were rival popes, one in Avignon and the other in Rome. This ugly dissension, often called the "Babylonian Captivity," greatly diminished the authority of the papacy. See Joëlle Rollo-Koster, *Raiding St. Peter: Empty Sees, Violence, and the Initiation of the Great Western Schism* (Leiden: Brill, 2008).

15. Heiko A. Oberman, *Luther: Man between God and the Devil* (New York: Doubleday Image, 1982), 140–41.

was depressed by "the casual mockery of saints and everything he held sacred."[16] Even if we should be inclined to take the incipient reformer's sense of injury *cum grano salis*, we need to appreciate that he was far from alone in his observations. Erasmus, for one, had visited in 1505 and was comparably depressed on the same grounds: "With my own ears I heard the most loathsome blasphemies against Christ and his apostles. Many acquaintances of mine have also heard priests of the curia uttering disgusting words so loudly, even during mass, that all around them could hear it."[17] Michelangelo himself, though in the employ of Pope Julius, shared in the general opinion. Among his more than three hundred poems, most of which are ostensibly addressed to his mistresses and others he admired, is a poem written just as he finished the Sistine ceiling (1512) entitled "On Rome in the Pontificate of Julius II." The poem sets an unhappy scene:

> Qua si fa elmi de calice e spade,
> E 'l sangue di Cristo se vend' a giumelle,
> E croce e spine son lance e rotelle,
> E pur da Cristo pazienza cade!
> Ma non c' arrive più 'n queste contrade,
> Ché 'n andré 'l sangue suo 'nsin alle stele,
> Poscia che a Roma gli vendon le pelle,
> E èci d' ogni ben chiuso le strade.

> (Here they make helmets and swords from chalices:
> The blood of Christ is sold by the jug,
> His cross and thorns are turned into spears and shields,
> Till even *his* patience will end.
> May he not come again into this place:
> For his blood would rise to the stars,
> Since now in Rome they sell his skin
> And close the road to every good deed.)[18]

Luther fretted much over such occasions of his own disillusionment, but made no comment on any of the art he saw, or even on the Vatican buzz about the work by Raphael and Michelangelo, which he could not

16. Oberman, *Luther*, 149.

17. Oberman, *Luther*, 149n55.

18. My translation. A good edition and translation of all the poems is *The Poetry of Michelangelo: An Annotated Translation*, trans. James M. Saslow (New Haven and London: Yale University Press, 1991); especially helpful is the introduction.

have seen. Erasmus saw much more, in the Vatican and elsewhere, and by the time he wrote his treatise *On Christian Matrimony*, he had come to views on the penchant of religious artists largely identical to those held by Calvin and Luther: "What shall I say about the license so often found in statues and pictures? We see depicted and exposed to the eyes what would be disgraceful even to mention. . . . A young man and girl lying in bed? David looking from a window at Bathsheba and luring her into adultery? The daughter of Herodias dancing? These subjects, it is true, are taken from the scriptures, but when it comes to depictions of women, how much naughtiness is admixed by the artists!"[19] The painting of biblical narrative, in short, was often by this time a pretext. As we shall see in the next chapter, manuscript painting and even altarpiece painting in the period provide myriad examples of gratuitous eroticism, and Erasmus could certainly find examples closer to home than in Rome and the Papal States; one need only think of the *Garden of Earthly Delights* (1504) by Hieronymus Bosch[20] or Hans Baldung Grien's *Death and a Woman*, also known as *The Kiss of Death* (1510). These are works of moral allegory, designed ostensibly as cautionary instruction, but their appeal was clearly other than that for most viewers. The same might be said for many of the Renaissance-era paintings of Mary Magdalene, occasioned in large numbers as a "defense of the sacrament of penance."[21] Unlike Donatello's wooden sculpture discussed in chapter 5, itself entirely appropriate to the Baptistry of the Duomo in Florence because it was convincing as an invitation to repentance, Titian's *Saint Mary Magdalene* (1533) was more likely to be seen as an invitation to something else (fig. 58).[22]

The dislocation of beauty from holiness in Renaissance art happened at many levels. Patrons and others still wanted beauty, but increasingly eroticized beauty is what they had in mind. The depiction of classical sub-

19. Quoted in Erwin Panofsky, "Erasmus and the Visual Arts," *Journal of the Warburg and Courtauld Institutes* 32 (1969): 209–10.

20. See the image and discussion in Brown, *The Lion Companion to Christian Art*, 242. For the anticlericalism of Bosch's lay confraternity, reflected in his "Hooiwagen" triptych, see David Lyle Jeffrey, *Houses of the Interpreter: Reading Scripture, Reading Culture* (Waco: Baylor University Press, 2003), 135–54.

21. Émile Mâle, *Religious Art from the Twelfth to the Eighteenth Century* (New York: Noonday Press, 1949, 1963), 171.

22. According to Vasari, Titian reflects here the legend that during the thirty years the Magdalene (who was sometimes conflated with Saint Mary of Egypt) lived in the desert, her clothes literally fell apart. Despite the garments' deterioration, Titian's Mary Magdalene herself seems here remarkably well preserved. Titian signed this work on the conventional ointment jar of the Magdalene.

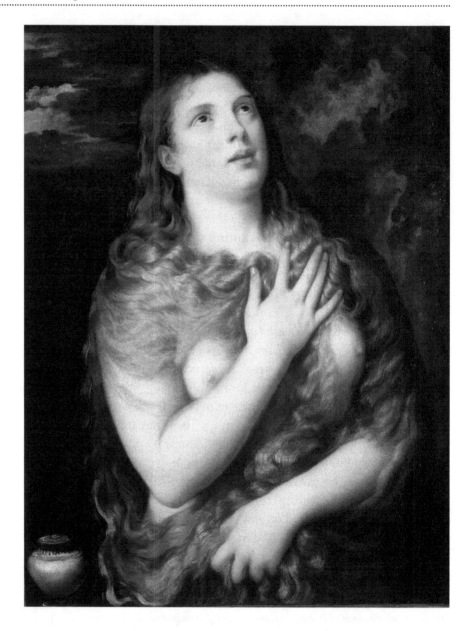

jects provided a ready excuse, and from this period forward stories such as that of Diana and Apollo or Venus and Jupiter provided the occasion for a majority of the large output in Italy, but also in Germany and the Netherlands. Lucas Cranach the Elder, Luther's friend, painted and sold more than two dozen small, boudoir-sized depictions of the suicide of Lucretia, all quasi-pornographic, as well as many of "Venus," often using the same models as for his depictions of Eve (fig. 59).

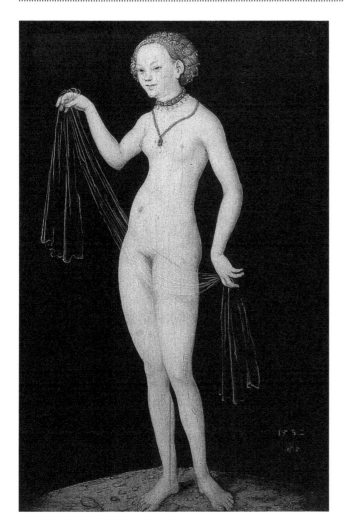

Figure 59. Lucas
Cranach the Elder,
Venus, ca. 1532

While not so eroticized as his paintings of Venus or Lucretia, his Adam and Eve compositions have evident sexual overtones. Plainly, there was a market for erotica all over Europe by the beginning of the sixteenth century, and it continued to grow apace after that, with the consequence that distinguishing between a classical and a biblical or "holy" subject could become difficult, as Titian's allegory *Sacred and Profane Love* (1514) makes particularly clear (fig. 60).[23]

Panofsky's brilliant analysis of this painting casts doubt on its conven-

23. Originally this painting was said to be commissioned for a wedding gift from Nicolo Aurelio, secretary to the Venetian Council of Ten, to celebrate his marriage to a young widow, Laura Bagarotta.

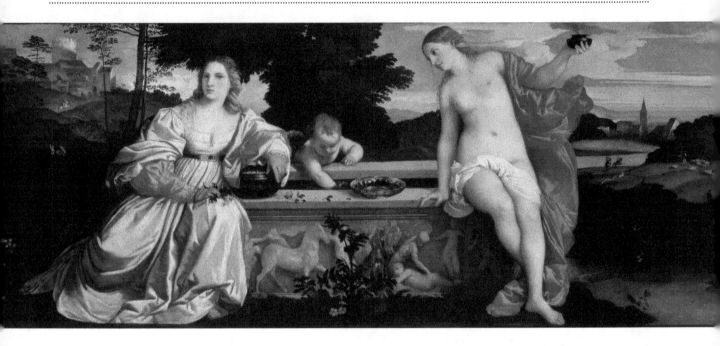

Figure 60. Titian, *Sacred and Profane Love*, ca. 1514

tional title; he sees the clothed woman as in her iconographic attributes the exemplar of profane beauty (or, as Umberto Eco would have it, the "terrestrial Venus"), while the nude figure on her left has aspects of the Nereids of classical Roman sculpture, here in a posture that welcomes the blessed into eternal life. It may be that in fact the two figures are the same woman represented at two stages of a transformation, with the figure on the right looking back with compassion on her former or "natural" self. Using an early Roman sarcophagus filled with water as a baptismal font, with the little angel stirring the waters (as at Siloam, John 9:7–11), is an ingenious touch; in the ancient Roman Christian past, people sometimes were baptized in a water-filled sarcophagus, some of which found an afterlife as water troughs for horses in the piazzas of Italian villages. There is much more to see in this painting, and in terms of iconography it will support reading it in one way as an allegory of baptism, a passage from secular to sacred realities.[24] Above all, however, it is a truly beautiful work of art, although beautiful in such a way that for most viewers an allegory of baptism is not likely to be immediately evident.

24. Erwin Panofsky, *Problems in Titian: The Wrightsman Lectures* (New York: New York University Press, 1965), 111–16. Umberto Eco takes the painting to be about the "Twin Venuses" of Dante's *Convivio*, here depicting symbolically "the celestial Venus and the terrestrial Venus, two distinct manifestations of a single ideal of Beauty." See Umberto Eco, ed., *History of Beauty*, trans. Alastair McEwan (New York: Rizzoli, 2004), 188.

Nudity in Sacred Art: The Council of Trent

That the Catholic Church has had conflicting views regarding protocol for the making of Christian images, especially where nudity is concerned, is well known. As recently as 1994, in a homily addressing controversy over nudity in the figures of Michelangelo's Sistine Chapel painting (cleaned in 1984), Pope John Paul II defended the depiction of nude Adam and Eve as appropriate to the text of Genesis and useful for addressing questions about the theology of the body.[25] These theological matters he took up in a separate text, distinguishing between representations of "original man" before the Fall, "historical man" after the Fall, and "eschatological man," who partakes of the divine nature in heaven.[26] To each of these contexts in representation different conventions apply; with respect to nudity, in historical figures after the Fall, we have historical man, stripped of the glory of primal innocence, so that nakedness has lost its possibility of an innocent depiction.[27] On this view nudity for historical figures from the Bible has become unsuitable for portrayal in ecclesiastical settings but not so nudity in Edenic or eschatological contexts, where John Paul II argues, it can still be appropriate.

I want to stress that this protocol had not yet been established in the

25. Homily of His Holiness John Paul II (April 8, 1994), 6.

26. John Paul II, *Man and Woman He Created Them: A Theology of the Body*, trans. Michael Waldstein (Boston: Pauline, 2006); John Paul II here resists strongly "the representatives of so-called naturalism who appeal to the right to 'everything that is human' in works of art" (370–72).

27. For a recent discussion, see David Clayton, "What Is the Place of the Nude in Sacred Art?" in *The Beauty of God's House: Essays in Honor of Stratford Caldecott*, ed. Francesca Aran Murphy (Eugene, OR: Cascade Books, 2014), 242. Clayton quotes from the Sistine Chapel homily of John Paul II, referring to original and eschatological man, "On the basis of this logic in the context of the light that comes from God, the human body also keeps its splendor and its dignity. If it is removed from this dimension, it becomes in some way an object, which depreciates very easily, since *only before the eyes of God* can the human body remain naked and unclothed, and keep its splendor and its beauty intact" (quoted in Clayton, 245; Homily of His Holiness John Paul II, 6). The distinction between "nude" and "naked" needs more clarification, I would suggest. The reaction of Kenneth Clark, who finds the nudes of Rembrandt "disgusting" and "deplorable," led him to his famous distinction: "To be naked is to be deprived of our clothes, and the word implies the embarrassment most of us feel in that condition. The word 'nude,' on the other hand, carries, in educated usage, no uncomfortable overtone." *The Nude: A Study in Ideal Form* (Princeton: Princeton University Press, 1972), 338–39; see also his *Rembrandt and the Italian Renaissance* (London and New York: New York University Press, 1966), 10, 342. Clark's distinction seems to me problematic; I shall return to it in the following chapter.

Renaissance, for in that era there were strongly divergent views of the matter within the Catholic Church as well as divergence from Protestants, themselves lacking any unified perspective. The Council of Trent (1543–1564)[28] was concerned to counteract not only Protestant iconoclasm, but also what it considered excessively "lascivious" and even pagan representations of the body in Catholic ecclesiastical art—as we have seen, one of the very things the church had been criticized for internally as well as by Reformation voices. In the publication of Session 25 of Trent, the section "On the Invocation, Veneration, and Relics of Saints, and on Sacred Images" was accordingly an initial attempt to constrain the sorts of images we have just seen, but which were rapidly proliferating in sixteenth-century art, even in prayer books.[29] The council directed that "all lasciviousness be avoided; in such wise that figures shall not be painted or adorned with a beauty exciting to lust . . . there be nothing seen that is disorderly, or that is unbecomingly or confusedly arranged, nothing that is profane, nothing indecorous, seeing that holiness becometh the house of God. And that these things may be the more faithfully observed, the holy Synod ordains, that no one be allowed to place, or cause to be placed, any unusual image, in any place, or church, howsoever exempted, except that image have been approved of by the bishop."[30]

What troubled the bishops was not beauty, and perhaps not even erotic images in private environments, but rather the insinuation of erotic beauty into sacred space, detracting from holiness.[31] Earlier, the defense of Johannes Eck against Luther's objections[32] had been to say that the problem was not the artwork itself, but the miscreant imagination of priggish viewers such as Luther; that is to say, he asserts that concupiscence is entirely in the eye of the beholder. This rationale, however, was soon per-

28. *Canones et Decreta sacrosancti oecumenici et generalis Consilii Tridentini sub Paulo III, Julio III et Pio IV pontificibus maximis cum Patrum Subscriptionibus* (Vienna: J. B. Gress, 1850), 25.176–79.

29. The council was rushed at the end, and the text of Session 25 was for that reason not debated. John W. O'Malley, *Four Cultures of the West* (Cambridge, MA: Belknap Press, 2006), 221. This would lead to many episcopal clarifications.

30. *Canones et Decreta*, 25.3–4.

31. The first draft called such work *impudica et lasciva*; the final draft settled for *lasciva*. See O'Malley, *Trent*, 244. Cf. Shirley Smith, "The Fresco Decoration in the Sistine Chapel: Biblical Authority and the Church of Rome," in *The Edinburgh Companion to the Bible and the Arts*, ed. Stephen Prickett (Edinburgh: Edinburgh University Press, 2014), 254–71.

32. Johannes Eck, *De non tollendis Christi et sanctorum imaginibus contra haeresim Faelicianam sub Carolo magno damnatum* . . . (Ingolstadt, 1522), cap. 15.

ceived as an insufficient justification by Catholics as well as Protestants. Pope Pius IV, in the years immediately following the council, ordered that sexual organs in any such nude images in sanctuaries be covered with overpainting; fig leaves soon appeared on the genitalia of naked Adams and Eves, as in this example by Masaccio (fig. 61; leaves have since been removed with restoration), and modestly draped robes or floral screening suddenly appeared to cover nakedness elsewhere, including over some of the nude bodies in paintings in the Vatican itself.[33]

For the cultural historian of art, especially one interested in art as a register of theological reflection and reading practices for the Bible, art apologetics in the post-Tridentine era offers especially interesting insights. For example, Gilio de Fabriano, a Roman theologian, both advocates for biblical art in churches and at the same time takes a dim view of what he regards as the erotic excesses of high mannerist painting. In his *Dialogo degli errori e degli abusi de' pittori* (1564),[34] published only a year after the conclusion of the council, he attacks one of the very artworks Pope John Paul II was most concerned to defend, Michelangelo's *Last Judgment* in the Sistine Chapel.[35] Gilio objects to what he deems the "inclusion of distracting trivialities," namely, the seminude body of the returning Christ as well as the nonbiblical Charon from Dante's *Inferno*. He argues—almost as a Protestant critic might—against the perils of artistic virtuosity leading both artists and their patrons to impious arrogance, and inveighs against syncretism of biblical and pagan stories, which he thought posed grave risks to theological orthodoxy.[36]

33. Karolien de Clippel, "Altering, Hiding and Resisting: The Rubesian Nude in the Face of Censorship," in *The Nude and the Norm in the Early Modern Low Countries*, ed. Karolien de Clippel, Katharina Van Cauteren, and Katlijne van Stighelen (Turnhout: Brepols, 2001), 201–20, gives examples and contexts; 208. Pope Paul IV had Daniele da Volterra add drapes and incidental clothing to some of Michelangelo's nude saints; these overpaintings were removed in the 1984 cleaning.

34. P. Barocchi, ed., *Trattati d'arte del Cinquecento*, 2 vols. (Rome: Bari, 1960–1962), 2:46.

35. Rubens's own *Great Last Judgment* (ca. 1616), once high above the altar of the Jesuit church at Neuburg an der Danau, was ordered taken down in response to objections that it was "extremely unedifying"; it is now in the Alte Pinakothek in Munich. See R. Rooses, *L'oeuvre de P. P. Rubens* (Antwerp, 1888), 1:100.

36. A. Galizzi Kroegel, "Giovanni Andrea Gilio da Fabriano, Due Dialogi . . . , Camerino 1564," in *Arte e persuasione: La strategia delle immagini dopo il concilio di Trento* (Trento, Italy: Museo Diocesano Tridentino-Tipografia Editrice Temi, 2014), 154–56.

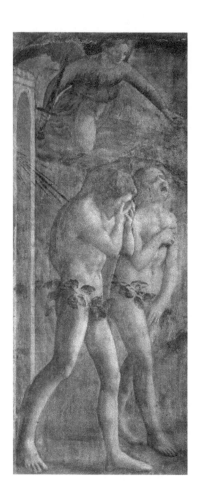

Figure 61. Masaccio,
Expulsion from Eden fresco,
ca. 1424–1427

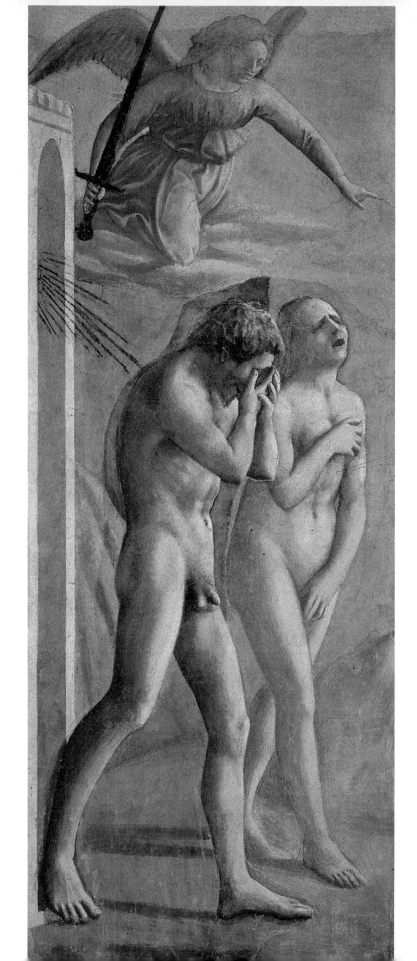

APOCRYPHA AND INVENTION

Farther north, Johannes Molanus (Jan Vermeulen), a professor of theology at the Louvain, had begun to address these issues as early as 1568, in his *De historia sanctarum imaginum et picturarum*.[37] He also wrote a commentary on Session 25 of the Council of Trent, *De picturis et imaginibus sacris* (1570). Revised and republished in 1594 as *De historia sanctarum imaginum*, his work is the most thorough and encyclopedic of all the commentaries on this chapter of Trent.[38] Molanus, irritated by what he regards as the excesses of Franciscan spirituality, is primarily concerned to banish the narratives of apocryphal books from Catholic painting, rejecting not only Susannah and the Elders from the apocryphal additions to Daniel but also the Assumption of the Virgin as noncanonical.[39] At the same time, he is most rigorously critical also of Protestant iconoclasm, and he draws on Erasmus effectively to that end. (One can only imagine what he would have thought of the proliferation of even more extremely "noncanonical" painting that appeared everywhere over the next half century, such as Rubens's *Intercession of the Virgin and St. Francis* [ca. 1635, Brussels Museum of Fine Arts] or Giovanni Lanfranco's *Assumption of the Magdalene* [ca. 1618, Museo di Capodimonte], to take two of hundreds of innovative religious works with noncanonical subject matter [fig. 62].)[40]

37. See the accessible commentary by Veerle De Laet, "*Een Naeckt Kindt, een Naeckt Vrauwken ende Ander Figueren*: An Analysis of Nude Representations in the Brussels Domestic Setting," in de Clippel, Van Cauteren, and van Stighelen, *The Nude and the Norm in the Early Modern Low Countries*, 117–28.

38. Johannes Molanus, *De picturis et imaginibus sacris* (Leuven, 1570). See here Ralph Dekoninck, "Art Stripped Bare by the Theologians, Even: Image of Nudity/Nudity of Image in the Post-Tridentine Religious Literature," in de Clippel, Van Cauteren, and van Stighelen, *The Nude and the Norm in the Early Modern Low Countries*, 109–15. Molanus (1568) is translated for the pertinent material in D. Freedberg, "Johannes Molanus on Provocative Paintings: *De historia sanctarum imaginum et picturarum*, book II, ch. 42," *Journal of the Warburg and Courtauld Institutes* 34 (1971): 229–45.

39. Although endorsed as fitting doctrine for the faithful as early as the sixteenth century by Lancelot Politi, archbishop of Conza, it encountered a great deal of early resistance, the record shows. A desire to refute Protestant objections to the cult of Mary intensified toward the end of the century, and at that time especially many defenses and depictions of the subject were made. See Émile Mâle, *L'art religieux du XVIIIe siècle en France* (Paris: Librairie Armand Colin, 1951), 360–62, for a list of the most important.

40. See the discussion by Willibold Sauerländer, *The Catholic Rubens: Saints and Martyrs* (Los Angeles: Getty Research Institute, 2014), 134. The image relates to the legend that the Magdalene was kept alive for thirty years in the desert by angels transporting her daily to heaven for nourishment.

Figure 62. Giovanni Lanfranco, *Assumption of the Magdalene*, 1605

The second edition of Molanus's book was informed by the work of other theologians, such as Gabriele Paleotti, cardinal archbishop of Bologna, whose own treatise (1582) is a ringing critique of the patronage of the many Roman churchmen whose taste, Paleotti observes, still ran to Ovidian immoralities and lascivious depictions of any biblical scene with

erotic potential.[41] For Paleotti, who had been present at the council, these paintings were particularly damaging to moral formation, especially of the illiterate poor, who, lacking the sophistication to read such depictions as a sort of Christian allegory, could only be expected to be confused at best, or pornographically enticed at worst. Paleotti's rebuke strikes a similar note to that of Erasmus: "the Demon attempts to divert the true and proper use of images into other twisted and illicit channels. . . . He sees to it that figures are painted nude for the most part and very lasciviously."[42] The list of notable bishops who thought the painting of nude bodies and suggestive scenes in churches and church-related precincts was morally dangerous includes Saint Carlo Borromeo, archbishop of Milan (1538–1584), and his cousin, Cardinal Federico Borromeo (1564–1631), his successor at Milan. Federico wrote *De pictura sacra* (1625; reprinted 1634), there expressing views common to both Borromeos, urging especially that canonical Scripture be the basis for religious painting and that modesty in presentation be required.[43] It will be clear that to some considerable degree John Paul II, in his remarks on the Sistine Chapel restoration, was seeking to qualify these immediately post-Tridentine judgments.

The post-Tridentine commentators, like the council itself, were careful to urge restraint in depictions of pieties not formally sanctioned by the church. There was reason to be concerned, since some elements of Marian legenda not yet approved as matters of faith were very frequently depicted in one way or another in both painting and sculpture, sometimes to the occlusion of expected subjects, as in Titian's massive altarpiece (22′ 8″ × 11′ 10″) of the assumption of the Virgin for the Basilica of Santa Maria Gloriosa dei Frari, a Franciscan church in which the campaign for Marian spirituality was as advanced as the name suggests.[44] In addition to the assumption of the Virgin, most popular in Italy, the immaculate conception of Mary was one of the most common postbiblical subjects, found not only in Italian and Spanish but also in German art. For the im-

41. Gabriele Paleotti, *Discorso interno alle imagini sacre e profane*, trans. William Mc-Cuaig (Bologna, 1582; reprint, Los Angeles: Getty Research Institute, 2012), especially part II.1–3, pp. 157–83.

42. Paleotti, *Discorso interno alle imagini sacre e profane*, 158.

43. Federico Borromeo, *Sacred Painting*, trans. and ed. Kenneth S. Rothwell Jr. (Cambridge, MA: I Tatti Renaissance Library, Harvard University Press, 2010), 21–23, 54–59, 120–23.

44. Many regard this work, as did Antonio Canova the sculptor, as the most beautiful treatment of the subject; the young Oscar Wilde declared it to be the most beautiful picture in Italy.

Figure 63. Albrecht Dürer, *Virgin and Child on a Crescent with a Crown of Stars and a Scepter*, ca. 1516

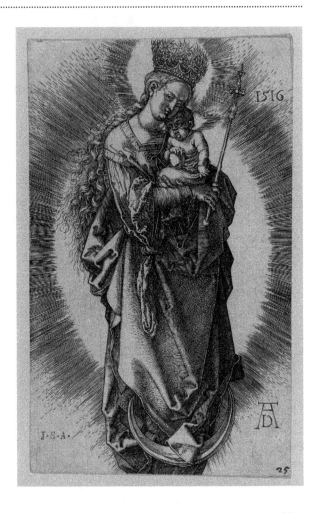

maculate conception, a robust iconography was already well developed by the early sixteenth century.

Albrecht Dürer, an artist influenced by Luther and his movement, created a traditional woodcut sequence on the life of the Virgin and made several engravings (1498 to 1516) of immaculate conception symbolism (e.g., fig. 63). Although the mantle of sun rays and starry crown owe to a biblical image of the "woman clothed with the sun" (Rev. 12:1–2), the iconography that has the Virgin standing on a crescent moon is Mediterranean in origin; from that latitude Venus, the "evening star," rises in some seasons just above the sliver of the moon. The ancient iconography of Venus, in which she appears as if lying on a scallop shell, may be a reflection of it.[45] Lucas Cranach did his own versions, as did many more

45. André Grabar, *Christian Iconography: A Study of Its Origins*, Bollingen Series, no.

artists in the south. Paleotti does not presume to formally condemn such works, but he regards it as theological rashness (*temerarie*) to "represent as certainties things that the Holy Church has refrained from determining—like the conception of the glorious Virgin." He continues with a firm guideline for preachers and painters alike:

> As a general rule, anyone presuming to define knowledgeably and verbally persuade others of things that the Holy Church has chosen for good reasons not to determine would undoubtedly be branded with temerity; and likewise anyone who tried to express the same notions in a painting would appear to be all the more reprehensible in that, pictures being exposed to the gaze of all, he would be making a public display of his obtuse boldness, not with fleeting words but in a permanent work. It would amount to rendering certain and indubitable testimony to what everyone else regards as unknown and so making oneself the author of new opinions while displacing ones from the past.[46]

Paleotti elsewhere backs up his strictures by insisting on the distinction between the canonical texts of the Bible, which "have authority and necessity because they constrain us to believe them in matters of faith," and "apocryphal books [which] have neither authority nor necessity."[47]

In the light of these and other comments occasioned by the council, we can see that there were real concerns among the Catholic bishops over the proliferation of unapproved doctrine as well as *lascivia*, and that in this regard they actually shared a great many concerns with the Reformers. They were, however, entirely ineffectual in stemming the tide of a popular

35 (Princeton: Princeton University Press, 1968), traces the origin of the star to the sixth century, and shows that "the use of the star above the figure of Mary . . . was suggested by pagan iconography, understood by all to mark the divine presence" (132–33). See also the essay by Amina Alyal, "There's Something about Diana: Ovid and the Development of Reformation Poetics," in *The Survival of Myth: Innovation, Singularity, and Alterity*, ed. David Kennedy and Paul Hardwick (Cambridge: Scholars Press, 2010), 65–67. A good deal of speculation on the possible syncretism of Venus and Mary has attended scholarship on Sandro Botticelli's *The Birth of Venus*; see Diana Blake, "*La Primavera*: Botticelli's Mythological Masterpiece," BellaOnline, accessed October 22, 2016, http://www.faculty.umb.edu /gary_zabel/Courses/Phil%20281b/Philosophy%20of%20Magic/Images/art31091.htm. In some cases Minerva was identified with the Virgin Mary as well; see Jean Seznec, *The Survival of the Pagan Gods: The Mythological Tradition and Its Place in Renaissance Humanism and Art* (New York: Harper, 1961), 105.

46. Paleotti, *Discorso interno alle imagini sacre e profane*, 161.

47. Paleotti, *Discorso interno alle imagini sacre e profane*, 171.

Figure 64. Francisco
Pacheco, *Immaculate
Conception*, 1621

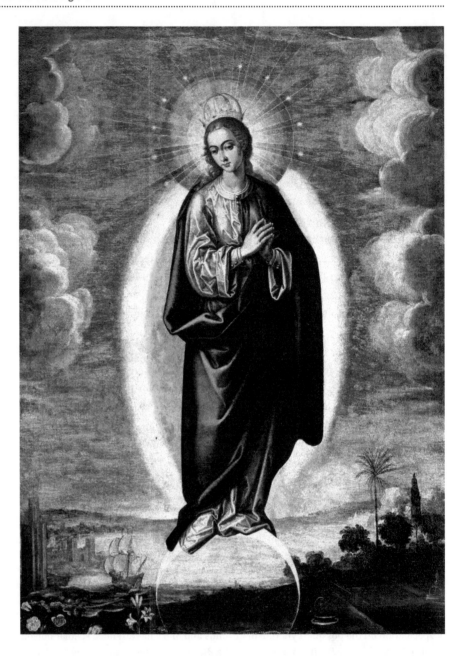

piety based on apocryphal texts and pagan iconography, as Seznec, in his
discussion of Paleotti, has observed.[48] Moreover, iconography once asso-
ciated with Venus and Diana (the moon) was increasingly employed by
artists well after both the council and these episcopal directives. Painters

48. Seznec, *Survival of the Pagan Gods*, 267.

such as Francisco Pacheco (1564–1644) (fig. 64) and Bartolomé Esteban Murillo (1617–1682) (fig. 65) were leading proponents of Marian themes that many, both clerics and laypeople, wanted to become official doctrine of the Catholic faith. Sometimes entire cities would back such a doctrine; Seville in Spain, for example, was officially devoted to the cult of the immaculate conception from early in the seventeenth century. Murillo was a native of Seville, and Pacheco had settled there as well; the many versions each did on this theme express a vigorous civic patronage. Here and elsewhere, Marian partisans would succeed in eventually establishing doctrine for which artists were likely the most effective advocates.

Viewed retrospectively, the general development of Marian art can be seen to reflect a deep desire to unite once again beauty and holiness in such a way as to provide for an intimacy of spiritual presence that had often been lost or obscured as art became a means to express the power of popes and princes. Like Titian's altarpiece in Venice, Murillo's rendition of the immaculate conception theme is beautiful in a pure, uncompromised way; the Virgin was always presented modestly in this period, more so than any other biblical personage.[49] That said, for many Catholics these images and their referents in popular piety became Catholic distinctives, identity markers for authentic faith opposed to Protestant impiety where the Virgin was concerned.[50] Émile Mâle describes a fresco by Domenichino (Domenico Zampieri, 1581–1641) in the chapel of Sant' Januarius in Naples showing the triumph of Marian spirituality over the Reformation, featuring a young champion treading underfoot the bodies of Luther and Calvin, so identified with inscriptions; he carries a banner that reads "Semper Virgo—Dei Genetrix—Immaculata."[51] This painting was probably in its motive a defense of holy beauty, but is not itself very beautiful.

Polemical art certainly existed on the Reformers' side as well, as in this quite unlovely grisaille by Girolamo da Treviso (ca. 1495–1544), which mimics an antipapal woodcut found in the Bible of Miles Coverdale (1535)

49. In his book *The Art of Painting* (1649), Pacheco gives an account of the iconography he thinks appropriate to the subject: "In this loveliest of mysteries Our Lady should be painted as a beautiful young girl of twelve or thirteen years of age . . . wearing a white tunic and a blue mantle . . . surrounded by the sun . . . with rays of light emanating from her head, around which is a ring of twelve stars." He adds, "An imperial crown adorns her head, without, however, hiding the stars."

50. Another example is *The Intervention of Christ and Mary* by Filippino Lippi (1495), at Alte Pinakothek, Munich, expressing the doctrine that prayer should be made to Mary, who would then intercede with Christ, begging his intervention with God the Father.

51. Mâle, *Religious Art*, 169.

Figure 65. Esteban Murillo, *Walpole Immaculate Conception*, 1678

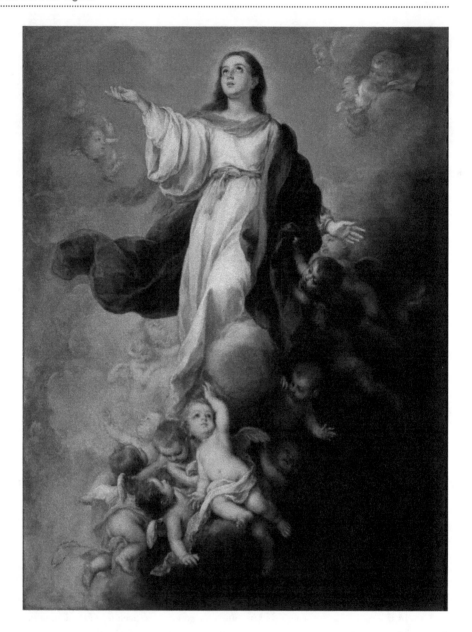

(fig. 66). Here the pope, presumably Paul III, accompanied by courtesans (allegorically representing avarice and hypocrisy), is being stoned by the four Evangelists, Matthew, Mark, Luke, and John. No such artwork, it need hardly be said, does much to advance an appreciation of either holiness or beauty; it gratifies instead an appetite for self-righteousness and vindication, as presumably here it was intended to do for its patron, King Henry VIII.

Figure 66. Girolamo da Treviso, *Protestant Allegory*, 1543

Art in the service of doctrinal agendas can easily fail to inspire either worship or tender admiration, as countless such examples show. On both sides of the Reformation split, much of it became ugly, even grotesque. One such painting, begun by the elder Cranach but finished by Lucas Cranach the Younger (1515–1586) after his father's death, was painted at Wittenberg between 1553 and 1555 (fig. 67). It shows as well as any work of the period the dislocations that can occur when an artist aspires to reflect theological innovation while depicting a holy subject. The scene at the foot of the cross is a bizarre composite, symbolizing the meaning of Christ's atoning death on the left, namely, his triumph over sin and death, hell and the grave, while those who stand by the cross next to John the Baptist, who presumably explain this meaning, are the elder Lucas Cranach and Martin Luther, preaching "Christ and him crucified" (1 Cor. 2:2). Mary and the usual biblical figures found in crucifixion images (other than the Baptist) are excluded, and instead of the older allegorical blood of the symbolic Lamb flowing into a chalice, we see the blood from Christ's pierced side flowing out in an arc and landing on the head of the preaching Luther. The message here is emphatically one of personal salvation and the receipt of grace individually, proclaimed as Lutheran doctrine. No

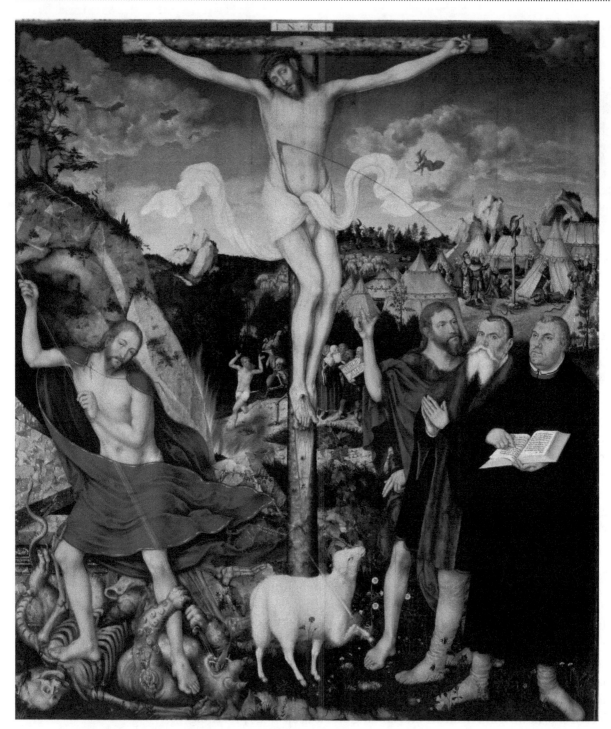

Figure 67. Lucas Cranach the Younger, *Allegory of Redemption, Weimar Altarpiece,*
Stadtkirche Sankt Peter und Paul, Weimar, 1555

one, perhaps not even the first viewers of the work, need look too long at the crucified Savior; in the left foreground the risen Christ, putting down sin and death, balances the gravity of Luther preaching on the right. This is not art for holy contemplation on the passion, Christ suffering for the sins of all, but is art for confirming the specific Lutheran doctrine that "before you take Christ as an example, you first accept and recognize him as a gift and present that is given to you by God and is your own."[52] Although it resembles devotional altarpieces such as those by the van Eycks and Grünewald superficially, the viewer is in this case asked to affirm a specific and individualistic interpretation rather than to lose herself in grateful wonder before the *mysterium tremendum*, that Christ Jesus died for the sins of the world, or, in the Franciscan manner, be moved in contrition to identify with Christ in his suffering. The beauty of the holy, the beautiful deed done at Calvary, is less an objective of the artist's work than is the communication of a distinctive doctrine.

CONCLUSION

The sixteenth century was a time of bountiful opportunity for artists, in Rome and the Papal States perhaps especially, but also in the Lowlands and Spain. Munificent patronage was to be had, for serious artwork had enormous prestige. But it was also a confusing time, not least because of uncertainty about the complication of iconography. Most of the learned found it possible to see how pagan myth might be construed as an allegory of Christian doctrine, but not all of them found the conflations sound; Luther and Melanchthon were among the critics, but many of the humanists, Erasmus included, enjoyed the analogies.[53] Other humanists were prepared to abandon biblical stories altogether in favor of allegorized classical narratives, leading Jean Seznec to observe: "Neoplatonic exegesis, which had presented them [the humanists] with hitherto undreamed-of possibilities of reconciliation between the Bible and mythology, had now so obscured the distinction between the two that Christian dogma no longer seemed acceptable in anything but an allegorical sense."[54]

52. *Luther's Works*, ed. Jaroslav Pelikan and Helmut T. Lehmann, 55 vols. (Saint Louis: Concordia, 1957–1986), 35:119.

53. Seznec, *Survival of the Pagan Gods*, 96n56, 99n71.

54. Seznec, *Survival of the Pagan Gods*, 99.

The confusion was exacerbated by the fact that Christian iconography itself had undergone significant development since the early period (300–700 CE). In that time it had three dominant themes: (a) it pointed to Christ; (b) it expressed doctrines about Christ; (c) it presented Mary as the Theotokos. All of this, as we have seen, had to that point a largely fixed iconic vocabulary. When biblical narrative entered so forcefully into Christian iconography after the twelfth century, accelerating in the thirteenth century, painting especially became the means of a visual or graphic gospel for the unlettered, and the iconography was simplified by virtue of more perspicuous narrative. Then, with the enormous popularity in Italy of Franciscan legenda, stressing *imitatio Christi* as the singular path to holiness, there was added a new set of meanings and images showing parallels between the saints' lives and biblical stories. Franciscans then began, especially from the last quarter of the thirteenth century to the beginning of the sixteenth century, to focus on Marian themes that had their basis in the noncanonical lives of the Virgin, stories which themselves stressed parallels with (rather than imitation of) the life of Christ. The immaculate conception paralleled the virgin birth, the assumption of Mary paralleled the ascension of Christ. This required a new and more symbolic iconography, one prone to draw on classical analogies. The pattern of parallelism extended to other saints both biblical (such as Mary Magdalene) and medieval. Reiteration and inevitable conflation created confusion for the artists themselves, let alone for learned interpreters and ordinary laypeople; hence the enormous effort in the seventeenth century by professional iconographers to sort it out (see appendix B).

To top it all, the great style change of the thirteenth century, with its fresh emphasis on verisimilitude and psychological realism, increased tension between the beautiful surfaces of visible reality and the transcendent spiritual or intelligible realities toward which depicted physical persons, objects, and gestures were supposed to lead the mind. A huge problem for thoughtful artists emerged: If ultimate reality is invisible, how does the artist render visibly convincing a sign of that reality? Leonardo da Vinci, in his two versions of the painting known as *The Virgin of the Rocks*, depicted the scene with two different iconographic vocabularies. In the London National Gallery canvas Mary and an angel are overseeing an infant John the Baptist, with his standard cruciform staff, worshiping the smaller infant Jesus, whose hand gesture signifies the blessing of the Trinity. Each of the human figures has a slender nimbus. In the version at the Louvre, the halos and John's staff are absent, and the wings of the

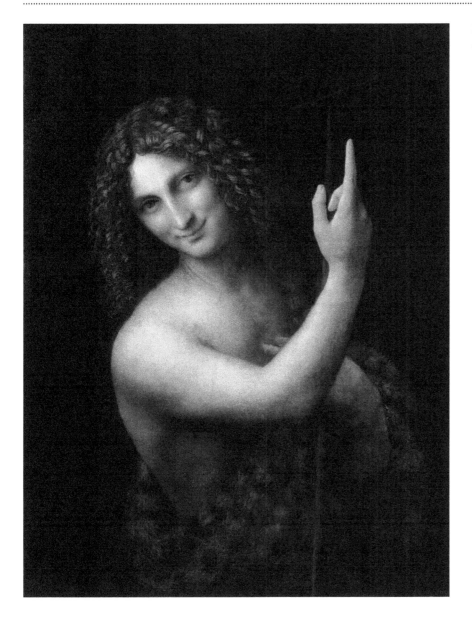

Figure 68. Leonardo da Vinci,
Saint John the Baptist, 1516

"angel" have disappeared into the texture of the rock; the Virgin is now a young woman, but she points with her hand toward the infant John so as to cause the viewer to see that he is worshiping the other child. How is the painter to let nature be natural, and still point to the supernatural? The Louvre version was painted in the midst of a dispute over iconography in which Leonardo resisted the directions of the ecclesiastical patron, the Confraternity of the Immaculate Conception, and it was finished about 1485. The London National Gallery painting was finished by about 1490,

and despite the dispute over iconography (and money), is assumed to have satisfied the confraternity.[55]

As far as we know, the last painting of Leonardo's life was his *Saint John the Baptist* (1514–1516), worked and reworked in his studio at Cloux, in France, and completed on the eve of the Reformation. It was and is a puzzle. The iconographic gesture and the cross-staff as well as the hair-cloth mark the figure of John the Baptist indubitably, but his hand points neither to Christ on earth nor to the cross. The hand presumably gestures, like the right hands of Plato and Saint Ambrose in the Stanza della Segnatura, upward to an unseen reality. Yet the chiaroscuro and soft focus around the model's face highlight the hand and index finger distinctively. The expression of the Baptist is bemused and ambiguous; it is the more sharply focused iconographic sign of the hand itself at which the painting forces us to look. Nothing in the face of the one who cried out in the wilderness now gives any assurance as to the meaning of the gesture—which is the real subject of this work (fig. 68).

With all narrative context stripped away, what are we to make of this painting? Can it be described as beautiful? Was it intended as a holy image? What does it signify? The work raises all these questions, and more. This was a work done without a commission, a personal painting of the artist on which he worked on and off for at least two years. We may wonder if Leonardo, the genius who had solved so many technical problems, did not come to the end of his days with the problem of how to depict the meaning of the holy still fundamentally unsolved.

55. Angelina Ottio della Chiesa, *The Complete Paintings of Leonardo da Vinci* (New York: Abrams, 1967), 93–95, offers a good discussion of the dispute and provenance.

8 BEAUTY AND THE EYE OF THE BEHOLDER

Men should not paint or carve anything but such as can be seen by the eye.

CALVIN, *INSTITUTES*

I f there is a human character from the Hebrew Scriptures whom Jews and Christians might be expected to associate with holiness, it is probably "good King David." The poet who sang the praises of "the Holy One of Israel" (Pss. 22:3; 71:22; 89:18), who was said by the author of 1 Samuel to be a man after God's own heart (1 Sam. 13:14), and whose line was chosen to produce the Messiah has been associated for centuries by Christians with divine election, sanctification, and exemplary piety. Interestingly, he is also associated with beauty, not only because of the timeless grace of his poetry, but also because the subject of so much of it is "the beauty of the LORD" (Pss. 27:4; 50:2). But as we saw in chapter 1, in the poetry attributed to him he is also well aware of the beauty of women (Ps. 45:11). For her part, Bathsheba, one object of the king's wandering eye, was nothing if not beautiful (2 Sam. 11:2). These associations with reputed holiness and striking beauty, respectively, subsequently heightened by both Jewish and Christian commentary, seem to have made the story of David and Bathsheba irresistible for artists and patrons on both sides of the Reformation split.

Viewed from a contemporary perspective, the story of Bathsheba and King David remains perhaps the best-known exemplum of voyeurism and its consequences in biblical tradition. The focus in exegesis and literary paraphrase has been overwhelmingly on King David: his lust, abuse of

power, and murder of Bathsheba's noble husband, Uriah, followed by his shaming by Nathan the prophet and abject repentance, reflected in the magnificent biblical poem *Miserere mei, Deus* (Ps. 51), one of the foremost sacred songs of Christian tradition. But while David's anguished poem of repentance has been set to music often and brilliantly (compositions by Josquin Desprez, William Byrd, Giovanni Gabrieli, Heinrich Schütz, and Gregorio Allegri are among the best), the manuscript illustrators, printmakers, and painters have tended to linger over the occasion of it (2 Sam. 11:2–3), unable to turn the eyes of their imagination away from the "fair Bathsheba" herself. It is as though they see the story from the tempted David's point of view rather than that of Nathan the prophet, or the narrator, the chronicler, or later commentators; to these artists the repentance of David is much less interesting than his sin.

The disposition to focus on Bathsheba involves, of course, artistic license—even a deliberate imposition upon the biblical narrative. The case is far from unusual. Biblical narrative may even be said to invite such interpolations.[1] But traditionally, any imaginative "filling of the gaps" is to some degree constrained, forced back to the original text for credible warrant. In regard to any imaginary character development in literary or artistic treatment, ordinarily there must be some plausible prompt or kernel of suggestion in the original biblical account. To wit: in our example, a possible question in the mind of the reader arises as to whether Bathsheba was, in her own way, seeking the attention that came to her. On this matter, the text, though cryptic, leaves much to the imagination.

Subsequent aspects of the narrative development being what they are, imagination has not been wanting, even from the first, to gratify a variety of desires for amplification. In early etymologies given for her name there are already hints: *bat-sheba'* suggests "daughter of fullness" or "well-endowed daughter," and while later Jewish commentaries soften this somewhat, suggesting the meaning is "a fine quality of figs" (Sanhedrin 107a), erotic overtones still clearly linger. In the Chronicles, a later text than 2 Samuel, in which she is remembered chiefly as the mother of four sons of David, her name is given as "Bath-shua" (1 Chron. 3:5), more narrowly "daughter of opulence," a suggestion that, in the light of the history of the kings of Israel, there was need by this point to turn the focus away from her seduction by David to her royal role as mother of Solomon. The shift is more emphatically expressed when she is cited in

1. See, e.g., Robert Alter, *The Art of Biblical Narrative* (New York: Basic Books, 1981), 12, 36–37, 114–29.

later Jewish commentary of the Talmudic period: Bathsheba now becomes one of the "twenty-two virtuous women," and is even regarded as possibly the wise woman celebrated in the last chapter of Proverbs as "the mother of Lemuel," or Solomon (Sanhedrin 70b; Mishle 30, 107–8; 31, 112). This rather impressive Jewish makeover fails to carry over into early or medieval Christian commentary. There, from the fathers through to the *Glossa ordinaria*, Bathsheba is remembered only minimally as the occasion of great sin by an otherwise largely noble king through whom the Messiah descends. Despite Bathsheba's indispensable role in that descent, there is already a hint of embarrassment in Matthew's genealogy, where her name disappears and she becomes simply "her that was wife to Uriah" (Matt. 1:6). Though the grievousness of David's sin is not entirely elided, the focus has shifted somewhat, away from his act of adultery to his murder of Bathsheba's first husband.

SAVING APPEARANCES

This lingering embarrassment relates in patristic exegesis to the requirements of typology: the early commentators cannot avoid seeing David as an antitype of Christ. Accordingly, various forms of exculpation of David rather than of Bathsheba, different in strategy but not in purpose from those in haggadic commentary,[2] are employed either to downplay the Bathsheba incident or to allegorize it away. Saint Augustine is representative of the first stratagem in his *De doctrina Christiana*, in which he excuses David as "not lustful, though he fell into adultery" (3.21).[3] Elsewhere, the diminished focus on Bathsheba shifts almost entirely toward her later life, when her intervention secures Solomon's ascendancy to the throne (1 Kings 1:11–31), permitting the Middle English *Cursor mundi*, for example, to minimize the seduction scene (ll. 7888–7892) and develop her character rather more positively and certainly far more extensively in terms of her display of rhetorical skill as a kingmaker, pleading for Solomon over Adonijah (ll. 8331–8434). More cryptic still is Saint Bonaventure, who simply overlooks David's *lapsus calumni* altogether.[4] A minimalist

2. See Louis Ginzberg, *The Legends of the Jews* (Philadelphia: Jewish Publication Society of America, 1967), especially 4:103, 117–18; 6:260–65, 281.

3. Augustine, *On Christian Doctrine*, trans. D. W. Robertson Jr. (New York: Macmillan Library of Liberal Arts, 1958).

4. *Cursor mundi*, ed. Richard Morris, 3 vols., Early English Text Society (London: Oxford University Press, 1875; reprint 1966), 2:455, 481–87; Bonaventure, *Hexaemeron: Col-*

approach to Bathsheba's beauty and its consequences may have seemed to medieval commentators a kind of charity toward the larger narrative.

Gregory the Great exemplifies, perhaps even originates, a more demanding allegorical strategy for regal exculpation in his ingenious account in the *Moralia in Iob*:

> It very often happens that a circumstance . . . is sometimes in the performance of the action a ground for condemnation, but in the writing a prophecy of merit. . . . For who that hears of it does not utterly loathe this, that David, walking upon his solarium, saw and lusted after Bathsheba, the wife of Uriah? . . .
>
> But of whom does David walking upon the terrace prefigure, other than that one of whom it is written, "he has set his tabernacle in the sun" [Ps. 19:4]? And what else is it to draw Beersheba to himself, but to join to himself by a spiritual meaning the Law of the formal letter, which had been united to a carnal people?[5]

This raises the rabbinic art of "saving the appearances" to a whole new level. Gregory goes on to etymologize "Beersheba," his unexplained substitute for her name, as "the seventh well" (cf. Gen. 21:28–31; 26:32–33), which alias lets him slide on into still more ingenious allegories about the yielding of the knowledge of the law to spiritual wisdom.

Such moves, however awkward, presage later medieval tradition: Gregory's purloined etymology becomes the "seven-fold well" in the *Glossa ordinaria*,[6] where it contributes to the iconography of Bathsheba's bathing scene and the resulting temptation of King David, allowing for a loose conflation with Jesus's discourse with the Samaritan woman by the well and the superposition of more modest iconography appropriate to the New Testament episode (John 4:6–39). Also in the *Glossa ordinaria*, Saint Eucherius and the *Etymologiae* of Saint Isidore of Seville are invoked to represent Bathsheba as a type of the Law, and her seduction and later marriage to David as liberation from the carnal letter of the Law and marriage to its spirit.[7]

What is notable here is the strength of Gregory the Great's influence: his typological associations form the basis of subsequent convention in

lation on the Six Days, trans. Jose de Vinck, in *Collected Works of Bonaventure* (Paterson, NJ: St. Anthony Guild Press, 1984), 5.19.

5. Gregory, *Moralia in Iob* (supra Job 2:13) 3.55.

6. Patrologia Latina 113:571–72.

7. Patrologia Latina 113:571b.

allegory, despite their awkward disjunction with the story at its literal level. Thus, in the *Aurora*, or *biblia versificata*, of Peter Riga, Bathsheba is described as the "denuded" law, divested of its legalistic encumbrances, and hence those "white lilies of the Scriptures" that Christ loves.[8] Riga's language in this passage manages nonetheless to be oddly suggestive, and may be reflective also of another passage in Augustine in which, to make a moral point, he was unable to evade the literal level of the narrative. Those who are susceptible to the lust of the eye, Augustine had suggested, should be warned by this story to "raise not complying eyes to strange balconies, to strange terraces. For from afar David saw her with whom he was captivated. Woman afar, lust near. . . . Carnal pleasure, especially if directed toward unlawful and strange objects, is to be bridled, not let loose; by governance to be tamed, not set up as a principle of governance."[9] Now what is perhaps surprising, and yet of primary interest in our present context, is that this mainstream of traditional Christian exegesis—a moral or tropological reading of the story in which Bathsheba figures as an irresistible temptation to carnal appetite—receives less attention in medieval literature than it does in medieval art. Later on, the temptation scene and its moral dimension are accented both in commentary and book illustration, especially in the period immediately following the Reformation.

Martin Luther still regards the incident of David's adultery typologically, and, at the literal level, in a matter-of-fact fashion, as something not to pause over much. Though medieval theologians may have seen the challenge presented by the text as primarily maintaining David's exemplary role after his predatory adultery with Bathsheba, in Luther's reading there is no trace of comparable concern; like his disciple Philipp Melanchthon, who recommended a second wife to Henry VIII, Luther was inclined to be untroubled by polygamy in general, let alone polygamy among biblical kings and patriarchs.[10] John Calvin, however, entirely self-consistently,

8. "Designat Christum David, Vrias synagogam, / Bethsabee legem, si bene quoque notes. / Nuda placet Regis species, in corpore nudo, / Non in uestito regius heret amor: / Nuda placet Christo lex, non uestita figuris; / Candida scriptorum lilia Christus amat." In *Aurora: Petri Rigae Biblia Versificata*, ed. Paul Beichner, CSC (Notre Dame: University of Notre Dame Press, 1965), 1.278; *liber secundus regum*, 195–200.

9. Augustine, *On the Psalms*, supra 51.2–4, 3.

10. "I confess that I cannot forbid a person to marry several wives, for it does not contradict the Scripture. If a man wishes to marry more than one wife he should be asked whether he is satisfied in his conscience that he may do so in accordance with the word of God. In such a case the civil authority has nothing to do in the matter" ("Letter to Chancel-

is neither indulgent of David's sin nor much interested in Bathsheba's predicament one way or the other. For him, distinctively, the illicit liaison is just one more indication that the sovereign purposes of God in salvation history are not dependent on the virtues or vices of any human protagonist. For Calvin, David's sexual misadventure offered a warning that should have been heeded by the Jews collectively: so, "this human misconduct, . . . [an] ugly episode at the start of the kingdom, should have stopped the Jews from glorying in the flesh. But God wished to testify that . . . he gave no weight to human merits."[11] This seems rather dry and unsatisfying from a literary point of view. Yet despite Luther's apparent lack of surprise at David's "bold sin" and Calvin's dismissive generalization, Protestant artistic treatment of this story over the next few decades tends increasingly toward psychological realism. This development becomes at least as interesting in its own modest way as the more frankly erotic treatment by Catholic artists, and, in the work of Rembrandt, it eventually produces something both novel and compelling.

BATHSHEBA'S BEAUTY

The biblical narrative is famously terse where physical or physiological description is concerned: according to the biblical narrative, from his rooftop garden David rises up from his bed in the *ha'erev* (not in the exculpatory "late one afternoon from his couch" of the ESV, but from his bed "in the evening," suggesting an extremity of indolence or something like unto it), and he looks down into the courtyard of a nearby house to see "a woman washing herself, and the woman was very beautiful" (2 Sam. 11:2). The English translation usually given (RSV/NIV/ESV) euphemizes: the Hebrew is more explicit—she was *tovoth mr'h m'd*, "of extremely good shape." This follows, naturally, the rather earthy confirmations of female comeliness suggested by her name, but also highlights the pending

lor Gregory Bruck, Jan. 13, 1524," in *Luthers Briefe*, ed. W. M. L. de Wette [Berlin, 1825–28], 2:459, see also 329–30); regarding the story of David and Bathsheba, he said, "no sin or crime is an impediment to marriage. David committed adultery with Bathsheba, Uriah's wife, and had her husband killed besides. He was guilty of both crimes; still he took her to wife and begot King Solomon by her, and without giving any money to the pope!" Martin Luther, *The Estate of Marriage* (1522), in *Luther's Works*, ed. Jaroslav Pelikan et al., 55 vols. (Philadelphia and Saint Louis: Fortress, 1957), 36:26.

11. John Calvin, *Harmony of the Gospels* 1, in *Calvin's New Testament Commentaries*, ed. David W. Torrance and Thomas F. Torrance (Grand Rapids: Eerdmans, 1972), 1:59.

Figure 69. Peter Comestor, biblical paraphrase of 2 Samuel 11, thirteenth-century French translation, Museum Meermano MMW 10B 23, fol. 145r

problem. Though she is obviously sexually appealing, her roof tops the house of another man. From the biblical narrative we do not know to what degree she was unclothed while bathing, but if we are to assume that her bathing was ritual purification (following menstruation), then perhaps her drapery was minimal to nonexistent.[12] In early medieval illustration this probability is distinctly muted, as in the Petrus Comestor MS illustration here (fig. 69), in which she appears merely to be combing out her wet hair.[13] Manuscripts of the thirteenth-century *Bible moralisée* are a little more explicit, but not much. Books of hours by the late fifteenth and early sixteenth century, however, can be much more risqué, even though it is not the narrative in 2 Samuel but the repentant king's *Miserere* (Ps. 51) that

12. Cf. Lev. 15–17; see also Deut. 23:11.

13. Petrus Comestor, Bible Historiale, MS Den Haag, MMW, 10 B 23, dated about 1372. In some medieval manuscripts the scene is simply omitted altogether, as, e.g., in the *Tres riches heures du Jean, Duc de Berry* (Jean de Columbe), fol. 67v.

Figure 70. MS Den Haag
MMW 10 F 33, penitential
psalms, 1524

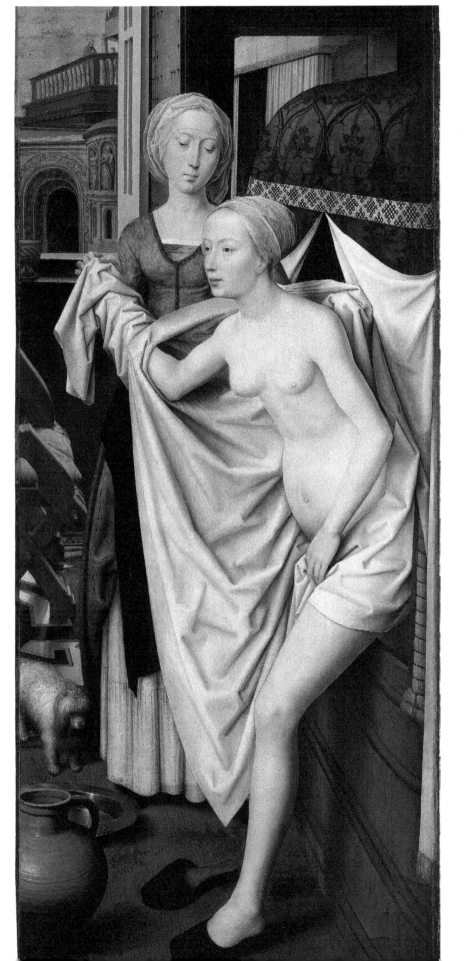

Figure 71. Hans Memling,
Bathsheba Bathing, 1485

Figure 72. Luther, *Seven Penitential Psalms*, 1525
Figure 73. German Catechism, 1531

they are supposedly illustrating.[14] In the penitential psalms of a book of about 1524 found in the Museum Meermanno in the Hague (MS Den Haag MMW 10 F 33), Bathsheba stands erect in the fountain, breasts partially exposed to the prurient gaze of the king, while her buttocks are partially exposed to the viewer (fig. 70). This follows an earlier (1510) miniature (MS Den Haag, KB 129 GZ) for the same text (Ps. 51), in which the viewer sees a near frontal full exposure of Bathsheba standing in a pool, while David views her back only (fig. 71), a stratagem perhaps imitative of Hans Memling's better-known oil on wood "Bathsheba" of a few years earlier. In these representations the viewer is allowed to see what David cannot quite, and thus is even more directly than the king himself, so to speak, enticed as a voyeur.

Early Lutheran book illustration follows this approach to varying degrees but generally with more modesty, as notably in an illustration for

14. Cf. Thomas Kren, "Bathsheba Imagery in French Books of Hours Made for Women, ca. 1470–1500," in *The Medieval Book: Glosses from Friends and Colleagues of Christopher de Hamel*, ed. James H. Marrow et al. ('t Goy, Houten, Netherlands: Hes & de Graaf, 2010), 169–82.

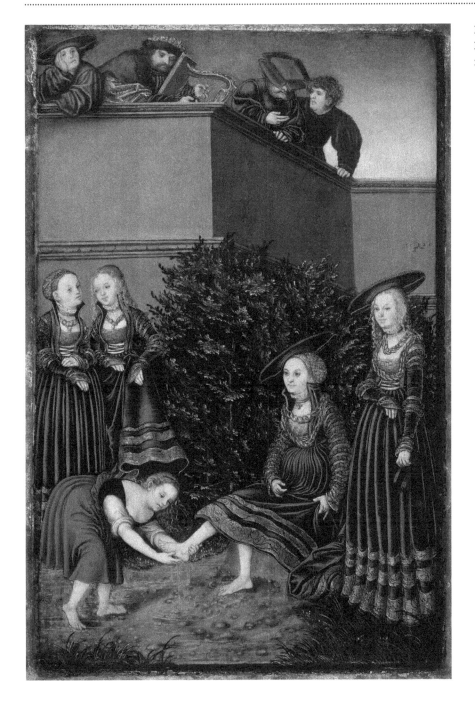

Figure 74. Lucas Cranach the Elder, *David and Bathsheba*, 1526

Martin Luther's printed commentary on the seven penitential psalms of 1525 (fig. 72).[15] But there is equally apparent, among the flood of Bathsheba representations of the sixteenth century, a yet more modest mien emerging. For example, the new German catechism of 1531 (*Deutsch Catechismus*) (fig. 73) follows closely the depiction of Lutheran painter Lucas Cranach in his 1526 oil-on-wood painting, showing David and a group of courtiers looking down upon an elegantly attired Bathsheba among her ladies-in-waiting, one of whom makes as if to wash her extended foot (fig. 74). Learned awareness of the Hebrew euphemism "feet" for genitalia (*regel*—cf. Deut. 28:57; 2 Kings 18:27; Ezek. 16:25) is doubtless behind the iconography; a postmenstrual ritual purification would seem quite possibly to have been intended. This Lutheran iconographic turn to modesty appears in illustrations also for the Swiss-German dialect translation, *Die gantze bibel* (1536)—sometimes called the "Zurich Bible" (fig. 75)—here for the 2 Samuel narrative itself. The type is found as well in Michael

15. Martinus Luther, *Die Sieben Buosz Psalmen, mit ainer Kurtzen Auszlegung* (1525), Pitts Theological Library Archive.

Figure 76. Michael Helding,
*Brevis institutio ad
Christianum pietatem*, 1548

Helding's *Brevis institutio ad Christianum pietatem* (1548), also known as the Helding Catholic Catechism (reprinted 1557), in a discussion of the Decalogue (fig. 76).

At this point we have returned to an earlier medieval decorum. After midcentury, however, third-generation Protestant illustrators seem happy enough to revert to more frankly erotic depictions of partial to full female nudity in the later medieval style. One sees this especially in editions of Luther's translation of the Bible, but also in a work attributed variously to Philipp Melanchthon and Johannes Coglerus, essentially catechetical, entitled the *Imagines elegantissimae* (1558). In this work the Bathsheba scene illustrates the sixth commandment, against adultery (fig. 77).

In the same period, catechisms for children display Bathsheba discreetly, mostly clothed, with little more than legs bare to midthigh, while David leers over the balcony, strumming his harp; in the illustrated Luther

Figure 77. Philipp
Melanchthon and Johannes
Coglerus, *Imagines
elegantissimae*, 1558

Bible designed for family use, the scene is even more modestly depicted.[16]
In later Calvinist catechetical literature one can observe a considerably
stricter concern regarding the perils in all such visual indulgence; for Cal-
vin himself, apparent nudity is to be eschewed in biblical illustration and
catechesis alike as a "Romanish" distraction from proper worship: "For
what are the pictures or statues to which they append the names of saints,
but exhibitions of the most shameless luxury [lechery] or obscenity? In-
deed, brothels exhibit their inmates more chastely and modestly dressed
than churches do images intended to represent virgins."[17] We might ex-
pect this view from Calvin, and recognize his scruple as presaging the
image-free, whitewashed churches of Protestant Amsterdam that, in their
austere beauty, so fascinated the painter Saenredam. But a view very like

16. Andreas Osiander, *Catechismus oder kinder predig* (Wittenberg, 1548).

17. John Calvin, *Institutes of the Christian Religion* (1536), 1.11.7, trans. Henry Beveridge,
2 vols. (Grand Rapids: Eerdmans, 1981), 1:96. Calvin develops his argument at length on
pp. 91–102.

Figure 78. Jan David,
Christeliicken Waerseggher,
1603

it appears, as we have seen, in Erasmus, in Session 25 of the Council of Trent, and in the writing of distinguished post-Tridentine bishops.

Here again, at the turn of the seventeenth century, with no less stern an admonition and even shrewder pedagogical ingenuity, it appears concisely in the Jesuit Jan David's *Christeliicken Waerseggher* (1603) (fig. 78). In one of the most striking engravings in that volume, we are shown a diagram of a human skull as a house of the mind, showing the eyes as portals

for visual temptation, with textual accompaniment warning against any "unconscious gaze" that may allow the eyes to become a gateway for the entrance of sin. This is an old motif indeed, tracing at least to Saint Augustine's *De Sermo Domini in Monte* (supra Matt. 5:28), and in Jan David's book it is illustrated by articulated mechanical notions of the operation of the phantasm, entering through the eyes, and firing the imagination to culpable *delectatio cogitationis*.

Such warnings seem not to have been much heeded by the illustrators and painters who were Jan David's contemporaries, many of whom seem to have been almost as attracted to Bathsheba as was King David. Moreover, there is in some of their work evident adumbration of the Bathsheba narrative with classical stories of temptation and seduction. The myth of Venus and Adonis, for example, is recollected in *David and Bathsheba* (1562) by Jan Massys (fig. 79). Massys, a son of Quentin Massys, had been temporarily banished for heretical (not necessarily Protestant) opinions in 1543, and had returned from a sojourn in Italy much affected by the depictions he saw there of classical subjects, particularly from Ovid. In this lush oil painting, executed just as the Council of Trent was drawing

to a close (1563), sexual iconography predominates:[18] the emissary courtier for David greets a nearly nude Bathsheba, bowing as he does so with extended leg, simultaneously pointing aloft to his waiting master (almost as if in parody of some representations of the annunciation). The courtier is accompanied by a hunting hound of the sort one might associate with Adonis; it evidently starts up Bathsheba's spaniel, which for its own part responds rather more playfully than in any convincing show of resistance. In this painting Bathsheba's response is coquettish bemusement, while that of her attendants is a sympathetic titillation. After this period the lady's spaniel is increasingly present in the iconography of David's immodest proposal, but whereas in medieval iconography of a heroine of *amour courtois* such a canine might have been a reminder of the virtue of fidelity (hence "Fido," from *fides*), here the traditional purpose is invoked, perhaps somewhat in the fashion of the sleeping dog in Titian's *Danae* or his *Venus of Urbino*, slyly to suggest that the guardian of fidelity is off-duty, or even more cynically, that *fides* is a losing proposition. In numerous other examples of Counter-Reformation depictions of Bathsheba in her bath, the dog is dispensed with altogether in the interest of an undistracted visual bacchanalia, more like an orientalist imagination of a harem bath scene than anything that one could connect with the biblical story.[19] Not for nothing was Jan David concerned with "perils of an incautious gaze," as his text puts it. Yet in most of the Bathsheba paintings being commissioned—even after the Council of Trent—such caution was thrown to the wind.

In Peter Paul Rubens's more famous *Bathsheba at the Fountain* (1635), this general development achieves its apogee (fig. 80).[20] In Rubens's depic-

18. A year before he had used the same model for his *Venus of Cithera*, Cithera being the fabled garden of lovers' delights (Stockholm, Nationalmuseum).

19. E.g., the versions by Giovanni Battista Naldini (1572), Jacopo Zucchi (1573), and Cornelis Cornelisz (1594).

20. According to Paul Oppenheimer in *Rubens, a Portrait: Beauty and the Angelic* (London: Duckworth, 1999), Rubens was conventionally Catholic but a passionate apostle of mortal beauty, especially the sexual beauty of women; he painted in search of beauty as a kind of earthly universal: "he is convinced that he has actually solved the problem of beauty, of what the word must ultimately mean, and his exemplary solution, which is not simply his own but a universal one, manifests itself in his every brush stroke and in virtually all else he does, whether in his painting or in the rest of his astonishingly diverse life" (5). It is probably necessary to qualify this view somewhat in recognition of Rubens's evident attraction to Stoicism and to Roman, not necessarily Roman Catholic, mores; see here Mark Morford, *Stoics and Neo-Stoics: Rubens and the Circle of Lipsius* (Princeton: Princeton University Press, 1991).

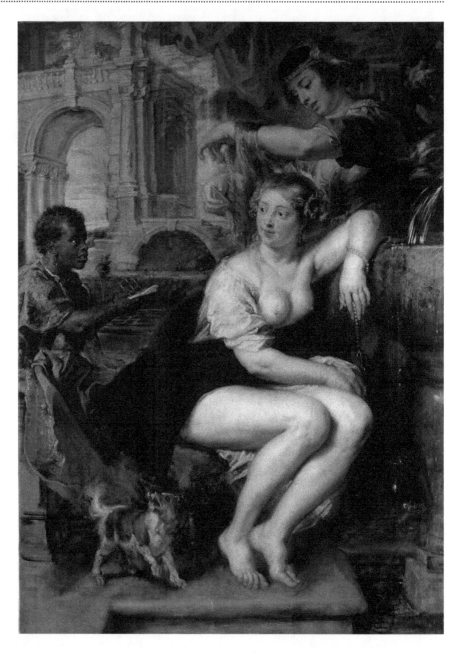

tion, those features of the iconographic tradition for Bathsheba's *toilette*
are unambiguously arranged in such a way as to invite the viewer of the
art to experience vicariously the temptation to which King David suc-
cumbed. David himself has a prospect on Bathsheba's nudity only from
behind, and his minimized shadow is executed in the manner of Hans
Memling's *Bathsheba* and Luther's *Penitential Psalms*. The viewer, on the

other hand, sees what the artist sees. Rubens's *Bathsheba* was painted almost simultaneously with his flamboyantly lascivious *Susanna and the Elders* (1635); the Susannah story from the apocryphal Daniel 13 had by this time become another favorite biblical subject among seventeenth-century painters, and was explicitly associated with predatory voyeurism and similarly encouraged rather than discouraged voyeurism in the viewer.

It has been thought that both paintings may have been inspired to some degree by Rubens's infatuation with his second wife, Hélène Fourment. He had married her five years earlier (when he was fifty-three and she, sixteen). Whatever the merit of this theory in respect to his choice of a model, her depiction in his *Bathsheba* is frankly sensual and cheerfully erotic, without a hint of any interest either in typology or moral instruction.[21] Though Rubens was raised in an intensely religious household (his father had been a persecuted Calvinist, and after his father's death his pious Catholic mother raised him in her own faith), this painting is, in effect, a secular work of art.[22] One may say on the evidence, in fact, that though he was the leading figure among Counter-Reformation (baroque) painters, his popularity with wealthy patrons—including ecclesiasts—was because of just such voluptuous depictions.[23]

We see Bathsheba seated, provocatively semidraped, after her bath, having her hair combed by her young maidservant. Her aspect is coquettish and casual; looped loosely around her left arm, where it rests against

21. Oppenheimer describes this as "an undistorted appreciation of her charms" (*Rubens, a Portrait*, 307).

22. R.-A. D'Hulst and M. Vandenven, *Rubens: The Old Testament*, trans. P. S. Falla (New York: Oxford University Press, 1989), 24. It is interesting that renditions of the subject in verse drama were also popular in the sixteenth century. In France the tendency was to follow the exculpation motif fairly closely, even in Richard Belleau's *Les amours de David et Bathsabee* (1572), and narrowly so in A. Montchréstien's *David, ou l'adulterie* (1595) and A. Pape's *David, victus et victor* (1602). But in Hans Sachs's *Comedi David mit Bathsheba* (1556) and George Peele's *The Love of King David and Fair Bethsabee* (1599), one sees a much more prominent interest in sexual intrigue. Peele's Bathsheba rather coyly opens the play in her bath, singing a song that recalls the "too much protesting" topos and the ablutions of Diana; she immediately afterward lets herself be dried by the breezy Zephirus with his "delicate perfumes," only later rather languidly to drape herself with "loose delightsome robes" ([London: Oxford University Press, Malone Society Reprint, 1912], ll. 28–52).

23. See Thomas L. Glen, *Rubens and the Counter-Reformation: Studies in His Religious Paintings between 1609 and 1620* (New York and London: Garland, 1977), 20–21; notable in his oeuvre is the series of engravings made from drawings he did of *The Life of St. Ignatius*, first published in 1609, recently edited by Jan Graffius (Stonyhurst, UK: St. Omers Press, 2005).

the fountain, is an unclasped string of pearls, iconographically suggesting her availability. A black servant boy presents her with a note from the king, who, like the lecherous elders in many a Susannah painting, leers down from the middle distance of his palace balcony. Bathsheba herself is presented as nubile but very young, and she has an enticed (more than enticing) smile for the messenger. Oblivious to the agitated barking of her appropriately protective spaniel, she seems far more alert, in every sense, to a new opportunity. Rubens paints her quite precisely as though she had been expecting the message all along. This is a "reading" of the biblical narrative in which Bathsheba is at the very least complicitous in the affair. Rubens's painting quite deliberately also occasions a certain complicity in the viewer.

REMBRANDT'S IMAGINATIVE INTERPOLATION

In Rembrandt van Rijn (1606–1669), by contrast, there occurs an artistic breakthrough of almost the entire set of conventions to which Rubens was the optimal heir, and in particular a rejection of the focus of centuries of biblical commentary, iconography, and Christian catechesis. Rembrandt shows himself to be as uninterested as Rubens in the typical didacticism of Protestant catechisms *or* the patristic and medieval allegory that served primarily to exculpate David, but for different reasons. As he does in his depiction of other biblical narratives, for example, his *Woman Taken in Adultery* (1644), Rembrandt considers this story from the viewpoint of the character who in most other treatments is in fact simply a "fair object" or occasion of temptation, and reflects on her as one who suffers indignity, alienation, and loss.[24] While his *Bathsheba at Her Bath* (1643) had been still to some degree within the older iconographic tradition, in design as

24. Cf. his *Jeremiah*—and compare his pensive and exhausted *St. Paul* (National Gallery) with Rubens's robust iconic version. Though his model for the 1654 *Bathsheba* was clearly Hendrikje, his own second wife, it is clear enough that Hélène Cixous is on the mark in saying that "it isn't with the appetite of desire that Rembrandt paints Bathsheba" (*New Literary History* 24, no. 4 [1993]: 831). Rather, as Simon Schama has it, "Rembrandt . . . makes the most beautiful nude of his career, in fact, the last nude painting of his career, a vessel of pure tragedy" (*Rembrandt's Eyes* [New York: Knopf, 1999], 551). Even in his depiction of Andromeda, chained to the rock (1629), the conventional erotic elements are downplayed; in the words of Anat Gilboa, "by exposing the naked figure to the viewer with such immediacy, the artist also challenges the voyeuristic viewer to have compassion on a suffering woman" (*Images of the Feminine in Rembrandt's Work* [Delft: Euberon, 2003], 103).

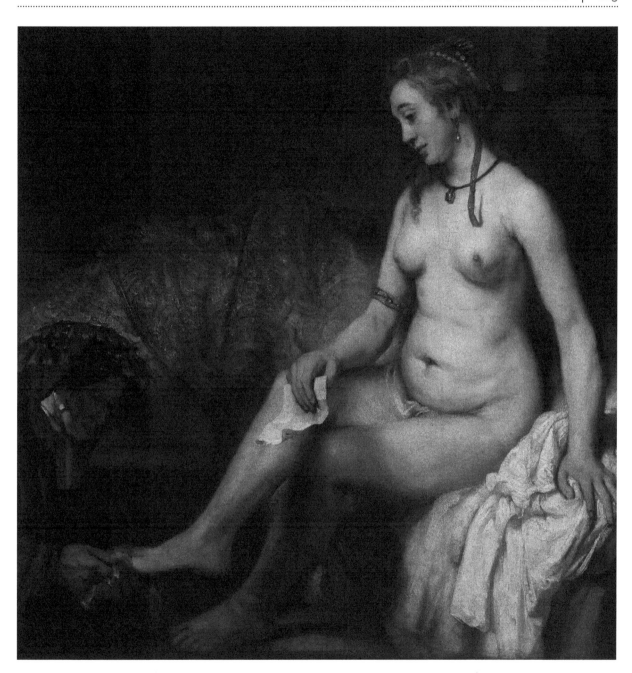

Figure 81. Rembrandt, *Bathsheba at Her Bath*, 1654

well as iconography, it evidently left him unsatisfied. In this second effort (1654), something dramatic has happened at the conceptual level. The earlier version literally has a soft focus, *sfumato* style; here the outlines are sharp; indeed, the artist is so focused on Bathsheba alone that he strips away most of the other figures altogether (fig. 81) from his canvas. There is

no messenger; from the crumpling of the paper in her right hand we may gather that Bathsheba has already read the letter many times. Her hair has already been coiffed for her assignation: only the pedicure, dimly recollecting the iconographic washing of the "feet," remains to be completed, and now by a much older, partially obscured attendant. All sense of sexual adventure has disappeared. Weighed down in somber reflection, her flesh textured and toned so as to suggest premature aging, this Bathsheba is torn in anguish between fidelity to her husband and what she must have seen as inescapable acquiescence to the king's imperious lust. There is in Rembrandt's more attuned psychological perspective no need for an unclasped string of pearls or ineffectually barking dog. Moreover, though as in many earlier treatments, Bathsheba is presented almost frontally and completely nude, no comparable voyeurism is invited. Indeed, unlike Rubens's version, this painting has an almost countererotic force, amply warranting Hélène Cixous in her judgment that "it isn't with the appetite of desire that Rembrandt paints Bathsheba" (see n. 24 above).[25] Rembrandt's chiaroscuro, like his dramatic exclusion from the scene of all elements except her own personal crisis and weighty sadness, underscores the ethical dimension of the biblical narrative not from David's or the voyeur's point of view, but from Bathsheba's. He thus both reinterprets and repositions the story itself in the biblical reader's mind.

Rembrandt's masterpiece is that of one who reads the biblical story with an eye for the personal in biblical narrative rather than for catechesis, which is to say, he is not thinking about doctrines of justification or exculpation or even of David's eventual repentance and the history of human salvation, but rather is exhibiting compassionate identification with the victim, her sad betrayal by a tyranny of lust and power. We see this deliberate inculpation of the king plainly also in his painting *David and Uriah* (1665), where he turns the viewer's attention to the plight—and thoughts—of the doomed Uriah. (Uriah knows.) In terms of the prompting biblical narrative, Rembrandt's two works form a diptych (fig. 82).

These two paintings of the king's incipient sexual conquest and subsequent betrayal of the wronged husband, I would suggest, are metonymic for Rembrandt's great overall artistic breakthrough. Rembrandt offers a freshness in approach to a traditional topos made possible precisely

25. Gilboa, *Images of the Feminine*, 146, is among those who have noted that in 1654, the same year as this painting, Hendrickje, Rembrandt's common-law wife and model for this Bathsheba, was found to be pregnant and subsequently "barred from attending the Lord's Supper because she was living in sin, in 'hoererije' with Rembrandt."

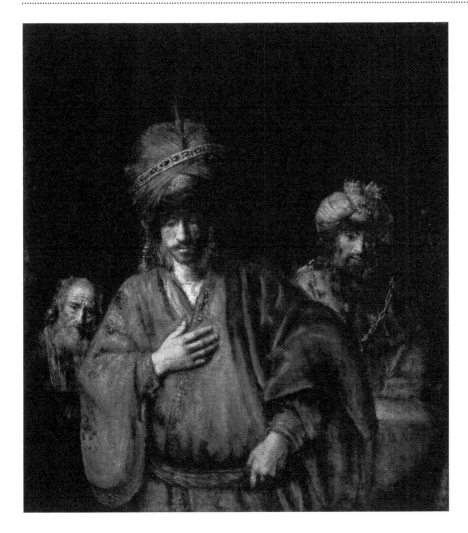

Figure 82. Rembrandt, *David and Uriah*, 1665

by turning away from catechesis and traditional typology without, as in Rubens, a corresponding loss of the subject's religious dimension. What seems to make this counterintuitive success possible is a meditative and reflectively sympathetic reading of the Bible as participated, imagined narrative.[26] Though not exclusively a Protestant achievement (in painting

26. Though Rembrandt would not likely have known it, the Hebrew of the 2 Samuel narrative supports his reading. David is the subject of all the verbs in 11:1–5: he *arose*, he *walked*, he *saw*, he *sent and inquired*, he *sent* messengers, he *took* her, and he *lay* with her. Walter Brueggemann draws attention to this swift and unequivocal display of royal power: "the entire narrative happens between *qum* and *shuv*: David 'arose' and Bathsheba 'returned.'" But verse 5, he adds, takes the affair outside the administrative control of the king: "the woman conceived." In Brueggemann's apt analysis, "There is no speech in the

he is anticipated to some degree by Caravaggio), Rembrandt's realization of the potential of terse, biblical narrative for a dramatic realization of inner character becomes a tour de force of biblical interpretation in this work, and at the same time a subversion of the voyeurism that had increasingly characterized much of the earlier depiction of Bathsheba as subject. Beauty here is a victim of vulgar appetite, not a value-free occasion for voyeuristic self-indulgence in which the viewer may pretend to excuse lasciviousness because it has an exalted biblical precedent.[27] Rembrandt's 1654 *Bathsheba* is accordingly, I think, both an important moment in the history of style and a moral judgment on the abuse of putatively holy subjects in late Renaissance art. Though the subject matter is an Old Testament story, it represents very well Rembrandt's version of the affectual breakthrough in representing biblical narrative first achieved three centuries earlier in the frescoes of Giotto.

CONCLUSION

As we have seen, sixteenth-century Lutheran examples of the depiction of 2 Samuel 11:2 generally distinguish themselves from Catholic representations in their avoidance of nudity, and in a more general modesty and visualized euphemism. It should be noted that all of our available Protestant examples except for the painting by Cranach are engravings for printed Bibles and catechisms, where illustration rather than artistic interpretation of a biblical text is the purpose. Calvinist art for our subject, though sparse after this period, frequently forgets Calvin's scruples, going in quite another direction. By the mid-seventeenth century, as in *Bathsheba Receiving David's Letter* by Willem Drost, Rembrandt's assistant in the same year (1654) (fig. 83), and by another sometime assistant Govaert

middle of the seizure, no consent, no resistance. The narrative is carefully crafted to get to this point. She says only two words, 'I'm pregnant' . . . and the world is changed." Brueggemann, *David's Truth in Israel's Imagination and Memory* (Minneapolis: Fortress, 1985), 56; similarly, Stephen McKenzie, *King David: A Biography* (Oxford: Oxford University Press, 2000), 157–58. I am indebted to my colleague Mikeal Parsons for drawing Brueggemann's exegesis to my attention.

27. Rembrandt would not have known the withering critique of David's lust and abuse of power by Benedictine nun Arcagela Tarabotti (1604–1652), who wote of Bathsheba that "she is more worthy of pardon than the royal harp player," in her *Paternal Tyranny*, ed. and trans. Letizia Panizza (Chicago: University of Chicago Press, 2004), 115, but his 1654 depiction parallels well her early feminist point of view.

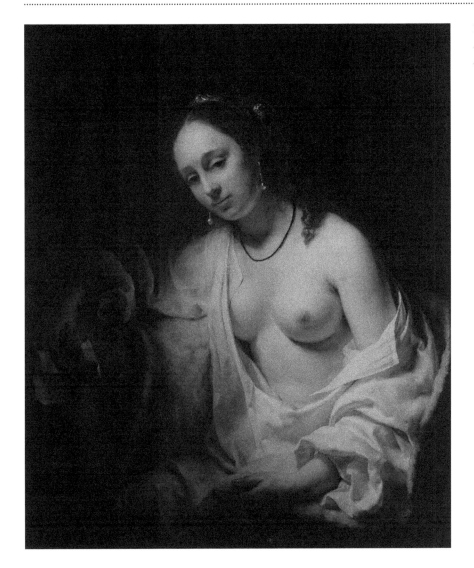

Figure 83. Willem Drost,
*Bathsheba Receiving David's
Letter*, 1654

Flinck (1659, The Hermitage, Saint Petersburg), the erotic element we
might imagine to have been eschewed by Protestant art can be as much
the actual subject as it is among Counter-Reformation artists. These are
of course private and secular paintings; the patronage for Calvinist artists
was no longer ecclesiastical.[28] Yet the biblical warrant we might expect

28. In his *Institutes of the Christian Religion* 1.11, Calvin is at pains to make an extensive
and detailed refutation of earlier patristic and medieval defenses of the use of images for
Christian instruction, and argues that in any place of Christian worship they represent
pagan idolatry.

from Calvinism was fading from view. Without titles, few laypersons could confidently connect these images meaningfully with the narrative in 2 Samuel 11, and none at all with David's penitential psalm.

None of his immediate successors achieved what Rembrandt did conceptually; though less flamboyant than Rubens, they appealed to their audience in much the same way. Ironically, no major painter of this period, Catholic or Protestant, came closer to the circumspection sought by the Council of Trent than Rembrandt, and he probably never looked at that document.[29] Bathsheba after Rembrandt returned to what she was before him for two centuries—an invitation to erotic fantasies. Rembrandt was distinctive. Reading the text with literary sensitivity and compassion rather than according to catechetical or dogmatic presuppositions, he simply saw more deeply into the biblical story than his peers, and recognized that the subject was anything but holy, and rather a sad story about the victimization of beauty. Who can say that his *Bathsheba* does not, more than any other, lead us ineluctably into a deeper appreciation of David's *Miserere*?

29. Rubens, by contrast, almost certainly would have known it, as it was published in a handsome edition with royal patronage in Antwerp in 1565, and was widely discussed then and later in the artistic community. F. Willocx, *L'introduction des décrets du Concile de Trente dans les Pays-Bas* (Leuven, 1929), 92.

9 ROMANTIC RELIGION AND THE SUBLIME

The time of the glory of the temple and its servants is past.

CASPAR DAVID FRIEDRICH

With the passing away of the first generation of Protestant Reformers (Luther, Melanchthon, Calvin, Beza, and Zwingli), and with them their sympathizers among the painters (Dürer, the Cranachs, and Holbein), there came about a break in the tradition of Christian art in northern Europe as definitive as, if less overtly contested than, the schism in the European Christian ecclesial communion. This breach was especially pronounced in the two largest Protestant domains, Germany and England. One form of it was violent: periodic eruptions of iconoclasm such as were prompted in England by Henry VIII's suppression of the monasteries[1] and by Oliver Cromwell's Puritan revolution.[2] Another was much less visible, namely, a kind of shunning, a turning away from expressions of Christian art that now seemed to be oppressive reminders of corrupt institutional power in the Roman Church, an aversion especially evident in Germany. This disenchantment becomes a theme in nineteenth-century Protestant art; to take one example, in a letter about one of his paintings (now lost), the German painter Caspar David Friedrich writes:

1. Eamon Duffy, *The Stripping of the Altars: Traditional Religion in England, 1400–1580* (New Haven: Yale University Press, 1992, 2005), is the best account.

2. John Phillips, *The Reformation of Images: Destruction of Art in England, 1535–1660* (Berkeley: University of California Press, 1973); G. G. Coulton, *Art and the Reformation* (Oxford: Basil Blackwell, 1928).

Like the painting I mentioned in my last letter, it represents the interior of a ruined church. I've based it on the beautiful cathedral in Meissen, which is still in a good state of preservation. The interior is piled high with rubble, out of which soar the mighty pillars with slender, delicate columns that still support some of the lofty vault. The time of the glory of the temple and its servants is past; another time and a new desire for clarity and truth have risen from the ruined whole. Tall, slender, ever-green pines have grown up out of the rubble, and on the rotting images of saints, broken altars and shattered sacred vessels stands an Evangelical [i.e., Lutheran] priest. With the Bible in his left hand and his right hand on his heart, he leans on a ruined memorial to a bishop, his eyes raised to the blue sky, thoughtfully contemplating the pale, light clouds.[3]

These words and the image they conjure mark as well as any the rejection of the past and general disdain for its cultural legacy typical of Friedrich's time; they also exemplify the idealist romanticism that came to characterize popular Protestant piety in the wake of the Enlightenment in Germany and, to a lesser extent, in England as well. In place of a medieval contemplation of the passion of Christ, the priest now contemplates "the pale, light clouds."

England, perhaps because of the institutional memories Anglicanism still kept of its pre-Reformation heritage and the still essentially Catholic form of its liturgy, alloyed its own anti-Catholic sentiments with ambivalent nostalgia, a kind of yearning to connect with old roots, mixed with disclaimers. Nineteenth-century English travelers were drawn to Florence, Venice, and Rome almost in the way some North Americans and Australians are drawn back to Britain and elsewhere in Europe, seeking to discover some aspect of their lost identity in the "old country." In such situations, of course, things often turn out to be different in the actual encounter than inherited memory and fancy have imagined them. Many a nineteenth-century English poet was to experience in Italy his or her genuine enchantment with the compelling beauty of much Renaissance art somewhat diminished by discomfort with the ambience of its baroque ecclesial settings. This frisson produced some memorable English poetry, perhaps most famously the dramatic monologues of Robert Browning, but it also found expression earlier in the verse of the English Romantics, especially Lord Byron and William Wordsworth.

3. Translated in Werner Hofmann, *Caspar David Friedrich* (London: Thames and Hudson, 2000), 52.

WORDSWORTH'S HISTORY OF THE CHURCH

William Wordsworth (1770–1850) was a contemporary of Caspar David Friedrich, and like him, was drawn powerfully to nature as a resource for both aesthetic and religious consolation. He was likewise ambivalent about Christian tradition. His *Ecclesiastical Sonnets* were written in midcareer (mostly in 1820–1821) and published as a collection in 1837. Though in general they reveal his distinctly Protestant bias,[4] Wordsworth seems occasionally capable of sympathy for earlier Catholicism, when

> . . . from the Papal Unity there came,
> What feebler means had failed to give, one aim
> Diffused thro' all the regions of the West;
> So does her Unity its power attest
> By works of Art, that shed, on the outward frame,
> Of worship, glory and grace, which who shall blame
> That ever looked to heaven for final rest?[5]

Wordsworth was fond of Renaissance art (as Friedrich apparently was not). During a tour of Italy in 1837 he wrote poems in praise of Leonardo da Vinci's *Last Supper*, Raphael's *John the Baptist*, and the sculpture he saw by Michelangelo; he apparently even attempted to translate about fifteen of Michelangelo's sonnets.[6] In what may have begun as a free translation of one of these, he penned lines that could almost serve as a response to the sculptor's great *Pietà*, a work Wordsworth would have seen on his visit to Saint Peter's Basilica:

4. He has sonnets entitled "Papal Abuses" (37) and "Papal Dominion" (39) that reflect conventional Protestant views; see also his "From the Alban Hills, Looking towards Rome" and "Near Rome, in the Sight of St. Peter's," nos. 11 and 8, respectively, from *Memorials of a Tour in Italy, 1837*.

5. Wordsworth, *Ecclesiastical Sonnets* 9; similar sentiments characterize "From the Alban Hills, Looking towards Rome," in which he both laments the "monuments decayed or overthrown" and "faith crushed, yet proud of weeds, her gaudy crown" and hopes for spiritual renewal and commencement of Rome's "third stage of thy great destiny." All citations of Wordsworth's poems can be found either in the Oxford Standard Edition, ed. Thomas Hutchinson et al. (Oxford: Oxford University Press, 1933, et seq.), or in the Wordsworth Poetry Library edition of 1998.

6. Wordsworth, *Memorials of a Tour in Italy, 1837*, 20, 21, 22, and *Memorials of a Tour on the Continent, 1820*, 26, responding to *The Last Supper* by Leonardo da Vinci.

Rapt above earth by power of one fair face,
Hers in whose sway alone my heart delights,
I mingle with the blest on those pure heights
Where Man, yet mortal, rarely finds a place.
With Him, who made the Work that Work accords
So well, that by its help and through His grace
I raise my thoughts, inform my deeds and words,
Clasping her beauty in my soul's embrace.
Thus, if from two fair eyes mine cannot turn,
I feel how in their presence doth abide
Light which to God is both the way and guide;
And, kindling at their lustre, if I burn,
My noble fire emits the joyful ray
That through the realms of glory shines for aye.[7]

One looks in vain to find in Wordsworth's poems any comparable admiration for an English or any other northern painter or sculptor;[8] this fact is but one of many evidences of an effect of the Reformation on which the poet does not comment, namely, the failure of Protestant artists to produce anything comparable in power and grace—especially for religious contexts—to the masterpieces of the Italian Renaissance.

Music offers a strikingly different history. Worship music of great beauty continued in a tradition unbroken from Palestrina (1525–1594), Tomás Luis de Victoria (1548–1611), Orlando di Lasso (1532–1594), and Giovanni Gabrieli (ca. 1556–1612), through Claudio Monteverdi (1567–1643), to the likes of Heinrich Schütz (1585–1672), Johann H. Schein (1586–1630), J. S. Bach (1685–1750), and Wolfgang Amadeus Mozart (1756–1791) in Germany, and through William Byrd (1543–1623), Thomas Tallis (1505–1585), and Orlando Gibbons (1583–1625) to G. F. Handel (1685–1759) in England, almost as if the Reformation and Counter-Reformation had not occurred.

Nothing comparable can be said about serious religious painting, let alone sculpture, in Protestant domains. It was as if some invisible hand had hung a great banner in all the cathedral squares, "Not the eye; just the ear." Poetry and drama flourished in England as perhaps nowhere else:

7. Wordsworth, *Memorials of a Tour in Italy, 1837*, 21.
8. He remarks in general and favorable terms on the work of his friend, the amateur painter John Harden (*Miscellaneous Sonnets* 26, 29), and on his response to historical portraits he has seen (*Miscellaneous Sonnets* 32, 33), including his own portrait by W. Pickersgill (*Miscellaneous Sonnets* 24), but little else, even in his guide to the Lake District (see below).

from Spenser through Shakespeare and Marlowe to the lyric poetry of John Donne, George Herbert, Henry Vaughan, Thomas Traherne, Thomas Carew, and Richard Crashaw, the vigor and beauty of religious poetry are such that the older Christian tradition continues to find expression; even today there is debate about whether this "metaphysical" poetry is more Catholic or Protestant in its character.[9] The great English hymnists of the eighteenth century, Isaac Watts, Charles Wesley, and John Newton, extended the tradition in such a way that both Protestant and Catholic congregations sing their hymns today. But because the visual arts made no such contribution to the religious sphere, there was a rupture in the tradition of religious art. Some brief notice of what dropped out of northern European consciousness is necessary if we are fully to appreciate the dislocation as well as innovation of the Romantics.[10]

BYPASSING THE BAROQUE

When we think of "baroque" art now, we often associate it with hyperbolic gesture, color, and virtuosity for virtuosity's sake, and those certainly are elements that often force themselves upon us. A little more subtly, but as importantly for the future of painting, a number of Italian artists in this period were seeking in various ways to achieve in their work a more dynamic encounter with physical reality, or, as they sometimes said, "Nature." In France, Georges de La Tour (1593–1652) would seek a heightened realism in religious scenes, using candlelight and chiaroscuro for dramatic effect, ironically giving his tableaux a Madame Tussaud's wax-museum static quality in the process.[11] Such attempts were for their contemporaries quite controversial, but the controversy went almost completely unnoticed in northern Europe.

9. Useful studies include Louis Martz, *The Poetry of Meditation: A Study in English Religious Literature of the Seventeenth Century* (New Haven: Yale University Press, 1976); Barbara Lewalski, *Protestant Poetics and the Seventeenth-Century Religious Lyric* (Princeton: Princeton University Press, 1979, 2014); and Patrick Grant, *The Transformation of Sin: Studies in Donne, Herbert, Vaughan, and Traherne* (Montreal: McGill-Queen's University Press, 1974).

10. French Romanticism, characterized by the violence of the revolution in 1789 and following, is substantially a rejection of Christianity and substitution for it of the omnipotent secular state, so is bypassed here, given the nature of our study.

11. Jean-Claude Le Floch, *Le signe de contradiction: Essai sur Georges de La Tour at son oeuvre* (Rennes: Presses universitaire de Rennes 2, 1995).

After the age of Dürer and Cranach, owing in part to a lack of ecclesiastical commissions, painting for worship environments diminished sharply in Germany as well as in England. By the time painting in those countries once again attracted artists of genius, the demand for art to enhance worship spaces had long since dried up. Much in the way of Spanish and Italian painting that still sought to create beauty for holy spaces remained either unknown to northern tourists or, as seems to apply to the work of Guercino, Caravaggio, and Domenichino, even when viewed on their tours of Italy, not received by them very empathetically.[12] The dynamic, dramatic (and often homoerotic) works of Caravaggio seem to have left their mark upon the memory and imagination of Rembrandt for their technique, but not for their spiritual character. Caravaggio's religious works, striking as they still are today, are not defended even by his apologists as art that might prompt devotion.[13] His contemporary Agguchi describes him as having "abandoned the idea of beauty" for the sake of a crude realism,[14] and Giovanni Bellori (1613–1696) went so far as to say that Caravaggio pursued nature—vulgar nature—at beauty's expense.[15] In his paintings of episodes in the life of Christ, we can clearly see the hyper-affectualism he achieved as original, yet, in striking contrast to the meditative identification prompted by the work of Giotto and Fra Angelico, his naturalistic paintings tend to shock rather than move the heart (fig. 84). Caravaggio's desire to paint physical nature as he saw it, however grubby and untidy, is nevertheless a milestone in the road to the emphasis on nature that was growing steadily and that would not always emphasize beauty; physical realism would become grotesquely morbid in his French successors Théodore Géricault and Eugène Delacroix. Such "realism" was simply beyond the pale for most English connoisseurs, and was actively reviled by their German counterparts.

Another missing link between Catholic art tradition and Protestant

12. Some Catholic artists still regard the baroque style as optimal for religious art, a view shared by no Protestant religious artist of whom I am aware. See David Clayton, "What Is the Place of the Nude in Sacred Art?" in *The Beauty of God's House: Essays in Honor of Stratford Caldecott*, ed. Francesca Aran Murphy (Eugene, OR: Cascade Books, 2014), 238–41.

13. Michael Kitson, *The Complete Paintings of Caravaggio* (New York: Harry N. Abrams, 1967), 9.

14. Translated in Kitson, *Complete Paintings of Caravaggio*, 10.

15. Kitson, *Complete Paintings of Caravaggio*, 11–12. Caravaggio's personal ambivalence about religious belief as well as his sexually avant-garde sensibility invite comparison with the brilliant Elizabethan poet and dramatist Christopher Marlowe, a northern contemporary whose similarly tumultuous life came to a similarly violent end.

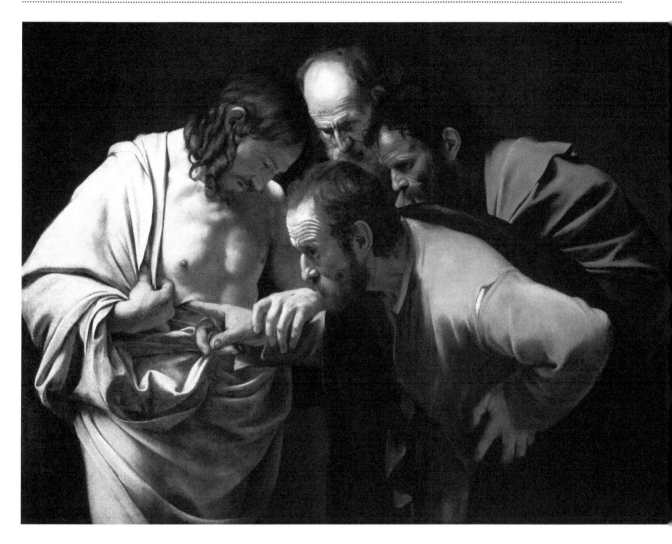

Figure 84. Caravaggio,
The Incredulity of St. Thomas,
1601–1602

sensibilities pertains to sacramentalism, especially the post-Tridentine view that seven official sacraments of the Roman Church, outward signs of inward grace, are necessary for a full life of faith. Sacramental realities on the Catholic view are actions visible in nature even though experienced by the believer as supernatural grace. This made desirable artistic realism such as might connect immediately with the life of ordinary believers. Doctrinal or catechetical painting on the sacraments was rare; painting on the sacraments was famously represented by the much more constrained and yet authentically religious neoclassicism of Nicolas Poussin (1594–1665). Poussin had experimented with the baroque style but come to believe that religious subjects in general needed a more genteel expression. He lived most of his adult life not in France but in Rome, where he was

Figure 85. Nicolas Poussin,
The Baptism of Christ,
1641–1642

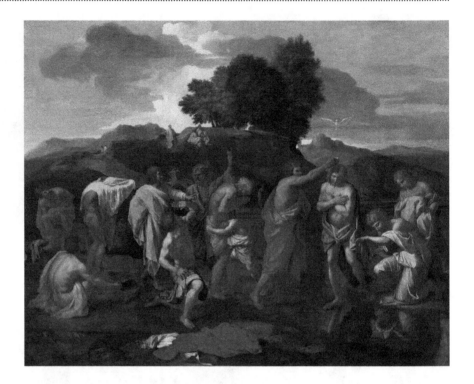

Figure 85. Nicolas Poussin, *The Baptism of Christ*, 1641–1642

an ardent student of antiquities, and his merit has been aptly described as having "combined the study of nature and the art of antiquity in an original way that simultaneously revivified this past and signified a 'living' tradition."[16] Although Poussin does not follow closely the guidelines of the Council of Trent, in his two separate series on the seven sacraments he reveals himself to have been a serious Counter-Reformation artist who sought to link beauty with holiness in very specific ways.

His *Baptism of Christ* from the Chantelou series is a thoroughly Catholic painting in which the problem of showing the supernatural presence of God in a natural scene is solved not merely by the symbolic descending dove, but in a fresh, psychologically realistic manner; two figures on the right look up and point in the direction of the divine voice, which is understood to be saying (as those familiar with the passage could remember), "This is my beloved Son, in whom I am well pleased" (Matt. 3:17; Luke 3:22) (fig. 85). Poussin in this way advances a solution to the iconographic dilemma with which Leonardo had wrestled in his "Virgin among the Rocks" paintings; the dove looks natural even though it is a recognizable

16. Elizabeth Cropper and Charles Dempsey, *Nicolas Poussin: Friendship and the Love of Painting* (Princeton: Princeton University Press, 1996), 8.

symbol for the Holy Spirit, and the voice of God the Father booms through from the biblical narrative to the canvas (as though coming from just above its frame), here indicated naturally through the awareness of some of those present, though it clearly has a supernatural source. Poussin's Seven Sacraments series thus offers a species of "natural supernaturalism" not paralleled among Protestant art in the same era. Ironically, both the first version of these seven paintings that Poussin did for Cassiano dal Pozzo between 1636 and 1642 and the second version (1644–1648) for his French patron, Paul Fréart de Chantelou, came in the end to Britain. The first series was purchased by the Duke of Rutland for Belvoir Castle in 1784; the second series was obtained by the Duke of Sutherland (1798). Unfortunately, neither Wordsworth nor his contemporaries saw them, their geographical proximity notwithstanding.

Northern lack of familiarity with much of the artistic development that took place between Leonardo, Raphael, and Michelangelo and their own time makes the Romantic revolution in artistic sensibility, in which Wordsworth was an English leader, seem all the more abrupt from a religious point of view. On the one hand, although there were English sympathizers with the French Revolution (Wordsworth, like William Blake, was among them), there was in England no political determination on divorcing all art from religion such as happened in France. In the Romanticism of Wordsworth and several of his contemporaries, religious interest and even faith can be found.[17] Yet there was little or nothing in the visual art of their culture to connect that faith to the broader Christian story, at least nothing that could compare to the still vigorous Continental Catholic artistic tradition.[18]

Spiritual stimulation for the English Romantics came consequently less from the beauty of art and architecture than from something that seemed to them less tainted by alien dogma, "the pale, light clouds," or

17. Not, except by opposition, in Percy Bysshe Shelley and John Keats, but critically in Byron and centrally in Samuel Taylor Coleridge and Robert Southey. I think Joseph Leo Koerner was right to see in Wordsworth Friedrich's closest ally in poetry. See Koerner, *Caspar David Friedrich and the Subject of Landscape*, 2nd ed. (London: Reaktion Books, 2009), 183.

18. Wordsworth met John Constable in 1806 at the Windemere home of his friend, the amateur painter John Harden; Constable remarked "upon the high opinion Wordsworth has of himself," but beyond that there seems to have been little in the way of mutual impression. Peter Bicknell, ed., *The Illustrated Wordsworth's Guide to the Lakes* (Exeter: Webb and Bower, 1984), 24. Although Constable toured the Lake District in 1783, making a number of drawings, and J. M. W. Turner in 1797 produced also oils and watercolors, Wordsworth had little to commend even in Turner (Bicknell, 27, 34).

landscape beneath—the beauty of pristine nature. Nature's unspoiled and untutored beauty had become steadily a more powerful allure for Wordsworth since his earliest days as a hiker in the Lake District, and his adoration of it seems to have been deepened by his conversations with Coleridge following their sojourn in Germany in the winter of 1797–1798. Already in "Lines Composed a Few Miles above Tintern Abbey" (1798), Wordsworth speaks of nature as "a presence that disturbs me with the joy of elevated thoughts; a sense sublime of something far more deeply interfused," and he confesses himself to be

> A worshipper of Nature, hither come
> Unwearied in that service: rather say
> With warmer love—oh! With far deeper zeal
> Of holier love. (ll. 152–155)

What he describes here and elsewhere is, in effect, a gradual religious conversion from Protestant pietism to natural supernaturalism[19] such as was occurring all over Protestant Europe.[20] Notably, in this famous poem, a personal meditation inspired by gazing out at the ruins of a medieval abbey church—just such a vista as fired the imagination of Caspar David Friedrich in his lost painting—we may grasp well enough the situation of artists in the north generally; the ruins of the religion that was, the broken and empty shells of the Catholic past, seemed to call forth a search for some new locus for the holy.

19. The term is Meyer Abrams's and indicates "the general tendency, in diverse degrees and ways, to materialize the supernatural and humanize the divine." M. H. Abrams, *Natural Supernaturalism: Tradition and Revolution in Romantic Literature* (New York: Norton, 1971), 67.

20. In Wordsworth in particular, Abrams's contention that in natural supernaturalism "characteristic concepts and patterns of Romantic philosophy and literature are displaced and reconstituted theology" (Abrams, *Natural Supernaturalism*, 65) is precisely what was seen by readers such as William Hale White, the disenchanted dissenting minister, who wrote the pseudonymous *Autobiography of Mark Rutherford* (1881; London: Oxford University Press, 1936), 22: "God is nowhere formally deposed, and Wordsworth would have been the last man to say that he had lost his faith in the God of his fathers. But his real God is not the God of the Church, but the God of the hills, the abstraction Nature."

CASPAR DAVID FRIEDRICH

For members of the Lutheran state church in Germany, similar gaps pertained. The pre-Reformation past had largely vanished from cultural memory, invisible except perhaps for ruined abbeys and ritual denigrations of Catholic dogma in sermons. But Lutheran dogmatics had themselves begun to ossify; the more subjective faith of pietism (not unlike the Moravian-inspired Methodism and evangelicalism of the English Church) had flourished in part as a reaction, especially in midcentury, though by this point it was waning somewhat in the cities. When Caspar David Friedrich (1774–1840) was a young student in Greifswald on the Prussian Baltic coast, life was still marked outwardly by formal holidays, much as in Wordsworth's England—Christmas, Easter, Whitsuntide, each with three days of observance—and additional holidays with church services were given on Lady Day, Midsummer Day, and Michelmas. Indeed, each Sunday most Lutheran parishes had three services with sermons of an hour or more, with robust hymn singing, including prominently the beautiful hymns of the Lutheran pastor and pietist Paul Gerhardt (1606–1676).[21] In these hymns, old Lutheran and pietist sensibilities continued side by side, sometimes uneasily, sometimes in convincing rapprochement. A kind of Hegelian synthesis of old Lutheran and pietist modes that emerged in the seminaries eventually became the *ur*-form of modern Protestant liberalism, with its emphasis on feeling over form, on subjective faith over objective creedal doctrine, and proclaiming above all that moral rectitude can be authentically grounded not in traditional doctrine but only in the emotions.[22] To many intellectuals this movement away from doctrine and into feeling seemed liberating, even if it came at the expense of conviction in the authority of the Bible.

This was a period of unprecedented intellectual and artistic flourishing in Germany, far surpassing that of the Reformation, and it had multiple streams. The rationalism of the Enlightenment, itself a direct challenge to Lutheran theological doctrine, became dominant in the theological writings of Johann David Michaelis (1717–1791), Johann Gottfried Eichhorn (1752–1827), Gotthold Ephraim Lessing (1729–1781), Moses Mendelssohn (1729–1786), Johann Gottfried Herder (1744–1803), and much of

21. A useful translation of Gerhardt's *Spiritual Songs*, translated by John Kelly (London: Alexander Strahan, 1867), is now available online in a Project Gutenberg reprinting.

22. Johann Gottfried Herder, in his *On the Cognition and Sensation of the Human Soul* (1778), would follow David Hume and Kant in arguing that moral formation and ethical comportment are more a matter of habituated sentiment than of cognition.

it persisted in a still more subjective vein in Friedrich Schleiermacher (1768–1834). Revisionist theology found a visceral echo among quite dissentient Romantic sensibilities in the arts. Such prominent figures as Johann Wolfgang Goethe (1749–1832); Friedrich Schiller (1759–1805); "Novalis," or Friedrich Leopold, Freiherr von Hardenberg (1772–1801); Jean Paul (1763–1825); Heinrich von Kleist (1777–1811); E. T. A. Hoffman (1776–1822); and Ludwig Gotthard Kosegarten (1758–1818) wrote poetry, drama, and fiction that celebrated the liberation of both reason and feeling from orthodox faith. In philosophy this was the era of Immanuel Kant (1724–1804), Johann Georg Hamann (1730–1788), Johann Gottlieb Fichte (1762–1814), G. W. F. Hegel (1770–1831), and Friedrich Wilhelm Schelling (1775–1854).[23] And in music Franz Joseph Haydn (1732–1809), Wolfgang Amadeus Mozart (1756–1791), Ludwig van Beethoven (1770–1827), and Franz Schubert (1797–1828) were flourishing, not least because of their ability to summon up something resembling the old religious emotions with their compositions. This roll call is staggering for its concentration of intellectual firepower in one period. This was as much a zenith for German culture as was the Renaissance for Italian culture. Yet there were really only two painters of outstanding merit to put with this magnificent German academy, Philipp Otto Runge (1777–1810) and Caspar David Friedrich (1774–1840), and of the two only Friedrich has remained of primary interest outside of Germany. Both were from the northern, sparsely populated Baltic coastal region of Pomerania, then in the domain of Sweden and only later to become part of Prussian Germany.

Friedrich himself was, like Wordsworth, raised in a region remote from urban culture. Greifswald was both small and isolated, with many among the populace of five thousand still uneducated serfs.[24] But this area produced intellectual giants in philosophical theology such as Hamann and Herder, and also the poet, theologian, and critic Kosegarten. All three were ordained Lutheran pastors.[25] The ideas and sympathies

23. On Hamann, of whom little notice can be given here, see Oswald Bayer, *A Contemporary in Dissent: Johann Georg Hamann as a Radical Enlightener*, trans. Roy A. Harrisville and Mark C. Mattes (Grand Rapids: Eerdmans, 2012), and Gwen Griffith Dickson, *Johann Georg Hamann's Relational Metacriticism* (Berlin: Walter de Gruyter, 1995), especially for a discussion of Hamann's *Aesthetica in nuce*, in which *aesthēsis* means basically all sensuous knowledge.

24. Hofmann, *Caspar David Friedrich*, 15.

25. Of them, only Kosegarten was known to Friedrich personally, and that through a three-day visit. Lewis M. Holmes, *Kosegarten's Cultural Legacy: Aesthetics, Religion, Literature, Art, and Music* (New York: Peter Lang, 2005), 121–23.

of Kosegarten (who collected several prints and drawings by Friedrich) were a proximate distillation of the ideas of such thinkers as Hamann and Herder, themselves friends and protégés of Kant. The poems of Kosegarten,[26] the aesthetics of Kant, and the philosophical theology of Hamann, Herder, and one more Lutheran theologian, Schleiermacher, all help us to situate Friedrich's painterly work within the ambient Zeitgeist of German Romantic sensibility.

First, the pietism. One of the distinguishing hallmarks of Friedrich's painting, most of which is landscape, is that unlike the Dutch landscape artists of the seventeenth century[27] or the English landscape painters of the eighteenth and early nineteenth centuries,[28] Friedrich makes highly visible, even if decentered, Christianity's most perdurable symbol, the cross (fig. 86).

This painting, for which he had Gottlieb Kühn carve a frame, is one of many of Friedrich's landscapes in which there is a prominent cross, usually as here, found in the mountains and on a pinnacle.[29] This work is distinctive, however, even among those many others with an identical or similar subject, for it was apparently first designed by Friedrich as an altarpiece painting for a chapel of the Swedish King Gustav IV Adolf.[30] As it happened, Countess von Thun-Hohenstein in German-speaking Czechoslovakia saw a sepia print of the image in an exhibition in Dresden in 1808, and asked Friedrich to do a full-scale painting for her private chapel in Schloss Tetschen. The resulting canvas is the first altarpiece in Christian tradition to feature landscape as a primary subject. When it is compared with medieval altarpieces, this difference invites us to wonder if the *Tetschen Altar* could have for many viewers evoked the presence of the Holy. It may be, as has been suggested by Rudolf Otto, that Lutheran theology itself had "not done justice to the numinous side of the Christian idea of

26. Holmes, *Kosegarten's Cultural Legacy*, 73–78. Kosegarten's sonnet cycle, several poems of which are translated here by Holmes, is clearly indebted to Kant.

27. Wolfgang Stechow, *Dutch Landscape Painting of the Seventeenth Century* (London: Phaidon, 1966).

28. For example, John Constable, Thomas Gainsborough, and J. M. W. Turner.

29. Other examples by Friedrich include *The Cross beside the Baltic* (1815), *The Cross in the Forest* (1820), *The Cross in the Mountains* (1811–1812), and *Winter Landscape with Church* (1811).

30. Hofmann, *Caspar David Friedrich*, 41, suggests that the design was possibly first conceived as an idea by Kosegarten, who wanted an altarpiece for his chapel in Rügen. Hofmann's book-length study, to which I am gratefully indebted, provides an excellent analysis of Friedrich's most important paintings.

Figure 86. Caspar David
Friedrich, *Tetschen Altar*,
1808

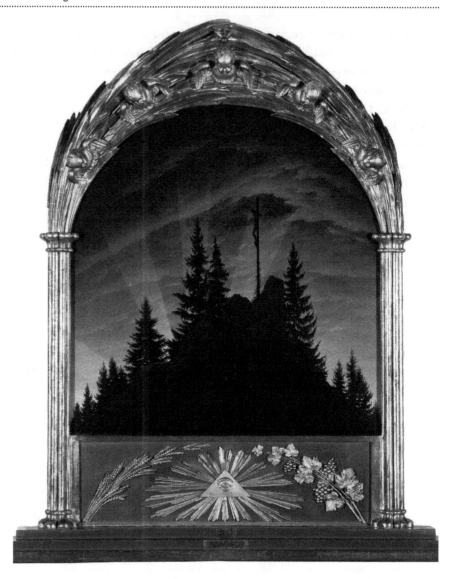

God,"[31] and that this unprecedented landscape altarpiece is in some sense a reflection of it.

Friedrich's iconography has both vestigial roots and highly innovative properties. The cross—actually here a crucifix with an apparently metallic corpus—is placed high but asymmetrically among the fir trees. More-

31. Otto, a Lutheran theologian of the early twentieth century, suggests that "By the exclusively moral interpretation it gave to the terms, it distorted the meaning of 'holiness' . . . returning to the doctrine of divine *apatheia or passionlessness*." Rudolf Otto, *The Idea of the Holy*, trans. John W. Harvey (Oxford: Oxford University Press, 1958), 108.

over, the crucifix faces away at a three-quarter turn from the viewer, as if looking into the fading glory of a setting sun; three dominant rays shoot up and through the clouds at an angle oblique to the viewer but perhaps central to the corpus on the cross. The five putti or cherubs on the upper arch of the gilded frame, strangely reminiscent of those painted into Giotto's crucifixion in the Arena Chapel, look down on the scene, while the bottom of the frame features familiar Lutheran symbols for the bread and wine of the Eucharist; a sheaf of wheat and a branch with grapes are symmetrically arched over an "eye of God" or "eye of Providence" set in a triangle with the radiant beams suggesting the *shekinah* glory behind and around it. As the critic Friedrich Wilhelm von Ramdohr noted at the time, there is an acute discrepancy between the heightened naturalism of the painting and the labored iconography of the frame, even though it was designed to the painter's specifications. Werner Hofmann's view is that Friedrich "did not invite the viewer to see anything visionary or supernatural in his painting, but compensated for this by transferring the supernatural content that our empirical vision cannot see to the picture frame, where it takes the form of Christian symbols."[32] This judgment seems apt. Natural supernaturalism has not quite been achieved; vestigial symbols of doctrine still frame, however awkwardly, an emotional and subjective response to the wellspring of that iconography, the passion of Christ, in a way that is in fact conflicted. The averted "face" of the Crucified is the key; we do not have to see it, much less think about it, to respond. Rather, we observe that the face of historic Christian meaning is turned away toward the setting sun, as if contemplating its own demise. Here, as Hegel anticipated would increasingly be the case in religious art, the image functions less well as a medium for devotion than as the occasion for an aesthetic experience.[33]

There is not sufficient evidence to convict Friedrich himself of this specific intention. In fact, he claims that his painting is in the tradition of Christian iconography, and that it ought to function as an encouragement to traditional Christian faith. In explaining his image Friedrich writes:

> With the teachings of Jesus, an old world died, the time when God the Father walked directly on earth. The sun went down and the earth could no longer grasp the departing light. The Savior on the cross shines in

32. Hofmann, *Caspar David Friedrich*, 44–45.

33. Quoted in Joseph Leo Koerner, *Caspar David Friedrich and the Subject of Landscape* (New Haven: Yale University Press, 1990), 148.

the gold of sunset with the purest, noblest metal, and reflects the light onto the earth with a gentler gleam. The cross stands on a rock, as unshakably firm as our faith in Jesus. Fir trees grow around the cross, evergreen and everlasting, like the hope of men in Him, Christ crucified.[34]

In short, from the artist's own point of view, the work is entirely consistent as an expression of pietism; the rock is neither Christ nor Peter, but "*our* faith," subjective as that may be, and the "spruce trees signify our hope in Christ that likewise remains ever green and everlasting." We ought not to doubt that he believed this in all sincerity, despite that, tellingly, the body of his Christ has become metallic rather than human flesh.[35] As Werner Hofmann, Friedrich's best modern critic, puts it, "it was from his Lutheran-Evangelical faith that he derived the basic tenets that determined his artistic decisions."[36] But this was Lutheran faith as characterized by Schleiermacher in *On Religion: Speeches to Its Cultured Despisers* (1799), a book with which the artist may well have been familiar.[37] In brief, the religion of this painting is grounded not in a cognitive relation to the witness of history, revelation, and doctrine, but, as theologian Schleiermacher among others had framed it, in subjective personal experience and emotions.[38] As such, it was vulnerable to adverse experience and emotional turbulence.

Like most people, Friedrich had his emotional (and spiritual) ups and downs. He lost his younger brother Christopher to a skating accident in 1787 when, in the act of saving Friedrich after he had broken through the ice, he was himself drowned. Friedrich had already lost his mother when he was but seven years of age, and later one of his sisters died in what were said to be "tragic circumstances."[39] These events probably did not help with his preponderantly melancholy disposition, which pervades his work through most of his life. But there seem to have been deeper reasons for his gloom, and they form a leitmotif in his art. A little over a year after com-

34. Translated in Hofmann, *Caspar David Friedrich*, 44.

35. Cf. Hofmann, *Caspar David Friedrich*, 48.

36. Hofmann, *Caspar David Friedrich*, 245, 250.

37. Richard Crouter's translation (Cambridge: Cambridge University Press, 1996) is the most accessible; Hofmann records (*Caspar David Friedrich*, 50) that Schleiermacher, who had been a Lutheran pastor in the Pomeranian town of Stolp (1801–1802), came to visit Friedrich in Dresden and admired his work.

38. This is the central argument of Schleiermacher's magnum opus, *Der christliche Glaube nach den Grundsätzen der evangelischen Kirche* (1830–1831).

39. Helmut Börsch-Supan, *Caspar David Friedrich* (New York: Braziller, 1974), 11. Friedrich seems to have attempted suicide sometime during 1801–1802, the period of his woodcut *The Woman with the Raven at the Precipice* (1802); see note 74 below.

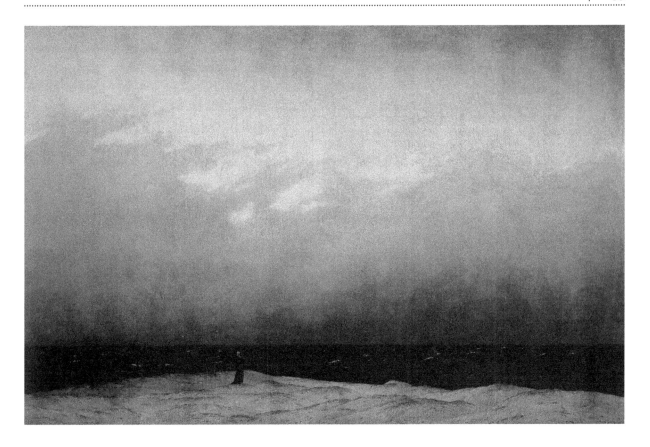

pleting his *Tetschen Altar*, he painted a pair of large canvases that exhibit his ongoing brooding over the question of meaning in religion. In these works there is no attempt at intellectual iconography of any kind, but there is certainly what we might call emotional iconography, *Sehnsucht* longing expressed in an image, and it is powerful. In the first of these paintings, *Monk by the Sea*, he seems to have struck a resonant chord with viewers at the Prussian Royal Academy exhibition in 1810 (fig. 87).

The contrast with his altarpiece is striking, yet this work also has a deliberate religious ambience. The monk of the title has been described as a Capuchin (Franciscan), although there is no unambiguous warrant for that in the image. What is more likely is that the solitary "monkish" figure, alone and musing before the enormity of nature as a storm gathers over the sea and a front bears down, represents an alienated religious sensibility, possibly that of the artist himself. Hofmann notes that in his last self-portrait (there are seven), Friedrich drew himself "with monkish attributes."[40] Even

Figure 87. Caspar David Friedrich, *Monk by the Sea*, 1808–1810

40. Hofmann, *Caspar David Friedrich*, 57.

were this not so, it is easy enough to feel the artist's emotional identification with the solitary figure, who, as in so many of Friedrich's works, is viewed from behind, a *Rückenfigur*. As numerous critics have observed, we do not so much see the figure as we feel his vulnerability; we see *with* the lonely viewer the immense and unfathomable power of nature, and are cowed by it.

The second painting is in some respects quite different. *Abbey in an Oak Forest*, with its ombered foreground and pale, receding light of day, creates a feeling of gloom to match the waning light, but here are many figures, also monks, likewise with backs turned to us, in an irregular procession carrying into the precincts of a ruined abbey church graveyard a coffin, presumably the body of one of their fellow monks (fig. 88). If the fir trees, "ever green and everlasting," were prominent in the *Tetschen Altar*, the gnarled and leafless oaks, sacred trees of the pre-Christian peoples of northern Germany, are even more prominent here; indeed, such oaks grew to be increasingly a motif, often with pagan burial sites, in Friedrich's painting. The mood in this image is not the gentle melancholy of Thomas Gray's "Elegy in a Country Church Yard" (1751) or even, as has been suggested, a version of the spectral morbidity of Edward Young's *Night Thoughts* (1742), with its meditations on the inevitability of death, though each of these has been compared with it. These monks, like their ruined abbey, are here the last remnants of a superannuated faith.[41]

Neither of these images is like Friedrich's description of his lost painting, a triumphalist vindication of the spirit of the Reformation. Rather, what we see in this pair of canvases are variants on the theme presaged in the *Tetschen Altar*, there ventured only subconsciously perhaps, but here openly: both 1809 works depict the inability of past religion (symbolically Catholic in all of Friedrich's work) to sustain spiritual life in the present. Yet nothing is offered to take its place. The result is despair of formal religion generally. Dogmatic religion in these paintings has lost, when confronted by nature, the consolation of assurance; faith is dying with the light, declining into darkness and a sepulchral, vacuous gloom. Both the *Monk* and *Abbey* paintings are certainly in one sense religious, but they are wholly negative about both ancient and future faith.

Friedrich has a little-known drawing, *Old Woman with Hourglass and Book* (1802), drawn early in his career and in quite traditional iconography, that depicts the vulnerability of faith in the context of the painter's

41. Cf. a recent discussion of this pair of Friedrich's paintings and critical perspectives in Jonathan A. Anderson and William A. Dyrness, *Modern Art and the Life of a Culture: The Religious Impulses of Modernism* (Downers Grove: InterVarsity, 2016), 142–62.

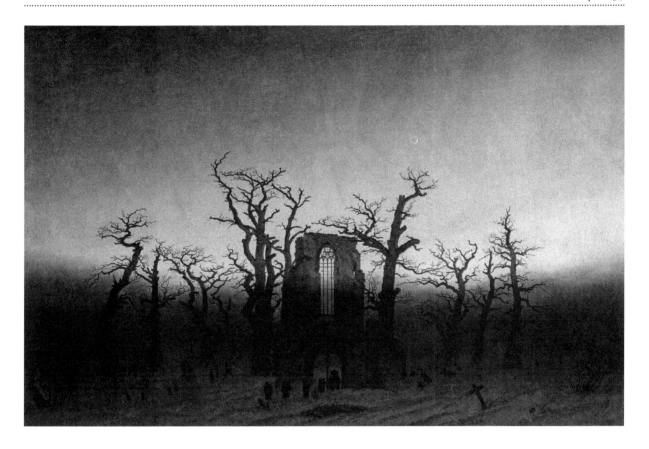

early experience.[42] On the right-hand page one can make out the text "Seelig sind die da glauben, ob sie gleich nicht sehen"—"Blessed are those who have not seen and yet have believed" (John 20:29b)—Jesus's response to the declaration of Thomas the Doubter after he put his hand into the wounds, "My Lord and my God." This is precisely the text interpreted by Caravaggio in his shocking portrayal of Saint Thomas with his finger in the open wound in the side of Jesus. In Friedrich's drawing, however, the reference is not, as in Caravaggio's painting, to the physical event, but rather to faith inculcated by a book—not even the Bible directly, but an anthology of religious aphorisms. On the left-hand page we can make out the words "He who trusts in the Lord will find grace." Johannes Grave regards the two statements as the "fundamental tenets of Lutheran Protestantism."[43] Yet deprived of their narrative context and anchor in tangible

Figure 88. Caspar David Friedrich, *Abbey in an Oak Forest*, 1809–1810

42. Reproduced by Johannes Grave, *Caspar David Friedrich* (Munich: Prestel, 2012), 85; this black chalk drawing, 35.8 cm × 31.2 cm, is in the Kunsthalle in Mannheim.

43. Grave, *Caspar David Friedrich*, 85.

experience, the aphorisms of pietism too easily become mere platitudes or sentimentalism, moving Friedrich's imagination only enough to produce an image of an old woman reading—perhaps just one more sign of the passing away of a vital, living faith into enfeebled memory, as the hourglass seems also to suggest.[44] It is not without significance that this work, like his woodcut of the woman standing at the precipice, followed closely on his clinical depression and possible suicide attempt in 1801–1802.[45]

For much of the balance of his career, Friedrich seems to have alternated between the sort of gloom represented by his great diptych of 1809 (images of graveyards, pagan tombs with withered oaks, other versions of monastic burials near ruined medieval churches) and intermittent attempts to believe that by sheer willpower, ascending the barren mountains of experience, one might obtain a breakthrough vision of supernatural reality. His *Morning in the Reisengebirge* (sometimes titled *The Cross in the Mountains* (1810–1811) (fig. 89) captures such a moment. Here a woman in white, perhaps in a wedding dress, appears as an anima figure reaching down to pull up her pilgrim lover to the foot of the cross. Yet the figures are tiny specks, lost in an overwhelmingly vast and rugged landscape; hope may persist, but it grows smaller and more tenuous in the great sweep of a forbidding wilderness, now with no trees at all, evergreen or otherwise.

BEAUTY AND THE SUBLIME

We have been concerned from the beginning in this study with beauty and holiness; with regard to the first, by this point it will be apparent that though standards of beauty may vary culturally, as a concept it had remained relatively stable, somewhat easier to define than holiness. But in the period we are now examining, the nature and meaning of the beautiful came to be more contested. On the one hand, Johann Gottfried Herder could write confidently in 1769, "Why is beauty the supreme law in plastic art? Because art achieves its effects *through the coexistence of its parts*, because its effect is therefore encompassed *within a single moment* and creates its work for *a single eternal glance*. This single glance therefore delivers the utmost degree of that which holds us fast in its

44. This work compares to the image sometimes called *Rembrandt's Mother* by Gerrit Dou, and several others of this type by Dutch painters of the seventeenth century.

45. Grave, *Caspar David Friedrich*, 76.

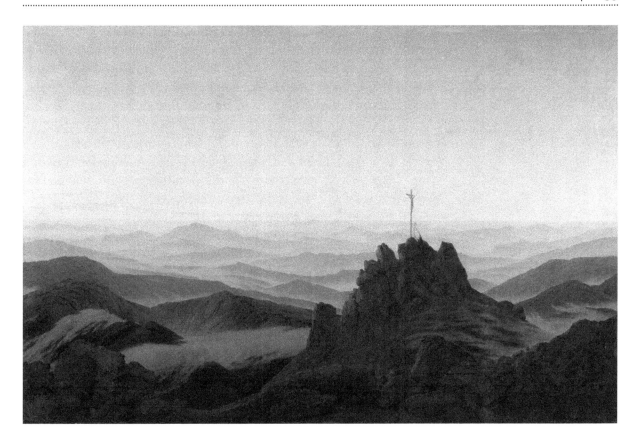

arms forever—beauty."[46] Clearly, beauty here still, even if in a diminished degree, offers a glimpse of the transcendent that, as in Plato, emanates from Ultimate Reality and informs our world; its origin as a concept lies in visual experience, but has been extended to cover "everything that is pleasurable to the soul." Yet Friedrich, writing in his journal in 1803, is resistant: "Who would claim to know what alone is beautiful, and who could teach it? And who could set limits to things of a spiritual nature and lay down laws about them? O you dry, leathery, mundane people, go on thinking up rules! The crowd will praise you for the crutch they provide, but those with a will of their own will scorn you and laugh."[47] Friedrich's

Figure 89. Caspar David Friedrich, *Morning in the Riesengebirge*, 1810–1811

46. Herder, *Critical Forests*, "First Grove," largely a defense of Winckelmann's account of the Laocöon against Lessing; in Johann Gottfried Herder, *Selected Writings on Aesthetics*, trans. and ed. Gregory Moore (Princeton: Princeton University Press, 2006), 101.

47. Quoted in Hofmann, *Caspar David Friedrich*, 270. Cf. Brad Prager, "Sublimity and Beauty: Caspar David Friedrich and Joseph Anton Koch," in *Aesthetic Vision and German Romanticism: Writing Images* (Rochester, NY, and Woodbridge, UK: Camden House, 2007), 93–122.

scorn recalls that of William Blake, when around 1790 he read Sir Joshua Reynold's *Discourses on Art*; by the first decade of the nineteenth century, beauty had succumbed to the changeable eye of many a beholder.[48] In his *Critique of Judgment* (1790), Immanuel Kant famously set out to resolve the dissonance between an epistemological or cognitive understanding of beauty as having "laws" and the clear evidence of great variability in individual taste: "If we wish to decide whether something is beautiful or not, we do not use understanding to refer the presentation [*Vorstellung*] to the object so as to give rise to cognition; rather, we use imagination (perhaps in connection with understanding) to refer the presentation to the subject and his feeling of pleasure or displeasure. Hence a judgment of taste is not a cognitive judgment and so it is not a logical judgment but an aesthetic one, by which we mean a judgment whose determining basis *cannot be other* than *subjective*."[49] Such a judgment for Kant, paradoxically, must exclude interest in the one who makes it, treating that as a matter of indifference.[50] Yet, he adds, inasmuch as one attributes beauty as a property of the object, then one "requires the same judgment from others."[51] Thus, for Kant, "*Beautiful* is what, without a concept, is liked universally." For all that, "there can be no objective rule of taste, no rule of taste that determines by concepts what is beautiful."[52] Here we may be seeing what Friedrich, who was familiar with Kant's work, intended in his own fierce rejection of "rules" for beauty. Yet in Friedrich's journals beauty remains connected with a higher spiritual reality. Unlike Kant in this respect, but more like Kant's sometime students Herder, Hamann, and most proximately Kosegarten (for whom "real beauty was godliness"),[53] we can see in the artist a continuing desire to give physical beauty some sort of transcendent spiritual value.[54]

48. Herder, in *Calligone* (1800), had himself already begun to think, contra Kant, that standards of beauty vary greatly from one period to another and one culture to another.

49. Immanuel Kant, *Critique of Judgment*, trans. Werner S. Pluhar (Indianapolis: Hackett, 1987), 1.1, p. 44.

50. Kant, *Critique of Judgment*, p. 46; 1.6, p. 54; cf. 1.16, p. 78.

51. Kant, *Critique of Judgment*, 1.7, pp. 55, 56–59; 1.22, p. 89.

52. Kant, *Critique of Judgment*, 1.9, p. 64; 1.17, p. 79.

53. Hans Urs von Balthasar, *The Glory of the Lord: A Theological Aesthetics*, vol. 3, *Studies in Lay Theological Styles* (Edinburgh: T. & T. Clark, 1986), 245–50, reads Hamann's *Ästhetik in nuce* so as to show that for Hamann, Scripture was like the holy of holies in the temple, with nature as its forecourt, while beauty for Hamann was like unto the *shekinah* of God within the inner sanctum.

54. Werner Busch, *Caspar David Friedrich: Ästhetik und Religion* (Munich: Verlag, 2003), offers a detailed analysis. Kosegarten included the essay "On the Essential Beauty"

There is much more to Kant's rather diffuse distinctions regarding the beautiful, but this much is sufficient to prepare us for the next section of his third *Critique*, in which he announces his more influential theory, that concerning the sublime, by saying in a teasing way, "the beautiful and the sublime are similar in some respects."[55] Before we can follow Kant's idea, we need to reckon with just how well trodden were the more conventional paths to the sublime, a very fashionable subject in the decades before he wrote.

THE VARIABLE SUBLIME

The "sublime" has long been a contested concept. For the postmodern French philosopher and literary theorist Jean-François Lyotard (1924–1998), this difficulty is intrinsic: the sublime points to an aporia in human reason, expressing the boundary of our conceptual powers, and thus revealing the multiplicity and instability of the postmodern world.[56] In a fashion aslant from what Lyotard intends, another notion of aporia pertains in the eighteenth-century spiritual sublime. Further back still, the sublime was an effect of poetic diction.

For the Greeks the sublime had been a rhetorical category, defining what one felt in response to magnificence, what the pseudonymous Athenian Cassius Longinus called "the grand or noble elements in a work of art" (*Peri hypsous*).[57] Although Longinus clearly associates the sublime with great ideas, enthusiasm, and lofty language, the effect of such language is dependent on an infused emotional rather than simply rational assent; in the moment of sublimity the mind is transported suddenly, taking the reader or hearer "out of himself." One of his examples is the phrase "Father Zeus, kill us if thou wilt, but kill us in the light."[58] The

in his *Rhapsodies* (1790), a collection of poems, essays, stories, and sermons, in which he argues that "everything beautiful in nature is god-derived, a trace of the god-head in the creation, reflecting his countenance and his majesty." See Holmes, *Kosegarten's Cultural Legacy*, 7–9.

55. Kant, *Critique of Judgment*, 2.23, p. 97.

56. Jean-François Lyotard, *Lessons on the Analytic of the Sublime*, trans. Elizabeth Rottenburg (Palo Alto, CA: Stanford University Press, 1994).

57. Quoted in Lillian Feder, *The Handbook of Classical Literature* (New York: Da Capo, 1998), 232.

58. Longinus, *On the Sublime*, in *Classical Literary Criticism* (London and New York: Penguin, 1965, 2000), 124.

thrill in such a rhetorical moment is to Longinus cathartic, and indicates that the Greek sublime, though primarily a rhetorical conception, is akin to religious *ex-stasis*, as in the tragedies of Sophocles, with their stark antinomies of noble intention and tragic destruction, captured in high moments of lofty speech in which truth speaks to power. (One thinks not merely of *Oedipus* but also of *Antigone*.)

The Romans had by the time of Longinus relocated the sacred in imperial power itself. The worship of godlike Caesar was a concomitant both of political self-interest and the *pietas* one owed to the glory of Rome; while the rhetorical sublime of the Greeks persisted in writings as divergent as Virgil's *Aeneid* and the orations of Cicero, the public appetite for horror increasingly favored a more visual thrill. Much later, a European revival of Longinus by figures such as Nicolas Boileau-Despréaux, the French neoclassicist, also turned attention away from poetic diction, a verbal and rhetorical sublime, to a notion more often prompted visually by phenomena in nature, and which came to be called the "natural sublime." The gentlemanly sense of aesthetic awe produced by a traveler's mountaintop experience, characterized in the writing of John Dennis as "delightful horror," is of this species.[59] For Dennis, such vistas from the precipice are a pleasure to the eye, much as is music to the ear, but "mingled with Horrours, and sometimes almost with despair."[60] For Joseph Addison this effect becomes an "agreeable terror," while Edmund Burke defines the sublime as a kind of edgy narcotic unsettling produced by nightfall, and darkness makes it more clearly a desired state of mind.[61] Addison's agreeable terror, like James Thomson's "rapturous terror," in his long poem *The Seasons* (1730), is of itself neither holy nor unholy—though when Thomson ties his notion of sublimity so closely to his religious vision, it may substitute for either.[62] Such conflations came to be increasingly frequent, prompting John Baillie in his *Essay on the Sublime* (1747) to write, "We often confess the *Sublime* as we do the Deity; it fills and dilates our Soul without being

59. Dennis, as Phillip Donnelly has shown, misunderstood Longinus, but for his time in a representative way: "Enthusiastic Poetry and Rationalized Christianity: Poetic Theory of John Dennis," *Christianity and Literature* 54, no. 2 (2005): 236–64.

60. Dennis, *Miscellanies* (1693), in *The Critical Works of John Dennis*, ed. E. N. Hooker, 2 vols. (Baltimore: Johns Hopkins University Press, 1939), 2:380–81.

61. Joseph Addison, "XXII. Pleasures of the Imagination," *Spectator* 411 (June 21, 1712); Edmund Burke, *A Philosophical Enquiry into the Origin of Our Ideas on the Sublime and Beautiful* (London, 1757).

62. David B. Morris, *The Religious Sublime* (Lexington: University of Kentucky Press, 1972), 143–45.

able to penetrate into its Nature and define its Essence."[63] In short, the sublime gives a religious sort of "rush" of powerful emotion without any disagreeable compunction to repentance. Thomas Gray's remark about mountain landscapes, that there is "not a precipice, nor a torrent, not a cliff, but is pregnant with religion and poetry," indicates the general drift.[64] Thus, in certain contexts, the place of the "holy" for Enlightenment neoclassicism had gradually become some order of the natural sublime long before Wordsworth thought of it.[65] Edward Young's long poem *Night Thoughts* (1742) argues for the "infinite" of the nighttime starry sky as a primary source of sublime emotion, while for Edmund Burke: "Whatever is in any sort terrible . . . or operates in a manner analogous to terror, is a source of the sublime, that is, productive of the strongest emotions of which the mind is capable of feeling."[66] Among Burke's preferred sources of the sublime he lists "Vacuity, Darkness, Solitude and Silence."

By the time of Wordsworth's *Guide to the Lakes* (1810), the "scary" sort of natural sublime could be tamed to the rustic "picturesque"; vignettes of wilderness beauty sought by the painters on their mountain hikes through the Lake District were often framed by them in a mirror—a convex "Claude glass"—for the sake of concentrating the sublime elements for representation on tidy little canvases for the drawing room. In fact, such holiday painters turned their backs on the actual landscape to find in their looking glass a new picturesque sublimity, a second-order domestic remove from the ostensible source of the sublime in raw nature. In poetry, the "Wordsworthian egotistical sublime," as the poet John Keats dubbed Wordsworth's poetic—that is, a primary focus on himself and his own inner mental processes—involved a different sort of mirror; rather than contemplate the external nature that Keats believed was merely an excuse for self-indulgence in a poem like "Tintern Abbey," we see the poet turn increasingly toward subjective resources for the sublime.[67] In "Tin-

63. Quoted in Morris, *The Religious Sublime*, 130.

64. *The Correspondence of Thomas Gray*, ed. Padget Jackson Toynbee, Leonard Wibley, and Herbert W. Starr (Oxford: Clarendon, 1971), 1:128; Morris, *The Religious Sublime*, 131, 245.

65. Immanuel Kant, *Observations on the Feeling of the Beautiful and Sublime* (1764). In Mark Aikenside's *The Pleasures of the Imagination* (1744), the sublime is simply the highest spiritual form of Beauty.

66. Edward Young, *The Complaint, or Night Thoughts on Life, Death, and Immortality* (London, 1742); Burke, *A Philosophical Enquiry*, 36.

67. Keats to Richard Woodhouse, in a letter of October 27, 1818, included in *The Poems of John Keats: A Sourcebook*, ed. John Strachan (New York: Routledge, 2003), 17.

tern Abbey," fully seven-eighths of the lines are not about the landscape but about the mind of the poet, his internal musings:

> A presence that disturbs me with the joy
> Of elevated thoughts; a sense sublime
> Of something far more deeply interfused,
> Whose dwelling is the light of setting suns,
> And the round ocean and the living air,
> And the blue sky, and the mind of man. (ll. 94–99)[68]

In his misty interiority, Wordsworth elides natural and supernatural, as has memorably been observed elsewhere.[69]

To summarize: by the beginning of the nineteenth century there had been two prominent general understandings of the "sublime" in Western aesthetic theory, classical and late neoclassical, the rhetorical sublime of Longinus and the natural sublime of the eighteenth-century poets and landscape painters. In principle, both can provoke an apprehension of the divine, the sacred, or holy presence. The second of these, however, could quite literally substitute for it. This substitution had the effect of diminishing the idea of the holy until it was emptied of transcendence. The term could even be applied to art in which subject matter akin to campfire ghost stories is featured (e.g., the gothic novel, a rough equivalent to horror movies or *The Walking Dead* in our own time); these fictions likewise inspired in some a facsimile for the awe once associated with religious experience.

In our context, however, despite some superficial similarities, biblical conceptions of "the holy," and even, if we stretch our sense of the term, of "the sublime," are notably at sharp variance with both classical and neoclassical formulations. In the Judaism of the Old Testament, for example, sublimity and the holy are in some contexts (e.g., in the Psalms and Isaiah) arguably indistinguishable; sublimity is experienced when the voice of the Holy is heard to speak. Thus in biblical narrative, an experience of the holy is not a matter of aesthetic pleasure such as one may have in visiting an art gallery or Pikes Peak. It is rather an encounter, psychologically real and morally radical, compelling either abject silence

68. William Wordsworth, "Lines Written a Few Miles above Tintern Abbey," in *William Wordsworth: The Major Works*, Oxford World Classics (Oxford and New York: Oxford University Press, 1984, 2000), 134.

69. Abrams, *Natural Supernaturalism*, 65–70.

or scrupulous worship of a deity who is, after all, too terrifying even to name. Artists may do high honor to the deity, as in the cherubim made by Bezalel, son of Uri, to hover over the ark, but representation of the divine nature itself (Exod. 20) is absolutely forbidden. Face-to-face encounter is more likely to bring about death than enlightenment simply because God's holiness is so all-qualifying that it cannot be directly endured by sinful mortal creatures (Gen. 32; Isa. 6). This is much more than a matter of poetic diction and its special effects, or the thrill of a remarkable mountain vista. Rhetorically, "a word fitly spoken" may be "like apples of gold in pictures of silver" (Prov. 25:11)—that is, lofty language can be aesthetically pleasing where the ear is concerned—but in the Old Testament no one who has not already lost his mind will approach the holy of holies for an experience of Addison's "agreeable horror." The sublime encountered in the Hebrew Scriptures often achieves lofty rhetorical expression, but charming poetic diction is not the point; one thinks of the annihilating power of God's speech from the whirlwind to Job (Job 38–42), a discourse that ends not in Job's being thrilled but in his repentance. A similar overpowering presence is manifest in the searing vision of Isaiah (chap. 6). God's voice from heaven at the baptism of Jesus (Matt. 3:17), which Poussin attempts to register in his *Baptism*, is another example, as is the divine rebuke of Peter's religious enthusiasm at the transfiguration (Luke 9:35). Thus, though rhetorically grand biblical eloquence may achieve heights of the rhetorical sublime, typically this occurs when God commands, and thus parallels more closely the example Longinus chose from Genesis, "Fiat lux!" (Gen. 1:3). The terror experienced by the Israelites when Moses spoke with God on Mount Sinai (Exod. 19:16) is indicative. When in the Bible the "Holy One of Israel" speaks, it is with such absolute power and authority that even his chosen people tremble. When prophets later announce a word of the Lord or when angelic messengers appear, they thus routinely begin with the assurance "Fear not!" There is no equivalent in the Bible of the eighteenth-century "natural sublime," on a mountain or anywhere else; the sublimity is unambiguously supernatural.

SECULARIZING THE SUBLIME

Immanuel Kant, in his *Critique of Judgment*, acknowledges the concept of holy fear. Though he wants a thoroughly secular definition, he admits that a religious precedent exists: "a virtuous person fears God without being

afraid of him."[70] Fear of the Lord, in short, he sees as composed of an apprehension of God's absolute power and our own human contingency, but in a pious person subtended by trust in God's provident benevolence. He likens the believer's awe of a holy God to the way we typically respond to the truly terrifying power of nature, "threatening rocks, thunderclouds piling up in the sky . . . the boundless ocean heaved up, the high waterfall of a mighty river, and so on," of which the view is "all the more attractive the more fearful it is, provided we are in a safe place" (1.28; p. 120). The comment that follows, however, seems to evade the expected conclusion: "Perhaps the most sublime passage in the Jewish Law is the commandment: 'Thou shalt not make unto thee any graven image, or any likeness of anything that is in heaven or on earth, or under the earth,' etc. This commandment alone can explain the enthusiasm that the Jewish people in its civilized era felt for its religion when it compared itself with other peoples" (1.29; p. 135). Yet Kant promptly rejects his straw man analogy between his secular sublime and the response of believers to the commands of a holy God. There is more than a hint of Nietzschean disdain in his observation that "in religion in general the only fitting behavior in the presence of the deity is prostration, worship with bowed head and accompanied by contrite and timorous gestures and voice" (1.28; p. 122). It soon becomes apparent that his notion of the sublime is not something occasioned by the divine commands in Scripture or even in the manifest powers of nature, but is resident "only in our mind, insofar as we can become conscious of our superiority to nature within us, and therefore also to nature outside of us (as far as it influences us)" (1.28; p. 123). Whatever arouses our feelings of awe or terror is therefore "only improperly called the sublime"; what is properly sublime is the strength of our own mind in control.

Now we can see how far removed is Kant's notion of the sublime from earlier notions of the natural or religious sublime; what in Dennis, Addison, Burke, or Thomson bore a relationship to power *not* under our control is here colonized and made a property of the strong mind. "Thus, any spectator who beholds massive mountains climbing skyward, deep gorges with raging streams in them, wastelands lying in deep shadow and inviting melancholy meditation . . . is seized by amazement bordering on terror, by horror and a sacred thrill; but since he knows he is safe, this is not actual fear" (1.28; p. 129). The sacred thrill that once was occasioned

70. Kant, *Critique of Judgment*, 1.28; p. 119. Hereafter, references from this work will be given in parentheses in the text.

by the divine voice, incense in the sanctuary, or images of the incarnate deity has been transferred inwardly, subsumed to a power of individual mind, mind over matter. Correspondingly therefore, Kant does away with the traditional transcendentals as we might find them in Platonism or medieval Christianity: in place of the True, the Good, the Beautiful, and Being, we are given respectively the *agreeable*, the *beautiful*, the *sublime*, and the *absolute good* "in relation to the feeling of pleasure" occasioned by an object.[71] When we pair Kant's "agreeable . . . beautiful . . . sublime . . . absolute good" with the traditional terms the True, the Good, the Beautiful, and Being, we can see how radical is his turn; we shall come back to it in chapter 12.

The best known of Caspar David Friedrich's paintings, *Wanderer above a Sea of Fog*, culminates a movement in his art away from lingering pietist and Lutheran sensibilities and announces the artist as just such a man as both the poet Goethe and the philosopher Kant could have approved. For Goethe, *Sehnsucht*, the longing or wanderlust that propels the "Wanderer" (fig. 90), is the authentic romantic virtue:

> What pulls at my heart so?
> What tells me to roam?
> What drags me and lures me
> From hearth and from home?
> How round the cliffs gather
> The clouds high in the air!
> I fain would go thither,
> I fain would be there![72]

For Kant, the triumph of such a "Wanderer" over the powers of nature is a proof of his superior strength of mind. Both sentiments correspond to Friedrich's masterpiece.

Even though the canvas is smaller than that of most of his works, the psychologically telltale diminutive figures there have been replaced here by a strong figure who really is the painting's subject, a hiker who has reached the pinnacle he has set himself to climb, and who stands there confidently looking out over the mountains and crevasses half obscured

71. Kant, *Critique of Judgment*, "General Comment on the Exposition of Aesthetic Reflective Judgments," 126.

72. Goethe, "Longing" (1803), in *The Poems of Goethe: Translated in the Original Metres*, ed. Edgar Alfred Bowring (New York: Hurst, 1853), 88.

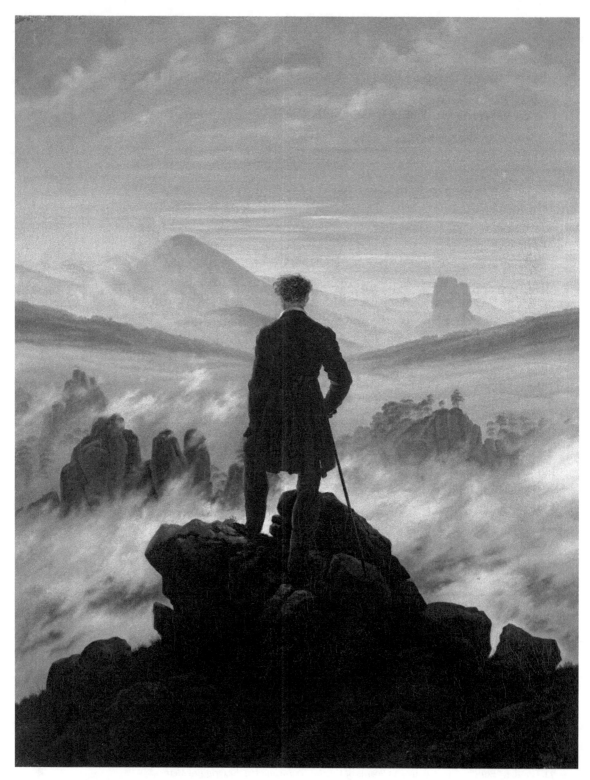

Figure 90. Caspar David Friedrich, *Wanderer above a Sea of Fog*, ca. 1817

by rolling mists of fog. It seems not to matter that he cannot see what lies below; he is a man who now looks down on the clouds, not up. The unkempt red hair immediately identifies him with the artist, his body language bespeaks the self-confidence of accomplishment, and the sky is still light and illuminating. Friedrich's *Rückenfigur*, which has been called "the simplest of devices for representing aesthetic experience in the new, Kantian sense," centers the painting literally and metaphorically "on the observing subject."[73] There is no terror in this figure, holy or otherwise, but rather an agreeable sense of mastery over the extremes of his environment. He has arrived, and is, so to speak, master of all he surveys.[74] His arrival culminates a pilgrimage that parallels that of many wanderers in the Romantic period.

WORDSWORTH'S ENDLESS PRELUDE

When Wordsworth and Coleridge went to Germany in the winter of 1797–1798, one of their aspirations was to acquire materials both intellectual and spiritual that would enable them to write conjointly a long epic poem on "man, nature, and society" titled *The Recluse*; their intent was, in Wordsworth's words, to rival or surpass Milton's great epic, *Paradise Lost*.[75] The first part of that project, *The Prelude; or Growth of a Poet's Mind; An Autobiographical Poem*, was conceived by Wordsworth as "a review of his own mind [to] examine how far Nature and Education had qualified him for such an employment." While Coleridge and his friend John Chester went south to Ratzeburg to live until mid-February with a Lutheran pastor, then on to Göttingen to the university for further study of German theology and metaphysics (Kant, Schelling, Schleiermacher, and Herder) till June, Wordsworth and his sister Dorothy went to remote Goslar in Saxony. There, despite being cut off from daily conversation with the always more intellectual Coleridge, Wordsworth began to write his rambling autobiographical poem, periodically encouraged by letters from Coleridge. *The Prelude* would come to have three editions, each an expansion on the previous one; these

73. Elizabeth Prettejohn, *Beauty and Art, 1750–2000* (Oxford: Oxford University Press, 2005), 54.

74. This work may be contrasted with Friedrich's 1801 woodcut *The Woman with the Raven at the Abyss*, suggestive of suicide, in which the woman wanderer, teetering on the edge of a precipice, looks in distress toward the viewer.

75. William Hazlitt, *Table Talk: Essays on Men and Manners* (London, 1830), 2:70–71.

were published in 1799, in 1805, and finally, after his death, as edited by Dorothy, in 1850.

Wordsworth had little direct contact at any point in his life with the writings of the German Enlightenment; the echo of these ideas in his work, already instanced at the beginning of this chapter, came to him largely secondhand.[76] They form, nonetheless, themes in his poetry that link well enough to the paintings of Friedrich. Some passages, reminiscent of Friedrich's images, derive simply from observation, as when Wordsworth remembers from his alpine walking tours how

> . . . with uplifted eyes beheld,
> In different quarters of the bending sky,
> The cross of Jesus stand erect, as if
> Hands of angelic powers had fixed it there,
> Memorial reverenced by a thousand storms.
>
> (*The Prelude*, bk. 6, ll. 482–486)

He remembers also how

> From a bare ridge we also beheld
> Unveiled the summit of Mont Blanc, and grieved
> To have a soulless image on the eye
> That had usurped upon a living thought
> That never more could be. The wondrous Vale
> Of Chamouny stretched far below. (bk. 6, ll. 524–528)

Further, in an almost Kantian vein, he tells how "Imagination—here the Power so called" became for him the source of mental strength he had sought:

> That awful Power rose from the mind's abyss
> Like an unfathered vapour that enwraps,
> At once, some lonely traveler. I was lost;
> Halted without an effort to break through;
> But to my conscious soul I now can say—

76. A good account of Coleridge's imperfect mediation of Kant and the German idealists to Wordsworth is provided by Mary Warnock, *Imagination* (Berkeley: University of California Press, 1976), 72–130; see also John Spencer Hill, *Imagination in Coleridge* (London: Macmillan, 1978).

"I recognize thy glory:" in such strength
Of usurpation, when the light of sense
Goes out, but with a flash that has revealed
This invisible world, doth greatness make abode,
There harbours; whether we be young or old,
Our destiny, our being's heart and home
Is with infinitude, and only there. (bk. 6, ll. 592–605)

As with Friedrich's *Wanderer above a Sea of Mists*, Wordsworth's poem recalls a "mountaintop experience" in which the powers of his own mind are transfigured. But the glory Wordsworth finds is certainly not any more than in Friedrich's case the *shekinah kabod* of the biblical God; rather, it is that of the powers of his own imagination when awakened to discover itself superior to all external reality, in effect to *achieve* the sublime, or holy, as a power of his own mind. As with Kant's *Prolegomena to Any Future Metaphysic*, so with Wordsworth's *Prelude* to whatever summa he may less clearly and distinctly have conceived; once transcendence has been redefined merely as a power of the individual imagination, then it ceases to have communicable moral authority. Authentication can proceed no further than, as with Schleiermacher, the emotions.

Conclusion

William Wordsworth and Caspar David Friedrich, each in his own way, are hallmark representatives of the Romanticism that arose following the disenchantments of Enlightenment philosophy and Protestant pietism. Independently but almost simultaneously they faced the challenge of finding a convincing locus for transcendent meaning to replace what Wordsworth called the "ancient Piety for ever flown."[77] Both grasped at older images for religious ideas that, in Wordsworth's phrase from that same poem, "even then seemed like fleecy clouds" backlit by a sun already set. When that effort failed, they both turned to nature, especially nature in its most awe-inspiring manifestations, seeking there a replacement for the faded glory of an ancient faith from which the sensibilities of the Reformation had cut them off both aesthetically and spiritually. Needing a place marker for the holy, they sought it outwardly in nature rather than in nature's God, but finally found it in their own imaginations. The absence

77. William Wordsworth, "Decay of Piety" (1827), in *Miscellaneous Sonnets* 22.

of holy images of Christ and the apostles in the poetry of Wordsworth and the painting of Friedrich alike is striking; what we have in their place is images of holy images. And while beauty as a category, debated though it is, continues to have some order of transpersonal if not transcendent reference in their poetry and painting, holiness has disappeared like their symbolic setting sun, its ebbing light now subsumed into the category of the aesthetic sublime.

10 ART AFTER BELIEF

Mystery, philosophic truth, and the symbol are affairs of religion and of art, the one, moreover, being only the second form of the other.

<div align="right">

ANDRÉ BARRE

</div>

Orthodoxies of any kind, when insisted on too rigidly, tend to generate opposition. The neoclassicism of eighteenth-century Europe as represented in the national art academies of England, Germany, and France began in the early nineteenth century to attract the scorn of artists whose interests and creativity did not fit the neoclassical mold. While this sputtering revolution of artists was hardly so momentous as the political revolution of 1789 or the religious Reformation before it, it nevertheless had significant consequences for the arts and for Western culture generally. In this chapter we shall consider some of the diverse reactions among prominent European artists in the nineteenth century, several of whom had a quasi-spiritual ambition to regain through art an authentic contact with the holy. There were two general orientations in this otherwise diffuse search for the holy, one of which looked back in the hope of emulating and revivifying the masters of medieval and Renaissance Christian art, the other of which looked the other way, even beyond Europe and Christian culture, to exotic and pagan cultures.

Beauty had not yet been eclipsed. Indeed, it would famously become the primary good of the impressionists. These artists, though for the most part not personally religious, might almost be said to have worshiped beauty, beauty in nature and the beauty of women in particular. Pierre-

Auguste Renoir (1841–1919), master of this school, had a Catholic education, and though he rarely darkened the door of a church in his adult life, he retained his conviction that creation was an inexhaustible source of wonder and believed that an artist, "unless he has driven away God and in so doing . . . has driven away happiness,"[1] should always collaborate with nature in his work. Other impressionists—notably Paul Cézanne (1839–1906), Edgar Degas (1834–1917), Édouard Manet (1832–1883), Claude Monet (1840–1926), Mary Cassatt (1844–1926), and Berthe Morisot (1841–1895)—have little or nothing to say about religion, and their compositions are essentially secular. Even though Monet famously made thirty paintings of the facade of the great cathedral in Rouen, it is not as a holy place that he painted it. Rather, the facade is a textured surface for experiments in color, light, and subjective play, his real subject. If anything, the cathedral is ironic, a "facade" in another sense. Finally, while the impressionists were certainly not classicists, neither were they in spirit an avant-garde. They were middle-class artists who largely lived with their families, and their comparatively long and happy lives echoed the tranquillity they sought in their paintings. Though they produced some of the most beautiful art in all modernity, their work is conspicuously innocent of religious interest or concern. In pursuit of connections of beauty and holiness, we must accordingly turn our focus elsewhere.

The Nazarenes

A generation earlier, a group of German painters only slightly younger than Caspar David Friedrich shared with him a romantic resistance to the classicism represented by Johann Joachim Winckelmann and the Viennese Academy, but they did not share Friedrich's Protestant horror of the Catholic past. In fact, they found it a contradiction that their professors taught them "to compose like Raphael, use color like Titian, incorporate chiaroscuro like Caravaggio, and convey grandeur and power like Michelangelo"[2]—while denying them the freedom to work on religious themes. Though many of the artists who felt this tension were raised in a Protestant context, the group developed a shared conviction that it was time for northern art to reach back to the pre-Reformation past and to

1. Quoted in Michel Florisoone, *Renoir* (New York: Hyperion, 1938), 20.
2. Charlene Spretnak, *The Spiritual Dynamic in Modern Art: Art History Reconsidered, 1800 to the Present* (New York: Palgrave Macmillan, 2014), 23.

Figure 91. Johann Overbeck, *Jesus Raising the Daughter of Jairus*, 1815

find a means of repairing broken links.[3] In 1809 a group of these students, eventually including Johann Friedrich Overbeck (1789–1869), Joseph Sutter (1781–1866), Peter von Cornelius (1783–1867), and Julius Schnorr von Carolsfeld (1794–1872), formed a brotherhood (*Gesellschaft*), calling themselves the Lukasbund after Saint Luke, patron saint of artists. Highly idealistic, they were also antimodernist, and took to wearing their hair long, parted in the middle, and to dressing in medieval-styled clothing.

When they went to Rome and moved into a half-empty Irish Franciscan monastery, the Lukasbund created quite a stir. The Italians called them *Nazareni* for their icon-imitating hairstyle especially, and the name stuck. After Overbeck, whose background had been Lutheran, converted in 1813, the group became increasingly Catholic, uniting admiration for the great Renaissance painters with the faith those painters served.[4] Living

3. Mitchell Benjamin Frank, *German Romantic Painting Redefined: Nazarene Tradition and the Narratives of Romanticism* (Aldershot, UK: Ashgate, 2001), 11–13.

4. Albert Boime, *Art in an Age of Counterrevolution, 1815–1848* (Chicago: University of Chicago Press, 2004), 36. Boime compares the Nazarenes to a medieval guild; much the same might be said of the Pre-Raphaelite Brotherhood and, later, the Nabis.

in what had been the cells of Franciscan conventuals, they even fancied themselves as ersatz monks.[5] Overbeck in particular became increasingly devoted to depicting the Virgin Mary and other female saints,[6] and though he would return to Germany after the Lukasbund dissolved in 1820, the impact of those years in Rome with his brethren was definitive for his mature style as well as subject matter. Overbeck thus well illustrates the desire felt by some northern artists to search for a deeper, more personal experience of the earlier Christian tradition from which they felt the art academies had cut them off.

Overbeck also explored scenes from the Bible that he felt had been neglected and, precisely because they involved miracles of Jesus, needed special attention in the skeptical nineteenth century (fig. 91). In this depiction of the raising of Jairus's daughter, the typical Nazarenic clarity of line, washed color, and idealized setting frame the miracle clearly as a religious symbol; in both the theological and painterly sense, it captures the idea more plausibly than it conjures up the historical moment or its literary expression (in Luke's account, for example, a major feature is the keening of the professional mourners turned to derisive laughter at the claim of Jesus that she would awake—Luke 8:52–56). In effect, Overbeck's painting is an abstraction *from* the story rather than a depiction of it. As it happens, abstraction to symbol is a hallmark of Nazarene painting more generally, so that it tends to communicate an *idea* of the holy rather than project holy presence.

We see this movement representatively in the large fresco Overbeck did around 1830–1840, commissioned by the Städelsches Kunstinstitut in Frankfurt, entitled *The Triumph of Religion in the Arts* (fig. 92). The composition is geometrically organized in a fashion strikingly reminiscent of Raphael's *Disputa del Sacramento* in the Stanza della Segnatura,[7] and no one who had seen Raphael's great fresco could avoid a comparison. Here the area above the clouds shows the heavenly court (Overbeck called this a "vision") in which, in place of Raphael's Trinity with Christ at the center, Mary and the infant Jesus are enthroned. In place of Raphael's court of both biblical and traditional saints, Overbeck included select biblical figures from both Testaments who, according to him, "served Christian art." On Mary's left, Luke (representing painting) and John (architecture,

5. Frank, *German Romantic Painting Redefined*, 12n7, 49–79.

6. Frank, *German Romantic Painting Redefined*, 65. The inspirational painting was Raphael's *Sistine Madonna*, acquired by King August III for his Dresden collection in 1745.

7. Frank, *German Romantic Painting Redefined*, 100–103; Boime, *Art in an Age of Counterrevolution*, 76–78.

Figure 92. Johann Overbeck, *The Triumph of Religion in the Arts*, 1840

for his vision of the new Jerusalem) are joined by New Testament martyrs. On Mary's right are David (music), Solomon (sculpture, somewhat curiously), and other Old Testament patriarchs and prophets. "Poetry," according to Overbeck's guide, "appears in the middle, symbolized by the Virgin herself, who writes down her sublime hymns of praise." For Overbeck, poetry centers all the arts, "just as the secret of God becoming man from the Virgin Mary is the center of all religious ideas."[8]

Painting on a grand scale for interior worship space became a central objective of the Nazarene painters when they eventually returned to Germany. Peter Cornelius made his own contribution in a fresco cycle for the church of Saint Ludwig in Munich, of which the centerpiece was a massive *Last Judgment* modeled on that of Michelangelo in the Sistine Chapel. Cor-

8. Translation in Frank, *German Romantic Painting Redefined*, 101; see Frank's notes, 83, 84.

Figure 93. Peter von Cornelius, *Last Judgment*, 1836–1840

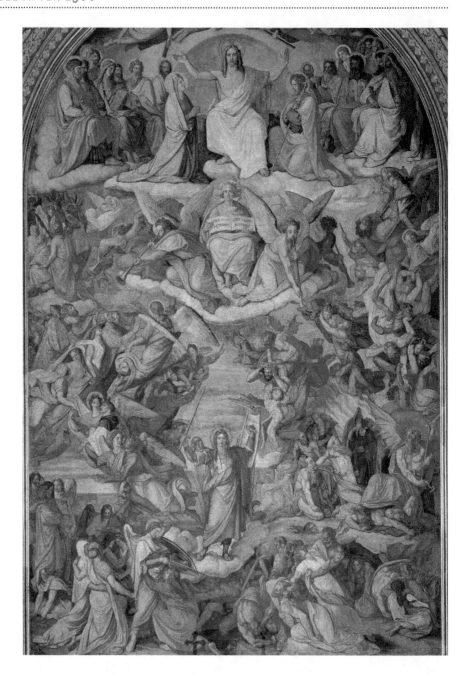

nelius's version, over sixty feet high by thirty-eight feet wide, is perhaps the apogee of fresco painting in Germany, but it was poorly received by the king and local Roman clergy alike. It is a risky thing to attempt to outdo a well-known masterpiece; by comparison with Michelangelo's dynamic composition, the *Last Judgment* of Cornelius appeared flat, static, even

stilted. As has been observed, the depiction as symbol is intelligible;[9] the ideas are all there, and, as the Council of Trent would have preferred it, the figures are appropriately clothed (fig. 93).

Unfortunately, however, the grand composition, hieratic and artificial, is uninspiring. The Nazarenes' medievalism and their aspiration to recover the grandeur and awe of holy space were as indebted to German Romanticism as was Caspar David Friedrich's work; ultimately, their art fell short of the painters' explicitly religious ideals. In Catholic Bavaria, where the old cathedrals remained standing and new ones were being built, the Nazarenes' attempt to revivify Renaissance models resulted only in pale imitations. In fact, much of their oeuvre now strikes the viewer almost as Christian kitsch.

The Pre-Raphaelites

The other prominent nineteenth-century group to self-consciously reject the standards of the classical academy and, in so doing, reach back into an idealized medieval past, were the painters and poets of the Pre-Raphaelite Brotherhood. In their case, the *bête noir* against whom they rebelled in symbolic fashion was Sir Joshua Reynolds, founder of the Royal Academy of Arts in London,[10] while their sense of the high-water mark in European painting, much as for the Nazarenes, was the work of Raphael. Dante Gabriel Rossetti (1828–1882), the chief figure in this movement, had been a student at the academy along with William Holman Hunt (1827–1910) and John Everett Millais (1829–1896); they were joined by Ford Madox Brown (1821–1893) to form a secret society, and pledged to sign the back of their canvases "PRB." Brown had visited the studios of both Overbeck and Cornelius, and he admired both their idealism and some aspects of their technique.[11] Unlike the Nazarenes, by whose medievalism especially they were influenced through Brown, the Pre-Raphaelite Brotherhood did not decamp for Rome, and their own medievalism, more Gothic than Italian in style, focused less on ecclesiastical art than on the poetry of Dante and the Arthurian tales championed by Alfred Lord Tennyson (1809–1892), John Ruskin (1819–1900), and William Morris (1834–1896). Biblical sub-

9. Cordula Grewe, "Historicism and the Symbolic Imagination in Nazarene Art," *Art Bulletin* 89, no. 1 (2007): 82–107, especially 87.

10. William Blake, *Annotations to Reynolds' Discourses*, in William Blake, *Discourses*, ed. Pat Rogers (London: Penguin, 1992).

11. David G. Reide, *Dante Gabriel Rossetti* (New York: Twayne, 1992), 39.

jects were less frequently attempted, except by Hunt, notably after his evangelical conversion.

Rossetti was in his own time highly regarded as a poet, though his sister Christina has in that respect subsequently eclipsed him. His early poems and paintings are often closely related, and for his two most famous "Anglo-Catholic" paintings, the connection between poem and painting is direct. His seminal Marian poem is his verse prayer to "Mater Pulchrae Delectationis," titled simply "Ave" in the edition by his brother William.[12] It reprises many of the titles accorded to Mary in late medieval tradition, and echoes overall the themes of the Joys and Sorrows of the Virgin. This poem and others in the collection he first called *Songs of the Art Catholic* (1847) are indebted to the Anglo-Catholic movement begun a generation earlier under the leadership of Keble, Pusey, and John Henry (later Cardinal) Newman (1801–1890). From his midteens through his midtwenties, Rossetti and his family worshiped in Anglo-Catholic parishes, and it was there that his religious sensibility was apparently formed.[13] It is not surprising that his early paintings should have this Marian focus, even though, as his brother among others suggested, his theological convictions were rather vague and unformed.[14] In any event, Rossetti's first exhibited picture was *The Girlhood of Mary Virgin*, at the Free Exhibition in London (fig. 94), and it develops one of his Marian themes from "Ave."

The iconography in this work is conventional, but oddly arranged; the dove is perched rather than hovering in midair, and it is adorned with a halo; the anachronistic angel is a child propping up the predictable lily, and the girlhood of Mary is represented as an apprenticeship to female tasks of the hearth, with Mary being instructed by Saint Anne, while her father Joachim tends vines in the background. The composition as a whole has a certain Victorian sentimental appeal, although, somewhat disjunctively, near the seven palm fronds on the floor is a stack of large folio vol-

12. *The Works of Dante Gabriel Rossetti* (London: Ellis, 1911), 661–63. Here I am citing the American edition of the *Poems*, with William M. Rossetti's introduction (New York: Thomas Y. Crowell, n.d.), 32–35.

13. D. M. R. Bentley, "Rossetti's 'Ave' and Related Pictures," *Victorian Poetry* 15, no. 1 (1977): 21–35, argues for Rossetti's conventional Catholic upbringing. Sharon Smulders, "A Breach of Faith: D. G. Rossetti's 'Ave,' Art Catholicism, and 'Poems, 1870,'" *Victorian Poetry* 30, no. 1 (1992): 63–74, argues that in his revision of 1869 the poet takes a more ambiguous stance. For Rodger Drew, *The Stream's Secret: The Symbolism of Dante Gabriel Rossetti* (Cambridge: Lutterworth, 2007), such ambiguity is resolved if one takes into account his Rosicrucianism and other occult influences.

14. Reide, *Dante Gabriel Rossetti*, 28.

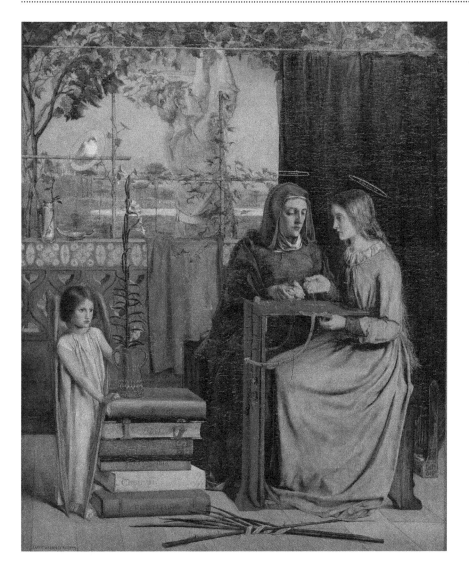

Figure 94. Dante Gabriel Rossetti, *The Girlhood of Mary Virgin*, 1848–1849

umes representing all but justice of the seven traditional virtues: *fortitudo, temperantia, prudentia, fides, spes*, and *caritas* (fortitude, temperance, prudence, faith, hope, and charity). A small scroll in the foreground reads "*Tot dolores, tot gaudia*" (so many sorrows, so many joys), the subject of Rossetti's poetic prayer. It may be that the painting is intended to suggest a penultimate moment in salvation history, just before the annunciation and nativity, and that *justitia* is to be imagined as forthcoming in Christ. Rossetti's mother and his sister Christina were his models, and their faces are pensive, focused on the domestic work at hand. The reaction to this picture at the exhibition was muted.

Figure 95. Dante Gabriel
Rossetti, *Ecce Ancilla
Domini! (The Annunciation)*,
1849–1850

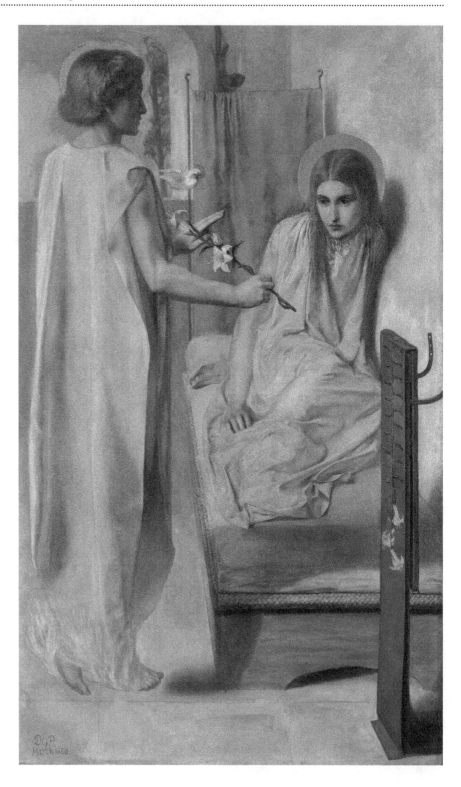

The next painting Rossetti exhibited, *Ecce Ancilla Domini!*, later named *The Annunciation* (fig. 95), was shown at the National Institution in 1850, and widely interpreted as a sequel to *The Girlhood of Mary Virgin*. There is nonetheless a striking disjuncture in tone from the first painting. Rossetti has gone from four figures to two, with the focus most intently on the face of the Virgin, modeled by Christina again, now eighteen years old. By comparison with earlier treatments of the annunciation, the free agency of Mary to grant consent is here radically diminished. She is found in her bed, not studiously reading Holy Writ as in medieval and Renaissance depictions, but cowering in fear against the wall, staring intently at the stem (rather than blossom) of the lily that is being thrust at her suggestively by a scantily attired "angel." This angel certainly does not kneel, but rather approaches her bed directly, feet aflame. The visual pun, drawn on the Hebrew euphemism *regel*, "feet," for genitalia, effects a reversal of the courtliness of traditional depictions by Rogier van der Weyden, the van Eycks, and Giotto. The first stanza of Rossetti's poem below, originally appended to the frame of *The Girlhood*, ostensibly serves as a commentary to that image; the second stanza applies better to this present image, but does not square with it:

This is that blessed Mary, pre-elect
God's Virgin. Gone is a great while, and she
Was young in Nazareth of Galilee.
Her kin she cherished with devout respect.
Her gifts were simpleness of intellect
And supreme patience. From her mother's knee
Faithful and hopeful; wise in charity;
Strong in grave peace; in duty circumspect.

So held she through her girlhood; as it were
An angel-watered lily, that near God
Grows, and is quiet. Till one dawn, at home,
She woke in her white bed, and had no fear
At all,—yet wept till sunshine, and felt awed,
Because the fullness of the time was come.[15]

15. This is the first version; *The Paintings and Drawings of Dante Gabriel Rossetti (1828–1882): A Catalogue Raisonné*, ed. Virginia Surtrees, 2 vols. (Oxford: Clarendon, 1971), 1:10; the version in his brother William's edition shows several revisions.

The Mary of *Ecce Ancilla Domini!*, however, has real fear in her face, and its occasion is clearly the point of Rossetti's execution. His Mary is *acted upon* in a way that thoroughly undercuts her free agency. While we can readily imagine Saint Bonaventure chafing at the idea that the first of Mary's gifts was "simpleness of intellect," the increasingly negative reaction of the public to both paintings, though less specific, was at least in part a rejection of sexually charged "Art Catholicism" as well as the ideals of the Pre-Raphaelite Brotherhood generally. One effect of the rejection was to send Rossetti in another direction, away from a quest to depict holiness to a focus on beauty as its surrogate. His own actual amours, licit and otherwise, were to be apotheosized: "Beauty like hers is genius," he would write of Elizabeth Siddal,[16] and he would describe his "first love remembered" in terms of his lady's bedchamber, "wheresoe'er / It be, a holy place,"[17] and refer to sexual intimacy as the "Holy of Holies."[18] But if religious devotion in his poetry and painting (e.g., *The Blessed Damozel*) could thus be readily transmuted to erotic devotion, both desires in the end come to be subsumed in a worship of art itself. In his praise of William Blake, Rossetti envisions the artist's workroom as a temple to art:

> This cupboard, Holy of Holies, held the cloud
> Of his soul writ and limned.[19]

In such misappropriations of language about the sanctuary to a worship of *erōs* and art, Rossetti presages, as we shall see, the postimpressionists' conception of art as a substitute for religion and its creation for worship.

William Holman Hunt, by contrast with Rossetti, began as an atheist or agnostic, but became steadily more engaged in the practice of Christian faith after his conversion through reading the Bible in 1851. As a result of his powerful response to the Scriptures, he found himself more attracted to evangelical than high church liturgy and spirituality. By 1853 he painted the iconic *The Light of the World*, one copy of which is now in Keble College, Oxford; the other is in Saint Paul's Cathedral in London. Determining on a "single-minded application of [his] art to the service of Christ,"[20] he desired to depict biblical scenes as faithfully as possible, going so far

16. Dante Gabriel Rossetti, "Genius in Beauty," sonnet 18, in *Poems*, 235.

17. Dante Gabriel Rossetti, "First Love Remembered," in *Poems*, 145.

18. Dante Gabriel Rossetti, "Known in Vain," sonnet 65, in *Poems*, 259.

19. Dante Gabriel Rossetti, "Five English Poets," in *Poems*, 295.

20. Eva Péteri, *Victorian Approaches to Religion as Reflected in the Art of the Pre-Raphaelites* (Budapest: Akadémiai Kiadé, 2003), 62.

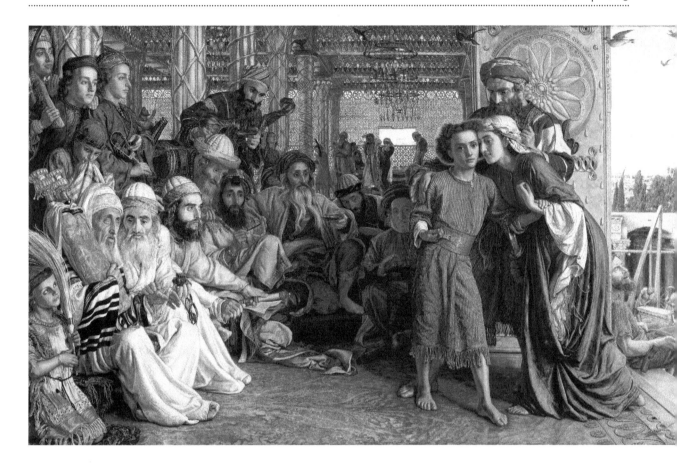

as to travel to the Holy Land in 1854 to capture the atmosphere and local color more accurately. Later that year he began work on *The Finding of the Saviour in the Temple*, his masterpiece (fig. 96); he was not to decide the work was finished for almost six years.

Figure 96. William Holman Hunt, *The Finding of the Saviour in the Temple*, 1854–1860

This painting, focused on the twelve-year-old Christ, captures a remarkable moment in Saint Luke's narrative, but Hunt surrounds it with typological clues and symbolic elements in such a way as to supercharge that moment with more extensive christological significance.[21] While the focus is on the face of Jesus, absorbed in thought, the maternal embrace of Mary, whispering rather than rebuking him aloud, captures a familial moment emotionally. Emotions are registered also on the faces of the elders, who are represented by Hunt in such a way as to display a variety of responses. These are not the faces of wonderment and suspended judg-

21. Péteri, *Victorian Approaches to Religion*, 70; George Landow, *William Holman Hunt and Typological Symbolism* (New Haven: Yale University Press, 1979), 125.

ment that one finds in Giotto's version (which more clearly reflects the elders' astonishment in the biblical account—Luke 2:47), but rather express self-conscious, hardened attitudes designed to make the elders in this episode proxy to the Pharisees and Sadducees who will later contest Jesus in his ministry.[22] One of the elders is blind, like the blind beggar leaning against the outside corner (Luke 6:39–40; cf. John 9:1–11). Inside, in the background, a lamb is being prepared for slaughter, while outside we can see that a cornerstone for some edifice is being set, and it is receiving the scrutiny of the builders (cf. Matt. 21:42). A part of Malachi's prophecy, "And the Lord, whom ye see, shall suddenly come to the temple" (Mal. 3:1), is inscribed in Latin and Hebrew on the golden frame of the temple door. Iconographically, there is more detail here than in the Marian paintings of Rossetti, but as is typical of Hunt, the references are christological, self-consciously organized so as to show that the traditional place of the holy, the temple, was in the fullness of time entered in a bodily way by the one who alone is holy, and that neither the elders nor Mary and Joseph really understood that most crucial fact at the time. Hunt's search for a locus for the holy has taken him in a different direction from Rossetti, one in which the canonical Scriptures rather than Marian or analogous legenda hold the interpretive key. In their subsequent careers, Hunt would continue to strive to understand and depict the presence of the holy while Rossetti would be obsessed almost exclusively with the evanescence of mortal beauty.

POSTIMPRESSIONISTS

The word "after" in the title to this chapter permits of two senses; the first, suggesting that art in the nineteenth century exhibits a "searching after" belief, has been illustrated here by the Nazarenes and Pre-Raphaelites in diverse ways. The temporal sense, "after belief has been abandoned," pertains more fully to the two dominant postimpressionist painters, Vincent van Gogh (1853–1890) and Paul Gauguin (1848–1903), each of whom had an early religious formation that he subsequently rejected in his pursuit of art. Their experience and personal dedication to art were in part a reaction against, and marked by their disappointment with, institutional religion, Protestant and Catholic, respectively. In their rejection of the or-

22. F. G. Stephens, Hunt's friend, provided a detailed explanation of this work that was approved by Hunt. See Landow, *William Holman Hunt*, 87–92.

thodoxies in which they were educated, van Gogh and Gauguin are among the most luminous signals that art was entering a post-Christian age. Despite that, each artist exhibits a continuing yearning after tacit spiritual realities, and each in his own way resembles Rossetti and others among the Pre-Raphaelites in believing beauty to be the nearest path and portal to an approximate knowledge of the holy.

Vincent van Gogh

Van Gogh is an optimal transitional figure between the two senses of "after." His religious experience compares in interesting ways to that of William Holman Hunt, whose *Light of the World*, painted in the year of Vincent's birth, he saw and admired during his London sojourn.[23] Van Gogh's father was a Dutch Reformed clergyman, not of a Calvinist bent as has sometimes been imagined, but of the Arminian Groningen school. Van Gogh's religious ideas were thus formed in a marginal *Hervormd* environment (nominally Reformed church culture), with sensibilities essentially anti-Catholic, but rejecting the doctrines of predestination and limited atonement. The Groningen theology, well exemplified in the writings of Vincent's uncle Johannes Stricker, a modernist biblical scholar, echoes the broad outlines of Friedrich Schleiermacher's idea that "the contemplation of the pious is the immediate consciousness of the universal existence of all finite things."[24] This notion implies an inward-looking quest for religious certitude.

Van Gogh's letters make clear in many places that he found the staid pieties of his family to be insufficiently engaged with the world, and that his rejection of their traditions was fundamentally emotional; in his passionate altruism he sought something more transformative. In 1873, while working for a family art dealership in Brussels, he was offered a position at the London branch of the firm and took it. (Van Gogh had excellent

23. *The Complete Letters of Vincent van Gogh, with Reproductions of All the Drawings in the Correspondence*, 3 vols. (Boston: New York Graphic Society, 1958, 1981), 3:614 (letter 229).

24. Friedrich Schleiermacher, *On Religion: Speeches to Its Cultured Despisers* (New York, 1958), 36. Kathleen Powers Erickson, *At Eternity's Gate: The Spiritual Vision of Vincent van Gogh* (Grand Rapids: Eerdmans, 1998), is especially illuminating on the religious tradition of the van Gogh family. See also her essay, with David G. Murphy, "Testimony to Theo: Vincent van Gogh's Witness of Faith," *Church History* 61, no. 2 (1992): 206–20, for a portrait of van Gogh's evangelical turn. Cf. David Hempton, *Evangelical Disenchantment: Nine Portraits of Faith and Doubt* (New Haven: Yale University Press, 2008), 155–57, 132.

command of English as well as of German and French.) By October 1874 he had crossed the Channel more than once. To his travels the twenty-one-year-old added wide reading in contemporary fiction (Dickens) and poetry (Baudelaire), as well as the sermons of Charles Haddon Spurgeon, and notably he began an intensive rereading of the Bible, Thomas à Kempis's *Imitation of Christ*, and John Bunyan's *Pilgrim's Progress*.[25] By May 1875 he had experienced a classic evangelical conversion, similar to that of Hunt, not mediated by clergy or church attendance so much as by the Bible directly. When his passionate convictions and literalist biblical ethic cost him his job at the art dealership (January 1876), he soon found a teaching position in which he assisted a Methodist minister, Rev. T. Slade Jones. This gave him the opportunity also to preach; his famous sermon at the Holiness Wesleyan Chapel in Richmond (1876) is the principal surviving example.

The theme of Vincent's sermon is that Christian life is a pilgrimage, that all faithful believers are engaged in a lifelong journey through trials and tribulations, heading toward "the arms of our Father in Heaven." One travels, he says, "as being sorrowful yet always rejoicing. For those who believe in Jesus Christ, there is no death or sorrow that is not mixed with hope—no despair—there is only a constant being born again, a constantly going from darkness into light."[26] He mentions a picture he has seen by George Henry Boughton, supposedly depicting pilgrims on their way to Canterbury, which van Gogh refers to allegorically as "the Holy City." On the road a pilgrim asks a woman in black (whose name is "Sorrowful yet always Rejoicing"), "Does the road go uphill then all the way?" and her answer is, "Yes, to the very end." "And will the journey take all day long?" "Yes, from morn to night, my friend."[27] These lines allude to Christina Rossetti's poem "Uphill," unattributed and incorrectly copied, yet another intriguing link to the Pre-Raphaelites, although the themes are conventional, established long before Boughton's painting and Rossetti's poem by Bunyan and Saint Paul.[28] Even after van Gogh's brief and unsuccessful attempt to win the approval of missions overseers and his crushing sense

25. Nathaniel Harris, *The Masterworks of Van Gogh* (London: Paragon, 1996), 17; Erickson and Murphy, "Testimony to Theo," 209.

26. Erickson, *At Eternity's Gate*, 52.

27. Van Gogh also recounts his story in a letter to Theo; *The Complete Letters of Vincent van Gogh*, 1:74 (letter 66); the text of Vincent's sermons is reproduced in the same volume, 1:87–91.

28. Patrick Grant, *The Letters of Vincent van Gogh: A Critical Study* (Edmonton: Athabasca University Press, 2014), 197–98.

of rejection by the Belgian evangelical church for his missionary work among the coal miners of the Borinage, these themes would stay with him, sublimated.

What van Gogh discovered in his interviews with the leaders of his new religious denomination was that while his radical identification with the poor he was sent to serve made him popular with the people, it alienated his overseers. In the trenchant words of his biographer Nathaniel Harris, "However desirable, imitating Christ was not enough in itself to qualify as a clergyman in nineteenth-century Holland."[29] Vincent's own sense of a vocation crushed was deep. "There may be a great fire in our soul," he wrote despondently, "yet no one ever comes to warm himself at it."[30] Nor was this the only injury to his ardor. Having already been rejected three times by young women for whom he had an unrequited passion, the rejection of the mission board in 1879 was especially devastating, a rebuke to the spiritual passion he had developed for imitating Christ. Henceforth he was to give up his aspiration for married life and become well acquainted with prostitutes; likewise, after his rejection by the mission board, his letters ceased to be filled with biblical quotations and no longer expressed a desire for Christian service.[31] Van Gogh, ever passionate and needing an object for his passion, would now serve another high ideal—or die trying.

It would be a mistake, however, to imagine that because he rejected organized religion van Gogh entirely lost either his admiration for the example of Christ or his appreciation of the God behind religious representations. In 1880 he could still write, "Everything which is really good and beautiful—of inner moral, spiritual and sublime beauty in men and their words—comes from God, and all which is bad and wrong in men and their works is not of God, and God does not approve of it."[32] He could also ask in the same letter that his brother Theo come to a deeper understanding of the religious value of art: "Try to understand the real significance of what the great artists, the serious masters, tell us in their masterpieces, that leads to God; one man wrote and told it in a book; another in a picture. Then simply read the Gospel and the Bible; it makes you think, and think much, and think all the time." In drawings accompanying letters to his brother Theo in December 1882 he includes two sketches, both sympa-

29. Harris, *Masterworks of Van Gogh*, 32.
30. *The Complete Letters of Vincent van Gogh*, 1:109.
31. Hempton, *Evangelical Disenchantment*, 129.
32. *The Complete Letters of Vincent van Gogh*, 1:133 (letters 197–198).

thetically executed, one of a man reading the Bible and another of a man giving thanks before his simple meal.[33] Later he would write that while he was no friend of the "present Christianity," he thought "its *Founder* was sublime." "The present Christianity I know only too well. That icy coldness hypnotized even me in my youth, but I have taken my revenge since—how? By worshiping the love which they, the theologians, call *sin*, by respecting a whore, etc., and *not* respecting many would-be-pious ladies."[34] This comment comes in a series of letters in which he asks after one of his earlier would-be fiancées, his cousin Kee Vos, amid comments on Flaubert's *Madame Bovary* and on a rumored suicide attempt by himself.[35] By the spring of 1889, van Gogh had been reading Ernst Renan's *Vie de Christ*, an early French attempt at a historical and undoctrinal Jesus, which Vincent said he found "a thousand times more comforting than so many papier maché Christs that they serve up to you in the . . . establishments called Protestant, Catholic, or something-or-other churches."[36] Van Gogh's uncle, J. P. Stricker, had published much the same kind of book as Renan in his *Jezus van Nazareth* (1868), likewise an early "quest for the historical Jesus" that cast doubt on the reliability of the Bible while upholding a nebulous faith.[37] Whether or not Vincent had read much of it, by 1880 it is clear that theologically he had moved away from the spiritual immediacy of his evangelical days, however ironically, to something not so far from the Groningen theology of his father and uncle Stricker that he had once disdained. In Vincent's case, it must be admitted, such belief as remained had been stripped of its codes of morality and propriety.

Van Gogh saw well enough that his family's religious tradition had already become something of a relic. In *The Old Church Tower at Nuenen* (1884), a depiction of a ruin in a graveyard, and in *Congregation Leaving the Reformed Church in Nuenen* (1884–1885), he reflects on the diminishing tradition and waning flock of his father. In what David Hempton regards as the third of a religious trilogy, van Gogh's *Still Life with Bible* (1885), we are shown an open Bible (his late father's), illegible except for the book title, Isaiah, and chapter heading, LIII (fig. 97). Beside it is a well-worn copy of Émile Zola's recently published novel *La joie de vivre* (1884). Zola

33. *The Complete Letters of Vincent van Gogh*, 1:253 (letter 573).
34. *The Complete Letters of Vincent van Gogh*, 2:378 (letter 309).
35. *The Complete Letters of Vincent van Gogh*, 2:376, 377.
36. *The Complete Letters of Vincent van Gogh*, 3:587 (letter 158).
37. Erickson, *At Eternity's Gate*, 30–31. Stricker's kind of piety is perhaps best illustrated by his statement in *Jezus von Nazareth*: "If faith is proved to be an illusion, I pray you, let us keep the illusion" (30–31n67).

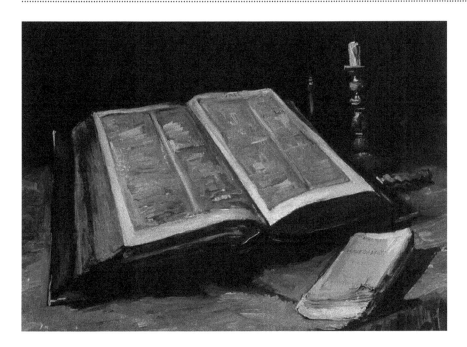

Figure 97. Vincent van Gogh, *Still Life with Bible*, 1885

was a popular social realist; his protagonists were often prostitutes (*filles de joie* in colloquial French) and other antiheroic types. Thus, as one might expect, Zola's title for his novel is heavily ironic; his characters suffer much. Perhaps it is this connection—the suffering of common humanity juxtaposed with the most famous Suffering Servant song in Isaiah 53, a text seen by Christians since the apostolic age as predicting the passion of Christ—that attracted van Gogh's attention. In any case, the juxtaposition is striking, and the symbolic character of the image heightened by the extinguished candle (of Ps. 119:105). It is possible to imagine any number of intentions in this work; among the darkest might be the possibility that van Gogh was saying that Scripture no longer illumines his path—at least not any more than the fiction of Zola. Or he might be saying that only one who has "borne our griefs and carried our sorrows" (Isa. 53:4) and who was "numbered with the transgressors" (v. 12) could meaningfully identify with the real world of human suffering.

Famously, van Gogh rejected any suggestion that he paint biblical scenes, even though there was still a market for them. "Of course with me there is no question of doing anything from the Bible," he wrote to Theo in December 1889,[38] reiterating the point at length to Emile Bertrand, while criticizing Bertrand's and Gauguin's attempt at just such

38. *The Complete Letters of Vincent van Gogh*, 3:615 (letter 233).

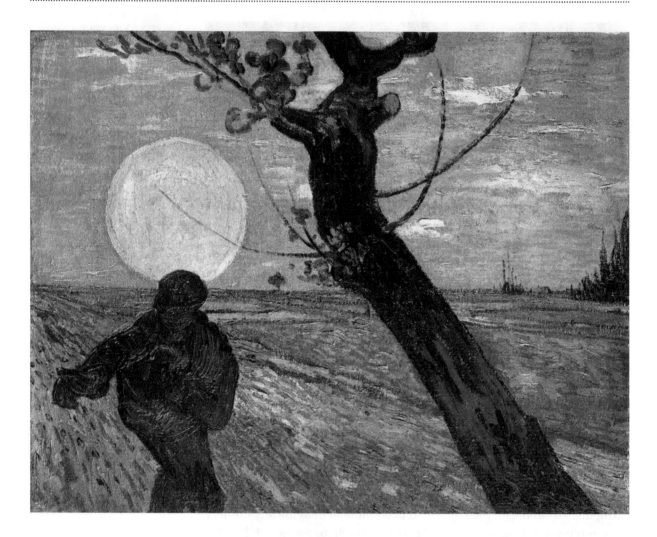

Figure 98. Vincent van Gogh, *The Sower*, 1888

subjects from the Bible. His preferred model was Jean-François Millet: "The Bible! The Bible! Millet, having been brought up on it from infancy, did nothing but read that book! And yet he never, or hardly ever, painted Biblical pictures."[39] Vincent is somewhat inconsistent, wanting a reproduction of the *Pietà* by Delacroix for his studio[40] and admiring Delacroix's *Christ Asleep during the Tempest* exceedingly, yet in general seeming to prefer the poetry (or parables) of the Bible to biblical nar-

39. *The Complete Letters of Vincent van Gogh*, 3:B21 (letter 524). Cf. Daphne Lawson, "Van Gogh: Framing a Biblical Vision," in *The Edinburgh Companion to the Bible and the Arts*, ed. Stephen Prickett (Edinburgh: Edinburgh University Press, 2014), 346–60.

40. *The Complete Letters of Vincent van Gogh*, 3:542 (letter 52).

rative. This in part accounts for his high admiration for Millet, whose iconic *Sower* (1850) inspired more than thirty versions of his own between 1881 and 1889 (e.g., fig. 98).[41]

Anytime an artist obsessively reworks a single theme or image, we know it has struck a deep chord in his own being. With van Gogh this obsession with Millet can be traced to the dawn of his evangelical period. In an early letter (1875), van Gogh reflects on his visit to a sale of Millet's drawings, and tells Theo that when he entered the exhibition hall, "I felt like saying, 'Take off your shoes, for the place where you are standing is Holy Ground.'"[42] He was far from alone in his high assessment of Millet's work,[43] but van Gogh's conviction that Millet was "the archetype of a *believer*" whose painting had an "evangelical" quality and who "painted the doctrine of Christ"[44] without painting conventional biblical pictures marks Millet as a spiritual link between van Gogh's evangelical days and his troubled later life.

The parable of the sower (Matt. 13:3–23; Mark 4:3–20) contains both an evangelical and an esoteric meaning. In respect to the sowing of the seeds, Jesus makes it clear that the Word of God is the seed but that the seed falls on all types of ground and that only the soil prepared by a disposition to spiritual understanding receives the Word fruitfully (Matt. 13:18–23).[45] The parable has thus become an epitome for evangelical proclamation. The esoteric meaning has typically been less well noted by evangelical commentators, but we may reasonably guess that for van Gogh it was part of what he took to be the "doctrine of Christ." When the disciples ask Jesus why he speaks so much in parables, he says, in effect, so that those who have "not been given to know the secrets of the kingdom of heaven" will be left without understanding, effectively the result of their hardened disposition: "seeing they do not see, and hearing they do not hear, nor do they understand" (Matt. 13:10–14). In short, the parable serves as a diagnostic tool, distinguishing the conventionally or professionally religious (scribes, Pharisees, Sadducees) from simple laborers who have at least a keen desire to understand what Jesus is say-

41. Erickson, *At Eternity's Gate*, 99.

42. *The Complete Letters of Vincent van Gogh*, 1:29 (letter 28).

43. The indispensable account here is by Judy Sund, "The Sower and the Sheaf: Biblical Metaphor in the Art of Vincent van Gogh," *Art Bulletin* 70, no. 4 (1988): 660–76, especially 660–63.

44. *The Complete Letters of Vincent van Gogh*, 1:136, 181, 240, 277; 2:333, B8, B221.

45. See Erickson's discussion of this text (*At Eternity's Gate*, 33n), in which she also stresses this conventional reading, though with emphasis on the moral life.

ing.[46] For van Gogh (fig. 98), the applicability of the meaning to his own experience among the coal miners and subsequently at the hands of the conventionally religious must have seemed direct and unambiguous. It seems to me that Judy Sund is on the mark when she writes that "Working outside the bounds of traditional religious narrative, Van Gogh effectively *evokes the holy*, drawing inspiration not only from earlier art, but from the Bible itself—wherein Christ 'works in the living spirit and the living flesh, [making] men instead of statues.'"[47] Van Gogh increasingly thought of art—and the work of the artist—as a means of encounter with the holy. He meant by this not all artists, evidently, but those who, like Millet, understood the role of the artist to be in some sense an imitator of Christ: "Christ alone—of all the philosophers, Magi, etc.—has affirmed as a principle of certainty, eternal life, the infinity of time, the nothingness of death, the necessity and raison d'être of serenity and devotion. He lived serenely, *as a greater artist than all other artists*, despising marble and clay as well as color, working in living flesh."[48] In his own art he seems to have wished to extend this principle of creative sanctification: "I want to paint men and women with that something of the eternal which the halo used to symbolize, and which we seek to convey by the actual radiance and vibration of our coloring . . . to express hope by some star, the eagerness of a soul by sunset radiance."[49] In his rendition of the *Sower* pictured above, he allows the golden disk of the sun to become a radiant halo behind the figure, making the ground the sower treads holy ground. The effect is to create his own species of "natural supernaturalism," as Debora Silverman, among others, has noted.[50]

The last phase of van Gogh's life was marked by alternating moods of hope and despair. His joy in his work was considerable, but his pictures did not sell. That left him in frequent despondency, dependent for his daily bread on the largesse of his brother Theo. If art had early on come to be for him a kind of religion, he later would look back in disenchantment

46. See, e.g., Frank Kermode, *The Genesis of Secrecy* (Cambridge, MA: Harvard University Press, 1979); and David Lyle Jeffrey, *People of the Book: Christian Identity and Literary Culture* (Grand Rapids: Eerdmans, 1996), 360–65.

47. Sund, "Sower and the Sheaf," 668, quoting *The Complete Letters of Vincent van Gogh*, 3:B9 (498–500), of late June 1888, my emphasis.

48. *The Complete Letters of Vincent van Gogh*, 3:B8 (letter 496), June 1888.

49. *The Complete Letters of Vincent van Gogh*, 3:531 (letters 24–26).

50. Debora Silverman, *Van Gogh and Gauguin: The Search for Sacred Art* (New York: Farrar, Straus and Giroux, 2000), 155; cf. her discussion of the Groningen theologian Allard Pierson, 157–61.

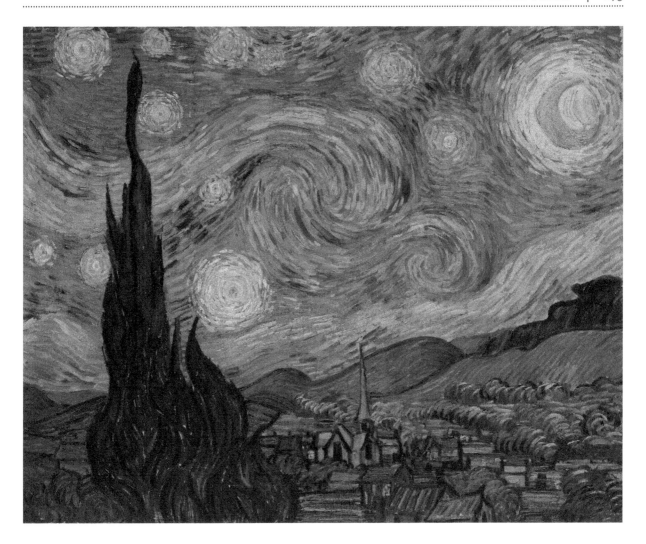

and write to Theo as if that phase too had passed, that he once "considered art a holier thing than I do now."[51] But hope would occasionally return, and he would in such moments call painting itself the "quelque chose en Haut," the Something on High,[52] and claim that the artist's aim is "walking with God."[53] Perhaps his most memorable pictorial expression of "hope by some star" is his evocative and justly famous *Starry Night* (1889) (fig. 99).

Figure 99. Vincent van Gogh, *The Starry Night*, 1889

51. Harris, *Masterworks of Van Gogh*, 122.

52. *The Complete Letters of Vincent van Gogh*, 2:333 (letter 175); 2:337 (letter 193); cf. 2:339 (letters 197–204).

53. *The Complete Letters of Vincent van Gogh*, 2:338 (letter 192).

After the image of the sower itself, perhaps no painting so well captures van Gogh's desire that his art could provide a means of reaching out to the infinite. He wrote of a "terrible need of religion" that drove him "to go out at night to paint the stars."[54] His are not quite the "starry skies above" that Kant felt overpowered his reason; nor, I think, are they the apocalyptic portents of Revelation 7:1–4, or astronomical studies imagined by some,[55] but simply van Gogh's image for divine presence *somewhere*, an expression of his infinite longing for the comforts of the religion he had lost, tinged with apprehension and regret, suggested symbolically here by the ominous cypress trees as much as by the spectral church spire beneath the starry sky. In this painting his recurrent hope—almost—overcomes the despair that would nevertheless lead to his suicide the next year.

Paul Gauguin

We associate Paul Gauguin now with the symbolist movement in art, though technically he is sometimes characterized as a *cloisonniste* (for his delineated, enameled surfaces and sharply demarcated colors)[56] or as a synthetist, an overlapping term that evokes antinaturalism, subjectivism, and individualism of the artist as well. Symbolists such as Baudelaire in poetry cultivated the idea of the artist's personality as the real subject of art; "son roi, son prêtre et son Dieu" (his own king, his own priest, his own God).[57] At the same time, the artist, in H. R. Rookmaaker's words, was supposed "to represent and elucidate reality itself in its deepest essence."[58]

54. *The Complete Letters of Vincent van Gogh*, 3:543 (letter 56).

55. Meyer Schapiro, *Van Gogh* (New York: Harry Abrams, 1979), 30; also, Albert Boime, *Revelation of Modernism: Responses to Cultural Crises in Fin de Siècle Painting* (Columbia: University of Missouri Press, 2008), 1–5, argues for the astronomical accuracy of van Gogh's night paintings, and suggests that his interest in astronomy somehow proves that Vincent had incorporated it into his post-Christian outlook.

56. Goethe's theory of color had by this time obtained a wide influence among theosophists; the idea was that "colour includes the mood which it arouses, and which can belong as much to the nature of the colour as to the person who experienced it." See Alec Morison and Gladys Morison, "The Activity of Colour in the Art of Painting," in *The Faithful Thinker: Centenary Essays on the Work and Thought of Rudolf Steiner, 1861–1935*, ed. A. C. Harwood (London: Hodder and Stoughton, 1961), 153.

57. Hans R. Rookmaaker, *Synthetist Art Theories: Genesis and Nature of the Ideas on Art of Gauguin and His Circle* (Amsterdam: Swets and Zeitlinger, 1959), 73.

58. Rookmaaker, *Synthetist Art Theories*, 111.

The notion of "synthesis" was aimed at a forceful resolution of this sharp contradiction between ego-preoccupation and mind-independent reality. The synthetists thought to achieve this by redefining "reality" in a nonnaturalistic way, hoping to "elucidate the meaning of nature—and expressing their idea of it with the aid of purely artistic means, eschewing allegory."[59] A painting was to be a painting *tout court*, "essentiellement une surface plane recouverte de couleurs en un certaine ordre assemblées" (essentially a flat surface covered with colors arranged in a certain order).[60]

Symbolism itself can seem at first blush less overtly self-contradictory, perhaps, but it is no less a response to epistemic confusion. In the phrasing of Baudelaire,

> Nature is a temple where from living pillars
> Confused voices sometimes emerge;
> Man passes through forests of symbols
> Which watch him with familiar glances.
> Like long echoes that from afar merge
> Into a shadowy and profound unity,
> Vast as the night and as the light,
> The perfumes, the colors, and the sounds correspond.[61]

Baudelaire here captures something of the spiritual disconnectedness of late-nineteenth-century culture. Out from the thick forest of symbols seeking some form of correspondence, various new quasi-philosophical, quasi-theological cult systems emerged, proposing to offer guidance. The Rosicrucianism that has been associated with Rossetti and some others among the Pre-Raphaelites was one such quasi religion, but for others, notably French painters jaded with both academicism and naturalism, Theosophy was appealing. Theosophy arose from the thought of Emanuel Swedenborg and Madame Helena Petrovna Blavatsky, especially in her *Key to Theosophy*. Blavatsky's then somewhat daring observation that all "religions consist of some truth under different vestments"[62] marked out the comparative and universalizing scope of Theosophy that was to have such appeal to some artists and others cynical about their own early reli-

59. Rookmaaker, *Synthetist Art Theories*, 116.

60. Maurice Denis, quoted in Rookmaaker, *Synthetist Art Theories*, 160.

61. Charles Baudelaire, "Correspondences," in *Les fleurs du mal*, ed. Jacques Crepet and Georges Blin (Paris: Librairie José Corti, 1942), 9.

62. Helena Petrovna Blavatsky, *The Key to Theosophy* (London: Theosophical Publishing Society, 1890), 5.

Figure 100. Paul Gauguin,
Self-Portrait, 1889

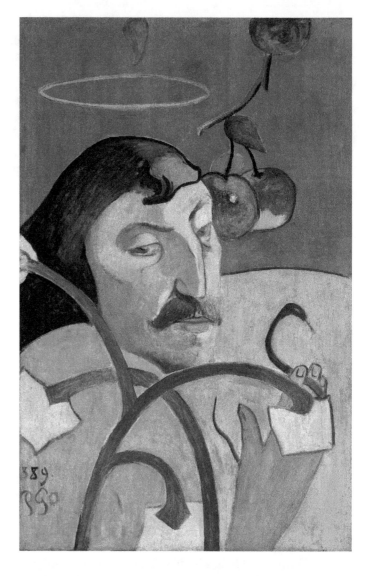

gious experience and now living in an increasingly post-Christian culture. Theosophy purported to be a modern religion for a new and pluralistic age. The mature theosophist would have great powers of synthesis; he would be, in effect, a master of symbols, a magus. Some of the general aspiration is filtered in an essay by Émile Bernard: "Behold the sublime in art: to point out one of the truths hidden in the mystery. . . . The sublime is to ally sound, color, scent to form this union; harmony is the gift of analogy, of affinity, of penetration; it is, in a word, the gift of vision."[63]

63. Émile Bernard, "Vincent Van Gogh," *Mercure de France* 40 (April 1893): 26.

Bernard was at once complimenting the memory of van Gogh, affirming the symbolism of Baudelaire, and marking out the high ambition of synthetist art as it was perhaps most prominently practiced by Paul Gauguin (fig. 100).

Gauguin, like van Gogh, was an obsessive painter of self-portraits, yet unlike van Gogh, his portraits show no anxiety about his own identity. Indeed, he projected his own facial features onto those of the subjects of others in portraiture and famously (and at the time, scandalously) represented himself as Christ in *Christ in the Garden of Olive-Trees* (1889), painted his own face as the face of Christ in *The Yellow Christ* (1889), and, to make sure no one missed the point, superimposed his portrait on that work again in *Self-Portrait in Front of the Yellow Christ* (1890). He also did a *Self-Portrait 'près du Golgotha'* (1896). What he intended in some of these gestures may be summarized by his saying to the art critic Jules Huret about the first in this series, "This is my portrait which I painted . . . but it is to symbolize the failure of an ideal, the suffering which was both divine and human, Jesus deserted by all his disciples, and his surroundings are as sad as his soul."[64] Gauguin had long before abandoned his wife and children to pursue art, and was wildly promiscuous and in other ways self-indulgent in his avant-garde lifestyle; nevertheless, he persistently imagined himself to be experiencing sufferings comparable to those of Christ, painting himself as Christ fifteen times.[65] *Self-Portrait* (fig. 100), with its allusion to the apple of Eden, the halo on Gauguin, and occult snake-sconce, is a stretch beyond all these toward a still darker identity.[66] The self-attributed halo of Gauguin is a very long way spiritually from those with which van Gogh desired to sanctify the labors of the working peasant.

Gauguin's *Jacob Wrestling with the Angel*, or *Vision after the Sermon* (1888), is perhaps the most famous of his "religious" paintings, and a thoroughly symbolist work, both technically and thematically (fig. 101). The theme was popular among the symbolist painters, with versions by Gustave Moreau (1878) and Odilon Redon (1910), and, as we shall see, a

64. Wladyslawa Jaworska, "'Christ in the Garden of Olive Trees' by Gauguin: The Sacred or the Profane?" *Artibus et Historiae* 19, no. 37 (1998): 84. See also, Thomas Buser, SJ, "Gauguin's Religion," *Art Journal* 27, no. 4 (1968): 375–80.

65. Jaworska, "Christ in the Garden," 98.

66. Edward D. Powers, "From Eternity to Here: Paul Gauguin and the Word Made Flesh," *Oxford Art Journal* 25, no. 2 (2002): 89–106. See also, Vojtech Jirat-Wassiutynski, "Paul Gauguin's 'Self-Portrait with Halo and Snake': The Artist as Initiate and Magus," *Art Journal* 46, no. 1 (1987): 22–28.

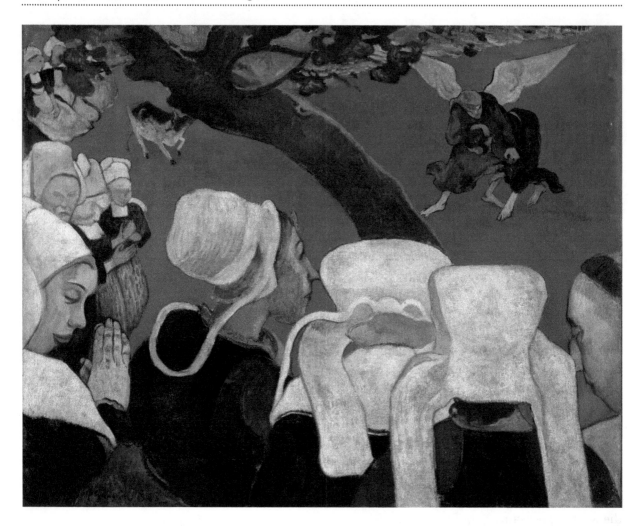

Figure 101. Paul Gauguin, *Vision of the Sermon (Jacob Wrestling with the Angel)*, 1888

more striking depiction by Maurice Denis (fig. 103).[67] In his own painting Gauguin does not so much depict the biblical story from Genesis 32 as show Breton peasant women, notable for their unmodern Catholic piety, as if they were "seeing" the event in a vision following a powerful sermon. We see them "seeing"; the painting is not really a work of religious art, but an anthropological illustration of how simple religious people might be imagined to experience the stories of the Bible. It is curious that Gauguin here positions himself among the Breton peasants whose intense piety fascinates him as a phenomenon, though he does not share it. This juxtaposition, in the words of Suzanne M. Singletary, "induces

67. See Suzanne M. Singletary, "Jacob Wrestling with the Angel: A Theme in Symbolist Art," *Nineteenth-Century French Studies* 32, no. 3–4 (2004): 298–315.

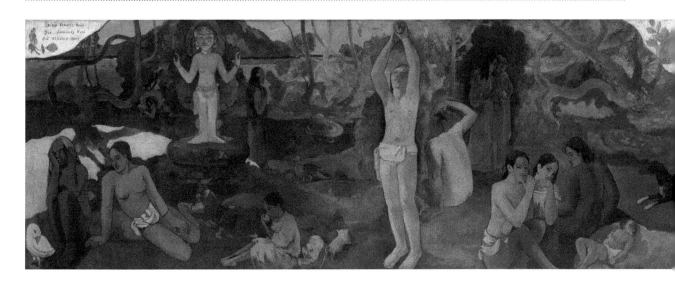

a heightened sense of the supernatural and fluidity between reality and illusion. Gauguin evokes a 'double vision' in the Baudelarian sense, that of Gauguin as a priest, conjoined with the Breton community in a hypnotic trance, and that of Gauguin the artist, observing with the viewer their mystical communion."[68] In an unusual moment of self-consciousness, or perhaps of guilt, Gauguin tried to donate the painting to the local Breton parish priest, suggesting that his *cloisonné* technique would complement the stained glass windows, and that his image could function like a fresco on the grey stone walls of the church. He was rebuffed, not least, it seems, because of his local reputation as a frequenter of brothels.[69]

In Tahiti and other Polynesian islands where he traveled in 1891, searching for primitive life unspoiled by Christian mores, Gauguin pursued his appetites still more flamboyantly, enjoying many *vahines*, much alcohol, and excessive opium in his effort to prove to himself that there really was a paradise on earth and that he had found it.[70] The myths of primitivism and eroticism persisted in his mind right to the end, despite less than paradisal real-life consequences. The major painting that culminated Gauguin's career, done in Atuona not long before his demise, is very large (55″ × 148″), and clearly intended as his magnum opus. He began work on it while slowly succumbing to syphilis and a heart condition in

Figure 102. Paul Gauguin. *D'où venons-nous? Que sommes-nous? Où allons-nous?*, 1897–1898

68. Singletary, "Jacob Wrestling with the Angel," 306.

69. Silverman, *Van Gogh and Gauguin*, 115–17.

70. Daniel Gorin, "The Quest for Spiritual Purity and Sexual Freedom: Gauguin's Primitive Eve," *Valley Humanities Review* (Spring 2010): 1–11.

1897. It is titled *D'où venons-nous? Que sommes-nous? Où allons-nous?* (Where do we come from? What are we? Where are we going?) (fig. 102).

Ironically, this Polynesian work actually reached a long way back into his European memory, even as far as his days in the seminary school in Orléans with his fellow student Ernst Renan. Both were taught there to resist rationalistic scholastic and Enlightenment theology by the rector, Bishop Dupanloup, whose new catechism posed the questions, "Where does the human species come from? Where is it going? How does it go?"[71] The evolutionary questions obviously remained in Gauguin's mind. But this last major painting also comes hard on the heels of his strongly anticlerical diatribe against Catholicism in an essay eventually titled "L'esprit moderne et le Catholicism."[72] Here Gauguin blamed the church for misrepresenting the spirit of the Gospels and "draining away their truly religious substance," a substance that he insisted could be recovered only by returning to the "Bible's genuine teachings" and "the doctrine of Christ," which just happened in his view to accord nicely with avant-garde ideas, especially when interpreted "symbolically" rather than literally. The reader who looks for coherent theology in this document will be disappointed, but one who understands that the Christ of Gauguin is a self-projection, an ego with unfettered authority, will not be surprised to find in his jeremiad an astonishingly narcissistic bent, leading to such revelations as that we should take the commandment in Genesis 1:28 simply as a directive to frequent and promiscuous copulation, claiming in "support" that "Christ indicates no *legal form* of coupling."[73] Unencumbered by the actual biblical text, Gauguin here creates a Christ in his own image, much as he did in his self-portraits.

That said, his last great canvas offers a panorama of life, from birth (on the right) through experience (the naked initiate and the figure reaching for symbolic fruit), the symbolization of religious feeling (the idol), and finally, on the left, the eternal feminine figure, gazing at the old hunched-up woman beside her who represents death.[74] Above this old woman are the inscripted questions of the painting's title at the top left

71. Silverman, *Van Gogh and Gauguin*, 382.

72. The manuscript was published by the Saint Louis Museum. Cf. Silverman, *Van Gogh and Gauguin*, 479n36.

73. Quoted in Naomi Margolis Maurer, *The Pursuit of Spiritual Wisdom: The Thought and Art of Vincent van Gogh and Paul Gauguin* (Madison, NJ: Fairleigh Dickinson University Press, 1998), 17. The "interpretation" is reminiscent of Chaucer's burlesque character the Wife of Bath.

74. Silverman, *Van Gogh and Gauguin*, 383–91.

corner. The structural inversion—reading from right to left—is oriental, but it may also represent a counterstatement to the entire Western way of painting narratively. For in the end, this is a narrative painting, a narrative of mundane vitalist symbols, yet lacking spiritual transcendence.

Upon completing his painting, Gauguin went "up into the mountains, swallowed a large dose of arsenic, and waited to die."[75] He failed. After a night of vomiting and misery, he returned home to his shack. He continued in very poor health in his pornography-lined "House of Pleasure," as he called it, on the Marquesan island of Hiva-Oa, for more than five years. By 1903, he was in trouble with the law and thoroughly addicted to injected morphine. He died suddenly on the morning of May 8 of that year, alone, and was buried the next day in the Atuona cemetery. He had asked that his ceramic figurine of Oviri, the goddess of death, be placed on his grave instead of the conventional cross; this was postponed until seventy years later when a bronze casting of the original was installed in 1973.[76]

If the symbolists had anything like a "theology," it appears to have been, as in Gauguin's case, to some degree informed by Theosophy, but it was really a kind of self-divinizing construct in which the magus-artist plays the role once accorded to theologians and priests. André Barre has characterized the thought of the symbolists (and, by extension, the synthetists) in much the same way: "Mystery, philosophic truth, and the symbol are affairs of religion and of art, the one, moreover, being only the second form of the other. Artists are, in effect, creators of religious symbols and by that they are superior to priests. Direct emanations of the Divinity, they reproduce his word, they translate his thoughts. They are the prophets of this always hidden truth. . . . Art is not separate from religion, because art derives from a superior morality and is itself a religion."[77] Whether Gauguin qualifies as a "direct emanation of the Divinity" we may perhaps set aside as an unanswerable question; the claim that art is its own religion is more tractable. For him, as for many in the art world at the turn of the twentieth century, it seems to have *functioned* as a separate religion, and was accorded a comparable level of reverence. Evidently there were many besides the artists themselves who wanted art and the artist to provide a new locus for the holy and a new worldview.

75. Silverman, *Van Gogh and Gauguin*, 383n44.

76. Ziva Amishai-Muisels, "Gaughin's Early Tahitian Idols," *Art Bulletin* 60, no. 2 (1978): 331–41.

77. André Barre, *Le symbolisme* (Paris: Joure et cie, 1911), 18.

THE NABIS

Technically, the symbolist/synthetist painters had a continuing tradition, most fruitfully among artists with diverse religious interests who in 1889 formed a group calling itself Les Nabis (based on the Hebrew word for prophet). Philosophically these artists were at first influenced by Swedenborgian thought, the writings of synthetists such as Stéphane Mallarmé, esoteric texts on sacred number and mystical geometry, and especially by Eduard Schuré's *The Great Initiates: A Study of the Secret History of Religions* (1889), a theosophical text imbued with ideas similar to those of Gauguin. Among the artists included in the formation of the Nabis were Maurice Denis (1870–1943), Pierre Bonnard (1867–1947), and Paul Ranson (1864–1909), in whose studio they first met, calling it their "Temple." Ranson invented a secret language for the members, who gathered to hear esoteric texts read aloud, referring to each other as "Brother Nabi."[78] Remarkably, several of the group, a little like the earlier Nazarenes (Lukasbund), became gradually more interested in recovery of the mystical tradition in Catholicism. Nabi artists cultivated a trance-like quality (*rêve*) that allowed for what Denis would call a "subjective deformation" of the material plane in order to convey the "spiritual quality" of the artist's perception. This focus led in the case of Bonnard and Denis especially to a revived Catholic piety of the sort that characterized the Catholic renewal movement of the 1890s, making it seem in some ways continuous with the Catholic revival pursued by the Nazarenes.

In seeking for both artist and viewer a trance-like engagement with the work, it seems that the Nabis were reaching for something like the experience of Christian painting before modernity, when to respond to a holy image was to enter into a sense of the presence signified by the image. In such an experience, the image becomes something more, almost an icon. In his landmark book on the history of the Christian icon, Hans Belting offers a convincing argument that, considered from a devotional perspective, traditional religious images were understood, almost as much in the West as in the East, as a corridor into the very presence of Christ, Mary, or the saints depicted, but that this conception begins to dissolve in the late Italian Renaissance.[79] On this view, late medieval panel paintings and altarpieces in Tuscany still had *in situ* a traditional

78. Spretnak, *Spiritual Dynamic in Modern Art*, 44–45.

79. Hans Belting, *Likeness and Presence: A History of the Image before the Era of Art*, trans. Edmund Jephcott (Chicago: University of Chicago Press, 1994).

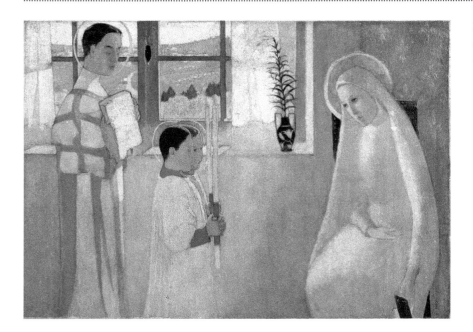

Figure 103. Maurice Denis, *Mystère Catholique (Catholic Mystery)*, 1890

iconic function, but when removed and placed in museums the iconic function was lost and the works became "art." Belting then poses from a modern perspective a question that helps us see the asymptotic character of nineteenth-century attempts to revive such painting: "Could the work be a paradigm of art if it was painted for the altar of a church?"[80] The form of the question marks the gulf that was beginning to open up in the tradition of biblical representation in the West; the iconic function of religious depiction had not only been lost, it was becoming for many inimical to "real art." Still, there seemed to be a felt need for something like it.

For Belting and others, "pious Romantics" like the Nazarenes and Nabis had effectively trivialized the iconic function of Christian painting in their attempts to revive it. This is a view we will return to—and test—in the last chapter of this book. We close our reflection on the Nabis here with two examples, each of which shows artistic continuity with the secular postimpressionists and yet aims to achieve a kind of spiritual vision or at least an imaginative insight into biblical narrative. In his *Catholic Mystery* Denis draws on the *cloisonné* style of synthetist art to create a bejeweled emblem of the Marian focus of his faith and devotion, in effect a personal vision of the Annunciation (fig. 103).

In other works, Denis offered an equally stylized and mystical de-

80. Belting, *Likeness and Presence*, 484.

Figure 104. Maurice Denis, *The Women Find Jesus' Tomb Empty (Luke 20:11–18)*, 1894

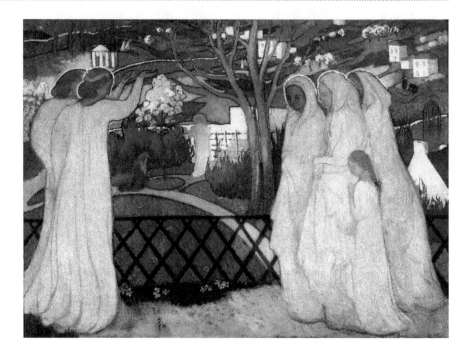

piction of New Testament narratives (e.g., fig. 104). In the foreground of this second work are the women discovering the empty tomb, and being told by the angel that he is not here (Mark 16:1–8; Matt. 28:1–7). In the background we see from behind the shadowy figure of Jesus, turning away from Mary Magdalene and going out of the cemetery (cf. Mark 16:9; Luke 24:1–10; John 20:11–18). The painting synthetizes the several Gospel accounts, evoking the tension between initial despair and scarce-believing hope of the faithful, evoking a spectral sense of the absent yet somehow mysteriously present Lord. Or is it the other way round? In effect, such painting is a medieval revival in subject matter, but cloaked in an aura of personal vision expressed in the synthetist style.

Conclusion

The nineteenth century was awash in artistic movements seeking vision and community that both consciously and unconsciously reflect nostalgia for a lost religious milieu and its spiritually formative Christian art. The Nazarenes were a Bavarian Catholic movement straightforwardly trying to recapture Catholic tradition in sanctuary art that they felt had been battered by the Reformation and needed revival. The Pre-Raphaelites,

with less articulate theological self-understanding, nevertheless began with similar aspirations for art that could embody transcendent meaning, yet most of them gradually succumbed to eroticism and fantasy. Van Gogh and Gauguin are two faces of reaction both to academic classicism and the impressionists' descent, as they saw it, into an indulgence in beauty for its own sake. For van Gogh painting became a means to the holy he felt had been denied to him by institutional religion; his scruple against painting traditional religious subjects was in effect a rejection of the iconic tradition, perhaps because it seemed to him too Catholic. For Gauguin, rejection of Catholic doctrine was more personal, and took the form of subverting insights from his schooling to justify self-creation and an immersion in sensuality; ironically, his final masterpiece is an anti-icon, a self-consciously pagan riposte to the sanctuary altarpiece of Catholic tradition. Stylistically, the symbolism and synthetism that Gauguin's work helped to initiate had a range of successors, among them artists like Maurice Denis and his fellow Nabis, who in effect tried to conclude the experiment in recovery of the Catholic past, not by imitation, as with the Nazarenes, but by a revival of what they took to be the spirit of early Christian thought adapted to synthetist method. By this appropriation they hoped to evoke both in themselves and their viewers something like an aura of mystical vision, providing a sense of personal contact with the holy, if not an experience of actual worship. There is accordingly no general consensus to record for this period, only vignettes from a remarkably energetic but ultimately unsuccessful series of efforts to use art itself as a means to unite beauty and holiness. The failure of the Nabis to develop a more specific view on how such a goal might be achieved owed not only to semantic but also to conceptual imprecision; "synthetism" became a blanket term to cover widely diverse psychic and philosophical as well as spiritual ideas. In the apt phrase of Maurice Denis himself, by the end of the century "synthetism" had come to refer to "a certain eclectic habit of mind and individualist interpretation of optical sensations."[81] We have arrived, in short, at the threshold of artistic postmodernity.

81. Quoted in Rookmaaker, *Synthetist Art Theories*, 176.

11 ART AGAINST BELIEF

I believe the moment is drawing near when . . . it would be possible . . . to systematize confusion and thereby contribute to a total discrediting of the world of reality.

SALVADOR DALI

In the previous chapter we examined nineteenth-century efforts by the Nazarenes, Pre-Raphaelites, and Nabis, realized with mixed success, to engage or depict the holy. We also encountered principled artistic rejections of traditional "holy" subjects, as in van Gogh, and calculated subversions of the holy in Gauguin. In this chapter we shall consider twentieth-century artists who, despite their childhood years in pious Christian family environments, rejected Christian belief and ethical practice altogether. In their case, as in the case of many others, the practice or performance of art became a "modernist antidote to religion,"[1] complete with alternate creeds and substitutes for liturgy. Gauguin now appears to have marked out more indicatively than any other nineteenth-century artist the path many twentieth-century artists would follow to its logical conclusion.

The cultural context was by this time somewhat more complex. For one thing, Ernest Renan's conviction that science rather than art would replace religion was beginning to become fashionable. Renan had predicted that "Everything that the state has extended in the past to religious

1. John Milbank, *Theology and Social Theory: Beyond Secular Reason* (Oxford: Wiley Blackwell, 1990, 2006), 434.

exercise will rightfully return to science, the only definitive religion. . . . Science, in fact, will only be valuable insofar as it replaces religion."[2]

In one development, psychology emerged as an academic discipline and was widely used to diagnose and treat symptoms of personal disorder that once would have been considered spiritual problems and referred to clergy. So fashionable did this new academic discipline become that it fulfilled Renan's prediction almost by itself, becoming the scientific substitute for pastoral "soul-care."[3] Studies of hysteria and hypnosis by the French psychologist Jean-Martin Charcot were used by him and others to "explain" religious phenomena such as the miracles at Lourdes as merely mass hysteria or the effects of individual neurosis. Sigmund Freud became Charcot's student in 1885, and would go on to be a magus of much greater influence.[4] This wave of "science against religion" increasingly characterized religious experience such as visions and mystical transport in prayer as evidence of emotional or rational disturbance. Gauguin's painting of Breton women having a vision of Jacob wrestling with the angel (fig. 101) anticipates the condescension typically involved, the treatment of religious experience as the province of psychotic "marginalized women, peasants, colonized peoples, Catholics and Jews."[5]

French novelist Joris-Karl Huysmans, though at first sympathetic to positivist social realism, later sensed that its inherent psychological determinism threatened to marginalize art as much as religion. He then began to oppose all such analysis as reductionistic by trying to show that what the psychologist wanted to call neurosis was intrinsic to "the only true and great art." This "higher art" he defined as "supernaturalism": "The only true formula, sought after by Rogier van de Weyden, Metsys, Grünewald, [is] absolute realism combined with flights of the soul, *which is what materialistic naturalism has failed to understand.*"[6] In terms we have already used, Huysmans was finding in Grünewald's *Isenheim Al-*

2. Ernest Renan, *L'avenir de la science—pensées de 1848* (Paris: Calmann-Levy, 1890), quoted in Stephen Schloesser, SJ, "From Spiritual Naturalism to Psychological Naturalism: Catholic Decadence, Lutheran Munch, and *Madone Mystérique,*" in *Edvard Munch: Psyche, Symbol, and Expression*, ed. Jeffrey Howe (Chicago: University of Chicago Press, 2001), 78.

3. Schloesser, "From Spiritual Naturalism," 86. See John J. Cerullo, *The Secularization of the Soul: Psychical Research in Modern Britain* (Philadelphia: Institute for the Study of Human Issues, 1982), for a general treatment of the literature.

4. Schloesser, "From Spiritual Naturalism," 86.

5. Schloesser, "From Spiritual Naturalism," 86. It might be said of Gauguin that he was an anthropologist of the marginalized.

6. Joris-Karl Huysmans, *The Road from Decadence: From Brothel to Cloister; Selected Letters of J.-K. Huysmans*, ed. Barbara Beaumont (London: Athlone, 1989), 105.

Figure 105. Grünewald,
Isenheim Altarpiece, wings
closed, central panel

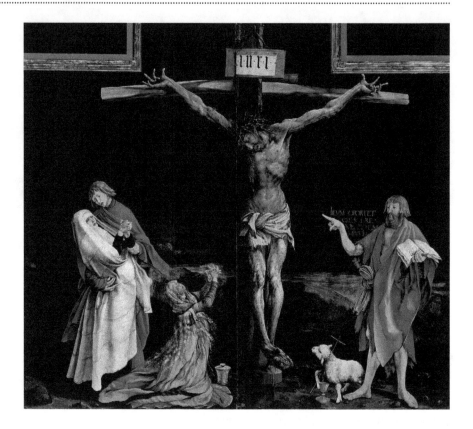

tarpiece crucifixion a palpable register of the ancient icon, not diminished
by realism, but having its supernaturalism actually magnified because
of the artist's skillful fusion. As we shall see, in drawing attention to the
positive spiritual element in psychic (soul) experience occasioned by art,
Huysmans was resituating art—in particular religious art—at the center
of the conflict between science and religion. He was also drawing atten-
tion to a distinctive masterpiece so powerful that it would come to trouble,
even obsess, many anti-Christian artists of the twentieth century; Munch,
Picasso, Ernst, and Dali are among them.

Diane Apostolos-Cappadona has suggested that traditionally Chris-
tian works of art have been categorized as follows: "*Didactic* images that
taught 'the faith'; *liturgical* objects used for ritual worship; *devotional* vi-
sions that nurtured prayer and contemplation; *decorative* entities whose
beauty elevated the soul to the spiritual realm; *symbolic* forms that re-
vealed coeval objective and subjective meanings; and works of art that
combined any or all of the earlier categories."[7] She goes on to say that the

7. Diane Apostolos-Cappadona, "Beyond Belief: The Artistic Journey," in Rosemary

Reformation "created the problematic of 'how to define Christian art'" after the common theological ground was lost, a point with which I have been in substantial agreement in these pages. What Apostolos-Cappadona calls "liturgical" art—in effect, the formal icon—more than any other genre had long been abandoned by the twentieth century. That it had not been forgotten, however, is made clear by the substantial body of anti-iconic subversions in twentieth-century painting.

Given the subject of the present book, a chapter featuring Edvard Munch, Pablo Picasso, Max Ernst, and Salvador Dali might well seem out of place. Any reasonably informed reader will recognize that "the beauty of holiness" is a concept distinctly alien to the work of these prominent artists. A brief explanation is therefore in order. As we have already observed, artists after the Enlightenment who try to advocate for art as a religion substitute often have recourse to traditional religious symbols and ideas, if only to subvert them. That art is at least in part an *antidote* to religion for Munch, Picasso, Ernst, and Dali is highlighted in the fact that all were raised in pious Christian families, but that each rebelled violently against his religious upbringing with an intense animosity that fueled his artistic passion. Thus, rather than, like van Gogh, attempting to construe art itself as a locus of the holy, these artists made repeated artistic attacks on belief, on holiness, and on natural beauty. To a greater or lesser degree, each had moments when he could identify with Max Beckmann, a contemporary, who said, "In my paintings I accuse God of his errors. . . . My religion is hubris against God, defiance of God, and anger that he created us [such] that we cannot love each other."[8] Though it may seem counterintuitive that anyone so promiscuous as Picasso or Dali could be alienated from "loving" others, Beckmann is speaking of something more than casual sex; he is acutely aware of the alienated "self" of modern man. Each of our artists in this chapter is an artist *contra*, not only "beyond belief" but against belief. Yet they are very important to our subject because their impact was so strong that they almost succeeded in divorcing art from traditional Christian belief once and for all. The recoveries of belief that we shall consider in chapter 12 are all the more remarkable because of this "almost," and perhaps not entirely appreciable without our "against" artists as a standard of comparison.

Crumlin, *Beyond Belief: Modern Art and the Religious Imagination* (Melbourne: National Gallery of Victoria, 1998), 21.

 8. Quoted in Peter Selz, *Max Beckmann* (New York: Abbeville Press, 1996), 8.

EDVARD MUNCH (1863–1944)

Edvard Munch is a transitional figure in much the same way as van Gogh was a transitional figure between nineteenth-century artists trying to recover a Christian devotional role for art, and Gauguin and the synthetists who wished to subvert Christian piety. An exhibition at the Van Gogh Museum in Amsterdam (September 25, 2015–January 17, 2016) paired Munch and van Gogh so as to reveal both similarities and differences; though the two artists never met, they frequently chose eerily similar subject matter. Both were products of pious Protestant families. Each became disillusioned with the faith and religious observance of his family, and each sought to define his postbeliever stance in his work. Like van Gogh, Munch was a reader, though more obsessive. He kept copies of the Bible and Dostoevsky's *The Idiot* along with several works by Søren Kierkegaard by his bedside, and read and reread especially Kierkegaard. (Given his paranoia and repeated bouts of suicidal depression, not all these texts may have been equally helpful.) Van Gogh recorded his ideas in a massive collection of letters; Munch in a lifelong series of notebooks. Yet their differences are more important than their similarities.

Munch's conventionally pious Lutheran family was guided principally by his mother. That he kept always with him his mother's deathbed letter to her children reveals much about her influence. She had written, "it is important to keep close to the Lord, to dare to pray, to read God's Word and keep true to him, who has redeemed your Souls, so that we may all, whom God has so carefully bound together, be united in Heaven, never again to be parted."[9] Yet Edvard's choices in lifestyle and subject matter made it difficult for his family to believe that he was practicing his mother's faith.[10] His *Madonna* (1893), of which there are five versions, suggests that the doubts of his family and of others were not unfounded (fig. 106).

The model is represented as a young woman experiencing sexual ecstasy; except for the red nimbus behind her head on the tousled sheets, one could make no sense of the title. In another version (lithograph, 1896) there is a fetus in the lower left-hand corner, while the erotic figure is surrounded by swimming spermatozoa. The paintings are blasphemous

9. Quoted in Haakon Mehren, *Munch through New Eyes: His Holy Universe* (Oslo: Arvinius and Orfeus, 2013), 26. Mehren's book makes a valiant but unsuccessful attempt to claim a lifelong Christian worldview for Munch.

10. Mehren, *Munch through New Eyes*, 11.

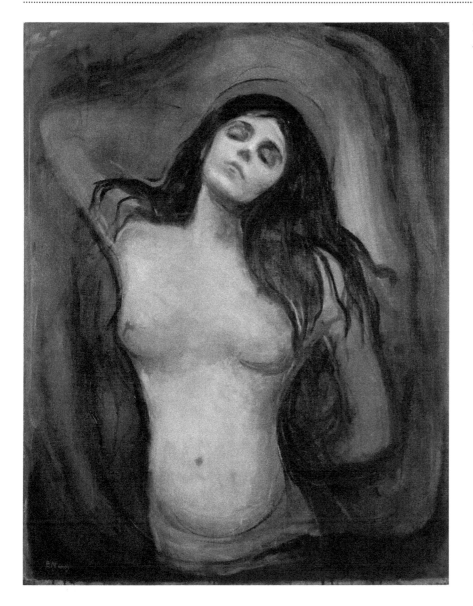

Figure 106. Edvard Munch, *Madonna*, 1894–1895

in as deliberate a fashion as Gauguin's self-representations as Christ, and for many they are more disturbing. Munch's famous *Geschrei* (*The Scream*, 1893) and the more paranoid *Anxiety* (1894) have distressed many viewers, but not in this overtly antireligious way. Destructive eroticism increasingly preoccupied Munch; in 1902 he reworked his *Vampire* (1895), of which there are also several versions. Munch had fallen in with a group of artists and hangers-on called the Kristianiabohemen, described by their historian as "a group of disillusioned youth, losers, depressives, unimag-

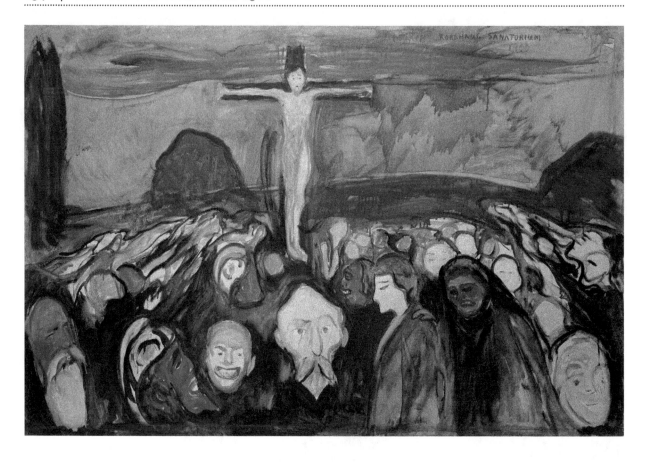

Figure 107. Edvard Munch, *Golgotha*, 1900

inative failures, world weary whoremongers and revelers."[11] These companions did little for Munch's residual religious reputation, and less for his productivity in the studio. He had been convinced that his art could provide him the necessary meaning for life; he would later record in his notebooks, "I sought the light through it and believed that I could bring light to others."[12] In a gesture very reminiscent of van Gogh, he wrote, "People will understand the sanctity of it and they will take off their hats as in a church."[13] Van Gogh has had some viewers respond almost in this reverent way to a few of his canvases, but Munch, one suspects, has had hardly any. Only after he had broken with the Kristiana Bohemians was he

11. Kristiania was the old name for Oslo. Merhren's quotes (*Munch through New Eyes*, 35) are from a study of the Kristiania Bohemians by Halvor Fosli, published in Norwegian in 1994. A good brief account is found in Howe, *Edvard Munch*, 13–14.

12. Quoted by Mehren, *Munch through New Eyes*, 27.

13. This very van Gogh–like remark is from Munch's letters, quoted by Mehren, *Munch through New Eyes*, 29.

able to attempt painting an iconic Christian subject. His *Golgotha* (1900) is clearly an effort to come to grips with both the fact of Christ's crucifixion and the wide range of modern responses to it (fig. 107).

The composition is dark and brooding; from the anxious face of Christ on the cross we can infer that the crowd is deserting him in silence. The faces that dominate the foreground are carnival grotesques, registering everything from passive indifference to demonic glee. Few onlookers seem to identify with Christ, and they, like the supplicant Magdalene to the right of the cross, are faceless. This is a traditional iconic subject, the most holy image in Christendom, yet Munch's work is not really a religious affirmation, but rather an expression of despair and rejection of Christian redemption. He would continue to paint nudes—especially erotic nudes—and even landscapes, but this work was his farewell to the symbols of Christian faith. Though not as overtly subversive as his *Madonna* images, *Golgotha* nevertheless resists worshipful response; it distances the viewer and raises troubling questions about the meaning of the Calvary event.

Pablo Picasso (1881–1973)

Pablo Diego Jose Francisco de Paula Juan Nepomuceno Maria de los Remedios Cipriano de la Santisima Trinidad Ruiz y Picasso was born, as his name suggests, into a traditionalist Catholic family in Malaga, Spain. Initially a realistic painter, he executed remarkable works in his midteens, among them *First Communion* (1896), a traditional *Crucifixion* (1896), and *Science and Charity* (1897). In the latter work a doctor is taking the pulse of a sick woman on one side of her bed, while on the other stands a nun holding the woman's child in one arm and extending with her other hand a cup of broth, urging her to take some nourishment. The woman looks frightened; perhaps she is dying, with neither science nor religion able to heal her.[14]

The death of Picasso's sister Conchita of diphtheria in 1895, notwithstanding his prayers and vow to give up painting if God would spare her, commenced a dark period for the young artist. His father sent him to the Royal Academy of Madrid in 1897, but he skipped classes and did not stay long. In 1899, as an eighteen-year-old, Picasso appar-

14. A detailed account is given by Jane Dagget Dillenberger and John Handley, *The Religious Art of Pablo Picasso* (Berkeley: University of California Press, 2014), 24–26.

ently parted company with the church of his youth, never to return. The suicide of his friend Carlos Casagemas two years later hung like a shroud over his imagination for several years. When slowly he grew out of his despair (Blue Period, 1901–1904), his style became more modernist and his subject matter erotic (*La Vie*, 1903; *Crucifixion with Embracing Couples*, 1903). In 1904 he met a bohemian artist, Fernande Olivier, who soon became his lover. She was to inaugurate not only his Rose Period but also an astonishing retinue of formal and informal sexual liaisons with other women, often overlapping, which continued chaotically to the end of his life. Some of his mistresses "moved on," others were devastated at being replaced by younger models; two of the longer-term amours ended their lives in suicide.[15] Arthur Danto, noting that Picasso preferred his serial amours to hiring models, describes his oeuvre as a "vast pictorial autobiography" that helps warrant the impression that "Picasso invented a new style each time he fell in love with a new woman."[16] In him, stylistic variety and sexual variety were more or less synchronous.

By 1907 Picasso was in a new mood, influenced by African art, which yielded his famous *Demoiselles d'Avignon*, a depiction of prostitutes on display for customers in a brothel in which the figures of the women are chopped up into geometric shapes. This began the style still most associated with Picasso, namely, cubism. As it happens, two works that stand out in this vein came after World War II, though many more strictly cubist works were produced in the intervening two decades, including a remarkable *Crucifixion* in pencil.[17] By this time André Breton, in his essay "Le surréalism et la peinture," published in *Révolution surréaliste* in 1925, had declared Picasso "one of ours."[18] Though Picasso continued to see himself as a cubist, one can see in his 1930 *The Crucifixion* (fig. 108) elements that seem plausibly surrealist.

In studying this work, it becomes apparent that it is visually a pastiche of several elements in traditional depictions of the crucifixion narrative. In the foreground are the hands and dice of those casting lots for Christ's

15. Olivier Widmaer Picasso, *Picasso: The Real Family Story* (Munich: Prestel, 2004), attempts to make light of the sad consequences of his grandfather's promiscuity, which entailed the suicide of two of his forsaken mistresses.

16. Arthur Danto, "Picasso and the Portrait," *Nation* 263, no. 6 (August 1996): 31–35.

17. Reproduced in Dillenberger and Hadley, *Religious Art of Pablo Picasso*, 35; at the Musée Picasso, Paris.

18. André Breton's *Révolution surréaliste* is available online; the essay is in the issue for July 1925.

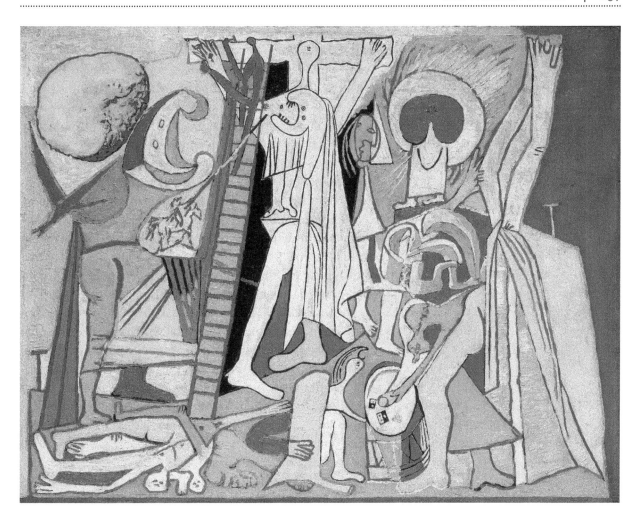

garments; at the left is Longinus on a horse lifting his lance to pierce the Savior's side. The ladder on the left, leaning against the crossbeam, recalls paintings of the "deposition," where the body of Jesus is taken down to be prepared for burial (the large gray boulder, upper left, may be intended to suggest the stone that covered the tomb). On the right are upstretched arms and hands in supplication, as in Grünewald's depiction of Mary Magdalene at the foot of the cross. It is not, however, the juxtaposition of allusions to earlier iconography that defines the impression created by this work. Rather, it is the sense of a grotesque dislocation, a deconstruction of the familiar so that the image can in no way serve as a devotional or iconic focus for worship; in fact, it is a refutation of traditional depictions. Picasso's subsequent drawings (1932–1936) similarly break the altarpiece of Grünewald down into abstract shapes and juxtapositions in such a

Figure 108. Pablo Picasso, *The Crucifixion*, 1930

way that the titles make the viewer aware that all original meaning in the subject has been lost.[19]

Picasso's most famous work is his *Guernica* (1937), a very large painting that portrays the grief and chaos effected by a fascist bombing raid on a small town in the Basque region during the Spanish Civil War. It is perhaps the best-known antiwar painting of the century, graphically portraying the destruction by saturation bombing of people and animals, all blown to bits at once and stretched out with one another in death or agony—a bloody chaos. But there is no color. The horror is reduced to something like "the grainy newspaper photography of the era," as critics have suggested.[20] Picasso's cubist style makes the dismemberment a stark matter of horrible fact; perhaps in no other context does his cubism seem so naturally allied to his subject matter (fig. 109).

On the right is a figure reaching to heaven, arms outstretched in supplication for mercy (it has been suggested that his gesture may also be borrowed from Grünewald). But no mercy comes for *Guernica*. The painting is thus a bitter protest, not only against war, but also against the order of the universe in which desperate prayer may go unanswered. One wonders if this motif does not extend from Picasso's bitter experience at the death of his sister right into this powerful work. Paul Tillich, the modern Lutheran theologian, called it "the best present-day Protestant religious picture . . . because it shows the human situation without any cover."[21] Whether or not we see this work as Protestant (that seems, given its allusions, a stretch), we can surely see that it is a protest, effectively analogous to existential protests (e.g., Sartre, Camus) that would become common in post-Catholic literature following World War II. But to protest is not necessarily a religious gesture, and Picasso's *Guernica* seems, if anything, an antireligious rather than a religious statement.

Picasso was also a prolific writer. His more than three hundred poems and plays are characterized overwhelmingly by erotic and scatological

19. Diane Apostolos-Cappadona, "The Essence of Agony: Grünewald's Influence on Picasso," *Artibus et Historiae* 13, no. 26 (1992): 31–47. The influence of Grünewald's crucifixions had begun in the nineteenth century, largely though the enthusiasm of Huysmans, prompting visual quotations also by Odilon Redon. See Nancy Davenport, "The Revival of Fra Angelico and Matthias Grünewald in Nineteenth-Century French Religious Art," *Nineteenth-Century French Studies* 27, no. 1–2 (1998–1999): 157–99. The nineteenth-century interest was by way of tribute, and nothing like the obsessive deconstructions of the twentieth-century artists featured here.

20. Dillenberger and Hadley, *Religious Art of Pablo Picasso*, 61.

21. Dillenberger and Hadley, *Religious Art of Pablo Picasso*, 61.

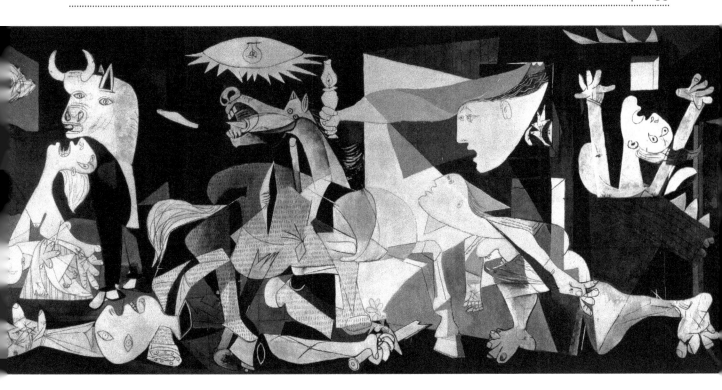

Figure 109. Pablo Picasso, *Guernica*, 1937

imagery; there isn't a hint of religious interest in them. When, in 1944, he joined the Communist Party, it was as much as anything an expression of his sincerely felt atheism. Later treatments of the crucifixion as a bull-fight, as in *Corrida* (1959), treat the "Man of Sorrows" in a recognizably ironic way, but his title paganizes the thorn-crowned agony of Christ at the same time it evokes the familiar Christian image.[22] It seems that Picasso retained his curiosity about Christian beliefs long after he himself lost faith, adapting its symbols to the service of other causes.

DADA AND THE RISE OF SURREALISM

In Europe, the years before World War I were charged with an impending sense of doom. The forces of rationalism and industrial power appeared to many as a threat not only to peace but also to the order of nature itself. Franz Marc (1880–1916), a member of a group of German painters who called themselves Der Blaue Reiter, painted *The Fate of the Animals* (1915)

22. Dillenberger and Hadley, *Religious Art of Pablo Picasso*, 82–88. I would not myself describe Picasso's 1959 drawing *Corrida* as having "a breath-taking beauty of design."

as a kind of expressionist confirmation, witting or not, of the judgment of the psalmist: "Man in his pomp and without understanding is like the beasts that perish" (Ps. 49:20). In 1916 Marc died in the offensive at Verdun. Like many artists in this grim period, he had been revolted by what he regarded as the insanity of modern life and set out to create an anti-art as a disturbing, even ugly, protest against residual ideas of beauty. Along with Marcel Duchamp (1887–1968), he set in motion a resistance movement that would come to be known as Dada—phonemes that in Russian mean "yes, yes," in German "babble," in French "rocking horse," and in English, a baby's typical first name for "father."

Dada, as a movement, became rather quickly absorbed into the burgeoning surrealist movement, a grouping of French artists with a similar revulsion from what they saw as the dead hand of a corrupt social order. The early leader of the movement was André Breton (1896–1966), an avant-garde writer of polemical essays and poetry as well as an art collector. His review, *Littérature*, was a prolegomenon to his *Manifesto of Surrealism* (1924) and magazine *La révolution surréaliste* in the same year. In the third issue of the magazine we are introduced to a prime tenet of the movement: "Ideas, logic, order, Truth, Reason—all this is given over to the nothingness of death. You do not know how far the hatred we have against logic can lead us."[23] In his *Manifesto of Surrealism*, Breton makes clear that in the place of conscious rational thought the surrealists will favor the realm of the subconscious, and happily pursue "the discoveries of Sigmund Freud."[24] Henceforth, psychotic experiences, self-induced, were to be regarded as the true and indeed sole realm of beauty (4). Gratitude for all previous traditional exemplars is explicitly rejected: "isn't what matters that we be the masters of ourselves, the masters of women, and of love too?" In a pithy rejection of a traditional proverb, he writes: "*Man* proposes *and* disposes. He and he alone can determine whether he is completely master of himself, that is, whether he maintains the body of his desires, daily more formidable, in a state of anarchy" (5). The surrealist aim is "to lay waste the ideas of family, country, religion."[25] Nothing is to be regarded as sacrosanct except the

23. *La révolution surréaliste*, no. 3 (1925).

24. André Breton, *Manifesto of Surrealism*, p. 3/15. For a translation of the whole text, see Breton, *Manifestoes of Surrealism*, trans. Richard Seaver and Helen R. Lane, 2nd ed. (Ann Arbor: University of Michigan Press, 2002). The numbers in parentheses in the text refer to pages in the original, available online at http://poetsofmodernity.xyz/POMBR /French/Manifesto.htm.

25. Breton, *Manifestoes of Surrealism*, 48.

random destructive/creative will of the artist, who as a prime principle and presence eclipses God. For Celia Rabinovitch, "the fundamentally dual nature of the holy, both daemonic and sublime, daunting yet fascinating, illuminates the contradictions of surrealist art."[26] This is more than about creating works of art for Breton, however; it is about transgressing, in Nietzsche's sense, the old boundaries between good and evil. In a later *Manifesto of Surrealism*, Breton says, "The simplest Surrealist act consists of going into the street, revolver in hand, and firing at random into the crowd as often as possible."[27]

The predictive capacity of surrealism has proven greater than was then imagined. Its influence was not limited to art. Breton claims that surrealism succeeds and transforms in Dionysian fashion what Carlyle (*Sartor Resartus*) and other Romantics called "supernaturalism" (7); he sees the *Night Thoughts* of Edward Young (7) and the gothic novels of Samuel Monk (8) as early harbingers of the "omnipotence of dream . . . the disinterested play of thought." Picasso had been a nearer pioneer (8), but for Breton and his circle the best was yet to come. Automatic writing, trance-induced, and its equivalent in painting are seen as the ultimate route to liberation of the personal subconscious (9); narcissism is prerequisite to artistic authenticity, and it is to be expected that pursuit of the trance-like state will become as all-encompassing and addictive as drugs. "It is true of Surrealist images as it is of opium images that man does not evoke them; rather they come to him spontaneously, despotically. He cannot chase them away; for the will is powerless now and no longer controls the faculties" (11). To love contradiction is inevitably to embrace the absurd; what begins as anarchy often ends as enslavement. In this too the surrealists enacted a prophetic dramaturgy for some elements of what we now call postmodernism.

Max Ernst (1891–1976)

Max Ernst was born into a devout Catholic family, the third of nine children, near Cologne. His father, a teacher of the deaf and amateur painter who painted a copy of Raphael's *Disputa* in 1924, enforced Catholic moral-

26. Celia Rabinovitch, *Surrealism and the Sacred: Power, Eros, and the Occult in Modern Art* (Boulder, CO: Westview, 2002), 48.

27. Breton, *Manifestoes of Surrealism* (1924, issue no. 6); Maurice Nadeau, *The History of Surrealism*, trans. Richard Howard (London: Cape, 1968), 57.

ity in the home, unwittingly engaging thereby the antipathy and resistance to moral authority that characterized the entire life of his son.[28] Despite that, in his early years Ernst was one of several German artists to paint a crucifixion (1913), perhaps, as William A. Camfield has suggested, "reflecting a lingering influence of his upbringing as well as his participation in a strong medievalizing tendency in German Expressionist art."[29] In particular, one may sense in this early work the influence of Grünewald's crucifixion panel in the *Isenheim Altarpiece*. By 1920 he would parody Murillo's painting, *The Holy Family*, before moving even more sharply in an anti-Christian direction.

Ernst wanted also to move, as he put it, "beyond painting" itself into collage. He wrote an essay, "Au delà de la peinture," to announce this purpose for a special issue of *Cahiers d'art* in which his work was featured.[30] The medium, involving painting, photography, and images pasted in from newsprint and elsewhere, seemed to him a natural expression of his interest in alchemy, psychology, and the occult.[31] His preoccupation with Freudianism and sexual imagery, as well as alchemical symbolism, colored deeply his synthetic recollection of childhood experiences, especially the death of his older sister Moria and birth of his younger sister, Loni, the latter of which somehow prompting his fascination with the occult, magic, and witchcraft at the age of fifteen. On the morning when his father announced to him the birth of Loni, he discovered that his pet cockatoo had died overnight. In his imagination the events were connected, and he blamed the baby with taking the bird's life. A series of mystical crises, fits of hysteria, and "exaltations and depressions" followed. A dangerous confusion between birds and humans became encrusted in his mind and asserted itself in his drawings and paintings.[32] Ernst would later identify himself with "Loplop, the Superior of the Birds," an identification that became most graphic in his *L'ange du foyer*, otherwise known as *The Angel of the Home* or *The Triumph of Surrealism* (fig. 110). This painting captures

28. William A. Camfield, *Max Ernst: Dada and the Dawn of Surrealism* (Munich: Prestel-Verlag, 1993), 27.

29. Camfield, *Max Ernst*, 38. See Ernst, *The Pool at Bethesda* (1911).

30. M. E. Warlick, *Max Ernst and Alchemy: A Magician in Search of Myth* (Austin: University of Texas Press, 2001), 9.

31. Warlick, *Max Ernst and Alchemy*, 1, 5.

32. Max Ernst, "Some Data on the Youth of M.E.," in *Beyond Painting and the Other Writings by the Artist and His Friends*, trans. Dorothea Tanning, ed. Robert Motherwell, Documents of Modern Art (New York: Wittenborn, Shultz, 1948), 30. Cited in Warlick, *Max Ernst and Alchemy*, 16.

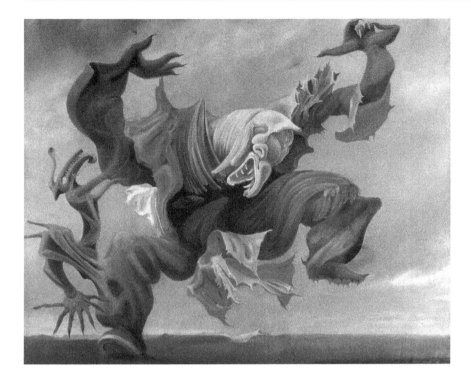

Figure 110. Max Ernst, *Triumph of Surrealism* (*L'ange du foyer*), 1937

the psychotic element in surrealism rather well. (It seems also to have influenced similar psychotic identities in real time, as life imitates art.)[33]

The growth of surrealism coincided with a revival of the occult in France,[34] and with renewed interest in primitive art and its magical or shamanistic aura—effectively a popularization of the impulse we have already observed at work in Paul Gauguin.[35] Along with his friends Paul Éluard, Éluard's then wife Gala (Elena Ivanova Diakonovna), André Breton, and others, Ernst began to participate in séances, the calling up of spirits in trance-like states. Breton's article "Entrée des mediums" summarizes some of these activities, using "the term 'surrealism' twice in the article, connecting it both to psychic automatism and to 'magic diction.'"[36] Ernst painted his *Rendezvous of Friends* (1922) showing members of the séance group along with such figures as Raphael and Dostoevsky holding Ernst on his lap, all near the edge of a precipice in the Tyrolean Alps.[37] One

33. See http://www.mirror.co.uk/news/weird-news/animal-lover-more-100-tattoos-6643757. The plastic surgery, like the colored tattoos, seem to mimic *L'ange du foyer*.

34. Warlick, *Max Ernst and Alchemy*, 23, 33, 61.

35. Rabinovitch, *Surrealism and the Sacred*, 11.

36. Warlick, *Max Ernst and Alchemy*, 65.

37. Image reproduced with discussion in Warlick, *Max Ernst and Alchemy*, 66–68.

Figure 111. Max Ernst, *Virgin Mary Spanking the Infant Jesus before Three Witnesses, André Breton, Paul Éluard, and the Artist*, 1926

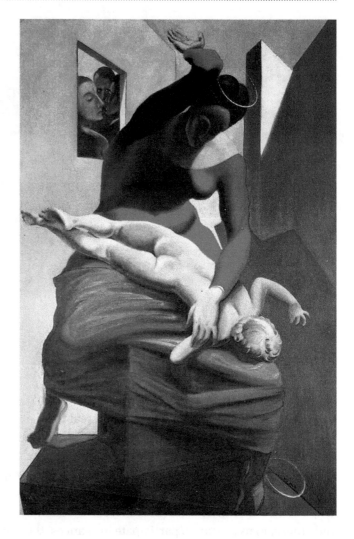

wonders if the séance was not, in some extraordinary way, becoming their replacement for the Kantian and pre-Kantian sublime.

While on occasion Ernst's use of religious allusion in his titles is more bizarre than blasphemous (e.g., *Massacre of the Innocents* [1920]), in many of his paintings it is easy to see a deliberate intention to make the central tenets of Christian belief seem grotesque. Given that he had been a Catholic, it is perhaps to be expected that the apogee of Ernst's blasphemy would involve the Virgin Mary as well as Christ; in his *Virgin Mary Spanking the Infant Jesus before Three Witnesses, André Breton, Paul Éluard, and the Artist*, he mocks the ideal of sinless purity in both (fig. 111).

The Virgin sits on an insecure pedestal, her face stern with impassive anger. While the halo that identifies her floats airily above her head, the

halo of the Christ child is falling to the floor. The three witnesses in the window are disdainful or disinterested; unlike the piously kneeling patrons in medieval icons, Éluard and Ernst were dubious witnesses from a Catholic point of view, living as they were in a *ménage a trois* with Gala, Éluard's then wife, adding to the deliberately anti-iconic character of the painting. Ernst would go on to do hermetic and occult works of many kinds, as well as a Marquis de Sade–like pictorial novel of erotic collages, ironically titled *Une semaine de bonté* (A week of kindness), in 1934,[38] as well as illustrations for some of the works of Lewis Carroll. But *The Virgin Mary Spanking the Infant Jesus* would remain his signature work.

SALVADOR DALI (1904–1989)

Salvador Dali was raised in a traditional Catholic family headed by a disciplinarian father. He had lost interest in faith by his late teens, about the time he was taking up painting in a serious way. He joined the surrealists in 1929 as an already famous cubist artist; by 1938 he would again shift, moving in another direction, and so be "excommunicated" from the group by André Breton. Nonetheless, he remains the most prominent of the surrealist painters and, in his later work, one of the dominant artists of the twentieth century. In the late 1920s he experimented with a variety of styles, but after 1929 he eagerly embraced the iconoclasm and anarchic impulses associated with the Paris surrealists, notably Breton and Paul Éluard. He also began to write voluminously about himself, his own art theories and those of other surrealists, publishing a torrent of essays, often inchoate and inflammatory, that appeared from then until the early 1940s.[39] In these writings one may trace not only his judgment on the painters whose works arouse his admiration or scorn, but also the considerable influence upon him of the psychoanalytic works of Freud, whom he

38. A translated second edition was published by Dover Publications in 1976, with all 182 plates. For Georges Bataille, "sadism is comprehensible from the moment one perceives that what is at stake in Sade's conception is really complete destruction, not simply of the object of sadism but of the subject. Sadism is conceivable only on condition that for him the tortures he inflicts on others, which gives others the most unbearable distress, are transformed for him if he experiences them, in his turn, only as delights." Georges Bataille, *Visions of Excess: Selected Writings, 1927–1939*, trans. Alan Stoekl (Minneapolis: University of Minnesota Press, 1985), 111.

39. *The Collected Writings of Salvador Dali*, ed. Haim Finkelstein (Cambridge: Cambridge University Press, 1998).

met in 1938, and of Jung, whose books on dream theory reportedly were prominent on his shelves.[40]

In an essay dedicated to the Catalonian art critic Sebastià Gasch in 1928, Dali announced his sympathy with Gasch in his judgment that in impressionism art had sunk to "the moment of its greatest discredit," becoming little more than "the most subjective sentimentalism."[41] He much preferred Hieronymus Bosch (1450–1516), whose fantastic images "seem to obey this surreality which is contained in reality itself."[42] In short, he admired grotesque distortion much more than conventional notions of beauty. But it was not only conventional ideals of beauty that irked him; conventional ideas of religious devotion and piety he found still more distasteful. In 1929 he painted two pointedly blasphemous works, *Sometimes I Spit with Pleasure on the Portrait of My Mother*, in which those words (in French) are written over an outline image of the icon of the Sacred Heart of Jesus, and *The Great Masturbator*, in which he has lewdly superimposed the face from Dante Gabriel Rossetti's *Beata Beatrix*.[43] In 1930 he added a pornographic sexual coupling in pen and ink entitled *L'Immaculée Conception*.[44]

These works help to contextualize his obsession with a strikingly contrary image, Jean-François Millet's extremely popular painting *The Angelus* (fig. 112), which Dali denigrated and deconstructed obsessively, both in painting and in print. His obsession with Millet's image recalls the deep admiration of van Gogh for Millet's work, but is clearly its polar opposite. In one of the essays he devotes to it, Dali says that Millet's *L'Angelus* is "beautiful like the fortuitous encounter on a dissecting table of a sewing machine and an umbrella,"[45] and in another he elaborates an erotic deconstruction of Millet's painting as an exemplar for his own "Paranoiac-Critical Interpretation." Confessing that Millet's painting has been since his childhood a recurring, haunting mental image, he describes it as "the pictorial work that is the most disturbing, the most enigmatic, the most

40. Dawn Ades and Michael R. Taylor, *Dali* (Venice: Rizzoli, in association with the Philadelphia Museum of Art, 2005), 178; see also, Michael R. Taylor, ed., *The Dali Renaissance: New Perspectives on His Life and Art after 1940* (New Haven: Yale University Press, 2008), 5; cf. Ades and Taylor, 213.

41. In his "The New Limits of Painting," in *The Collected Writings of Salvador Dali*, 82.

42. *The Collected Writings of Salvador Dali*, 94.

43. Ades and Taylor, *Dali*, 108, 116–17.

44. Felix Fanés, *Salvador Dali: The Construction of the Image, 1925–1930* (New Haven: Yale University Press, 2007), 131. *The Collected Writings of Salvador Dali*, 279 and n. 7, 423.

45. *The Collected Writings of Salvador Dali*, 279 and n. 7, 423. Also 233, 282–97.

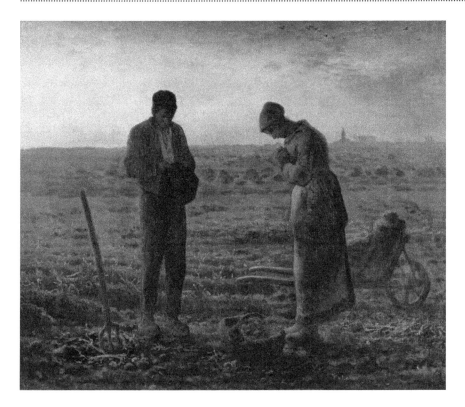

Figure 112. Jean-François Millet, *The Angelus*, 1857

dense, and the richest in unconscious thoughts ever to have existed."[46] The "obsessive form" of Millet's image prompts in him one delirium after another through which he seeks to subdue the original meaning (which had been to record a pious gesture in which field laborers stop their labors at the sound of the Angelus bells from a nearby church to pray the Lord's Prayer and an *Ave*). Dali subverts this content by describing the man and woman as enacting a contorted erotic allegory,[47] in which the woman becomes a praying mantis, preparing to devour her mate after sex. In the versions painted in 1932 and 1933, the church in the distance disappears altogether along with the wheelbarrow and potatoes, replaced by a wasteland. Perhaps the best-known version is the suggestively titled *Archaeological Reminiscence of Millet's "Angelus"* (1935). In a still darker version, *Atavism at Twilight* (1933–1934), the man has become a skeleton with the wheelbarrow stuck by one handle in his skull, while the woman appears to be transfixed by a pitchfork (fig. 113). In *Gala and the Angelus of Millet Preceding the Imminent Arrival of the Conical Anamorphoses* (1933),

46. *The Collected Writings of Salvador Dali*, 233, 282–97.
47. *The Collected Writings of Salvador Dali*, 294–96.

Figure 113. Salvador Dali, *Atavism at Twilight*, 1934

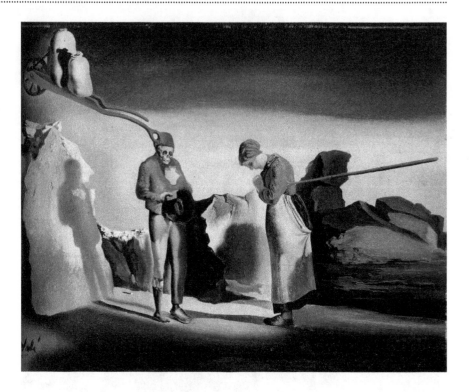

the viewer sees beyond a doorway, over which a moderately distorted *Angelus* is hanging, a demonically grinning Gala Éluard (by now Dali's regular live-in) confronting a figure said to be Lenin, while a monstrous Maxim Gorky lurks menacingly just outside the door.[48] Millet's piety has been replaced by ambiguity and fear—or revulsion. Dali's grotesque *The Resurrection of the Flesh* (1945) turns the perennial Christian hope in the resurrection of the body to a macabre vision of gruesome decay and despair. It is some index to his state of mind, perhaps, that Dali worried sufficiently about his preoccupation with destructive spiritual influences that he submitted to a rite of exorcism in 1947.[49]

The elevation of psychic disorders to a necessary condition for surrealist art continued to have its followers all through the second half of the twentieth century, and not all the adherents would be regarded as surrealists. In fact, Dali had been disavowed by Breton and the other (mostly Communist Party member) surrealists for his support of Dictator Franco

48. Ades and Taylor, *Dali*, 196–99.

49. Concern over cultivation of the demonic in art led Paul Tillich in 1916 to publish (in German) "The Demonic," which appears in English in his *Interpretation of History* (New York: Scribner, 1936), 77–115.

as well as his change in style even before he wrote his *Declaration of the Independence of the Imagination and the Rights of Man to His Own Madness*, published in New York in 1939. Yet the ideas of the original surrealists, especially André Breton, were clearly still at work in him.[50] In his *Rotting Donkey* (1930), Dali had seen himself as the prophet of a new order—disorder: "I believe the moment is drawing near when, by a thought process of a paranoic and active character, it would be possible (simultaneously with automatism and other passive states) to systematize confusion and thereby contribute to a total discrediting of the world of reality."[51] A decade later, that basic ambition remained; his choice of a more classical style, influenced by Renaissance painting, actually heightened the communication of psychic disorder. Conjoined to this change of style is his stated need to disconnect art and nature, achieving thereby what he termed a "Holy Objectivity,"[52] so to redefine the central iconic elements of Western Christian art. His desire to paint a crucifixion in every way opposite to that of Grünewald was by the early 1950s becoming another obsession, an achievement he believed required a postsurrealist "new mysticism": "Finished are the denials and demotions, finished the Surrealist malaise and existentialist anxiety. Mysticism is the paroxysm of joy in the ultra-individualist affirmation of all man's heterogeneous tendencies within the absolute unit of ecstasy. I want my next Christ to be a painting containing more beauty and joy than anything I will have painted up to the present. I want to paint a Christ that will be the absolute contrary in every respect to the materialist and savagely anti-mystical Christ of Grünewald!"[53] This recurrent ambition (1951) seems to have crystallized soon after Dali's brief attempt to ingratiate himself with Pope Pius XII, to whom he presented his first version of *The Madonna of Port Lligat* (1949) at a papal audience on November 23, 1949 (fig. 114).

Dali was hoping for a special dispensation to marry Gala, whose first husband, Paul Éluard, was then still living. The pope expressed pleasure in the painting, though the proposed marriage was not sanctioned until Éluard had died in 1952. Dali and Gala were married in a Catholic church in 1958, even though both were to continue in extravagant liaisons with many other partners, Gala tolerating Dali's dalliances with younger muses and Dali accepting her series of brief but torrid affairs. Nevertheless, Gala

50. *The Collected Writings of Salvador Dali*, 331–34; Ades and Taylor, *Dali*, 547.

51. Ades and Taylor, *Dali*, 550.

52. Fanés, *Salvador Dali*, 57.

53. Ades and Taylor, *Dali*, 564.

Figure 114. Salvador Dali, *The Madonna of Port Lligat*, 1949

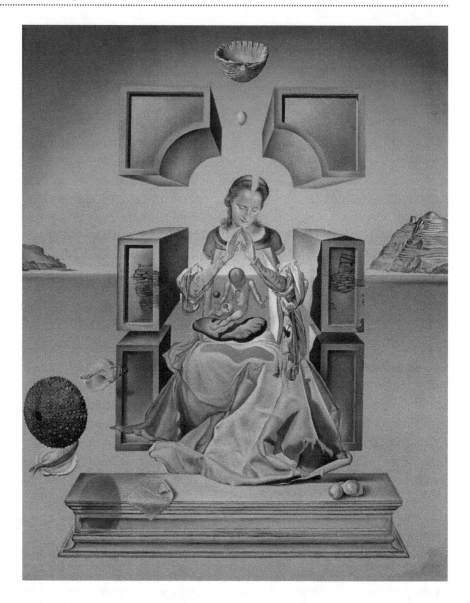

was Dali's primary model both for the Virgin Mary, in the Madonna above, for example, and for the Magdalene as well as for some of his more exotic voyeuristic fantasies.

Perhaps unsurprisingly, despite his advertised return to the Church, this Madonna is not theologically coherent from a Catholic point of view. Though based in part on Piero della Francesca's *Madonna and Child with Angels and Six Saints* (1470–1475), it is an example of what Dali referred to as "nuclear mysticism"; everything floats in space, nothing seems fully embodied. The effect is to deconstruct the iconic image to which it alludes.

Dali did other versions in 1950. These were followed in 1951 by his famous *Christ of St. John of the Cross*, in which, as if by magic, the suspended body of Christ, unblemished and unnailed, hovers along with the cross itself over a sunset maritime sea above some fishermen who tie up their boat. This well-known but not often well-understood image certainly has some claim to the mystical beauty to which Dali aspired, but having no contact with planet earth, it obscures the historical and theological reality of the atonement. The desired contrast with Grünewald could hardly be greater; in that much he succeeded.[54] The aura of unreality attends even more obviously to Dali's *Crucifixion–Corpus Hypercubus* (1953–1954), in which a resplendently robed Gala, posing as Magdalene, stares up at a hyper-cubed cross (geometrically suggesting a fourth dimension) and detached, floating, quasi-erotic male body, luminous against a black sky over a chessboard.[55] A close inspection shows that there are likenesses of both Dali and Gala visible on the knees of this "Christ" (fig. 115).

None of these crucifixions, nor his famous work *The Sacrament of the Last Supper* (1955), a translucent image vaguely modeled after Leonardo da Vinci and laid out in careful geometric symmetries, were ever encouraged or commissioned by a church or religious institution. Despite his claim that his "revolution ... [was] ... very close to Catholicism," most of the works of Dali's putative "Catholic period" have at one time or another been regarded as seriously transgressive of the Christian iconic works they seem superficially to resemble, with Protestant theologian Paul Tillich expressing such a judgment of *The Sacrament* especially.[56] In recent years some have tried to make a contrary case for their piety; in a paper delivered at the Notre Dame Center for Ethics and Culture in 2005, Catholic theologian Michael Anthony Novak defended *The Sacrament* as a representation of the relationship of any eucharistic celebration, across time, to the original Holy Thursday.[57] At the time these works were created,

54. Ades and Taylor, *Dali*, 354–57, 368–71.

55. Ades and Taylor, *Dali*, 368–71. The mathematician Thomas Banchof gave a lecture at Notre Dame in 2014, "Science, Mathematics and Catholicism: The Four-Dimensional Geometry and Theology of Salvador Dali," in which he suggested that Dali was consciously or unconsciously anticipatory of the possible philosophical significance of many dimensions (Notre Dame, College of Science, 2014); for more on this, see Linda Dalrymple Henderson, *The Fourth Dimension and Non-Euclidian Geometry in Modern Art* (Boston: MIT Press, 1983; rev. ed. 2013).

56. Paul Tillich, in an essay for *Time* magazine (November 19, 1956), 46; cf. George A. Cevasco, "Dali's Christianized Surrealism," *Irish Quarterly Review* 45, no. 180 (1956): 437–42.

57. Michael Anthony Novak, "Misunderstood Masterpiece: Salvador Dali's 'The Sacrament of the Last Supper,'" *America: The National Catholic Review*, November 5, 2012,

Figure 115. Salvador
Dali, *Crucifixion–Corpus
Hypercubus*, 1954

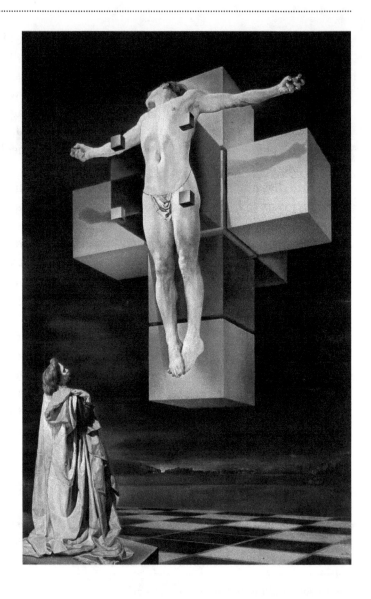

however, there were few such apologists. The juxtaposition of Christian
icon and dematerialized, distorted reality led art critics to suspect Dali not
only of betraying his surrealist roots but also of either fishing in vain for
lavish commissions from the Catholic Church or engaging in a blasphe-
mous joke. Dali at the time was still claiming to have returned to his Cath-

http://americamagazine.org/issue/misunderstood-masterpiece/; see also Matthew Mil-
liner, "God in the Gallery," *First Things*, December 12, 2012, http://www.firstthings.com
/web-exclusives/2007/12/god-in-the-gallery/.

olic roots (he did not, however, much go to church), but his pretensions irritated both sides and caused his ostensibly "religious" paintings to be relegated by many contemporaries to the category of burlesque or kitsch.[58]

Dali continued for a time to paint quasi-religious subjects. His *Ascension* (1958), in which a nude male body levitates through a golden, luminous sunflower orb (reminiscent of the sun in Grünewald's resurrection panel), rising toward the face of Gala, as if she were in heaven, is representative. His *Virgin of Guadalupe* (1959) and *Ecumenical Council* (1960) further support the contention that he was doing religious painting more to create a stir than out of genuine piety. The extraordinarily promiscuous lives of both Dali and Gala independently and together certainly contradict the claim to sincere Catholic faith.[59] Perhaps one should see all these paintings as expressions of a different kind of religion, or a religion substitute.

In his "Anti-matter Manifesto" (1958) Dali wants his readers to believe that he has moved from psychoanalysis to quantum mechanics: "In the Surrealist period I wanted to create the iconography of the interior world—the world of the marvelous, of my father Freud. I succeeded in doing [so]. Today the exterior world—that of physics—has transcended the one of psychology. My father today is Dr. Heisenberg. It is with pi-mesons and the most gelatinous and indeterminate neutrinos that I want to paint the beauty of the angels and of reality."[60] Unsurprisingly, his old colleagues in the surrealist movement, antinuclear to a person, took him to be pro–nuclear arms and making a deliberately antagonistic statement. He was; it was always his impulse. His "nuclear mysticism" and floating Christs are likewise antagonistic to the historical element in the biblical narrative and generally subversive of the Christian doctrine that flowed from it. By the mid-1960s Dali claimed to be an agnostic, and referred to himself in the third person as the Divine Dali, perhaps thereby indicating his ultimate "transcendent" principle.[61]

58. Taylor, *The Dali Renaissance*, 7–10.

59. Brian Sewel, in a Channel 4 BBC broadcast, June 3, 2007, described behaviors during the 1960s that were overtly blasphemous, not pious; also Ian Gibson, *The Shameful Life of Salvador Dali* (New York: Norton, 1997). See also Taylor, *The Dali Renaissance*, 82.

60. Taylor, *The Dali Renaissance*, 82. Robert Descharmes and Giles Néret, *Salvador Dali, 1904–1989* (Berlin: Benedict Taschen, 1994), 166.

61. Descharmes and Néret, *Salvador Dali, 1904–1989*, 166.

CONCLUSION

These twentieth-century artists, Munch, Picasso, Ernst, and Dali, provide in their flamboyant rejection of Christian orthodoxy and their principled aversion to traditional notions of beauty and holiness a formidable challenge to the long European history of Christian art, bringing it to a breaking point. Henceforth, Christian and Jewish—not secular—artists would be seen as the cultural expatriates, not so much a new avante-garde as simply out of step with the dominant culture. In modernity, beauty (following Kant) is increasingly identified with the subjective sensibilities of private individuals; each person decides for himself what counts as beautiful. So also with the holy: "The sacred becomes internalized and now is of interest only to the [individual] soul. . . . All external criteria appear insufficient from the moment the sacred is abstracted from collective manifestation towards a pure attitude of consciousness."[62] That is to say, so far from being something "set apart" or "above," the definition of the *holy* is determined (whether at whim or with serious intent) anarchically, much as in the case of *glory* for Lewis Carroll's Humpty Dumpty in *Through the Looking-Glass*. Examples establish no norm. For Georges Bataille, writing contra Rudolf Otto's *Idea of the Holy*, "Omaphagia, that form of sacrifice in which the victim is devoured alive by the unrestrained participants, is doubtless the most complete image of the sacred, implying as it always does an element of horror and criminality."[63] Bataille likely has in mind Meret Oppenheim's *Cannibal Feast*, exhibited in the 1957 Exposition Internationale du Surréalisme. In this work (earlier called *Fertility Feast*), a naked model painted gold and covered with food, fruit, and flowers except for her breasts, was laid on a banquet table with candles and place settings.[64] This parody of Holy Communion represents graphically the subversive anti-iconic intentions found to varying degrees in each of the artists examined in this chapter, from Munch's *Madonna* through Picasso's *Crucifixion* and Ernst's *Virgin Mary Spanking the Infant Jesus* to Dali's *Crucifixion–Corpus Hypercubus*. Whereas the iconoclasts of the eighth or sixteenth centuries attacked holy images physically, these latter-day iconoclasts used art itself (rather than hammers, swords, and fire) to attack the idea of the holy. That the altarpiece of Grünewald should

62. Georges Bataille, *Visions of Excess,* 117, commenting on Roger Caillois, *L'homme et le sacré* (Paris: Gallimond, 1950); ET: *Man and the Sacred*, trans. Meyer Barash (Champaign, IL: Free Press of Glencoe, 1959).

63. Bataille, *Visions of Excess*, 117; Rabinovitch, *Surrealism and the Sacred*, 217–18.

64. Rabinovitch, *Surrealism and the Sacred*, 217–18.

haunt so many modern artists, including each of the four discussed here, or that Dali should repeatedly feel compelled to deconstruct Millet's *L'Angelus*, indicates a spiritual struggle to repress something they feared. Elements of a kind of beauty can be found in the work of these artists, but it is usually a fragment of beauty whose disunifying purpose is to subvert the holy. Any attempt to reestablish an intimate connection of beauty to an idea of the holy conceived in biblical and traditional Christian terms would subsequently have to build on other foundations. In the words of Georges Bataille, "Between surrealists and Christians there is certainly the deepest abyss."[65] But between many other artists of all descriptions in the twentieth century, whether or not they dallied much with surrealism, the abyss grew wider and deeper as the decades passed, nowhere more evidently than in their signature deconstructions of traditionally Christian holy subjects.

65. Bataille, *Visions of Excess*, 184: "The numerous Christians who praise surrealism finally seem naïve, but they have been led astray by the demands of theological discourse, which condemns their pliancy as much as Breton's position does." The abyss remains.

12 RETURN OF THE TRANSCENDENTALS

The moment one touches a transcendental, one touches Being itself, a likeness of God, an absolute, that which ennobles and delights our life; one enters in[to] the domain of the Spirit.

JACQUES MARITAIN

A s we noted in chapter 2, the transcendentals of Plato—the True, the Good, and the Beautiful—all considered as properties of Being, coinherent and convertible with each other, were affirmed by early Christian thinkers, most prominently Augustine, who grounded them in the authority of Scripture as well as that of Plato. Through Augustine's influence (and later that of Bonaventure and Aquinas), this double foundation had the effect until the Reformation of uniting aesthetic reflection with ethical and epistemological contemplation, and ultimately with theology and the metaphysics of Being.[1] After the Enlightenment, as we have also seen, the category of transcendence itself tended to become less and less available to basic thinking; immanence made a more pressing case, and the metaphysic of convertibility came to seem counterintuitive to such a degree that art not only achieved independence from the church and theology, but also asserted its divorce from truth and morality as necessarily concomitant to the increasingly autonomous authority of

1. David Bentley Hart has explored these theological ideas in *The Beauty of the Infinite: The Aesthetics of Christian Truth* (Grand Rapids: Eerdmans, 2003); see 15–22 for an anticipation of his argument. See also, Etienne Gilson, *The Arts of the Beautiful* (New York: Scribner, 1965), 27–29, 77.

the artist. Eventually, beauty itself would become suspect,[2] since it was deemed to have vestigial traces of earlier views of convertibility about it, such as are resonant in Keats's "'Beauty is truth, truth, beauty,'—that is all / Ye know on earth, and all ye need to know."[3] For the surrealists and others, as we have seen, the denigration of conventional notions of beauty in relation to truth and the moral good becomes itself a primary goal of art.

At a philosophical level, the rejection of the true, the good, and the beautiful was simultaneously a rejection of Being; in religious terms, it was a rejection of belief, which the prominent social scientist Daniel Bell has described as "the real problem of modernity." The seriousness of this problem, Bell goes on to say, is that, "to use an unfashionable term, it is a spiritual crisis, since the new anchorages have proved illusory and the old ones have become submerged."[4] At its worst, as we now have an overwhelming body of social and political experience to demonstrate, as western European people in the twentieth century have lost not merely their religious but even to some degree their national identity, they have experienced a severe devaluation of the human person. For philosopher Jacques Maritain, an intimate of artists as well as university culture in France at the beginning of the twentieth century, it became obvious that "if there is no man, there is no artist: in devouring the human, art has destroyed itself."[5] The eager participation of the surrealists, from Breton to Dali, in "devouring the human" has proved to be self-destructive, nihilistic, and, however unwittingly, suicidal. The obverse of Breton's sociopathic surrealist act—wandering into a crowd and firing a revolver at random for as long as possible—is one or another form of self-annihilation.

Philosophers who regarded the increasingly surreal world as a judgment against credible rational order, such as existentialists Jean-Paul Sartre, Simone de Beauvoir, and Albert Camus, tended to insist that the question of how to make one's peace with absurdity was the primary issue for philosophy in the twentieth century. Their solution was to make individual, self-actualizing choice the only meaningful personal action,

2. Wendy Steiner, *The Trouble with Beauty* (London: Heinemann, 2001), provides an interesting secular analysis.

3. John Keats, "Ode on a Grecian Urn," in *The Poetical Works of John Keats*, ed. H. Buxton Forman (London: Oxford University Press, 1937), 234; Gilson discusses the confusion in philosophers' minds between intelligible beauty and what he calls "beauty qua beauty" (*Arts of the Beautiful*, 25–28).

4. Daniel Bell, *The Cultural Contradictions of Capitalism* (New York: Basic Books, 1976, 1996), 28.

5. Jacques Maritain, *Art and Scholasticism* (New York: Scribner, 1962), 90, 95.

irrespective of its communal or traditional moral implications. Another group of what today we would call philosophers of religion, representing Catholics, Protestants, and Jews in their backgrounds, began in the early 1960s to consider if viable social order could be kept intact without some intelligible concept of transcendence. Yet how, in a postreligious world, could *any* conception of transcendence be made intelligible? Among these philosophers was Emmanuel Levinas. By the time of his important 1984 essay, "Transcendence et intelligibilité," Levinas was coming to the conclusion that this question might more appropriately be put the other way around: "can there be any intelligibility without a category of transcendence?"[6]

Thoughtful people in a wide variety of occupations, certainly including those well outside the secular cloisters of academe, were becoming more aware of the personal as well as social consequences of moral instability; to recall the psalmist, it was becoming apparent for anyone with eyes to see and ears to hear that "man without God is without [self-] understanding, like unto the beasts that perish" (Ps. 49:20). Daniel Bell, writing in the 1970s, seems to echo the judgment of the biblical poet in his own analysis: "The effort to find excitement and meaning in literature and art as a substitute for religion led to modernism as a cultural mode. Yet modernism is [now] exhausted and the various kinds of post-modernism (in the psychedelic effort to expand consciousness without boundaries) are simply the decomposition of the self in an effort to erase individual ego."[7]

The "decomposition" had been under way for a long time by 1974, when Bell tried to summarize the social consequences. Such was the state of mind of many intellectuals who did commit suicide in the early years of the century, as well as of others, like Jacques and Raïssa Maritain, who went right to the brink and stepped back, only because at the last minute they recovered faith in transcendent Being. The Maritains were friends of two of the artists to be considered in this chapter, and Jacques Maritain's essays have been an influence on the third. With varying degrees of personal suffering and sacrifice, yet a persistent will to choose life, Georges Rouault, Marc Chagall, and Jean-Marie Pirot, better known as Arcabas, also looked into the abyss, rejected it, and then resolved to look beyond the detritus and ashes of exhausted modernism. Respectively, each has

6. Emmanuel Levinas, "Transcendence and Intelligibility," in *Basic Philosophical Writings*, ed. Adriaan T. Peperzak, Simon Critchley, and Robert Bernasconi (Bloomington and Indianapolis: Indiana University Press, 1996), 149–60.

7. Daniel Bell, *Cultural Contradictions*, 29.

been drawn toward an existential affirmation of transcendental truth; each therefore has become a religious artist in a much more traditional sense, using exceptional artistic gifts to acknowledge the True (Rouault), the Good (Chagall), and the Beautiful (Arcabas). They are important countercultural voices, signs of resistance to the conclusions of modernism, and they deserve our attention.

GEORGES ROUAULT (1871–1958)

Georges Rouault was born to restively Catholic parents in the seedy, working-class suburb of Belleville, then near and now within Paris. Though his father was a competent cabinetmaker and piano polisher, an artisan's wages were barely enough to make ends meet. Craftsmen like Rouault Senior, if they are to be content with their lot, find satisfaction in the making of good work—excellence for its own sake rather than for the hope of easy reward. Such was Père Rouault, and this work ethic was communicated to his son in such a way as to characterize the painter's lifelong approach to his own vocation. At the age of fourteen, after two unhappy years in a Protestant school, Georges was apprenticed to a stained glass restorer, work that was to acquaint him both with the heritage of earlier Christian art (restoration of glass from Chartres Cathedral was one of the projects) and also with demand for painstaking care for which little financial recompense was available.[8] After hours he studied at L'École des Arts Decoratifs. As he would later say of these early years, "One starts out being a craftsman, then becomes an artist if he can. But is it not better to be a good craftsman than a mediocre artist?"[9] He took much time with his paintings, often reworking his canvases many times, sometimes throwing them out and starting over. Like his father with wood, Rouault was a kind of perfectionist with paint and ink.[10]

Also like his father, he was uncomfortable with some of the fashions of the modern French church. It may be that Waldemar George, inquiring why the church continued to ignore Rouault, was among the first to see one of the reasons: George accused the Dominican editors of *L'art sacré* of spiritual obtuseness for their infatuation with Picasso and the surreal-

8. William A. Dyrness, *Rouault: A Vision of Suffering and Salvation* (Grand Rapids: Eerdmans, 1971), 24–25. This remains the best general study in English.

9. Georges Rouault, *Soliloques* (Neuchâtel: Ides et Calendes, 1944), 104.

10. Fabrice Hergott and Sarah Whitfield, eds., *Georges Rouault: The Early Years, 1903–1920* (London: Royal Academy of Arts, and Lund Humphries, 1993), 26.

ists while ignoring the evidently orthodox Rouault. George concluded that their problem was a refusal "to understand that the Catholic artist is not the one who treats sacred themes, but the one whose every activity bears the imprint of Christian thought."[11] This pointed critique, with its curious echo of van Gogh, gets at something of the fiercely integral principles that motivated Rouault. In contrast to the psychedelic manipulation of "sacred themes" by such as Picasso and Dali, which too easily flattered the novelty-seeking vanity of some churchmen (blurring their judgment to the point that they would try to "baptize" blasphemy), Rouault quietly kept his focus on the spiritual suffering of ordinary people. It is not too much to say, I think, that he saw everyday emotional reality with the eyes of Christ.

Rouault's religious conversion occurred in 1904. It seems to have come about through a sudden insight followed by maturing contemplation over a period of several months. He said, "When I was about thirty I felt a stroke of lightning, or of grace, depending on one's perspective. The face of the world changed for me. I saw everything I had seen before, but in a different form and a different harmony."[12] This breakthrough capped four very difficult years following the death of his mentor, Gustave Moreau, in which he had become depressed to the point of mental breakdown.[13] When his sudden moment of grace turned him toward health, it did so in such a way as to firm his mind against the more fashionable modern artists, not only because of their ostentatious pursuit of self-glorification, but also because of their neglect of human suffering and their pretense that art could serve as a substitute for religious meaning. Their attempt at depicting sacred subjects he found especially hypocritical: "It is not always the subject that inspires the pilgrim [artist], but the accent that he puts there, the tone, the force, the grace, the unction. That is why some so-called 'sacred art' can be profane."[14] Here Rouault seems to have touched upon the very core of modernism as, much later, it would be described by

11. Waldemar George, "Georges Rouault: Oeuvres inédits," *La Renaissance* 5 (1937): 10. Dyrness (*Rouault*, 14–15) discusses the lack of interest in Rouault among churchmen at useful length.

12. Quoted by Dyrness, *Rouault*, 62.

13. Hergott and Whitfield, *Georges Rouault*, 11–12. During his apprenticeship in Moreau's workshop, he painted erotica such as his *Stella Matutina* and *Stella Vespertina* (1895) for the collector Leopold Benedict Hayum Goldschmidt, sensuous Venus images that he later redacts ironically in his anti-erotic images of *filles de joie*.

14. Rouault, *Soliloques*, 53. In this and other respects he was influenced by his reading of the Gospels and Isaiah (in the Segond translation); his attunement to the dark sham of hypocrisy owes much to these biblical texts.

Daniel Bell when he wrote that "the effort to find excitement and meaning in literature and art as a substitute for religion led to modernism as a cultural mode."[15] Rouault came to reject this "cultural mode" and to deplore its spiritual bankruptcy. He determined to become a sign of contradiction to the glib falsifications of his eminent contemporaries, even if it meant commercial failure.

From his conversion through the next decade, accordingly, Rouault strove to paint with spiritual realism, eschewing surface realism, especially any form of flattering light or perspective in order to evoke the actual emotional state of his subjects. This is evident in his anti-erotic treatment of prostitutes, in which he accentuates the chasm between the public image of the *filles de joie* exposing their naked bodies to those who purchase them for self-gratification, and the hardened impassivity and repressed grief of their actual personal experience (fig. 116). For Rouault, the nakedness of the prostitutes was, ironically, itself a kind of mask; they were attempting with an actor's feigned emotion to hide their actual emotional emptiness and frequently torturous anxieties.

He found in circus clowns a similar expression of what he regarded as the underlying deception—and self-deception—in modern French society, namely, the more general fabrication of public image in an effort to disguise private personal reality. The gap between *personne et personage* he saw metonymically in the entertainment industry of his day (e.g., *The Conjuror*, 1907), but alienated moderns in general are subsumed in his clowns (fig. 117). This image occurs in many versions[16] and is reproduced in Rouault's etchings for his *Miserere* series (1917–1927, published 1948), where he adds a comment: "Behind our glittering masks we all hide a tormented soul, a tragedy." Another of his clown images bears the title *Don't We All Wear Make-Up?* (1931). Many a circus clown conceals a tear behind his painted smile and still charms a child; so too with other more prosperous persons, pretending to good cheer and success externally while inside they are actually unhappy and unfulfilled. Rouault finds a more culpable split between mask and reality in his numerous images of judges (e.g., *Judges*, 1908) as well as of well-coiffed and morally vain society women (e.g., *Upper Class Woman Who Thinks She Has a Reserved Seat in Heaven*, plate 16 of the *Miserere* series, 1927).[17] As Soo Yun Kang puts it succinctly,

15. Bell, *Cultural Contradictions of Capitalism*, 26.

16. Dyrness (*Rouault*, 149) has counted 169 separate treatments between 1902 and 1956.

17. See the excellent studies by Holly Flora and Soo Yun Kang, *Georges Rouault's Miserere et Guerre: This Anguished World of Shadows* (New York: Museum of Biblical Art, 2006);

Figure 116. Georges Rouault,
Girl with Mirror, 1906

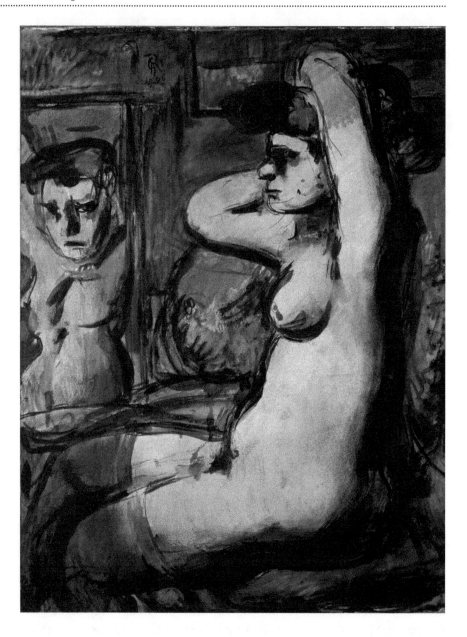

regarding his painstaking craftsmanship and method, the essay by Doris de Stephano (19–24) shows how Rouault would proceed from sketches to oil paintings as studies for his prints, and would then make plates using photoengraving technique. Then he would refine the impression on each plate to suit, granting the plates a *sfumato* effect—an exceedingly time-consuming effort at precision of a type that does not appear superficially. See also, Stephen Schloesser, *Mystic Masque: Semblance and Reality in Georges Rouault, 1871–1958* (Boston: McMullen Museum of Art, Boston College, 2008).

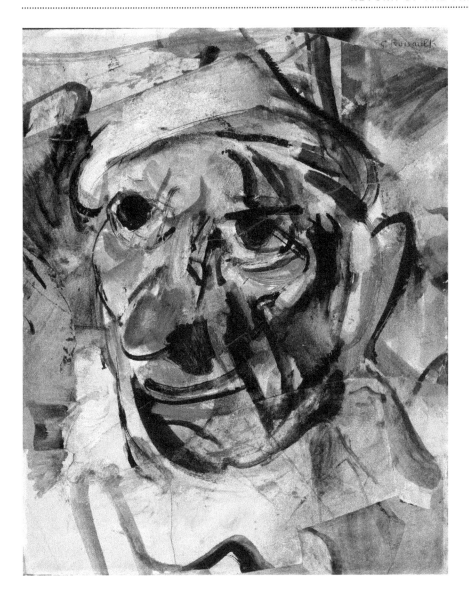

Figure 117. Georges Rouault, *The Clown*, 1907

"of all the masks it is the mask of hypocrisy that Rouault despised the most and thus tackled most fiercely."[18] This is one evidence among many that Rouault's form of Christian worldview was in conformity with the affections and disaffections of Christianity's founder.

Rouault's resistance to artistic modernism is thus part of a larger resistance to what he regards as a general trait of European modernity, namely, that it characteristically wants something other than truth to be

18. In Flora and Kang, *Georges Rouault's Miserere et Guerre*, 34.

taken for reality. Nowhere is this more visible than in the social pressures put upon people in all walks of life to be what in fact, at heart, they are not. They thus create an image of what they *wish* to be the truth, all the while suffering under the persistence of the lie. Maritain was among the first to see that Rouault's empathy with the emotional suffering of his contemporaries was the key to his abandoning of this early mode of "realism," and his postconversion choice to make his art evocative rather of inward truth: "What he sees and knows with a strange pity," says Maritain, "is the miserable affliction and lamentable meanness of our times, not just the affliction of the body, but the affliction of the soul, the bestiality and self-disguised vainglory of the rich and the worldly, the crushing reality of the poor, the frailty of us all."[19] To be empathetic means literally to "suffer with," to identify with the sorrows and even sins of others. Bernard Doering has observed that for Maritain, Rouault's *Miserere* series of fifty-eight black-and-white engravings (1917–1927), many of which are reworkings of his paintings, were a kind of summary expression of the artist's concern for inward and ultimate truth.[20] Rouault actually gave Maritain a complete set of the etchings, and their friendship, according to Raïssa Maritain, significantly influenced Maritain's *Art and Scholasticism* (1920).[21] The question at bottom, for both artist and philosopher, is at least as old as Plato: In what sense is art able to give us Truth? Louis Léon-Martin, in an essay of 1930, seems to have thought in a similar way to Maritain about Rouault's answer: "No one has made a work at once less exact and more true, and just here lay the initial misunderstanding of the artist with his public. He reported such justice of relations! Few artists have known how to capture the truth to this degree."[22] No one can capture truth in others, however, without a serious effort at truth telling about the self; the spiritual discipline of self-examination, or examination of conscience, is precisely opposite to what many of Rouault's artistic contemporaries meant when they spoke of "being true to myself." Persons who seek the truth about themselves as well as the truth in others necessarily have more than their own judgment as measure, and thus are far more vulnerable than an assertive ego. A work of art, so purposed, will reveal more

19. *Cahiers Jacques Maritain* 12 (1985): 24.

20. See Bernard Doering, "*Lacrimae rerum*—Tears at the Heart of Things: Jacques Maritain and Georges Rouault," in *Truth Matters: Essays in Honor of Jacques Maritain*, ed. John G. Trapani Jr. (Washington, DC: Maritain Association and Catholic University of America Press, 2004), 204–23.

21. Raïssa Maritain, *Les grandes amitiés* (Paris: Desclée de Brouwer, 1962), 169.

22. Louis Léon-Martin, "Jacques Maritain," *Art et décoration* 57 (1930): 112.

than its ostensible subject. Thus, for Rouault, "The work of art remains a vow and a confession of what we really are, without our suspecting it."[23] Elsewhere he adds, "The work of art, moreover, is a touching confession, more true than ever could be put into words."[24] When Rouault painted, he was self-consciously striving to represent the hard truths of modern humanity without in the least exempting himself from the common lot. In just this much, he reflects a central theme of the Christian gospel, namely, an empathetic identification, exemplified by Christ himself, with the lot of poor people, prostitutes, corrupt tax collectors, and the like.

Rouault's specifically religious paintings, a major group of which he produced in the 1930s, are thus on a continuum with his early paintings and his etchings for his *Miserere*; it is the passion of Christ, his vicarious suffering, which dominates this period. Rouault's Christ is preeminently the Suffering Servant announced in Isaiah: "wounded for our transgressions and bruised for our iniquities"; nor is it by accident that the *Miserere* series ends with the Veronica image of Christ's face bearing the words "It is by his wounds that we are healed" (Isa. 53:5) (plate 58). The images of Christ, inflected by quotations from Isaiah, the Gospels, and Saint Paul (e.g., Phil. 2:8), emphasize God's identification with human suffering.[25] They are executed in the manner of his earlier work—heavy outlines as if the units of an image were separated by the leaded glass of a cathedral window—but with a tenderness that elevates the corporeal and a radiance that sometimes lights the whole composition yet seems to come through the image from behind, as in stained glass painting (fig. 118).

In his many renditions of the face of Christ, or of the bodily sufferings of Christ, including on the cross itself, Rouault's intent is clearly the old Franciscan objective of engaging the viewer's affectual response to the suffering of Christ in his self-offering for the sins of the world. These are images that invite spiritual contemplation and personal contrition. The title Rouault gave to one crucifixion, *Love One Another* (*Miserere*, plate 31), recalls the discourse and prayer of Christ for his followers just before his passion, but here it is an invitation to imitate Christ directly in love: "Love one another as I have loved you" (John 15:12).

23. Quoted in Dyrness, *Rouault*, 76. See also, Gael Mooney, "Georges Rouault: Encountering God's Beauty through the Face of the Other," in *Violence, Transformation, and the Sacred: "They Shall Be Called Children of God,"* ed. Margaret R. Pfiel and Tobias L. Winright, Annual Publications of the College Theological Society 57 (Maryknoll, NY: Orbis, 2011), 99–114.

24. Quoted in Dyrness, *Rouault*, 76.

25. Cf. Mooney, "Georges Rouault," 99–114.

Figure 118. Georges Rouault, *Head of Christ*, 1937

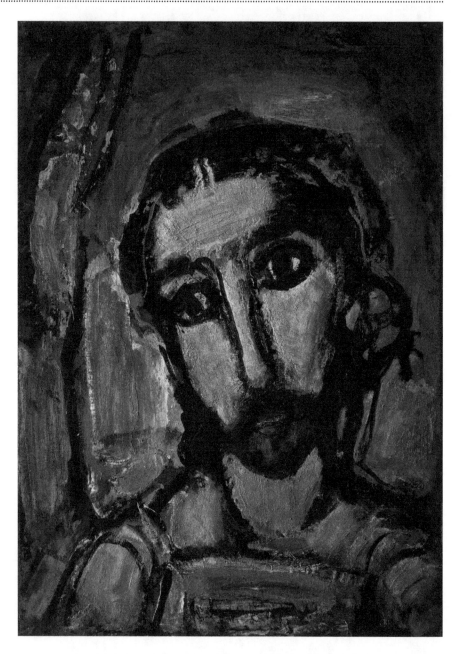

It soon becomes apparent that Rouault's religious paintings are deliberately evocative of medieval iconic art. Their purpose is not aesthetic pleasure but an invitation to enter into the presence of the Crucified. In short, they invite worship, but certainly not a worship of art. This iconic character has recently been noted as a feature that more clearly distinguishes Rouault from many of his contemporaries, in which art had long

since, in the words of Roland Bonnel, "passed from the metaphysical level to a level reflecting only the feelings of the artist . . . a turn toward the present and the world of nature in place of symbolic realities."[26] Bonnel's perception reflects the influence of Hans Belting, who, as we have seen, divided art history into a pre-Reformation period in which the icon dominated and a post-Reformation period in which art loses its inherently spiritual power.[27] Cornelia A. Tsakiridou has the same shift in mind, but concerns herself more directly with Rouault, adducing Maritain in answer to the question, "what is Christian art?" Maritain's answer she draws from *Art and Scholasticism*; it is the "art of humanity redeemed,"[28] a characteristic theme that strongly linked Fra Angelico and Rouault in the mind of Maritain. Tsakiridou touches here upon something common to all three of the artists treated in this chapter, namely, their explicit interest in painting that is not merely religious, but religious in a classic iconic way that, surprisingly, Maritain himself seems not fully to have explored. Rouault was fascinated with the *vera-icon*, the "true icon" of Christ, associated in Christian tradition with Veronica and the image impressed upon a cloth she is said to have used to wipe away his bloody sweat en route to Golgotha. This legendary incident, kept in Christian memory through the Franciscan-inspired Stations of the Cross, is explicitly recalled in Rouault's iconic image of Veronica herself (1945) and a representation of her imprinted cloth, *The Holy Countenance*, produced the following year. Tacitly, however, this iconic method and purpose can be detected even in some of his earliest religious works. Tsakiridou notes, as we did in chapter 6 of this book, that the deeper truth evoked by a Christian icon is not so much its past historical reality as its present and eternal metaphysical Reality. This, she observes, is "not to neglect the physical facts, but to attribute to them their changeless meaning." Maritain gets at this when he says that Rouault's painting "clings . . . to the secret substance of visible reality" in such a way that its "realism" refers to the "spiritual significance of what exists (and moves, and suffers, and loves, and kills)."

26. Roland Bonnel, "L'art sacré en France et l'icône," in *L'art Français et Francophone depuis 1980*, ed. Michael Bishop and Christopher Elson (Amsterdam and New York: Rodopi, 2005), 127–28.

27. Hans Belting's monumental *Likeness and Presence: A History of the Image before the Era of Art*, trans. Edmund Jephcott (Chicago: University of Chicago Press, 1994), remains the foundational work on this subject.

28. Cornelia A. Tsakiridou, "*Vera Icona*: Reflections on the Mystical Aesthetics of Jacques Maritain and the Byzantine Icon," in Bishop and Elson, *L'art Français et Francophone depuis 1980*, 224–46.

These are the qualities that make Rouault's work transfigurative,[29] not in the sense that all his darkness (so essential to his truthfulness) gives way in the end to light, but transfigurative in that the truths of existence, our own and those experienced by Jesus, are allowed to find their ultimate meaning in transcendent Truth.

MARC CHAGALL (1887–1985)

To place the art of Marc Chagall in the context of a discussion of modern religious painting is natural; to place him in the context of a re-crudescence of iconic painting may seem at first blush an error. From early in his career, Chagall's art has been regarded ambivalently by religious critics. Those viewing his work from within an orthodox religious perspective, be it Jewish or Christian, have been acutely aware that he paints askance to either tradition's normative worldview. It is easy to imagine how the scruples of his former Hasidic community might have been troubled by Chagall's early drawings, by which, in Hasidic eyes, as François Le Targat puts it, "he transgressed the Law by drawing human characters and animals, to the great displeasure of certain members of his family."[30] Le Targat cites in support of this observation the second of the Ten Commandments as it is repeated in Deuteronomy (4:15–18). In choosing to draw attention to the proscription in Deuteronomy rather than to the initial Torah text in Exodus (20:4), Le Targat was thinking, doubtless, that Chagall's primary symbols in his painting seem almost willfully to be drawn from the specific examples proscribed in that portion of the Book of the Law—animals, birds, fish, the sun, and anything that suggests the divine likeness in human form. Accordingly, despite his evident admiration for Chagall's artistic genius, the painter's apparently deliberate defiance of a law conventionally observed in his Hasidic community leads Le Targat, as it has led others, to conclude that "Chagall, accordingly, was certainly a Russian painter, but certainly not a Jewish painter, strictly speaking."[31]

This view, especially acerbic in regard to Chagall's use of the crucifixion as a recurrent symbol, is hardly singular. It was reiterated with vehemence in Yiddish periodicals and echoed in a way that is more readily

29. Jacques Maritain, *Georges Rouault* (New York: Abrams, 1954), 21–22.
30. François Le Targat, *Marc Chagall* (New York: Rizzoli International, 1985), 7.
31. Le Targat, *Marc Chagall*, 17.

accessible to non-Jewish readers in the English language novel by Chaim Potok, *My Name Is Asher Lev*.[32] Potok in that novel clearly intends to invite a nuanced comparison between his protagonist Asher Lev and Chagall, yet responses to both the actual and the fictional artist from Hasidic and Orthodox critics have been understandably negative. There is a camp that sees Potok as similar to Chagall, as an apostate and betrayer of his tradition. Sanford Pinsker refers to "misguided 'universalists' who try to make music by puffing on the shofar's wide end,"[33] while Cynthia Ozick declares a kind of anathema against artists such as Potok and Chagall, insisting that "nothing thought or written in Diaspora has been able to last unless it has been centrally Jewish."[34] Potok was both a Conservative rabbi and editor in chief of the Jewish Publication Society at the time he was writing *Asher Lev*, and this made his offense seem all the more outrageous to the offended. But he was also a painter who, in a manner reminiscent of Chagall, painted *Brooklyn Crucifixion*. The religious opprobrium occasioned by the artistic success of both men, each to some degree representative of Jewish tradition, is that they came to be regarded by their religious communities as what Daniel Walden calls "Zwischenmenschen," compromisers adrift in a sea of undifferentiated cultures.[35]

In the last two decades a more sympathetic understanding has emerged, namely, that Chagall (more than Potok) was in fact reappropriating the central Christian symbol of the crucified Savior to the site of its historic foreshadowing in Jewish experience, in particular to a conception of the whole Jewish people as Isaiah's Suffering Servant.[36] This is a more insightful approach. Chagall in effect reverses the polarity of type and antetype as developed in Christian tradition, achieving thereby a pointed critique of cultural Christianity by means of his typological reversal. But as will become evident, Chagall intends more than critique. In his painting we can discern a developing synthesis of symbolic meaning that seeks to

32. Chaim Potok, *My Name Is Asher Lev* (New York: Knopf, 1972).

33. Sanford Pinsker, "The Crucifixion of Chaim Potok/the Excommunication of Asher Lev: Art and the Hasidic World," *Studies in American Jewish Literature* 4 (1985): 39–51, 45.

34. Cynthia Ozick, "Toward a New Yiddish," in *Art and Ardor* (New York: Knopf, 1983), 171.

35. Daniel Walden, "Chaim Potok: A Zwischenmensch ('Between Person') Adrift in the Cultures," *Studies in American Jewish Culture* 2, no. 4 (1985), 19–25; cf. n. 51 below.

36. See Benjamin Harshav, *Marc Chagall and the Lost Jewish World: The Nature of Chagall's Art and Iconography* (New York: Rizzoli International, 2006), 62, 86; cf. Sylvie Forrestier, *Résistance, résurrection et libération de Marc Chagall* (Rennes: Editions Ouest-France, 1990).

violate neither tradition, but rather, in dark times, seeks to achieve an integrative reclamation of both Jewish and Christian sources of consolation. His work thereby challenges reflexive prejudices on both sides, revealing in Chagall a high spiritual idealism, one transcending conventional religious behavior as he finds it in the world, but necessitating a more detailed explanation than his Christian compatriots in this chapter.

Chagall is hardly the first artist to borrow iconography from another religious tradition; as we have seen, Christian artists have been doing it for two thousand years. It will be obvious that Christian iconography from earliest times has depended on narrative figures and symbols from the Hebrew Bible (Old Testament), adapting them to Christian exegesis and liturgy. The story of Jonah is one well-known source of typological significance, appearing on Roman Christian sarcophagi of the third century in a liberal application of a saying of Jesus about "the sign of Jonah" (Matt. 12:39–40);[37] the use of Joshua as a prefiguration of Jesus is another example.[38] Representations of Moses as typological precursor to Christ are ubiquitous in the first four Christian centuries, largely but not exclusively because of the consistency with which analogies are established in the Gospels themselves (e.g., Matt. 5–7; John 3:14; etc.). These and other biblical stories (e.g., David, Daniel) have subsequently been among the primary building blocks of western European iconography. What we are looking at in Chagall, while unusual for a Jewish artist, is not unique to Chagall. Nearly two millennia beyond the catacombs, in Jewish art and literature of the twentieth century, especially among the Yiddish speakers in central Europe, Lithuania, and Poland between the great wars, there began to appear ingenious adaptations of iconic Christian subjects and images, innovatively challenging conventional expectations. Christian symbols, especially the figure of Jesus himself, were taken up by numerous Jewish writers and painters in such a way as to recollect for Christian symbol and iconography more generally their origin in an essentially Jewish experience. In this respect the recent history of European art reveals an influence of biblical tradition that has come at last full circle. No one better exemplifies this return than Chagall, whether subtly and poetically, as in his *Solitude* (1933), or more overtly and dramatically, as in the *Yellow Crucifixion* (1942) and *Exodus* (1952–1966). These developments culminate

37. Robin M. Jensen, "Early Christian Images and Exegesis," in *Picturing the Bible: The Earliest Christian Art*, ed. Jeffrey Spier (New Haven and London: Yale University Press, 2008), 70–72; see chap. 1 above for an immediate example.

38. Herbert Kessler, "Bright Gardens of Paradise," in Spier, *Picturing the Bible*, 123–24.

in a paradigmatic iconic image by Chagall, his Akedah lithographs of the post–World War II period.

Jewish critics and scholars were understandably the first to see evidences of the biblical synthesis emerging in Chagall's work such as makes him central to the present study. To take a pertinent example, in her thoughtful and learned article "Marc Chagall's Portrayal of the Prophet Jeremiah,"[39] Mira Friedman argues that in responding to the theme of Jeremiah weeping over the destruction of Jerusalem and the temple, Chagall drew not only on passages from the liturgy (for 9th Av) of the *Siddur* but apparently also on Rembrandt's treatment of the same theme,[40] and as well, perhaps, on Geertgen tot Sint Jans's *John the Baptist in the Wilderness*.[41] Common to all three visual representations is a hunched-over figure, hand under the chin; in the latter case there is also a resting lamb with crossed forelegs, symbolic by the fifteenth century of Jesus as the "lamb of God." Among other conclusions, Friedman is led to suggest that the painting typically referred to as *Solitude* (fig. 119) should be associated with the passage in the Lamentations of Jeremiah that begins, "O how solitary sits the city that once was filled with people!" (Lam. 1:1). Friedman's insights are fruitful, but additional biblical allusions and borrowings from Christian folk art can further enrich our understanding of Chagall's important painting. *Solitude* functions both as visual exegesis of Jewish Scripture and as a reappropriation of a specifically Christian symbol to a Jewish understanding in a way that sets the pattern for much of his later work.

If we assume that the seated figure represents Jeremiah, then we must acknowledge that here he is cloaked with a *tallit* (prayer shawl) such as might be worn by an orthodox Jew of the modern era while in prayer, and that he is cradling a Torah scroll. These elements are in fact oblique to the Jeremiah connection; while they do not invalidate the allusion Friedman suggests, they introduce not the lamentation of a prophet, but cherishing of Torah and meditation as defining aspects of Jewish spiritual life. There

39. Mira Friedman, "Marc Chagall's Portrayal of the Prophet Jeremiah," *Zeitschrift für Kunstgeschichte* 47, no. 3 (1984): 374–91.

40. In Rembrandt's *The Prophet Jeremiah Lamenting the Destruction of Jerusalem* (1630), found in the Rijksmuseum, Amsterdam. Friedman notes that this painting was at one time in the Stroganoff collection in Saint Petersburg, then moved temporarily to Paris, and conjectures that Chagall may have seen the original ("Marc Chagall's Portrayal," 387).

41. This painting is in the Gemaldegalerie, Staatliche Museen Preussicher Kulturbesitz in Berlin. Friedman notes that Chagall saw it both before World War I and afterward, in 1922–1923, on his visits to Berlin ("Marc Chagall's Portrayal," 388).

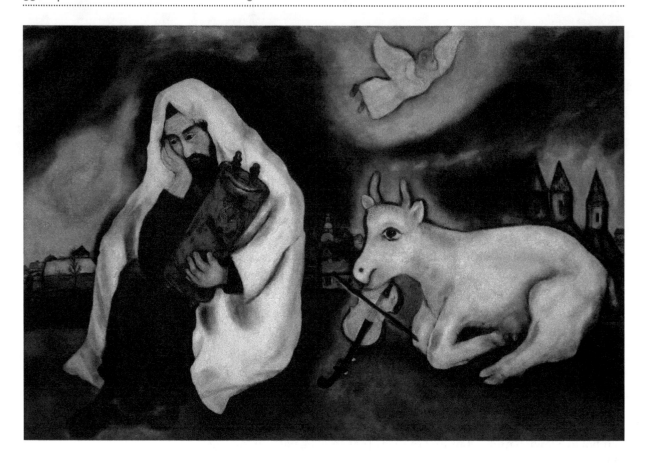

Figure 119. Marc Chagall, *Solitude*, 1933

are, of course, other prominent elements in the composition. The white heifer appears frequently in Chagall, but here she is lying down peacefully, apparently smiling at the man of prayer, perhaps a rabbi. Here a little Hebrew helps. A cow chewing its cud has in biblical Hebrew an evocative sense (found also in English), where someone can be said to "ruminate" on something that requires reflective thought. Thus the verb *hagah*, "to meditate," means also "to chew the cud"; it appears with a clear spiritual referent when the Lord says to Joshua: "This *sefer torah* shall not depart from your mouth, but you shall meditate (*hagah*) on it day and night, that you may observe to do all that is written in it" (Josh. 1:8). In Chagall's etchings on the Bible, done also for Vollard but shortly after Rouault's *Miserere* series (mostly between 1931 and 1937; finished 1952–1956), one of the most striking of Chagall's images captures this motif of ingesting the Word by depicting the command of the Lord to Ezekiel to "eat this scroll" (Ezek. 3:1–2). Fittingly, this is the image that concludes his *Bible* series (fig. 120).

The verbal icon is pervasive. Liturgically, Psalm 1:2 echoes the injunc-

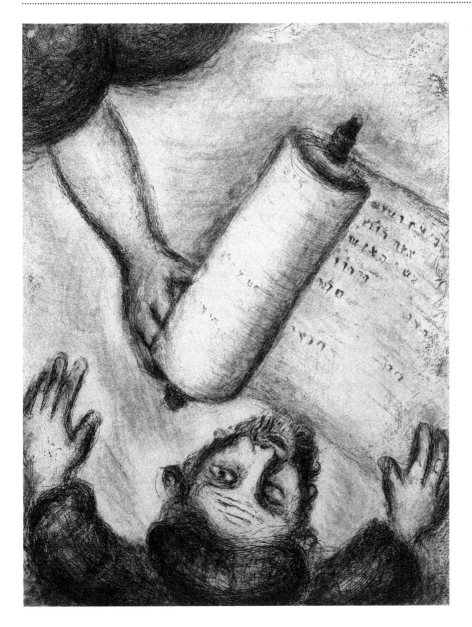

Figure 120. Marc Chagall,
The Calling of Ezekiel,
1952–1956

tion to "chew over" the lessons of Torah; by analogy with the peaceable heifer, a spiritually flourishing person is said to be one who meditates on the Word of God, day and night, when he lies down and when he rises up (Deut. 6:7). In fact, for a religious Jew after the Diaspora, the scrupulous reverence accorded the Torah scroll reflects a distant memory of reverent proximity to the presence of the Holy in the temple long ago. The association is not talismanic; it implies a cultivated, meditative, and worshipful

absorption in the content of Torah. Such *hagah* meditation corresponds closely to meditation prompted by an image in medieval Christian tradition, in which the image invites entrance meditatively into the presence of the Holy. Much earlier than has been supposed, the image had a similar function in the synagogue.[42]

That members of the Hasidic Jewish community were, as Raïssa Maritain puts it, inclined largely to ignore the secular world and to be "bathed each day in the living waters of the Scriptures" is well known; that the range of their response to Scripture extended into the arts has received less attention.[43] Beside the unblemished heifer, between it and the meditating lover of Torah, is a violin. Friedman suggests that the animal is playing it.[44] Even if not, we recognize that the violin is preeminent among the instruments of Yiddishkeit music, not excluding music in the Hasidic community in which Chagall was raised. Violins are found everywhere in Chagall's paintings, variously suggesting both joy and sorrow, new celebration and old memories. As the Broadway musical *Fiddler on the Roof* taught a wider American culture, for a Hasidic Jew, one of the ways in which meditation deepens and becomes articulate in other registers of the religious life is through the responsive meditation afforded by music. In a lesser but not insignificant way then, the violin is also iconographic, part of the language that points to the life of faith and worship.

It seems then that in this painting Chagall juxtaposes Torah and meditation, implying that meditation may be occasioned not only in one who reads and prays, but also in the imaginative reflection of an artist in whom the biblical grand narrative or story of the covenant is foundational memory. In this light his painting looks a little different: the city that "sat solitary" seems only to be sleeping; the meditation on Torah, in chiaroscuro here suggesting "by day and night," calls to mind the relationship between faithfulness to the covenant (*b'rith*) and the promised blessing of God (Ps. 1:2). Though the "city" is in fact recognizable as Vitebsk in which Chagall grew up, the guardian angel (*'ir re'em*) hovering over it seems to suggest that in virtue of faithful meditation on Torah this city is not desolated (no scenes of destruction such as are so evident in other paintings) but is somehow, at least for a season, protected. It is not too much of a stretch, I think, to recognize in this lovely work a kind of *hagah* meditation by

42. Ariel Sabar, "Unearthing the World of Jesus," *Smithsonian Magazine*, January 2016, http://www.smithsonianmag.com/history/unearthing-world-jesus-180957515/.

43. Raïssa Maritain, *Marc Chagall* (New York: Éditions de la Maison Française, 1943), 17–18.

44. Friedman, "Marc Chagall's Portrayal," 385–86.

the artist on Psalm 1:2. Yet this is a meditation in which, under the *tallit* and *tefillin* of the rabbi, not only a sorrowing Jeremiah but also another pensive and burdened figure seems to be contemplated.

One would need some familiarity with the Christian folk culture of Polish Lithuania (now Belarus), near Vitebsk, to recognize the other source for Chagall's iconography. All over Poland and Polish Lithuania one finds roadside folk sculptures bearing an uncanny resemblance to the meditating figure in this painting. These are known as *Chrystus frasobliwy*, "the pondering Christ," or "sorrowful Christ." Sometimes roughly carved in wood, sometimes in stone, the image typically represents the Christ, not so much of the passion itself, but earlier and eternally, in contemplation weighed down by his care for sinful humanity (figs. 121 and 122).[45]

Chagall would have seen many of these folk sculptures as a young man; they are ubiquitous. In this light, the figure of the pensive Jew is likely to be more immediately influenced by folk-art analogy than by the great paintings of Jeremiah and John the Baptist he was to see only in later life, and this probability lends a double resonance to *Solitude*, in which the faithfully meditating Jew evokes a burden that is not his alone, but also that of another Jew, concerned over the impending fate of the city.[46] Yet it is important to note that framing this image of burdened reflection in *Solitude* are other, more tranquil elements; there is also an aura of blessing. The city sleeps, the spotless heifer smiles.

Chagall's painting, which he donated to the Tel Aviv Museum of Art in 1951, may have an interesting echo in a poem by his younger contemporary Roman Brandstaetter (1906–1987), a Polish Jew and grandson of the eminent rabbi Mordechai David Brandstaetter. Whether the poet ever saw Chagall's work or a reproduction of it we do not know.[47] What we can be sure of is that he, like Chagall, would have encountered scattered around the countryside numerous examples of the *Chrystus frasobliwy* wayside

45. I am indebted to my colleague, philosopher Alexander Pruss, for pointing me to the widespread occurrence of these folk sculptures, and also to the writings of Roman Brandstaetter cited below.

46. This somatic form seems to be echoed again by Chagall in figure 90 of the *Bible* etchings, *Prophecy over Jerusalem*, executed about 1953, in which Isaiah is shown having his vision of Israel's redemption, while crowds rejoice below his hill and an angel aloft bears up an open Torah scroll. But cf. Luke 19:41.

47. Brandstaetter was, however, a man of enormous cultural erudition and interest in the arts. See Anna Rzymska, *Kamienny most: Tradycja judaistyczna w twórczosci Romana Brandstaettera* (Warsaw: Olsztyn, 2005). One of Brandstaetter's volumes of poetry, *Jerozolima swiatla i mroku* (Jerusalem of light and darkness) (1935), bears some thematic resemblances to Chagall's interwar painting.

Figures 121 and 122.
Chrystus frasobliwy wayside
sculptures

sculpture. This image may also thus be behind his poem entitled "Such Was Your Crucifixion, God" (1960). Brandstaetter had converted to Christianity during the last year of World War II, reportedly while spending the night alone with a photograph of a crucifixion painting in the Polish telegraph office in Jerusalem.[48] Here, in this poem, his persona imagines himself needing forgiveness for sin he has not actually committed. Though "born two thousand years later," he writes in his confession, "had I lived in your time, Jerusalem, / Certainly I would have called: / 'Your blood be on us, and on our sons.'" The probability of his sin, had he been there to commit it, torments him, and he imagines himself as one going home from the crucifixion scene, anticlimactically and meditatively, as

48. His account of this is as follows: "pojrzałem na reprodukcję. Wyobrażała Chrystusa w chwilę po Jego śmierci. Z półrozchylonych warg uszedł ostatni oddech. Kolczasta korona spoczywała na Jego głowie jak gniazdo uwite z cierni. Miał oczy zamknięte, ale widział. Głowa Jego wprawdzie opadła bezsilnie ku prawemu ramieniu, ale na twarzy malowało się skupione zasłuchanie we wszystko, co się wokół działo. Ten martwy Chrystus żył. Pomyślałem: Bóg." (I looked at the reproduction. It imaged Christ a moment after His death. From half opened lips the last breath had gone forth. The spiked crown lay on His head like a nest woven from thorns. His eyes were closed, but [He] saw. Although His head fell without strength to his right shoulder, on His face there appeared [lit. was painting itself] concentration, listening to everything happening around. This dead Christ lived. I thought: God.) http://www.olsztyn.luteranie.pl/pl/tekst5-nbprlic-6.htm.

. . . a small man, a bit of a coward,
A bit of an egoist, a bit of a mocking blackguard
Who prefers to dwell among calves,
Chewing on empty desert
Rather than die for a lonely truth.[49]

The genre of this poem, from a Christian point of view, is recognizable from the thousands of similar poems from all over Europe, east and west, over the centuries—it is a meditation on the crucifixion designed to provoke in its reader an examination of conscience. The image of the burdened persona in this poem, now obliged to see himself in the light of the Suffering One who died, has striking parallels to the *Chrystus frasobliwy* as Brandstaetter would likewise have encountered it—not only in the folk sculptures, but possibly also in Chagall's painting. His "calves" are an obvious parallel to Chagall's heifer, a symbolic reference to withdrawal and meditation. The Polish word for "desert," *pustynia*, comes from the radical *pusty*, which means "empty, abandoned, solitary."[50] In Brandstaetter's poem, meditation on the cross and on the burden of one's sins is coincident with meditation on the Suffering Servant who not only lamented the sins of the world, but also bore the burden of them in himself—a response clearly invited by the folk sculptures, which are often found at crossroads, in churchyards, and especially at the gates to cemeteries. It is clear that neither Chagall the irregular Jew nor Brandstaetter the Jewish-Christian convert[51] ever gave up on his deep affection for Jewishness; in this kind of borrowing they were connected to a much

49. *Piesn a moim Chrystusie* (Song about my Christ) (Warsaw: St. Wojciech, 1964); cf. his *Slowo nad slowami* (The Word above words) (Warsaw: St. Wojciech, 1964). I am indebted to my colleague Alexander Pruss for his translation of this poem. (It is most unfortunate that there are not yet available English translations of Brandstaetter's work.) I would note that another biblical reference, namely, Isa. 27:10, may lie behind Brandstaetter's and Chagall's images—in which case the sleeping city would be far from invulnerable.

50. In Russian, a *poustinia* is a small shelter in the wilderness where one goes to meditate; many of the Polish and Lithuanian *Chrystus frasobliwy* figures are represented under the roof of a small hut, others as alone in a wilderness setting.

51. Whether or not Brandstaetter was thinking of Chagall's *Solitude* when he wrote this poem, there is evidence to suggest Chagall's influence (or something very like it) at several points in Brandstaetter's *Jezus z Nazaretu* (1967–1973). In this novel, as also in his *Krag biblijny* (Bible study group) (1975), Brandstaetter brings together Jewish and Christian experience, symbols, and iconography in ways that parallel Chagall. That Brandstaetter, even and perhaps especially after his conversion, did not abandon his Jewish identity is a point stressed in all the biographical accounts.

larger movement in contemporary Yiddish-speaking Jewry, one which in revolutionary fashion sought to reappropriate Jesus to Judaism, to see him as a Jew among Jews.

THE JEWISH JESUS

Most theologically literate Christians are familiar with the traditional typological reading by which the Akedah, the binding for sacrifice of Isaac, becomes a prefiguration for the crucifixion of Jesus. For Jews, however, this traumatic event has repeated itself recurrently through history without the last-minute rescue, and at no time more obviously than during World War II and the Holocaust. Mordechai Ardon, Maryan S. Maryan, Leonard Baskin, Ben Shahn, and Marc Chagall are among the artists who make this connection in a Jewish way. But earlier artists used the crucifixion to represent archetypal Jewish suffering. Following Mark Antokolsky's *Ecco Homo* (1873), in which Christ appears with a Jewish face, wearing a *kippa* and *peyot* (sidecurls), artists of the early twentieth century began reclaiming the most prominent historical symbol of Christendom as a symbol of tortured and murdered Jews; the list includes Jakob Steinhardt, Abraham Rattner, Naftali Bezem, Graham Sutherland, Otto Pankok, Mordecai Moreh, Ernst Fuchs, Mauricio Lasansky, and preeminently, Marc Chagall. In the most accessible study of the American version of this phenomenon, Matthew Hoffman argues that "For many Jewish writers and artists, the Jewish Jesus they created was a weapon against Christian anti-Semitism . . . [and] served as a polemical thrust against Western Christian culture by depicting Jesus as an inherently Jewish cultural symbol, and the Jews as the quintessential Christ-like victims of Christian violence and persecution."[52] Well before World War II, Hoffman shows, there was intense debate among Jewish intellectuals of

52. Matthew Hoffman, *From Rebel to Rabbi: Reclaiming Jesus and the Making of Modern Jewish Culture* (Stanford: Stanford University Press, 2007), 9. Hoffman's argument in this respect parallels that of Ziva Amishai-Maisels in "Marc Chagall's 'Dedicated to Christ': Sources and Meanings," *Journal of Jewish Art* 21–22 (1995–1996): 68–94, in which she argues that in his early (1908–1912) use of crucifixion images Chagall is deliberately combating anti-Semitic propaganda by turning anti-Semitic symbols into philo-Semitic ones. For a discussion of Antokolsky's "Christ," see also her "The Jewish Jesus," *Journal of Jewish Art* 9 (1982): 92–96. This is quite different from the way Chaim Potok uses the crucifixion in *My Name Is Asher Lev* (1972), though the tensions are much the same. Potok's novel is set in New York in the 1940s.

eastern European extraction on this account. When in 1909 the New York Yiddish periodical *Dos naye lebn* (The new life) published stories with central images of the cross and Jesus by Lamed Shapiro ("Der tseylem" [The Cross]) and Sholem Asch ("In a karnival nakht"), the debate over *di tseylem frage* (the crucifix question) erupted on this continent as well. These two stories diverged representatively on the question: Shapiro's gruesome tale offers no hope of Jewish/Christian reconciliation, but the story by Asch presents a Jewish Jesus empathetic with the suffering of his fellow Jews. Considerable detail on the American version of the controversy is provided by Hoffman. But essentially the same debate has been carried on more subtly (though more voluminously) elsewhere, as in the pages of *Opinia*, a Polish intellectual journal that began publishing in 1933, and positions were staked out in stories and essays by Sholem Asch, Sholem Aleichem, Y. L. Peretz, as well as Roman Brandstaetter.[53] Asch, by this point, had attracted the interest and support of Chaim Zhitlovsky and others, some of whom took a still more radical view; in their polemic it was obviously European Christian culture that embodied the real misunderstanding of Jesus.[54]

The case was not flimsy. With more immediate empirical evidence of un-Christlike "Christian" behavior close to hand, the dissonant view was shared by the interwar Polish poets known as the Yung-Yiddish movement, who also turned from traditional Jewish motifs (e.g., of the "golem") in the direction of a more radical contradiction—Christ on the cross.[55] Jesus becomes the paradigmatic Jewish martyr; in one example, Asch's story "Kristos in geto" (1943) presents the eternal Jesus as a martyred Hasidic rabbi, who comes to life after being shot in the Warsaw ghetto, identifies with his fellow Jews, and seeks to bring about a reconciliation with their Polish neighbors and adversaries.

Marc Chagall was attuned to these revolutionary ideas in their European context, yet, as one of his own poems in Yiddish (1938) suggests, his artistic identification with Jesus's passion was to some degree already personal:

53. See Eugenia Prokop-Janiec, *Polish-Jewish Literature in the Interwar Years*, trans. Abe Shenitzer (Syracuse, NY: Syracuse University Press, 2004), especially 22–41. (In Brandstaetter's case, this was of course before his spiritual experience in Jerusalem and subsequent baptism in Rome.)

54. Hoffman, *From Rebel to Rabbi*, 88–89, 125–28.

55. Seth Wolitz, "*Die Khalyastre*, the Yiddish Modernist Movement in Poland: An Overview," *Yiddish* 4, no. 3 (1981): 10.

I carry my cross every day,
I am led by the hand and driven on,
Night darkens around me.
Have you abandoned me, my God? Why?[56]

Chagall's biblical knowledge is here revealed to include both Hebrew (Ps. 22) and Christian Scriptures (Luke 9:23), and the force of the combined allusions suggests that for Chagall Jesus was metonymic, plausibly the exemplary Suffering Servant whose example he felt called to follow as an artist. Chagall's famous painting *White Crucifixion* of that same year (1938) is generally regarded as a representation of Jesus on the cross, loins draped in a *tallit*, the image of what Hoffman calls "a quintessentially Jewish martyr,"[57] or, as his friend Raïssa Maritain in her poetic encomium on his art puts it, he shows us "Christ étendu à traverse le monde perdu."[58] Like her family friend Chagall, Raïssa Maritain was raised in a Polish-Lithuanian Hasidic community; unlike him, she converted to Christianity—at the same time as her husband, Jacques Maritain (1906). Her own newly embraced Catholic perspective may possibly be thought to overdetermine her understanding of Chagall, but that she retained close friendship with him through his life suggests otherwise. Taken together, the "Mayne trern" poem and *White Crucifixion* show Chagall wrestling with the artistic question of what to depict—the desolation and suffering

56. Marc Chagall, "Mayne trern," in *Di goldene Keyt* (1967); this poem is all the more powerful when we remember his childhood prayer to God on the Day of Atonement as recorded in *Ma Vie*—"Take me, make me nearer to you! Say something! Explain . . . hide me in the altar with the Torah." *Ma Vie* (Paris: Jean Dejarnac, 1957), 38.

57. Hoffman, *From Rebel to Rabbi*, 220. Chagall may have borrowed this idea from Uri-Zvi Grinberg's Yiddish poem "Uri-Zvi before the Cross"; see Benjamin Harshav, *Marc Chagall and His Times: A Documentary Narrative* (Stanford: Stanford University Press, 2004), 479. At this point his intention with regard to the image of the crucifixion was almost certainly consistent with his earlier defense against the charge that he had betrayed his Jewish heritage: "Moim Bogiem jest żydowski Bóg, moją świętą księgą jest Biblia. Bóg naszych Ojców! W mojej fantazji 'Chrystus' jest wyłącznie naszym żydowskim męczennikiem, wraz ze swoją żydowską matką, otoczony żydowskimi prorokami. Mój Chrystus, jak Go namalowałem, jest zawsze typem żydowskiego męczennika w czasie pogromów i innych naszych trosk. Wierzę, że świat mnie rozumie." (My God is the Jewish God, my holy book is the Bible. God of our Fathers! In my fantasy [or, imagination] "Christ" is exclusively our Jewish martyr, together with his Jewish mother, surrounded by Jewish prophets. My Christ, as I have painted Him, is always a type of the Jewish martyr in the time of pogroms and other worries of ours. I trust that the world understands me.) http://www.olsztyn.luteranie.pl/pl/tekst5-nbprlic-7.htm.

58. Raïssa Maritain, *Marc Chagall*, 28.

of "cities that burn, brothers who flee," or something else that was "in his heart."[59] We might put that burden as a question: In what sense is Christ himself—as distinct from the misprisions of those who claim Christianity—not so much the enemy as an epitome of Jewish identity? In that regard, when he and his wife Bella arrived as exiles in New York, despite his distaste for what he took to be Sholem Asch's self-promoting attempt to present Christ in a "goyisch" humanistic manner in *The Nazarene* (1939),[60] Chagall would not likely have found Asch's short story "Kristos in geto"—published in New York in 1943—an entirely alien vision. With nuances (see also, e.g., his painting *Martyr* [1940]), he could almost have written such a tale himself.

A survey of the criticism and general studies will reveal that Chagall's *White Crucifixion* (1938), declared by Pope Francis to be his favorite painting, has attracted considerable commentary, both positive and negative,[61] but that his *Yellow Crucifixion* (1942) has garnered almost nothing by comparison. It will be apparent that it represents something more complex and even, especially from the Jewish perspective, more disturbing than its predecessor (fig. 123).

In a preliminary sketch for *The Yellow Crucifixion*, begun in Europe and then developed in New York,[62] there are clear allusions to the Akedah motif, the preparation of Isaac as a sacrifice. This too, of course, is a motif borrowed by early Christian artists as a type for the crucifixion.[63] One of these allusions is a hand holding a knife superimposed on the open Torah scroll; in another there is a ram hanging from the cross and a man and a boy beside it. These original elements, however, are suppressed in the final painting. Structurally, moreover, the finished painting is distinctive: rather than using the crucifixion to focus the viewer's gaze and to order proportionally the other elements of the canvas, Chagall presents a strikingly balanced double subject. The cross is moved to the

59. Chagall, "Mayne trern," 96.

60. Chagall had read *The Nazarene* by 1940, as the letter cited by Harshav (*Marc Chagall and His Times*, 479) shows. Up to that time, like most Polish-Lithuanian and Russian Jews, he had liked Asch's work. Asch's new novel entered a territory politically unsavory to Chagall, whose Jewish loyalties are sharper even as his interest in "the Christ he exhibited" (letter to Opatoshu of April 18, 1940) is more deeply spiritual.

61. E.g., David Lyle Jeffrey, "The Christ of Marc Chagall," *First Things* (April 2014): 26–30; translated into Russian in *Artos* (Moscow, 2016): 88–95.

62. This work has been displayed also by the Pompidou Center in Paris and the Museum of Art in Chicago.

63. See, e.g., Jensen, in Spier, *Picturing the Bible*, 10–11; cf. Morgan Meis, "Context and Crucifixes," *Smart Set*, September 30, 2013, http://thesmartset.com/article09301301/.

Figure 123. Marc Chagall,
The Yellow Crucifixion, 1942

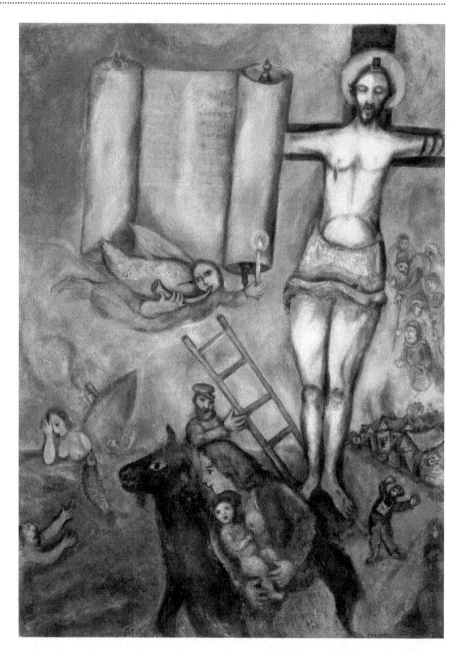

right, while next to the crucified figure at the same height is a huge open Torah scroll on which no words or images are visible, but under which a flying angel blows a shofar. The angel also holds a candle, which illuminates the body of a crucified Jew in a simple loincloth (no *tallit*), who has both Jewish phylacteries and a Christian nimbus, signifying holiness and fulfillment of the Torah, and yet also the presence of the Spirit and

the Word. Below and around are the evidences of destruction of a village by fire on the right, of fleeing exiles as a boat sinks at sea on the left, probably a reference to the sinking of the *Struma* in 1942 with 750 Jewish exiles lost. As a man on the right raises his arms in anguished outcry, a Jewish peasant raises a ladder toward the martyr on the cross—a familiar motif in Chagall, suggesting both the deposition of the victim and the inevitable confluence of the "way up" and the "way down." Perhaps, as Raïssa Maritain suggests in her comments on the crucifixion-motif paintings that anticipate it, the use of the ladder in these paintings refers less to Jacob's ladder than it reflects traditional Christian renderings of the "descent from the cross."[64]

If we allow ourselves to ask simple questions of the most basic elements in this iconography, we will be led to see that in some sense this is also a painting about the concept of atonement. This theme is anticipated in Chagall's earlier crucifixions, even in such small details as in the image of the cock, a bird that is sacrificed ritually as part of the purification ceremony preceding Yom Kippur; we see it in paintings such as *Martyr* (1940); *Obsession* (1943), in which the cock is reading from a s*iddur*; and *Descent*, in which the man who is lowering the body of the Crucified on the ladder has the head of a cock. But the shofar is another clue, one that suggests a specific liturgical as well as biblical context: "On the Day of Atonement you shall make the shofar to sound throughout your land," said Moses, "and [you shall] proclaim liberty throughout all the land to all its inhabitants" (Lev. 25:9–10). This passage in Torah is a reference to the Year of Jubilee, the Great Atonement, when for all who have been oppressed there is to be liberty. Moreover, on that great day, what has once been theirs is to be returned to them.

That the traditional Jewish day of repentance and forgiveness should be connected by the painter in this way to a wider and contemporary framework, so obviously at once to the Holocaust and to the Crucified, makes sense only in a context where the Christian theological concept of the atonement, the universal sacrifice and its proclamation of "liberty to captives," is being juxtaposed with its Jewish prototype, then deliberately brought into focus as *one* story—making the heart of the Christian gospel to be seen as at one with Torah and its hope for fulfillment. Here, in a

64. Raïssa Maritain, *Marc Chagall*, 30; in her *Marc Chagall ou l'orage enchanté* (Geneva and Paris: Éditions des Trois Collines, 1948), a slight expansion of the first volume with more illustrations of works by Chagall as well as some of Chagall's poems and some of her own, she comments that *The White Crucifixion* radiates a terrible beauty distinctive in Chagall's oeuvre.

most striking way, the biblical Yom Kippur and Golgotha, the Akedah and the cross, are paired. The juxtaposition of the black goat and the fleeing mother and suckling child in the bottom foreground lends to the visual confluence an additional apocalyptic overtone (cf. Matt. 24–25) that must have seemed altogether appropriate in 1943.

Why does Chagall balance so precisely the shofar-proclaimed Torah with the crucifixion? Why does he have the same angel who blows the shofar and bears up the Torah illumine the Crucified with his candle? These are gestures so deliberate as to deepen, rather than merely depend upon, the broad movement for a Jewish reclamation of Jesus of which he was a part. Here, I suggest, we can see Chagall not merely reclaiming, but crying out that whatever the sins of the people, surely they have been atoned for; his painting is a prophetic cry not unlike that of Isaiah (chaps. 40–43), an appeal for the *teudah* voice of consolation to Jerusalem that "her warfare is ended" (Isa. 40:2).

The Yellow Crucifixion is thus more than a reclamation of the Jewishness of Jesus; it is in fact a recognition of the continuity and confluence of Jewish and Christian history. Accordingly, Chagall's juxtaposition in this work can be viewed as a calculus for integration, an invitation to meditate collaboratively on the concept of atonement. Given Chagall's affection for the Hebrew Bible and his personal interest in Jesus (to whom he invariably refers in his letters as "my Christ"), we may reasonably imagine that he understood the Suffering Servant as portrayed by Isaiah (Isa. 52:13–53:12) to be intended to apply to both the Jews collectively and to Jesus representatively. This conjunction is, of course, itself biblical; for one who, like Chagall, came to the Gospel narratives from a rich training in the Hebrew Bible as a youth,[65] it might well seem unsurprising that Jesus would begin his ministry at a Nazareth synagogue by reading the *haftarah* passage from Isaiah 61:

65. Benjamin Harshav, in his *Marc Chagall and the Lost Jewish World: The Nature of Chagall's Art and Iconography* (New York: Rizzoli International, 2006), gives a good sense of his Hasidic culture and upbringing, yet he overlooks Chagall's own emphasis on the role of the Bible in shaping his imagination (16–18). Chagall has said that the rabbi to whom he was sent on Sabbath afternoons for instruction in the Bible had the greatest influence upon him of anyone (*Ma Vie*, 44, quoted in Jean Bloch Rosenaft, *Chagall and the Bible* [New York: Jewish Museum, Universe Books, 1987], 13). From 1932, when he visited Holland to study the works of Rembrandt, through to the early war years, when he was playing his part in the Yiddish artistic reexamination of Jesus, it is clear that he acquainted himself also with the New Testament to some degree, largely in the 1644 Geneva Bible.

> The Spirit of the Lord GOD is upon me,
> because the LORD has anointed me
> to preach good tidings to the poor.
> He has sent me to heal the brokenhearted,
> to proclaim liberty to captives,
> and the opening of the prison to those who are bound;
> to proclaim the acceptable year of the LORD,
> and the day of vengeance of our God,
> to comfort all those who mourn,
> to console those who mourn in Zion,
> to give them beauty for ashes, the oil of joy for mourning.
>
> (Isa. 61:1–3; cf. Luke 4:18–19)

The proclamation of the Jubilee ("the acceptable year of the LORD") in this eschatological sense implies the cessation of horrors: Who could not then have wished for such a shofar to sound?

Sadly, the present war was to drag on, his beloved Bella was to die because of misdiagnosis in a small hospital in upstate New York, and only later were the full horrors of the Holocaust to be revealed. Chagall would return to Europe in 1948, finish his marvelous etchings for the *Bible* series that he had begun for Vollard,[66] and so begin again to bring back beauty, beauty from ashes. But his synthetic icons continued to be a major part of his work; his *Exodus* (1952–1966) is a striking juxtaposition of the liberation from Egypt and the icon of Christ as Redeemer (fig. 124), simultaneously symbolizing the *aliyah* of many European Jews to the Jewish homeland now known again as Israel.

Perhaps Chagall's most compelling synthesis, however, is his rendition of the most iconic Jewish story of all, in his Akedah lithographs of the mid-1960s (fig. 125). Here the face of Isaac turns toward the viewer, unlike the depiction of Rembrandt (1635), in which Abraham shields Isaac's face.[67] Various versions of this image were executed by Chagall about the

66. For a good general account of the *Bible* etchings commissioned by Ambrose Vollard and executed from 1931 to 1939 (sixty-five of the etchings) and then completed (the final forty etchings) from 1952 to 1956, see Rosenaft, *Chagall and the Bible*, but also Meyer Schapiro, "Chagall's *Illustrations for the Bible*," in *Verve, Bible Marc Chagall*, vol. 7 (Paris, 1956), reprinted in Schapiro's *Modern Art: Nineteenth and Twentieth Centuries* (New York: Georges Braziller, 1978), 122–41.

67. Moshe Reiss has pertinently contrasted Rembrandt's covering Isaac's face (1635) with the emphasis of Emmanuel Levinas on the face of Isaac in which Abraham sees the image of God: "Abraham's Moment of Decision: According to Levinas and Rembrandt,"

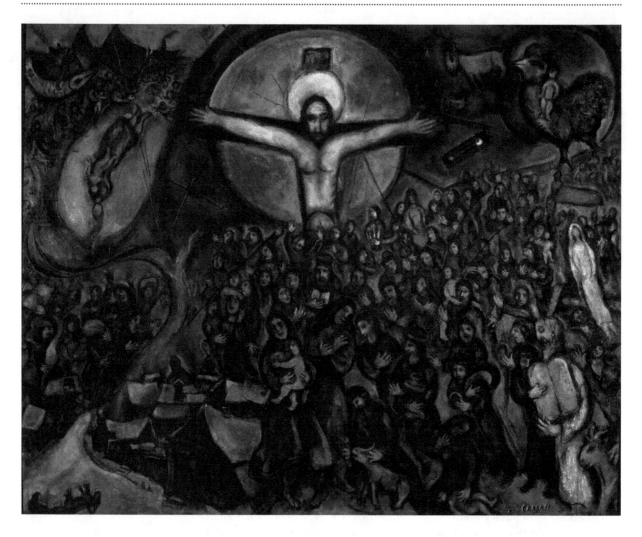

Figure 124. Marc Chagall, *Exodus*, 1952–1966

time he was creating stained glass windows for Saint Stephan's church in Mainz, in which the image is also found. Strikingly, in this depiction Isaac is unbound, reflecting a Jewish tradition that presents him as consenting of his free will to being sacrificed.

If Rouault's work is characterized by a commitment to truth in the light of transcendent Truth, then Chagall's corresponding emphasis is on the Good—the enduring goodness of God. This is his sense of the whole of Scripture as providing a redemptive view of human reality, such that he can say, "I see the events of life and works of art through the wisdom

Jewish Bible Quarterly 35, no. 1 (2007): 56–59; interestingly, here Chagall forces the viewer to see into the face of Isaac as the promised one of God.

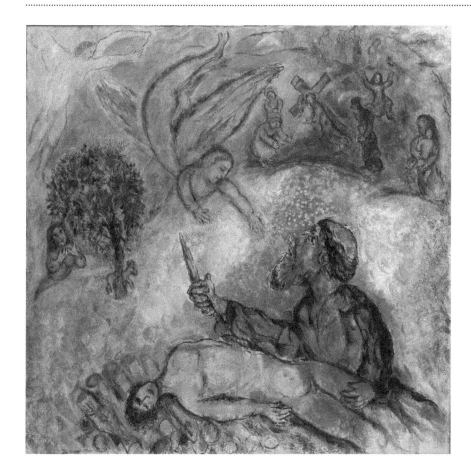

Figure 125. Marc Chagall, *The Sacrifice of Isaac*, 1960–1965

of the Bible."[68] His other dominant themes reflect it, in joyful color, including cherished happy memories of Jewish communal life, the joys of love and the beauty of marriage (in which he has no modern equal among artists), depictions of the great life-affirming stories of the Bible (he draws on a wider range of biblical texts than any other modern painter), the meditative music of the Psalms, and in brilliant colors his rendering of Ketuvim, scenes from the Song of Songs to the story of Ruth and Boaz. It is not difficult to see, whether in his depictions of the kinsman-redeemer or in his dreamlike images of adorned and beautiful Jewish brides (fig. 126), Chagall's aspiration for the redeemed daughter of Zion.

This wedding invites a spirit of worship, because it participates in the greater divine purpose for God's faithful people; one senses here again the

68. There are many quotations of this sort in Charles Sorlier, *Chagall on Chagall* (New York: Harrison House, 1979), of which this is printed on p. 193.

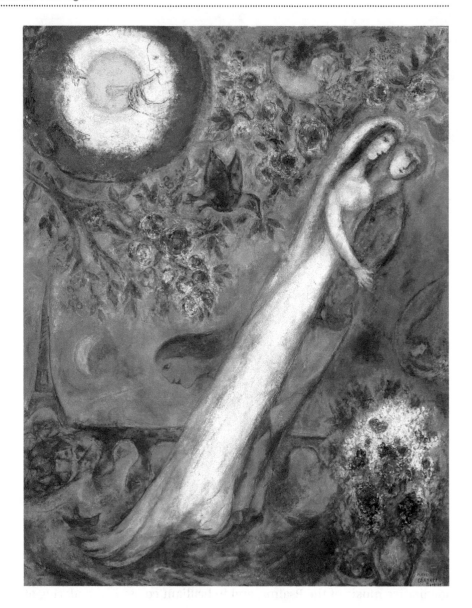

influence of Chagall's beloved Isaiah (Isa. 62:1–5). In Chagall the ingested *sefer torah* bears fruit across his oeuvre as in no other painter of his century, Jewish or Christian, in his apparently "secular" no less than overtly religious work. Chagall began as an artist in some respects questioning his religious tradition, but he proceeds to an understanding of art itself as a kind of worship, a sacrifice of the heart. Then, finally, in a concordance of scriptural understanding, he comes to an idea of Christ as "the greatest Jewish poet," the universal artist whose own sacrifice of the heart

becomes the symbol of atonement par excellence. In brief, it seems that Raïssa Maritain's claim that Chagall is "un artiste selon Isaie" is entirely justified.[69] All the evil in the world notwithstanding, Chagall proclaims the enduring Good.

Arcabas (1927–)

Not merely to include but to conclude with Jean-Marie Pirot (Arcabas) in this last chapter will seem for many readers, I realize, to introduce novelty just where a recapitulation might be expected. Both are intended. Actually, it would be difficult to find a better way to recapitulate the themes of this book than in the paintings of Arcabas, an artist still living at the time of this writing, and whose work carries us into the twenty-first century trailing clouds of past as well as present glory.[70] I am not the first to recognize that he belongs in the company of the other two artists included in this chapter. The Italian theologian Enzo Bianchi, in his introductory essay to *L'enfance du Christ*, a book devoted to Arcabas's polyptych installed in the archepiscopal palace of Malines in Belgium, records an interview with the painter in which he makes the following observation about the disappearance from the annals of modern painting of those still able to paint Christian mysteries. "I know of only Chagall, Rouault, and now you," he said to Arcabas, "who have produced art capable of manifesting the Presence." Arcabas's response was, "You have spoken of Rouault, of Chagall, limiting us to our own era, and I note that these artists had the faith."[71] By "faith" Arcabas meant more than membership (he was of course familiar with Chagall's Jewish identity), and something more profound than mere assent to the catechism as well.

Like Rouault, Arcabas was born into a nominal Catholic family, and like him, experienced an adult conversion; in his case, as for Chagall, something decisive happened when he began reading the Bible. "Faith fell upon me like a bucket of water," he later reported.[72] He became more than a casual reader:

69. Raïssa Maritain, *Marc Chagall ou l'orage enchanté*, 81.

70. I am indebted to my daughter, Kirstin Jeffrey Johnson, for introducing me to the work of Arcabas during a visit to her and her husband at their home near St. Hughes, France, in 2007.

71. Enzo Bianchi, interview with Arcabas, printed in Phillipe Verdin, ed., *Arcabas: L'enfance du Christ* (Paris: Cerf, 2002), 17.

72. Quoted in François Boespflug, *Arcabas: Saint-Hughes-de-Chartreuse* (Paris: Cerf, 1988), 11.

I am a Bible and New Testament enthusiast. I bury myself in it many times per week. I have an ancient edition of Luther's vernacular Bible, written in the gothic style. I also have a Chouraqui version of the Bible, which takes extraordinary shortcuts due to its direct translation from the Hebrew, as well as the Jerusalem Bible. Whenever I have a painting to paint, I draw from these Bibles the paragraph that inspires me. . . . I read a passage and am engrossed. It is an awe-inspiring book. One understands [in this way] how 2000 years later it still appears as a remarkable novelty. When I read the Bible, it seems like it all happened just yesterday, so much is its text present in my spirit.[73]

Kirsten Appleyard has remarked astutely that Arcabas seems to describe a kind of *lectio divina* experience, not just reading through the text but letting its words become prayer as he reads, a means of dialogue with the Scriptures.[74] As much in his painting suggests, his images have a similarly "prayed" intimacy of spiritual engagement. Of his act in painting the artist has said, "What I am in the midst of doing is prayer."[75] Consequently for Arcabas, "to express oneself has nothing to do with the [believing] painter's trade . . . the painter is delegated to give an idea of the great lake of gold that is the joy of God."[76] Not the mere codex of the Bible in one translation or another, he implies, but the living Spirit of Holy Scripture has become his "patron," directing and inspiring.

Nevertheless, the lack of formal and financial patronage, nearly impossible for a religious painter to find in postwar France (as Rouault discovered), led Arcabas to an innovative solution. He found a decrepit church in the Chartreuse mountains, all but abandoned, in the tiny village of St. Hughes. He wanted walls to paint on; he wanted, "like Michelangelo, to have walls and to be able to speak my art . . . and also to speak my faith."[77] He obtained permission in 1952 to do just that, only to discover that the

73. Quoted in Bénévent Tosseri, *Croire aujourd'hui* (April 2006): 9. The Chouraqui translation to which Arcabas refers is an excellent, fresh rendering from the Hebrew by an exceptionally sensitive translator, who also has done a New Testament translation. For this translation, see http://nachouraqui.tripod.com/id91.htm.

74. Kirsten Appleyard, "Moi je vis un peu avec les Anges: The Search for Transcendence in the Contemporary Art of Arcabas" (honors thesis, Baylor University, 2009), 17n16. At the present time, this is the most complete study available in English.

75. Christophe Batailh, *La coleur habitée* (Meylan, France: Centre Théologique de Meylan, 2004), 60.

76. Interview by Jean-Claude Salou, CFRT/France 2, 1998.

77. Quoted in Batailh, *La coleur habitée*, 11.

roof and walls of the church were in bad condition. He volunteered for the repair (like Rouault, he prefers to be known as an "artisan," a distinction that corresponds to that of Pope John Paul II in his *Letter to Artists*).[78] When the walls still proved too porous and too prone to dampness for direct mural work, he began to paint with honey and egg plus oil on jute canvas and to hang his works on the walls instead.

"It is a fact," he writes, "that I paint ten hours a day, two hundred and fifty days a year."[79] We recall the diligence and persistence of Rouault, but also note in Arcabas, a self-professed "man of few words," an admission that not only Sundays and feast days have been holidays from his studio, but "The hundred or so remaining days are given over to wanderings, distress and the obstinate search for a 'consciousness of being' suddenly lost and without which nothing is possible, especially not the passionate and often hazardous creation of these sorts of mirrors that we call works of art." To this glimpse into his interior life Arcabas adds an eloquent confession such as only an artist of faith could make so transparently:

> Days without inspiration are dark ones. They remind us constantly, as the author of Ecclesiastes does, that all is dust and returns to dust. This very fact kills all forms of joy and hope. But on a closer look this reality hides another axiomatic one: this cosmic dust, more or less coagulated and assembled in diverse forms, holds in its inmost being the Spirit of the Universe. Docile and friendly, this divine medium can be led astray, separated and made diabolical. But, captured in its innate unity, it bears the phosphorescent clarity of meaning and flows, thus enriched, like an incandescent river towards a greater destiny, a new form in the Creation.[80]

Arcabas is an unusually literate painter; his remarks reveal familiarity not only with the Bible (Luke's Gospel is his primary text),[81] but also with

78. Pope John Paul II, *Letter to Artists* (Chicago: Liturgy Training Publications, 1999), 4.

79. Arcabas, statement on his website: http://www.arcabas.com/accueil/index .php?lalangue=uk.

80. Arcabas website.

81. The characteristic emphases of his work feature not only distinctive Lukan narratives, including especially the preministry life and frequent recurrences of the appearance of Christ on the road to Emmaus, but an integral reflection of the distinctive character Francis Watson attributes to Luke's Gospel when he observes that it "is dominated by praise, celebration and thanksgiving." Watson, *The Fourfold Gospel: A Theological Reading of the New Testament Portraits of Jesus* (Grand Rapids: Baker Academic, 2016), 74.

classic works of Christian spirituality such as Augustine's *Confessions*, the novels of Georges Bernanos, the philosophical essays of Jacques Maritain, and the encyclicals of Pope John Paul II. He is musically literate as well, attuned to beauty and harmony in several genres. As he puts it in the foreword to *Passion/Resurrection*, he loves "to inquire into harmony and beauty in a modest imitation of my Creator."[82] These terms, reminiscent of Augustine's early preoccupation with *pulchre et apto* recollected at the beginning of his *Confessions*,[83] indicate that Arcabas likewise has both read and thought about aesthetics, and in particular about the transcendentals, especially in theological perspective. In an interview with theologian Christophe Batailh, he speaks of the obligation of a Christian artist who recognizes in himself a calling to "speak the truth, the goodness of things, and the beauty of the face of God."[84] Clearly, he would agree with Jacques Maritain, that "the moment one touches a transcendental, one touches Being itself, a likeness of God, an absolute, that which ennobles and delights our life; one enters in[to] the domain of the Spirit."[85] This is also to agree with Augustine (and Aquinas), anticipating John Paul II, for whom "beauty is the visible form of the good, just as the good is the metaphysical condition of beauty."[86] The pontiff's words seem especially applicable to Arcabas, and a commentary on the relationship that links him to Chagall (fig. 127).

In the case of Arcabas, Beauty is clearly the transcendental through which he most "touches Being itself," and thus the True and the Good:

Beauty will save the world! . . . Beauty is everything at once, it is Truth and Goodness. These three transcendentals, cleverly recognized by our intelligence and remaining intimately connected, constitute the reality of our world. If you eliminate one you eliminate the two others. It is like a trinity. When I speak of beauty I imply a much more elevated level, that of the transcendent realm where we find the face of God revealing the entire Trinity. This is Beauty. Beauty, like Truth, transforms you. . . . Alas, we find that people today no longer dare to evoke it.[87]

82. *Arcabas: Passion/Résurrection*, ed. Fabrice Hadjadi (Paris: Cerf, 2004), 7.

83. See chap. 2 above.

84. Quoted in Batailh, *La coleur habitée*, 30.

85. Jacques Maritain, *Art and Scholasticism*, trans. J. F. Scanlan (New York: Scribner, 1954), 32.

86. John Paul II, *Letter to Artists*, 7.

87. Quoted in Batailh, *La coleur habitée*, 80–81.

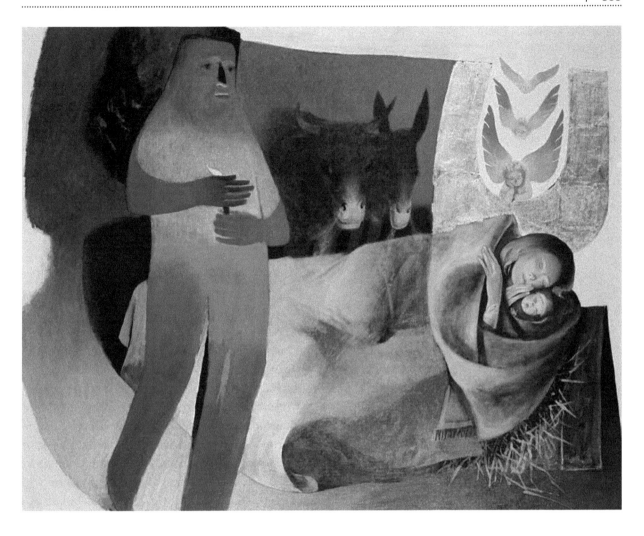

Figure 127. Arcabas,
La Nativité, Polyptych of
the Infancy of Christ, 2002

Arcabas dares, as his version of the visitation of Mary to Elizabeth in this series also shows (fig. 129).

He goes on to say that "especially in the fine arts" this reluctance to deal with beauty, to see it in human relations, amounts to an "inability to confront the face of God," an inability that, as we have seen, has often among artists of the last century taken the form of a grim animosity. For the celebrated American artist Barnett Newman, "The impulse of modern art is to destroy beauty."[88] Arcabas responds that this disposition is prima facie a rejection of the divine origin of beauty: "La Beauté, c'est Dieu. Si

88. Cited by Wendy Steiner, *Venus in Exile: The Rejection of Beauty in Twentieth-Century Art* (New York: Free Press, 2001), 111.

Figure 128. Arcabas,
La Nativité, detail

on est sensible a la beauté, on est sensible a Dieu" (Beauty is God. If one
is aware of beauty, one is attuned to God).[89]

Like both Rouault and Chagall, Arcabas designed stained glass win-
dows for worship spaces.[90] Arcabas also created altar furniture, including
a tabernacle (1969) carved in wood and gilded, for the Église Oecumenique
de Chamrousse. The orientation of art toward common (as distinct from
personal) worship is most prominent in Arcabas. Enzo Bianchi notes in
his extensive interview with the artist that Arcabas manages not only to
communicate in his painting the depiction of religious subjects, but also to
evoke a religious spirit that draws the viewer powerfully into a mysterious
sacred space. While this is true also of some of the works of Rouault and
Chagall, it is particularly evident in Arcabas, in many of whose paintings
ordinary objects, Bianchi notes, seem to be composed by "a grammar of
the transfiguration of things," an "impression of having rediscovered the
gravity of a presence, of something that is not said, the unspoken, and this
opens up to us a presence we could not otherwise enter."[91] What Bianchi
attributes to the artist in this remark, Arcabas resists taking credit for,

89. Quoted in Sr. Marie-Bruno, *A l'ombre du capuchin: Un saint François d'Arcabas*
(Paris: Editions Franciscaines, 2010), 47.

90. Chagall did his major stained glass work, however, for museums in Nice and
Jerusalem.

91. Bianchi, interview, 19–21.

Figure 129. Arcabas, *Visitation*, Polyptych of the Infancy of Christ, 2002

insisting that such "presence" is not a creation of the artist. But when Bianchi describes this sense of presence as inviting comparison with an icon but somehow attaining a greater sense of *l'intime du Coeur*, Arcabas is willing to acquiesce that this has been his desire.

Kirsten Appleyard has noted the synthesis of old iconic style and something new and more distinctly affectual in several of Arcabas's

works. Writing of his *Madonna with the Messiah* (fig. 130) from the nativity polyptych, she remarks, "This image bears the distinctive stamp of a medieval icon: on a shimmering gold background it presents a full frontal view of the Virgin Mother and child in flat, two-dimensional perspective."[92] She notes this also in the Emmaus sequence, and notes that Arcabas acknowledged that he deployed this technique deliberately, so as "to see to it that the canvas can come toward you without escaping to the background. Instead of one's glance fleeing toward the interior of the painting, burrowing itself there . . . the characters and objects are arranged in such a way as to present themselves and make their way toward the spectator, in order to inhabit him with a 'present' that recurs at every glance."[93] Thus, when we look at the *Madonna with the Messiah*, we see not only traditional iconic elements, such as the cross frame, and instruments of the passion, but in a reminiscence of depictions by Giotto and Fra Angelico, a more naturally childlike Christ.

This parousiac icon (*parousia* in Greek means "presence" or "arrival") is accompanied in this series, as in others, by narrative icons, images illustrating the biblical stories (e.g., figs. 127 and 128), and these act as a "frame" for the central iconic image.[94] In Arcabas the style of these narrative icons and even their striking use of color recall the frescoes of Giotto, so influenced by Franciscan spirituality, and yet are a fresh encounter with the Gospel stories themselves. As with this strain in medieval painting, we are given the "beauty of the Gospel alfresco" (even though the works are mostly on canvas), in a design less oriented to learned theological reflection than to evangelical engagement. Arcabas made just this point in his interview with Bianchi: "As long as we are, among ourselves, believers, it is possible to make the necessary effort to understand even rather difficult things: we know why we do it. But for the sheep who wait, who are not of this same fold, and yet who want to go toward the Shepherd, a language is needed—not one that will join them together, but one which will call them in."[95] Arcabas is a strikingly christocentric painter, not only in the sense that he has many images of Jesus, but that he imbeds cruciform design in multiple ways in a large majority of his paintings. Further, he has no one "icon face" for Christ, such as tended to become a

92. Appleyard, "Moi je vis un peu avec les Anges," 13–14. Bonnel, "L'art sacré en France et l'icône," names Arcabas as an evident example of the return of iconic painting among contemporary French painters (131).

93. Boespflug, *Arcabas*, 126.

94. Appleyard, "Moi je vis un peu avec les Anges," 18.

95. Bianchi, interview, 18.

Figure 130. Arcabas,
Madonna with the Messiah
(L'enfance series, 2002)

Figure 131. Arcabas,
The Samaritan Woman, 2002

type after the Mount Sinai icon. He represents Jesus in all stages of his life, ministry, death, and resurrection, each representation with a visage that seems to him to reflect the Christ who becomes present to each person and situation in a distinctive way.[96] In a painting in which Christ awaits the Samaritan woman (John 4:1–43), for example, we have little trouble imagining that "he was tempted in all points such as we are" (Heb. 4:15), and marvel that he remained "without sin" (fig. 131).

The Emmaus cycle of 1992–1994,[97] one of several polyptych paintings done by Arcabas on this story, is particularly effective in revealing the artist's new iconic technique, not least because the theme of this story from Luke's Gospel (24:13–35) is that Christ may be present, may indeed have been teaching us, but we haven't noticed. As in the case of the two earnest and grieving disciples, this happens because even though we are absorbed in searching out the meaning of his passion, our eyes are not yet opened

96. Quoted in Batailh, *La coleur habitée*, 59; cf. Appleyard, "Moi je vis un peu avec les Anges," 48.

97. *Les Pélerins d'Emmaüs*, 1992–1993, Carmel de la Fontaine Olive, Aubigny des Pothées, Ardennes, available in the book by François Boespflug, *Arcabas et les pélerins d' Emmaüs* (Paris: Tricorne, 1995).

to see *him*. In the Gospel, after their long walk together, Cleopas and his companion invite Jesus in to share a meal, then recognize him only in the "breaking of the bread," as their risen Lord prays the traditional blessings.[98] Arcabas transfigures this narrative sequence by making everything in it a blend of past Gospel narrative and present worship experience. To begin with, the two returning and confounded disciples are made to look like modern young men (fig. 132).

As they thank Jesus for his teaching (Luke 24:28–30), they suddenly realize that it is dark and he seems to have a ways to go, so hospitably they invite him in for a simple meal, and in acknowledgment of his teaching defer to him in the *berakah*. Only after his blessing, as he is breaking the loaf, will they recognize him, the light of his glory suddenly illuminating the table (fig. 133).[99] This is the iconic center of the Emmaus series.

But then he disappears, and they go rushing out to see where and how he has gone (fig. 134). This framing image is not itself the iconic center, but serves to intensify it emotionally and devotionally. In his disappearance panel, Arcabas achieves something that neither Caravaggio nor Rembrandt was able to do, simultaneously making the miracle tangible and the mystery participatory. The viewer sees—and feels—the presence as real, all the more so because of Christ's sudden absence and the scrambled exit of the disciples to look for him in the magnificent starry night. As the white spaces (*vides*) and jigsaw puzzle shapes suggest, not everything is explained; the viewer must piece things together both inside and outside the frame of the story. The open door and starry night after the communion at Emmaus ineluctably evoke a desire to reenter the presence.

This is what great art can do for worship, both personal and collective. It is what much great Christian art down through the ages has striven to achieve and often accomplished brilliantly. It remains the task and the challenge for Christian art today.

98. Cf. David Lyle Jeffrey, *Luke: A Theological Commentary* (Grand Rapids: Baker, 2013).

99. There is an obvious influence here of the depictions by Rembrandt and Caravaggio, but unlike them, Arcabas removes the servant and makes his focus not the prayer of blessing but the actual fraction; this occurs before the two friends, so intent on their conversation, snap out of their sad preoccupation.

Figure 132. Arcabas, Emmaus polyptych, 1993

Conclusion

Unlike some of their twentieth-century contemporaries, Rouault, Chagall, and Arcabas did not form a movement or have a manifesto, yet it will be evident, I hope, that our three artists in this chapter have a great deal in common. All spent a majority of their productive lives in France. All three were religious artists in the deepest sense, yet in terms of genre they were conventional in that each painted nudes, landscapes, and still lifes, as well as religiously saturated images. All three reflect their deep commitment

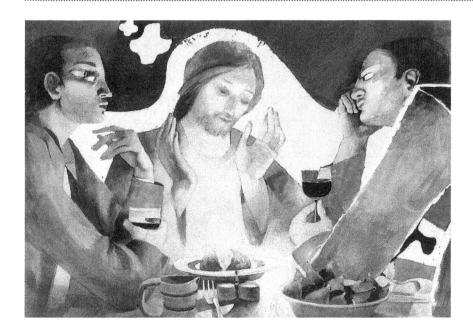

Figure 133. Arcabas,
The Breaking of the Bread,
Emmaus polyptych, 1993

to a countercultural special focus on the human spiritual condition and grounds of hope *sub specie aeternitatis*. For each a direct and intensive reading of the Bible was central to the formation of his spirituality and hence his imagery. Each was influenced by Jacques Maritain's philosophy of art, and Rouault and Chagall even more directly by personal friendship with the Maritains. All three created art for places of worship; each designed stained glass windows for reverential space, space "set apart" in the ancient sense. Each employs modern style and techniques, yet resists the fashions of conventional secularity and subjective individualism in the general art culture whereby these fashions have been held to be incompatible with anything transcendent, finding their most celebrated contemporaries often hypocritical or question begging where the moral good is concerned. Though their religious lives and spirituality differ in some particulars, each clearly possesses and projects a desire for divine presence, and has an eye for transcendence of ultimate value that exceeds what art can capture but to which a committed artist is recurrently drawn because of a deep conviction that transcendence is at the heart of human reality. Though their spiritual formation and life experience dispose them each to a particular empathetic reflection of one of the classic transcendentals more than the others—the True for Rouault, the Good for Chagall, and the Beautiful for Arcabas—it seems entirely reasonable that recent art historians and supreme pontiffs alike should have seen reflected in

Figure 134. Arcabas,
Disappearance, Emmaus
polyptych, 1993

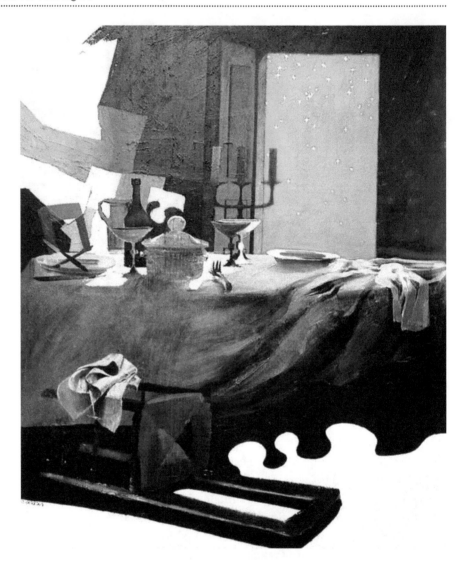

their art a more compelling radiance of that Being in which the True, the
Good, and the Beautiful have long been held to coinhere.[100] In their work,
the return of the transcendentals signals a recrudescence of hope, a re-
birth in modern art of its ancient, life-giving meaning and, yes, purpose.

100. For Hans Urs von Balthasar, "Beauty dances as an uncontained splendor around
the double constellation of the true and the good in their inseparable relation to one an-
other." *The Glory of the Lord: A Theological Aesthetics*, ed. Joseph Fessio and John Riches,
trans. Andrew Louth, Francis McDonagh, Brian McNeil, et al., 7 vols. (San Francisco: Ig-
natius, 1982–1989), 1:18.

The possibility of art as a means of giving thanks has accordingly been made thinkable, and with it a continuity with art in the biblical tradition such as makes it possible once again for art to be meet and right for worship. In an often nihilistic world, viewers of the work of these three artists (among others)[101] have been given a glimpse of fresh possibilities; not all of modern art has become cynical or complicitous. For lovers of art, at the end of the twentieth century and beginning of the twenty-first, this has been very good news.

101. Among the more prominent examples are Chinese painters He Qi, Peng Si, and Ding Fang, and Canadian artist and novelist Michael D. O'Brien.

Epilogue

he intent of this book has been to give an account of Christian art over the last two millennia in which the motive for its making and the place of its original engagement are taken as seriously as the features of its composition and style. The creation of so much artistic excellence as a means of giving thanks, as a prompt to worship and devotion, is a datum for the study of human creativity much too important to ignore. As we have seen, the annals of Western art bear witness to the perseverant power of biblical narrative to engage the heart, especially by artists whose imaginations have been continuously reformed both by the legacy of earlier Christian art and by reading the Bible.

The artists themselves, as reflective beings creating within a living tradition, have thus been a central concern of this book, not merely as the efficient cause whereby formless matter or pigments on a palette are formed into images of enduring attractiveness, turning other minds toward thanksgiving for beauty and its Source, but as participants in the ongoing human effort toward transcendence. Artists who engage the Christian story worshipfully become incidental theologians, simply because they attempt in their work to read and understand the story of God's love for the world.

When we consider the creation of a work of art, even as did Aristotle in his discussion of his "Four Causes" (*Physics* 2.3), we recognize that for most of us there is much that doesn't meet the eye. The formless block of marble (Aristotle's "material cause") in which only a Michelangelo can see the form he yearns to liberate from the stone would hardly interest anyone but an artist. The "formal cause," the *logos* or definition of what is to be, is entirely invisible to the rest of us until the artist goes to work.

The "efficient cause," not just the hands that work hammer and chisel, masterfully removing just enough and not too much, is not merely the skill but also the person of the artist, whose passions and predilections guide both heart and mind. Finally, after much labor, the beauty of the *Pietà* appears. When we call this finished work, after Aristotle, the "final cause," we may well miss noticing that for a Christian artist the finished work of art is not merely an art object; in many cases it will be an expression of personal devotion that now may enhance the worship of others.

That this can be so relates to the way in which many Christian artists have seen their work as witness, a contribution to the sanctifying work of the Spirit in the life of the church. This model finds its original in the pattern established in creation, the original art of the divine artist who made "heaven and earth, and all that in them is," including at its apex, the first human being. If we think of this originary work of divine art in Aristotelian terms, we may be struck by comparisons over which Christian poets and biblical exegetes have often mused. The "material cause" of Adam's body is described as mere dirt: Adam (a man) is of the earth, earthy (*adamah*), human from humus. This "material cause" is in itself even less noteworthy than the sculptor's marble. The "formal cause" in Genesis is said to be God's own image (*imago Dei*); the "efficient cause" is the *ne plus ultra* artist; while the "final cause" is nothing less than the *kavod*, the *doxa* or glory of God. In the words of the Shorter Westminster Catechism, "the chief end of man is to glorify God and enjoy him forever." When God breathes into Adam the breath of life (*neshemah*), the signature of the divine artist achieves what no other artist can hope to achieve; Pygmalion's dream by contrast remains a fantasy. The knowledge that God is an artist like none other, however, far from repressing human creativity, naturally informs and inspires the subcreative artistry of the whole biblical tradition. Material, formal, and efficient causes still answer quite well to Aristotle's paradigm, but the final cause for Christian artists is very often a form of considered tribute to the first artist—worship on more than one level.

There have been many misunderstandings and even perversions of this mimetic model, or principled rebellions against it by those who would make something other than God the focus of worship. As we have seen, for many secular artists the final cause can become the triumph of art itself, even a kind of worship of the human artist. The abiding legacy of Christian art, by contrast, bears ongoing witness to the love of God for the world, both in its creation and in the re-creation made possible by his advent. If at the moment of Adam's creation we can imagine the Creator

saying, in effect, "Here you are—like me," we may regard God's ultimate artistic triumph as re-creation of that marred first image, already announced at the moment of Jesus's baptism as God speaks from heaven, saying, "This is my beloved Son, in whom I am well pleased" (Luke 3:22). In this moment the divine artist presents *himself* in the form of our human flesh, saying, in effect, "Here I am—like you." Small wonder that this re-creative story has so dominated the imagination of Christian artists. No fully accountable theory of Christian art can overlook that its ultimate "final cause" is restoration in *us* of the image first given.

Holiness is accordingly essential to an understanding of artistic purpose in its biblical context. Not only does Torah ground human creativity in the context of holy worship, but we also find there the distinction between art ordered to God and art turned away from him to one or another species of idolatry. Knowledge of art history helps us to see that we ought not to deceive ourselves concerning the power of this impulse to make the gift of artistry either a god in itself or a demigod of the artist. Attempts to make of art itself an intrinsic good, even a substitute for the Holy, have nonetheless failed to sustain coherence, whether the substitutions have been masked in language praising mortal beauty or the "sublime," or merely passed off as decor, an accoutrement of affluence. Anxiety about the potential for such confusion has led some Christians, prudentially, to ascetic severity where art is concerned, whether in contexts of worship or domestic life. The moral revolt of Protestantism against a perceived idolatry of art should be recognized as far from unjustified on purely ethical grounds. Unfortunately, in the process much of value has been lost, not only to places of formal worship, but informally and spiritually, through a narrowing sense of the fullness of divine giftedness and the joy of creativity offered back in love for the Giver. The effect of the Reformation upon Christian culture in the West has—unintentionally perhaps, but quite markedly—left something of a vacuum where the "beauty of holiness" used to be in the Christian spiritual imagination, and largely secular or perceptually "neutral" elements have filled the gap. There has been a loss to the spiritual richness both of life and worship in many cases. It is hard to seek the holy in a negative state of mind, and harder still to appreciate its connection to beauty in a defensive or "two spheres" bifurcation of engagement with worship and the world. Assertive individualism, moreover, represses the desire for holiness, since an authentic encounter with the Holy requires self-abandonment, not self-absorption. The burden of this book has been to show that against the desiccating winds of a culture whose "one central psychological fact," as Daniel Bell puts it, "resides in

the phrase 'nothing sacred,'"[1] art that preserves a sense of the holy can be for those who thirst like streams in the desert. Especially is this true when one may encounter beauty in the service of worship, not because its images are in themselves what we are looking for, but because they open our weary imaginations to the Presence we do seek. What the annals of Western art teach us is that to want the gift without the Giver is ingratitude; to elevate the gift and not the Giver is idolatry. Happily, Scripture itself abounds with better choices, none more apt to our reflection than the prayer of the poet David:

> One thing have I asked of the LORD,
> that will I seek after:
> that I may dwell forever in the house of the LORD
> all the days of my life,
> to gaze upon the beauty of the LORD,
> and to meditate in his sanctuary. (Ps. 27:4)

Some of the world's finest artists have made their lives into such a prayer; appreciating their aspiration is crucial for a full and balanced appreciation of their work.

1. Daniel Bell, *The Cultural Contradictions of Capitalism*, twentieth anniversary ed. (New York: Basic Books, 1996), 167.

Ecclesial Architecture
in the Protestant Tradition

I n the period immediately following the Reformation, most large or national Protestant churches continued to use the edifices built before the split from Rome. They often removed images and even in some cases stained glass, overpainting the walls, as in the nave of the Buurkerk at Utrecht, preserved in a painting by Pieter Saenredam (1597–1664) (fig. 135). Retained here are the lineaments of Gothic arches and elevation; many (not only Reformed) visitors have found the whitewashed interior space conducive to serenity. For many Protestants, however, Gothic style was inherently "Catholic."

Elsewhere, Protestant church architecture developed in a fashion that reflected the more democratic taste of congregational worship, as well as the Protestant emphasis on preaching. The famous Calvinist round church in Lyons, no longer standing, was one such example (fig. 136). The functional elements of this style increasingly dominate over the adornments, as worship becomes more and more defined by the preaching/ teaching function. Everyone is able to be closer to the front, much as in Shakespeare's Globe Theatre. Altars give way to pulpits, and churches come more and more to resemble theaters or other auditoria, as in this seventeenth-century Baptist meetinghouse in Tewkesbury, England (fig. 137). Here we see that in front of the pulpit there is a small "table of the Lord," and in front of that, central to the view of those in the balcony as well as on the main level, an in-ground, *mikvah*-style baptistry for immersions.

The horseshoe auditorium format has had an enduring tradition in Baptist and evangelical communities, sometimes achieving a grand scale, as in Charles Haddon Spurgeon's massive Metropolitan Tabernacle in

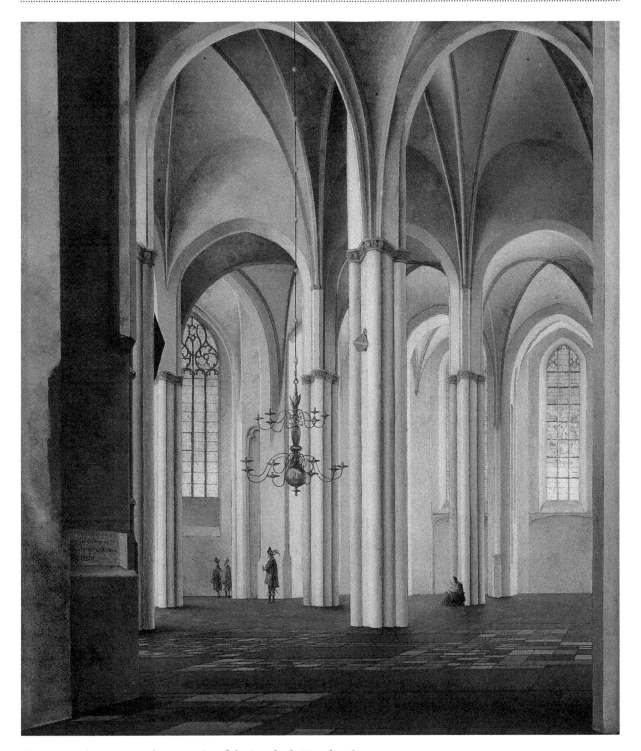

Figure 135. Pieter Saenredam, *Interior of the Buurkerk, Utrecht*, 1645

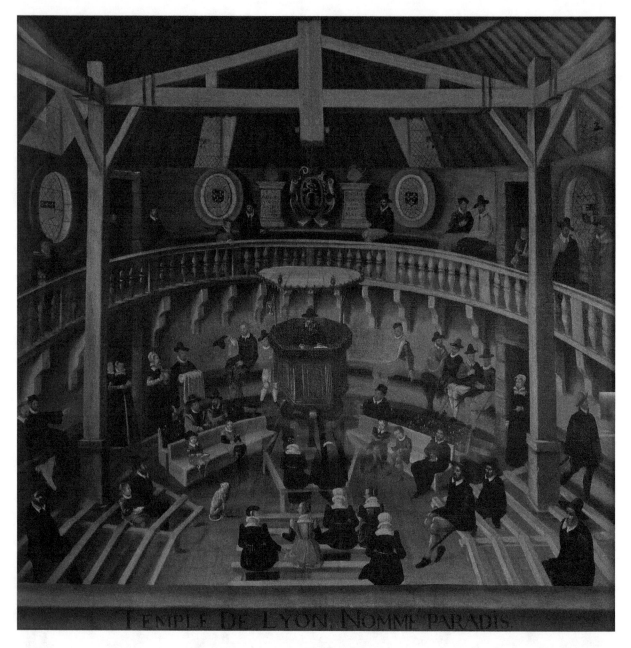

TEMPLE DE LYON, NOMME PARADIS.

Figure 136. Jean Perrisin, *Le Temple de Paradis*, late sixteenth century

London or in the Moody Memorial Church in Chicago (fig. 138), in which the apsoid frontal space is referred to as a "platform" and choir, while the baptistry is elevated behind the choir. The audio system is essential to such vast auditoria, and increasingly grew to be a feature in interior space.

An interesting architectural linkage to the Romanesque style, with rounded arches and windows, is perhaps unconsciously reflective of the

Figure 137. Old Baptist Chapel, Tewkesbury, England, seventeenth century

Figure 138. Moody Memorial Church, Chicago, interior, early twentieth century

late medieval association of Romanesque style with Jewish biblical architecture. In the beautiful First Baptist Church of Amarillo, Texas, built in 1929 at the beginning of the Great Depression, these basic features are given their most elegant American treatment, incorporating Byzantine revival pillars and medieval ornament as well as courtyards and fountain (figs. 139–142).

Figure 139. First Baptist
Church, Amarillo, Texas,
narthex, 1929

Meanwhile, churches in the Reformed tradition in America have tended to blend the auditorium style with the color tones of the first transformed Gothic cathedral spaces.

A feature of some Reformed churches, often eclipsing as a focus anything else, is a magnificent organ with decorated pipes; this marks the commitment of the worshiping community to an emphasis on music as the central mode of expression. Presbyterian churches are nonetheless of great variety in their style; New England buildings of the eighteenth and nineteenth centuries are likely to have clear glass windows and emphatically white interiors with a pulpit dominant in the chancel. Later examples include everything from Scottish traditional style with some stained glass to interiors more reflective of Episcopalian or Anglican tradition.

Figure 140. First Baptist
Church, Amarillo, Texas,
interior

Figure 141. First Baptist
Church, Amarillo, Texas,
column detail

"Big-box" evangelical and Pentecostal worship spaces, on the other hand, have tended to reflect increasingly nontraditional architecture, often having a gymnasium or theater-like quality in which windows are dispensed with or at least minimized, and artificial light, including prominent video screens, introduced in their place.

Figure 142. First Baptist
Church, Amarillo, Texas,
courtyard and fountain

Figure 143. Warrior Run Presbyterian Church, Northumberland County, Pennsylvania, interior

APPENDIX B

Sources for Iconography

EARLY: 200–600 CE

An indispensable reference text for serious study of early Christian iconography is André Grabar, *Christian Iconography: A Study of Its Origins*, in the Bollingen Series, no. 35 (Princeton: Princeton University Press, 1968).[1] Grabar traces how "Christians followed Jews and . . . both iconographies originated at the beginning of the third century" (19), with many examples found in the Roman catacombs. A dominant formal icon appears in the late fourth century in Byzantine mosaics as well as in two frescoes in the catacombs of Donatella and Commodila, and on sarcophagi: Christ seated among his apostles. A similar motif is in the apse mosaic of San Vitale in Ravenna.

Beginning in the sixth century in the Eastern Church, the Blessed Virgin Mary is shown enthroned with two angels, but sometimes with saints (80). The expression of theological doctrine in a single image involves two notable biblical narratives; aside from Abraham's visitation by the three visitors (in Gen. 18), the "baptism of Christ is the only iconographical interpretation of the Trinity that survived the paleo-Christian period and that remained valid throughout the Middle Ages and into modern times" (115).

Excellent detailed guides are provided by Jane Chance, ed., *Medieval Mythography*, vol. 1, *From Roman North Africa to the School of Chartres, A.D. 433–1177* (Gainesville: University Press of Florida, 1994); Jane Chance, ed., *Medieval Mythography*, vol. 2, *From the School of Chartres to the Court*

1. Hereafter, page references from this work will be given in parentheses in the text.

at Avignon, 1177–1350 (Gainesville: University Press of Florida, 2000); a third volume is forthcoming.

Some readily available historical texts follow.

MEDIEVAL: 600–1500

Isidori Hispalensiss Episcopi, *Etymologiarum sivo originum*, bk. 20, ed. W. M. Lindsay, 2 vols. (Oxford: Clarendon, 1911, 1966); Rabanus Maurus, *De universo*, in Patrologia Latina (1844–1855), ed. J.-P. Migne, vol. 112; Pseudo-Hugh of St. Victor, *De bestiis et aliis rebus*, in Patrologia Latina, vol. 176.

RENAISSANCE: 1500–1800

Caesare Ripa, *Inconologia* (Rome, 1593; reprint, 1603, with illustrations; modern facsimile ed., New York: Garland, 1976).[2] This is a widely used manual for artists and humanists into the late 1700s, with a five-volume polyglot version published at Perugia (1764–1767), and two editions published later in English, with updated illustrations and significant changes (1777–1779, 1785). Ripa draws on Cicero, the Bible, Aquinas, Boccaccio, and Vasari (e.g., 109) to attempt a synthesis that would standardize an increasingly fractured iconographic language. Ripa is focused largely on the intellectual and moral virtues and vices, but also includes iconographic norms for the authority and power of the church (40: an enthroned matron with keys and scepter), the "Fide Cattolica" of the church militant (163), many of the liberal disciplines (e.g., 431, 333), as well as an iconography for European nations and even regions (355–60). For today's student, Ripa is most valuable for later Renaissance and baroque art.

D. Philippi Picinelli, *Mundus symbolicus*, 2 vols. (Cologne, 1669; reissued in 1694; modern facsimile, New York: Garland, 1976). Picinelli's work is more massive, highly detailed, but without illustrations. Addressed to "orators, preachers, academicians, and poets," it discusses in book 1 the iconographical meaning of (1) the zodiac, (2) the elements, (3) pagan gods and classical heroes, (4) birds, (5) animals, (6) fish, (7) serpents, (8) insects and amphibians, (9) trees, (10) herbs and spices, (11) flowers, (12) gem-

2. Hereafter, page references from this work will be given in parentheses in the text.

stones, and (13) metals. Book 2 extends to manufactured instruments, buildings, tools, and more.

Tomas Munkerus, ed., *Mythographi Latini: C. Jul. Hyginus; Fab. Planciades Fulgentius; Lactantius Placidus; Albericus Philosophus* (Amsterdam: Joannis a Someren, 1681), offers a full Latin text of four of the most influential mythographers from late antiquity to the Renaissance.

Medieval Manuscript Illumination

In this book there appear in several chapters numerous examples of art from medieval manuscript books. This form of medieval art, particularly highly developed between the sixth and fifteenth centuries, derives its name ("illumination") from the fact that to paint images of narrative scenes or symbolic elements in a text was regarded as visual exegesis, "illumining" the text so adorned. These texts included primarily presentation manuscripts of the Bible, but also books of poetry, liturgical books including personal prayer books, and presentation copies of chronicles or historical narrative. The *Bible moralisée* is one of the best-known illustrated Bibles, but from the Vienna Genesis manuscript of the sixth century onward adornment was a sign that a text was precious and that its content was regarded as of extraordinary value—even holy. Additional examples of this art form given below are representative of the high quality and beauty of such manuscript painting.

In figure 144 it is evident that the artist wants us to see Matthew's Gospel in its relation to Moses, and the Sermon on the Mount in relation to the giving of the Law on Mount Sinai. Moses (in his Egyptian-style hair) peers around the curtain, holding Torah, while the angelic trumpeter blowing the shofar signals the Day of Atonement (Lev. 23:23–25), inaugurating the Jubilee (cf. Lev. 25:9). The angelic being is also *imago hominis*, the image of a man from Ezekiel's vision of the divine presence (Ezek. 1:4–14; cf. Rev. 4:6–7), traditionally associated with Matthew's Gospel, even as the lion was associated with Mark, the ox with Luke, and the eagle with John as heralds of the divine presence in Christ.[1]

1. A full and beautifully illustrated study of this Gospel book is by Michelle P. Brown,

Figure 144. Matthew page,
Lindisfarne Gospels, ca. 725

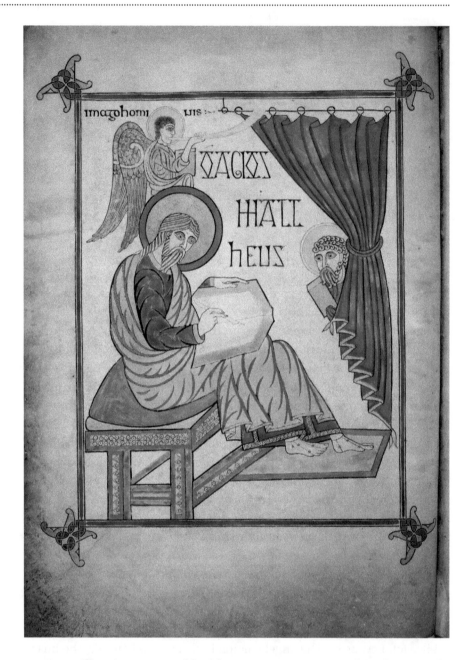

Later illuminators would make narrative events within the Gospels
stand in a symbolic way for biblical doctrine and its liturgical celebra-
tion. Thus, in a book of hours (fig. 145), essentially a personal prayer

The Lindisfarne Gospels: Society, Spirituality, and the Scribe (Toronto: University of Toronto
Press, 2003).

Figure 145. Elizabeth de Bohun Book of Hours and Psalter, ca. 1340

book with the Psalms appointed for each hour of the day, one would expect to find another image of the Word of God proclaimed, here in an illustration of the annunciation by Gabriel to Mary that the ancient promise of Emmanuel ("God with us") was to be realized through her. The tables on the left are a form of liturgical calendar, while the framing decor is an analogue with the decorative designs of books such as the Lindisfarne Gospels.

In the later Middle Ages Jewish Bibles and especially Passover Haggadah manuscripts began to appear. Some of these may have been commissioned by Jewish families or synagogue communities to be executed by Christian artists. Figure 146 is an introductory page for the Psalms, created in northern Italy in the late fifteenth century. The psalmist is represented as King David playing his harp in a garden made fruitful by the virtues of blessed life choices, hence *Ashray* (blessed), the first word of Psalm 1, an echo of medieval Christian manuscripts where the Latin word would be *Beatus*. In a manner also suggested by some Christian-illuminated initials for Psalm 1, there is a hint of the harp playing of Orpheus, which was said to have quieted the wild creatures, returning them to an Edenic peaceableness.

As we have seen, the expectation that Jewish art would be aniconic results from a narrow interpretation of Exodus 20:4–6, but in fact there

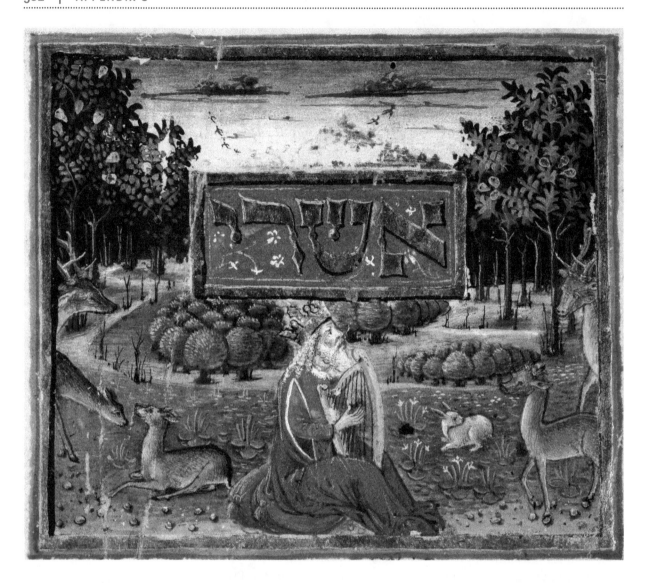

Figure 146. Rothschild
Miscellany, Psalms,
ca. 1460–1480

has been a tradition of art in places of worship for centuries, and in religious Hebrew manuscripts of the Middle Ages one finds an increasing presence of images reflecting the instruments of the tabernacle and the temple, and also some narrative illustration.[2]

2. See Joseph Gutmann, *Hebrew Manuscript Painting* (New York: George Braziller, 1978); also G. Sed-Rajna, *The Hebrew Bible in Medieval Illuminated Manuscripts* (New York: Rizzoli, 1987).

Bibliography

Abrams, M. H. *Natural Supernaturalism: Tradition and Revolution in Romantic Literature.* New York: Norton, 1971.

Addison, Joseph. "XXII. Pleasures of the Imagination." *Spectator* 411 (June 21, 1712).

Ades, Dawn, and Michael R. Taylor. *Dali.* Venice: Rizzoli, in association with the Philadelphia Museum of Art, 2005.

Aertsen, Jan. "Beauty in the Middle Ages: A Forgotten Transcendental?" *Medieval Philosophy and Theology* 1 (1991): 68–97.

Aikenside, Mark. *The Pleasures of the Imagination.* London, 1744.

Alexander of Hales. *Glossa in Quator Libros Sententiarum Petri Lombardi.* P. P. Collegi S. Bonaventurae. Bibliotheca francescana scholastica medi aevi, vols. 12–15. Florence: Quaracchi, 1951–1957.

Alison, James. *Raising Abel: The Recovery of the Eschatological Imagination.* New York: Crossroad, 1996.

Allsopp, Michael E., and David Anthony Downes, eds. *Saving Beauty: Further Studies in Hopkins.* New York: Garland, 1994.

Alter, Robert. *The Art of Biblical Narrative.* New York: Basic Books, 1981.

———. *The Art of Biblical Poetry.* 2nd ed. New York: Basic Books, 2011.

Alyal, Amina. "There's Something about Diana: Ovid and the Development of Reformation Poetics." In *The Survival of Myth: Innovation, Singularity, and Alterity*, edited by David Kennedy and Paul Hardwick, 65–89. Cambridge: Scholars Press, 2010.

Ambrose. *De officiis.* Translated for New Advent as *On the Duties of the Clergy.* New Advent. http://www.newadvent.org/fathers/3401.htm.

Ames-Lewis, Francis, and Mary Rogers, eds. *Concepts of Beauty in Renaissance Art.* London: Ashgate, 1999.

Amishai-Maisels, Ziva. "Gauguin's Early Tahitian Idols." *Art Bulletin* 60, no. 2 (1978): 331–41.

———. "The Jewish Jesus." *Journal of Jewish Art* 9 (1982): 92–96.

———. "Marc Chagall's 'Dedicated to Christ': Sources and Meanings." *Journal of Jewish Art* 21–22 (1995–1996): 68–94.

Anderson, Jonathan A., and William A. Dyrness. *Modern Art and the Life of a Culture: The Religious Impulses of Modernism.* Downers Grove: InterVarsity, 2016.

Andrejev, Vladislav. "Art and Religion: Creativity and the Meaning of 'Image' from the Perspective of the Orthodox Icon." Translated by Nikita Andrejev. *Theology Today* 61 (2004): 53–66.

Apostolos-Cappadona, Diane, ed. *Art, Creativity, and the Sacred: An Anthology in Religion and Art.* Rev. ed. New York: Continuum, 1996.

———. "Beyond Belief: The Artistic Journey." In Rosemary Crumlin, *Beyond Belief: Modern Art and the Religious Imagination,* 21–30. Melbourne: National Gallery of Victoria, 1998.

———. *Dictionary of Christian Art.* New York: Continuum, 1995.

———. "The Essence of Agony: Grünewald's Influence on Picasso." *Artibus et Historiae* 13, no. 26 (1992): 31–47.

Appleyard, Kirsten. "Moi je vis un peu avec les Anges: The Search for Transcendence in the Contemporary Art of Arcabas." Honors thesis, Baylor University, 2009.

ApRoberts, Ruth. *The Biblical Web.* Ann Arbor: University of Michigan Press, 1994.

Aquinas, Thomas. *Summa contra Gentiles.* English translation. New York: Hanover House, 1955–1957. http://dhspriory.org/thomas/ContraGentiles.htm.

———. *Summa theologica.* Translated by the Fathers of the English Dominican Province. 5 vols. Bel Air, CA: Christian Classics, 1981.

Arcabas (Jean-Marie Pirot). Arcabas website. http://www.arcabas.com/accueil/index.php?lalangue=uk.

———. *Arcabas: Passion/Résurrection.* Edited by Fabrice Hadjadi. Paris: Cerf, 2004.

Armstrong, John. *The Secret Power of Beauty.* Rev. ed. Harmondsworth, UK: Penguin Books, 2005.

Auden, W. H. "Postscript: Christianity and Art." In *The New Orpheus,* edited by Nathan A. Scott Jr., 74–79. New York: Sheed and Ward, 1964.

Auerbach, Erich. *Mimesis: The Representation of Reality in Western Literature.* Translated by Willard R. Trask. Princeton: Princeton University Press, 1953.

Augustine. *Augustine's Confessions.* Reedited by Michael P. Foley from the F. J. Sheed edition. Indianapolis and Cambridge: Hackett, 2006.

———. *Confessions.* Translated by J. G. Pilkington. *Nicene and Post-Nicene Fathers,* ser. 1, vol. 1. Peabody, MA: Hendrickson, 1995.

———. *De musica.* Translated by Robert C. Taliaferro. Fathers of the Church, vol. 4. New York: Cima, 1947.

———. *Enarrationes in Psalmos.* Translated by A. Cleveland Cox. *Nicene and Post-Nicene Fathers,* ser. 1, vol. 8. 1888. Peabody, MA: Hendrickson, 1994.

———. *On Christian Doctrine.* Translated by D. W. Robertson Jr. Indianapolis and New York: Bobbs-Merrill, 1958. Translation of *De doctrina Christiana.*

———. *On Order (De ordine).* Translated by Silvano Borruso. South Bend, IN: St. Augustine's Press, 2007.

———. *Saint Augustine: On Free Choice of the Will.* Translated by Anna S. Benjamin and L. H. Hackstaff. Indianapolis and New York: Bobbs-Merrill, 1964. Translation of *De libero arbitrio.*

———. *Tractates on the Gospel of John.* Edited by John W. W. Rettig. Washington, DC: Catholic University of America Press, 1988.

———. *The Works of Saint Augustine*. Edited by John E. Rotelle, OSA. Translated by Edmund Hill, OP. New York: New City Press, 1997.

Austin, Michael. *Explorations in Art, Theology, and Imagination*. New York: Routledge, 2005.

Avis, Paul. *God and the Creative Imagination: Metaphor, Symbol, and Myth in Religion and Theology*. London and New York: Routledge, 1999.

Baggley, John. *Doors of Perception: Icons and Their Spiritual Significance*. London and Oxford: Mowbray, 1987.

Balthasar, Hans Urs von. *The Glory of the Lord: A Theological Aesthetics*. Edited by Joseph Fessio and John Riches. Translated by Andrew Louth, Francis McDonagh, Brian McNeil, et al. 7 vols. San Francisco: Ignatius, 1982–1989.

———. *Theo-Drama: Theological Dramatic Theory*. Translated by Graham Harrison. 5 vols. San Francisco: Ignatius, 1988–1998.

Banchoff, Thomas. "Science, Mathematics and Catholicism: The Four-Dimensional Geometry and Theology of Salvador Dali." South Bend, IN: Notre Dame College of Science, 2014.

Bannister, T. C. "The Constantinian Basilica of St. Peter at Rome." *Journal of the Society of Architectural Historians* 27 (1968): 3–21.

Barasch, Moshe. *Icon: Studies in the History of an Idea*. New York and London: New York University Press, 1992.

Barocchi, P., ed. *Trattati d'arte del Cinquecento*. 2 vols. Rome: Bari, 1960–1962.

Barre, André. *Le symbolisme*. Paris: Joure et cie, 1911.

Barrett, Peter. "Beauty in Physics and Theology." *Journal of Theology for Southern Africa* 94 (March 1996): 65–78.

Barron, Robert. *And Now I See . . . : A Theology of Transformation*. New York: Crossroad, 1998.

Barrow, John D. *The Artful Universe: The Cosmic Source of Human Creativity*. Boston and New York: Little, Brown, 1995.

Barth, J. Robert. "Moral Beauty: Ignatius Loyola, Samuel Taylor Coleridge, and the Role of Imagination in Religious Experience." *Christianity and Literature* 50 (2000): 69–78.

Batailh, Christophe. *La coleur habitée*. Meylan, France: Centre Théologique de Meylan, 2004.

Bataille, Georges. *Visions of Excess: Selected Writings, 1927–1939*. Translated by Alan Stoekl. Minneapolis: University of Minnesota Press, 1985.

Baudelaire, Charles. "Correspondences." In *Les fleurs du mal*, edited by Jacques Crepet and Georges Blin. Paris: Librarie José Corti, 1942.

Bayer, Oswald. *A Contemporary in Dissent: Johann Georg Hamann as a Radical Enlightener*. Translated by Roy A. Harrisville and Mark C. Mattes. Grand Rapids: Eerdmans, 2012.

Beckett, Wendy. *The Gaze of Love: Meditations on Art and Spiritual Transformation*. San Francisco: Harper, 1993.

Beckley, Bill, and David Shapiro, eds. *Uncontrollable Beauty: Toward a New Aesthetics*. New York: Allworth Press, 1998.

Bede, the Venerable. *Bede: On the Tabernacle*. Translated by Arthur G. Holder. Liverpool: Liverpool University Press, 1994.

———. *Bede: On the Temple*. Translated by Seán Connolly. Introduction by Jenni-

fer O'Reilly. Translated Texts for Historians 21. Liverpool: Liverpool University Press, 1995.

Begbie, Jeremy, ed. *Beholding the Glory: Incarnation through the Arts*. Grand Rapids: Baker, 2000.

———. "Christ and the Cultures: Christianity and the Arts." In *The Cambridge Companion to Christian Doctrine*, edited by Colin E. Gunton, 101–18. Cambridge: Cambridge University Press, 1997.

———, ed. *Sounding the Depths: Theology through the Arts*. London: SCM, 2002.

———. *Theology, Music, and Time*. Cambridge: Cambridge University Press, 2000.

———. *Voicing Creation's Praise: Towards a Theology of the Arts*. Edinburgh: T. & T. Clark, 1991.

Bell, Daniel. *The Cultural Contradictions of Capitalism*. New York: Basic Books, 1978, 1998.

Belting, Hans. *Likeness and Presence: A History of the Image before the Era of Art*. Translated by Edmund Jephcott. Chicago: University of Chicago Press, 1994.

Bentley, D. M. R. "Rossetti's 'Ave' and Related Pictures." *Victorian Poetry* 15, no. 1 (1977): 21–35.

Benz, Ernst. *Ecclesia Spiritualis: Kirchenidee und Geschichtstheologie der Franziskanischen Reformation*. Stuttgart: W. Kohlhammer, 1934.

Berlin, Adele. *The Dynamics of Biblical Parallelism*. Bloomington: Indiana University Press, 1985.

Bernard, Émile. "Vincent Van Gogh." *Mercure de France* 40 (April 1893): 26–27.

Bertrand, Anne. "What's Up with Beauty? Questions and Answers." Translated by L. S. Torgoff. *Art Press* 258 (June 2000): 36–44.

Besançon, Alain. *The Forbidden Image: An Intellectual History of Iconoclasm*. Chicago: University of Chicago Press, 2000.

Bicknell, Peter, ed. *The Illustrated Wordsworth's Guide to the Lakes*. Exeter: Webb and Bower, 1984.

Bisconti, Fabrizio, ed. *Termi di iconografia paleochristiana*. Rome: Vatican City, 2000.

———. "Variazioni sul tema della traditio legis: Vecchie e nuove acquisitioni." *Vetera christianorum* 40 (2003): 251–70.

Blackwell, Albert L. "Can Beauty Save Us?" In *The Sacred in Music*, 159–67. Louisville: Westminster John Knox, 1999.

Blavatsky, Helena Petrovna. *The Key to Theosophy*. London: Theosophical Publishing Society, 1890.

Boespflug, François. *Arcabas: Saint-Hughes-de-Chartreuse*. Paris: Cerf, 1988.

———. *Arcabas et les pélerins d' Emmaüs*. Paris: Tricorne, 1995.

Boime, Albert. *Art in an Age of Counterrevolution, 1815–1848*. Chicago: University of Chicago Press, 2004.

———. *Revelation of Modernism: Responses to Cultural Crises in Fin de Siècle Painting*. Columbia: University of Missouri Press, 2008.

Bonaventure. *Breviloquium*. Translated by Erwin Esser Nemmers. Saint Louis: Herder, 1946.

———. *Commentary on the Gospel of Luke*. Edited and translated by Robert J. Karris, OFM. 3 vols. Saint Bonaventure, NY: Franciscan Institute Publications, 2001–2003.

———. *Hexaemeron: Collation on the Six Days.* Translated by Jose de Vinck. In *Collected Works of Bonaventure.* Paterson, NJ: St. Anthony Guild Press, 1984.

———. *Legenda Maior: Bonaventure; The Life of St. Francis.* Edited and translated by Emilie Griffin. New York: HarperCollins, 2005.

———. *Saint Bonaventure's De reductione artium ad theologiam.* Edited and translated by Emma Thérèse Healy. In *Works of Saint Bonaventure,* edited by Philotheus Boehner et al. Saint Bonaventure, NY: Franciscan Institute, 1955.

Bonnel, Roland. "L'art sacré en France et l'icône." In *L'art Français et Francophone depuis 1980,* edited by Michael Bishop and Christopher Elson, 122–29. Amsterdam and New York: Rodopi, 2005.

Borromeo, Federico. *Sacred Painting.* Translated and edited by Kenneth S. Rothwell Jr. Cambridge, MA: I Tatti Renaissance Library, Harvard University Press, 2010.

Börsch-Supan, Helmut. *Caspar David Friedrich.* New York: Braziller, 1974.

Brand, Hilary, and Adrienne Chaplin. *Art and Soul: Signposts for Christians in the Arts.* 2nd ed. Downers Grove: InterVarsity, 2002.

Brand, Peggy Zeglin, ed. *Beauty Matters.* Bloomington and Indianapolis: Indiana University Press, 2000.

Brandstaetter, Roman. *Jezus z Nazaretu.* 1967–1973. Reprint, Zielona Góra: Uniwersytet Zielonogórski, 2004.

———. *Krag biblijny.* Krakow: AA, 2015.

———. *Piesn a moim Chrystusie.* Warsaw: St. Wojciech, 1964.

———. *Slowo nad slowami.* Warsaw: St. Wojciech, 1964.

Breton, André. *Manifestoes of Surrealism.* Translated by Richard Seaver and Helen R. Lane. 2nd ed. Ann Arbor: University of Michigan Press, 2002.

———. *Révolution surrealiste.* Paris: Gallimard, 1924–1929.

Bridge, A. C. *Images of God: An Essay on the Life and Death of Symbols.* London: Hodder and Stoughton, 1960.

Bromberg, Sarah. "The Context and Reception History of the Illuminations in Nicholas of Lyra's *Postilla super totam Bibliam*: Fifteenth-Century Case Studies." PhD diss., University of Pittsburgh, 2013.

Brooks, Linda Marie. *The Menace of the Sublime to the Individual Self: Kant, Schiller, Coleridge, and the Disintegration of Romantic Identity.* Lewiston, NY: Edwin Mellen Press, 1995.

Brown, Carleton, ed. *English Lyrics of the XIII Century.* Oxford: Clarendon, 1932, 1962.

———, ed. *Religious Lyrics of the XIV Century.* Oxford: Oxford University Press, 1970.

Brown, David. *Tradition and Imagination: Revelation and Change.* Oxford: Oxford University Press, 2000.

Brown, David Allen, ed. *Virtue and Beauty: Leonardo's Ginevra de' Benci and Renaissance Portraits of Women.* Princeton: Princeton University Press, 2001.

Brown, Frank Burch. *Good Taste, Bad Taste, and Christian Taste: Aesthetics in Religious Life.* Oxford: Oxford University Press, 2001.

———. *Religious Aesthetics: A Theological Study of Making and Meaning.* Princeton: Princeton University Press, 1989.

Brown, Michelle P. *The Book and the Transformation of Britain, 550–1050.* London: British Library, 2011.

———. *The Lindisfarne Gospels: Society, Spirituality, and the Scribe.* London: British Library; Toronto: University of Toronto Press, 2003.

—————, ed. *The Lion Companion to Christian Art*. Oxford: Lion, 2008.

Brown, William P. *The Ethos of the Cosmos: The Genesis of Moral Imagination in the Bible*. Grand Rapids: Eerdmans, 1999.

Brueggemann, Walter. *David's Truth in Israel's Imagination and Memory*. Minneapolis: Fortress, 1985.

Bruyne, Edgar de. *Etudes d'esthétique médiévale*. 3 vols. Brugge: De Tempel, 1946.

Buechner, Frederick, and Lee Botin. *The Faces of Jesus*. New York and San Francisco: Stearn; Harper and Row, 1989.

Burke, Edmund. *A Philosophical Enquiry into the Origin of Our Ideas on the Sublime and Beautiful*. London, 1757.

Burn-Murdoch, H. *The Development of the Papacy*. New York: Praeger, 1955.

Busch, Werner. *Caspar David Friedrich: Ästhetik und Religion*. Munich: Verlag, 2003.

Buser, Thomas, SJ. "Gauguin's Religion." *Art Journal* 27, no. 4 (1968): 375–80.

Bychkov, Oleg V. "The Reflection of Some Traditional Ideas in the Thirteenth-Century Scholastic Theories of Beauty." *Vivarium* 34 (November 1996): 141–60.

Cahn, Walter. "Architecture and Exegesis: Richard of St. Victor's Ezekiel Commentary and Its Illustrations." *Art Bulletin* 76, no. 1 (1994): 53–68.

Caillois, Roger. *L'homme et le sacré*. Paris: Gallimard, 1950. ET: *Man and the Sacred*. Translated by Meyer Barash. Champaign, IL: Free Press of Glencoe, 1959.

Calvin, John. *Harmony of the Gospels*. In *Calvin's New Testament Commentaries*, edited by David W. Torrance and Thomas F. Torrance. Grand Rapids: Eerdmans, 1972.

—————. *Institutes of the Christian Religion* (1536). Translated by Henry Beveridge. 2 vols. Grand Rapids: Eerdmans, 1981.

Camfield, William A. *Max Ernst: Dada and the Dawn of Surrealism*. Munich: Prestel-Verlag, 1993.

Camille, Michael. *Gothic Art: Glorious Visions*. New York: Harry N. Abrams, 1996.

—————. *The Gothic Idol: Ideology and Image-Making in Medieval Art*. Cambridge: Cambridge University Press, 1995.

Canones et Decreta sacrosancti oecumenica et generalis Consilii Tridentum sub Paulo III, Julio III et Pio IV pontificibus maximis cum Patrum Subscriptionibus. Vienna: J. B. Gress, 1850.

Carr-Gomm, Sarah. *Hidden Symbols in Art: The Illustrated Decoder of Symbols and Figures in Western Painting*. New York: Rizzoli International Publications, 2001.

Carruthers, Mary. *The Craft of Thought: Meditation, Rhetoric, and the Making of Images, 400–1200*. Cambridge: Cambridge University Press, 1998.

—————. *The Experience of Beauty in the Middle Ages*. Oxford: Oxford-Warburg Studies, 2013.

Casciani, Santa, ed. *Dante and the Franciscans*. Leiden: Brill, 2006.

Catholic Encyclopedia. Edited by Charles G. Hebermann et al. 15 vols. New York: Encyclopedia Press, 1908.

Cerullo, John J. *The Secularization of the Soul: Psychical Research in Modern Britain*. Philadelphia: Institute for the Study of Human Issues, 1982.

Cevasco, George A. "Dali's Christianized Surrealism." *Irish Quarterly Review* 45, no. 180 (1956): 437–42.

Chapman, Emmanuel. *Saint Augustine's Philosophy of Beauty*. New York and London: Sheed and Ward, 1939.

Cixous, Hélène, and Catherine A. F. MacGillvray. "Bathsheba, or the Interior Bible." *New Literary History* 24, no. 4 (1993): 820–36.

Claridge, Amanda. *Rome: An Oxford Annotated Archaeological Guide.* Oxford: Oxford University Press, 1998.

Clark, Kenneth. *The Nude: A Study in Ideal Form.* Princeton: Princeton University Press, 1972.

———. *Rembrandt and the Italian Renaissance.* London and New York: New York University Press, 1966.

Clayton, David. "What Is the Place of the Nude in Sacred Art?" In *The Beauty of God's House: Essays in Honor of Stratford Caldecott,* edited by Francesca Aran Murphy. Eugene, OR: Cascade Books, 2014.

Cole, K. C. *The Universe and the Teacup: The Mathematics of Truth and Beauty.* Fort Washington, PA: Harvest Books, 1999.

Coleman, Earle J. "The Beautiful, the Ugly, and the Tao." *Journal of Chinese Philosophy* 18 (1991): 213–26.

———. *Creativity and Spirituality: Bonds between Art and Religion.* Albany: State University of New York Press, 1998.

Cook, G. H. *English Monasteries in the Middle Ages.* London: Phoenix, 1961.

Cory, Herbert Ellsworth. "The Interactions of Beauty and Truth." *Journal of Philosophy* 22, no. 15 (July 1925): 393–402.

Coulton, G. G. *Art and the Reformation.* Oxford: Basil Blackwell, 1928.

Couturier, M. A. *Sacred Art.* Austin: University of Texas Press, 1989.

Cowan, Louise. "The Frail Strength of Beauty." Accessed October 14, 2016. http://dallasinstitute.org/our-story/archive/the-frail-strength-of-beauty/.

Cropper, Elizabeth, and Charles Dempsey. *Nicolas Poussin: Friendship and the Love of Painting.* Princeton: Princeton University Press, 1996.

Crumlin, Rosemary. *Beyond Belief: Modern Art and the Religious Imagination.* Melbourne: National Gallery of Victoria, 1998.

Cursor mundi. Edited by Richard Morris. 3 vols. Early English Text Society. London: Oxford University Press, 1875; reprinted 1966.

Dali, Salvador. *The Collected Writings of Salvador Dali.* Edited by Haim Finkelstein. Cambridge: Cambridge University Press, 1998.

Dante Alighieri. *Purgatorio.* Translated by Anthony Esolen. New York: Modern Library, 2004.

———. *La vita nuova.* Translated by Barbara Reynolds. Harmondsworth, UK: Penguin, 1969.

Danto, Arthur. *The Abuse of Beauty: Aesthetics and the Concept of Art.* Peru, IL: Open Court, 2003.

———. "Picasso and the Portrait." *Nation* 263, no. 6 (August 1996): 31–35.

Davenport, Nancy. "The Revival of Fra Angelico and Matthias Grünewald in Nineteenth-Century French Religious Art." *Nineteenth-Century French Studies* 27, no. 1–2 (1998–1999): 157–99.

Dawtry, Anne, and Christopher Irvine. *Art and Worship.* Collegeville, MN: Liturgical Press, 2002.

Dean, William D. *Coming To: A Theology of Beauty.* Philadelphia: Westminster, 1972.

Deckers, Johannes G. "Constantine the Great and Early Christian Art." In *Picturing*

the Bible: The Earliest Christian Art, edited by Jeffrey Spier. New Haven: Yale University Press, 2007.

de Clippel, Karolien, Katharina Van Cauteren, and Katlijne van Stighelen, eds. The Nude and the Norm in the Early Modern Low Countries. Turnhout: Brepols, 2001.

De Gruchy, John W. Christianity, Art, and Transformation: Theological Aesthetics in the Struggle for Justice. Cambridge: Cambridge University Press, 2001.

———. "Holy Beauty: A Reformed Perspective on Aesthetics within a World of Unjust Ugliness." Accessed October 14, 2016. https://www.calvin.edu/admin/provost/faith/documents/holy_beauty.pdf.

Dekoninck, Ralph. "Art Stripped Bare by the Theologians, Even: Image of Nudity/Nudity of Image in the Post-Tridentine Religious Literature." In The Nude and the Norm in the Early Modern Low Countries, edited by Karolien de Clippel et al., 109–15. Turnhout: Brepols, 2011.

De Laet, Veerle. "Een Naeckt Kindt, een Naeckt Vrauwken ende Ander Figueren: An Analysis of Nude Representations in the Brussels Domestic Setting." In The Nude and the Norm in the Early Modern Low Countries, edited by Karolien de Clippel et al., 117–28. Turnhout: Brepols, 2011.

della Chiesa, Angelina Ottio. The Complete Paintings of Leonardo da Vinci. New York: Abrams, 1967.

Dennis, John. Miscellanies (1693). In The Critical Works of John Dennis, edited by E. N. Hooker. 2 vols. Baltimore: Johns Hopkins University Press, 1939.

Derbes, Anne. Picturing the Passion in Late Medieval Italy: Narrative Painting, Franciscan Ideologies, and the Levant. Cambridge: Cambridge University Press, 1996.

De Regt, H. W. "Beauty in Physical Science circa 2000." International Studies in the Philosophy of Science 16, no. 1 (March 2002): 95–103.

Descharmes, Robert, and Giles Néret. Salvador Dali, 1904–1989. Berlin: Benedict Taschen, 1994.

Devlin, K. "Beauty from Chaos." Mathematics: The New Golden Age, chap. 4. New York: Columbia University Press, 1999.

D'Hulst, R.-A., and M. Vandenven. Rubens: The Old Testament. Translated by P. S. Falla. New York: Oxford University Press, 1989.

Dickens, W. T. Hans Urs von Balthasar's Theological Aesthetics: A Model for Post-Critical Biblical Interpretation. South Bend, IN: University of Notre Dame Press, 2003.

Dickson, Gwen Griffith. Johan Georg Hamann's Relational Metacriticism. Berlin: Walter de Gruyter, 1995.

Dijkstra, Roald. The Apostles in Early Christian Art and Poetry. Supplements to Vigiliae Christianae, vol. 134. Leiden: Brill, 2016.

Dillenberger, Jane. Image and Spirit in Sacred and Secular Art. New York: Crossroad, 1990.

———. Style and Content in Christian Art: From the Catacombs to the Chapel Designed by Matisse at Vence, France. New York and Nashville: Abingdon, 1965.

Dillenberger, Jane Dagget, and John Handley. The Religious Art of Pablo Picasso. Berkeley: University of California Press, 2014.

Doering, Bernard. "Lacrimae rerum—Tears at the Heart of Things: Jacques Maritain and Georges Rouault." In Truth Matters: Essays in Honor of Jacques Maritain,

edited by John G. Trapani Jr., 204–23. Washington, DC: Maritain Association and Catholic University of America Press, 2004.

Donne, John. *Selections from Divine Poems, Sermons, Devotions, and Prayers*. Edited by John Booty. New York: Paulist, 1990.

Donnelly, Phillip. "Enthusiastic Poetry and Rationalized Christianity: Poetic Theory of John Dennis." *Christianity and Literature* 54, no. 2 (2005): 236–64.

Donoghue, Denis. "Every Wrinkle the Touch of a Master." *Sewanee Review* 110, no. 2 (Spring 2002): 215–30.

———. *Speaking of Beauty*. New Haven: Yale University Press, 2003.

Drew, Rodger. *The Stream's Secret: The Symbolism of Dante Gabriel Rossetti*. Cambridge: Lutterworth, 2007.

Drury, John. *Painting the Word: Christian Pictures and Their Meaning*. New Haven: Yale University Press, 1999.

Dubay, Thomas. *The Evidential Power of Beauty: Science and Theology Meet*. San Francisco: Ignatius, 1999.

Duby, Georges. *The Europe of the Cathedrals, 1140–1280*. Translated by Stuart Gilbert. Geneva: Editions d'Art Albert Skira, 1966.

———. *Medieval Art: The Making of Christian West, 980–1140*. Geneva: Bookking International, 1995.

Duffy, Eamon. *The Stripping of the Altars: Traditional Religion in England, 1400–1580*. New Haven: Yale University Press, 1992, 2005.

Dunaway, John M., and Eric O. Springsted, eds. *The Beauty That Saves: Essays on Aesthetics and Language in Simone Weil*. Macon, GA: Mercer University Press, 1996.

Dupré, Louis. *Symbols of the Sacred*. Grand Rapids: Eerdmans, 2000.

Dutton, Denis. "Kant and the Conditions of Artistic Beauty." *British Journal of Architecture* (July 1994): 226–41.

Dwyer, Ruth. "Boethius, the Quadrivium and the *Hagia Sophia*." YouTube, June 17, 2013. https://www.youtube.com/watch?v=q3rOdkfQgAc.

Dyrness, William A. "Aesthetics in the Old Testament: Beauty in Context." *Journal of the Evangelical Theological Society* 28 (1985): 421–32.

———. *Rouault: A Vision of Suffering and Salvation*. Grand Rapids: Eerdmans, 1971.

———. *Visual Faith: Art, Theology, and Worship in Dialogue*. Grand Rapids: Baker, 2001.

Eastwood, Bruce. "The Case of Grosseteste's Optics." *Speculum* 43, no. 2 (1968): 306–21.

Eck, Johannes. *De non tollendis Christi et sanctorum imaginibus contra haeresim Faelicianam sub Carolo magno damnatum. . . .* Ingolstadt, 1522.

Eco, Umberto. *The Aesthetics of Thomas Aquinas*. Translated by Hugh Bredin. Cambridge, MA: Harvard University Press, 1988.

———. *Art and Beauty in the Middle Ages*. Translated by Hugh Bredin. New Haven: Yale University Press, 1986.

———, ed. *History of Beauty*. Translated by Alastair McEwen. New York: Rizzoli, 2004.

Elgin, C. Z. "Creation as Reconfiguration: Art in the Advancement of Science." *International Studies in the Philosophy of Science* 16, no. 1 (March 2002): 13–25.

Elsner, Jas. *Imperial Rome and Christian Triumph: The Art of the Roman Empire, AD 100–450*. Oxford: Oxford University Press, 1998. Pp. 145–65.

Emmer, M., ed. *The Visual Mind: Art and Mathematics*. Cambridge, MA: MIT Press, 1993.

Engemann, Josef. *Deutung und Bedeutung frühchristlicher Bildwerke*. Darmstadt, 1997.

Engler, G. "Aesthetics in Science and Art." *British Journal of Aesthetics* 30, no. 1 (January 1990): 24–34.

Erickson, Kathleen Powers. *At Eternity's Gate: The Spiritual Vision of Vincent van Gogh*. Grand Rapids: Eerdmans, 1998.

Erickson, Kathleen Powers, and David G. Murphy. "Testimony to Theo: Vincent van Gogh's Witness of Faith." *Church History* 61, no. 2 (1992): 206–20.

Ernst, Max. "Some Data on the Youth of M.E." In *Beyond Painting and the Other Writings by the Artist and His Friends*, translated by Dorothea Tanning, edited by Robert Motherwell. Documents of Modern Art. New York: Wittenborn, Shultz, 1948.

———. *Une Semaine de Bonté* (A week of kindness): *A Surrealistic Novel in Collage*. Translated by Stanley Applebaum. New York: Dover, 1976.

Erp, S. van. *The Art of Theology: Hans Urs von Balthasar's Theological Aesthetics and the Foundations of Faith*. Leuven: Peeters, 2004.

Eusden, John Dykstra, and John H. Westerhoff III. *Sensing Beauty: Aesthetics, the Human Spirit, and the Church*. Cleveland: United Church Press, 1998.

Eusebius. *The History of the Church from Christ to Constantine*. Translated by G. A. Williamson. New York: Dorset Press, 1965. Translation of *Historia ecclesiae*.

Evans, Joan, and Mary Serjeantson, eds. *English Medieval Lapidaries*. Early English Text Society, o.s., 190. London: Oxford University Press, 1933.

Evdokimov, Paul. *The Art of the Icon: A Theology of Beauty*. Translated by Sven Bigham. Redondo Beach, CA: Oakwood Publications, 1990.

Fanés, Felix. *Salvador Dali: The Construction of the Image, 1925–1930*. New Haven: Yale University Press, 2007.

Farley, Edward. *Faith and Beauty: A Theological Aesthetic*. Aldershot, UK: Ashgate, 2001.

Farrer, Austin. *The Glass of Vision*. Bampton Lectures for 1948. Glasgow: University Press, 1948.

Ferguson, George. *Signs and Symbols in Christian Art*. Oxford and New York: Oxford University Press, 1961.

Ferreter, Luke. "The Power and the Glory: The Aesthetics of the Hebrew Bible." *Literature and Theology* 18, no. 2 (2004): 123–38.

Fields, Stephen. "The Beauty of the Ugly: Balthasar, the Crucifixion, Analogy and God." *International Journal of Systematic Theology* 9, no. 2 (2007): 172–83.

Finaldi, Gabriele. *The Image of Christ*. London and New Haven: National Gallery of London and Yale University Press, 2000.

Finney, Paul Corby. *The Invisible God: The Earliest Christians on Art*. Oxford: Oxford University Press, 1994.

———, ed. *Seeing beyond the Word: Visual Arts and the Calvinist Tradition*. Grand Rapids: Eerdmans, 1999.

Firpo, Massimo. "Storia religioso e storia dell'arte: I casi di Iacopo Pantormo e Lorenzo Lotto." *Belgafor: Rassegna di Varia Umanità* 59 (2004): 571–90.

Flanagan, Kieran. *Seen and Unseen: Visual Culture, Sociology, and Theology*. Basingstoke, UK: Palgrave Macmillan, 2004.

Fleming, John V. *From Bonaventure to Bellini: An Essay in Franciscan Exegesis*. Princeton: Princeton University Press, 1982.

Flora, Holly. *The Devout Belief of the Imagination: The Meditations on the Life of Christ and Female Franciscan Spirituality in Trecento Italy*. Turnhout: Brepols, 2009.

Flora, Holly, and Soo Yun Kang. *Georges Rouault's Miserere et Guerre: This Anguished World of Shadows*. New York: Museum of Biblical Art, 2006.

Florisoone, Michel. *Renoir*. New York: Hyperion, 1938.

Forrestier, Sylvie. *Résistance, résurrection et libération de Marc Chagall*. Rennes: Editions Ouest-France, 1990.

Francis of Assisi. "Rule." In *St. Francis of Assisi: Writing and Early Biographies*, edited by Marion A. Habig, 27–64. Chicago: Franciscan Herald Press, 1975.

Frank, Mitchell Benjamin. *German Romantic Painting Redefined: Nazarene Tradition and the Narratives of Romanticism*. Aldershot, UK: Ashgate, 2001.

Fraser, Hilary. *Beauty and Belief: Aesthetics and Religion in Victorian Literature*. New York: Cambridge University Press, 1986.

Freedberg, D. "Johannes Molanus on Provocative Paintings: *De historia sanctarum imaginum et picturarum*, book II, ch. 42." *Journal of the Warburg and Courtauld Institutes* 34 (1971): 229–45.

Friedman, Mira. "Marc Chagall's Portrayal of the Prophet Jeremiah." *Zeitschrift für Kunstgeschichte* 47, no. 3 (1984): 374–91.

Frisch, Teresa G. *Gothic Art, 1140–c. 1450: Sources and Documents*. Medieval Academy Reprints for Teaching #20. Toronto: University of Toronto Press, 1971.

Fujimura, Makoto. *Hours*. New York: Dillon Gallery, 1998.

———. *Images of Grace*. New York: Dillon Gallery, 1997.

Fujimura, Makoto, with Michael C. Sack and Kenjui Yagi. *Restaurant of the Soul*. Japan: Cultural Insights, 1999.

Fuller, Peter. *Theoria: Art and the Absence of Grace*. London: Chatto and Windus, 1988.

Gadamer, Hans-Georg. *The Relevance of the Beautiful and Other Essays*. Edited by Robert Bernasconi. Translated by Nicholas Walker. Cambridge: Cambridge University Press, 1986.

Gallavotti Cavallero, Daniella. "From Counter-Reformation to Baroque: Aspects of the Arts in Rome." In *The Lion Companion to Christian Art*, edited by Michelle P. Brown, 269–72. Oxford: Lion Hudson, 2008.

Garcia-Rivera, Alejandro. *The Community of the Beautiful: A Theological Aesthetics*. Collegeville, MN: Liturgical Press, 1999.

———. *A Wounded Innocence: Sketches for a Theology of Art*. Collegeville, MN: Liturgical Press, 2003.

Gawronski, Raymond. "The Beauty of the Cross: The Theological Aesthetics of Hans Urs von Balthasar." *Logos* 5, no. 3 (Summer 2002): 185–206.

George, Waldemar. "Georges Rouault: Oeuvres inédits." *La Renaissance* 5 (1937): 3–10.

Gerhardt, Paul. *Spiritual Songs*. Translated by John Kelly. London: Alexander Strahan, 1867.

Gibbs, A. C., ed. *Middle English Romances*. Evanston, IL: Northwestern University Press, 1966.

Gibson, Ian. *The Shameful Life of Salvador Dali*. New York: Norton, 1997.

Gilberton, Carol, and Gregg Muilenburg, eds. *Translucence: Religion, the Arts, and Imagination*. Minneapolis: Fortress, 2004.

Gilbert-Rolfe, Jeremy. *Beauty and the Contemporary Sublime.* New York: Allworth, 2001.

Gilboa, Anat. *Images of the Feminine in Rembrandt's Work.* Delft: Euberon, 2003.

Gilson, Etienne. *Arts of the Beautiful.* New York: Scribner, 1965.

Ginzberg, Louis. *The Legends of the Jews.* Philadelphia: Jewish Publication Society of America, 1967.

Glen, Thomas L. *Rubens and the Counter-Reformation: Studies in His Religious Paintings between 1609 and 1620.* New York and London: Garland, 1977.

Goethe, Wolfgang. *Dichtungen.* In *The Poems of Goethe: Translated in the Original Metres,* translated by Edgar Alfred Bowring. New York: Hurst, 1853.

Gogh, Vincent van. *The Complete Letters of Vincent van Gogh, with Reproductions of All the Drawings in the Correspondence.* 3 vols. Boston: New York Graphic Society, 1958, 1981.

Gorin, Daniel. "The Quest for Spiritual Purity and Sexual Freedom: Gauguin's Primitive Eve." *Valley Humanities Review* (Spring 2010): 1–11.

Grabar, André. *Christian Iconography: A Study of Its Origins.* Bollingen Series, no. 35. Princeton: Princeton University Press, 1968.

Graffius, Jan, ed. *Rubens' Life of St. Ignatius.* Stonyhurst, UK: St. Omers Press, 2005.

Grant, Patrick. *The Letters of Vincent van Gogh: A Critical Study.* Edmonton: Athabasca University Press, 2014.

———. *The Transformation of Sin: Studies in Donne, Herbert, Vaughan, and Traherne.* Montreal: McGill-Queen's University Press, 1974.

Grave, Johannes. *Caspar David Friedrich.* Munich: Prestel, 2012.

Gray, Thomas. *The Correspondence of Thomas Gray.* Edited by Padget Jackson Toynbee, Leonard Wibley, and Herbert W. Starr. Oxford: Clarendon, 1971.

Green, Garrett. *Imagining God: Theology and the Religious Imagination.* Grand Rapids: Eerdmans, 1989.

Greene, R. L., ed. *The Early English Carol.* Oxford: Clarendon, 1975.

Gregory, Brad. *The Unintended Reformation: How a Religious Revolution Secularized Society.* Cambridge, MA: Belknap Press of Harvard University Press, 2012.

Gregory the Great. *Morals on the Book of Job by S. Gregory the Great.* 3 vols. Oxford: John Henry Parker, 1844. Translation of *Moralia in Iob.*

Grewe, Cordula. "Historicism and the Symbolic Imagination in Nazarene Art." *Art Bulletin* 89, no. 1 (2007): 82–107.

Groothuis, Douglas. "True Beauty: The Challenge to Postmodernism." In *Truth Decay: Defending Christianity against the Challenges of Postmodernism,* 239–62. Downers Grove: InterVarsity, 2000.

Grosseteste, Robert. *On the Six Days of Creation.* Translated by Christopher Martin. Auctores Britanici Medii Aevi. Oxford: Oxford University Press for the British Academy, 1999. Translation of *In Hexaemeron.*

Gutmann, Joseph. *Hebrew Manuscript Painting.* New York: George Braziller, 1978.

Guyer, Paul. "Beauty and Utility in Eighteenth-Century Aesthetics." *Eighteenth-Century Studies* 35, no. 3 (2002): 439–53.

Hadot, Ilsetraut. *Arts libéraux et philosophie dans la pensée antique.* Paris, 1984.

Hales, Shelley, and Joanna Paul, eds. *Pompeii in the Public Imagination from Its Rediscovery to Today.* Oxford: Oxford University Press, 2011.

Hanby, Michael. *Augustine and Modernity.* London and New York: Routledge, 2003.

Harbinson, Colin. "The Arts: A Biblical Framework." In *Artrageous: Essays and Lectures by Cornerstone Festival Speakers*, 1–13. Chicago: Cornerstone Press, 1992.

Harned, David Bailey. *Theology and the Arts*. Philadelphia: Westminster, 1966.

Harries, Richard. *Art and the Beauty of God: A Christian Understanding*. London: Mowbray, 2000.

———. *The Passion in Art*. Ashgate Studies in Theology, Imagination, and the Arts. London: Ashgate, 2004.

Harris, Nathaniel. *The Masterworks of Van Gogh*. London: Paragon, 1996.

Harrison, Carol. *Beauty and Revelation in the Thought of Saint Augustine*. Oxford: Clarendon, 1992.

———. "An Essay in Saint Augustine's Aesthetics." *Federación Agustiniana Española, Estudio Agustiniano* (1990): 205–15.

Harshav, Benjamin. *Marc Chagall and His Times: A Documentary Narrative*. Stanford: Stanford University Press, 2004.

———. *Marc Chagall and the Lost Jewish World: The Nature of Chagall's Art and Iconography*. New York: Rizzoli International, 2006.

Hart, David Bentley. *The Beauty of the Infinite: The Aesthetics of Christian Truth*. Grand Rapids: Eerdmans, 2003.

Hart, Trevor. *Between the Image and the Word: Theological Engagements with Imagination, Language, and Literature*. Ashgate Studies in Theology, Imagination, and the Arts. London: Routlege, 2013.

———. *Making Good: Creation, Creativity, and Artistry*. Waco: Baylor University Press, 2014.

Hausherr, Rudolph. "Templum Salomonis und Ecclesia Christi: Zu einem Bildvergleich des *Bible moralisée*." *Zeitschrift für Kunstgeschichte* 31 (1968): 101–21.

Havely, Nick. *Dante and the Franciscans: Poverty and the Papacy in the "Commedia."* Cambridge Studies in Medieval Literature. Cambridge: Cambridge University Press, 2009.

Hediger, Christine, ed. *La Sainte-Chapelle de Paris: Royaume de France ou Jérusalem céleste?* Actes du Colloque. Paris, College de France, 2001. Turnhout: Brepols, 2007.

Hegel, Georg. *Introductory Lectures on Aesthetics*. Translated by Bernard Bosanquet. Edited by Michael Inwood. London and New York: Penguin Books, 1993. Translation of *Vorlesung über die Aesthetik* (1828).

Heisenberg, Werner. "Science and the Beautiful." In *Alexandria*, vol. 4, edited by David Fideler, 25–40. Grand Rapids: Phanes Press, 1997.

Heller, Scott. "Wearying of Cultural Studies, Some Scholars Rediscover Beauty." *Chronicle of Higher Education* (December 4, 1998): A15–16.

Hempton, David. *Evangelical Disenchantment: Nine Portraits of Faith and Doubt*. New Haven: Yale University Press, 2008.

Henderson, Linda Dalrymple. *The Fourth Dimension and Non-Euclidian Geometry in Modern Art*. Rev. ed. Boston: MIT Press, 2013.

Herbert, George. *The Works of George Herbert*. Edited by F. E. Hutchinson. Oxford: Clarendon, 1941.

Herder, Johann Gottfried. *On the Cognition and Sensation of the Human Soul* (1778). In *Selected Writings on Aesthetics*, translated and edited by Gregory Moore. Princeton: Princeton University Press, 2006.

Hergott, Fabrice, and Sarah Whitfield, eds. *Georges Rouault: The Early Years, 1903–1920*. London: Royal Academy of Arts, and Lund Humphries, 1993.

Heyer, George S., Jr. *Signs of Our Times: Theological Essays on Art in the Twentieth Century*. Edinburgh: Handsel, 1980.

Hildebrand, Alice von. "Debating Beauty: Jacques Maritain and Dietrich von Hildebrand." *Crisis* (July/August 2004): 38–41.

Hill, John Spencer. *Imagination in Coleridge*. London: Macmillan, 1978.

Hiscock, Nigel. *The Wise Master Builder: Platonic Geometry in Plans of Medieval Abbeys and Cathedrals*. Aldershot, UK: Ashgate, 2000.

Hodges, John Mason. "Aesthetics and the Place of Beauty in Worship." *Reformation and Revival* 9 (2000): 59–74.

Hoffman, Matthew. *From Rebel to Rabbi: Reclaiming Jesus and the Making of Modern Jewish Culture*. Stanford: Stanford University Press, 2007.

Hofmann, Werner. *Caspar David Friedrich*. London: Thames and Hudson, 2000.

Hofstadter, Albert. "Kant's Aesthetic Revolution." *Journal of Religious Ethics* 3 (Fall 1975): 171–91.

Holder, A. G. "The Mosaic Tabernacle in Early Christian Exegesis." *Studia Patristica* 25 (1993): 101–6.

Holmes, Lewis M. *Kosegarten's Cultural Legacy: Aesthetics, Religion, Literature, Art, and Music*. New York: Peter Lang, 2005.

Hopkins, Gerard Manley. *Mortal Beauty, God's Grace: Major Poems and Spiritual Writings of Gerard Manley Hopkins*. New York: Vintage, 2003.

Hornik, Heidi, and Mikeal Parsons. *Illuminating Luke: The Infancy Narrative in Renaissance Painting*. Valley Forge, PA: Trinity, 2003.

———. *Illuminating Luke: The Passion and Resurrection Narratives in Italian Renaissance and Baroque Painting*. London: T. & T. Clark, 2007.

———. *Illuminating Luke: The Public Ministry of Christ in Italian Renaissance and Baroque Painting*. London: T. & T. Clark, 2005.

Hugh of St. Victor. *Exposition on the Celestial Hierarchies of St. Dionysius the Areopagite*. Latin text edited by J.-P. Migne. In Patrologia Latina 175, cols. 923–1154.

Huhn, Tom. "Burke's Sympathy for Taste." *Eighteenth-Century Studies* 35, no. 3 (2002): 379–93.

Huntley, H. E. *The Divine Proportion: A Study in Mathematical Beauty*. New York: Dover, 1970.

Hurtado, Larry. "The Staurogram in Early Christian Manuscripts: The Earliest Visual Reference to the Crucified Jesus?" In *New Testament Manuscripts*, edited by Thomas Kraus, 207–26. Leiden: Brill, 2006.

Huysmans, Joris-Karl. *The Road from Decadence: From Brothel to Cloister; Selected Letters of J.-K. Huysmans*. Edited by Barbara Beaumont. London: Athlone, 1989.

Jaeger, C. Stephen. *The Envy of Angels: Cathedral Schools and Social Ideals in Medieval Europe, 950–1200*. Philadelphia: University of Pennsylvania Press, 1994.

Jaeger, Werner. *Paideia: The Ideals of Greek Culture*. 3 vols. Oxford: Basil Blackwell, 1944.

Jantzen, Grace. "Beauty for Ashes: Notes on the Displacement of Beauty." *Literature and Theology* 16, no. 4 (December 2002): 427–49.

———. *Foundations of Violence: Desire and the Displacement of Beauty*. London: Routledge, 2004.

Jaworska, Wladyslawa. "'Christ in the Garden of Olive Trees' by Gauguin: The Sacred or the Profane?" *Artibus et Historiae* 19, no. 37 (1998): 84.

Jeffrey, David Lyle, ed. *By Things Seen: Reference and Recognition in Medieval Thought.* Ottawa: University of Ottawa Press, 1979.

———. "The Christ of Marc Chagall." *First Things* (April 2014): 26–30.

———. *The Early English Lyric and Franciscan Spirituality.* Lincoln: University of Nebraska Press, 1975.

———. *Houses of the Interpreter: Reading Scripture, Reading Culture.* Waco: Baylor University Press, 2003.

———. *Luke: A Theological Commentary.* Grand Rapids: Baker, 2013.

———. "Medieval Hebrew Bibles: Art and Illumination." In *The Book of Books: Biblical Canon, Dissemination, and Its People*, edited by J. Pattengale, L. M. Schiffman, and F. Vukosavovic, 66–72. Jerusalem: Bible Lands Museum, 2013.

———. "Medieval Monsters: Skôgsra, eoten, feond, þyrs." In *Manlike Monsters*, edited by Marjorie Halpin and Michael M. Ames, 47–64. Vancouver: University of British Columbia Press, 1980.

———. "Meditation and Atonement in the Art of Marc Chagall." *Religion and the Arts* 16, no. 3 (2012): 211–30.

———. *People of the Book: Christian Identity and Literary Culture.* Grand Rapids: Eerdmans, 1996.

Jeffrey, David Lyle, and Brian J. Levy, eds. *The Anglo-Norman Lyric: An Anthology.* Toronto: Pontifical Institute of Medieval Studies, 1990, 2006.

Jensen, Robin Margaret. "Early Christian Images and Exegesis." In *Picturing the Bible: The Earliest Christian Art*, edited by Jeffrey Spier, 65–85. New Haven and London: Yale University Press, 2007.

———. *Understanding Early Christian Art.* London: Routledge, 2000.

Jenson, Robert W. "Beauty." In *Essays in Theology of Culture.* Grand Rapids: Eerdmans, 1995.

Jirat-Wassutynski, Vojtech. "Paul Gauguin's 'Self-Portrait with Halo and Snake': The Artist as Initiate and Magus." *Art Journal* 46, no. 1 (1987): 22–28.

John of Damascus. *On the Divine Images: Three Apologies against Those Who Attack the Divine Images.* Translated by David Anderson. Crestwood, NY: St. Vladimir's Seminary Press, 1980.

John Paul II. *Letter to Artists.* Chicago: Liturgy Training Publications, 1999. Also available as "Letter of His Holiness John Paul II to Artists." Vatican website, April 4, 1999. http://w2.vatican.va/content/john-paul-ii/en/letters/1999/documents/hf_jp-ii_let_23041999_artists.html.

———. *Man and Woman He Created Them: A Theology of the Body.* Translated by Michael Waldstein. Boston: Pauline, 2006.

———. "Unveiling of the Restorations of Michelangelo's Frescos in the Sistine Chapel." Catholic News Agency, April 8, 1994. http://www.catholicnewsagency.com/document/unveiling-of-the-restorations-of-michelangelos-frescos-in-the-sistine-chapel-708/.

Johnson, Kirstin Jeffrey. "Transformative Reception: Arcabas, L'onction du Nard." *ArtWay Meditations* (March 27, 2011).

Jones, Robert W. *Gender and the Formation of Taste in Eighteenth-Century Britain: The Analysis of Beauty.* New York: Cambridge University Press, 1998.

Jordan, Alyce A. *Visualizing Kingship in the Windows of the Sainte-Chapelle*. Turnhout: Brepols, 2002.

Josephus, Flavius. *Complete Works*. Translated by William Whiston. Grand Rapids: Kregel, 1960.

Kames, Lord [Henry Home]. *Sketches of the History of Man*. 3 vols. London, 1778.

Kandinsky, Wassily. *Concerning the Spiritual in Art*. Translated by M. T. H. Sadler. New York: Dover, 1977.

Kant, Immanuel. *Critique of Judgment*. Translated by Werner S. Pluhar. Indianapolis: Hackett, 1987.

———. *Observations on the Feeling of the Beautiful and Sublime*. Translated by John T. Goldthwaite. Berkeley: University of California Press, 1991.

Keats, John. *The Poems of John Keats: A Sourcebook*. Edited by John Strachan. New York: Routledge, 2003.

———. *The Poetical Works of John Keats*. Edited by H. Buxton Forman. London: Oxford University Press, 1937.

Kermode, Frank. *The Genesis of Secrecy*. Cambridge, MA: Harvard University Press, 1979.

Kessler, Herbert L. "Bright Gardens of Paradise." In *Picturing the Bible: The Earliest Christian Art*, edited by Jeffrey Spier, 111–40. London and New Haven: Yale University Press, 2007.

———. *Spiritual Seeing: Picturing God's Invisibility in Medieval Art*. Philadelphia: University of Pennsylvania Press, 2000.

Kirwan, James. *Beauty*. Manchester: Manchester University Press, 1999.

Kitson, Michael. *The Complete Paintings of Caravaggio*. New York: Harry N. Abrams, 1967.

Kittel, Gerhard, ed. *Theological Dictionary of the NBew Testament*. Translated by Geoffrey W. Bromiley. 10 vols. Grand Rapids: Eerdmans, 1965.

Klein, Robert. *Form and Meaning: Writings on the Renaissance and Modern Art*. Princeton: Princeton University Press, 1979.

Koerner, Joseph Leo. *Caspar David Friedrich and the Subject of Landscape*. 2nd ed. London: Reaktion Books, 2009.

Kogman-Appel, K. *Jewish Book Art between Islam and Christianity: The Decoration of Hebrew Bibles in Medieval Spain*. Medieval and Early Modern Iberian World 19. Leiden and Boston: Brill, 2004.

Kren, Thomas. "Bathsheba Imagery in French Books of Hours Made for Women, ca. 1470–1500." In *The Medieval Book: Glosses from Friends and Colleagues of Christopher de Hamel*, edited by James H. Marrow et al. 't Goy, Houten, Netherlands: Hes & de Graaf, 2010.

Krinsky, Carol Herselle. "Representations of the Temple of Jerusalem before 1500." *Journal of the Warburg and Courtauld Institutes* 13 (1970): 1–19.

Kroegel, A. Galizzi. "Giovanni Andrea Gilio da Fabriano, Due Dialogi . . . , Camerino 1564." In *Arte e persuasione: La strategia delle immagini dopo il concilio di Trento*. Trento, Italy: Museo Diocesano Tridentino-Tipografia Editrice Temi, 2014.

Lamoureux, Patricia, and Kevin J. O'Neil, eds. *Seeking Goodness and Beauty: The Use of the Arts in Theological Ethics*. Lanham, MD: Rowman and Littlefield, 2005.

Landow, George. *William Holman Hunt and Typological Symbolism*. New Haven: Yale University Press, 1979.

Landy, Francis. "Beauty and the Enigma: An Inquiry into Some Interrelated Episodes of the Song of Songs." *Journal for the Study of the Old Testament* 17 (1980): 55–106.

LeClercq, Jean. "Le Sermon sur la Royauté du Christ du moyen age." *Archives d'histoire doctrinale et littéraire du moyen age* 18 (1943–1945): 143–80.

Lee-Thorp, Karen, and Cynthia Hicks. *Why Beauty Matters*. Colorado Springs: NavPress, 1997.

Leeuw, Geraardus van der. *Sacred and Profane Beauty*. New York: Holt, Rinehart and Winston, 1963.

Le Floch, Jean-Claude. *Le signe de contradiction: Essai sur Georges de La Tour at son oeuvre*. Rennes: Presses universitaires de Rennes 2, 1995.

Leigh, Catesby. "The Stones of Babel: Modernist Sacred Architecture and the Mortification of the Senses." *Touchstone: A Journal of Mere Christianity*, May/June 1999. http://www.touchstonemag.com/archives/article.php?id=12-03-022-f.

Leithart, Peter J. "Making and Mis-making: Poiesis in Exodus 25–40." *International Journal of Systematic Theology* 2, no. 3 (November 2000): 307–18.

Léon-Martin, Louis. "Jacques Maritain." *Art et décoration* 57 (1930): 110–14.

Le Targat, François. *Marc Chagall*. New York: Rizzoli International, 1985.

Levinas, Emmanuel. "Transcendence and Intelligibility." In *Basic Philosophical Writings*, edited by Adriaan T. Peperzak, Simon Critchley, and Robert Bernasconi, 149–60. Bloomington and Indianapolis: Indiana University Press, 1996.

Levinson, Jerrold. "Hume's Standard of Taste: The Real Problem." *Journal of Aesthetics and Art Criticism* 60, no. 3 (2002): 227–38.

Lewalski, Barbara. *Protestant Poetics and the Seventeenth-Century Religious Lyric*. Princeton: Princeton University Press, 1979, 2014.

Lewis, C. S. *An Experiment in Criticism*. Cambridge: Cambridge University Press, 1961.

———. "The Weight of Glory." In *The Weight of Glory and Other Addresses*, edited by Walter Hooper. New York: Macmillan, 1962.

Lindsey, F. Duane. "Essays toward a Theology of Beauty." *Bibliotheca Sacra* 131 (1974): 120–36, 209–18, 311–19.

Little, A. G., ed. *Franciscan History and Legend in English Medieval Art*. British Society of Franciscan Studies, no. 19. Manchester: Manchester University Press, 1937.

Longinus. *On the Sublime: Classical Literary Criticism*. Translated by Penelope Murray. London and New York: Penguin, 1965, 2000.

Louth, Andrew. "'Beauty Will Save the World': The Formation of Byzantine Spirituality." *Theology Today* 61 (2004): 67–77.

Lubac, Henri de. *Exégèse médiéval*. Paris: Aubier, 1969.

Luther, Martin. *Luther's Works*. Edited by Jaroslav Pelikan and Helmut T. Lehmann. 55 vols. Saint Louis: Concordia, 1957–1986.

———. *Die Sieben Buosz Psalmen, mit ainer Kurtzen Auszlegung*. Wittenberg, 1525.

Lyotard, Jean-François. *Lessons on the Analytic of the Sublime*. Translated by Elizabeth Rottenburg. Palo Alto, CA: Stanford University Press, 1994.

MacDonald, George. "The Imagination: Its Function and Its Culture." In *A Dish of Orts: Chiefly Papers on the Imagination and on Shakespeare*. 1893. Reprint, Whitethorn, CA: Johannesen, 1996.

MacGregor, Neil, and Erika Langmuir. *Seeing Salvation: Images of Christ in Art*. New Haven: Yale University Press, 2000.

Mackey, James P., ed. *Religious Imagination*. Edinburgh: Edinburgh University Press, 1986.

Magister, Sandro. "The 'Extra' Synod Father: Raphael." *Chiesa*, October 17, 2005. http://chiesa.espresso.repubblica.it/articolo/40581?eng=y.

Mâle, Émile. *L'art religieux du XVIIIe siècle en France*. Paris: Libraire Armand Colin, 1951.

———. *The Gothic Image: Religious Art in France of the Thirteenth Century*. Translated by Dora Nussy. New York: Harper, 1958.

———. *Religious Art from the Twelfth to the Eighteenth Century*. New York: Noonday Press, 1949, 1963.

Marie-Bruno, Sr. *A l'ombre du capuchin: Un saint François d'Arcabas*. Paris: Editions Franciscaines, 2010.

Maritain, Jacques. *Art and Poetry*. New York: Philosophical Library, 1943.

———. *Art and Scholasticism*. Translated by J. F. Scanlan. New York: Scribner, 1954.

———. *Creative Intuition in Art and Poetry*. Cleveland and New York: World Publishing, 1954.

———. *Georges Rouault*. New York: Abrams, 1954.

Maritain, Jacques, with Raïssa Maritain. *The Situation of Poetry: Four Essays on the Relations between Poetry, Mysticism, Magic, and Knowledge*. New York: Philosophical Library, 1955.

Maritain, Raïssa. *Les grandes amitiés*. Paris: Desclée de Brouwer, 1962.

———. *Marc Chagall*. New York: Éditions de la Maison Française, 1943.

———. *Marc Chagall ou l'orage enchanté*. Geneva and Paris: Éditions des Trois Collines, 1948.

Marquardt, Reiner. *Mathias Grünewald und die Reformation*. Berlin: Frank & Timme, 2009.

Marrou, Henri-Irénée. *Saint Augustin et la fin de la culture antique*. 3rd ed. Paris: Brossard, 1958.

Marsh, Robert. "Akenside and the Powers of the Imagination." In *Four Dialectical Theories of Poetry: An Aspect of English Neoclassical Criticism*. Chicago: University of Chicago Press, 1965.

Martin, James Alfred, Jr. *Beauty and Holiness: The Dialogue between Aesthetics and Religion*. Princeton: Princeton University Press, 1990.

Martin, Regis. *The Last Things: Death, Judgment, Hell, Heaven*. San Francisco: Ignatius, 1998.

Martindale, Andrew. *The Complete Paintings of Giotto*. New York: Harry N. Abrams, 1966.

Marty, Martin. "Beauty and Terror: Rapture in Art and the Sacred." *Image* 17 (Fall 1997): 72–83.

Martz, Louis. *The Poetry of Meditation: A Study in English Religious Literature of the Seventeenth Century*. New Haven: Yale University Press, 1976.

Mascall, E. L. *Theology and Images*. London: Mowbray, 1963.

Maurer, Armand A. *About Beauty: A Thomistic Interpretation*. Houston: Center for Thomistic Studies, 1983.

Maurer, Naomi Margolis. *The Pursuit of Spiritual Wisdom: The Thought and Art of*

Vincent van Gogh and Paul Gauguin. Madison, NJ: Fairleigh Dickinson University Press, 1998.

McCormick, Peter J. *Modernity, Aesthetics, and the Bounds of Art.* Ithaca, NY: Cornell University Press, 1990.

McCracken, David. "Wordsworth, the Bible, and the Interesting." *Religion and Literature* 31 (1999): 19–42.

McGregor, Bede, and Thomas Norris, eds. *The Beauty of Christ: An Introduction to the Theology of Hans Urs von Balthasar.* Edinburgh: T. & T. Clark, 1994.

McIntyre, John. *Faith, Theology, and Imagination.* Edinburgh: Handsel, 1987.

McKenzie, Stephen. *King David: A Biography.* Oxford: Oxford University Press, 2000.

Meditations on the Life of Christ: An Illustrated Manuscript of the Fourteenth Century. Translated by Isa Ragusa. Edited by Isa Ragusa and Rosalie B. Green. Princeton: Princeton University Press, 1961.

Mehren, Haakon. *Munch through New Eyes: His Holy Universe.* Oslo: Arvinius and Orfeus, 2013.

Meiss, Millard. *Giotto and Assisi.* New York: Norton, 1960.

Mellinkoff, Ruth. *The Mark of Cain: An Art Quantum.* Berkeley: University of California Press, 1981.

Miccoli, Lucia. "Two Thirteenth-Century Theories of Light: Robert Grosseteste and St. Bonaventure." *Semiotica* 136, no. 1/4 (2001): 69–84.

Michalski, Sergiusz. *The Reformation and the Visual Arts: The Protestant Image Question in Western and Eastern Europe.* London and New York: Routledge, 1993.

Michelangelo. *The Poetry of Michelangelo: An Annotated Translation.* Translated by James M. Saslow. New Haven and London: Yale University Press, 1991.

Milbank, John. *Theology and Social Theory: Beyond Secular Reason.* Oxford: Wiley Blackwell, 1990, 2006.

———. *The Word Made Strange: Theology, Language, Culture.* Malden, MA: Blackwell, 1997.

Milbank, John, with Graham Ward and Edith Wyschogrod. *Theological Perspectives on God and Beauty.* Rockwell Lecture Series. Edinburgh: Trinity, 2003.

Miles, Margaret R. *Desire and Delight: A New Reading of Augustine's Confessions.* New York: Crossroad, 1992.

———. *Image as Insight: Visual Understanding in Western Christianity and Secular Culture.* Boston: Beacon Press, 1985.

———. *Plotinus on Body and Beauty.* Oxford: Blackwell Publishers, 1999.

———. "Santa Maria Maggiore's Fifth-Century Mosaics: Triumphal Christianity and the Jews." *Harvard Theological Review* 86, no. 2 (1993): 155–72.

Miller, John, ed. *Beauty.* San Francisco: Chronicle Books, 1997.

Milliner, Matthew. "God in the Gallery." *First Things,* December 12, 2007. http://www.firstthings.com/web-exclusives/2007/12/god-in-the-gallery.

Molanus, Johannes. *De picturis et imaginibus sacris.* Leuven, 1570.

Montgomery, Marion. *Making: The Proper Habit of Our Being; Essays Speculative, Reflective, Argumentative.* South Bend, IN: St. Augustine's Press, 2000.

———. *Romancing Reality: Homo Viator and the Scandal Called Beauty.* Chicago: St. Augustine's Press, 2002.

———. *Romantic Confusions of the Good: Beauty as Truth, Truth Beauty.* New York and London: Rowman and Littlefield, 1997.

———. *The Truth of Things: Liberal Arts and the Recovery of Reality*. Dallas: Spence Publishing, 1999.

Monti, Anthony. *A Natural Theology of the Arts: Imprint of the Spirit*. London: Ashgate, 2003.

Mooney, Gael. "Georges Rouault: Encountering God's Beauty through the Face of the Other." In *Violence, Transformation, and the Sacred: "They Shall Be Called Children of God,"* edited by Margaret R. Pfiel and Tobias L. Winright, 99–114. Annual Publications of the College Theological Society 57. Maryknoll, NY: Orbis, 2011.

Moore, T. M. "The Hope of Beauty in an Age of Ugliness and Death." *Theology Today* 61 (2004): 155–72.

Morford, Mark. *Stoics and Neo-Stoics: Rubens and the Circle of Lipsius*. Princeton: Princeton University Press, 1991.

Morison, Alec, and Gladys Morison. "The Activity of Colour in the Art of Painting." In *The Faithful Thinker: Centenary Essays on the Work and Thought of Rudolf Steiner, 1861–1935*, edited by A. C. Harwood. London: Hodder and Stoughton, 1961.

Morris, David B. *The Religious Sublime*. Lexington: University of Kentucky Press, 1972.

Morrison, Tessa. *Isaac Newton's Temple of Solomon and His Reconstruction of Sacred Architecture*. N.p.: Birkhäuser, 2011.

———. *The Origins of Architecture: An English Sixteenth to Eighteenth Century Perspective*. Champaign, IL: Common Ground Publishing, 2013.

Mothersill, Mary. *Beauty Restored*. Oxford: Clarendon, 1984.

Mouw, Richard J. *He Shines in All That's Fair: Culture and Common Grace*. Stob Lectures, 2000. Grand Rapids: Eerdmans, 2001.

Murphy, Francesca Aran. *Art and Intellect in the Philosophy of Etienne Gilson*. Columbia: University of Missouri Press, 2004.

———, ed. *The Beauty of God's House*. Eugene, OR: Cascade Books, 2014.

———. *Christ the Form of Beauty: A Study in Theology and Literature*. Edinburgh: T. & T. Clark, 1995.

Nadeau, Maurice. *The History of Surrealism*. Translated by Richard Howard. London: Cape, 1968.

Nagel, Alexander. *Michelangelo and the Reform of Art*. Cambridge: Cambridge University Press, 2000.

Navone, John. *Enjoying God's Beauty*. Collegeville, MN: Liturgical Press, 1999.

———. *Toward a Theology of Beauty*. Collegeville, MN: Liturgical Press, 1996.

Neff, Amy. "Lesser Brothers: Franciscan Mission and Identity at Assisi." *Art Bulletin* 88, no. 4 (2007): 676–706.

Nehamas, Alexander. "An Essay on Beauty and Judgment." *Threepenny Review* (Winter 2000). https://www.threepennyreview.com/samples/nehamas_w00.html.

———. "The Return of the Beautiful: Morality, Pleasure, and the Value of Uncertainty." *Journal of Aesthetics and Art Criticism* 58, no. 4 (Fall 2000): 393–403.

Newton, Eric. *The Meaning of Beauty*. New York: Whittlesey House, 1950.

Newton, Isaac. *Temple of Solomon and His Reconstruction of Sacred Architecture*. London, 1728.

Nichols, Aidan. *The Art of God Incarnate*. London: Darton, Longman and Todd, 1980.

Novak, Michael Anthony. "Misunderstood Masterpiece: Salvador Dali's 'The Sacrament of the Last Supper.'" *America*, November 5, 2012. http://americamagazine.org/issue/misunderstood-masterpiece.

Oberman, Heiko A. *Luther: Man between God and the Devil*. New York: Doubleday Image, 1982.

O'Connell, Robert J. *Art and the Christian Intelligence in St. Augustine*. Cambridge, MA: Harvard University Press, 1978.

O'Donnell, James J. *Augustine: Confessions; Commentary in Three Volumes*. Indianapolis and New York: Bobbs-Merrill, 1958.

O'Donohue, John. *Beauty: The Invisible Embrace; Rediscovering the True Sources of Compassion, Serenity, and Hope*. New York: HarperCollins, 2004.

Oliver, Simon. "Robert Grosseteste on Light, Truth and 'Experimentum.'" *Vivarium* 42, no. 2 (2004): 151–80.

Olson, Mary C. *Fair and Varied Forms: Visual Textuality in Medieval Illuminated Manuscripts*. New York and London: Routledge, 2003.

O'Malley, John W. *Trent: What Happened at the Council*. Cambridge, MA: Belknap Press of Harvard University Press, 2013.

Oppenheimer, Paul. *Rubens, a Portrait: Beauty and the Angelic*. London: Duckworth, 1999.

Osiander, Andreas. *Catechismus oder kinder predig*. Wittenberg, 1548.

Otto, Rudolf. *The Idea of the Holy*. Translated by John W. Harvey. Oxford: Oxford University Press, 1958.

Ouspensky, Leonid. *Theology of the Icon*. Translated by Anthony Gythiel. 2 vols. Crestwood, NY: St. Vladimir's Seminary Press, 1992.

Ozick, Cynthia. *Art and Ardor*. New York: Knopf, 1983.

Pacheco, Francisco. *The Art of Painting*. Edited by Bonaventura Bassagoda i Hugas. 3rd ed. Barcelona: Catedra, 2009. Translation of *Arte de la pintura* (1649).

Paleotti, Gabriele. *Discorso interno alle imagini sacre e profane*. Translated by William McCuaig. Bologna, 1582. Reprint, Los Angeles: Getty Research Institute, 2012.

Panofsky, Erwin. "Erasmus and the Visual Arts." *Journal of the Warburg and Courtauld Institutes* 32 (1969): 209–10.

———. *Meaning in the Visual Arts*. Middlesex: Peregrine, 1970.

———. *Problems in Titian: The Wrightsman Lectures*. New York: New York University Press, 1965.

Panofsky, Erwin, ed. and trans. *"De administratione" and "Scriptum consecrationis,"* by Abbot Suger. Princeton: Princeton University Press, 1946.

Panti, Celia. "Robert Grosseteste and Adam of Exeter's Physics of Light." In *Robert Grosseteste and His Intellectual Milieu: New Editions and Studies*, edited by John Flood, James R. Gunther, and Joseph W. Goering, 165–75. Papers in Medieval Studies 24. Toronto: Pontifical Institute of Medieval Studies, 2013.

Parry, Linda, ed. *William Morris*. New York: Harry N. Abrams, 1996.

Pastor, Ludwig. *The History of the Popes (1305–1732)*. Translated by F. I. Antrobus and others. 40 vols. 1899. http://www.archive.org/stream/thehistoryofthep25pastu oft/thehistoryofthep25pastuoft_djvu.txt.

Pattison, George. *Art, Modernity, and Faith: Towards a Theology of Art*. New York: St. Martin's Press, 1991.

———. *Kierkegaard, the Aesthetic, and the Religious: From the Magic Theatre to the Crucifixion of the Image*. New York: St. Martin's Press, 1992.

Pearl. *The Complete Works of the Pearl Poet*. Edited by Malcolm Andrew, Ronald Wal-

dron, and Clifford Peterson. Berkeley and Los Angeles: University of California Press, 1993.

Peel, George. *The Love of King David and Fair Bethsabee.* 1599. Reprint, London: Oxford University Press, Malone Society Reprint, 1912.

Pelikan, Jaroslav. *Fools for Christ: Essays on the True, the Good, and the Beautiful.* Philadelphia: Muhlenberg, 1955.

———. *The Illustrated Jesus through the Centuries.* New Haven: Yale University Press, 1997.

———. *Imago Dei: The Byzantine Apologia for Icons.* A. W. Mellon Lectures on the Fine Arts for 1987. Princeton: Princeton University Press, 1990.

Péteri, Eva. *Victorian Approaches to Religion as Reflected in the Art of the Pre-Raphaelites.* Budapest: Akadémiai Kiadé, 2003.

Phillips, John. *The Reformation of Images: Destruction of Art in England, 1535–1660.* Berkeley: University of California Press, 1973.

Picasso, Olivier Widmaer. *Picasso: The Real Family Story.* Munich: Prestel, 2004.

Pinsker, Sanford. "The Crucifixion of Chaim Potok/the Excommunication of Asher Lev: Art and the Hasidic World." *Studies in American Jewish Literature* 4 (1985): 39–51.

Plato. *Timaeus* (in Latin). Edited by Johann Wrobel. Reprint, Charleston, SC: Nabu Press, 2012.

Plotinus. *The Enneads.* Edited by Stephen Mackenna. 5 vols. London: Medici Society, 1917–1930. Reprint, New York: Pantheon, 1965.

Poilpré, Anne-Orange. *Maiestas Domini: Une image de l'Eglise en occident Ve–IXe siècle.* Paris, 2005.

Pontynen, Arthur. "Facts, Feelings and (In)coherence vs. the Pursuit of Beauty (Kandinsky and Florensky)." *St. Vladimir's Theological Quarterly* 40, no. 3 (1996): 173–80.

Pope-Hennessy, John. *Raphael: The Wrightsman Lectures.* London: Phaidon, 1970.

Potok, Chaim. *My Name Is Asher Lev.* New York: Knopf, 1972.

Powers, Edward D. "From Eternity to Here: Paul Gauguin and the Word Made Flesh." *Oxford Art Journal* 25, no. 2 (2002): 89–106.

Prager, Brad. "Sublimity and Beauty: Caspar David Friedrich and Joseph Anton Koch." In *Aesthetic Vision and German Romanticism: Writing Images,* 93–122. Rochester, NY, and Woodbridge, UK: Camden House, 2007.

Prettejohn, Elizabeth. *Beauty and Art, 1750–2000.* Oxford: Oxford University Press, 2005.

Prokop-Janiec, Eugenia. *Polish-Jewish Literature in the Interwar Years.* Translated by Abe Shenitzer. Syracuse, NY: Syracuse University Press, 2004.

"Protoevangelion of James." In *The Lost Books of the Bible,* edited by Frank Crane, 16–24. New York: Alpha House, 1926.

Prudentius. *Prudentius.* Edited by H. J. Thomson. 2 vols. Loeb Classical Library. Cambridge, MA: Harvard University Press, 1949.

Pruss, Alexander. "The Unwritten Esther." *Judaic Seminar* 1, vol. 8.

Rabinovitch, Celia. *Surrealism and the Sacred: Power, Eros, and the Occult in Modern Art.* Boulder, CO: Westview, 2002.

Ramos, Alice, ed. *Beauty, Art, and the Polis.* Washington, DC: American Maritain Association, 2000.

Rand, Herbert. "The Biblical Concept of Beauty." *Jewish Bible Quarterly* 30 (2002): 213–15.

Reide, David G. *Dante Gabriel Rossetti.* New York: Twayne, 1992.

Reiss, Moshe. "Abraham's Moment of Decision: According to Levinas and Rembrandt." *Jewish Bible Quarterly* 35, no. 1 (2007): 56–59.

Renan, Ernest. *L'avenir de la science—pensées de 1848.* Paris: Calmann-Levy, 1890.

Reynolds, Sir Joshua. *Discourses on Art.* Edited by Pat Rogers. London: Penguin, 1992.

Richards, Kirk, and Stephen Gjertson. *For Glory and for Beauty: Practical Perspectives on Christianity and the Visual Arts.* Minneapolis: Bruce, 2002.

Riches, John, ed. *The Analogy of Beauty: The Theology of Hans Urs von Balthasar.* Edinburgh: T. & T. Clark, 1986.

Riga, Peter. *Aurora: Petri Rigae Biblia Versificata.* Edited by Paul Beichner, CSC. 2 vols. South Bend, IN: University of Notre Dame Press, 1965.

Roberts, Louis. *The Theological Aesthetics of Hans Urs von Balthasar.* Washington, DC: Catholic University of America Press, 1987.

Rollo-Koster, Joëlle. *Raiding St. Peter: Empty Sees, Violence, and the Initiation of the Great Western Schism.* Leiden: Brill, 2008.

Rondeau, Marie-Caroline. "Laser Light on Gothic Architecture." *Reporter: The Global Magazine of Leica Geosystems* 68 (2013): 1–6.

Rookmaaker, H. R. *The Creative Gift.* Downers Grove: InterVarsity, 1981.

———. *Modern Art and the Death of a Culture.* Downers Grove: InterVarsity, 1978.

———. *Synthetist Art Theories: Genesis and Nature of the Ideas on Art of Gauguin and His Circle.* Amsterdam: Swets and Zeitlinger, 1959.

Rooses, R. *L'oeuvre de P. P. Rubens.* Antwerp, 1888.

Rosenaft, Jean Bloch. *Chagall and the Bible.* New York: Jewish Museum, Universe Books, 1987.

Rosenau, Helen. *Vision of the Temple: The Image of the Temple of Jerusalem in Judaism and Christianity.* London: Oresko, 1979.

Ross, Stephen David. *The Gift of Beauty: The Good as Art.* Albany: State University of New York Press, 1996.

Rossetti, Dante Gabriel. *The Paintings and Drawings of Dante Gabriel Rossetti (1828–1882): A Catalogue Raisonné.* Edited by Virginia Surtrees. 2 vols. Oxford: Clarendon, 1971.

———. *Poems.* Introduced by William M. Rossetti. New York: Thomas Y. Crowell, n.d.

———. *The Works of Dante Gabriel Rossetti.* London: Ellis, 1911.

Rouault, Georges. *Soliloques.* Neuchâtel: Ides et Calendes, 1944.

Routley, Erik. *A Panorama of Christian Hymnody.* Collegeville, MN: Liturgical Press, 1979.

Rubin, Miri. *Mother of God: A History of the Virgin Mary.* New Haven: Yale University Press, 2009.

Rudolph, Conrad. *Artistic Change at St. Denis: Abbot Suger's Program and the Early Twelfth-Century Controversy over Art.* Princeton: Princeton University Press, 1990.

Ruskin, John. *Selected Writings.* Edited by Kenneth Clark. London: Penguin Books, 1964.

———. *Unto This Last and Other Writings.* Edited by Clive Wilmer. London: Penguin Books, 1985.

Rzymska, Anna. *Kamienny most: Tradycja judaistyczna w twórczosci Romana Brand-staettera*. Warsaw: Olsztyn, 2005.

Santayana, George. *The Sense of Beauty: Being the Outline of Aesthetic Theory*. New York: Dover, 1955.

Sartwell, Crispin. *Six Names of Beauty*. New York: Routledge, 2004.

Sauerländer, Willibold. *The Catholic Rubens: Saints and Martyrs*. Los Angeles: Getty Research Institute, 2014.

Savage, Anne, and Nicholas Watson. *Anchoritic Spirituality*. New York: Paulist, 1991.

Saward, John. *The Beauty of Holiness and the Holiness of Beauty: Art, Sanctity, and the Truth of Catholicism*. San Francisco: Ignatius, 1996.

Sayers, Dorothy. *The Mind of the Maker*. San Francisco: Harper and Row, 1987.

———. "Towards a Christian Aesthetic." In *The New Orpheus*, edited by Nathan A. Scott, 3–20. New York: Sheed and Ward, 1964.

Scarry, Elaine. *On Beauty and Being Just*. Princeton: Princeton University Press, 1999.

Schama, Simon. *Rembrandt's Eyes*. New York: Knopf, 1999.

Schapiro, Meyer. "Chagall's *Illustrations for the Bible*." In *Modern Art: Nineteenth and Twentieth Centuries*, by Meyer Schapiro, 122–41. New York: George Braziller, 1978.

———. *Van Gogh*. New York: Harry Abrams, 1979.

Schiller, G. *Iconography of Christian Art*. London: Lund Humphries, 1971.

Schleiermacher, Friedrich. *On Religion: Speeches to Its Cultured Despisers*. Translated by Richard Crouter. 1799. Reprint, Cambridge: Cambridge University Press, 1996.

Schloesser, Stephen, SJ. "From Spiritual Naturalism to Psychological Naturalism: Catholic Decadence, Lutheran Munch, *Madone Mystérique*." In *Edvard Munch: Psyche, Symbol, and Expression*, edited by Jeffrey Howe, 74–86. Chicago: University of Chicago Press, 2001.

———. *Mystic Masque: Semblance and Reality in Georges Rouault, 1871–1958*. Boston: McMullen Museum of Art, Boston College, 2008.

Schönborn, Christoph. *God's Human Face: The Christ-Icon*. Translated by Lothar Krauth. San Francisco: Ignatius, 1994.

Seasoltz, Kevin. *Sense of the Sacred: Theological Foundations of Christian Architecture and Art*. London: Continuum, 2005.

Seerveld, Calvin. *On Being Human: Imaging God in the Modern World*. Burlington, ON: Welch Publishing, 1988.

———. *Rainbows for a Fallen World*. Toronto: Tuppence Press, 1980.

Seidel, Linda, ed. *Pious Journeys: Christian Devotional Art and Practice in the Later Middle Ages and Renaissance*. Chicago: University of Chicago Press, 2001.

Selz, Peter. *Max Beckmann*. New York: Abbeville Press, 1996.

Seznec, Jean. *The Survival of the Pagan Gods: The Mythological Tradition and Its Place in Renaissance Humanism and Art*. New York: Harper, 1961.

Shanzer, Danuta R. "Augustine's Disciplines: *Silent diutius Musae Varronis?*" In *Augustine and the Disciplines: From Cassiciacum to Confessions*, edited by Karla Pollmann and Mark Vessey, 69–75. New York: Oxford University Press, 2005.

Silverman, Debora. *Van Gogh and Gauguin: The Search for Sacred Art*. New York: Farrar, Straus and Giroux, 2000.

Simson, Otto von. *The Gothic Cathedral: Origins of Gothic Architecture and the Medieval Concept of Order*. Princeton: Princeton University Press, 1964.

Singletary, Suzanne M. "Jacob Wrestling with the Angel: A Theme in Symbolist Art." *Nineteenth-Century French Studies* 32, no. 3–4 (2004): 298–315.

Skillen, Anthony. "The Place of Beauty." *Philosophy* 77 (2002): 23–38.

Smithson, Hannah E., Giles E. M. Gasper, and Tom C. B. McLeish. "All the Colours of the Rainbow." *Nature Physics* 10 (2014): 540–42.

Smulders, Sharon. "A Breach of Faith: D. G. Rossetti's 'Ave,' Art Catholicism, and 'Poems, 1870.'" *Victorian Poetry* 30, no. 1 (1992): 63–74.

Soloviev, Vladimir Sergeyevich. *The Heart of Reality: Essays on Beauty, Love, and Ethics.* Edited and translated by Vladimir Wozniuk. South Bend, IN: University of Notre Dame Press, 2003.

Sorlier, Charles. *Chagall on Chagall.* New York: Harrison House, 1979.

Spargo, Emma Jane Marie. *The Category of the Aesthetic in the Philosophy of Saint Bonaventure.* Saint Bonaventure, NY: Franciscan Institute, 1953.

Speer, Andreas. "Is There a Theology of the Gothic Cathedral?" In *The Mind's Eye: Art and Theological Argument in the Middle Ages*, edited by Jeffrey F. Hamburger and Anne-Marie Bouché, 65–83. Princeton: Princeton University Press, 2006.

Spier, Jeffrey, ed. *Picturing the Bible: The Earliest Christian Art.* London and New Haven: Yale University Press, 2007.

Spretnak, Charlene. *The Spiritual Dynamic in Modern Art: Art History Reconsidered, 1800 to the Present.* New York: Palgrave Macmillan, 2014.

Stechow, Wolfgang. *Dutch Landscape Painting of the Seventeenth Century.* London: Phaidon, 1966.

Steiner, Wendy. *The Trouble with Beauty.* London: Heinemann, 2001.

———. *Venus in Exile: The Rejection of Beauty in Twentieth-Century Art.* New York: Free Press, 2001.

Stephens, Mitchell. *The Rise of the Image, the Fall of the Word.* Oxford: Oxford University Press, 1998.

Stiles, Kenton M. "In the Beauty of Holiness: Wesleyan Theology, Worship, and the Aesthetic." *Wesleyan Theological Journal* 32 (Fall 1997): 194–217.

Stock, Alex. *Poetische Dogmatik: Christologie; Figuren.* Paderborn: Ferdinand Schöningh, 2001.

Stokstad, Marilyn. *Medieval Art.* New York: Harper and Row, 1986.

Stolnitz, J. "Beauty: Some Stages in the History of an Idea." *Journal of the History of Ideas* 22 (1961): 185–204.

Strack, Bonifatius. "Das Leiden Christi im Denken des hl. Bonaventura." *Franziskanische Studien* 41 (1959): 129–62.

Stump, Eleonore. "Beauty as a Road to God." *Sacred Music* 134, no. 4 (Winter 2007): 11–24.

Sund, Judy. "The Sower and the Sheaf: Biblical Metaphor in the Art of Vincent van Gogh." *Art Bulletin* 70, no. 4 (1988): 660–76.

Svoboda, K. *L'esthétique de Saint Augustin et ses sources.* Brno, 1933.

Tatarkiewicz, W. "The Great Theory of Beauty and Its Decline." *Journal of Aesthetics and Art Criticism* 31 (1972): 165–80.

Tavener, John, and Mother Thekla. *Ikons: Meditations in Words and Music.* London: HarperCollins, 1994.

Taylor, Michael R., ed. *The Dali Renaissance: New Perspectives on His Life and Art after 1940.* New Haven: Yale University Press, 2008.

Tertullian. *Apologeticus adversus gentes pro Christianis.* Patrologia Latina 1.

Tillich, Paul. *The Interpretation of History.* New York: Scribner, 1936.

Trimolé, P. Bonaventura. "Deutung und Bedeutung der Schrift der hl. Bonaventura, 'De reductione artium ad theologiam.'" *Fünfte Lektorenconferenz der deutschen Franziskaner.* Werl: Franziskus-Druckerei, 1930.

Tsakiridou, Cornelia A. "*Vera Icona*: Reflections on the Mystical Aesthetics of Jacques Maritain and the Byzantine Icon." In *L'art Français et Francophone depuis 1980*, edited by Michael Bishop and Christopher Elson, 224–46. Amsterdam and New York: Rodopi, 2005.

Tuchman, Barbara W. *The March of Folly.* New York: Random House, 1984.

Turner, Frederick. *Beauty: The Value of Values.* Charlottesville: University Press of Virginia, 1991.

Turner, Steve. *Imagine: A Vision for Christians in the Arts.* Downers Grove: InterVarsity, 2001.

Ugolnik, Anthony. *The Illuminating Icon.* Grand Rapids: Eerdmans, 1988.

Varanni, Giorgio. *Laude degentesche.* Vulgares Eloquentes 8. Padua: Editorice Antenore, 1972.

Verdin, Phillipe, ed. *Arcabas: L'enfance du Christ.* Paris: Cerf, 2002.

Verdon, Timothy. *Art and Prayer: The Beauty of Turning to God.* Orleans, MA: Mount Tabor Books, 2014.

———. "The Disputation on the Sacrament: A Manifesto in Which the Church Tells Its Own Story." Chiesa, January 31, 2007. www.chiesa.

Verdon, Timothy, Melissa R. Katz, Amy Remensnyder, Miri Rubin, and Kathryn Wat. *Picturing Mary: Woman, Mother, Idea.* London: Scala Arts, 2015.

Viladesau, Richard. *The Beauty of the Cross: The Passion of Christ in Theology and the Arts from the Catacombs to the Eve of the Renaissance.* New York: Oxford University Press, 2006.

———. *Theological Aesthetics: God in Imagination, Beauty, and Art.* New York and Oxford: Oxford University Press, 1999.

———. *Theology and the Arts: Encountering God through Music, Art, and Rhetoric.* Mahwah, NJ: Paulist, 2000.

Visser, Margaret. *The Geometry of Love: Space, Time, Mystery, and Meaning in an Ordinary Church.* Toronto: Harper Perennial Canada, 2000.

Wainwright, Geoffrey. "The True, the Good, and the Beautiful: The Other Story." *Journal of Theology for Southern Africa* 107 (2000): 23–36.

Walden, Daniel. "Chaim Potok: A Zwischenmensch ('Between Person') Adrift in the Cultures." *Studies in American Jewish Culture* 2, no. 4 (1985): 19–25.

Walker, Keith. *Images or Idols? The Place of Sacred Art in Churches Today.* London: Canterbury Press, 1994.

Warlick, M. E. *Max Ernst and Alchemy: A Magician in Search of Myth.* Austin: University of Texas Press, 2001.

Warnock, Mary. *Imagination.* Berkeley: University of California Press, 1978.

Watson, Francis. *The Fourfold Gospel: A Theological Reading of the New Testament Portraits of Jesus.* Grand Rapids: Baker Academic, 2016.

Watson, J. R., ed. *An Annotated Anthology of Hymns.* Oxford: Oxford University Press, 2002.

Weymouth, R. F., ed. *The Castel off Love*. Early English Text Society. Oxford: Oxford University Press, 1864.

Wheeler, Marion, ed. *His Face: Images of Christ in Art*. New York: Smithmark, 1988.

White, Keith J. *Masterpieces of the Bible: Insights into Classical Art of Faith*. Grand Rapids: Baker, 1997.

White, William Hale. *Autobiography of Mark Rutherford*. 1881. London: Oxford University Press, 1936.

Wilder, Amos N. "Art and Theological Meaning." In *The New Orpheus*, edited by Nathan A. Scott, 407–19. New York: Sheed and Ward, 1964.

Williams, Charles. *Reason and Beauty in the Poetic Mind*. Folcroft, PA: Folcroft Library Editions, 1974.

Wilson, Mary. "Gothic Cathedral as Theology and Literature." Diss., University of South Florida, 2009.

Wolf, Naomi. *The Beauty Myth: How Images of Beauty Are Used against Women*. New York: Harper Perennial, 2002.

Wolitz, Seth. "*Die Khalyastre*, the Yiddish Modernist Movement in Poland: An Overview." *Yiddish* 4, no. 3 (1981): 1–11.

Wolterstorff, Nicholas P. *Art in Action*. Grand Rapids: Eerdmans, 1980.

———. *Works and Worlds of Art*. Oxford: Clarendon, 1980.

Wordsworth, William. *Poems*. Edited by Thomas Hutchinson et al. Oxford Standard Edition. Oxford: Oxford University Press, 1933 et seq.

———. *The Poetical Works*. Edited by F. Selincourt and H. Darbyshire. 2 vols. Oxford: Clarendon, 1959.

Young, Edward. *The Complaint, or Night Thoughts on Life, Death, and Immortality*. London, 1742.

Youngquist, Paul. "In the Face of Beauty: Camper, Bell, Reynolds, Blake." *Word & Image* (October/December 2000): 319–34.

Zangwill, N. *The Metaphysics of Beauty*. Ithaca, NY: Cornell University Press, 2001.

Zemach, Eddy M. *Real Beauty*. University Park: Pennsylvania State University Press, 1997.

Zuckert, Rachel. "Awe or Envy: Herder contra Kant on the Sublime." *Journal of Aesthetics and Art Criticism* 61, no. 3 (2003): 217–32.

Zuidervaart, Lambert, and Henry Luttikhuizen, eds. *Pledges of Jubilee: Essays on the Arts and Culture, in Honor of Calvin G. Seerveld*. Grand Rapids: Eerdmans, 1995.

Index

Page numbers in **boldface** represent images.

Abbey in an Oak Forest (Friedrich), 236, **237**

Abelard, Peter, 75

Abraham. *See* Akedah

Abrams, M. H., 228n

Adam and Eve in the Garden of Eden, 23–24, 104; *Ghent Altarpiece*, 137; illustration from *Speculum humanae salvationis*, 23n, **24**; John Paul II's defense of nudity in Michelangelo's Sistine Chapel painting, 175; late medieval altarpiece paintings, 137; Lucas Cranach the Elder's eroticized paintings, 173; Masaccio's *Expulsion from Eden* fresco, 177, **178**

Adam of Exeter, 88

Addison, Joseph, 242, 246

Aeneid (Virgil), 141, 242

Agamemnon's sacrifice of Iphigenia, 3

Akedah ("binding" of Isaac), 3; Chagall's Akedah lithographs, 331, 338, 345–47, **347**; Chagall's *Yellow Crucifixion*, 341; Christians and prefiguration of the crucifixion, 338; and Jewish artists' adaptations of crucifixion subject, 331, 338, 341, 345–47, **347**; Rembrandt's depiction and shielding of Isaac's face, 345; and the suffering of Jews in the Holocaust, 338

Al-Aqsa mosque, 71

Albrecht, Archbishop of Mainz and Magdeburg, 161

Aleichem, Sholem, 339

Alexander VI, Pope, 160

Alfresco wall paintings, 104–24; and fragility of paintings before twelfth century, 105; Giotto, 109, 114–21, 356; Roman alfresco techniques and Roman catacombs, 104. *See also* Giotto di Bondone; Thirteenth-century revolution in style

Allegory of Redemption, Weimar Altarpiece (Lucas Cranach the Younger), 187–89, **188**

Allegri, Gregorio, 194

Altarpiece paintings, late medieval, 130–44, 146–54; Bosch, 136n; Botticelli's *Madonna of the Magnificat*, 151–52, **152**; commissioned by trade guilds and religious confraternities, 148; contrasted to Friedrich's *Tetschen Altar*, 231–35, **232**, 236; depiction of sibyls from classical mythology, 141; depictions of Adam and Eve, 137; depictions of Gabriel, Mary, and the annunciation, **133**, 134, **138**, **139**, 140–44, 146, **147**, 148–50, **149**; depictions of Mary in private devotional paintings, 148–54, **149**, **152**, **153**; depictions of Mary Magdalene, 132–33; depictions of Mary reading, 151–52; family altars and private devotional paintings, 146–54; graphic realism of the crucifixion, 131–34, **132**; Grünewald's *Isenheim Altarpiece*, 131–34, **132**, **133**, 289–90, **290**, 298n, 314–15; John the Baptist and the lamb, 131, **132**; *Merode Altarpiece*, 148–50, **149**; Petrus Christus's *The Virgin of the Dry Tree*, 152–53, **153**; resurrection panels, **133**, 134; textual inscriptions, 137–42; van der Weyden's

Annunciation panel from the *Three Kings Altarpiece*, 146, **147**; the Van Ecks' *Ghent Altarpiece*, 134–44, **135**, **136**, **138**, **139**, 155

Altars, 126–28, 155; Abbot Suger on bejeweling with gemstones, 65–66, **66**, 89–91; Arcabas's creation of altar furniture, 354; earliest Christian, 126–28; and medieval rood screens, 128–30; patristic writers' term *altare* to distinguish from pagan altars, 126–27; Paul on the "table of the Lord," 126; in Raphael's *Disputa del Sacramento* mural, 164–69, **165**; Saint-Denis Cathedral, 65–66, 91, **93**; sixth-century stone altars, **127**, 127–28; and tombs or relics of martyrs (modeled on sarcophagi and Roman catacombs), 127–28. *See also* Altarpiece paintings, late medieval

Ambrose, Saint, 151, 167

Amiatinus Codex, Florence (seventh century), **70**, 71

Amiens cathedral, France, 78

Amishai-Maisels, Ziva, 338n

Angelico, Fra, 123, **124**, 224

Angelus, The (Millet), 306–8, **307**, 315

Anglo-Catholic movement, 260

Annunciation (Lotto), 142–43

Annunciation fresco, Arena Chapel, Padua (Giotto), **116**, **117**, 140

Annunciation fresco at San Marco in Florence (Fra Angelico), 123, **124**

Annunciation panel from the *Three Kings Altarpiece* (van der Weyden), 146, **147**

Anselm of Canterbury, 60

Anthemius of Tralles, 76

Anti-Christian artists of the twentieth century. *See* Twentieth-century artists, anti-Christian

"Anti-matter Manifesto" (Dali), 313

Antokolsky, Mark, 338

Anxiety (Munch), 293

Apocalypse of Saint John the Divine, 80–82, 86, 138

Apostolos-Cappadona, Diane, 290–91

Appleyard, Kirsten, 350, 355–56

Aquinas, Thomas: and Augustine, 60; Beauty and the transcendentals, 47; and Dante's *Paradiso*, 122; definition of beauty, 11, 26; depiction in Raphael's *Disputa del Sacramento*, 167; on Mary's scholarly knowledge of Scripture, 151

Arcabas (Jean-Marie Pirot), 318–19, 349–59, 360–63; affirmation of Beauty as transcendental, 319, 352–54, 361; *The Breaking of the Bread*, Emmaus polyptych, **361**; Catholic upbringing and adult conversion, 349–50; creation of altar furniture and a tabernacle, 354; *Disappearance*, Emmaus polyptych, **362**; Emmaus, polyptych, **360**; Emmaus cycle (1992–1994), 351n, 356, 358–59, **360**, **361**, **362**; familiarity with the Bible and theological texts, 349–52; foreword to *Passion/Resurrection*, 352; and Luke's Gospel, 351–52, 358–59; *Madonna with the Messiah* (L'enfance series), 356, **357**; medieval iconic style/technique, 355–59; narrative icons, **353**, **354**, 356; *La Nativité*, Polyptych of the Infancy of Christ, **353**, **354**; on painting as prayer, 350–51; *The Samaritan Woman*, 358, **358**; stained glass window designs for worship spaces, 354, 361; *Visitation*, Polyptych of the Infancy of Christ, **355**; wall paintings at village church in St. Hughes, 350–51; and worship music, 352

Archaeological Reminiscence of Millet's "Angelus" (Dali), 307

Ardon, Mordechai, 338

Arena Chapel frescoes (Giotto), **116**, 116–21, **117**, **118**, **119**, **120**, 233

Aristotle: and Augustine's *De ordine*, 40; cosmogony, 86; paradigm of the "Four Causes," 364–66; transcendentals, 47

Arnold, Matthew, 22–23, 28

Arnolfi Marriage (Jan and Hubert Van Eck), 146n

Ars poetica (Horace), 95–96

Art and Scholasticism (Maritain), 324, 327

"Art Catholicism": Pre-Raphaelites' rejection of, 264; and Rossetti's *Songs of the Art Catholic*, 260

Art of Painting, The (Pacheco), 185n

Ascension (Dali), 313

Asch, Sholem, 339, 341

Assumption of the Magdalene (Lanfranco), 179–80, **180**

Atavism at Twilight (Dali), 307–8, **308**

Augustine, 37–58; on beauty and notion of ascent, 40–42; on beauty and the artist/craftsman, 42–43; on beauty and the body, 41–42; on Beauty as a transcendental, 47–58, 65, 75; on the beauty of the cross/crucifixion, 46, 47–58, 66; *On Christian Doctrine* (*De doctrina Christiana*), 43–43, 195; on the church as bride of Christ, 54–56; *City of God*, 47, 141, 167; *Confessions*, 37, 38–39, 352; on Constantine and the cross, 52–54; contemplation of beauty in the natural order (creation), 40–43, 45–46; the cross and paradox of the beautiful and the ugly, 55; on the cross and the human perception of beauty, 56–57; on the cross as transcendent Beauty, 47–58; *De libero arbitrio*, 41; *De moribus ecclesiae cattolicae*, 148n; *De musica*, 40; *De ordine*, 40–41; depiction in Raphael's *Disputa del Sacramento*, 167; *De Sermo Domini in Monte*, 208; on Gospel of John's accounts of the crucifixion as *kairos*, 57; Hebraic/Jewish influences on, 38, 49–50n; on idolatry, 45, 58; on the incarnation and Christ making manifest God's Beauty in creation, 46; on Jerusalem, 59; lost work on aesthetics (*De pulchro et apto*), 37–38, 97, 352; on love (*amor*), 39; and Manicheanism, 39, 42; metaphysical teleology, 38, 64; method for reading Scripture (distinction between use and enjoyment), 43–46; and Neoplatonism, 38, 39–40, 43, 44–45, 65; on Plato's *Timaeus*, 47; on story of Bathsheba and King David, 195, 197; theological aesthetics, 37–58, 60, 65; on the transcendentals, 47–58, 65, 75, 316, 352

Aurora (Riga), 197

"Ave" (Rossetti poem), 260, 263–64

"Ave Maria" (Hail Mary) prayer, 153–54

Babylonian Captivity, 169n

Bach, J. S., 222

Baillie, John, 242–43

Baldung Grien, Hans, 171

Balthasar, Hans Urs von, 45, 56, 240n, 362n

Banchof, Thomas, 311n

Baptism (Poussin), **226**, 226–27, 245

Baptism of Christ fresco, Arena Chapel, Padua (Giotto), 117, **118**

Bardi chapel of Sante Croce in Florence, 118, 122, 123

"Baroque" art, 223–24

Barre, André, 283

Baskin, Leonard, 338

Batailh, Christophe, 352

Bataille, Georges, 305n, 314, 315

Bathsheba and King David story (Bathsheba's beauty in Renaissance art), 193–218; biblical narrative's physical descriptions, 198–99; books of hours, 199–202; Calvin's reading, 197–98; Christian commentaries minimizing and allegorizing the seduction, 195–98; David-focused exegesis, poetry, and musical compositions, 193–94; David's murder of Uriah, 101, 194, 195, 198n, 214–16, **215**; Drost, 216–17, **217**; early Lutheran book illustrations depicting Bathsheba's modesty, 202, 202–5, **203**, **204**, **205**, 216; early medieval manuscript illustrations, 194, **199**, 199–202, **200**, **201**; eroticism/voyeurism in Protestant art, 205–6, **208**, 208–12, **210**, 216–18, **217**; etymologies of name Bathsheba, 194–95, 196; Helding, 204–5, **205**; Jan David, **207**, 207–8; Jewish commentaries, 194–95; Lucas Cranach the Elder, **203**, 204; Luther's commentary on the *Seven Penitential Psalms*, **202**, 204, 210; Luther's reading, 197–98; Massys and classical myth of Venus and Adonis, **208**, 208–9; Memling, **201**, 202, 210; *Miserere mei, Deus* (poem), 194, 199; and Protestant illustrators' return to nudity and frank eroticism, 205–6; Rembrandt's subversion of voyeurism, 212–16, **213**, **215**, 218; Rubens, 209–12, **210**; and sixteenth-century verse drama, 211n; typological/allegorical readings, 195–98; warnings about visual indulgence and the gaze, 206–8, 209, 217n

Bathsheba at Her Bath (Rembrandt), 212–14, **213**, 216, 218

Bathsheba at the Fountain (Rubens), 209–12, **210**

Bathsheba Bathing (Memling), **201**, 202, 210

Bathsheba Receiving David's Letter (Drost), 216–17, **217**

Baudelaire, Charles, 268, 276, 277, 279

Beata Beatrix (Rossetti), 306

Beauty, 11–36; art and the impulse to give beauty back to God, 2–4, 366; Augustine on beauty in the natural order

(creation), 40–43, 45–46; Augustine on the beauty of the cross/crucifixion, 47–58; Augustine's theological aesthetics, 47–58, 65, 75; in the Christian tradition, 4, 7, 366–67; and concept of the sublime, 241–49, 252; definitions, 11–36; Friedrich's scorn for knowing what is beautiful, 239–40; Greek word *hōraios* in the New Testament, 28, 32; Greek word *kalos* in the Septuagint, 30; Hebrew Old Testament (beauty and holiness linked), 13, 20–27, 34–36; Hebrew words for, 22–27, 49n; Hellenistic thought and classical Greek texts, 29–30, 32–33; Hopkins's lament over the impermanence of, 1–3; *kalos* in Hellenistic thought and classical Greek texts, 29–30; *kalos* in the Greek New Testament, 32–35, 58; Kant on distinguishing what is beautiful, 240–41; metamorphosis/transformation of, 3–4; nineteenth-century impressionists' secular worship of, 253–54; Romantic revolution and the contested nature and meaning of, 238–49, 252; Scarry on, 12. *See also* Transcendental properties of being (the True, the Good, the Beautiful)

Beauvoir, Simone de, 317

Beckmann, Max, 291

Bede, the Venerable: and Augustine, 60; commentaries on continuity of medieval churches with Solomon's Temple, 68–73

Beethoven, Ludwig van, 230

Bell, Daniel, 317, 318, 321, 366–67

Bellori, Giovanni, 224

Belting, Hans, 284–85, 327

Benedictine spirituality, 114

Bernanos, Georges, 352

Bernard, Émile, 278–79

Bernard of Clairvaux, Saint, 113–14, 141, 142

Bernini, Gian Lorenzo, 2, 163, 164

Bertrand, Emile, 271–72

Bezem, Naftali, 338

Bianchi, Enzo, 349, 354–55, 356

Bible moralisée (ca. 1220), 89, **90**, 100–102, **101**, 379; images of Bathsheba bathing, 199; and stained glass windows of Sainte Chapelle in Paris, 100–102

Birth of Venus, The (Botticelli), 183n

Blake, William, 227, 240, 264

Blavatsky, Madame Helene Petrovna, 277–78

Boethius, 76

Boileau-Desprèaux, Nicolas, 242

Boime, Albert, 275n

Bonaventure, Saint, 91–97, 264; and Augustine, 60; on beauty and living in the imitation of Christ, 97; on beauty and the transcendentals, 47, 92; *Breviloquium*, 150; commentary on the annunciation narrative in Luke, 140–41, 142; depiction in Raphael's *Disputa del Sacramento*, 167; *De reductione artium ad theologiam*, 92–97, 99, 103; on four types of light, 95–97, 100; and the Franciscan order, 115–16, 146n; *Hexaemeron*, 91–92, 94; light metaphysics and Gothic cathedral design, 91–97, 103; on Logos and light in prologue to John's Gospel, 95, 103; and Sainte Chapelle in Paris, 99; on story of Bathsheba and David, 195–96; on universal design/divine cosmic patterns visible in Book of God's Word and Book of God's Works, 62, 94

Bonnard, Pierre, 284

Bonnel, Roland, 327, 356n

Borromeo, Carlo, archbishop of Milan, 181

Borromeo, Federico, archbishop of Milan, 181

Bosch, Hieronymus: altarpiece paintings, 136n; Dali and, 306; *Garden of Earthly Delights*, 171

Botticelli, Sandro, 151–52; *The Birth of Venus*, 183n; family altarpiece paintings, 151–52, **152**; *Madonna of the Book*, 151; *Madonna of the Magnificat*, 151–52, **152**

Boughton, George Henry, 268

Bramante, Donato, 161–62, 167

Branch, The (La Branche) (Chagall), **348**

Brandstaetter, Mordechai David, 335

Brandstaetter, Roman, 335–38, 339; and Chagall, 335–38; "Such Was Your Crucifixion, God," 336–37

Breaking of the Bread, The, Emmaus polyptych (Arcabas), **361**

Breton, André, 296, 300–301, 303, 305, 308–9, 317; and Dali's split with surrealists, 305, 308–9; "Entrée des mediums," 303; essay "Le surréalism et la peinture," 296; *Manifesto of Surrealism* (1924), 300, 301; reviews and magazines, 300

Brevis institutio ad Christianum pietatem (Helding), 204–5, **205**

Brooklyn Crucifixion (Potok), 329

Brown, Ford Madox, 259

Browning, Robert, 220

Brueggemann, Walter, 215–16n

Bunyan, John, 268

Burke, Edmund, 242, 243, 246

Byrd, William, 194, 222

Byron, Lord, 220, 227n

Byzantine art: Hagia Sophia, 76, **77**; iconic style, 51, 107, 114

Cain, sacrifice of, 20n

Calling of Ezekiel, The (Chagall), **333**

Calling of the Apostles Peter and Andrew (Duccio), **106**, 107

Calvin, John, 219; reading of story of David and Bathsheba, 197–98; warnings about visual indulgence and the gaze, 206–7, 217n

Camfield, William A., 302

Campagnia dei Laudesi, 106

Campin, Robert ("the Master of Flemaille"), 148

Camus, Albert, 38n, 298, 317

Cannibal Feast (Oppenheim), 314

Caravaggio, 216, 224, 359n; *The Incredulity of St. Thomas*, **225**, 237; naturalistic paintings and physical realism, 224, **225**

Carew, Thomas, 223

Carlyle, Thomas, 301

Carroll, Lewis, 305, 314

Casagemas, Carlos, 296

Cassatt, Mary, 254

Catacomb of Marcellinus and Peter, Rome, **18**

Catacomb of Priscilla, Rome, **15**, **16**

Catacombs: early medieval altars modeled on, 127–28; funerary art motifs, 13–17, **14**, **15**, **16**, **18**, 104; Good Shepherd imagery, **14**, 14–15, **15**; Old Testament miracle motifs, 15–17, **16**; Roman alfresco painting techniques, 104

Catherine of Siena, 60

Catholicism: Anglo-Catholic movement, 260; Dali and, 305, 309–13; Ernst and, 301–2; Gauguin's anti-Catholic essay, 282; nineteenth-century Nabis and, 284–86, 287; nineteenth-century Nazarenes and, 254–59, 284, 286; and northern European Protestant religious art, 219–20, 223–28; Picasso and, 295–96; Poussin and neoclassicism, 225–27; Pre-Raphaelites and "Art Catholicism," 260, 264; Raïssa Maritain's conversion, 340; Rouault's rejection of the modern French church's infatuation with surrealists, 319–21; sacramentalism, 225–27. *See also* Catholic protocols on nudity and eroticism in Christian images; Council of Trent

Catholic protocols on nudity and eroticism in Christian images, 175–85; Council of Trent (Session 25) on "lascivious" representations of the body, 176–77, 179, 207, 218, 259; depictions of Marian legends not sanctioned by the church, 181–85, 190; John Paul II's Sistine Chapel homily on nudity in Edenic or eschatological contexts, 175, 181;

post-Tridentine commentaries critiquing pagan iconography and imagery from apocryphal books, 180–81, 183; post-Tridentine commentaries on banishing apocryphal narrative, 179–80; reactions to appearance of noncanonical paintings, 179–80; sixteenth-century bishops' opposition to painting of nude bodies, 180–84, 207

Cave paintings at Lascaux, France, 104

Cézanne, Paul, 254

Chagall, Marc, 318–19, 328–49, 360–63; affirmation of the Good as transcendental, 319, 346–47, 361; Akedah lithographs, 331, 338, 345–47, **347**; *Bible* series (etchings), 332, 335n, 345; biblical knowledge and the Bible's influence on, 343, 344–47; *The Calling of Ezekiel*, **333**; crucifixion symbol/images, 328–30, 338–44, 338n, **342**, **346**; *Descent*, 343; *Exodus* (1952–1966), 330, 345, **346**; Hasidic and Orthodox Jewish responses to, 328–29; heifer symbol, 332–34, 337; and Isaiah's Suffering Servant, 329, 340, 344; and Jewish adaptations of Christian subjects and images, 328–41; juxtaposition of Christian concept of atonement and Jewish Yom Kippur, 343–44; *La Branche*, **348**; *Martyr*, 341, 343; "Mayne trern" poem and personal identification with Jesus' passion, 339–41; motif of Torah meditation and ingestion of the Torah scroll, 331–35; *Obsession*, 343; and Polish Lithuanian folk sculptures known as *Chrystus frasobliwy*, 335–36, **336**, 337; and Potok's *My Name Is Asher Lev*, 329; and Rembrandt, 331; *The Sacrifice of Isaac*, 345–47, **347**; *Solitude*, 330–35, **332**, 337n; stained glass window designs for worship spaces, 346, 361; violin images, 334; *White Crucifixion*, 340–41, 343n; *Yellow Crucifixion*, 330, 341–45, **342**

Chalcidius, 86

Charcot, Jean-Martin, 289

Charles V (Emperor), 161

Chartres Cathedral, 319

Chester, John, 249

Chivalric romance: and Franciscan lyric poems, 144–46; Franciscan motif of "knights of Christ," 144–45; Mary and the annunciation, 146; Mary as focus of Franciscan chivalric imagery, 145–46

Christ Asleep during the Tempest (Delacroix), 272

Christeliicken Waersegggher (Jan David), **207**, 207–8

Christ in the Garden of Olive-Trees (Gauguin), 279

Christ of St. John of the Cross (Dali), 311

Chrystus frasobliwy (Polish Lithuanian wayside folk sculptures), 335–36, **336**, 337

Cicero, 242

Cimabue (Cenni de Pepi), 105–9; and Dante, 121–22; and Duccio, 105–7; *Madonna Enthroned with St. Francis*, 106–7; *Madonna of the Holy Trinity*, 107, **108**

Cixous, Hélène, 212n, 214

Clark, Kenneth, 175n

Clayton, David, 175n

Clown, The (Rouault), **323**

Codex Grandior, 71

Coglerus, Johannes, 205

Coleridge, Samuel Taylor, 227n, 228, 249–50

Collage, 302, 305

Comestor, Peter, 199, **199**

Commentary on Ezekiel (Richard of St. Victor), **73**, 73–74

Communist Party, 299, 308

Confraternity of Our Lady of the Dry Tree, 152

Confraternity of the Immaculate Conception, 191–92

Congregation Leaving the Reformed Church in Nuenen (Van Gogh), 270

Conjuror, The (Rouault), 321

Constable, John, 227n

Constantine, 48–49, 52–54, 67; and the cross, 48–49, 52–54; *labarum* (cross-in-the-sky vision), 48; and Old Saint Peter's, 159–60

Cornelius, Peter von, 255, 257–59; *Last Judgment* fresco, 257–59, **258**

Corrida (Picasso), 299

Council of Ephesus, 85

Council of Florence, 167n

Council of Trent, 175–85; Paul III's convening of, 161; post-Tridentine era, 177–85; sacramentalism, 225–27; Session 25 protocols on "lascivious" representations of the body in ecclesiastical art, 176–77, 179, 207, 218, 259

Counter-Reformation, 209, 211, 217, 222, 226. *See also* Council of Trent

Coverdale Bible, 185

Cranach the Elder, Lucas, 172–73, 182–83; *David and Bathsheba*, **203**, 204; *Venus*, 172–73, **173**

Cranach the Younger, Lucas, 187–89, **188**

Crashaw, Richard, 223

Cromwell, Oliver, 219

Cross/crucifixion in Christian art: Chagall,

328–30, 338–44, 338n, **342**, **346**; Dali, 311, **312**, 314; Ernst, 302; Friedrich's *Tetschen Altar* painting, 231–35, **232**, 236; Grünewald's late medieval *Isenheim Altarpiece* (graphic realism), 131–34, **132**; Jewish artists' reappropriation of, 328–30, 338–41; Jewish-Christian poet Brandstaetter's meditation on, 335–38; and medieval rood screens, 128; Munch, **294**, 295; Picasso, 295, 296–99, **297**, 314; Rouault, 325–28, **326**; and Suffering Servant of Isaiah, 325, 329, 337, 340, 344

Cross in Christian history, 47–58; adorned crosses in mosaic apses, 50–51, **52**, **53**; Augustine on beauty of, 46, 47–58, 66; Augustine on paradox of, 55, 56–57; Constantine, 48–49, 52–54; Gospel of John's accounts of the crucifixion as *kairos*, 57; magical amulets, 50; making sign of the cross, 47–48; Maskell ivories (ca. 425), 50, **51**; Paul on the cross, 47–48; Roman sarcophagus with Chi Rho, 48–49, **49**; staurograms, 48, 50, 52

Crucifixion (Ernst), 302

Crucifixion (Picasso) (1896), 295

Crucifixion, The (Picasso) (1930), 296–98, **297**, 314

Crucifixion with Embracing Couples (Picasso), 296

Crucifixion–Corpus Hypercubus (Dali), 311, **312**, 314

Cubism, 296–98, 305

Culture and Anarchy (Arnold), 22–23

Cursor Mundi, 195

Dada movement, 299–300

Dali, Salvador, 291, 305–13; "Anti-matter Manifesto" and quantum mechanics, 313; *Archaeological Reminiscence of Millet's "Angelus,"* 307; *Ascension*, 313; *Atavism at Twilight*, 307–8, **308**; blasphemous works, 306–8, 312–13; change in style and putative "Catholic period," 309–13; *Christ of St. John of the Cross*, 311; *Crucifixion–Corpus Hypercubus*, 311, **312**, 314; and cubism, 305; *Declaration of the Independence of the Imagination and the Rights of Man to His Own Madness*, 309; early life and traditional Catholic upbringing, 305; *Ecumenical Council*, 313; essays and writings, 305–6; *Gala and the Angelus of Millet Preceding the Imminent Arrival of the Conical Anamorphoses*, 307–8; and Gala Éluard, 307–8, 309–11, 313; *The Great Masturbator*, 306; *L'Immaculée Conception*, 306; influence of

Freud and Jung, 305–6; *The Madonna of Port Lligat*, 309–11, **310**; and "nuclear mysticism," 309, 310–13; obsession with Grünewald's *Isenheim Altarpiece*, 290, 309, 311; obsession with Millet's *The Angelus*, 306–8, 315; opinions of impressionist art, 306; *The Resurrection of the Flesh*, 308; *Rotting Donkey*, 309; *The Sacrament of the Last Supper*, 311; *Sometimes I Spit with Pleasure on the Portrait of My Mother*, 306; surrealism/split with the surrealists, 305, 308–9, 313; *Virgin of Guadalupe*, 313

Dante Alighieri, 121–23; cathedral in *Divine Comedy*, 80; depiction in Raphael's *Disputa del Sacramento*, 167; and *dolce stil nuovo* (the sweet new style) in Italy, 122–23; and the Franciscan spiritual movement, 122; and nineteenth-century Pre-Raphaelites, 259; *Paradiso*, 79, 122; *Purgatorio*, 121–23; on repentance and restoration of beauty, 122–23; *Vita Nuova*, 122

Danto, Arthur, 296

Daphne and Apollo, myth of, 3

David: murder of Uriah, 101, 194, 195, 198n, 214–16, **215**; prayer in Psalm 27:4 (to gaze upon the beauty of the Lord), 367. *See also* Bathsheba and King David story (Bathsheba's beauty in Renaissance art)

David, Jan, **207**, 207–8, 209; *Christeliicken Waersegghers*, **207**, 207–8

David and Bathsheba (Lucas Cranach the Elder), **203**, 204

David and Bathsheba (Massys), **208**, 208–9

David and Uriah (Rembrandt), 214–16, **215**

Death and a Woman (The Kiss of Death) (Baldung Grien), 171

Declaration of the Independence of the Imagination and the Rights of Man to His Own Madness (Dali), 309

Degas, Edgar, 254

Delacroix, Eugène, 224, 272

Demoiselles d'Avignon (Picasso), 296

Denis, Maurice, 280, 285–86; *Mystère Catholique (Catholic Mystery)*, **285**, 285–86; and the Nabis, 284, 285–86, 287; and synthetism, 285–86, 287; *The Women Find Jesus' Tomb Empty (Luke 20:11–18)*, 285–86, **286**

Dennis, John, 242, 246

De pictura sacra (Borromeo), 181

Der Blaue Reiter, 299–300

De reductione artium ad theologiam (Bonaventure), 92–97, 99, 103

Descent (Chagall), 343

Desprez, Josquin, 194

Dialogo degli errori e degli abusi de' pittori (Gilio de Fabriano), 177

Dickens, Charles, 268

Ding Fang, 363n

Disappearance, Emmaus polyptych (Arcabas), **362**

Discourses on Art (Reynolds), 240

Disputa del Sacramento, secco mural, Stanza della Segnatura, Vatican (Raphael), 164–69, **165**, 256; geometry (vertical and horizontal axis), 166–67; key figures depicted, 166, 167; Sacrament of the Altar, 167

Doering, Bernard, 324

Domenichino (Domenico Zampieri), 185, 224

Dome of the Rock, 71

Donatello, 123; *Mary Magdalene* at Baptistry of the Duomo in Florence, 123, **123**, 171

Donna Velata, Catacomb of Priscilla, Rome (fourth century), **15**

Donne, John, 13, 55, 222

Don't We All Wear Make-Up? (Rouault), 321

Dos naye lebn (New York Yiddish periodical), 339

Dostoyevsky, Fyodor, 292

D'où venons-nous? Que sommes-nous? Où allons-nous? (Gauguin), **281**, 281–83

Dream of Innocent III fresco at San Francesco (Giotto), 110, **111**

Drost, Willem, 216–17, **217**

Duby, Georges, 100

Duccio di Buoninsegna, 105–9; *Calling of the Apostles Peter and Andrew*, **106**, 107; and Cimabue, 105–7; *Madonna of the Franciscans*, 106; *Rucellai Madonna*, 106

Duchamp, Marcel, 300

Duke of Sussex Hebrew Bible, Spain (early fourteenth century), **72**

Duns Scotus, 94

Dura Europus synagogue, wall painting (ca. 235 CE), **21**, 71, 104, 126

Dürer, Albrecht, 182, 219; *Virgin and Child on a Crescent with a Crown of Stars and a Scepter*, **182**

Dwyer, Ruth, 76

Eastwood, Bruce, 89

Ecce Ancilla Domini! (Rossetti), 143, **262**, 263–64

Ecce Homo (Antokolsky), 338

Ecclesial architecture. *See* Gothic cathedral architecture (late medieval sanctuaries); Protestant church architecture

Ecclesiastical Sonnets (Wordsworth), 221

Eck, Johannes, 176

Eco, Umberto, 174

Ecumenical Council (Dali), 313

Église Oecumenique de Chamrousse, 354

Eichhorn, Johann Gottfried, 229

"Elegy in a Country Church Yard" (Gray), 236

Elizabeth de Bohun Book of Hours and Psalter (ca. 1340), **381**

Éluard, Gala (Elena Ivanova Diakonovna), 303, 305, 307–8, 309–11, 313

Éluard, Paul, 303, 304–5, 309

Emmaus cycle (Arcabas), 351n, 356, 358–59, **360**, **361**, **362**

Emmaus polyptych (Arcabas), **360**

English Romanticism, 219–20, 227–28, 249–52; anti-Catholic disenchantment with Renaissance art, 219–20; Byron, 220, 227n; natural sublime and "agreeable terror," 242–43; Wordsworth, 221–23, 227–28, 243–44, 249–52. *See also* Romanticism, nineteenth-century; Wordsworth, William

"Entrée des mediums" (Breton), 303

Erasmus, Desiderius: *On Christian Matrimony*, 171; on ecclesial art of Renaissance Rome, 170, 171, 179, 181, 189, 207

Ernst, Max, 291, 301–5; anti-Christian direction, 302–5; collage medium, 302, 305; confusion of birds and humans, 302–3, **303**; *Crucifixion*, 302; deliberate blasphemy and intention to make Christian tenets grotesque, 304–5; early life and Catholic upbringing, 301–2; essay on collage ("Au delà de la peinture"), 302; and Grünewald's *Isenheim Altarpiece*, 290, 302; *Massacre of the Innocents*, 304; novel of erotic collages (*Une semaine de bonté*), 305; preoccupation with Freudianism, 302; preoccupation with the occult, 302–4; *Rendezvous of Friends*, 303–4; and surrealism, 301–5; *Triumph of Surrealism (The Angel of the Home)*, 302–3, **303**; *Virgin Mary Spanking the Infant Jesus before Three Witnesses, André Breton, Paul Éluard, and the Artist*, **304**, 304–5, 314

Essay on the Sublime (Baillie), 242–43

Etymologiae (Isidore of Seville), 196

Eucharist: *Ghent Altarpiece* as framing daily presentation of, 139–40; Raphael's *Disputa del Sacramento* mural depicting theological debate over, 164–69, **165**, 256

Eusebius, 48, 148n

Existentialism, 298, 317–18

Exodus (Chagall), 330, 345, **346**

Exposition Internationale du Surréalisme (1957), 314

Exposition on the Celestial Hierarchies of St. Dionysius the Areopagite (Hugh of St. Victor), 94–95
Expulsion from Eden fresco (Masaccio), 177, **178**

"Fairest Lord Jesus" ("Schönster Herr Jesu") (Jesuit hymn), 25, 25n
Fate of the Animals, The (Der Blaue Reiter), 299–300
Fichte, Johann Gottlieb, 230
Fiery Furnace, The, Catacomb of Priscilla, Rome (third century), **16**
Finding of the Saviour in the Temple, The (Hunt), **265**, 265–66
First Baptist Church of Amarillo, Texas, 371, **372**, **373**, **374**
First Communion (Picasso), 295
Five Joys of the Virgin Mary, 129n
Flaubert, Gustave, 270
Flinck, Govaert, 216–17
Four Causes (Aristotle's paradigm), 364–66; efficient cause, 365; final cause and God as artist, 365–66; final cause for Christian artists, 365–66; formal cause, 364–65; material cause, 364, 365
Francis, Pope, 341
Franciscan spirituality, 106, 109–24, 190; chivalric romance imagery and lyric poems, 144–46; Dante and, 122; dedication to itinerant poverty, 110–12; doctrine of immaculate conception, 150; Francis and origins of the order, 110–11; Franciscan aesthetics (everything in visible universe is charged with the divine), 93–94; Giotto and, 109, 114–24; Giotto's Arena Chapel frescoes, **116**, 116–21, **117**, **118**, **119**, **120**, 233; Giotto's *Dream of Innocent III* fresco, 110, **111**; Giotto's *Stigmata* fresco, **115**, 116; imitation of Christ (*imitatio Christi*), 112–14, 116, 119, 190; joyous exuberance of worship, 111–12; "knights of Christ" motif, 144–45; Marian devotion, 106–7, 113, 116–21, 145–46, 190; *Meditations on the Life of Christ* (illustrated manuscript), 112–14, 117, 130–31, 140, 150; and Pope Innocent III, 110, **111**; and thirteenth-century spiritual revolution, 106, 109–24, 190; and Trinitarian Christology, 150
Francis of Assisi, Saint: Giotto's *Stigmata* fresco at San Francesco, **115**, 116; origins of Franciscan Order, 110–11; and Pope Innocent III, 110, **111**; thirteenth-century spiritual revolution, 106, 109–24, 190

Franco, Francisco, 308–9
French Catholic Church, 319–21
French neoclassicists and the "natural sublime," 242
French Revolution, 227
French Romanticism, 223n
Freud, Sigmund (Freudianism), 289–90, 300, 302, 305–6
Friedman, Mira, 331, 334
Friedrich, Caspar David, 219–20, 229–40, 247–49, 254; *Abbey in an Oak Forest*, 236, **237**; altarpiece painting for *Tetschen Altar*, 231–35, **232**, 236; depictions of despair of formal religion, **235**, 235–38, **237**; early life in Greifswald, 229, 230–31, 234; iconography of the cross, 232–34; and Kant's notion of the sublime, 247–49, 251; letter describing his lost painting (on German turn to Romanticism), 219–20, 228, 236; and Lutheran faith, 229, 234; melancholy disposition and alienated religious sensibility, 234–38; *Monk by the Sea*, **235**, 235–36; *Morning in the Riesengebirge*, 238, **239**; on the nature and recognition of beauty, 239–40; *Old Woman with Hourglass and Book*, 236–38; and themes in Wordsworth's *Prelude*, 250–51; *Wanderer above a Sea of Fog*, 247–49, **248**, 251; *The Woman with the Raven at the Abyss*, 249n
Fuchs, Ernst, 338

Gabrieli, Giovanni, 13, 194, 222
Gala and the Angelus of Millet Preceding the Imminent Arrival of the Conical Anamorphoses (Dali), 307–8
Garden of Earthly Delights (Bosch), 171
Gasch, Sebastià, 306
Gauguin, Paul, 266–67, 276–83, 287; anti-Catholic essay "L'esprit moderne et le Catholicism," 282; *Christ in the Garden of Olive-Trees*, 279; cloisonné technique, 276, 281; death, 283; *D'où venons-nous? Que sommes-nous? Où allons-nous?*, 281, 281–83; influence on twentieth-century artists, 288; paintings of Tahiti and the Polynesian islands, 281, 281–83; *Self-Portrait* (1889), **278**, 279; *Self-Portrait in Front of the Yellow Christ*, 279; *Self-Portrait 'près du Golgotha'*, 279; self-portraits and projections of his own facial features on subjects, **278**, 279, 282, 293; and symbolist movement, 276–84, 287; and synthetist movement, 276–79, 287; and theosophy, 277–79, 283; *Vision of the Sermon (Jacob*

Wrestling with the Angel), 279–81, **280**, 289; *The Yellow Christ*, 279
Geertgen tot Sint Jans, 331
George, Waldemar, 319–20
Gerhardt, Paul, 229
Géricault, Théodore, 224
German catechism (1531), **202**, 204
German Catholic Nazarenes, 254–59, 284, 286
German romanticism, 219–20, 229–41, 247–49, 251–52; and Enlightenment rationalism in theological writings, 229–30; Friedrich, 219–20, 229–38, 247–49, 251–52; the movement away from Lutheran pietism toward feeling, 229, 234; and music, 230; and philosophy, 230; and revisionist theology, 230. *See also* Friedrich, Caspar David; Romanticism, nineteenth-century
Ghent Altarpiece, Saint Bavo Cathedral, Belgium (Jan and Hubert van Eck), 134–44, **135**, **136**, **138**, **139**, 155; depiction of Erythean Sibyl and Cumaean Sibyl, 141; depiction of glory of God, 137; depiction of the annunciation, **138**, **139**, 140–44; eschatological future vista of God's love, 135–37; as framing daily presentation of the Eucharist, 139–40; story of Adam and Eve, 137; textual inscriptions, 137–42
Gibbons, Orlando, 222
Gilboa, Anat, 212n, 214n
Gilio de Fabriano, Andrea, 177
Gilson, Etienne, 317n
Giocondo, Fra, 161
Giotto di Bondone, 109, 114–24, 224, 263; *Annunciation* fresco, **116**, **117**, 140; Arena Chapel frescoes (Scrovegni Chapel, Padua), **116**, 116–21, **117**, **118**, **119**, **120**, 233; *Baptism of Christ* fresco, 117, **118**; and Dante, 121–22; *Dream of Innocent III* fresco at San Francesco, 110, **111**; and the Franciscan spiritual revolution, 109, 114–24; *The Lamentation of Christ* fresco, 118, **120**; and Marian spirituality, **116**, 116–21, **117**, 263; *Marriage of Cana* fresco, 117–18, **119**; new techniques of alfresco wall painting and representation of human forms and faces, 109, 114–21, 356; *Pentecost: Descent of the Holy Spirit* fresco, 118–19, **121**; *Stigmata* fresco, San Francesco, **115**, 116
Girlhood of the Mary Virgin, The (Rossetti), 260–63, **261**
Girl with Mirror (Rouault), **322**
Girolamo da Treviso, *Protestant Allegory* (1543), 185–87, **187**

Glossa ordinaria, 195, 196

Goethe, Johann Wolfgang, 230, 247; and Friedrich's *Wanderer above a Sea of Fog*, 247; theory of color, 276n

Golgotha (Munch), **294**, 295

Gorky, Maxim, 308

Gospel of John: Augustine on accounts of the crucifixion as *kairos*, 57; prologue (incarnation of the Logos as the Light of the World), 87, 89, 95, 103; prologue and Bonaventure's light theory, 95, 103; prologue and Greek Platonic cosmogony, 87; prologue and medieval liturgies, 95; prologue and medieval reflections on the metaphysical implications of light, 87, 89, 95, 103

Gospel of Luke: Arcabas and, 351–52, 358–59; Bonaventure's commentary on the annunciation narrative, 140–41, 142; Denis's *The Women Find Jesus' Tomb Empty* (Luke 20:11–18), 285–86, **286**

Gothic cathedral architecture (late medieval sanctuaries), 59–82; Abbot Suger's rebuilding of Saint-Denis, 91, **92**, **93**; cathedral in Dante's *Divine Comedy*, 80; and classical ideas of transcendent Beauty, 64–65; consecration of holy sites, 68; design according to sacred ratios and harmonic proportions (divine cosmic patterns), 61–78, **77**, **78**, 81; differences between Roman basilicas and, 60–61, **61**; and light metaphysics, 83–103; the Middle English *Pearl* and Gothic architectural vision of new Jerusalem, 78–82, 138; mosaics of Santa Maria Maggiore, 51, 84–85, **85**; Old Testament temple imagery and allusions, 67–78, **70**, **72**, **73**, **74**, 83; and reflections on the beauty of the temple/sanctuary in sacred poetry, 78–82; Sainte Chapelle de Paris, 97–103, **98**, **99**, **102**; stained glass artistry, **93**, **98**, **99**, 99–102; tabernacle design (sacred mathematical ratios, numbers, and harmonic proportions), 75–78, **77**, **78**; thirteenth-century notions of taste and thinking about beauty, proportion, and purpose, 63–67; worship as participation in symbol of new Jerusalem, 59–60. *See also* Light metaphysics and theological symbolism of light

Grabar, André, 182–83n, 376

Grave, Johannes, 237

Gray, Thomas, 236, 243

Great Initiates, The (Schuré), 284

Great Last Judgment (Rubens), 177n

Great Masturbator, The (Dali), 306

Greek New Testament: bride of Christ,

35–36; Greek word *hōraios* (ripeness or fittingness), 28, 32; Hebrew idea of beauty as holiness, 34–35; *kalos* (goodness in the ethical sense), 32–35, 58; stories of transformation, 3–4

Greek Old Testament (Septuagint), 28–32; beauty and desire, 35–36; Greek word *kalos*, 30; the reduction and fading of Hebrew words for beauty, 28, 30–32, 35

Greek (Platonic) cosmogony: and the Logos in prologue to the Gospel of John, 87; and medieval Christian doctrine of creation, 86–87; Plato and Socrates's myth of the dark cave and the light of truth, 86–87; Plato's *Timaeus* and Raphael's *Disputa del Sacramento*, 166

Greek sublime, 241–42, 244

Gregory, Brad, 159n

Gregory of Nyssa, Saint, 50

Gregory the Great, Saint, 167, 196–97

Groningen theology (Dutch Reformed), 267, 270

Grosseteste, Robert, 88–89; *Le Castel d'Amour*, 84n; treatises on "light metaphysics," 88–89

Grundmann, Walter, 29

Grünewald, Matthias, 131–34, 289–90. *See also Isenheim Altarpiece* (Grünewald)

Guercino (Giovanni Francesco Barbieri), 224

Guernica (Picasso), 298, **299**

Guide to the Lakes (Wordsworth), 243

Gustav IV Adolf, King (Sweden), 231

Hagia Sophia, Istanbul, 51, 76, **77**, 114

Hals, Franz, 7

Hamann, Johann Georg, 230–31, 240

Hanby, Michael, 56–57, 58n

Handel, G. F., 222

Harden, John, 222n, 227n

Harris, Nathaniel, 269

Harrison, Carol, 39

Hart, David Bentley, 43n

Haydn, Franz Joseph, 230

Head of Christ (Rouault), **326**

Healy, Emma Thérèse, 94

Hebrew Bible, 13, 20–32, 34–36; and art of the sanctuary in both tabernacle and temple, 20–22, 59; and Augustine's vocabulary for beauty, 49–50n; beauty and desire, 24–25, 26–27, 35–36; beauty and holiness linked, 13, 20–27, 34–36; concept of the sublime, 244–45; divine attributes used as metaphors for beauty in the world, 25–26; Duke of Sussex Hebrew Bible (early fourteenth century), **72**; examples of early Christian

iconography borrowing from narratives, 330; Exodus, 20–22; Greek Old Testament (Septuagint), 28–32; Greek word *kalos*, 30; Hebrew term *qodesh/qadosh* ("set apart"), 19–20; Hebrew word *kabod* ("glory"), 21–22; Hebrew words for beauty, 22–27, 49n; human beauty (*yapheh*), 23–25, 32, 49n; idolatry warnings, 22, 32, 35; instructions to Moses for building and furnishing the tabernacle, 20–21; prophecies of Isaiah, 22; Psalms on beauty of the sanctuary, 22; Solomon's Temple, 20–22, 34, 68–75; temple artwork in illustrated manuscript Bibles, **70**, **71**, **72**, **73**, **74**; *tipharah* (used in connection with holiness), 22–23; vestments of Aaron (adornment), 21–22; wall painting at Dura Europus synagogue, **21**, 71, 104, 126

Hegel, Georg W. F., 120, 230, 233

Helding, Michael, 204–5, **205**

Hempton, David, 270

Henry VIII, King, 186, 197, 219

He Qi, 363n

Herbert, George, 13, 78, 102–3, 222

Herder, Johann Gottfried, 229n, 230–31; on beauty, 238–39, 240n

Herodotus, 32

Hexaemeron (Bonaventure), 91–92, 94

Historical Jesus, early quest for, 270

Hoffman, Matthew, 338–39, 340

Hoffmann, E. T. A., 230

Hofmann, Werner, 231n, 233, 234, 235–36

Hogarth, William, 7

Holiness: art and religious awareness of, 12; beauty and holiness in the Hebrew Bible, 13, 20–27, 34–36; as biblical concept (and the terms "holy" and "holiness"), 18–20; Greek New Testament and Hebrew idea of beauty as, 34–35; Hebrew term *qodesh/qadosh* ("set apart"), 19–20; Leonardo's iconographic dilemma of how to depict, 190–92, 226–27; New Testament (as essence of faithful life), 20; nineteenth-century groups' efforts to engage or depict, 253–87; Protestant Reformation and loss of link between beauty and, 366; sublimity and the holy in Hebrew Bible, 244–45; *tipharah* in the Hebrew Bible, 22–23. *See also* Sublime, concept of

Holiness Wesleyan Chapel in Richmond, Van Gogh's 1876 sermon at, 268–69

Holocaust, 338, 343, 345

Holy Countenance, The (Rouault), 327

Holy Family, The (Murillo), 302

Homer's *Odyssey*, 2, 29, 32

Hopkins, Gerard Manley, 1–3, 13, 93–94

Horace, 95–96

Hugh of St. Victor, 60, 94–95

Hunt, William Holman: desire to paint biblical scenes as faithfully as possible, 264–66; *The Finding of the Saviour in the Temple*, **265**, 265–66; *The Light of the World*, 264–65, 267; and Pre-Raphaelites, 259–60, 264–66

Huret, Jules, 279

Hurtado, Larry, 48

Huysmans, Joris-Karl, 289–90, 298n

Idea of the Holy, The (Otto), 232n, 314

Idiot, The (Dostoyevsky), 292

Idolatry: Augustine on, 45, 58; Greek word *kalos* in the Wisdom of Solomon and warning of, 22, 31–32; Hebrew Bible's warnings about, 22, 32, 35; Reformation and moral revolt against perceived idolatry in art, 366

Image of God: and Bonaventure on the imitation of Christ, 97; Genesis, 23, 365; human beauty and the Christian tradition, 23

Imagines elegantissimae (Melanchthon and Coglerus), 205, **206**

Imitation of Christ (Thomas à Kempis), 268

Immaculate Conception (Pacheco), **184**, 185

Impressionists, 253–54. *See also* Postimpressionists

Incredulity of St. Thomas, The (Caravaggio), **225**, 237

Innocent III, Pope, 63–65, 110, 167

Innocent VIII, Pope, 160

Intercession of the Virgin (Rubens), 179

Interior of the Buurkerk, Utrecht (Saenredam), 368, **369**

Isaac, "binding" of. *See* Akedah

Isaiah's Suffering Servant, 325, 337, 340, 344; and Chagall's use of crucifixion symbol, 329, 340, 344; Rouault's depictions of the crucifixion, 325; and Van Gogh's *Still Life with Bible*, 270–71

Isenheim Altarpiece (Grünewald), 131–34, **132**, **133**, 289–90, **290**; central panel, **132**; chiaroscuro technique, 131; Dali and, 290, 309, 311; depiction of sorrows of Mary and Mary Magdalene, 132–33; Ernst and, 290, 302; Gabriel and Mary in the annunciation panel, **133**, 134; graphic realism of the crucifixion, 131–34, **132**; influence on anti-Christian artists, 289–90, **290**, 297–98, 298n, 314–15; John the Baptist and the lamb, 131, **132**; Luther and, 134; Picasso and,

290, 297–98; resurrection panel, **133**, 134

Isidore of Miletus, 76

Isidore of Seville, 196

Jaeger, Werner, 29–30

Jerome, Saint, 26, 167

Jerusalem Stone, 59

Jerusalem temple, destruction and loss of (70 CE), 59, 125–26

Jesus Raising of the Daughter of Jairus (Overbeck), **255**, 256

Jewish artists' adaptations of iconic Christian subjects and images, 328–35, 338–44; Akedah motif, 331, 338, 341, 345–47, **347**; Chagall's Akedah lithographs, 331, 338, 345–47, **347**; Chagall's juxtaposition of Christian concept of atonement and Jewish Yom Kippur, 343–44; Chagall's use of crucifixion symbol/images, 328–30, 338–44, 338n, **342**, **346**; Hasidic and Orthodox Jewish responses to Chagall, 328–29; Hoffman on crucifixion debate among American Jewish writers and artists, 338–39; and the Holocaust, 338, 343; Jewish-Christian poet Brandstaetter's meditation on the crucifixion, 335–38; and Moses as typological precursor to Christ, 330; and Potok's *My Name Is Asher Lev*, 329; reappropriation of crucifixion symbol (as representing Jewish suffering), 328–30, 338–41; Yung-Yiddish movement, 339

Jewish Publication Society, 329

Jezus van Nazareth (Stricker), 270

John Chrysostom, Saint, 148n

John Paul II, Pope: and Arcabas, 351, 352; homily on nudity in Michelangelo's Sistine Chapel painting, 175, 181; *Letter to Artists*, 351; on the transcendentals, 352

John the Baptist (Raphael), 221

John the Baptist in the Wilderness (Geertgen tot Sint Jans), 331

Jonah Sarcophagus, St. John Lateran, Rome (third century), 15–16, **16**, 330

Jones, Rev. T. Slade, 268

Judges (Rouault), 321

Julius II, Pope, 160–64

Jung, Carl, 306

Kalos (beauty): Greek New Testament (goodness in ethical sense), 32–35, 58; Greek Old Testament (Septuagint), 30; Philo of Alexandria, 30; Platonic thought on the beautiful good, 29–30, 32, 36;

Plato's depiction of Socrates and moral fitness in *Phaedrus*, 29–30, 35; Plotinus's *Enneads*, 30; Wisdom of Solomon (warning of idolatry), 22, 31–32

Kames, Lord [Henry Home], 63–65, 68

Kang, Soo Yun, 321–23

Kant, Immanuel, 230, 231, 240–41, 245–49, 276; on beauty (distinguishing what is beautiful), 240–41; *Critique of Judgment*, 240–41, 245–46; notion of the sublime, 245–49; *Prolegomena to Any Future Metaphysic*, 251; and the transcendentals, 247

Keats, John, 227n, 243, 317

Keble, John, 260

Kierkegaard, Søren, 292

Kirwan, James, 27, 31

Kleist, Heinrich von, 230

Kosegarten, Ludwig Gotthard, 230–31, 231n, 240–41n

Krinsky, Carol, 73–74

Kristianiabohemen (Kristiania Bohemians), 293–95

"Kristos in geto" (Asch), 339, 341

Kühn, Gottlieb, 231

La Branche (The Branch) (Chagall), **348**

La joie de vivre (Zola), 270–71, **271**

Lamentation of Christ fresco, Arena Chapel, Padua (Giotto), 118, **120**

La Nativité, Polyptych of the Infancy of Christ (Arcabas), **353**, **354**

Lanfranco, Giovanni, 179, **180**

La révolution surréaliste (magazine), 296, 300

Lasansky, Mauricio, 338

Lasso, Orlando di, 222

Last Judgment fresco (Cornelius), 257–59, **258**

Last Judgment fresco, Sistine Chapel (Michelangelo), 25, **168**, 168–69, 175, 177, 257–59

Last Supper (Leonardo da Vinci), 221

La Tour, Georges de, 223

La Vie (Picasso), 296

Lay voluntary associations and spiritual societies, fifteenth century, 148, 148n, 159

"Leaden Echo and the Golden Echo, The" (Hopkins), 1–3

LeClerq, Jean, 145

L'École des Arts Decoratifs (Paris), 319

Leo X, Pope, 161

Leonardo da Vinci, 151, 190–92; iconographic dilemma of how to depict the meaning of the holy, 190–92, 226–27; *Saint John the Baptist*, **191**, 192; two

versions of *The Virgin on the Rocks*, 190–92, 226–27; Wordsworth's poem in praise of *Last Supper*, 221

Léon-Martin, Louis, 324

Lessing, Gotthold Ephraim, 229

L'esthétique de Saint Augustin et ses sources (Svoboda), 38n, 43

"Le surréalism et la peinture" (Breton), 296

Le Targat, François, 328

Le Temple de Paradis (Perrisin), 368, **370**

Levinas, Emmanuel, 318, 345n

Light metaphysics and theological symbolism of light, 83–103; Abbot Suger's rebuilding of Saint-Denis to allow more light, 91, **92**, **93**; biblical association of light with God himself, 85–86; Bonaventure on four types of light, 95–97, 100; Bonaventure's light theory, 91–97, 103; Grosseteste's treatises on light metaphysics, 88–89; late medieval breakthroughs in physics and optics, 83–84, 88–89; late medieval Gothic cathedral architecture, 83–103; medieval Christian idea of God as cosmic geometer, 89, **90**; medieval philosophy and the metaphysical implications of light, 83–84, 88–97; mosaics of Santa Maria Maggiore, 51, 84–85, **85**; Platonic cosmogony and medieval Christian doctrine of creation, 86–87; prologue to John's Gospel (Logos as the Light of the World), 87, 89, 95, 103; Sainte Chapelle de Paris, 97–103, **98**, **99**, **102**; stained glass windows, **93**, **98**, **99**, 99–102

Light of the World, The (Hunt), 264–65, 267

L'Immaculée Conception (Dali), 306

Lindisfarne Gospels, 379, **380**, 381

"Lines Composed a Few Miles above Tintern Abbey" (Wordsworth), 228, 243–44

Lippi, Filippino, 185n

Littérature (Breton's review), 300

Liturgy: consistency and changes in, 60, 63; prologue to Gospel of John and, 95

Longinus, Cassius, 241–42, 244, 245

Lotto, Lorenzo, 142–43

Louis IX the Pious, King, 98–99, 154n

Love One Another (Rouault), 325

"Love Ron" (Thomas of Hales), 145

Luther, Martin: depiction in Lucas Cranach the Younger's *Allegory of Redemption*, 187–89, **188**; early opinions of art in Rome, 169–71, 176–77, 189; and Grünewald's *Isenheim Altarpiece*, 134; illustrations for commentary on the *Seven Penitential Psalms*, **202**, 204, 210; Ninety-Five Theses, 161; on polygamy, 197–98n; and story of David and Bathsheba, 197–98, 204, **204**, 210

Lutheran Church: early Lutheran book illustrations depicting Bathsheba's modesty and decorum, **202**, 202–5, **203**, **204**, **205**, 216; and Friedrich's altarpiece painting for *Tetschen Altar*, 231–35, **232**, 236; Friedrich's upbringing, 229, 234; and German Romanticism, 229, 231–35, **232**, 236; Munch's upbringing, 292

Lyotard, Jean-François, 241

Lyra, Nicholas, **74**, 74–75

Macrina, Saint, 50

Madame Bovary (Flaubert), 270

Maderno, Carlo, 162

Madonna (Munch), 292–93, **293**, 314

Madonna and Child with Angels and Six Saints (Piero della Francesca), 310

Madonna Enthroned with St. Francis (Cimabue), 106–7

Madonna of Port Lligat, The (Dali), 309–11, **310**

Madonna of the Book (Botticelli), 151

Madonna of the Franciscans (Duccio), 106

Madonna of the Holy Trinity (Cimabue), 107, **108**

Madonna of the Magnificat (Botticelli), 151–52, **152**

Madonna with the Messiah (L'enfance series) (Arcabas), 356, **357**

Magdala Stone, 71n

Maimonides, 74

Mâle, Émile, 80, 109, 185

Mallarmé, Stéphane, 284

Manet, Édouard, 254

Manicheanism, 39, 42

Manifesto of Surrealism (Breton), 300, 301

Marc, Franz, 299–300

"Marc Chagall's Portrayal of the Prophet Jeremiah" (Friedman), 331

Maritain, Jacques: and Arcabas, 352; *Art and Scholasticism*, 324, 327; on Christian art (as art of humanity redeemed), 327; conversion, 318, 340; and Rouault, 324, 361; on Rouault's empathy, 324; on the transcendentals, 352; on twentieth-century art and the human being, 317

Maritain, Raïssa, 318, 340; on Chagall, 340, 342, 349, 361; conversion to Catholicism, 340; on Hasidic Jewish community's response to Scripture, 334; on Rouault and Jacques Maritain, 324

Marlowe, Christopher, 223, 224n

Marriage of Cana fresco, Arena Chapel, Padua (Giotto), 117–18, **119**

Martyr (Chagall), 341, 343

Marvel, Andrew, 4

Mary: Arcabas's paintings, **353**, **354**, **355**, 356, **357**; Dali's paintings, 306, 309–11, **310**, 313; depictions of Mary reading and her scholarly knowledge of Scripture, 151–52; depictions of the annunciation, **133**, 134, **138**, **139**, 140–44, 146, **147**, 148–50, **149**, 263–64; Dürer's *Virgin and Child on a Crescent with a Crown of Stars and a Scepter*, **182**; Ernst's blasphemous *Virgin Mary Spanking the Infant Jesus*, **304**, 304–5, 314; Franciscan chivalric imagery, 145–46; Franciscan spirituality, 106–7, 113, 116–21, 145–46, 190; Giotto and Marian spirituality, **116**, 116–21, **117**, 263; late medieval altarpiece paintings, 132–34, **133**, **138**, **139**, 140–44, 146, **147**, 148–54, **149**, **152**, **153**; Leonardo's two versions of *The Virgin on the Rocks*, 190–92, 226–27; medieval Christians and the "Ave Maria" prayer, 153–54; Michelangelo's *Pietà*, **163**, 163–64; Munch's blasphemous *Madonna*, 292–93, **293**, 314; Murillo's *Walpole Immaculate Conception*, 185, **186**; Overbeck's fresco *The Triumph of Religion in the Arts*, 256–57, **257**; Pacheco's *Immaculate Conception*, **184**, 185; post-Tridentine reactions to depictions not sanctioned by the church, 181–85, 190; Rossetti's *Ecce Ancilla Domini!*, 143, **262**, 263–64; Rossetti's Marian poetry and iconography, 260–64, **261**, **262**; Santa Maria Maggiore mosaics, 84; and thirteenth-century revolution in style, 106–7, 113, 116–21, 190

Maryan, Maryan S., 338

Mary Magdalene: catacomb painting depicting encounter with resurrected Christ in the garden, 17, **18**; Donatello's *Mary Magdalene* and the thirteenth-century revolution in style, 123, **123**, 171; Grünewald's *Isenheim Altarpiece*, 132–33; Lanfranco's non-canonical *Assumption of the Magdalene*, 179, **180**; Titian's eroticized *Saint Mary Magdalene*, 171, **172**

Mary Magdalene at Baptistry of the Duomo in Florence (Donatello), 123, **123**, 171

Masaccio, 177, **178**

Maskell ivories, Rome (ca. 425), 50, **51**

Massacre of the Innocents (Ernst), 304

Massys, Jan, *David and Bathsheba* (1562), **208**, 208–9

Medici, Lorenzo de, 160

Medieval manuscript illumination, 379–82; Bathsheba and King David story, 194, **199**, 199–202, 199–205, **200**, **201**, **202**, **203**, **204**, **205**; *Bible mor-*

alisée, 89, **90**, 100–102, **101**, 199, 379; books of hours, 199–202, 380–81, **381**; Jewish Bibles and Passover Haggadah manuscripts, 381–82, **382**; Lindisfarne Gospels, Matthew page, 379, **380**; *Meditations on the Life of Christ* (fourteenth-century Franciscan manuscript), 112–14, 117, 130–31, 140, 150; *Speculum humanae salvationis* (early fourteenth century), 23n, **24**; temple artwork in illustrated Hebrew manuscript Bibles, **70**, 71, **72**, **73**, **74**; Vienna Genesis manuscript, 379

Meditations on the Life of Christ (fourteenth-century illustrated manuscript), 112–14, 117, 130–31, 140, 150

Melanchthon, Philipp, 189, 197, 205

Memling, Hans, *Bathsheba Bathing*, **201**, 202, 210

Mendelssohn, Moses, 229

Merode Altarpiece (ca. 1428), 148–50, **149**

Metropolitan Tabernacle (London), 368–70

Michaelis, Johann David, 229

Michelangelo Buonarroti: *Pietà* at Saint Peter's Basilica, 151, **163**, 163–64, 221–22; poem "On Rome in the Pontificate of Julius II" and opinions of Rome's art, 170; and Raphael, 168; Saint Peter's Basilica, 161–64, **162**; Sistine Chapel ceiling fresco (*Last Judgment*), 25, **168**, 168–69, 175, 177, 257–59

Millais, John Everett, 259

Millet, Jean-François: *The Angelus*, 306–8, **307**, 315; Dali's obsession with *The Angelus*, 306–8, 315; *Sower*, 273; Van Gogh's admiration for, 272–73, 274

Milton, John, 249

Miserere mei, Deus (poem), 194, 199

Miserere series (Rouault), 321, 324, 325

Modernism, 316–19; Bell on social consequences of, 317, 318, 321, 366–67; exhausted, 318–19; existentialists' solution to absurdity of, 317–18; Maritain on, 317; Nazarenes' antimodernist medievalism, 255, 259; philosophers of religion on implications of a postreligious world, 318; problem of devaluation of meaning and the human, 316–19; rejection of the transcendentals and loss of transcendence, 316–19; Rouault's circus clowns as alienated moderns, 321, **323**; Rouault's rejection of artistic, 319–21, 323–24; surrealists' nihilism and denigration of beauty, 317

Molanus, Johannes (Jan Vermeulen), 179–80

Monet, Claude, 254

Monk, Samuel, 301

Monk by the Sea (Friedrich), **235**, 235–36

Monteverdi, Claudio, 222

Moody Memorial Church, Chicago, 370, **371**

Moreau, Gustave, 279, 320

Moreh, Mordecai, 338

Morisot, Berthe, 254

Morning in the Riesengebirge (Friedrich), 238, **239**

Morris, William, 259

Morrison, Tessa, 76–77n

Mosaic of Jesus the Teacher, Apse of Santa Pudenziana, Rome (ca. 400), 50–51, **52**

Mosaics: adorned crosses in mosaic apses, 50–51, **52**, **53**; apse of Santa Costanza, Rome, 49, 61; apse of Sant' Apollinaire in Classe, Ravenna, 51, **53**; apse of Santa Pudenziana, Rome, 50–51, **52**; and light metaphysics, 51, 84–85, **85**; Marian themes, 84; *pantocrator* mosaics, 51, **85**; Santa Maria Maggiore, Rome, 51, 84–85, **85**, 114; and thirteenth-century revolution in style, 105

Mozart, Wolfgang Amadeus, 222, 230

Munch, Edvard, 291, 292–95; *Anxiety*, 293; blasphemous antireligious paintings with destructive eroticism, 292–95, **293**; early life and pious Lutheran upbringing, 292; *Golgotha*, **294**, 295; and the Kristianiabohemen, 293–95; *Madonna*, 292–93, **293**, 314; reading, 292; *Vampire*, 293–94; and Van Gogh, 292, 294

Munkerus, Tomas, 378

Murillo, Bartolomé Esteban: *The Holy Family*, 302; *Walpole Immaculate Conception*, 185, **186**

Muro della Marea, Fra Giovanni di, 115–16

Museo Poldi Pezzoli in Milan, 151

Museum Meermanno in the Hague, **199**, **200**, 202

My Name Is Asher Lev (Potok), 329, 338n

Mystère Catholique (Catholic Mystery) (Denis), **285**, 285–86

Nabis: Denis, 284, **285**, 285–86, **286**, 287; and iconic function of Christian painting, 284–85; recovery of mystical tradition in Catholicism, 284–86, 287; and the synthetist style, 284–86, 287

"Natural supernaturalism," 227, 228, 233, 274

Nazarene, The (Asch), 341

Nazarenes, 254–59, 284, 286; abstraction to symbol, 256; antimodernist medievalism, 255, 259; Cornelius's *Last Judgment* fresco, 257–59, **258**; depictions of biblical scenes, **255**, 256; depictions of Mary, 256–57, **257**; and Lukasbund brotherhood, 255; move to Rome, 255–56; Overbeck, **255**, 255–57, **257**

Neoclassicism, eighteenth-century, 242–44, 253; French, 242; and "natural sublime" of poets and landscape painters, 242–44; and Poussin's Catholic Seven Sacraments series, 225–27, **226**

Neoplatonism: Augustine's theological aesthetics, 38, 39–40, 43, 44–45, 65; and notions of sacred numbers and ratios, 75–78; Plotinus's *Enneads*, 30, 39

New Testament. *See* Greek New Testament

Newman, Barnett, 353

Newman, John Henry, 260

Newton, Isaac, 77n

Newton, John, 223

Nicholas V, Pope, 160

Nietzsche, Friedrich, 301

Night Thoughts (Young), 236, 243, 301

Nineteenth-century groups' efforts to engage or depict the holy, 253–87; Nabis, 284–86, 287; Nazarenes, 254–59, 284, 286; postimpressionists, 266–83, 287; Pre-Raphaelites, 259–66, 286–87. *See also* Nabis; Nazarenes; Postimpressionists; Pre-Raphaelites

Notre Dame de la Couture, Le Mans, France, altar in crypt of (sixth century), **127**

Novak, Michael Anthony, 311

Novalis (Friedrich Leopold, Freiherr von Hardenberg), 230

"Nuclear mysticism," 309, 310–13

O'Brien, Michael D., 363n

Obsession (Chagall), 343

Occult and surrealism, 302–4

O'Donnell, James, 43

Old Church Tower at Nuenen, The (Van Gogh), 270

Old Testament. *See* Greek Old Testament (Septuagint); Hebrew Bible

Old Testament temple (Solomon's Temple), 20–22, 34, 68–75; Bede's commentaries on, 68–73; and Ezekiel's temple vision, 70–71, **73**, 73–74, 75; in illustrated Hebrew manuscript Bibles, **70**, 71, **72**, **73**, **74**; imitations using literal descriptions and measurements, 71–78; influence of temple imagery for late medieval Gothic cathedrals, 67–78, **70**, **72**, **73**, **74**, 83; instructions to Moses concerning building and furnishing the tabernacle, 20–21; Lyra's *Postilla* and ground plan for, **74**, 74–75. *See also* Jerusalem temple

Oliver, Simon, 88

Olivier, Fernande, 296

O'Malley, John W., 148n

On Christian Matrimony (Erasmus), 171

On Religion: Speeches to Its Cultured Despisers (Schleiermacher), 234

Opinia (Polish journal), 339

Oppenheim, Meret, 314

Oppenheimer, Paul, 209n

Otto, Rudolf, 7, 231–32, 232n, 314

Overbeck, Johann Friedrich, 255–57; depictions of Mary, 256–57; *Jesus Raising of the Daughter of Jairus*, **255**, 256; and the Nazarenes, 255–57; *The Triumph of Religion in the Arts*, 256–57, **257**

Ovid, 2, 3, 208

Ozick, Cynthia, 329

Pacheco, Francisco: *The Art of Painting*, 185n; *Immaculate Conception*, **184**, 185

Paleotti, Gabriele, 180–81, 183

Palestrina, Giovanni Pierluigi da, 222

Pankok, Otto, 338

Panofsky, Erwin, 91n, 173–74

Papyrus manuscripts, 48

Parable of the sower, 273–74

Paradise Lost (Milton), 249

Paul, Jean, 230

Paul, Saint: on the altar as "table of the Lord," 126; on the cross, 47–48; on physical objects and spiritual meaning, 65

Paul III, Pope, 161, 168, 186

Paul IV, Pope, 177n

Paul V Borghese, Pope, 162

Pearl, The, 78–82, 138; and Apocalypse of Saint John the Divine, 80–82; and Gothic architectural vision of new Jerusalem, 80–82

Peng Si, 363n

Pentecost: Descent of the Holy Spirit fresco, Arena Chapel, Padua (Giotto), 118–19, **121**

Peretz, Y. L., 339

Perrisin, Jean, 368, **370**

Petrus Christus, 152; *The Virgin of the Dry Tree*, 152–53, **153**

Philo of Alexandria, 30

Picasso, Pablo, 291, 295–99; Blue Period, 296; *Corrida*, 299; *Crucifixion* (1896), 295; *The Crucifixion* (1930), 296–98, **297**, 314; *Crucifixion with Embracing Couples*, 296; cubism, 296–98; *Demoiselles d'Avignon*, 296; early life and traditional Catholic family, 295–96; early modernist and erotic subject matter, 296; early traditional, realistic paintings, 295; *First Communion*, 295; and Grünewald's

Isenheim Altarpiece, 290, 297–98; *Guernica*, 298, **299**; *La Vie*, 296; leaving the Catholic Church, 295–96; Rose Period, 296; *Science and Charity*, 295; serial mistresses and sexual liaisons, 296; surrealism, 296–98, 301

Picinelli, D. Philippi, 377

Piero della Francesca, 151; *Madonna and Child with Angels and Six Saints*, 310

Pietà (Michelangelo), **163**, 163–64, 221–22

Pilgrim's Progress (Bunyan), 268

Pinsker, Sanford, 329

Pius IV, Pope, 177

Pius XII, Pope, 309

Plato: cosmogony, 86–87, 166; and Raphael's *Disputa del Sacramento*, 166; *Republic*, 87; Socrates and moral fitness in *Phaedrus*, 29–30, 35; Socrates's myth of the dark cave and the light of truth, 86–87; *Timaeus*, 29–30, 47, 86–87, 166; transcendentals, 29–30, 32, 36, 47, 239, 316. *See also* Transcendental properties of being (the True, the Good, the Beautiful)

Plotinus: Augustine and, 38, 39–40, 43, 44–45, 65; *Enneads*, 30, 39; *Peri tou kalou*, 30, 39. *See also* Neoplatonism

Postilla super totam Bibliam, volume 1 (Nicholas Lyra), **74**, 74–75

Postimpressionists, 266–83, 287; Gauguin, 266–67, 276–83, 287; and symbolist movement, 276–84, 287; and synthetist movement, 276–79, 287; Van Gogh, 266–76, 287. *See also* Gauguin, Paul; Van Gogh, Vincent

Potok, Chaim, 329; *Brooklyn Crucifixion* (painting), 329; and Chagall, 329; *My Name Is Asher Lev*, 329, 338n

Poussin, Nicolas: *Baptism*, **226**, 226–27, 245; Catholic neoclassicism and Seven Sacraments series, 225–27

Prelude, The (Wordsworth), 249–51

Pre-Raphaelites (Pre-Raphaelite Brotherhood), 259–66, 286–87; and "Art Catholicism," 260, 264; Hunt, 259–60, 264–66, **265**; Marian poetry and iconography, 260–64, **261**, **262**; Rossetti, 259–64. *See also* Hunt, William Holman; Rossetti, Dante Gabriel

Procopius, 76

Prophet Jeremiah Lamenting the Destruction of Jerusalem, The (Rembrandt), 331n

Proportion and ratio (sacred ratios and harmonic proportions): Augustine's *De pulchro et apto*, 37–38, 97, 352; Bonaventure on divine cosmic patterns, 62, 94; Gothic cathedral architecture, 61–78,

77, **78**; medieval Christian idea of God as cosmic geometer, 89, **90**; medieval optics and geometry, 89; Neoplatonism and notions of sacred numbers and ratios, 75–78; reliquary design, 62, **62**; tabernacle design, 75–78, **77**, **78**; thirteenth-century notions of taste and beauty, 63–67; vision of new Jerusalem in Apocalypse of Saint John the Divine, 81

Protestant Allegory (Girolamo da Treviso), 185–87, **187**

Protestant art: eroticism/voyeurism in depictions of Bathsheba's beauty, 205–6, **208**, 208–12, **210**, 216–18, **217**; polemical art of the Reformation, 185–89, **187**, **188**; reformers' moral revolt against perceived idolatry, 366; reformers' polemical art, 185–89, **187**, **188**; reformers' reactions to eroticized biblical painting, 169–71, 176–77, 189; rupture between tradition of Catholic art and Protestant sensibilities, 219–20, 223–28. *See also* Protestant church architecture; Romanticism, nineteenth-century

Protestant church architecture, 74n, 368–75; "big-box" evangelical and Pentecostal churches, 373; Calvinist round church in Lyons, 368, **370**; First Baptist Church of Amarillo, Texas, 371, **372**, **373**, **374**; horseshoe auditorium format, 368–70, **371**; medieval Romanesque style of rounded arches, windows, and ornament, 370–71, **372**, **373**, **374**; Moody Memorial Church, Chicago, 370, **371**; Old Baptist Chapel, Tewkesbury, England, 368, **371**; organs with decorated pipes, 372; post-Reformation removal of Gothic and Roman edifices and overpainting of walls, 368, **369**; Presbyterian churches of eighteenth- and nineteenth-century New England, 372, **375**; reflecting congregational worship and emphasis on preaching and the pulpit (function over adornment), 368–70, **370**, **371**; Reformed tradition in America, 372; Saenredam's *Interior of the Buurkerk, Utrecht*, 368, **369**; Warrior Run Presbyterian Church, Pennsylvania, **375**

Protestant Reformation: and costs of Saint Peter's Basilica construction, 161; loss of link between beauty and holiness, 366; Luther's Ninety-Five Theses, 161; moral revolt against perceived idolatry in art, 366; polemical art of, 185–89, **187**, **188**; and problem of how to define Christian art (Apostolos-Cappadona on), 291;

reformers' commentaries on Bathsheba and King David story, 197–98; reformers' reactions to eroticized biblical painting, 169–71, 176–77, 189; removal of Gothic and Roman edifices from churches and overpainting of walls, 368, **369**; Rome at the time of, 159–60, 169–74

Protoevangelium of James, 113, 117

Prudentius, 104, 136–37, 141

Psalms: and Augustine's theological aesthetics, 43, 55, 56; on beauty of the sanctuary, 22; David's prayer in Psalm 27:4 (to gaze upon the beauty of the Lord), 367; Luther's commentary on the *Seven Penitential Psalms*, **202**, 204, 210; Rothschild Miscellany (ca. 1460–1480), 381, **382**

Pseudo-Dionysius, 88, 91n

Psychology discipline, early twentieth-century, 289–90; Charcot's studies explaining mass hysteria, 289; diagnoses for spiritual disorders, visions, and mystical experiences, 289–90; Freudianism, 289–90, 300, 302, 305–6; Huysmans on the threat to art, 289–90; and surrealism, 300, 302, 305–6

Pusey, Edward Bouverie, 260

Qoheleth, 36

Rabbula Gospels (586 CE), 51–52

Rabinovitch, Celia, 301

Ramdohr, Friedrich Wilhelm von, 233

Ranson, Paul, 284

Raphael, 151, 161, 164–69; and Bramante's Saint Peter's Basilica plan, 161; *Disputa del Sacramento* fresco at the Vatican's Stanza della Segnatura, 164–69, **165**, 256; and Michelangelo, 168; and the Nazarenes, 256; and the Pre-Raphaelites, 259; *School of Athens*, 166, 167; *Transfiguration*, 167n; Wordsworth's poem in praise of *John the Baptist*, 221

Rashi, 74

Rattner, Abraham, 338

Redon, Odilon, 279, 298n

Reiss, Moshe, 345n

Reliquary, Limoges (ca. 1200–1230), 62, **62**

Rembrandt van Rijn, 212–16, 218, 359n; *Bathsheba at Her Bath*, 212–14, **213**, 216, 218; Chagall and, 331n; *David and Uriah*, 214–16, **215**; depiction of the Akedah and shielding of Isaac's face (1635), 345; *The Prophet Jeremiah Lamenting the Destruction of Jerusalem*

(1630), 331n; subversion of voyeurism in Bathsheba and King David story, 212–16, 218; *Woman Taken in Adultery*, 212

Renaissance art, 159–92; and Catholic Church protocols on nudity and eroticism, 175–85; depictions of Marian legends not sanctioned by the church, 181–85, **182**, **184**, **186**, 190; Dürer, 182, **182**; Erasmus on, 170, 171, 179, 181, 189, 207; eroticism and Bathsheba's beauty, 193–218; eroticized biblical painting, 169–78, 193–218; eroticized depictions of classical subjects, 171–74, **173**, **174**; Leonardo's *Saint John the Baptist*, **191**, 192; Leonardo's *The Virgin on the Rocks*, 190–92, 226–27; Luther on, 169–71, 176–77, 189; Michelangelo's *Last Judgment* fresco at Sistine Chapel, 25, **168**, 168–69, 175, 177, 257–59; Michelangelo's *Pietà*, **163**, 163–64, 221–22; nineteenth-century Nazarenes and, 254–59, 284, 286; nineteenth-century Pre-Raphaelites and, 259–66, 286–87; noncanonical subjects, 179–80, **180**; post-Tridentine commentators on, 179–85; and Protestant England's Romantic revolution, 219–20, 221–22; and Protestant reformers' polemical art, 185–89, **187**, **188**; Protestant reformers' reactions to, 169–71, 176–77, 189; Raphael's *Disputa del Sacramento* fresco, 164–69, **165**, 256; and Rome in the late fifteenth century and early sixteenth century, 159–60, 169–74; Saint Peter's Basilica, 159–64; Titian, 171, **172**, 173–74, **174**; Vatican paintings, 164–69, **165**. *See also* Bathsheba and King David story (Bathsheba's beauty in Renaissance art)

Renan, Ernst, 270, 282, 288–89

Rendezvous of Friends (Ernst), 303–4

Renoir, Pierre-Auguste, 253–54

Republic (Plato), 87

Resurrection of the Flesh, The (Dali), 308

Reynolds, Sir Joshua, 240, 259

Richard of St. Victor, **73**, 73–74

Riga, Peter, 197

Ripa, Caesare, 377

Roman basilicas, 60–61, **61**; adaptation of legal architecture (law court), 60–61, **61**, 67–68

Roman *coemetaria* and Christian funerary art: carved stone sarcophagi, 13–14, **14**; catacombs and motifs, 13–17, **14**, **15**, **16**, 18, 104; sarcophagus with Chi Rho (ca. 350), 48–49, **49**

Roman sublime, 242

Romanticism, nineteenth-century, 219–52; ambivalence about Christian tradition, 221–23; concept of the sublime, 241–49, 252; and the contested nature and meaning of beauty, 238–49, 252; disenchantment with Renaissance art, 219–20, 221–22; England, 219–20, 227–28, 249–52; Friedrich, 219–20, 229–38, 247–49, 251–52; Friedrich's letter on German anti-Catholic disenchantment and, 219–20, 228, 236; Friedrich's works depicting despair of formal religion, **235**, 235–38, **237**; German, 219–20, 229–41, 247–49, 251–52; Kant's notion of the sublime, 245–49; and "natural supernaturalism," 227, 228, 233; and nature/landscape, 221–23, 228, 235–36, 251; Neoclassicism, 242–44; and rupture between Catholic and Protestant sensibilities in religious art, 219–20, 223–28; Wordsworth, 221–23, 227–28, 249–52. *See also* Friedrich, Caspar David; Wordsworth, William

Rome in the late fifteenth and early sixteenth century, 159–60, 169–74. *See also* Renaissance art; Saint Peter's Basilica

Rood screens, medieval, 128–30; crosses surmounting, 128; and iconostasis in the Eastern churches, 130n; and realism of lifelike crucifixes, 128; Sheepstor Parish Church, Dartmoor, England, **129**; and thirteenth-century poem *Speculum ecclesiae*, 128–30

Rookmaaker, H. R., 276

Rosenau, Helen, 75

Rosicrucianism, 277

Rossetti, Christina, 260, 261, 263, 268

Rossetti, Dante Gabriel: and Anglo-Catholic movement, 260; "Ave" (verse prayer to "Mater Pulchrae Delectationis"), 260, 263–64; *Beata Beatrix*, 306; *Ecce Ancilla Domini!*, 143, **262**, 263–64; *The Girlhood of the Mary Virgin*, 260–63, **261**; Marian poems and iconography, 260–64, **261**, **262**; and the Pre-Raphaelites, 259–64

Rossetti, William M., 260

Rothschild Miscellany, Psalms (ca. 1460–1480), 381, **382**

Rotting Donkey (Dali), 309

Rouault, Georges, 318–28, 360–63; affirmation of the True as transcendental, 319, 324–25, 361; anti-erotic treatment of prostitutes (*filles de joie*), 320n, 321, **322**; circus clowns as alienated moderns, 321, **323**; *The Clown*, **323**; *The Conjuror*, 321; craftsman work ethic, 319; depictions of the passion/crucifixion, 325–28, **326**; *Don't We All Wear*

Make-Up?, 321; empathy with emotional suffering of others, 324–25; French Catholic upbringing, 319; *Girl with Mirror*, **322**; *Head of Christ*, **326**; *The Holy Countenance*, 327; iconic art, 326–28; *Judges*, 321; *Love One Another*, 325; and Maritain, 324, 327–28, 361; masks, 321–23, **323**; *Miserere* series, 321, 324, 325; painting technique, 322n; postconversion paintings and spiritual realism, 321–24, **322**, **323**, 327–28; rejection of artistic modernism, 319–21, 323–24; rejection of the modern church's infatuation with surrealists, 319–21; religious conversion, 320–21; stained glass windows restoration apprenticeship, 319, 361; on surrealists' hypocritical attempts at depicting sacred subjects, 320; *Upper Class Woman Who Thinks She Has a Reserved Seat in Heaven*, 321; the *vera*-icon (Veronica and imprinted image of Christ), 325, 327

Royal Academy of Arts in London, 259

Rubens, Peter Paul, 209–12, 209n; *Bathsheba at the Fountain*, 209–12, **210**; and Council of Trent protocols, 218n; *Great Last Judgment*, 177n; and his wife, Hélène Fourment, 211; *Intercession of the Virgin*, 179; *Susanna and the Elders*, 211

Rucellai Madonna (Duccio), 106

Runge, Philipp Otto, 230

Ruskin, John, 259

Sacramentalism, Catholic, 225–27

Sacrament of the Last Supper, The (Dali), 311

Sacred and Profane Love (Titian), 173–74, **174**

Sacrifice, rituals of, 3. *See also* Akedah

Sacrifice of Isaac, The (Chagall), 345–47, **347**

Sade, Marquis de, 305n

Saenredam, Pieter, 206, 368, **369**

Saint-Denis Cathedral, France: Abbot Suger's bejeweling of medieval altar with gemstones, 65–66; Abbot Suger's chalice, 66, **67**; Abbot Suger's rebuilding to permit more light, 91; apse and altar, 91, **93**; the great cross at Saint-Denis, 66; nave, 91, **92**

Sainte Chapelle de Paris, 97–103; Bonaventure and, 99; King Louis IX and building of, 98–99; stained glass windows, **98**, **99**, 99–102

Saint John the Baptist (Leonardo da Vinci), **191**, 192

Saint Mary Magdalene (Titian), 171, **172**

Saint Peter's Basilica, Vatican: Bernini's *baldacchino*, 164; Bramante's design, 161–62, **162**; design and construction, 159–64; financing, 161; floor plans, **162**; Julius II and, 160–64; Maderno's plan, 162, **162**; Michelangelo and Julius II's tomb, 161; Michelangelo's *Pietà*, **163**, 163–64, 221–22; Michelangelo's plan, 161–62, **162**; Old Saint Peter's (Constantine's church), 159–60, **162**; as papal monument, 162–63; Raphael and, 161

Salisbury Cathedral, 77–78, **78**

Samaritan Woman, The (Arcabas), 358, **358**

San Francesco in Assisi: Cimabue's frescoes for the upper church, 109; Giotto's *Dream of Innocent III* fresco, 110, **111**; Giotto's *Stigmata* fresco, **115**, 116

Sangallo, Giuliani da, 161

Santa Costanza, Rome: apse mosaic of the *traditio legis*, 49, 61; Mausoleum of, 49

Santa Maria Maggiore, Rome, 60, 67–68, 84; mosaics, 51, 84–85, **85**, 114; original *sol invictus* art in inner portal arch, 84

Santa Maria Novella in Florence, 106

Sant' Apollinaire in Classe, Ravenna (ca. 549), 60; Apse Mosaic, 51, **53**

San Vitale in Ravenna, 51, 376

Sarcophagi, 13–14, **14**; early altars and tombs or relics of martyrs modeled on, 127–28; Jonah Sarcophagus, St. John Lateran, Rome, 15–16, **16**, 330; Roman sarcophagus with Chi Rho (ca. 350), 48–49, **49**; Sarcophagus of the Shepherds, Catacomb of Praetextatus, **14**

Sarcophagus of the Shepherds, Catacomb of Praetextatus, Rome (late fourth century CE), **14**

Sartre, Jean-Paul, 298, 317

Sayers, Dorothy, 65

Scarry, Elaine, 12, 29

Schama, Simon, 212n

Schein, Johann H., 222

Schelling, Friedrich Wilhelm, 230

Schiller, Friedrich, 230

Schleiermacher, Friedrich, 230, 231, 234, 251, 267

Schnorr von Carolsfeld, Julius, 255

School of Athens (Raphael), 166, 167

Schubert, Franz, 230

Schuré, Eduard, 284

Schütz, Heinrich, 13, 194, 222

Science: academic discipline of psychology, 289–90; early twentieth-century conflict between religion and, 289–90; late medieval breakthroughs in physics and optics, 83–84, 88–89

Science and Charity (Picasso), 295

Scrovegni, Enrico degli, 116

Seasons, The (Thomson), 242

Self-Portrait (Gauguin), **278**, 279

Self-Portrait in Front of the Yellow Christ (Gauguin), 279

Self-Portrait 'près du Golgotha' (Gauguin), 279

Seven Penitential Psalms, Luther's commentary on, **202**, 204, 210

Seznec, Jean, 184, 189

Shahn, Ben, 338

Shakespeare, William, 223

Shapiro, Lamed, 339

Sheepstor Parish Church, Dartmoor, England, rood screen, **129**

Shelley, Percy Bysshe, 227n

Shorter Westminster Catechism, 365

Siddal, Elizabeth, 264

Silverman, Debora, 274

Singletary, Suzanne M., 280–81

Sir Gawain and the Green Knight (Pearl poet), 78, 129n

Sistine Chapel: Michelangelo's *Last Judgment* fresco, 25, **168**, 168–69, 175, 177, 257–59; restoration and John Paul II's 1994 homily on nudity in art, 175, 181

Sixtus IV, Pope, 160, 167

Sketches of the History of Man (Lord Kames), 63–65

Solitude (Chagall), 330–35, **332**, 337n

Solomon's Temple. *See* Old Testament temple (Solomon's Temple)

Sometimes I Spit with Pleasure on the Portrait of My Mother (Dali), 306

Songs of the Art Catholic (Rossetti), 260

Sophocles, 242

Southey, Robert, 227n

Sower (Millet), 273

Sower (Van Gogh), **272**, 273–74

Speculum ecclesiae (A mirror [or glass] for the church), 128–30, 139, 142

Speculum humanae salvationis, illustration of Genesis 3 (early fourteenth century), 23n, **24**

Speer, Andreas, 91n

Spenser, Edmund, 223

Spurgeon, Charles Haddon, 268, 368–70

Stained glass artistry: Arcabas, 354, 361; Chagall, 346, 361; Gothic cathedral of Sainte Chapelle de Paris, **98**, **99**, 99–102; Herbert on beauty of ("The Windows"), 102–3; and late medieval light metaphysics, 99–102; Rouault, 319, 361; Saint-Denis Cathedral, **93**; twentieth-century artists and window design for worship spaces, 319, 346, 354, 361

Starry Night, The (Van Gogh), **275**, 275–76

Staurograms, 48, 50, 52

Steinhardt, Jakob, 338

Stephano, Doris de, 322n

St. Erkenwald (Pearl poet), 78n

Stigmata fresco at San Francesco (Giotto), **115**, 116

Still Life with Bible (Van Gogh), 270–71, **271**

Stock, Alex, 48

Stricker, Johannes, 267, 270; *Jezus van Nazareth*, 270

St. Winifred's Well (Wales), 1

Sublime, concept of, 241–49, 252; eighteenth-century neoclassicists and "natural sublime," 242–43; English natural sublime ("agreeable terror" and religious rush of emotion), 242–43; French neoclassicists and the "natural sublime," 242; Kant and the transcendentals, 247; Kant's notion, 245–49; Longinus and ancient Greek rhetorical sublime, 241–42, 244; Old Testament Judaism and sublimity/the holy in Hebrew Bible, 244–45; postmodern, 241; Roman, 242; Wordsworth and natural sublime as "picturesque," 243–44; Wordsworth and the interior natural sublime, 243–44

Suger, Abbot of Saint-Denis, 65–66, 68; bejeweling of medieval altars with gemstones, 65–66, 89–91; chalice of Saint-Denis, 66, **67**; rebuilding Saint-Denis to permit more light, 91, **92**, **93**

Sund, Judy, 274

Surrealism, 299–313, 317; Bataille on the abyss between surrealists and Christians, 315; Breton, 296, 300–301, 303, 305, 308–9, 317; and Dada movement, 300; Dali and split with, 305, 308–9, 313; Ernst, 291, 301–5; and Freudianism, 300, 302, 305–6; influence of, 301, 317; Picasso and, 296–98, 301; postsurrealist "new mysticism" (Dali's nuclear mysticism), 309, 310–13; Rouault on hypocritical attempts at depicting sacred subjects, 320; Rouault's rejection of the modern French Catholic church's infatuation with, 319–21; séances and the occult, 303–4. *See also* Breton, André; Dali, Salvador; Ernst, Max

Susanna and the Elders (Rubens), 211

Sutherland, Graham, 338

Sutter, Joseph, 255

Svoboda, Karol, 38n, 43

Swedenborg, Emanuel, 277, 284

Symbolist movement, 276–77; Baudelaire, 276, 277, 279; Gauguin, 276–84, 287; and theosophy, 277–79, 283

Synthetist movement, 276–77, 284–86, 287; Gauguin, 276–79, 287; and the Nabis, 284–86, 287

Tallis, Thomas, 222

Tarabotti, Arcagela, 216n

Taste, thirteenth-century notions of aesthetic, 63–65

Tennyson, Alfred Lord, 259

Tertullian, 47

Tetschen Altar (Friedrich), 231–35, **232**, 236

Tetzel, Johann, 161

Theodoric (Emperor), 76

Theosophy, 277–78, 283

Thirteenth-century revolution in style, 104–24, 190; and Byzantine iconic style, 51, 107, 114; Cimabue, 105–9, **108**; Dante, 121–23; *dolce stil nuovo* (the sweet new style) in Italy, 122–23; Donatello's *Mary Magdalene*, 123, **123**, 171; Duccio, 105–9, **106**; Fra Angelico's *Annunciation* fresco, 123, **124**; and Franciscan spiritual revolution, 106, 109–24, 190; Giotto and the Franciscan spiritual revolution, 109, 114–24; Giotto's alfresco wall painting techniques, 109, 114–21, 356; Giotto's Arena Chapel frescoes, **116**, 116–21, **117**, **118**, **119**, **120**, 233; influence of Franciscan *Meditations on the Life of Christ*, 112–14, 117, 130–31, 140, 150; and Marian devotion, 106–7, 113, 116–21, 190; mosaics, 105; naturalistic representations of human faces, 107, **108**, 117–18. *See also* Giotto di Bondone

Thomas à Kempis, *Imitation of Christ*, 268

Thomas of Hales, 145

Thomson, James, 242, 246

Thun-Hohenstein, Countess von, 231

Tillich, Paul, 298, 308n, 311

Timaeus (Plato), 29–30, 47, 86–87, 166

Titian, 181; *Sacred and Profane Love*, 173–74, **174**; *Saint Mary Magdalene*, 171, **172**

Traherne, Thomas, 223

"Transcendence et intelligibilité" (Levinas), 318

Transcendental properties of being (the True, the Good, the Beautiful), 316–19, 361–63; Aquinas on Beauty, 47; Arcabas and Beauty, 319, 352–54, 361; Aristotle, 47; Augustine, 47–58, 65, 75, 316, 352; Balthasar on Beauty, 362n; Bonaventure on Beauty, 47, 92; Chagall and the Good, 319, 346–47, 361; Gothic cathedral architecture and classical ideas of transcendent Beauty, 64–65; John Paul II on, 352; Kant and the agreeable, the beautiful, the sublime, and the absolute good, 247; and Kant's notion of the sublime, 247; Maritain on, 352; modern rejection and loss of transcendence, 316–19; and

Philo of Alexandria, 30; Plato, 29–30, 32, 36, 47, 239, 316; and Plotinus's *Enneads*, 30, 39; Rouault and the True, 319, 324–25, 361; and thirteenth-century notions of beauty, proportion, and purpose, 64–65; twentieth-century artists and return of, 316–19, 324–25, 346–47, 352–54, 361–63

Transfiguration (Raphael), 167n

Triumph of Religion in the Arts, The (Overbeck), 256–57, **257**

Triumph of Surrealism (The Angel of the Home) (Ernst), 302–3, **303**

Tsakiridou, Cornelia A., 327

Turner, J. M. W., 227n

Twentieth-century artists, anti-Christian, 288–315; and conflict between science and religion, 288–90; Dada movement, 299–300; Dali, 291, 305–13, **308**, **310**, **312**; Ernst, 291, 301–5, **303**, **304**; and Grünewald's *Isenheim Altarpiece*, 289–90, **290**, 297–98, 298n, 314–15; Munch, 291, 292–95, **293**, **294**; Picasso, 291, 295–99, **297**, **299**; psychology and Freudianism, 289–90, 300, 302, 305–6; rejections of early pious religious upbringings, 288, 291, 292, 301–2, 305; surrealist movement, 299–313, 315, 317. *See also* Dali, Salvador; Ernst, Max; Munch, Edvard; Picasso, Pablo; Surrealism

Twentieth-century artists and recovery of beauty in art and religion, 6–7, 316–63; Arcabas, 318–19, 349–59, 360–63; Chagall, 318–19, 328–49, 360–63; crucifixion images, 325–30, **326**, 338–44, 338n, **342**, **346**; iconic style, 326–28, 355–59; and Maritain, 317, 324, 327–28, 361; and problem of modernity (devaluation of meaning and the human), 317–19; Rouault, 318–28, 360–63; and the transcendental properties of Being, 316–19, 324–25, 346–47, 352–54, 361–63. *See also* Arcabas (Jean-Marie Pirot); Chagall, Marc; Rouault, Georges

Une semaine de bonté (Ernst), 305

"Uphill" (Rossetti), 268

Upper Class Woman Who Thinks She Has a Reserved Seat in Heaven (Rouault), 321

Vampire (Munch), 293–94

Van der Weyden, Rogier, 263; *Annunciation* panel from the *Three Kings Altarpiece*, 146, **147**

Van Eck, Jan and Hubert, 263; *Arnolfi Marriage*, 146n; *Ghent Altarpiece*, 134–44, **135**, **136**, **138**, **139**, 155

Van Gogh, Theo, 269–70, 271, 273, 274–75

Van Gogh, Vincent, 266–76, 287; admiration for Millet, 272–73, 274; *Congregation Leaving the Reformed Church in Nuenen*, 270; early life and pious Protestant family religion, 267–68, 270, 292; and early quest for historical Jesus, 270; early travels and reading in contemporary fiction, poetry, and sermons, 267–68, 292; evangelical period and intensive Bible reading, 268–69, 273; and the imitation of Christ, 269, 274; late life despair and despondency, 274–76; letters, 267–68, 269–70, 273, 292; mission board's rejection and split with organized Christianity, 268–70; and Munch, 292, 294; "natural supernaturalism," 274; new understanding of religious value of art, 269–70; *The Old Church Tower at Nuenen*, 270; rejection of painting traditional biblical scenes, 271–73; sermon on Christian life as pilgrimage (1876), 268–69; *Sower* (and parable of the sower), **272**, 273–74; *The Starry Night* (hope and longing for the infinite), **275**, 275–76; *Still Life with Bible*, 270–71, **271**

Van Steen, Jan, 7

Vasari, 116n, 171n, 377

Vatican: Michelangelo's Sistine Chapel ceiling fresco, 25, **168**, 168–69, 175, 177, 257–59; Raphael's *Disputa del Sacramento* fresco in the Stanza della Segnatura, 164–69, **165**, 256; Raphael's *School of Athens*, 166, 167; Renaissance paintings, 164–69; Saint Peter's Basilica, 159–64

Vatican Cross (ca. 570), 51–52, **54**, 65

Vaughan, Henry, 223

Venus: Botticelli's *The Birth of Venus*, 183n; Lucas Cranach the Elder's quasi-pornographic depiction, 172–73, **173**; Massys's *David and Bathsheba*, **208**, 208–9; Titian's *Sacred and Profane Love*, 173–74, **174**

Venus (Lucas Cranach the Elder), 172–73, **173**

Victoria, Tomás Luis de, 13, 222

Vie de Christ (Renan), 270

Viennese Academy, 254

Vilalpando, Juan Bautista, 77n

Virgil's *Aeneid*, 141, 242

Virgin and Child on a Crescent with a Crown of Stars and a Scepter (Dürer), **182**

Virgin Mary Spanking the Infant Jesus before Three Witnesses, André Breton, Paul Éluard, and the Artist (Ernst), **304**, 304–5, 314

Virgin of Guadalupe (Dali), 313

Virgin of the Dry Tree, The (Petrus Christus), 152–53, **153**

Virgin of the Rocks, The (Leonardo da Vinci), 190–92, 226–27; London National Gallery canvas, 190–92; Louvre version, 190–92

Vision of the Sermon (Jacob Wrestling with the Angel) (Gauguin), 279–81, **280**, 289

Vision of the Temple, The (Rosenau), 75

Visitation, Polyptych of the Infancy of Christ (Arcabas), **355**

Walden, Daniel, 329

Walpole Immaculate Conception (Murillo), 185, **186**

Wanderer above a Sea of Fog (Friedrich), 247–49, **248**, 251

Warrior Run Presbyterian Church, Northumberland County, Pennsylvania, **375**

Watson, Francis, 351n

Watts, Isaac, 223

Wesley, Charles, 223

White, William Hale, 228n

White Crucifixion (Chagall), 340–41, 343n

Winckelmann, Johann Joachim, 254

Wisdom of Solomon: and Augustine's theological aesthetics, 40, 43; Greek word *kalos* and warning of idolatry, 22, 31–32; and mathematical structure of reality (in 11:20), 89

Woman Taken in Adultery (Rembrandt), 212

Women Find Jesus' Tomb Empty (Luke 20:11–18), The (Denis), 285–86, **286**

Wordsworth, Dorothy, 249–50

Wordsworth, William, 221–23, 227–28, 249–52; ambivalence about Christian tradition, 221–23; and Coleridge, 228, 249–50; *Ecclesiastical Sonnets*, 221; England's Romantic revolution, 221–23, 227–28, 249–52; and the German Enlightenment, 250; *Guide to the Lakes*, 243; interest in Renaissance art (response to Michelangelo's *Pietà*), 221–22; "Lines Composed a Few Miles above Tintern Abbey," 228, 243–44; and the "natural sublime," 243–44; and nature/landscape, 221–23, 228; *The Prelude; or Growth of a Poet's Mind*, 249–51; themes reminiscent of Friedrich's images, 250–51

World War I, 299–300

Xenophon, 32

Yellow Christ, The (Gauguin), 279

Yellow Crucifixion (Chagall), 330, 341–45, **342**

Young, Edward, 236, 243, 301

Yung-Yiddish movement, 339

Zhitlovsky, Chaim, 339

Zola, Émile, 270–71

Zurich Bible (*Die gantze bibel*) (1536), 204, **204**

Printed in the USA
CPSIA information can be obtained
at www.ICGtesting.com
LVHW061628010923
756968LV00002B/29